CRITICAL ISSUES IN
AMERICAN ART

CRITICAL ISSUES IN AMERICAN ART

A Book of Readings

edited by
Mary Ann Calo

ICON EDITIONS

A Member of the Perseus Books Group

For David Tatham and
Eric Van Schaack

Copyright © 1998 by Westview Press, A Member of the Perseus Books Group

Published in 1998 in the United States of America by Westview Press, 5500 Central Avenue, Boulder, Colorado 80301-2877

Library of Congress Cataloging-in-Publication Data
Critical issues in American art : a book of readings / edited by Mary
 Ann Calo.
 p. cm.
 "Icon editions."
 ISBN 0-06-430987-8
 1. Art, American—Themes, motives. I. Calo, Mary, Ann, 1949–
N6505.C75 1998
709'.73—dc21 97-23797
 CIP

Design by Heather Hutchison

The paper used in this publication meets the requirements of the American National Standard for Permanence of Paper for Printed Library Materials Z39.48-1984.

10 9 8 7 6

Contents

Preface

The purpose of this anthology is to encourage the formation of a critical perspective on the history of American art through a selection of diverse readings on a wide range of issues, artists, and objects of material culture. It has been created in response to the need for a collection of readings in American art that exemplifies scholarship of the past two decades, during which the discipline of art history in general—and the study of American visual culture in particular—have undergone significant growth. Although directed toward an undergraduate audience, the selection should be of interest to any serious student or devotee of American art and culture.

Like all areas of humanistic study, the history of American art has been greatly enriched (and to a certain extent muddled) by an infusion of theoretical and interpretive approaches to the study of art that have undermined the hegemony of traditional methodologies and modes of inquiry. Recent scholarship suggests that the understanding of art can be grounded in visual analysis; biography and historical documents; intellectual, political, and social history; the circumstances of patronage; theoretical systems such as marxism, semiotics, psychoanalysis, and feminism; or the personal subjectivity of the viewer. What was once a rather tidy narrative of stylistic development and general historical context has become an exciting but intractable array of discursive possibilities.

In assembling this collection, I sought to provide students and teachers with varied examples of recent historical scholarship unified by a common vision of American art as encoded with a complex fusion of individual and cultural values

that have sustained and shaped its production. Wanda Corn's seminal essay on the historiography of American art supplies the intellectual frame and rationale for the selections. As a whole, the collection can be understood as an implicit endorsement of the methodological diversification Corn describes, the kind of lively inquiry that has come to characterize a field that has finally "come of age."

Although the articles are arranged chronologically, no effort has been made to present an exhaustive "survey" of American art. The responsibility of the teaching scholar (as I understand it) is to acquaint undergraduate students with the dynamic state of the field while, at the same time, giving them a solid basis of information and grasp of fundamentals. This collection is meant to supplement, complicate, and deepen the kind of general history that emerges in textbooks and in the classroom. Each article raises a specific set of questions about some notable aspect of American art, about the work of a particular artist, or about historiography and criticism. Brief editorial comments on the author's methodology and conclusions precede each selection.

The large number of essays devoted to nineteenth-century art is indicative of the tremendous expansion of scholarship on this era. American visual culture of the nineteenth century is increasingly understood in terms of the subtle merging of aesthetics and ideology, whereby works of art serve the interests of nation building. A number of these articles examine the consequences of economic development and territorial expansion as well as the subsequent interaction of cultures as borders are dissolved and realigned.

In addition to the traditional media of painting and sculpture, consideration is also given to issues of interpretation and historical analysis as they are brought to bear on photography, folk art, and popular culture.

Gender is understood here in terms of both masculinity and femininity and as such is examined across a wide matrix of related concerns, such as evolving concepts of the family in colonial portraiture, the emergence of modern feminism, the language of sexual difference in art criticism, and the articulation of urban modernity in early twentieth-century painting. The construction of racial and ethnic identity in art is explored as a process of exclusion and marginalization by which the majority culture was able to control minority peoples and assign value to their cultural production. It is also considered as an act of agency that enabled artists outside of the majority culture to undermine stereotypes and resist the encroachment of homogenizing forces on ethnically specific cultural and religious practices.

In order to reflect the current state of scholarship in American art history (inclusive of traditional methodologies and newer approaches to the interpretation of objects and context), all of these articles were selected from periodical literature published since 1980. A wide range of journals is represented and many of the articles are interdisciplinary, in keeping with the growing tendency within the field to structure art historical narratives around intellectual, social, and political history rather than stylistic developments and biography.

The decision to limit myself to periodical literature was deliberate. It has been my experience that undergraduate students rarely seek information in specialized journals because they have become accustomed to the convenience of working from the print sources (monographs and exhibition catalogs) easily identifiable through standard search devices such as on-line library catalogs and databases; this tendency has always struck me as regrettable. Periodical articles provide unique opportunities for examining art historical practice; they consist of brief but instructive examples of concisely focused, well-supported arguments—the kind we would like our students to make.

Finally, this anthology is "student oriented" insofar as the selections have been made (partly) on the basis of their potential to engage the interests of the current undergraduate population. The issues examined in these essays are indicative of questions being asked by scholars working in the field; but they also represent my sense of what, among those questions, might be particularly compelling for students today. Without pandering to the growing demand among our students for consideration of only those historical issues they regard as relevant to contemporary experience, I believe we can and must take their curiosities and questions seriously. The participation of my students at Colgate University has been invaluable in the shaping of this book, and I thank them for their candor, insight, and abiding receptivity to an expansive and dynamic history of American art.

MARY ANN CALO

1

Coming of Age

Historical Scholarship in American Art

WANDA M. CORN

As stated in the Preface, Wanda Corn's essay on the historiography of American art provides an intellectual frame for the works included in this anthology and the collection itself can be understood as implicit endorsement of the methodological diversification Corn describes. The following article was published originally in The Art Bulletin *in a series devoted to the state of scholarship in various fields of art history. The text of the essay is followed by a brief Afterword written by Corn for this anthology.*

Introduction

Although others in this series have begun their essays by attending to the upheaval within art history, that is not my first thought in writing about American art.[1] To be sure, not all is well; the same divisiveness marks the study of American art as other fields. But this in itself is remarkable. There are now enough mature scholars of American art to give this once-fledgling field the same diversity, the same "crises," and the same kind of intellectual ferment to be found in better-established areas of art history.

Personally, I champion the unrest in my field. I do so, however, because in the field of American art—so long the impoverished, unwanted stepchild of art history—controversy is a mark of health and accomplishment. Scholars of American art now enjoy the full privileges as well as the intrigues and power plays of the family table.

By any kind of quantitative yardstick, American art has recently come of age. There has been a quantum leap in the number of historians working in the field and in the amount of American scholarship published annually. There are a goodly number of museum exhibitions dedicated to American art, some of them blockbusters. All of the major museums now have curators of American collections, and several museums are given over exclusively to exhibiting and researching American art.[2] The curators and directors of American collections, many of them under forty years of age, bring with them doctoral degrees from major university art history programs, where, for the first time, American art enjoys some respectability and legitimacy. As evidence of this new status, four art history graduate programs in the past two years have

announced endowed chairs for historians of American art and a major foundation has undertaken to support graduate work in American art.[3] Three graduate art history programs, those at the University of Delaware, at the City University of New York, and Yale University, offer programs with a strong concentration in the field. Each year, too many symposia on American art take place to enumerate, and a good number of journals solicit American art scholarship.[4] In recent years, the Smithsonian has become the national home for several specialized archives and libraries dedicated exclusively to the field.[5] There is even now an informal organization, the Association of the Historians of American Art (AHAA), which meets annually at the College Art Association convention and issues a newsletter to keep its members abreast of activities and to solicit information for scholarly projects. Finally, as the art headlines remind us often, there is an appetite and a pocketbook for the collecting of American art today that is unprecedented. Million-dollar price tags for nineteenth-century masterworks by such artists as Samuel F.B. Morse and Frederic Church have set records that have taken everyone by surprise.[6]

This situation is vastly different from when I began my study in the field twenty-five years ago. In the early 1960s, the support system for American art scholarship was almost nonexistent. There was very little intellectual or financial encouragement from graduate schools to work on objects most teachers and students found dull and provincial or in a field that had almost no specialized literature. The most prominent scholars were doing their work from the museum, whereas in the academy one could find only an occasional undergraduate survey course in American art. And everyone in American art was self-trained, motivated by love for the work or curiosity about the development of the field. Some, like Lloyd Goodrich, Robert Hale, Oliver Larkin, and Daniel Mendelowitz, were artists turned historians of American art. Others, like

E.P. Richardson and John Baur, had transferred skills they had acquired as historians of European art to the American field, a pattern that would be followed by people like Wayne Craven in a later generation. A few, such as Virgil Barker, James Flexner, and Alfred Frankenstein, were free-lance writers or journalists who had discovered an unexplored gold mine in the story of American art. Charles Coleman Sellers, a descendant and an important historian of the Charles Willson Peale family, was a librarian.[7]

To learn the American art field without the benefit of courses was not an awesome task; one could read the secondary literature in a short period of independent study. This literature consisted of a few early, Vasari-like histories, and an occasional monograph on major artists such as John Singleton Copley, Winslow Homer, and Thomas Eakins.[8] There were useful thematic surveys, most of them the first of their type, which mapped out areas such as Colonial painting, romantic painting, still-life painting, and landscape.[9] There were but two early studies on American sculpture, and one on early twentieth-century American painting.[10] What the field had in any number were survey texts that charted the past through a series of artists' names and works organized according to style and period. Two of them, those by Suzanne LaFollette and Oliver Larkin, today stand out for their early efforts to place art in a historical setting.[11]

Unlike fields such as Renaissance art or modern French painting, the specialized literature in scholarly journals was minuscule. There were very few articles on individual artists or single works of art, almost no iconographical or patronage studies, and little that might be called theoretical. The only big issue that scholars openly debated was the "Americanness of American art," which I will return to later.

The recent efflorescence of scholarship in American art stands in marked contrast to the scattered activities of a quarter of a century ago. In 1988, it is as difficult to keep up with current

literature as it was easy in 1963 to get a grasp of 150 years of writing about American art. Not only are there now a host of new scholars writing about American art but there is cross-over from other art-historical subfields, as established scholars of European or contemporary American art, such as Michael Fried, Albert Boime, and Robert Rosenblum, write on historical American art.[12] Scholars from abroad have also entered the field, writing dissertations, books, and exhibition catalogues of pre-1945 American art, many in their native tongue.[13] And like other fields in art history, American art is increasingly attracting scholars from literature and history who bring to their study the traditions of other disciplines.

It is the astonishing growth and maturation of American art scholarship since the early 1960s that I shall address in this essay. This was the approximate date when a first generation of university-trained art historians elected to make American art the primary focus of their study and slowly replaced the self-tutored art historian who once dominated American art scholarship. In outlining the academization of American art, I obviously cannot touch upon every scholar and scholarly publication of the period. Rather, I have chosen to mention or briefly discuss only those works which help support a general theme or observation. And since all but the younger historians of American art know these events well, I direct this essay as much to those outside the field as those within.

Before turning to the development of American art scholarship since 1960, I want to discuss three traits that have been characteristic of the study of this fledgling field from the nineteenth century to the present. First, I shall say a word about a certain nervousness encountered in American art scholarship over questions of quality. Historians of American art have until very recently felt that they had to defend the aesthetic merits of the work they study or, conversely, to assert clearly that the art they studied was provincial and indebted to Europe. Secondly, I

will comment briefly upon the fact that American art has almost always been viewed from a national rather than an international perspective; and, thirdly, I will speak to the strong influence of the museum on the kinds of scholarship that have traditionally been pursued. At the conclusion of my essay, I will offer some personal reflections about problems in the field, for the late coming-of-age has given Americanists much to celebrate but left them with handicaps to overcome.

The Matter of Quality in American Art

Traditionally, critics and historians of American art have pursued their work knowing that the objects they study are considered inferior by others. This has often led them to be overly apologetic. The roots of this feeling run deep, stretching back into the eighteenth century when the first American artists and intellectuals voiced their doubts whether a country as young and unsophisticated as theirs could breed fine arts: "A taste of painting is too much Wanting," lamented John Singleton Copley in the 1760s.[14] In the nineteenth and early twentieth centuries, these concerns continued and were exacerbated by European critics who routinely judged New World painting and sculpture inferior to their own. While American architecture was often praised for its competence and even, in time, for its originality, the visual arts rarely received any compliments. From the Englishman Sydney Smith, who in 1820 asked disdainfully, "Who Looks at an American picture and statue?" to the Art Nouveau entrepreneur, Siegfried Bing, whose treatise of the 1890s on the American arts judged local painting and sculpture ambitious but unoriginal, to the influential Marcel Duchamp who in 1917 proclaimed American contributions to world culture to be bridges and plumbing, foreign critics have ignored or maligned the achievements of New World artists.[15] Given that

Americans for a long time looked to Europe for legitimation of their arts, and for their models of art-historical scholarship, these judgments have deeply colored scholarly responses to native talents.

After World War II, the primacy of connoisseurship and formalism as general art-historical methods reinforced the ongoing view that American art has always developed within the shadow of Europe. The connoisseur's concern for quality and exquisite surfaces, and the formalist's obsession with originality of composition or invention of form, made it difficult for all but the most determined to see in American art anything other than pale reflections of Europe. American landscape painters were seen as less adventuresome and more literal than French ones; Winslow Homer and Mary Cassatt were judged incapable of dissolving form as did their peers among the Parisian Impressionists; the early moderns were considered timid abstractionists and followers of the European avant-garde.

The pressure to underline the provinciality of American art by comparing it to the sophistication of art in Rome, London, and Paris came not just from European-oriented connoisseurs but even more from modernist critics and historians whose formalist methods and building of family trees around "isms," influences, and pedigrees dominated so much art-historical thinking in the 1950s and 1960s. These methods—so very useful in promoting the originality and progressive character of contemporary American art—badly damaged and retarded the appreciation of earlier American expression. In the exhilaration over American abstract painting, and the touting of New York's long-awaited "triumph" over Paris, critics like Clement Greenberg attached the new painting to the lineage of European modernism, not that of America. Abstract Expressionism became the natural heir to European Cubism and Surrealism. In this view, the history of "good" and "important" American art began in the 1940s, and anything earlier was an undistinguished prologue.

The effects of such thinking on the study of the history of American art, a field that had gained some momentum in the 1930s and 1940s, were dramatic. In 1949, the trustees of the Whitney Museum of American Art, the guardians of the only New York museum dedicated to American art, voted to sell *all* of their fine collection of American works prior to 1900, the proceeds to be used to buy twentieth-century art. (The decision was reversed in 1966 but then reinstated in 1978. In December of last year the Whitney Museum sold at auction two gifts the museum had received in the 1960s, a Martin J. Heade painting and one by John Singer Sargent, and in January, 1988, a rare painting by one of the country's first black artists, Joshua Johnson, which the Whitney had received as a gift in 1970. These are steps in the final divestiture of the museum's collection of early American art.)[16] In the university curriculum during these years, classes in American art came increasingly to mean courses in contemporary art, rather than historic art. And when earlier art was taught or exhibited, it was presented as leading the way to the "triumph" of 1945. Just as the late, misty paintings of Turner and Monet were voided of content to become early models of flat and abstract painting, so were seascapes by Winslow Homer and Albert Pinkham Ryder. William Harnett and John Frederick Peto, both rediscovered during this period, were presented as proto-Surrealist and proto-Cubist respectively. And in one deservedly controversial exhibition, "The Natural Paradise: Painting in America 1800–1950," the Museum of Modern Art's Bicentennial exhibition in New York (1976), all the early American nature and landscape painters were interpreted as precursors of the New York School.[17] Although the exhibition was intended as a corrective to those which would place the roots of contemporary American abstraction in Europe, rather than America, and was a beautiful display of sublime paintings, its interpretive structure was completely ahistorical, uprooting nineteenth-century American art from its own moment in time and

making its prime importance that of anticipating a great moment yet to come.

In suggesting that there was something like an artistic tradition in the American painters' transcendent and sublime responses to nature, however, "The Natural Paradise" exemplified one defensive strategy that was very successful in surmounting the inferiority problem and keeping the study of American art alive. This strategy pictured American art not as a stepchild to Europe but as having its own, exclusively national character. This brings me to a second prominent feature of much American art scholarship, its nationalist thrust.

The National Focus of American Art Scholarship

Though most art historians tend to define their specialty according to national or at least linguistic areas, as indeed do historians of all persuasions, scholars of American art are more *obviously* national in focus than others.[18] They do not disguise the fact, as could be said of historians in other fields, that their interest has geographic boundaries. Unlike scholars of nineteenth- and twentieth-century French, Italian, Dutch, or German art, all of whom we call "modernists," scholars who write about pre-1945 American art are not called modernists but "Americanists." American art is generally exhibited separately from other art in our major museums (thus the familiar ring of museum nomenclature like the "American wing" or the "American rooms"). Whereas Europeans are likely to refer to their great museums of national expression by the name of the building—the Musée d'Orsay or the Uffizi, for example, and not the National Museum of French or Italian art—in this country there is the National Museum of American Art, the Terra Museum of American Art, the New Britain Museum of American Art, and the Whitney Museum of American Art. This country also has the

Archives of American Art, the *American Art Journal,* the *Smithsonian Studies in American Art,* and the *American Quarterly,* which by their very titles distinguish themselves from European journals and announce an exclusive dedication to national studies.

Such language did not come into being accidentally. It originated in the habit that many collectors and scholars formed early on of isolating the study of American art from the larger culture of the West. Indeed, twentieth-century scholarship has often been at its strongest and most innovative when it studied American art within the specialty of American conditions. Such a mode of discourse had its beginnings in the years around World War I, when a number of cultural critics—Van Wyck Brooks, Paul Rosenfeld, Waldo Frank, and Lewis Mumford, for example—began to think about what was inherently national and "American" about American art and letters. It was in these same years that artists spoke of writing the great American novel or painting the great American picture, and when both American history and literature began to be taught in university curricula as specialized subjects. Eventually a large number of analytical studies emerged from the academic world that examined American thought and culture in the context of its social setting: one thinks of the great works by Vernon Parrington, F.O. Mathiessen, Perry Miller, and Samuel Eliot Morison. By the 1930s and 1940s, there was so much interest in native traditions and habits of thought that American Studies programs—or American Civilization programs, as they were often called—proliferated throughout the country.[19]

Scholars of American art never became intellectual leaders in American Studies circles in those early days, but many of the questions they posed of American art were molded by the same self-conscious examination of the national mind and character as expressed in these new studies and academic programs. Some, like LaFollette, Larkin, and James Thomas Flexner, wrote histories connecting art to social and economic forces

peculiar to the New World.[20] Others, such as Alan Burroughs, Holger Cahill, and Oscar Hagen—and later John McCoubrey and Barbara Novak—were more intent upon identifying an indigenous and exclusive "American" style in art.[21] Using the tools of stylistic analysis, this latter group posited relationships between recurring forms and national temperament. If American art seemed predominantly linear, descriptive, and tied to fact, it was because the culture was pragmatic, middle-class, and materialist. If American art was blunt, unsensuous, and restrained in emotion, this had to do with the country's Protestant and Puritan heritage.

From the 1930s through the 1960s, there was a great deal of such argument, particularly around questions of eighteenth- and nineteenth-century American painting. Most of it seems dated today, and younger generations are embarrassed by the insistent nationalism in this "Americanness of American art" school of writing, and its broad sweeping consensus statements that forced the rich diversity of American art and experience into hegemonic categories. But in our quickness to condemn our elders, we should not lose sight of why it once seemed so important to try and define "Americanness." Nor should we forget that it was precisely this kind of nationalist focus that brought into being most of today's museum collections, wings, and galleries of American art. This scholarship, by avoiding the bugaboo of provinciality, was responsible for finding the terms in which pre-1945 American art could be exhibited and studied. By focusing on uniqueness and exclusivity, one could explain the visual and intellectual appeal of American art without having to apologize for the fact that it did not measure up to the innovation and originality of its European peers. One could judge the extraordinary realism of Copley's Colonial portraits on their strengths as middle-class, democratic, American-style portraiture rather than hold them up against the late eighteenth-century English aris-

tocratic portraits painted by more schooled artists. And if one understood Winslow Homer as someone whose nationality preordained him to be a pragmatic realist, one could rescue him from those art historians so tied up with mainstream styles that they could only see the artist as an Impressionist *manqué*.

The Americanness issue enabled scholars to turn what had commonly been assumed to be a provincial and marginal body of work into a complex and intellectually exciting project. The whole exercise helped legitimate American art for the classroom and serious scholarship. Furthermore, by separating American endeavors from European art, historians of American art found a new audience for their work: the student of American culture. Long before the recent interest in interdisciplinary studies, historians of American art formed a natural affinity with their colleagues in American literature and history. But, ironically, by accentuating the special nature of the nation's art, the "Americanness of American art" approach also served to ghettoize the field within art history. Given that American art seemed to engender its own set of scholarly problems, it became easy and convenient for colleagues in other subfields of art history to leave Americanists to their own devices. There has never been, sad to say, any significant criticism of American art studies from cognate fields within the discipline of art history.

One reason that many art historians take minimal interest in American art is that it has never had the kind of towering figure, a Charles Rufus Morey, Bernard Berenson, or Erwin Panofsky, whose work decisively shaped or ordered the field. Nor has it had scholars whose writings are so innovative and provocative that they have set new art-historical standards of scholarship. The writing of the history of American art has been a more collective effort, a brick-by-brick construction of a national history. Many of these bricks have been documentary or archival in focus, of interest primarily to specialists, collec-

tors, and museum-goers within the American field.

The Dominance of the Documentary Monograph

Scholarship in American art has always been dominated by a documentary tradition, usually focused upon the life and work of a single artist, a school of artists, or a genre of art (still-life painting, the portrait, genre painting, marble sculpture, etc.). Though critics have recently complained that art-historical scholarship as a whole suffers from an overly documentary emphasis, if one compares work in American art with, say, French painting studies of the nineteenth and twentieth century, there have traditionally been far fewer types of questions raised and approaches used in the American field. Americanists tend to be very much tied to the reconstruction of careers, the description of styles, and the delineating of paths of influence. They have never done much with iconography. And there are relatively few studies of institutions, patronage, taste, and art criticism. Apart from survey textbooks and studies of the "Americanness of American art," there are few good exemplars of the broad-based, synthetic scholarly study. Nor are there many books or essays based on what might be called historical or intellectual "problems": such as why three major artists, Eastman Johnson, Homer, and Eakins, simultaneously lost interest in genre painting in the 1880s; or why William Harnett succeeded as a *trompe-l'oeil* still-life painter just at the point that other painters were giving up illusionism altogether.

There are reasons why American art scholars have been predominantly archaeological and documentary in approach. The one put forth most often is that the field is young and still lacks the basic foundation literature of more established fields. There are no biographical or stylistic studies for many important American artists and there are few *catalogues raisonnés*. Many museums

have yet to publish their American collections, and important works in private hands are still unpublished. Given how very few people have worked in the field, there has been plenty to do just figuring out who did what when and discovering where paintings and sculptures reside.

But a more important reason for the prevalence of the documentary monograph has to do with the intimate ties between American art scholarship, the museum, and the marketplace. The museum—not the university—traditionally has been the primary sponsor of scholarly work and, until fairly recently, the main source of employment for those wanting to work in the American field. From the 1930s through the 1960s, almost all of the important American art scholarship—excepting that of textbooks and "American mind" studies—had some connection to exhibitions and objects in museum collections. Much of it still does today. As a result, the museum's standard approach to scholarship, that of cataloging, describing, and venerating the artist and the work, has dominated American art studies, even when pursued by nonmuseum scholars. Because the academy has been so hesitant in its support, the American art field has not been much affected, as have more established fields, by the philosophical and methodological diversity typical of the university.

In the last decade, however, scholarship in American art has begun to entertain new approaches, some of them coming from the new interests in literary and critical theories, others from interdisciplinary exchanges. The new breadth of work also has something to do with the fact that the museum has ceased to be the only publisher or employer for Americanists. There are now alternative outlets for scholarship in the strong entry of university presses into the art history market, along with periodicals such as *Winterthur Portfolio* and *Prospects,* which, unlike other journals in American art, encourage argumentative and interpretive work. Most important, the creation of university jobs for the

teaching of American art has afforded American-
ists the opportunities long available to other
fields: an open-ended forum for ideas that do not
necessarily lend themselves to exploration
within a museum exhibition.

Ironically, as some scholars move away from
the museum, with its inevitable links to collecting,
others are drawing closer to the commercial
world. In recent years, private galleries have be-
gun to hire resident scholars to do archival re-
search on paintings and produce *catalogues
raisonnés*. Indeed, if this practice becomes popu-
lar, galleries may someday be a primary under-
writer of basic research on individual artists in the
same way that corporations have become the fi-
nancial backbone of exhibitions. It seems a curi-
ous coincidence that, at the very moment many
Americanists are moving away from publishing
basic monographic studies, galleries have stepped
in to take over the job.[22] Though American art
needs professionally prepared *catalogues raison-
nés,* and scholars need financial support for such
mammoth and time-consuming undertakings,
there are dangers when scholarship gets inti-
mately tied to commerce, without the mediation
of a more interest-free agency, such as a museum
or foundation. For no matter who pays for the
writing of a monograph, one of the uses it will al-
ways have is to help find lost pictures, sell works,
and increase the value of the artist's entire *oeuvre.*
A gallery need sell only a few paintings a year to
recover the salary of the scholar or scholars whose
research can generate many more sales. The new
marriage between dealers and scholars may be a
sign of our times, but should be a matter of much
more discussion and concern.

**The Academic Study of American Art:
The First Generation**

We can picture today's scholarly community of
university-trained Americanists as forming an
inverted pyramid, one that has grown much fatter
in the 1980s, as increasing numbers of students

elect to pursue doctoral studies in American art.
Milton Brown, who did his doctoral work in the
1930s and early 1940s, occupies the narrow base
of the pyramid.[23] Above him would be a group of
art scholars who wrote dissertations in American
art in the late 1950s and 1960s. The pyramid
then widens out at the next level with a second,
slightly younger, and larger number of Ph.D.-
holding scholars who began to publish on Amer-
ican art in the 1970s. Finally, at the top of the
pyramid, we find a third group, those scholars
whose first books, articles, and museum cata-
logues have begun to appear in the last few
years. This last group is the first to have had reg-
ular courses in American art, having been taught
by those below them in the pyramid.

The first institution to award a large number of
graduate degrees in American art was Harvard
University, ironically the only leading graduate
art history program in the country today to show
no interest in hiring an Americanist for its faculty.
But in the 1950s and 1960s, conditions were fa-
vorable at Harvard for students interested in
American art. There was a distinguished program
in the History of American Civilization at the
university, which included such major figures as
Perry Miller, Samuel Eliot Morison, Oscar Hand-
lin, and Kenneth Murdock. And at the Fogg Mu-
seum at Harvard, until his death in 1972, there
was Benjamin Rowland, Jr., who recruited more
students into the study of American art than any
other figure of his day. Rowland was a specialist
in Oriental art, especially that of India, but he
also wrote about and taught Western art, and took
a special interest in American art. As a very ac-
complished watercolorist and an eclectic collec-
tor, he found it as easy to talk about John
Audubon, Charles Demuth, and Charles Burch-
field as he did about Chinese painting or Indian
miniatures.[24] His courses on American art in-
spired a number of students to write M.A. theses
and doctoral dissertations on American topics.

Collectively, this group—Richard McLan-
athan, Jules Prown, Nicolai Cikovsky, William

Gerdts, Barbara Novak, William Homer, Stuart Feld, John Wilmerding, and Theodore Stebbins—began in the late 1950s and 1960s to map the still largely virgin American field, particularly the nineteenth century. Along with David Huntington from Yale's department, Abraham Davidson and Irma Jaffe, who did American art dissertations at Columbia, E. Maurice Bloch and Sheldon Reich at the Institute of Fine Arts, and Matthew Baigell, who did his work at the University of Pennsylvania, this was the pioneer generation in the academy. Among their numbers one must also count three important cultural historians who have made art a primary focus of their work: Lillian Miller, who took her degree in American History at Columbia, and Neil Harris and Roger Stein, who were students at Harvard, Harris in the History department and Stein in the History of American Civilization program.

The contributions of this group were, and continue to be, manifold. Lillian Miller's and Neil Harris' books on American art patronage and institutions, both published in 1966, still stand alone as the only major studies on their subject.[25] Roger Stein's book on John Ruskin's influence in American art and thought gave American art one of its few intellectual histories and opened up a subject that was explored more recently in the Brooklyn Museum's beautiful exhibition on the short-lived Pre-Raphaelite movement in mid-nineteenth-century American art.[26] From those trained in art history came the first modern studies of John Singleton Copley, Washington Allston, Frederic Church, Fitz Hugh Lane, Martin J. Heade, George Caleb Bingham, Winslow Homer, George Inness, Robert Henri, John Marin, and Joseph Stella.[27] From these scholars also came the grand exploratory survey, opening up new areas of artistic study: Wilmerding's survey of American marine painting; Stebbins' exhibition and catalogue on American drawing and watercolors; and Gerdts's exhibitions and books on still-life painting, American Impressionism, and Neoclassical sculpture.[28] Along with

Gerdts's scholarship on sculpture, a medium that has always been the artistic underdog in American culture, came Wayne Craven's pioneering survey text of the subject in 1968, and his creation of an important resource, the Inventory of American Sculpture, now administered by the National Museum of American Art.[29]

Using the museum exhibition as one of their primary tools, the generation of the 1960s, if we might call them that, often used exhibitions and catalogues for dissemination of new research. Indeed, one of the distinguishing marks of this group is their strong connections to museums and collecting. Almost all of them have served at one time or another in museum posts, or have directed exhibitions as guest curators. Some have served as advisors to private collectors of American art; a few have built their own collections. One of this first generation of academically trained scholars, Stuart Feld, began his career as a curator at the Metropolitan Museum and is today a major New York dealer in American art.

When, in 1970, the Metropolitan Museum mounted the stunning exhibition "19th-Century America: Paintings and Sculpture" and invited scholars from around the country to both a black-tie dinner and symposium, it was a highwater mark for scholars in the field.[30] The study of American art now seemed to have a center of gravity in the nineteenth century. This was reenforced by Jules Prown's Skira survey text on eighteenth- and nineteenth-century American art, with its handsome tipped-in illustrations, and John McCoubrey's extremely useful *Sources and Documents* book in the Prentice-Hall series, which helped root the study of American art in primary sources.[31]

In most of this new work, it was mid-nineteenth-century landscape painting that garnered attention. At the same moment that Rachel Carson was writing *The Silent Spring* (1962), the book that ushered in the modern ecology movement, and the Pop artists were bringing theatricality and literalness back into modern painting,

scholars began to find new visual excitement and meaning in romantic and realist landscape paintings. Their rediscoveries also owed something to the New York School painters, whose wall-sized canvases helped scholars see anew such grand-manner landscapists as Church and Albert Bierstadt.

David Huntington was the first to re-explore the great operatic canvases of Frederic Church, so famous in the nineteenth century but, in the mid-twentieth, roundly condemned for their "emotional inflation" and Hollywood rhetoric.[32] In the mid-1960s, while completing his book on the artist, Huntington initiated the successful campaign to save Olana, Church's extravagantly neo-Moorish house and studio, dramatically sited on a hillside high above the Hudson River. His efforts helped preserve the house and its exotic furnishings, today one of the country's few architectural treasures connected to a fine artist. While Huntington worked on Church, his peers at Harvard began to look anew at Lane and Heade, taking their cues from Maxim Karolik's maverick collection of nineteenth-century American paintings, watercolors, and drawings, given to Boston's Museum of Fine Arts in 1949, and from Robert Vose and Charles D. Childs, dealers who were among the first to promote the canvases of the American landscape school.[33]

Rich in the work of Heade, Lane, and Bierstadt, as well as other landscape and marine paintings by artists whose names had been forgotten, the storerooms of the Karolik collection were a treasure trove to the young Americanists, some of whom began to scout for similar paintings up and down the Atlantic seaboard. First Richard McLanathan and then Wilmerding, Stebbins, and Novak began to write on artists featured in the collection, particularly Lane and Heade. ("I wrote all my first books out of that collection," said Wilmerding recently.)[34] Their efforts culminated in two scholarly events: the publication in 1969 of Barbara Novak's important study of American art and, eleven years

later, a blockbuster exhibition of nineteenth-century American landscape painters inaugurating John Wilmerding's appointment as curator of American art at the National Gallery of Art in Washington, D.C. The exhibition was accompanied by a catalogue of essays written by nine contributors, five of whom, significantly, had taken their degrees from Harvard University.

Novak's book, *American Painting of the 19th Century,* was an ambitious effort to rework the question of an American identity in art. In searching for the ever-elusive "Americanness" of American art, her book followed by a few years the much shorter *American Tradition in Painting* published by John McCoubrey in 1963.[35] Taken together, these were the last two major efforts to try to define a continuous American tradition from Copley to the present. Both were richly theoretical and stimulated response and debate as few books in American art ever had.

While Novak and McCoubrey each found a thread that gave unity to their inquiry, it was by no means the same one. Indeed, the two works provide a fine illustration that writing history is culturally determined and bound to its moment as much as to its writer. In McCoubrey's study, conceived in the late 1950s, one finds the kind of existentialist and psychological probing common to intellectuals following World War II, while in Novak's work not quite a decade later, one is struck by the heavy presence of formalist analysis that so dominated aesthetic discourse in the 1960s. McCoubrey's description of national traits led to a natural conclusion in the anguish and soul-searching of the Abstract Expressionists, whereas Novak's theories, based primarily on her study of the limners and nineteenth-century painting, had their most current manifestations in the depersonalized works of the Minimalists.

For McCoubrey, American painting had from the eighteenth century been about alienation, loneliness, and dislocation, precisely those qualities which so many artists and intellectuals

found characteristic of modern life in the Post-war period. Indeed, McCoubrey suggested, American art could be said to be the first truly modern art in that it had always documented man's inability to be at home in an inhospitable land. From the country's earliest portraits revealing "the unyielding Puritan temperament," to the Hudson River School where the figure was dwarfed by the immense, immeasurable void of the landscape, to the chaos and instability one felt before a New York School painting, the American artist expressed a perpetual inability to root himself in his land and culture.[36]

If Novak eschewed McCoubrey's psychological readings of canvases, in the same way that the young Frank Stella would have none of Jackson Pollock, she was still committed to the quest of uncovering native qualities in American painting. She looked at the ways American artists translated their perceptions of reality through enduring concepts and ideas about nature, many of which she found expressed in the writings of the nineteenth-century Transcendentalists. Drawing upon Wölfflin, Greenberg, and Gombrich, she posited that there were two traditions in American art, a dominant mode that was linear, measured, and conceptual, and an ancillary one that was painterly, atmospheric, and romantic. The first tradition, she argued, gave rise to an indigenous school of nineteenth-century painting exemplified by Heade and Lane, which she called "Luminism," a descriptive term that John Baur had earlier applied to a few nineteenth-century artists.[37] Novak's second tradition described artists who were more international and cosmopolitan in their outlook and had often been trained in Europe. By way of these two traditions, she accounted for the "look" and surface quality of virtually every major American artist.

Novak's book gave to the study of American art the dignity of a Wölfflinian-type treatise and to American Studies an interdisciplinary approach that placed artists on the same plateau as such well-established writers as Emerson. That was an event in itself, and the book was well reviewed, particularly by literary historians. In her central argument about "Luminism," however, which alleged that an indigenous American tradition could be found in painters as diverse as Lane, Heade, Mount, Bingham, and Homer, Novak gave the study of nineteenth-century painting a concept that has bedeviled subsequent scholarship. Though Novak has always been clear about what *she* meant by the term—she has outlined the characteristics of "Luminism" point by point in a subsequent essay—others have not.[38] The term today is applied in such wildly different ways that no one, professional scholar or beginning student, can understand what it means or how it should be used. Every exhibition of American landscape painting since Novak's book has only added to the confusion. In his exhibition "American Light: The Luminist Movement, 1850–1875" (1980), John Wilmerding applied the term "luminism" as a kind of synonym for "light," so that it fit almost every American artist in the nineteenth century, including landscape photographers. Yet in the catalogue to that exhibition, an anthology of different essayists, one contributor complained about a term that took paintings completely out of context and purported to describe indigenous American qualities when there were English, German, Scandinavian, and Russian paintings that were as "luminist" as any done in this country.[39] The scholars of the recent exhibition of Hudson River School paintings at the Metropolitan Museum (1987) admitted that the term is not as useful as it once was, and carefully described how the word came into currency, but they politely skirted the whole controversy and continued to use "luminism" to describe certain stylistic features in Gifford, Kensett, and Heade.[40] Confusion reigns and will not go away until scholars are willing to debate the subject openly and come to some new agreements as to how nineteenth-century landscape painting ought to be ordered and described. For all the scholarly attention lav-

ished upon nineteenth-century landscape paint-
ing, it is remarkable how muddled the issues
continue to be.

The Revisionists

Before the first generation of academically
trained Americanists had much of a chance to
exert any influence, another group was emerging
from the academy and bringing different con-
cerns to the study of American art. Developing
as scholars in the heated political atmosphere of
the late 1960s and early 1970s, this group (of
which I count myself), like their peers in most
fields of art history, chafed at the narrow defini-
tion of their field. They rebelled against the
elitism and restrictiveness of a canon that privi-
leged male artists and high art masterpieces—
particularly landscape artists and paintings from
the Northeast. The defense of this canon, primar-
ily on aesthetic grounds rather than historical
ones, led this new group to question the way that
art historians wrote history.

In the 1970s, scholars did not so much reject
the artists in the existing canon as they added to
it: women artists, black artists, Chicano artists,
academic artists, untutored artists, regional
artists, mural painters, and genre painters, all of
whom had not yet received the same kind of at-
tention that the landscapists had.[41] By the end of
the decade there was so much new information
and so many new questions raised about tradi-
tional art-historical taxonomies and methodolo-
gies that survey books in American art suddenly
stopped appearing.[42] Synthesis, at least in the
sense that consensus historians had understood
it, no longer seemed possible.

No one did more to implement this new revi-
sionism than Joshua Taylor, whose eleven years
as director of the National Museum of American
Art (then called the National Collection of Fine
Arts) were given to exhibiting and researching
artists that the more established museums ig-

nored. Under his leadership, artists who were but
names in textbooks received full-dress exhibi-
tions: George Catlin, David Blythe, Lily Martin
Spencer, Emanuel Leutze, Elihu Vedder, Arthur
Wesley Dow, Marguerite Zorach, Peggy Bacon,
Alfred Mauer, Hugo Robus, H. Lyman Saÿen,
and Lee Gatch.[43] In 1976, at the time of the Bi-
centennial, Taylor did his own kind of survey ex-
hibition, "America as Art," which played down
landscapes, the most respected American paint-
ing at the time, and instead highlighted images
of people, folk and community life, the Wild
West and city scenes, and popular American
symbols and myths. The book he wrote to ac-
company the exhibition, innovative in its consid-
erations and scholarly in tone, was not intended
exclusively for the specialist but for the broad
new audience Taylor wanted to cultivate for
American art.[44] A man who loved his prose as
well as the art he wrote about, Taylor traded off
footnotes for accessibility whenever possible, a
habit that often infuriated his colleagues. But in
looking back over his accomplishments, it is
clear that his underlying populism, and his impa-
tience with the official readings of American art,
as well as his attention to works made in regional
art centers throughout the country, not just the
Northeast, were qualities in sympathy with the
times. In an era when the Smithsonian still gave
its museum directors time to be scholars, and did
not ask them to be fundraisers, Taylor emerged
as a major leader and facilitator in the field. His
early death in 1981 was a great loss.

Many of Taylor's exhibitions focused on inter-
national artists, drawing attention away from the
"Americanness" issue to questions of transat-
lantic influence and exchange. (At the time of
his death, he was planning a major historic exhi-
bition on American artists who worked in Italy.)
In his resurrecting of the academic and Beaux-
Art traditions in America, he was joined by a
number of younger scholars whose first museum
exhibitions and dissertations steadily recovered
the work of artists who had trained and worked

in Europe. The issue had become, as Barbara Weinberg succinctly put it, to see artists in the light of their "nurture" abroad rather than their American "nature."[45] The focus of this new work was primarily on the late nineteenth century, the period historians traditionally dramatized as the time of conflict between official, mainstream culture and the adventuresome art of a few Realist and proto-modern artists. But the emphasis now was less on celebrating those polarities, or the marginality of a Whistler or Homer, than on understanding the complexities and diversities of visual tastes in the Gilded Age. To do this, scholars had to understand the mainstream culture that modernist artists and scholars had long rejected.

As scholars of European art turned to reassessments of major French academicians and Beaux-Arts architecture, Americanists looked at American-born artists and architects who worked in those same traditions. Lois Fink, Barbara Weinberg, and David Sellin resurrected the careers of dozens of artists who worked in France.[46] Michael Quick mounted an exhibition on artists who had studied in Italy, France, Germany, and the Netherlands, followed by another on Grand Manner portraiture.[47] One team of scholars put together an eye-opening exhibition on the American Renaissance, while another began to tackle the multifaceted career of John LaFarge.[48] With a slightly different emphasis, but equally international in focus, two major museum exhibitions examined the influence of the Barbizon School painters and Jean-François Millet on American painters.[49] Monographic studies on Neoclassical sculptors began to appear, as did guides to outdoor public sculpture.[50] When the Whitney Museum mounted two broad, panoramic exhibitions in the late 1970s, one on sculpture and another on turn-of-the-century art, the new pluralism put academic artists side by side with progressive ones.[51]

The full range of modernist expression also began to emerge as art historians debunked both the mythology of the isolated and struggling genius as well as the evolutionary construct that presented early twentieth-century modernists as "pioneers" paving the way for the New York School. Charles Eldredge's exhibition, "The Imaginative Tradition," demonstrated that, alongside Ryder, Homer, and Eakins, there were indeed Symbolist painters at work, artists once thought wholly foreign to American shores.[52] Other exhibitions located further American variants of Post-Impressionist styles and sensibilities, helping to fill in the gap between Impressionism and the Armory Show.[53] William Homer, in a path-breaking exhibition at the Delaware Art Museum on American avant-garde painting and sculpture from 1910 to 1925, began to uncover and reassess some sixty different men and women who worked in modern idioms, fleshing out the skimpy accounts to be found in textbooks at the time.[54] He continued this work in studies of Alfred Stieglitz and the artists in his circle, efforts that helped encourage a host of monographic dissertations piecing together the careers of the early twentieth-century modernists.[55] Several museums joined in this work, granting major retrospectives to Patrick Henry Bruce, Arthur Dove, Marsden Hartley, Ralston Crawford, and John Storrs.[56] In the fall of 1987, there may not have been a single major museum exhibition of an early 20th-century European modernist, but there were no less than three full-dress shows given to Americans of the period: Charles Sheeler, Charles Demuth, and Georgia O'Keeffe.[57] Scholarly interest in early modernism is at an unprecedented peak.

While most of this revisionism has found a growing and responsive audience, this was not necessarily the case with the scholarship resurrecting the much scorned Regionalists and WPA artists of the 1930s. Here the revisionists often met with criticism if not derision. Many people in the artistic community remembered the tensions of the art world in the 1930s and had no desire to re-experience them. Critics such as

Hilton Kramer and Clement Greenberg stood ready to continue the Regionalist-bashing that was endemic in modernist circles in the late 1930s and 1940s.[58] But as respected museums such as the National Museum of American Art and the Whitney began to examine and exhibit material of the 1930s, and as scholarship proliferated—on New Deal art, Regionalist art, figurative artists like Reginald Marsh and Isabel Bishop, and social realists such as Peter Blume, Philip Evergood, Ben Shahn, Paul Cadmus, and O. Louis Guglielmi—this "lost" decade, like those of the 1880s and 1890s, has slowly come into focus.[59] The richness and complexity of Depression era culture have only been underscored in recent years with major exhibitions on vanguard sculpture, abstract painting, and machine age art in the 1930s.[60]

Although it once seemed ironic that liberal or radical students would spend their time reviving artists deemed conservative or reactionary, there were several aspects to this revisionist work that were in accord with the progressive social agendas of the past twenty years. With all the talk in the 1960s and early 1970s about "power to the people" and grassroots politics, there was a populist side to some of the revisionism. Scholars were emboldened to focus on art that once had served either a community or mass audience, feeling that artists who had attracted regional audiences, or who had been extremely popular with a mass public, deserved serious historical attention. Art historians have traditionally criticized artists who showed local concerns and possessed national popularity, like Bierstadt and Church in the nineteenth century and Andrew Wyeth in our own. The new art historians, however, sought to understand the nature of these artists' appeal. They were also interested in questions of public values and ideology and in the interactions between popular styles and more erudite approaches. Such motivations helped sponsor research on Salon art and Regionalism, and inspired work on artists of all periods who did the bulk of their work in a particular state, in a region such as the Great Plains, the South or the West, or around a particular river or mountain range.[61]

There was also a desire to break down prejudices against middle and lowbrow art and recognize what we might call the democracy of aesthetic experience, that one man's kitsch is another man's art and that most people—even the most educated—have an appetite for a wide range of visual stimulation. It was in the 1970s that it became possible to admit that one enjoyed William Bouguereau and Grant Wood along with Claude Monet and Frank Stella, and found pleasure in neon signs as well as mountain ranges. Taste for one did not eliminate taste for the other.

Many were pushed towards their revisionist stance by the radical critique of art history itself, which questioned a discipline that focused so exclusively on art considered innovative and aesthetically superior. Joining the historian, who had long maintained that history could be written about virtually any kind of event or behavior—the key to success lay in what questions you ask—Americanists began to examine various artists, not because their work was deemed of high quality, but because they had made art that was a significant part of the historical record. This was not an easy step to take, and revisionist art historians still offer nervous assurances to readers that they know they are treating material that may be of dubious aesthetic quality, but that they do so with new goals and purposes. On the acknowledgments page of her book on post-office murals, Karal Ann Marling poked fun at her own material as well as her would-be detractors. Her graduate students, she wrote, found the murals she studied "so screamingly terrible" that she was "forced to stick with the topic to salvage [her] credibility."[62] And Barbara Weinberg reminded us at the end of her study of the American students of Gérôme that she is neither "endorsing or decrying late-nineteenth-century

French academic tendencies" and that she does not necessarily prefer Gérôme to Manet; her task, rather, was to understand that period in our history.[63]

Though much of the revisionist art history of the 1970s did little more than give us standard biographical and stylistic studies of new artists, the most innovative and experimental historians broke new ground methodologically. Finding the prevailing analytical techniques, particularly formalist analysis and the concern for artistic influences, insufficient for the tasks at hand, they struggled to replace them—or at the very least to supplement them—with techniques borrowed from other disciplines, particularly history and the social sciences, but also, in some cases, neo-Marxist and feminist theories.[64]

To take but two examples, we might look at Elizabeth Johns's study of Thomas Eakins, and one of Alan Wallach's articles on Thomas Cole's patronage, where each turned a magnifying glass on the specific culture in which the artist worked.[65] In her book Johns asked why Eakins had concentrated so much of his work on portraits of men and women in very particular occupations, some of which, like rowing, surgery, and concert singing, are not activities artists would turn to today. This led her to study the textbooks Eakins used as a boy and the curriculum of his school system, and to trace the history of rowing, medicine, and music-making in nineteenth-century Philadelphia. Though her book relied on some biographical detail, and often cited past art, its thrust was not to chart the artist's biography or discover his sources in older art, but to show how much Eakins was guided by what nineteenth-century Philadelphia honored as significant public achievement.

Wallach's work is also specific in locating those pressures within a specific community which disposed the artist to paint one kind of picture rather than another. Because Wallach is interested in social tensions, and in the way in which art is shaped by class and monied inter-ests, he studied Cole's patronage. This helped him explain what has always been recognized as a major unhappiness in Cole's life: the artist preferred to paint large, allegorical pictures conveying ideas and moral treatises, but he made a better living from his smaller easel paintings of the American landscape. By studying the complex network of Cole's patrons, and finding that they came from the old Federalist aristocracy as well as the *nouveau riche,* and by looking closely at the nature of specific commissions, Wallach demonstrated how much Cole was caught in a web of frustration from which he could not escape. The artist identified with the values of the declining aristocracy whom he wanted to please. But they were the ones who often rejected his ambitious history pictures, such as the *Course of Empire,* and bought instead Cole's paintings of landscapes. Ultimately, Wallach concluded, the aristocracy "nurtured the artist to serve their needs, not his."[66]

Both Johns's and Wallach's studies were close-up views of relatively narrow problems: what they traded off in breadth, they gained in specifics. At the time, their approaches offered striking departures from what had been the norm in the history of American art. First, they clearly identified a particular problem within an artist's work and, secondly, they used historical and social analysis to help solve it. Such problem-oriented scholarship broke away from the pattern of "doing" an artist or linking artists in great chains of style and influence. And the assumption that culture and social forces shaped art began to change the equation between art and history. Instead of history being seen as background or *juste milieu* for the work of art, as had been common in writing about American art (and still is, in some quarters), the artist and the work of art became inseparable from history. Background material now became part of the foreground; one could not have one without the other.

Perhaps the most telling index of the new efforts to locate the artist and work of art within

history in the 1970s was the dramatic increase in the number of essays that historicized single works of art. With the exception of the standard museum bulletin piece about a work in the permanent collection, or the short catalogue entry, the decoding of *specific* works of art had never been an important genre of writing for Americanists. But with the new interest in "art in context," scholars increasingly confined themselves to a single object, so they could focus on its content, patronage, relationships to cultural or political events, historical sources and/or critical or popular reception—all of which have come to pass for "context." In this spirit, Roger Stein and Ann Abrams wrote in-depth studies of early American paintings; Nicolai Cikovsky tackled canvases by Winslow Homer; Michele Bogart, Jean Yellin, and Vivien Green Fryd contextualized works of sculpture; and Karal Ann Marling wrote on major works by Demuth and Benton.[67] Exhibitions began to be created around single paintings: Gerald Carr's exhibition of Church's *The Icebergs,* for example, or Jeremy Adamson's around Church's *Niagara.*[68] In 1979 John Wilmerding, acknowledging the new trend, organized a session at the College Art Association's annual meeting on "Individual Works of Art." And in Johns's book on Eakins each of the five chapters is structured around an individual painting.

The quarrel with this scholarship is that context is often dramatized at the expense of the work of art, whose presence remains passive and inert. This is even more the case in those exhibitions and writings which try to examine social and cultural history by bringing together artists' renderings of a single theme: childhood, games, labor, schools, medicine or family life. These efforts seldom succeed, either as exhibitions or books, because they are too reductive. Works of art become illustrations of changes in social history, and the history, because it is told around pictures, tends to be overly simplified and incomplete.[69] These are, as we now recognize, some of the problems with the new efforts to historicize art. Even the most sophisticated studies of art and society—those using post-structuralist analysis to locate the work of art within history, and history within art—raise questions they do not resolve about determinacy and cause-and-effect. The project, however, continues, and contextual studies, when imaginatively conceived, offer one of the promising avenues of scholarship in the American field today.

Recent Work

While revisionism continues apace, the critique of art history that began in the 1970s has recently given rise to scholarship that goes beyond the democratizing and historicizing of the fine arts canon we have been discussing. I am thinking of the new interdisciplinary work by both art historians and literary scholars, many of whom have been allied to American Studies programs. Their writings take two different forms: the more controversial one of interpretive criticism, with its deeply theoretical bent; and the less abrasive (but potentially just as subversive) genre of material culture studies, where the fine arts are analyzed alongside popular and mass culture artifacts for their collective ideological insights into the values of the culture that produced them.

In American art, interpretive criticism has transfigured the close-up study of the single work of art, shifting the grounds of analysis from social and political concerns to psychological and sexual ones. Taking their premises from theorists of deconstruction, post-structuralism, and psychology, the new interpretive critics have found their most provocative representatives in Bryan Wolf and David Lubin, who were trained in American Studies programs; in Jules Prown, who was one of Wolf's and Lubin's teachers; and in Michael Fried, whose previous interpretive work on French art—and now on American art—has served as one kind of model for this

new work. Though all of these men envision their projects differently, they base their writing on similar theoretical premises. They presume that historians read the past guided by their own needs and values, and that history-writing is no less an act of imaginative creation than the work of the art itself. Furthermore, the meaning of the work of art is not fixed at the time of its making, but changes over time. The job of the critic (the term they use to describe themselves) is *not* to try and recover the past, as if it were immutable, so much as it is to read the work anew, to reanimate the painting by a close reading of its structure and content through the lens of a late twentieth-century sensibility.[70] From this presentist vantage point, Fried, Lubin, Prown, and Wolf have all interpreted individual nineteenth-century American paintings, choosing works like Eakins' *The Gross Clinic*, Homer's *Life Line*, and Sargent's *The Boit Children*, which are narrative in content, theatrical in nature, and built upon complicated structures of representation.[71]

The intense self-consciousness of this new writing, the autobiographical and aggressive presence of the author with his insistent use of "I," the eschewal of causal relationships, and the seemingly free flights of open-ended, but not necessarily historically verifiable, speculation have already received much comment in both the scholarly and popular press and need no further rehearsal here.[72] But the extent to which this kind of writing has animated the American art field does. For whatever one may think about the new interpretive criticism, the fact is that every serious student of American art has been reading these new essayists of late and debating their methods and contentions. That in itself is no small achievement. Not since McCoubrey's and Novak's books appeared in the 1960s has there been work in American art that has aroused such wide discussion and vehement passion.

The greatest success of this new interpretive criticism is the way in which it foregrounds the

object, and dramatizes the act of looking, and questions the oddities of what one sees. If one reads these essays as personal journeys, much like that of Walter Pater's impassioned reading of the *La Gioconda,* the interpretive approach makes for an exciting vicarious experience.[73] Like Virgil leading Dante, readers are taken by the hand through a painting much as they were under the tutelage of formalist critics, but now instead of stopping to look at elements of space, line, color, and shape, they delve into corners the new critics find important: disjunctions of narrative, evidences of fetishistic behavior, covert meanings in small details, dialectics of form, evidence of gender and class biases, sexual and psychological frustrations. There is something of the thriller here, seeing tensions and dark sides in old friends that one never suspected before. One is constantly turning the pages to look back at the work under consideration to see what the interpreter says is there. Even if one dislikes the way such writing aggrandizes the critics and theatricalizes *his* act of looking, the insistence that one look hard at works of art—and concentrate on what is puzzling and unclear—is salutary, particularly for those who have grown rusty in using their eyes or who use them predictably to talk only about style and influence.

But what antagonizes many scholars about this new work is its ambivalent if not cavalier attitude toward the writing of "traditional" history. On the one hand, these commentators present their work as if it is *not* history, but a new form of criticism. On the other hand, they often employ bona fide methods of historical analysis, and borrow liberally from the research of those very art historians whose discourse they claim is no longer their own. They act like separatists who have not yet figured out their relationship to the mother church; they want to get out and to stay in at the same time. Fried, in particular, rankles his colleagues by readily acknowledging all the ideas and facts he has borrowed from the research of other art historians, but then chastises those same

historians for "normalizing discourse," and elevates his own approach as beyond "the usual techniques of art-historical inquiry."[74] Bryan Wolf, in a more conciliatory gesture, suggests that the historian and the critic are complementary, but grants supremacy to the critic whose work begins where the historian's "leaves off."[75] Prown, the scholar most rooted in the traditions of art history, tends to wear two hats, sometimes writing as a fairly straight "historian" and at other times as the interpretive "critic." In a recent essay, he begged the question of synthesis by dividing the meaning of a work into two halves—the intended meanings (presumably for the art historian to ferret out) and those meanings "conveyed unconsciously by its deeper structure" (the work of the interpretive critic).[76]

Were these critics *just* to read deeper structures, as they often do in compelling terms, their work might well evolve into a genre in and of itself, co-existing with that of the historian. The critic would explore and speculate while the historian would offer explanation. But I doubt that any of the new critics would be satisfied with such a role. No matter how much skepticism they profess towards "normal" history writing, and how much they insist that they are critics, not historians, they all call upon historical models—some psycho-historical, others cultural—and tease the reader with bits and pieces of external evidence and suggestions of causal arguments. But "explaining" is never a primary concern. In this respect, the new interpretive work in American art is very different from that existing in French art, where T.J. Clark and Tom Crow, to take the two most prominent examples, solidly position themselves within the historical enterprise; they read works of art as texts, but they use their readings as material evidence for exploring the intimate and determinative relations between art-making and social history. The interpretive critics in American art, on the other hand, are so mesmerized by the narrative of their text that they only name historical relationships

between art and maker, or art and culture. They do not probe them, but they hint that such relationships do exist. In his essay on *The Gross Clinic,* Fried suggests there is some connection between the primacy of writing in Eakins' life, the extraordinary way people hold implements and the many references to words and letters in the artist's paintings. But he asserts this provocative connection without analyzing, either through Eakins' psychological make-up or his relationship to culture, the mechanisms behind it. Similarly, in the introduction to his book, Lubin talks about "historical causation," including the "dominant social forces of the era, and the artist's personal history," and ventures that the Civil War is the key event leading to the rise of the new psychological portraiture that he studies. But once he begins his analysis of specific works, causation takes a distant back seat; the Civil War is not even listed in the index.[77] And when Lubin does suggest links between the sexual messages he finds imbedded in pictures and those of Victorian culture, he is never as thorough, analytical, or nuanced as he is in narrating his own experience of a painting.

Lubin's strength in reading pictures, as well as his weakness as a historian, could be said to be written into the analytical method that Jules Prown teaches and has written about in two major essays.[78] In Prown's method, historical evidence plays a role, but only very late in the analytical process. Only after exhaustively studying, describing, and experiencing the object and formulating speculations and hypotheses is the scholar free to shift "the inquiry from analysis of internal evidence to the search for and investigation of external evidence."[79] While the prescription here is a good one—it keeps students from running off to libraries to read documents before they have looked to the object itself for argument and evidence—in practice, some interpreters never get beyond the first steps, beyond speculation and hypotheses. Indeed, if one is skeptical about history, or desirous of depoliticizing art

and divorcing it from culture, Prown's theories can be particularly appealing. Some practitioners of his method, like born-again formalists, can read and experience objects obsessively but never get to the point of asking any "why" questions of their material.

This new passion for reading canvases as texts of hidden messages and especially for their recondite, psychological meanings, has precipitated American art's version of the art-historical "crisis" that Donald Kuspit wrote about in an earlier essay in this series.[80] Those who want the security of tried and true ways of writing about art, and who are upset by the speculative ahistoricism of interpretive criticism, are in protest. I personally take heart, however, in the plurality of approaches in art history today and envision in the future some healthy cross-breeding between interpretive and historical approaches. Because American art has traditionally been dominated by what I earlier called the documentary approach, the emphasis on self-conscious interpretation could expand the vision of historical writing. It could help historians become less presumptuous about the "objectivity" with which they write and more conscious of the ways in which the living present always intrudes upon our knowledge of the past. Were Americanists to define the scholar's job as interpretive and reconstructive, rather than the discovery of a neutral "reality" in the past, they might ask different—and more probing—questions of the data they collect.

In its privileging of the object, the new interpretive work may also lead some Americanists, particularly those dedicated to contextualizing art, to find better ways to keep the object central to their work. There are already signs that some scholars are trying to synthesize the close textual reading of pictures (events, spaces, buildings) with concerns for social and cultural analysis. By the same token, it may also be that the new interpretors are moving toward a more historically-based exegesis of art.[81] Time will tell.

A second genre of new scholarship that has recently impinged upon the field of American art comes from scholars such as Martha Banta, Cecelia Tichi, and Elizabeth McKinsey, all of whom had their primary training in American literature, but who write cultural history, broadly conceived. They look not only to literary texts but to visual imagery to interpret the values and ideological complexity of American culture. What is new about their work, as compared to earlier interdisciplinary efforts to combine art and literature, is the effort to view culture holistically, eschewing the usual distinctions between verbal and visual artifacts or "high" and "low" culture. This ecumenical and non-hierarchical approach is at the theoretical heart of Martha Banta's new book about female stereotyping in American culture between 1876 and 1918. *American Women: Idea and Ideals in Cultural History* examines over five hundred images—ranging from academic art and society portraits to photographs, cartoons, and magazine covers, as well as novels, romances, and scientific treatises—with the aim of decoding the roles that women were expected to fulfill at the turn of the century.[82] Similarly, Cecelia Tichi, in *Shifting Gears,* studies a broad range of cultural artifacts, including novels and poetry, painting and sculpture, but also engineering texts, advertisements, and medical illustrations, to analyze the various stages by which technological change brought engineering metaphors and streamlined language into all aspects of American culture in the period from 1890 to 1930.[83] Elizabeth McKinsey's book *Niagara Falls* takes the same panoramic view, studying the "great" works of literature and art alongside artifacts of popular and mass culture.[84]

The appearance of these interdisciplinary studies, as well as the interpretive ones coming from Prown and his students, can be linked to the revitalization of American Studies programs nationwide and the new emphasis of many of these programs on the study of visual and mate-

rial culture. In the 1970s, with the waning of interest in the history of ideas and great events, and the strong academic opposition to "consensus" history, American Studies programs suffered something of an identity crisis. But in recent years, with the infusion of ideas from the social sciences into humanistic studies, and the new respect throughout the academy for interdisciplinary work, American Studies has reconstituted itself and is once again a lively forum of discussion between not only literary and intellectual historians, but musicologists, geographers and anthropologists, landscape and urban historians, folklorists, specialists in communications and media, feminist and ethnic scholars in every American field, and a few art and photographic historians, along with students of architecture and the decorative arts. Indeed, thanks to the increased presence of art historians, and the rise of interest in the study of artifacts from all quarters, slide projectors have become as standard a piece of equipment at the American Studies Association's national meetings as they have always been at those of the College Art Association.

But whereas the presentation of images at CAA meetings has generally been confined to the fine arts, those at ASA meetings are apt to include magazine illustrations and advertisements, clothing and toys, commercial strips and shopping malls. The rubric under which much of this scholarship is conducted is that of material culture, an umbrella term that covers the study of anything "made or modified by humans," as one historian defined it, and presumes that all manmade objects or landscapes "reflect the belief patterns of individuals who made, commissioned, purchased, or used them, and, by extension, the belief patterns of the larger society of which they are a part."[85] Because material culture is so broadly defined, its proponents have come from many disciplines. Some are architectural and decorative art historians while others are social historians and anthropologists, folklorists,

and geographers. The literature here is growing steadily, augmented by the work of a few historians of American painting and sculpture whose primary contributions to date have been to demonstrate how the time-honored skills of the art historian, those of stylistic and iconographical analysis, and the locating of inventiveness and change, can be effectively applied not only to art but to the study of all kinds of artifacts and objects. Here the leading voice has been that of Jules Prown. His often cited essays on method are directed as much to students of material culture as they are to art historians. In the first of them, Prown teaches the usefulness of stylistic analysis in reading the cultural and social meanings of objects, and in the second, he offers an art-historically based method for interpreting material goods—not just works of art, but clothes, toys, home furnishings, tools, and mechanical devices.[86]

Other art historians, Karal Ann Marling and her students foremost among them, have begun to write about twentieth-century mass and popular culture, bringing to the study of, say, Mt. Rushmore or wigwam motels the same affection, seriousness of purpose, and analytical techniques they might bring to signed works of art in paint and bronze. Analyzing the souvenirs of world's fairs, the landscaping and architecture of the miniature golf course, the neo-Spanish revival style of a shopping mall, or the roadside sculpture-architecture of Paul Bunyan and the Jolly Green Giant, these scholars argue that mass and popular culture have their own grand moments of invention, meaning, and vitality.[87] While the stance of these art historians is often ironic, and occasionally admits to whiffs of nostalgia, it is not condemnatory; there is no desire here to critique the thinness of mass culture, nor view it as critics of the left generally do, as the capitalist's means of manipulating the taste, values, and pocketbook of unsuspecting citizenry. Marling and her peers are heirs to those writers of the 1920s who first declared mass and popular

cultural forms to be this country's folklore, but they owe an even greater debt to Warren Susman, a historian who, before he died in 1985, led the way in studying ordinary culture, whether that of the museum, street, or commerce, for what it can reveal about the way Americans order their lives and preserve their values.[88] For Susman, it came close to an article of faith that mass culture, in its various rituals and artifacts, fulfills basic community and individual wants, aesthetic pleasure being one of them. In Marling's view, both the post office murals of the 1930s and the gigantic roadside sculptures so popular in the 1920s and 1930s can be analyzed for the ways in which they gave communities the security of a local identity and answered people's need for fantasy, myth, and story-telling. It may hardly be coincidental that this interest in studying artifacts that reinforce local identities comes from a scholar working out of the Midwest, a region of the country that has always been conscious (and often proud) of its middle-brow culture and colorful local habits.

For other art historians, the study of material culture has not changed *what* they examine as much as it has shifted the focus of the questions they ask. Nowhere is this more evident than in recent studies of seventeenth- and eighteenth-century art, an area that since the 1976 Bicentennial has enjoyed something of a scholarly revival. Colonial art has always had its scholars, drawn from antiquarians and museum people in particular; until recently, such work has often been documentary in approach and overshadowed by the concentrated attention on nineteenth-century art.[89] But in the last decade or so, scholars have begun to show new interest in Colonial art. Their questions now are those of social history, stimulated in part by an overdue response to Prown's important study in 1966 of Copley's life and patronage, and by pioneering scholars outside of art history such as John Demos, James Deetz, and Alan Ludwig, all of whom found in things like Colonial furniture,

clothes, utensils, and gravestones, rich historical evidence for how people in the early colonies thought and behaved.[90] In Wayne Craven's recent book *Colonial American Portraiture,* and the National Portrait Gallery's exhibition, "American Colonial Portraits: 1700–1776," the emphasis has shifted away from connoisseurship and the identification of hands to content analysis, class considerations, and patronage questions: what class do the sitters belong to; what is the significance of the style of wig or clothes they are wearing; what is the relationship between family members in a multifigural work; what are the differences between the representation of men and women; what can be discovered of the studio practices of the Colonial artist; and how did these paintings function in their domestic settings?[91]

The most radical application of material culture theory is not yet, however, in studies or exhibitions of painting and sculpture as much as it is in those of vernacular architecture, costume, and utilitarian and decorative objects. Here some of the leadership is coming from curators in a few American museums whose collections are predominantly decorative arts and historical objects—the Dewitt Wallace Gallery in Williamsburg, for instance; the Margaret Woodbury Strong Museum in Rochester, New York; the National Museum of American History at the Smithsonian; and the Henry Francis Du Pont Winterthur Museum. Only a few tentative steps have been taken to bring material culture ideas to the fine arts museums, always a tricky proposition because of the inherent expectation that quality and aesthetic considerations—not history—should be the guiding principle of exhibitions.

The most successful of these exhibitions have again been in the Colonial and early national period where there seems to be more tolerance for exploring the links between art and culture, and where the arts of painting and sculpture have natural historical links to those of furniture,

crafts, and architecture. In the eighteenth century, artists often pursued multiple trades. Thus we have had what might be called mixed-media exhibitions, such as "Paul Revere's Boston 1735–1818," "American Art: 1750–1800; Towards Independence," and "Charles Willson Peale and His World," which presented a wide variety of artifacts, including paintings, and sought to convey something about the production of arts and crafts in a culture very different from our own.[92] The most ambitious effort of this sort was Jonathan Fairbank's exhibition, "New England Begins: The Seventeenth Century" at the Museum of Fine Arts, Boston (1982), which included every conceivable type of artifact produced in that century, excluding only the towns themselves. The sweep was worthy of Fernand Braudel, encompassing maps, silver, pewter, woodwork, broadsides, books, tapestries, furniture, gravestones, paintings, prints, tools and clothes made by European settlers, and a selection of the garments and artifacts made by the Native Americans whom the white man evicted. In the courtyard of the museum, one could watch the building of a wooden Colonial house by craftsmen using seventeenth-century tools and talk with their female counterparts dressed in costume and speaking in the dialect of the day. The three-volume catalogue, with contributions by seven different scholars, was equally comprehensive, one volume given to "Migration and Settlement," another to "Mentality and Environment," and the last on "Style."[93]

Such an exhibition walked a tightrope between the traditional concerns of the art museum for objects of the finest quality and the desire to tell us through artifacts about how people lived, and the values they upheld, at a distant point in the past. In many ways Fairbank's exhibition was, first, a *cultural history* exhibition and, second, an object show. What is surprising is how little public debate there has been about such an anthropological approach to exhibitions

and scholarship and the implications of this work for what museum curators ordinarily do. While historians of American art have been openly antagonistic toward the new interpretive criticism, there has been relatively little said about those material culture studies and exhibitions which present paintings and artifacts as belonging to something much bigger that we call "culture."

Some of this silence, I suspect, stems from fear of opening Pandora's box. No doubt a number of art historians, many in the museum field, hope that if they ignore material culture it will go away—or at the very least that its assumptions and practices will be confined to the history museum and not intrude upon their galleries. They assume that material culture students are so callous to the aesthetic qualities of the object that they have nothing to say to the art historian. And on their part, advocates of material culture—who often *are* insensitive to the pleasures of the eye—often spend more time and energy criticizing the art historian than they do formulating ways in which their concerns can be addressed in the museum and scholarship. Nowhere is this lack of exchange more vivid than on the subject of American "folk art," which for more than ten years now has been the target of a radical critique by anthropologists and folklorists who claim, with much justification, that what collectors and art historians call "folk art" is not that at all. The label "Folk Art," these critics contend, should be used only to describe those artifacts which emerge from the life and rituals of enclosed, traditional communities, and not paintings, sculpture, and crafts arising out of modern, market-oriented societies. Works linked to high styles and Western traditions, even if by untutored amateurs, are by this definition something other than folk art. Indeed, the word "folk," critics further charge, mythologizes the conditions surrounding the production of these works. Portraits by itinerant painters, stencil paintings

by young ladies, and ships' figureheads, carousel carvings, and cigar-store Indians by craftsmen were nineteenth-century consumer goods and domestic arts, not quaint artifacts from simpler bygone days. The master myth, according to the folklorists, is the one promoted by dealers and collectors (and most museums), that so-called folk art is beautiful because it is proto-modern in design. This notion supports an art market that promotes the sale of nineteenth-century provincial paintings and wooden sculpture by presenting them not as the work of wage-earners, women, or hobbyists, but as authentic modernist works.[94]

Though these critiques are taken seriously by scholars in material culture circles, most art historians have yet to acknowledge their existence. When the National Gallery mounted its exhibition, "An American Sampler: Folk Art from the Shelburne Museum" in the fall of 1987, there was a great deal of visual fun and abstract beauty in the quilts and weather vanes, but hardly a clue as to who the producers of these articles were or how these articles once functioned in their own community and cultural settings.[95] The objects on view were so decontextualized, as they have been ever since the 1920s when American "folk art" was first discovered, that they seemed like natural art objects, as if this had been their destiny from the beginning. The museum might have shown some cognizance of the irony in this stance or given the folklorist equal time in the catalogue or in a symposium. Instead, one came away with the impression that the views held by art historians in this area are so different from those of other scholars of folk art that the two groups might as well live on separate planets, which point brings me to my conclusion. Americanists desperately need more open dialogue and exchange. They must talk more across the street between the academy and the museum; they must exchange ideas with their colleagues in other subfields of art history; and they must engage in a deeper dialogue with scholars in the humanistic fields outside the discipline altogether.

Final Remarks

Americanists have reason to feel some satisfaction in the progress of scholarship in their field. The efforts of the past twenty-five years have given them new identity and confidence. This is manifested in many ways, among them being the invitation to be a part of this *Art Bulletin* series and the recent predilection of some Americanists, myself included, to look back and attempt to make sense of the intellectual growth of their field.[96] Furthermore, the future in the American field looks promising. As I write, the Luce Foundation has just publicly announced three years of fellowship support for dissertation fellowships in American art; the Center for Advanced Study of the Visual Arts at the National Gallery has inaugurated a new predoctoral fellowship for American art; and the National Endowment for the Humanities has announced its intention to fund editions of the letters and papers of major American artists. The various anniversary celebrations around the American Revolution, the Constitution, and the Statue of Liberty, along with President Reagan's calls to take "pride in America," have all helped put American art on center stage. When the fires of nationalism are fanned, as they were in the 1930s and have been in the 1980s, interest in American art inevitably grows and opportunities for scholarship multiply.

But for all its strength and maturity, the scholarly community in American art still does not represent a major voice in the discipline. Too much of the work in the field is narrow in focus and addressed to specialists. Or it is timid and lacks the kind of ambition that so often marks the innovative study. Some have claimed that American art scholarship is still too young, and

its community too small to nurture scholars who will tackle major problems and attract readers throughout the discipline. Others would blame the larger discipline itself, some of whose members still refuse to acknowledge the study of American art as a worthwhile pursuit. But it is precisely this kind of excuse-making that must be overcome if historians of American art are to continue to make progress. Old habits have to be broken. There is no reason today, as there was twenty-five years ago, for scholars of American art to feel sorry for themselves. Today the support for the American field is ample and growing. But so accustomed are Americanists to gathering together in self-protection, and bemoaning the lack of respect they garner from their colleagues in other areas of art history, that they often forget the many advantages they have won over the years.

Rather than perpetuate the tradition of defensiveness and finger-pointing, Americanists need to initiate more opportunities for self-criticism of their work. Whatever explains the long absence of debate and constructive criticism within the field, it is time to end this polite avoidance of difficult questions and differences. Leaders in the field could help initiate reforms that would bring more rigor and tough-mindedness to scholarship. One of the oldest art journals in the field, the *American Art Journal,* and one of the newest, the *Smithsonian Studies in American Art,* do not send out submissions for blind review, do not publish letters to the editor, and do not commission scholarly book reviews. Nor do they take responsibility for regularly reviewing exhibition catalogues, which, in a field as museum-oriented as American art, are often the most important publications of the year. Given that exhibitions themselves are often innovative, scholarly events, their curators should be held accountable for their interpretations through peer-review in professional journals. This would not only enliven scholarly discourse but help engender respect for museum scholarship in the academic world, especially as exhibitions and catalogues are often evaluated in academic tenure decisions.

Finally, there should be much more opportunity for scholarly exchange, particularly in symposia that do not double, as is increasingly the case today, as "public programming" for general museum audiences. When scholars come together, there is always an exchange of information, but too commonly in the field there are no formal respondents and little debate or discussion. Furthermore, Americanists tend to talk only to one another, and not enough with colleagues outside American art. There is no reason, for example, why Americanists should not plan symposia to bring themselves together with scholars working in the art of other nations. From my experience, Americanists are sometimes invited to participate in symposia planned by scholars in European art, but the reverse does not happen; when Americanists hold symposia, such as the recent one on the Hudson River School, they almost never invite "outsiders." There could also be more conferences built upon an interdisciplinary model. Today scholars in literature, history, and material culture are often asking challenging questions about painting and sculpture, and yet art historians, talking among themselves, may be the last to hear about them. There could also be much more dialogue between museum-based scholars and those in the university. At a time when these two institutions sometimes seem to be moving in two different directions—the one openly celebrating the genius of art while the other deconstructing and calling into question the very idea of art—there need to be more opportunities to examine differences and learn from one another. Although there is a healthy diversity of approach today in the American field, there are also timidity and clannishness. Understandable as the last vestiges of a longstanding historical insecurity and insularity, they are no longer defensible now that American art has finally come of age.

Afterword

I wrote this essay ten years ago as a part of a commissioned series in the *Art Bulletin* on the state of scholarship in various fields. Rereading it in March 1997, I am surprised (and pleased) that it still describes what I take to be the recent history and state of scholarship in my field. This is not to say that there have not been important additions to scholarship over the past decade, but only that the basic structures and patterns of thinking in the field of American art—and this really was the focus of my essay—have not undergone any right turns or paradigmatic leaps. In the name of revisionism, there continues to be a steady infusion of monographs about forgotten figures and a host of new regional studies to remind us that New York and New England were not the only art-producing centers in the country. Study of art during the Gilded Age and Progressive Era is on the rise, whereas attention to antebellum visual culture seems to have abated. Interdisciplinary incursions from other fields have continued, as have the debates around "high" and "low" culture: The Luce Foundation continues to support the field, both in the university and in the museum.

The changes I detect have to do with a shift in the nature of revisionism. Scholars today revise more often in the name of race, ethnicity, religion, and sexuality rather than gender, class, and marginality, emphases that dominated the earlier moment. In the past decade, new work has prominently featured monographs on artists of color, both past and present, along with more comprehensive studies that look across time at the history of the African-American artist, the Chicano art movement, and, most recently, the contributions of Asian Americans and Native Americans to art making. Along with race, issues of sexuality—homosexuality in particular—have prominently surfaced, bringing into focus the interface of art and sexuality as manifest in the work and lives of artists such as Romaine Brooks, Charles Demuth, Paul Cadmus, and Jared French, as well as influential figures like Gertrude Stein. In tandem with these investigations, there are new studies on the construction of masculinity in American art, especially at the end of the nineteenth century. Another pressing interest is the examination of the tensions between ethnicity and assimilation, and in this vein immigrant artists, many of them Jewish, are now receiving renewed attention. Not far behind are studies of artists, both fine and popular, whose religious imagery constructed mainstream Christianity in the American past.

There also seems to be an increased tendency, barely perceptible a decade ago, for art historians to take their skills as visual analysts into new domains. It is now an everyday occasion to find scholars who once confined themselves to art in museums looking at Hollywood films, advertisements, cartoons, popular illustrations—by Norman Rockwell or N. C. Wyeth, for example—and at images of cult figures such as Josephine Baker, Elvis Presley, Rock Hudson, and Marilyn Monroe. Although it is too early to assess whether this move will unhinge the hold that the fine arts have traditionally had on historians of the visual, it is noteworthy—and quite understandable—that art historians dealing with American culture have shown greater flexibility and curiosity about the circulation of popular images than scholars dealing with other nations and cultures.

When this essay first appeared, I received a lot of mail about its formulations, including a few letters pointing out errors of fact; I have corrected these in this reprinting. Never has anything I have written stimulated such an outpouring, particularly from outsiders to the American field. These letters were, in the main, grateful, although there were those who wanted a name added to the record: Why had I not mentioned this or that scholar or a particular title? One person—a name still unfamiliar to me—wrote to complain about my not according him a place of

importance in the field. A couple of people took me to task for calling into question the alignment of some Americanist projects with the commercial marketplace, while others wrote to testify further to the objectionably thin line that exists between Americanists in the academy and the commercial art gallery. I see no reason to modify my original concerns. Many applauded my effort to bring the museum and academy together, but all of us were naive as to what was about to happen as the country pulled to the political right, thereby undermining the public museums' ability to sustain independent scholarly inquiry. Indeed, if there is one area in which I am more pessimistic in 1997 than I was in 1987, it is the potential for the museums and universities to work together in a common enterprise. The external pressures on the museums have become so great, and so many senior curators have withdrawn from trafficking with academic scholars, that the museum-academy divide today seems more severe and unforgiving than it did ten years ago. That art history departments now regularly offering courses on critically deconstructing museum culture only adds to the standoff. Eternally optimistic and hoping for a bottom-up rejuvenation of museum practices, I now look to university museums to invent new kinds of exhibition thematics and installations. Recent exhibitions at the Harvard University Art Museums, Yale University Art Gallery, and the Memorial Art Gallery of the University of Rochester give me reason to think that, in the censorious 1990s, it is rightfully the university museum that should take on the laboratory function of conveying new forms of knowledge through new forms of display and spectatorship.

To those who wished I had added more names to the record of achievement in the field of American art, I remind them that my essay was not about particular individuals so much as about constructions of art history. I aimed to explore the metanarrative of the writing of the history of American art, not to document every scholar or individual study that contributed to that narra-

tive. I was moved, however, by those letter-writers who regretted the minimal attention I gave to the generation of scholars from the 1930s through the 1960s who wrote about American art. In concentrating my study on those who had been academically trained and had plied their trade primarily within the world of universities, I inadvertently marginalized those who were autodidacts—John Baur, E. P. Richardson, Lloyd Goodrich, Alfred Frankenstein, James Flexner, and Virgil Barker. They are discussed in my introduction, leading some to suggest, I think fairly, that my story about the making of an American art history began a generation too late. Given that I had learned my art history from the exhibitions and publications of these men, I regret any misconception I may have given as to my admiration for their adventuresome work and hope someone will take on a deeper study of their early mappings of the field.

The most serious omission in my essay, however, was making no mention whatsoever of those self-trained women whose names should rightfully have appeared alongside the men I just named: Nina Fletcher Little, Alice Ford, Alice Winchester, Jean Lipman, and Mary Black. These enterprising collectors, archivists, and exhibition planners (along with Holger Cahill, whom I also did not name) skirted the worlds of antique-collecting, museums, and art history and invented the American field of "folk" expression and inserted it into our country's history. If Richardson and Baur were the pioneer scholars of America's mainstream artists, these women chronicled the country's marginal artists, introducing into scholarship a gendered division of labor that I did not see clearly ten years ago. (This is all the more astonishing to me because I knew this body of work well, having written my master's thesis on the "discovery" of American folk art in the early decades of this century. I must have internalized not only art history's disinterest in folk art, and its first women scholars, but also doubts about my own work as a young scholar.) Given the current boom in exhibitions of what we today call "out-

sider" art, the leading role that women took in creating a taste and a scholarly framework for the untrained artist also deserves study.

Lastly, I thank Mary Ann Calo for reprinting this essay in her volume and granting it another cycle of readership. If I may be allowed one further prediction, I would suggest that it will be this new set of readers who may give up the study of American art as a national inquiry and turn instead to comparative histories. If so, I hope I am around ten years from now to chronicle those exciting changes.

NOTES

Revised by the author from *The Art Bulletin*, vol. 70, no. 2 (June 1988). Reprinted by permission of the author and the College Art Assoc.

1. I am using the term "American art" as shorthand for pre-1945 painting and sculpture in the United States. I am not considering post–World War II art here, or painting and sculpture made in our neighboring countries, north and south. Nor am I looking at developments in other media such as architecture, decorative arts, or photography, each of which deserves its own essay. I am grateful to the National Museum of American Art, whose generous support of a research year at the Smithsonian allowed me time to write this essay. I also thank the predoctoral fellows at NMAA in 1987, and Charles Eldredge, Director, for discussing a preliminary outline, and Joseph Corn, Elizabeth Johns, Karen Lucic, Roger Stein, Alan Wallach, and John Wilmerding for their thoughtful responses to an early draft. Michele Bogart generously responded to my questions about bibliography in American sculpture, and Michelle Korjeff and Amanda Bowan of Stanford University gave me valuable assistance in tracking down references. Many others graciously responded to specific queries; I thank them all.

2. The National Museum of American Art, the Whitney Museum of American Art, the Pennsylvania Academy of the Fine Arts, the Terra Museum of American Art, and the Amon Carter Museum are the most obvious examples of institutions that devote their collections and scholarship to American art. Other museums, such as the National Portrait Gallery and the Corcoran Gallery of Art, concentrate on American art, though their collections are multi-national. The Addison Gallery of American Art, the New Britain Museum of American Art, and the Butler Institute of American Art have exclusively national collections. The field has one endowed lecture series, followed by publication, in The Anne Burnett Tandy Lectures in American Civilization at the Amon Carter Museum.

3. The endowed chairs are at the University of Kansas, Princeton University, the University of Pennsylvania, and the University of Pittsburgh. The Luce Foundation undertook a five-year program of granting $7 million in support of American art exhibition scholarship, and made a $2.5 million grant to the Metropolitan Museum of Art for The Henry R. Luce Center for the Study of American Art. It has now committed nearly a million dollars to the support of dissertation fellowships in American art at eight universities. In 1977–80, the Rockefeller Foundation awarded $200,000 to ten art history graduate programs to support students of American art.

4. The most regular and oldest of the American art symposia is the biennial Symposium in American Art begun in 1972 by the University of Delaware. Of the journals, the most important are the *Archives of American Art Journal* (begun 1960), the *Winterthur Portfolio* (begun 1964), the *American Art Journal* (begun 1969), *Prospects* (begun 1975), and the *Smithsonian Studies in American Art* (begun 1987).

5. At the Smithsonian, the resources include the Archives of American Art; the Inventory of American Paintings Executed before 1914; the Inventory of American Sculpture; the Pre-1877 Art Exhibition Catalogue Index; and the Peter A. Juley and Son Collection of photographs documenting American works of art and artists. With the exception of the first in this list, which is an independent bureau of the Smithsonian, the other inventories are administered by the National Museum of American Art.

6. I am thinking here of the Sotheby's sale in 1979 of Church's *The Icebergs* for $2.5 million, and of the

private sale of Morse's *Exhibition Gallery of the Lou-vre*, owned by Syracuse University, to Daniel Terra in 1982 for $3.5 million.

7. For references to the writings of these self-trained Americanists, see the bibliography in John Wilmerding's *American Art*, New York, 1976, and the one compiled by Elizabeth Johns at the end of her "Scholarship in American Art: Its History and Recent Developments," *American Studies International*, XXII, October, 1984, 3–40. This generation of scholars continued to research and write about American art well into the period of 1960–88 I am considering here.

8. For the former, see William Dunlap, *History of the Rise and Progress of the Arts of Design in the United States*, New York, 1834; and Henry T. Tuckerman, *Book of the Artists, American Artist Life*, New York, 1867. Early artist biographies include Barbara Neville Parker and Anne Bolling Wheeler, *John Singleton Copley: American Portraits in Oil, Pastel, and Miniature, with Biographical Sketches*, Boston, 1938; and Lloyd Goodrich's *Thomas Eakins*, New York, 1933, and *Winslow Homer*, New York, 1944.

9. I think, for instance, of books such as Louisa Dresser, *XVIIth Century Painting in New England*, Worcester, MA, 1935; Frederick Sweet, *The Hudson River School and the Early American Landscape Tradition*, New York, 1945; E.P. Richardson, *American Romantic Painting*, New York, 1945; Wolfgang Born, *Still-Life Painting in America*, New York, 1947, and *American Landscape Painting; An Interpretation*, New Haven, 1948; Alfred Frankenstein, *After the Hunt; William Harnett and Other American Still-Life Painters, 1870–1900*, Berkeley, 1953; and Waldron Phoenix Belknap, *American Colonial Painting: Materials for a History*, Cambridge, MA, 1959.

10. Lorado Taft, *The History of American Sculpture*, New York, 1903; Albert T. E. Gardner, *Yankee Stonecutters: The First American School of Sculpture, 1800–1850*, New York, 1944; and Milton W. Brown, *American Painting from the Armory Show to the Depression*, Princeton, 1955.

11. Suzanne LaFollette, *Art in America*, New York, 1929, and Oliver W. Larkin, *Art and Life in America*, New York, 1949. Other survey texts of importance were those by Sadakichi Hartmann (1902), Samuel Isham (1905), Charles Caffin (1907), Eugen Neuhaus (1931), Virgil Barker (1950), E.P. Richardson (1956), and Alexander Eliot (1957).

12. See, for example, Michael Fried, *Realism, Writing, Disfiguration: On Thomas Eakins and Stephen Crane*, Chicago, 1987; Albert Boime, "Newman, Ryder, Couture and Hero-Worship in Art History," *American Art Journal*, III, Fall, 1971, 5–22, and more recently his "Sargent in Paris and London: A Portrait of the Artist as Dorian Gray," in Patricia Hills, *John Singer Sargent*, New York, 1986, 75–109; and Robert Rosenblum, "The Primal American Scene," in *The Natural Paradise: Painting in America 1800–1950*, New York, 1976, 13–37.

13. Perhaps the first important study of American art from a European scholar was René Brimo's *L'évolution du goût aux États-Unis d'après l'histoire des collections*, Paris, 1938. For more recent foreign publications on American art, see Roland Tisot, *L'Amérique et ses peintres (1908–1978); Essai de typologie artistique*, Lyon, 1980, and Madeleine Deschamps, *La peinture américaine; Les mythes et la matière*, Paris, 1980. For foreign Ph.D. dissertations on American painting, see Terence Edwin Smith, "Making the Modern: The Visual Imagery of Modernity, U.S.A., 1908–1939," University of Sydney, 1985, and Jonathan P. Harris, "The New Deal Art Projects: A Critical Revision—Reconstructing the 'National Popular' in New Deal America 1935–43," Middlesex Polytechnic, London. The recent wave of exhibitions of historical American art overseas includes "Peinture Américaine, 1920–1940," at the Palais des Beaux-Arts Bruxelles, 1979, and "Amerika, Traum und Depression, 1920/40," at the Akademie der Künste, Berlin, 1980, as well as three exhibitions planned by American art historians for museums abroad: Milton Brown, "The Modern Spirit: American Painting, 1908–1935," for the Arts Council of Great Britain, 1977; Peter Selz, "2 Jahrzehnte amerikanische Malerei, 1920–40," for the Stadtischen Kunsthalle, Düsseldorf, 1979; and Theodore E. Stebbins, Jr., Carol Troyen, and Trevor J. Fairbrother, "A New World: Masterpieces of American Painting 1760–1910," an exhibition of 1983–84 that went to the Grand Palais in Paris after two stops in this country. I should also note the interest today of European collectors in pre-1945 American art, most notably Hans Heinrich Thyssen-Bornemisza. See *20th Century Masters: The Thyssen-Bornemisza Collection*, Washington, DC, 1982, and *American Masters, The Thyssen-Bornemisza Collection*, Milan, 1984.

14. John Singleton Copley in a letter, ca. 1767, quoted in John W. McCoubrey, *American Art 1700–1960*, Englewood Cliffs, NJ, 1965, 18.

15. [Sydney Smith], *The Edinburgh Review,* XXXIII, no. 65, article III, 1820, 79; Samuel Bing, transl. B. Eilser, in *Artistic America, Tiffany Glass, and Art Nouveau,* Cambridge, MA, 1970; and [Marcel Duchamp], *The Blind Man,* no. 2, May, 1917, 5.

16. See John I.H. Baur's introduction to *Whitney Museum of American Art, Catalogue of the Collection,* New York, 1975, 9–10. For the sale of the Heade and Sargent, see the sales catalogue *Sotheby's Important American Paintings, Drawings and Sculpture, December 3, 1987,* no. 53 and no. 213. The Whitney Museum's decision in 1978 "to focus the collection in the 20th century" and the sale of the Joshua Johnson were reported in the *New York Times,* 7 Feb. 1988, Section II, 38.

17. Kynaston McShine, ed., *The Natural Paradise: Painting in America 1800–1950,* New York, 1976.

18. Of modern historians, E.P. Richardson is the major exception to my remarks here. His *The Way of Western Art, 1776–1914,* Cambridge, MA, 1939, thoroughly integrated American art into European traditions. His later *Painting in America from 1502 to the Present,* New York, 1956, presented American work following the European pattern of styles—Baroque, Rococo, Neoclassicism, Romanticism, Impressionism, etc. One might also note the occasional scholar of European art who has attended to American art in broad studies of Western art. See, for example, Marcel Brion, *Romantic Art,* New York, 1960; Benjamin Rowland, Jr., *Art in East and West,* Cambridge, MA, 1954, and *The Classical Tradition in Western Art,* Cambridge, MA, 1963; and Robert Rosenblum and H.W. Janson, *Nineteenth-Century Art,* New York, 1984.

19. For an excellent analysis of the growth and development of scholarship and programs in American Studies, and for a very useful bibliography of formative writings about American history and culture (excluding, unfortunately, those in art history), see Gene Wise, ed., "The American Studies Movement: A Thirty-Year Retrospective," *American Quarterly,* XXXI, 3, 1979, entire issue.

20. LaFollette and Larkin (as in n. 11). James Thomas Flexner, *First Flowers of Our Wilderness, American Painting,* Boston, 1947; *idem, The Light of Distant Skies, 1760–1835,* New York, 1954; *idem, That Wilder Image: The Paintings of America's Native School from Thomas Cole to Winslow Homer,* Boston, 1961.

21. See, for example, Alan Burroughs, *Limners and Likenesses; Three Centuries of American Painting,* Cambridge, MA, 1936; Oskar Hagen, *The Birth of the American Tradition in Art,* New York, 1940; Holger Cahill and Alfred H. Barr, Jr., eds., *Art in America,* New York, 1934; John W. McCoubrey, *American Tradition in Painting,* New York, 1963; and Barbara Novak, *American Painting of the Nineteenth Century: Realism, Idealism, and the American Experience,* New York, 1969.

22. The Salander-O'Reilly Galleries are supporting scholars who are preparing *catalogues raisonnés* of Marsden Hartley and Stuart Davis. The Coe Kerr Gallery is preparing a complete catalogue on Sargent; Hirschl & Adler is doing one on Childe Hassam; and the Spanierman Gallery is working on a John Henry Twachtman catalogue. Gallery support of scholarship in the America field is not new; ever since the magazine's inception in 1969, Kennedy Galleries have published the *American Art Journal* and paid the salaries of its editors.

23. Although I am not at all sure my list is complete, the first three dissertations in American art appear to be: Sherman Lee, "A Critical Survey of American Watercolor Painting," Case Western Reserve, 1941; Frank A. Seiberling, Jr., "George Bellows, 1882–1925: His Life and Development as an Artist," University of Chicago, 1948; and Milton Brown, "American Painting (1913–1929) from the Armory Show to the Depression," Institute of Fine Arts, New York University, 1949.

24. For discussion of Rowland as an artist and teacher, see the exhibition catalogue, *Benjamin Rowland, Jr. Memorial Exhibition,* Fogg Art Museum, Harvard University, 1973. Rowland's major scholarly contribution to the history of American art was his editing of James Jackson Jarves, *The Art-Idea,* Cambridge, MA, 1960.

25. Lillian B. Miller, *Patrons and Patriotism: The Encouragement of the Fine Arts in the United States, 1790–1860,* Chicago, 1966, and Neil Harris, *The Artist in American Society: The Formative Years 1790–1860,* New York, 1966.

26. Roger Stein, *John Ruskin and Aesthetic Thought in America, 1840–1900,* Cambridge, MA, 1967; and Linda S. Ferber and William H. Gerdts, *The New Path: Ruskin and the American Pre-Raphaelites,* New York, 1985.

27. Jules David Prown, *John Singleton Copley,* Cambridge, MA, 1966; William H. Gerdts and Theodore Stebbins, *"A Man of Genius": The Art of Washington Allston,* Boston, 1979; David C. Huntington, *The Landscapes of Frederic Edwin Church: Vision of an American Era,* New York, 1966; John Wilmerding, *Fitz Hugh Lane,* New York, 1971; Theodore E. Stebbins, *The Life and Works of Martin Johnson Heade,* New Haven, 1975; Maurice E. Bloch, *George Caleb Bingham,* Berkeley, 1967; John Wilmerding, *Winslow Homer,* New York, 1972; Nicolai Cikovsky, Jr., *George Inness;* New York, 1971; William Innes Homer, *Robert Henri and His Circle,* Ithaca, 1969; Sheldon Reich, *John Marin: A Stylistic Analysis and Catalogue Raisonné,* Tucson, 1970; and Irma B. Jaffe, *Joseph Stella,* Cambridge, MA, 1970.

28. John Wilmerding, *A History of American Marine Painting,* Salem, MA, 1968; Theodore E. Stebbins, Jr., *American Master Drawings and Watercolors,* New York, 1976; William H. Gerdts and Russell Burke, *American Still-Life Painting,* New York, 1971; William H. Gerdts, *American Neo-Classical Sculpture, The Marble Resurrection,* New York, 1979; and *idem, American Impressionism,* Seattle, 1979, and *American Impressionism,* New York, 1984.

29. Wayne Craven, *Sculpture in America: From the Colonial Period to the Present,* New York, 1968.

30. Metropolitan Museum of Art, *19th-Century American Paintings and Sculpture,* New York, 1970.

31. Jules David Prown, *American Painting from Its Beginnings to the Armory Show,* and its companion volume, Barbara Rose, *American Painting of the 20th Century,* Geneva, 1969. John W. McCoubrey, *American Art, 1700–1960: Sources and Documents,* Englewood Cliffs, NJ, 1965.

32. For example, Novak (as in n. 21), 94.

33. *M. and M. Karolik Collection of American Paintings, 1815–1865,* Cambridge, MA, 1949. Eight years earlier, the Karoliks had given a collection of 18th-century American art to the Museum of Fine Arts, Boston. See Edwin J. Hipkiss, *Eighteenth-Century American Arts: The M. and M. Karolik Collection,* Cambridge, MA, 1941.

34. Private conversation, December, 1987.

35. Novak (as in n. 21); McCoubrey (as in n. 21).

36. McCoubrey (as in n. 21), 20.

37. Baur developed the use of the term in three different articles: "Early Studies in Light and Air by

American Landscape Painters," *Bulletin of the Brooklyn Museum,* IX, Winter, 1948, 1–9; "Trends in American Painting, 1815–1865, *M. and M. Karolik Collection* (as in n. 33), XV–LVII; and "American Luminism: A Neglected Aspect of the Realist Movement in Nineteenth-Century American Painting," *Perspectives USA,* IX, Autumn, 1954, 90–98.

38. Barbara Novak, "Defining Luminism," in John Wilmerding, *American Light, The Luminist Movement, 1850–1875,* Washington, DC, 23–29.

39. Theodore E. Stebbins, Jr., "Luminism in Context: A New View," in Wilmerding (as in n. 38), 211–234.

40. See Metropolitan Museum of Art, *American Paradise, The World of the Hudson River School,* New York, 1987. Kevin J. Avery, in his essay in *American Paradise,* "A Historiography of the Hudson School" (pp. 3–20), describes how the term evolved as a scholarly label and addresses its confusing connotations. Yet the word is continually used by other essayists in the catalogue and in the wall labels for the exhibition.

41. Scholarship reviving or discovering artists is still very much in process and the relevant citations are too many to enumerate. But as a sample of the kind of scholarship stretching the canon, I might mention David Driskell, *Two Centuries of Black American Art,* Los Angeles, 1976; Lynda Roscoe Hartigan, *Sharing Traditions: Five Black Artists in Nineteenth-Century America,* Washington, DC, 1985; Studio Museum in Harlem, *Harlem Renaissance: Art of Black America,* New York, 1987; Hermann W. Williams, Jr., *Mirror to the American Past: A Survey of American Genre Painting: 1750–1900,* Greenwich, CT, 1973; Patricia Hills, *The Painter's America: Rural and Urban Life, 1810–1910,* New York, 1974; Larry Curry, *The American West: Painters from Catlin to Russell,* New York, 1972; Vassar College Art Gallery, *The White, Marmorean Flock: Nineteenth-Century American Women Neo-classical Sculptors,* Poughkeepsie, 1972; Christine Jones Huber, *The Pennsylvania Academy and Its Women: 1850–1920,* Philadelphia, 1973; Eleanor Munro, *Originals: American Women Artists,* New York, 1979; Charlotte Steifer, *American Women Artists: From Early Indian Times to the Present,* Boston, 1982; and Eleanor Tufts, *American Women Artists, 1830–1930,* Washington, DC, 1987.

42. The last two major survey texts to be published on American art were John Wilmerding, *American*

Art, New York, 1976, in the Pelican History of Art series; and Milton Brown, *American Art to 1900: Painting, Sculpture, Architecture*, New York, 1977, which was then combined with other texts by Sam Hunter, John Jacobus, *et al.* and republished by Harry N. Abrams as *American Art*, New York, 1979. In 1984, Matthew Baigell, who had written *A History of American Painting* for the Praeger World of Art Paperback series (1971), published *A Concise History of American Painting and Sculpture*, Icon Editions, Harper & Row, New York.

43. William H. Truettner, *The Natural Man Observed: A Study of Catlin's Indian Gallery*, Washington, DC, 1974; Bruce W. Chambers, *The World of David Gilman Blythe*, Washington, DC, 1980; Robin Bolton-Smith and William H. Truettner, *Lily Martin Spencer, 1822–1902*, Washington, DC, 1973; Barbara S. Groseclose, *Emanuel Leutze, 1816–1868*, Washington, DC, 1975; Joshua C. Taylor and Jane Dillenberger, *Perceptions and Evocations: The Art of Elihu Vedder*, Washington, DC, 1979; Frederick C. Moffatt, *Arthur Wesley Dow, 1857–1922*, Washington, DC, 1977; Roberta K. Tarbell, *Marguerite Zorach: The Early Years, 1908–1920*, Washington, DC, 1973; *Peggy Bacon, Personalities and Places*, Washington, DC, 1976; Sheldon Reich, *Alfred H. Maurer*, Washington, DC, 1973; Roberta K. Tarbell, *Hugo Robus*, Washington, DC, 1980; Adelyn Breeskin, *H. Lyman Saÿen*, Washington, DC., 1970; and *idem, Lee Gatch 1902–1968*, Washington, DC, 1971.

44. Joshua C. Taylor, *America as Art*, Washington, DC, 1976.

45. H. Barbara Weinberg, "American Impressionism in Cosmopolitan Context," *Arts*, LV, Nov., 1980, 160.

46. Lois Fink and Joshua Taylor, *Academy: The Academic Tradition in American Art*, Washington, DC, 1975; H. Barbara Weinberg, *The American Pupils of Jean-Léon Gérôme*, Fort Worth, TX, 1984; David Sellin, *Americans in Brittany and Normandy, 1860–1910*, Phoenix, AZ, 1982. Also see Mary Alice Heekin Burke, *Elizabeth Nourse, 1859–1938*, Washington, DC, 1985.

47. Michael Quick, *American Expatriate Painters of the Late Nineteenth Century*, Dayton, OH, 1976, and *American Portraiture in the Grand Manner, 1729–1920*, Los Angeles, 1981.

48. Brooklyn Museum, *The American Renaissance*, New York, 1979; Henry Adams, *et al., John LaFarge*, New York, 1987.

49. Peter Bermingham, *American Art in the Barbizon Mood*, Washington, DC, 1975; Laura L. Meixner, *An International Episode: Millet, Monet and Their North American Counterparts*, Memphis, TN, 1982.

50. See, for example, James M. Dennis, *Karl Bitter, Architectural Sculptor, 1867–1915*, Madison, WI, 1967; Michael Richman, *Daniel Chester French: An American Sculptor*, New York, 1976; Burke Wilkinson, *Uncommon Clay: The Life and Works of Augustus Saint-Gaudens*, New York, 1985; Kathryn Greenthal, *Augustus Saint-Gaudens: Master Sculptor*, New York, 1985; J. Carson Webster, *Erastus D. Palmer*, Newark, DE, 1983; and Lewis I. Sharp, *John Quincy Adams Ward, Dean of American Sculpture*, Newark, DE, 1985. For public sculpture in cities, see James M. Goode, *The Outdoor Sculpture of Washington, D.C.: A Comprehensive Historical Guide*, Washington, DC, 1974; Lewis I. Sharp, *New York City Public Sculpture by 19th-Century American Artists*, New York, 1974; and Fairmount Park Art Association, *Philadelphia's Treasures in Bronze and Stone*, New York, 1976.

51. Tom Armstrong, *et al., 200 Years of American Sculpture*, New York, 1976; and Patricia Hills, *Turn-of-the-Century America*, New York, 1977.

52. Charles Eldredge, *American Imagination and Symbolist Painting*, New York, 1979.

53. See, for example, my own *Color of Mood: American Tonalism, 1880–1910*, San Francisco, 1972; William H. Gerdts, *et al., Tonalism, An American Experience*, New York, 1982; and High Museum of Art, *The Advent of Modernism, Post-Impressionism and North American Art, 1900–1918*, Atlanta, GA, 1986.

54. Delaware Art Museum, *Avant-Garde Painting & Sculpture in America 1910–25*, Wilmington, DE, 1975. The text that for over two decades now has presented the rudiments of early 20th-century American art to wide audiences is Barbara Rose's *American Art since 1900: A Critical History*, New York, 1967.

55. William Innes Homer, *Alfred Stieglitz and the American Avant-Garde*, Boston, 1977.

56. William C. Agee and Barbara Rose prepared "Patrick Henry Bruce, American Modernist," for the Museum of Modern Art, New York, 1979; Barbara Haskell organized "Arthur Dove," for the San Francisco Museum of Modern Art, 1975, and, for the

Whitney Museum, "Marsden Hartley," New York, 1980, and "Ralston Crawford," New York, 1985; the Whitney also sponsored Gail Levin's "Synchromism and American Color Abstraction, 1910–1925," New York, 1978, and Noel Frackman's exhibition of John Storrs, New York, 1986. In this context, one should mention three very good catalogues on American collectors of modern art: for an exhibition at the Hirshhorn Museum and Sculpture Garden, Judith Zilczer, *"The Nobler Buyer": John Quinn, Patron of the Avant-Garde,* Washington, DC, 1978; for the Phillips Collection, *Arthur Dove and Duncan Phillips: Artist and Patron,* Washington, DC, 1981; and for the Museum of Fine Arts, Boston, *The Lane Collection: 20th-Century Paintings in the American Tradition,* 1983.

57. Carol Troyen and Erica E. Hirshler, *Charles Sheeler: Paintings and Drawings,* Boston, 1987; Theodore E. Stebbins, Jr., and Norman Keyes, Jr., *Charles Sheeler: The Photographs,* Boston, 1987; Barbara Haskell, *Charles Demuth,* New York, 1987; and Jack Cowart and Juan Hamilton, *Georgia O'Keeffe, Art and Letters,* Washington, DC, 1987.

58. See, for example, Hilton Kramer, "The Return of the Nativist," *The New Criterion,* II, October, 1983, 58–63, and "The Benton Affair: A Showdown in the Show Me State," *Art and Antiques,* Summer, 1987, 113–15. The second of these two articles reports upon a symposium on Thomas Hart Benton held at the Nelson-Atkins Museum of Art in Kansas City, Missouri, 11 April 1987, in which both Kramer and Greenberg delivered attacks upon revisionism and Regionalism.

59. See, for example, Francis V. O'Connor, ed., *The New Deal Art Projects,* Washington, DC, 1972, and *Art for the Millions,* Boston, 1973; Matthew Baigell, *The American Scene,* New York, 1974, and *Thomas Hart Benton,* New York, 1974; Karal Ann Marling, *Wall-to-Wall America,* Minneapolis, 1982; James Dennis, *Grant Wood,* New York, 1975; Wanda M. Corn, *Grant Wood: The Regionalist Vision,* New Haven, 1983; M. Sue Kendall, *Rethinking Regionalism, John Steuart Curry and the Kansas Mural Controversy,* Washington, DC, 1986; Marilyn Cohen, *Reginald Marsh's New York,* New York, 1983; University of Arizona Museum of Art, *Isabel Bishop,* Tucson, AZ, 1974; Kendall Taylor, *Philip Evergood,* Lewisburg, PA, 1987; Philip Eliasoph, *Paul Cadmus, Yesterday and Today,* Oxford, OH, 1981; John Baker,

O. Louis Gugliemi, Rutgers, NJ, 1980; and Patricia Hills, *Social Concern and Urban Realism: American Painting of the 1930s,* Boston, 1983.

60. Roberta K. Tarbell and Joan M. Marter, *Vanguard American Sculpture. 1913–1939,* New Brunswick, NJ, 1979; John P. Lane and Susan C. Larsen, eds., *Abstract Painting and Sculpture in America, 1927–1944,* New York, 1983; and Richard Guy Wilson, Dianne H. Pilgrim, and Dickran Tashjian, *The Machine Age in America, 1918–1941,* New York, 1986.

61. These regional studies have considerable range. As examples, see Rena M. Coen, *Painting and Sculpture in Minnesota, 1820–1914,* Minneapolis, 1976; Donald Keyes, *et al., The White Mountains: Place and Perception,* Durham, NH, 1980; J. Gray Sweeney, *Artists of Grand Rapids, 1840–1900,* Grand Rapids, MI, 1981, and *idem, Artists of Michigan from the Nineteenth Century,* Muskegon, MI, 1987; William Benton Museum of Art, University of Connecticut, *Connecticut and American Impressionism,* Storrs, CT, 1980; Owensboro Museum of Fine Art, *The Kentucky Tradition in American Landscape Painting from the Early 19th Century to the Present,* Owensboro, KY; Ella-Prince Knox, *et al., Painting in the South: 1564–1980,* Richmond, VA, 1983; Rick Stewart, *Lone Star Regionalism, the Dallas Nine and Their Circle 1928–1945,* Dallas, TX, 1985. For a helpful theoretical essay on interpreting regional art, see Roger Stein, "Packaging the Great Plains: The Role of the Visual Arts," *Great Plains Quarterly,* V, Winter, 1985, 3–23.

62. Marling (as in n. 59), v.

63. Weinberg (as in n. 46), 99.

64. Although there has been very influential feminist scholarship in American history and literature, and in other fields of art history, there has been relatively little in American art beyond the work of resurrecting the lives and biographies of individual women artists. For two studies that stand out for their attempt to apply feminist theory to American art, see Griselda Pollock, *Mary Cassatt,* New York, 1980; and Bernice Kramer Leader, "Antifeminism in the Paintings of the Boston School," *Arts,* LIV, Jan., 1982, 112–19.

65. Elizabeth Johns, *Thomas Eakins: The Heroism of Modern Life,* Princeton, 1983; Alan Wallach, "Thomas Cole and the Aristocracy," *Arts,* LVI, Nov., 1981, 94–106.

66. Wallach (as in n. 65), 104.

67. Roger B. Stein, "Charles Willson Peale's Expressive Design: The Artist in His Museum," *Prospects*, VI, 1981, 139–85, and "Thomas Smith's Self-Portrait: Image/Text as Artifact," *Art Journal*, XLIV, Winter, 1984, 316–27; Ann Abrams, "Politics, Prints, and John Singleton Copley's *Watson and the Shark*," *Art Bulletin*, LXI, 1979, 265–76, and *idem*, "Benjamin West's Documentation of Colonial History: *William Penn's Treaty with the Indians*," *Art Bulletin*, LXIV, 1982, 59–75; Nicolai Cikovsky, "Winslow Homer's *Prisoners from the Front*," *Metropolitan Museum Journal*, XII, 1978, 155–72, and "Winslow Homer's *School Time*: 'A Picture Thoroughly National,'" *In Honor of Paul Mellon: Collector and Benefactor*, Washington, DC, 1986, 47–69; Michele H. Bogart, "Maine Monument Memorial and Pulitzer Fountain: A Study in Patronage and Process," *Winterthur Portfolio*, XXI, Spring, 1986, 41–63; Jean Fagan Yellin, "Caps and Chains: Hiram Power's Statue of 'Liberty,'" *American Quarterly*, XXXVIII, Winter, 1986, 797–826; Vivien Greene Fryd, "Hiram Powers' *Greek Slave*: Emblem of Freedom," *American Art Journal*, XIV, Autumn, 1982, 31–39; and *idem*, "Hiram Powers' *America*: 'Triumphant as Liberty and in Unity,'" *American Art Journal*, XVIII, 1986, 55–75; Karal Ann Marling, "*My Egypt*: The Irony of the American Dream," *Winterthur Portfolio*, XV, Spring, 1980, 25–40, and "Thomas Hart Benton's *Boomtown*: Regionalism Redefined," *Prospects*, VI, 1981, 73–137.

68. Gerald L. Carr, *Frederic Edwin Church: The Icebergs*, Dallas, TX, 1980; and Jeremy Elwell Adamson, *Niagara, Two Centuries of Changing Attitudes, 1697–1901*, Washington, DC, 1985.

69. See, for example, William H. Gerdts, *The Art of Healing, Medicine and Science in American Art*, Birmingham Museum of Art, Birmingham, AL, 1981; and Lee M. Edwards, *Domestic Bliss, Family Life in American Painting, 1840–1910*, The Hudson River Museum, Yonkers, NY, 1986. One of the most successful "contextualized" exhibitions and catalogues was David Park Curry, *Winslow Homer, The Croquet Game*, Yale University Art Gallery, 1984, in which the curator looked at the rituals and manners of croquet in Homer's work and the culture of his time. Because there are so many fine paintings and prints of croquet games by Homer, and a rich lode of other visual ma-terial about the game, all from the same two decades, the exhibition had a tight focus and communicated its message about the game as much visually as through words. One learned about the history of the game, which in turn illuminated the art.

70. The most concise statement of this position is in David M. Lubin's *Act of Portrayal, Eakins, Sargent, James*, New Haven, 1985, IX–XII, where he argues "that the best way for us in the 1980s to know the 1880s through its portraiture is to read the portraits with a deliberate and ongoing consciousness that our present needs and values are unavoidably superimposed."

71. See *ibid;* Fried (as in n. 12); Bryan Jay Wolf, *Romantic Re-Vision; Culture and Consciousness in Nineteenth-Century American Painting and Literature*, Chicago, 1982; and Jules D. Prown, "Winslow Homer in His Art," *Smithsonian Studies in American Art*, I, Spring, 1987, 31–45.

72. For a recent example, see Janet Malcolm's review of Fried's book, "The Purloined Clinic," *New Yorker*, 5 Oct. 1987, 121–26.

73. Walter Pater, "Leonardo da Vinci," in *The Renaissance: Studies in Art and Poetry*, Portland, ME, 1912, 130–68. Pater wrote his famous essay in 1869.

74. Fried (as in n. 12), 10.

75. Wolf (as in n. 71), XV.

76. Prown (as in n. 71), 31.

77. Lubin (as in n. 70), 5.

78. Jules David Prown, "Style as Evidence," *Winterthur Portfolio*, XV, Autumn, 1980, 197–210; and *idem*, "Mind in Matter: An Introduction to Material Culture Theory and Method," *Winterthur Portfolio*, XVII, Spring, 1982, 1–19.

79. Prown, "Mind in Matter," 10.

80. Donald Kuspit, "Conflicting Logics: Twentieth-Century Studies at the Crossroads," *Art Bulletin*, LXIX, 1987, 117–32.

81. See, for instance, Bryan Wolf, "All the World's a Code: Art and Ideology in Nineteenth-Century American Painting," *Art Journal*, XLIV, Winter, 1984, 328–33, where he makes a stronger attempt than in his previous work to relate his interpretations to historical events and class analysis.

82. Martha Banta, *Imaging American Women: Idea and Ideals in Cultural History*, New York, 1987.

83. Cecelia Tichi, *Shifting Gears: Technology, Literature, Culture in Modernist America*, Chapel Hill, NC, 1987.

84. Elizabeth McKinsey, *Niagara Falls, Icon of the American Sublime,* Cambridge, 1985.

85. This definition was originally formulated by Jules Prown in "Mind in Matter," 1–2, and used without citation by Thomas Schlereth, a historian who has done much to explain and publicize recent scholarship in material culture. See his anthology, Thomas J. Schlereth, ed., *Material Culture Studies in America,* Nashville, 1982, 3; and for an earlier collection of essays, most of which were originally published as a special number of *American Quarterly* under the guest editorship of Schlereth, see his *Artifacts and the American Past,* Nashville, 1980.

86. Jules David Prown (as in n. 78).

87. See, for example, Karal Ann Marling, *The Colossus of Roads, Myth and Symbol along the American Highway,* Minneapolis, 1984; and Helen Harrison, *Dawn of a New Day: The New York World's Fair 1939/40,* New York, 1980. M. Sue Kendall delivered a paper on the pioneering Country Club Plaza shopping mall of 1922 in Kansas City, "Giralda in the Heartland: 'A Day in Spain' at the Country Club Plaza and the Role of Fantasy in Commerce," at the American Studies Association convention, New York City, 23 Nov. 1987.

88. I think here of earlier mass culture celebrants such as Matthew Josephson and his oft-cited essay, "The Great American Billposter," *Broom,* III, no. 4, November, 1922, 304–312, and Gilbert Seldes, *The Seven Lively Arts,* New York, 1924. Warren I. Susman's essays are collected in *Culture as History, The Transformation of American Society in the Twentieth Century,* New York, 1985.

89. Two important archival studies published in our period are Marvin S. Sadik, *Colonial and Federal Portraits at Bowdoin College,* Brunswick, ME, 1966; and Lillian B. Miller, ed., *The Selected Papers of Charles Willson Peale and His Family,* New Haven, 1983, the first of seven projected volumes. Another significant contribution to work in the Colonial field is Ian M.G. Quimby, ed., *American Painting to 1776: A Reappraisal,* Charlottesville, VA, 1971.

90. For Prown on Copley, see n. 27. John Demos, *A Little Commonwealth: Family Life in Plymouth Colony,* New York, 1970; James Deetz, *In Small Things Forgotten: The Archaeology of Early North American Life,* Garden City, NY, 1977, and Alan Ludwig, *Graven Images: New England Stone-carving and Its Symbols, 1650–1815,* Middletown, CT, 1966.

91. Wayne Craven, *Colonial American Portraiture,* Cambridge and New York, 1986; and Richard H. Saunders and Ellen G. Miles, *American Colonial Portraits, 1700–1776,* Washington, DC, 1987.

92. Museum of Fine Arts, Boston, *Paul Revere's Boston: 1735–1818,* 1975; Charles F. Montgomery and Patricia E. Kane, eds., *American Art: 1750–1800,* Boston, 1976; and Edgar P. Richardson, Brooke Hindle, and Lillian B. Miller, *Charles Willson Peale and His World,* New York, 1982.

93. Jonathan L. Fairbanks and Robert F. Trent, *New England Begins: The Seventeenth Century,* 3 vols., Boston, 1982.

94. The literature criticizing the art historian's approach to American folk art is extensive, but can be sampled in Henry Glassie, "Folk Art" (1972), reprinted in Schlereth, 1982 (as in n. 85), 124–42; Kenneth L. Ames, *Beyond Necessity: Art in the Folk Tradition,* The Winterthur Museum, Wilmington, DE, 1977; and Ian M.G. Quimby and Scott T. Swank, eds., *Perspectives on American Folk,* New York, 1980. For other perspectives, see John Michael Vlach, "American Folk Art, Questions and Quandaries," *Winterthur Portfolio,* Winter, 1980, 345–55, and Vlach and Simon J. Bronner, eds., *Folk Art and Art Worlds,* Ann Arbor, MI, 1986. In this latter anthology, the two relevant articles are John Michael Vlach, "'Properly Speaking': The Need for Plain Talk about Folk Art," 13–26, and Eugene W. Metcalf, Jr., "The Politics of the Past in American Folk Art History," 27–50.

95. *An American Sampler: Folk Art from the Shelburne Museum,* Washington, DC, 1987. The essay by art historian David Park Curry in this catalogue, "Rose-Colored Glasses: Looking for 'Good Design' in American Folk Art" (pp. 24–41), mulls over the folklorists' dissatisfactions, but seems to have exerted no influence on the installation of the exhibition or the writing of the wall labels.

96. For other personal and historiographical retrospectives, see Jules David Prown, "Art History vs. the History of Art," and Elizabeth Johns, "Histories of American Art: The Changing Quest," both in *Art Journal,* XLIV, Winter, 1984, 313–14, 338–44. Also see Johns (as in n. 7).

2

Reading Eighteenth-Century American Family Portraits

Social Images and Self-Images

MARGARETTA M. LOVELL

Combining close visual analysis of eighteenth-century American and British portraits with insight into social attitudes and practices, Margaretta Lovell extends our understanding of the group family portrait as a primary document in the history of American colonial culture. Lovell departs from familiar historical accounts of early American art that tend to attribute the greater naturalism and complexity of composition in many late eighteenth-century American group portraits to either individual artistic achievement or increased technical mastery among colonial painters as a group. Instead, she suggests a more complex reading of these images as embodiments of a variable social order in which evolving conceptions of gender and family relations generate new kinds of pictorial arrangements.

Lovell argues that both the growing interest in family group (as opposed to individual) portraits and the shift from a rigidly patriarchal model of the family to one structured around animated children and motherhood as the center of domestic harmony signal an altered sense of values and beliefs about the nature of the family and the meaning of childhood. These patterns are traced through the gradual modification of portrait conventions that actively contributed to a new social consensus regarding gender and family dynamics.

In 1772 London-based American artist Benjamin West painted a portrait of his family. It is one of about fifty group portraits by American artists surviving from the eighteenth century. The image includes the artist himself at the extreme right, his elder son, Raphael, by the window, the seated figures of his father and half brother, and, on the left, his wife and infant son. The artist has portrayed himself and Raphael in complementary leaning poses and in similar plum-colored clothing, the two seated Quakers are dressed in somber brown and black, and all the men direct our eyes—by their gestures, poses, and gazes—toward the brightly lit maternal group. In many ways this posed vignette portraying three generations of one family confirms our expectations of an eighteenth-century domestic group. But the visual emphasis on the maternal pair—enthroned in a generous, damask-covered easy chair—seems slightly hyperbolic or at least disproportionate given the dignity one would ordinarily attribute to the patriarch or to the meteorically successful artist himself. Observation of other late eighteenth-century family portraits confirms this "matricentric" pictorial arrange-

ment, and comparison with works from the first half of the century indicates that paintings by West and his contemporaries represent a departure from earlier practice in the arrangement of the figures and the focus of the composition. This distinct and somewhat puzzling change appears to point to a shift in social practice or social ideology and seems to reinforce and amplify the findings of historians investigating the late eighteenth century from other points of view.

The pictures that were painted by American artists in the eighteenth century record a specific social strata: the gentry, merchant, and professional classes (not the court on the one hand or the laboring classes on the other)—precisely those groups identified by Lawrence Stone, Neil McKendrick, and others as the "pacemakers of cultural change." These were the classes in which new concepts of family relationships and new patterns of home-oriented consumerism were rapidly evolving in the mid eighteenth century, exactly that moment when family portraits were dramatically changing from earlier patterns—as in *Isaac Royall and Family* by Robert Feke of 1741 [1]—to those exemplified by the West family group. The matter of class is complicated in an investigation of these portraits as the artists—West, Charles Willson Peale, John Singleton Copley, Gilbert Stuart, and others—were, by and large, born into and raised in artisan, often quite impoverished, and certainly ungenteel environments. They were, through marriage and the artistic achievement recorded in images of their own families, actively upwardly mobile themselves. The difference, for instance, between West's presentation of himself—clad in pastel, embroidered silks and a fashionable wig—and that of his father—in homely wool and with lank locks—represents more than a geographical relocation to London and a weakening enthusiasm for Quakerism; West is clearly portraying the outward signs of self-propelled success. And yet it is important to note that the model of upward emulation in the

matter of consumer aspiration and social relationships that many historians enthusiastically endorse does not fully account for the actions, desires, or material acquisitions of Americans at this period. Henry Glassie and others have suggested a modified "reception theory" which postulates the priority of a felt need for an object, ideology, floor plan, facade, or style before long-extant models are appropriated or emulated.[1] This need is based on shifting attitudes toward time, privacy, authority, and other basic issues rather than on a superficial desire for the objects and images of a wealthier or more powerful class. According to this model, the causes of change (or of resistance to change) are more complex, more fundamental, and more interesting than many have thought. An instance of apparently deliberate nonemulation in the matter of family portraits will be touched on below.

Although this study has involved the detailed investigation of individual pictures, the overall direction has been to discover commonalities, groups of works and patterns of usage that indicate widespread practice rather than the invention or achievement of individual artists. Parenthetically it is important to note that although capturing "a good likeness" was one of the key measures of a painting's success in the eighteenth century, there seems to have been little emphasis on penetrating the sitter's inner character or psychological state. These are works that record, above all, the physiognomy of individuals and the posture, material attributes, and "manner" appropriate to broad class, age, and gender groups. They were at least in part intended and may usefully be read as documents of socially appropriate behavior and relationships if not of specific realities.

Family portraits are relatively rare. Most Americans choosing to be memorialized in portrait form in the eighteenth century were painted as single figures on canvases of roughly standardized sizes in a vertical format. Characteristic of the full-length portrait, Feke's *Brigadier Gen-*

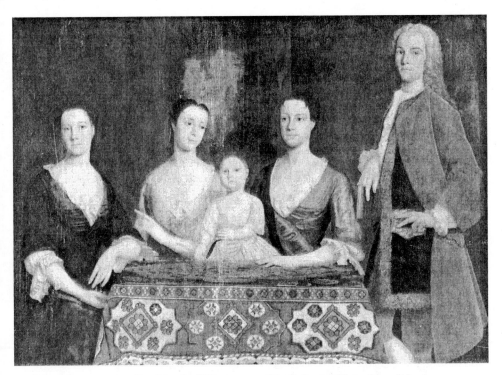

1. Robert Feke, *Isaac Royall and Family,* 1741; courtesy of Art Collection, Harvard Law School.

eral Samuel Waldo (1748–1750) records the dig-
nity and attributes of a bewigged general who
clasps his baton of command in one hand, places
the other hand on his hip, and assumes the con-
versational posture recommended in a popular
etiquette book, *The Rudiments of Genteel Behav-
ior,* published a decade earlier in London: "The
whole body must rest on the right foot and the
right knee, . . . the Back be kept straight; the left
leg must be foremost and only bear its own
weight, and both feet must be turned outwards."[2]
The akimbo gesture and the firm grasp of a man-
made instrument of action in the world (some-
times a quill pen, a sword, a walking stick, a
maulstick, a cannon, or a similar elongated in-

strument) remain male attributes in portraits
throughout the century, but the freestanding
"genteel" baroque stance of Feke's general does
not. Men begin to cross their legs and *lean* on ex-
terior support (as West and his elder son do in
The Artist's Family) about 1750. Posture
changes; attributes remain constant. Some of this
"body rhetoric" is conscious and articulated (as
the text on genteel behavior makes clear). Some
is less conscious, giving us outward clues to in-
ner assumptions, values, and attitudes.

Throughout the seventeenth, eighteenth, and
early nineteenth centuries, most couples desiring
to be memorialized would commission paired
portraits. In matching frames and on canvases of

equal size, the almost life-size figures slightly inflected toward one another, paired portraits such as those by Copley of Mr. and Mrs. Isaac Smith were by far the commonest form of family portraiture.[3] The figures are equal in size and visual weight, complementary in dominant hue, and parallel in scale and posture. The major differences between them are gender-specific attributes, environments, and gestures. As mentioned above, men often touch and are associated with elongated instruments of contact with the outside world, as in the case of Smith's papers and quill pen. Mrs. Smith, on the other hand, holds a bunch of grapes—characteristic of the more rounded organic objects, most commonly fruit, flowers, and dogs and other pets, that were seen as appropriate attributes for women. Beyond Mrs. Smith a pair of entwined trees suggests her married state. But most interesting is the limp, muscleless grasp with which she supports (or rather, fails to support) a heavy bunch of grapes. In these portraits visual and very real gender-specific social conventions differentiate between the kinds of objects (man-made or natural) and the type of appropriation (firm, possessive grasp or limp gesture) that link individuals to the outside world and to outside experience.

Surprisingly rare among eighteenth-century portrait types are double portraits of husband and wife portrayed together on a single canvas. More difficult to compose than single-figure canvases, these works are probably uncommon also because childlessness was uncommon, and, as the group portraits make clear, the presence of children within the household was important enough to warrant the inclusion of even the smallest infant. The few extant examples of American dual portraits from the first half of the eighteenth century—usually of childless couples or of those with grown children (for example, *Captain Johannes Schuyler and His Wife* [ca. 1725–1730])—follow the English convention of a standing husband accompanied by a seated wife as in Thomas Gainsborough's *Robert Andrews*

and His Wife (ca. 1750). The alert verticality of the husband's posture is balanced by the sedentary horizontal or pyramidal figure of his wife— a balancing composition of opposites. And parenthetically, although most of what I have found to be true of American portraiture in the eighteenth century is also true of English paintings at this time, there is one dramatic difference, perceivable in this pair. In the American painting—and this is almost universally the case—the space pictured is shallow and the setting vague; the figures are pressed close to the picture plane. In the English work the Andrewses share their canvas with a generous expanse of countryside, a distinct and enveloping setting. This seems to be a consistent pattern even when both images represent mercantile rather than landed gentry, and it may suggest that the English family retained a firmer grasp on the concept of family line (the extended family in time and space), while the Americans preferred the image of an independent unitary household vaguely located in an unancestral, unspecific space. But in most other matters, there is a close and not surprising similarity between the products of the English painters and those of the Americans.[4]

After about 1760, when a husband and his wife are pictured together in one composition they usually assume the same posture: they both sit or they both stand, as in the case of Copley's *Mr. and Mrs. Isaac Winslow* (1774) and John Trumbull's portrait of his parents. There is an evenness in the relationship implied. They seem equal partners in a joint enterprise with perhaps a slight hint of dominance in the husband's hand and arm gestures, and a modest deference in her recession behind the furniture.[5]

In the last two decades of the eighteenth century these dual-figure portraits underwent a further modification. In such works as *Benjamin and Eleanor Ridgely Laming* by Peale and *Captain John Purves and His Wife* by Henry Benbridge, the figures touch and lean on each other in postures and with gestures that suggest the

popularity of love matches and a new acceptability of public demonstrations of private affection. Stone has established that the "companionate marriage" at the heart of the modern family is characterized by an "intensified affective bonding of the nuclear core" and "a weakening of the association of sexual pleasure with sin and guilt."[6] We need only to read Benjamin Laming's telescope and Eleanor's peaches as anatomical analogues (as the artist seems to suggest) in order to see the intensity of this new social and personal vision.

As we have seen, images of pictorially childless couples change from the early eighteenth century when active, vertical, akimbo male figures were balanced by passive, horizontal female figures to more companionate, parallel couples sitting or standing together in close harmony. The shift is significant and seems to occur about 1760. Turning to multifigure groups, we find that the portrait tradition exhibits an even more dramatic change at the same time. The early eighteenth-century multifigure works—such as Feke's *Isaac Royall and Family*—include standing, akimbo males contrasted with clustered female figures and male associates. The compositions include a dizzying variety of hand gestures, neck turnings, and direct gazes, but the principal male figure coolly ignores the household and gazes intently at the spectator or, as in the case of philosopher-theologian Berkeley in *Dean Berkeley and His Entourage (The Bermuda Group* [1728 or 1739]) by John Smibert, at the heavens. Most of the attributes and props that accompany sitters in single-figure portraiture disappear in the group context where gender confirmation and relationships depend on subtler clues. We can get a fairly clear sense of the social ideals and realities mapped here if we read these paintings with the interrogatives suggested by Ronald Paulson in a related context: "who is next to whom, who is how far from or inclining toward or away from or touching whom; whose eyes turn, whose eyes meet, and who is standing or sitting next to

what." The location of the males in *The Bermuda Group* is marked and punctuated by three stout columns (fictional columns, as Berkeley's extant house in Newport, Rhode Island, has no such embellishment), while the women in both this and the Feke images are associated with the emphatic horizontality of the foreground table. The households pictured by Smibert and Feke are characterized in pictorial terms by the balancing of opposite elements: male and female, dark and light, vertical and horizontal. The patriarch in these images remains aloof and freestanding—he neither touches nor looks at his kinfolk. The children in these early eighteenth-century paintings pose stiffly in their mothers' arms; they are still, composed, obedient, attentive, and easily overlooked minor actors in the complex tableaux. The women sit in quiet horizontal groups and direct their attention to the spectator and their gestures to their companions. In Stone's terms, these are families characterized by "distance, deference, and patriarchy."[7]

In paintings of families by American artists *after* 1760, much changes. Numerically speaking, although single-figure canvases still greatly outnumber family groups, there are many more family portraits than in the first half of the century. This increase may partly be explained by the growing technical expertise of American artists willing to take on more complex pictorial problems, but it appears to reflect primarily a social fact: a greater interest in, enthusiasm for, and celebration of the family.

Taking the cast of characters one at a time, the most dramatic shift occurred in the figure of the child. Characteristic of children in family portraits from the second half of the eighteenth century, the four children in Copley's *Sir William Pepperrell and His Family* [2] play games and cavort with a freedom and spontaneity in their gestures foreign to their pictorial predecessors. They are treated differently by the artist, and we sense that they are treated differently by their parents. John Witherspoon wrote in 1797: "In the former

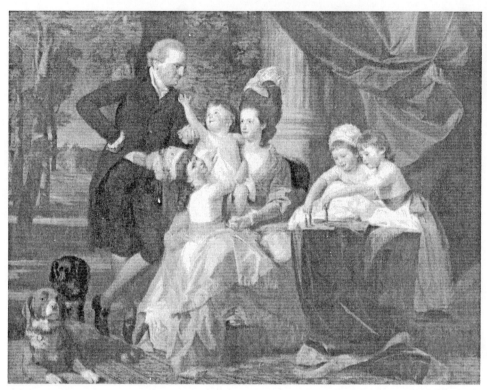

2. John Singleton Copley, *Sir William Pepperrell and His Family,* 1778; courtesy of North Carolina Museum of Art, Raleigh, purchased with funds from the State of North Carolina.

age, both public and private, learned and religious education was carried on by mere dint of authority. This to be sure, was a savage and barbarous method. . . . Now . . . persuasion, and every soft and gentle method is recommended." The behavior of the Pepperrell children suggests that theirs is a "gentle" rather than an authoritative upbringing, one consistent with emerging attitudes toward the young. In the seventeenth and early eighteenth centuries most parents felt compelled to apply strict adult controls to counter a deeply rooted natural depravity in youngsters, a sentiment memorably captured in Anne Brad-

street's "Stain'd from Birth with Adams sinfull fact / Thence I began to sin as soon as act." But by the 1760s a more hopeful sense of human nature prevailed, and the theories of John Locke and Jean-Jacques Rousseau concerning the impact of early experience on mature personality were becoming broadly known and endorsed. As a result, certain families—Philip Greven calls them "genteel"—developed permissive child-rearing practices, practices that shaped, in his opinion, adults with a sense of "self-worth, self-love, and self-confidence."[8] While Greven associates these fortunately nurtured children with distinct religious

allegiances, the evidence of the portraits suggests that the introduction of new attitudes toward the young crossed sectarian boundaries, and to some degree class boundaries, becoming almost universal among family portrait purchasers from 1760 on.

After 1760 these reaching, clamoring, grinning youngsters become the focus of the picture's action and threaten to break the elegant tone set by their parents. But these children are different from their predecessors in more than their freedom of movement, as Karin Calvert has made eloquently clear; they are equipped with toys (such as the discarded doll in the lower left and the coral and bells, on a pink sash which the baby shows to her grandfather in Copley's portrait of his own family). Moreover, Calvert has found that these children go through a complex, many staged series of costumes before donning adult garb, suggesting that, in their parents' eyes, they changed as persons in more identifiable stages than their predecessors had.[9]

While the painters of the revolutionary generation were clearly more talented than their predecessors, the changes that occur in portraits about 1760 are not attributable to this alone. The "stiffness" of Feke's *General Waldo* or Smibert's figures in *The Bermuda Group* compared with the "naturalness" of West's or Copley's figures suggests a shift in adult models of deportment away from the formality prescribed by early eighteenth-century etiquette and advice books as much as an increased artistic fluency. Similarly the shift from the image of the infant or very young child who boldly, motionlessly observes the spectator to that of the clamoring youngster whose attention is completely absorbed by objects and persons within the tableau represents a change in society's understanding of the child as well as a greater mastery of anatomy and perspective on the artist's part. The characteristics that mark images of family members are widespread and more period-specific than artist-specific. Individual artists whose careers span the eighteenth century change the "body rhetoric" and relative positions of their figures as the conventions of self-presentation shift. Gainsborough, for instance, alters his interpretation of the couple from that of the early contrasting standing, vertical man and horizontal, seated woman in 1750 (*Robert Andrews and His Wife*) to that of the parallel couple who walk arm in arm in his 1785 *Mr. and Mrs. Hallett* (National Gallery, London). And his interpretation of the family group changes from the classic early eighteenth-century format of *Mr. and Mrs. John Gravenor and Their Daughters* to the matricentric *Baillie Family* of circa 1784. The pictorial evidence taken as a whole points away from issues of individual talent and toward issues of social consensus.

While the shift in the social and pictorial role of the child in Anglo-American portraiture is clearly the most significant difference between early and late eighteenth-century images, alterations in the portrayal of other family members change the look, impact, and interpretation of these portraits. The child's new centrality involves a corollary shift in the father's role: he cedes visual dominance and, turning sideways to the picture plane, leans toward, plays with, looks at, and touches the child as he never did in early eighteenth-century portraits. While in such early images as Feke's *Isaac Royall and Family* the father anchored the composition and riveted the spectator with his authoritarian gaze, in such later works as Peale's *General John Cadwalader, His First Wife, Elizabeth Lloyd, and Their Daughter, Ann* (1772) and West's *Arthur Middleton, His Wife, Mary (née Izard) and Their Son, Henry* (1770–1771), his presence is reduced and contingent. This new status is often emphasized by his recession from the picture plane and his presentation to the beholder with a marginalizing profile physiognomy. In such portraits as West's family group, the father's position, his posture, and often his attention encour-

age us to focus on his progeny and not on him. Clearly the withdrawal from a posture of authority involves an admiration for, perhaps even a nostalgia for, the special state of childhood, as it was newly perceived.

Similarly when there is a young child in the family portrait, the position of the mother vis-à-vis her infant and her husband are markedly different from the relationships perceived in the first half of the eighteenth century. Where formerly (as in Feke's *Isaac Royall and Family*) she presented a quiet foil to the assertive figure of her husband, in such late eighteenth-century works as *The Wright Family* (1793) by Joseph Wright and in the familiar West family group she commands the primary attention of the viewer and of the family members pictured. The husband retreats visually, and although he usually maintains his standing posture, his gaze, coloration, gesture, and orientation subordinate his figure to that of his brightly lit, seraphic wife, absorbed in her identity as mother. Her centrality, however, is not assertive; rather, it is unself-conscious and modest. The curious mid eighteenth-century reversal of time-honored stereotypes of women as the sinful, deceptive, and disobedient weaker vessel to the chaste, honest guardian of domestic harmony and republican virtue has been interestingly analyzed by numerous historians including Nancy Cott and Marlene Le Gates. That this new role is in a sense artificial is rather cynically granted by such influential writers as Rousseau: "If the timidity, chastity, and modesty which are proper to [women] are social inventions, it is in society's interest that women acquire these qualities." The celebration of these virtues and ideals is well known from the verbal documents, but the concurrent retreat of the husband from centrality in the domestic sphere is nowhere as emphatic in the documents as it is in these paintings. Legal realities and written sources assure us that Stone is correct when he says: "As a social system, the nuclear family has two castes—

male and female—and two classes—adult and child. The male caste always dominates the female, and the adult class the child. . . . In the Early Modern Period, a female adult took precedence over a male child, but only up to the age of about seven." When we look at both English and American pictures, however, precedence is uniformly granted to the maternal figure; she glows and looms over the family like a triumphant Madonna—a fact that has puzzled some.[10] But it is clear that in the mime show of the portrait (as in the newly popular medium of the novel) certain fictions and ideals are being asserted that helped the early modern family adjust to the strains of new economic and social relationships. Where some historians point to this moment as the beginning of a dramatic decline and a disabling sentimentalization of womanhood, the paintings give us some sense of the apparent privileging of women in their role as mother. As we have seen, portraits of childless couples, even those from the late eighteenth century, give her no such precedence as we find in such incongruously titled paintings as Sir Joshua Reynolds's *Duke of Marlborough and His Family* (1778). Clearly it is the altered role of the child in the ideology of the day that is responsible for the mother's elevation as custodian. And in America—as John Adams makes clear—there was a political as well as a moral goal at stake in this enterprise: "I say . . . that national Morality never was and never can be preserved without the utmost purity and chastity in women; and without national Morality, a Republican Government cannot be maintained."[11]

It is no coincidence that during this late eighteenth-century period we find a rare interest among American artists in religious painting, especially in images of the Nativity, Holy Family, and Madonna. In part, of course, this interest was sparked by the ambitious goals of some of these artists to compete and establish themselves on a par with first-rank European artists at a time when taste favored history painting (and its sub-

genre, religious painting). There was little market for religious subjects in Protestant colonial America, but the general secularization of American life during the later eighteenth century permitted the experimentation, especially by American artists resident in England, in these formerly untried subjects. The degree to which these images were *secularized*—that is, liberated from their historic religious context and incorporated into a context of modern domestic life—is suggested by the literal conflation of the two spheres in such paintings as Copley's *Nativity* (1776–1777) and West's *Mrs. West and Her Son Raphael* (ca. 1770). In the former, Copley has used his wife as a model for the Madonna, and her head and upper body appear in a pose almost identical to that in *The Copley Family*. Similarly, West has incorporated his wife and elder son in a composition that consciously quotes the well-known tondo by Raphael known as *The Madonna of the Chair*. The intersection of the domestic and religious spheres in these images, and the move by these artists to reinterpret and quote the Renaissance masters in numerous other related images, suggests not only their personal artistic ambition but also their consciousness of an identity between the Holy Family and an idealized version of the modern domestic sphere.[12] They have appropriated for their wives—in their role as mother—the supreme example of female virtue.

While visually childless couples in the second half of the eighteenth century exhibit an evenness of emphasis between the figures with a slight element of dominance on the part of the husband, all the portraits in which there are infants and young children are dominated by the maternal group.[13] There is one interesting exception: folk, or naive, family portraits from the late eighteenth century. Here, in such works as *Family Group* (ca. 1795) by an unknown artist and *Family Portrait* (1804) by Ralph E. W. Earl, as in the contemporary childless couples painted by Copley, Trumbull, Peale, and others, there is an evenness of emphasis; the wife is never visually

dominant.[14] At this point it is impossible to determine whether we are looking at evidence of different, older, child-rearing patterns in nonurban areas, at *retardataire* painterly conventions, or at certain habits of mind characteristic of the naive painter (by and large the naive painter organized his composition for overall two-dimensional pattern rather than interlocking dominant and subordinate elements). These naive pictures are uniformly even in their tone and in their attention to family members; they present us with an interesting example of nonemulation as these artists certainly knew—at least in print form—the work of their urban contemporaries and declined to imitate the compositions and family relationships they saw there. The social gulf between the urban mercantile elite (represented by most of the portraits included here) and the rural gentry (pictured in these last two examples) was probably greater than we imagine—great enough to give us this evidence of distinctly different pictorial conventions, social ideologies, and child-rearing practices.

While much has been written on the nature of folk art and on its relation to urban art, there is little consensus on its boundaries or even on proper nomenclature. Some maintain that it is *the* locus of creativity in America, privileging it and valuing it beyond mainstream developments and European-oriented art forms, while others assert that it is simply a poorly understood, poorly executed version of its urban cousin.[15] In looking at this narrow group of family portraits—images that share certain characteristics of technique (and, we believe, of market, although it is difficult to find a body of conclusive research on the patrons of these elusive, often anonymous, works of often unknown sitters)—it is clear that the "rules" by which they are composed differ from those common in the urban centers of Boston, Philadelphia, and London. While the absolute number of naive family portraits rises as dramatically during this period as in the urban centers, the execution differs markedly, which supports

the complex "reception theory" of cultural change in which novel forms are selectively adopted rather than poorly mimicked.

By reading eighteenth-century family portraits in terms of the relationship of the figures, their attributes, and their activities and by finding consistent patterns in the portrayal of these elements, we can gain some insight into the larger questions of changing (and class-distinct) family manners, ideologies, and attitudes toward au-

thority. The hyperbole we read in these portraits by West, Copley, and Peale is particularly telling. In the post-1760 urban works the children are more unleashed, the fathers more reticent, and the mothers more central than the verbal documents lead us to expect. In this breech between "reality" as social historians have come to understand it and the fiction the artists have described, we can locate the confirming factors of a new social order.

NOTES

From *Winterthur Portfolio* (1987). Reprinted by permission of the author and the University of Chicago Press.

1. Lawrence Stone, *The Family, Sex and Marriage in England, 1500–1800* (London: Weidenfeld and Nicolson, 1977), pp. 12, 20; Neil McKendrick et al., *The Birth of a Consumer Society: The Commercialization of Eighteenth-Century England* (Bloomington: Indiana University Press, 1982), p. 10 and passim; Henry Glassie, *Folk Housing in Middle Virginia* (Knoxville: University of Tennessee Press, 1975), pp. 66–193.

2. François Nivelon, *The Rudiments of Genteel Behavior* (London, 1737), n.p.

3. That the portraits were intended to be hung facing one another is indicated by such contemporary documents as the parental pair on the wall in Johann Zoffany's *Prince George and Prince Frederick in an Interior in Buckingham House* (1765, Royal Collection); that the convention was commonly understood is suggested by William Hogarth's pointed and witty inflection of the betrothed couple away from each other in *Marriage à la Mode: The Marriage Contract* (1743–45, National Gallery, London).

4. Philippe Ariès, *Centuries of Childhood: A Social History of Family Life,* trans. Robert Baldick (New York: Random House, 1960), p. 353; Georges Duby, *The Knight, the Lady and the Priest: The Making of Modern Marriage in Medieval France,* trans. Barbara Bray (New York: Pantheon Books, 1983), pp. 228ff. Other English dual portraits from the first half of the eighteenth century include Arthur Devis's *William Atherton and His Wife, Lucy* (ca. 1744, Walker Art

Gallery, Liverpool) and *Mr. and Mrs. Hill* (1750, Yale Center for British Art).

5. Other examples include Ralph Earl's *Justice Oliver Ellsworth and His Wife* (1792, Wadsworth Atheneum) and Copley's *Mr. and Mrs. Ralph Izard* (1775, Museum of Fine Arts, Boston).

6. Stone, *Family, Sex and Marriage,* pp. 8, 325–404; English dual-figure portraits, such as Henry Raeburn's *Sir John and Lady Clark of Penicuik* (ca. 1790, Sir Alfred Beit Collection) and Gainsborough's *Mr. and Mrs. Hallett* (1785, National Gallery, London), include similar instances of couples leaning on and touching one another.

7. Ronald Paulson, *Emblem and Expression: Meaning in English Art of the Eighteenth Century* (London: Thames and Hudson, 1975), p. 157; Stone, *Family, Sex and Marriage,* p. 4. Other pre-1760 family groups by American artists include John Greenwood's *Greenwood-Lee Family Group* (1747, private collection) and Joseph Blackburn's *Isaac Winslow and His Family* (1755, Museum of Fine Arts, Boston); English works exhibiting these characteristics include Gainsborough's *Mr. and Mrs. John Gravenor and Their Daughters* (ca. 1748–50, Yale Center for British Art), Hogarth's *William Ashley Cowper with His Wife and Daughter* (1731, Tate Gallery), Devis's *Robert Gwillym of Atherton and His Family* (ca. 1749, Yale Center for British Art), and Francis Hayman's *Margaret Tyers and Her Husband* (ca. 1750–52, Yale Center for British Art).

8. John Witherspoon, "Letters on Education" (1797), in Philip J. Greven, Jr., *Child-Rearing Con-*

cepts, *1628–1861: Historical Sources* (Itasca, Ill.: F. E. Peacock Publishers, 1973), p. 89; Philip J. Greven, Jr., *The Protestant Temperament: Patterns of Child-Rearing, Religious Experience and the Self in Early America* (New York: Alfred A. Knopf, 1977), pp. 29, 274.

9. Karin Calvert, "Children in American Family Portraiture, 1670 to 1810," *William and Mary Quarterly,* 3d ser., 39, no. 1 (January 1982): 87–113. Surviving coral and bells include a remarkable gold example of ca. 1760–70 by Daniel Christian Fueter of New York at the Yale University Art Gallery (1942, 91).

10. Nancy Falik Cott, "In the Bonds of Womanhood: Perspectives on Female Experience and Consciousness in New England, 1780–1830" (Ph.D. diss., Harvard University, 1974), chap. 4, "Sexual Passionless-ness: An Hypothesis," pp. 217–63; Marlene Le Gates, "The Cult of Womanhood in Eighteenth-Century Thought," *Eighteenth Century Studies* 10, no. 1 (Fall 1976): 21–39; Jean-Jacques Rousseau, *Lettre à M. D'Alembert sur les spectacles* (Paris, 1758), p. 160 (my translation). Stone, *Family, Sex and Marriage,* p. 22; Stephen Brobeck, "Images of the Family: Portrait Paintings as Indices of American Family Culture, Structure and Behavior, 1730–1860," *Journal of Psychohistory* 5, no. 1 (Summer 1977): 81–106.

11. For a review of recent literature on the family in early America, see Daniel Blake Smith, "The Study of the Family in Early America: Trends, Problems, and Prospects," *William and Mary Quarterly,* 3d ser., 39, no. 1 (January 1982): 3–28. In paintings that include only adolescent and grown children with their parents, the mother retreats from prominence. Examples include William Dunlap, *The Dunlap Family* (1788, New-York Historical Society), and Peale, *The Goldsborough Family* (1789, private collection). John Adams to Benjamin Rush, as quoted in John A. Schutz and Douglas Adair, eds., *The Spur of Fame: Dialogues of John Adams and Benjamin Rush, 1805–1813* (San Marino, Calif.: Huntington Library, 1966), p. 76; see also an entry on this subject in Adams's diary as early as June 2, 1778, in Charles F. Adams, ed., *The Works of John Adams,* vol. 3 (Boston: Little, Brown, 1851), p. 171.

12. Other examples include West, *The Holy Family* (ca. 1760–63, Old St. Joseph's Church, Philadelphia) and *The Golden Age* (1776, Tate Gallery), and Trumbull, *St. Jerome at Parma,* after West's copy of Corregio's painting of the subject (1780–81, Yale University Art Gallery), *The Holy Family* (ca. 1804, Yale University Art Gallery), and *The Holy Family* (1802–6, Yale University Art Gallery). See also Jules D. Prown, "Benjamin West's Family Picture: A Nativity in Hammersmith," in *Essays in Honor of Paul Mellon,* ed. John Wilmerding (Washington, D.C.: National Gallery of Art, 1986), pp. 269–86.

13. Other American examples include *The Peale Family* (1770–1809, New-York Historical Society), *The Edward Lloyd Family* (1771, Winterthur Museum), and *Gov. Thomas Johnson and Family* (1772, C. Burr Artz Library, Frederick, Md.) by Peale; *The Todd Family* (ca. 1785, Detroit Institute of Arts) by an unknown artist; *Sir John Temple and Family* (1784, private collection) and *The Vernet Family* (1806, Yale University Art Gallery) by Trumbull; and West's *Portrait of Arthur Middleton, His Wife, and Their Son, Henry* (private collection). English examples include *The Baillie Family* (1784, Tate Gallery) by Gainsborough.

14. Other folk or naive family portraits include Earl, *The Angus Nickelson Family* (ca. 1790, Museum of Fine Arts, Springfield, Mass.), William Wilkie, *Nathan Hawley and Family* (1801, Albany Institute), unknown artist, *The Sargent Family* (1780, National Gallery of Art, Washington, D.C.), and William Williams, *The Denning Family* (1772, private collection).

15. See Henry Glassie, "Folk Art," in *Folklore and Folklife: An Introduction,* ed. Richard M. Dorson (Chicago: University of Chicago Press, 1972), pp. 253–80; and Ian M. G. Quimby and Scott T. Swank, eds., *Perspectives on American Folk Art* (New York: W. W. Norton, 1980).

3

Ariadne and the Indians

Vanderlyn's Neoclassical Princess, Racial Seduction, and the Melodrama of Abandonment

DAVID M. LUBIN

In his provocative discussion of this well-known painting, David Lubin takes issue with the premise that Vanderlyn's conventional image of the classicized female nude exists in a privileged space of universal—and therefore apolitical—meaning. As a representation of an eroticized female body positioned in the domain of nature, Ariadne can be identified with a familiar archetype in European painting. But, as Lubin argues, this association does not preclude readings of the work in terms of issues relevant to its specifically American social and historical context.

Lubin links the subject of the painting to personifications of the American republic as an Indian princess and, later, a classical goddess, and to the revival in America of melodrama as a popular art form. He then suggests a possible understanding of the legend of Pocahontas as an American variant of the Ariadne myth, with its attendant themes of seduction and abandonment. Lubin argues for the existence of a powerful political subtext generated by unacknowledged guilt and anxiety over the betrayal, and subsequent degradation, of Native American peoples in the interest of nation-building.

Art historians have tended to regard John Vanderlyn's (1775–1852) *Ariadne Asleep on the Is-*land of Naxos as a painting that, while technically proficient, is cold and derivative—a formula hybrid of romanticism and neoclassicism that depicts ardor without possessing or generating any of its own [1]. The title's allusion to classical mythology appears to be little more than a ruse at drumming up cultural validity for a slickly provocative representation, life-sized and leering, of a curvaceous naked woman.

Despite the painting's lush romanticism, sensational voyeurism, and stagy contrivance, however, we can discern in *Ariadne* more meaning than meets the eye. By considering the work in terms of the social and political history of its era, we will find its significance increase and its alleged vacuity diminish if not entirely disappear. In fact, *Ariadne* resonates with several critical themes from the early nineteenth century, among them the volatile relationship in early America between whites and Indians. Certainly in the Madisonian years of westward expansion, when Vanderlyn was painting *Ariadne*, no single question was more publicly troubling than how the new American republic was to maintain its high moral ground and yet respond, with the fullest economic and military advantage, to the indige-

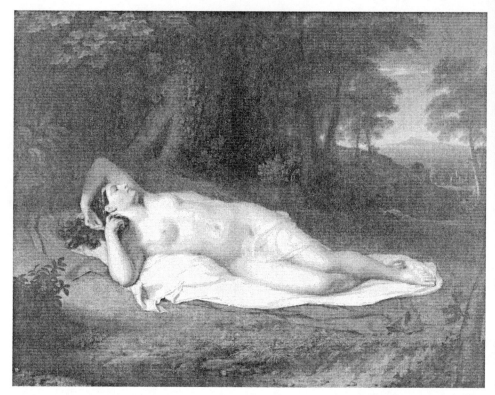

1. John Vanderlyn, *Ariadne Asleep on the Isle of Naxos,* 1809–1814; courtesy of the Museum of American Art of the Pennsylvania Academy of the Fine Arts, Philadelphia. Gift of Mrs. Sarah Harrison (The Joseph Harrison Jr. Collection).

nous peoples who possessed prior claim to the land.

While I would not argue that Vanderlyn equated nude Ariadne with the American Indian and intended the painting as a vehicle for addressing the problem of Indian relations, the painting's subject (nude female figure in pastoral setting), style (possessing both French neoclassical and romantic elements), and theme (seduction and betrayal) interact so that the work is surprisingly relevant to this particularly pressing social issue. The aesthetic choices Vanderlyn made in this work, whether or not he realized as much, are related to the urgent social choices that were then confronting the new nation and its citizens.

It was the beginning of the century, and Vanderlyn had already won Parisian acclaim with two provocative paintings, *The Death of Jane McCrea* (1804) and *Marius Amidst the Ruins of Carthage* (1807). With these works he had shown himself to be not only current in his pictorial aesthetics but also strikingly political.

Jane McCrea, illustrating an alleged episode from the American Revolution in which a young

colonial woman was hatcheted to death by Indian mercenaries hired by the British, was roundly applauded in Paris at a time when hostilities between France and England were at high pitch. The painting was commissioned by Joel Barlow, President Jefferson's envoy to France, who had described the incident in *The Columbiad,* his epic poem celebrating America's rejection of British authority and rule.[1] *Marius,* no less timely than *Jane McCrea,* depicts an exiled Roman general who scowls while contemplating revenge on his enemies. Bonaparte himself is said to have awarded the painting a gold medal when it was exhibited at the Louvre. Obsessed with bending an unappreciative world to his will, the young emperor, against whom all the counterrevolutionary armies of Europe were arrayed, might indeed have been pleased to identify with this rippling fantasy of hard-bodied, hard-minded masculinity defiant of the corrupt and corrupting opposition.[2]

In 1809, fresh from these two triumphs, Vanderlyn began work on *Ariadne* and devoted to it the following three years of his life. While probably his best-known painting, it is usually considered apolitical, as though in his zeal to scale the heights of academic neoclassicism the ambitious young artist abandoned his commitment to political art. A recent commentator on Vanderlyn, pointing out that *Ariadne* "makes no overt reference to the American or French political climate," interprets it exclusively in terms of formal sources, artistic styles, ancient myths, and timeless symbols, and describes it "not only as a neoclassical idealization, but also as an essentially romantic investigation that is at once universal and intensely individual."[3]

Even so, the painting can be viewed meaningfully with regard to the important political issues of the day: "the Indian question" among them. Given that Vanderlyn moved within or close to political circles throughout his life and that from time to time he specifically incorporated Native American figures into his art, an explicitly polit-

ical reading of the painting is amply justified, even if the painting itself is not explicitly political. Whether the artist and his contemporaries understood *Ariadne* as being metaphoric of Anglo-Indian relations, there are legitimate grounds for doing so, as we shall see.

Before we pursue this reading, however, we should recognize that little documentary evidence exists concerning the reception of *Ariadne* by Vanderlyn's contemporaries. While scattered written comments have led scholars to suppose that the painting was initially well received by both connoisseurs and the general public, hard evidence for this is lacking. We simply have no way of knowing how representative was the enthusiasm of a few friends, or the extent to which Vanderlyn himself embellished the success of his painting, and whether or not visitors attended his pay-as-you-enter exhibitions in New York, Baltimore, New Orleans, and other cities more for *Ariadne*'s notoriety than for artistic merit. Perhaps the blood-chilling *Jane McCrea* and the prize-winning *Marius* were the real draws, with *Ariadne* only a mild curiosity to take in along the way. In any event, ticket revenues did not provide Vanderlyn with the funds to continue rental payments on his permanent New York exhibition space. Later, he reluctantly sold *Ariadne* to the brilliant young engraver Asher B. Durand, whose faithful transcription of this image also failed to turn a profit (1835).[4]

If we cannot even determine the extent to which viewers of the period actually *liked* the painting, we stand little or no chance of ascertaining the deeper meanings it may have held for them. Still, although a reading of *Ariadne* in terms of white territorial expansion cannot be verified, it is worth pursuing. Works of art function politically even when they appear to be nonpolitical. Viewers and artists are always subject to politics in the broad sense of belonging to social groups that have material interests in alliance with or opposition to the interests of other social groups. For that reason they are drawn to or repelled by works

of art for political reasons, *even when not realizing it.* Our political unconsciousness is always at work, even if our political consciousness is not. To ignore the latent political content of an art object—in this case, an interracial theme—simply because the resulting speculations cannot be documented or otherwise certified trivializes the art by disregarding one of its essential dimensions, albeit a dimension that can be grasped only indirectly, through reference to both form and context. What follows, then, is an attempt to begin such a process with regard to *Ariadne.*

It is an oil painting of heroic scale. A life-sized naked woman—pink and opalescent amidst dusky green, brown, and gray—luxuriates across much of the canvas. The thinnest, most translucent of veils rolls damply over the rounded contour of her left thigh and extends over the genital delta, a ridge in the fabric falling in line with the crease between leg and hip while a crescent curve in the cloth counterbalances by reversal the rounded underside of the abdomen. She wears a thin silver and blue band on her head and a tawny one bound tautly around her upper right arm.

Mythological Ariadne, protected from but also connected to the earth by abundant white and red drapery, sleeps on a gentle hillock surrounded by a grove of trees. The lustrous black hair falling away from her headband spills down and outward in myriad loose curls, lockets, and S-shaped tendrils that echo the openness of her form. The curved contours of the hair are repeated in the folds of her ear, the drapery across her leg, and in the ivy clinging to the base of the maple tree above and behind her.

Hair, ear, and ivy compose a diagonal axis starting at the painting's lower left with a triangularly shaped sprig of foliage that points directly toward the hair, as if reaching out to touch it. Thus, the rounded forms of Ariadne's reclining body suggest the curving shapes of the landscape surrounding her, perhaps alluding to a close relationship between nature and woman. For example, the rounded contour of her hip is repeated in the shadowed shape immediately above or beyond her, as is the curve of her bosom in the distant mountain.

But if Ariadne appears to be a part *of* nature, in other ways she seems distinctly apart *from* it. Her body is lightly colored, in contrast to the dark landscape; her reclining position, arms behind head, suggests an openness of form, while nature closes in around her. She floats on the white and red draperies that swirl in a sort of cloud, forming an island that separates her from the natural environment. *Ariadne* recalls a long tradition of pastoral nudes going back to the Venetian Renaissance of the early sixteenth century, invoking both culture—the antithesis of nature—and that which is spontaneous, unstudied, and natural. Similarly, Vanderlyn's nude might also connote Arnoldian culture and light, an island amidst the darkness and anarchy of nature.

In the upper right corner of the painting a crescent-shaped sailing vessel stands tethered in the water at the edge of the narrow beach, a red pennant atop its mast. Nearby, a figure prepares to board. Viewers in republican America familiar with works such as Thomas North's translation of Plutarch, Andrew Tooke's *Pantheon of Heroes and Gods,* or various renditions of Ovid's *Metamorphoses* would have known that if the female nude is Ariadne, the figure on the beach must be Theseus, the valiant Athenian warrior who Minos, the Minoan king and Ariadne's father, sent into the Cretan labyrinth to confront the monstrous Minotaur.

Opposing her father's authority, the beautiful princess saved Theseus by supplying him with a ball of thread that he unraveled as he found his way into the maze, allowing him to retrace his steps and return safely. He then eloped with the lovestruck maiden, who fell peacefully asleep upon the grass of Naxos after their lovemaking, not suspecting that Theseus would set sail for home without her. Forsaking Ariadne and the

sensual indulgences she represented, Theseus soon became the ruler of Athens, transforming that city into the glorious cradle of Western civilization. In narrative terms, then Ariadne represents primal nature. In one version of the myth the princess dies alone on the island, but in another version she is rescued by the nature god Bacchus, who takes her as his wife. Occasionally, the latter version appears in Italian Renaissance and mannerist painting, as in Titian's *Bacchus and Ariadne* (1520–1523), Guido Reni's *Marriage of Bacchus and Ariadne* (1619–1620), or Tintoretto's *Bacchus, Ariadne, and Venus* (1578).

In Vanderlyn's time, however, the logical conclusion to the Ariadne legend is more likely to have been melodramatic death rather than comedic marriage, and the reasons for this are historical. During the late eighteenth and early nineteenth centuries, melodramatic sentimentalism prevailed in the art, literature, and drama of the European and American middle classes. Indeed, the term *melodrama* was first applied to a 1781 Parisian production of a play recounting the tale of the abandoned Ariadne.[5]

Melodrama, a form of artistic expression depicting family relationships with high, almost hysterical, intensity, became prominent during a time when the family as a nuclear unit confronted enormous social pressures and changes.[6] During the late eighteenth and early nineteenth centuries, the American and French political revolutions and the British Industrial Revolution severely tested family unity at both the microcosmic level of the individual (brothers and sisters, parents and children) and at the macrocosmic level of classes and nations (where one class, for example, could no longer successfully portray itself as the father of another, or where one nation was castigated as the ungrateful child of the other).[7]

A young English sailor named John Davis published a typical family melodrama in America in 1805. *The First Settlers of Virginia* is a sensationalized narrative of a young woman who defies the wishes of her father the king to save the life of his condemned captive, an adventurous foreigner with whom the daughter has fallen in love at first sight. Although she wishes to elope with the prisoner after rescuing him, he abandons her and she eventually dies brokenhearted after marrying another member of his race. The beautiful young maiden in Davis's melodrama happens to be an Indian princess, and the man she rescues from death is a white settler—symbolically America's first white settler—Captain John Smith. The princess, of course, is Pocahontas. With the success of Davis's novel. Princess Pocahontas quickly began her career as one of nineteenth- and twentieth-century America's most revered legendary figures. Literary historian Philip Young observes that the narrative concerning a native American woman who saved a white man out of love and then was abandoned by him is "one of our few, truly native myths, for with our poets she has successfully attained the status of goddess . . . offered as a magical and moving explanation of our national origins."[8]

The Pocahontas story may be an indigenous myth, but variants of it can be found throughout history: "The tale of an adventurer . . . who becomes the captive of the king of another country and another faith, and is rescued by his beautiful daughter, a princess who then gives up her land and her religion for his, is a story known to the popular literatures of many peoples for many centuries."[9] The original version of this long-lived myth is none other than the ancient story of Theseus and Ariadne.

One might measure Davis's description of an Indian princess at rest beside a stream with Vanderlyn's rendition of *his* princess beside a stream: "There was a delicious redness in her cherub lips, a red, a little riper than that which burnt on her cheek, and the nether one somewhat fuller than the other, looked as if some bee had newly stung it. Her long black hair . . . flowed in

luxuriant tresses down her comely back and neck, half concealing the polish and symmetry, the rise and fall, of a bosom just beginning to fill."[10]

The comparison between a classical princess and an Indian princess should come as no surprise. First, we have already seen how the classicized nude in Vanderlyn's painting is linked by compositional elements and color resonances to the surrounding landscape, suggesting at a certain level that she is an extension of it. To Europeans and Europeanized Americans of the late eighteenth and early nineteenth centuries, no one embodied nature more so than the noble savage—the red man (or woman). The idealized American Indian had already figured prominently in trend-setting literary works such as François René de Châteaubriand's 1801 *Atala* and, in painting, Benjamin West's *The Death of General Wolfe* (1770).

West's celebrated comparison, when he came to Rome in 1760, of the Apollo Belvedere to an American Indian ("My God, how like it is to a young Mohawk warrior") established the neoclassical and subsequently the romantic conception of the Indian as both nature's true child and the reincarnation of antique civilization, with its Greek beauty and simplicity. As late as 1815, the editor of the prestigious *North-American Review* stated for his readers, who apparently never tired of hearing it, the commonplace observation that America's "aborigines" of bygone years "possessed so many traits in common with some of the nations of antiquity, that they perhaps exhibit the counterpart of what the Greeks were in the heroick [*sic*] ages."[11] The Grecian look of the Indians in Joseph Wright of Derby's *The Indian Widow* (1785) and Anne-Louis Girodet-Trioson's *Entombment of Atala* (1808) was a result of this thinking. Girodet's half-Indian maiden, who is being laid to rest in her tomb, is wrapped in a semitransparent shroud, her hair dark and flowing. The striking similarity between the two heroines is both visual and narra-

tive because Atala, like Ariadne and Pocahontas, was tragically in love with but unable to marry an enemy warrior whom she had saved from a violent death at the hands of her own tribal family. Even more so, in terms of bright red drapery, opulent naked flesh, and magnificent jet black tresses, does Ariadne resemble the Indian warrior himself, who mourns at Atala's feet.

We have already noted the decidedly reddish cast to Ariadne's skin. Although this tint reflects upward from the red groundcloth on which she rests, and in narrative terms represents a residual glow from lovemaking, the ruddiness of her flesh might also suggest Ariadne's "Indianness," as does the tautly bound band across her upper arm.

As art historian E. McClung Fleming illustrates in some detail, from the earliest periods of colonization until the Revolution, artists, explorers, writers, and political thinkers conventionally personified America by means of a seminude Indian woman, a so-called Caribbean Queen.[12] Later, as the thirteen British colonies of mainland North America began to contemplate independence from England, the typical allegorical representations of America shifted away from the Caribbean Queen to a more youthful anglicized or classicized Indian princess. Based on his examination of numerous political cartoons, commemorative medals, and public statues of the period, Fleming's description of this updated but still seminude symbol for America could almost stand as a description of Vanderlyn's seminude Ariadne: "a handsome, vigorous, Indian woman in her twenties or thirties. She is of noble visage . . . [and has] long, dark hair. . . . Her complexion is sometimes dark, sometimes only moderately 'tawney' and often indistinguishable from that of Britannia."[13] Perhaps rosy-cheeked Ariadne's complexion gives her a more European than native American appearance, but her flowing black tresses associate her with the aboriginal American and the New World.

The conventional symbol for America eventually "metamorphosed," to use Fleming's term, from an Indian princess to a Greek goddess sometime during the first fifteen years of the nineteenth century—precisely when Vanderlyn was painting his Greek goddess asleep in the forest. The artist may not have intended the viewer to see his seminude classical princess as an Indian princess, symbol for America or not, but inasmuch as the parallel (real or imagined) between Greeks and Indians existed at the time, it is worthwhile to examine the painting in these terms.

At various times throughout his career Vanderlyn specifically depicted Native Americans. The most notable instance is *The Death of Jane McCrea,* in which the three figures, one white and two American Indian, are linked tightly together in a neoclassical frieze, their arms plunging rhythmically like movable parts in a machine. In this dramatic piece of propaganda, the American Indian symbolizes the brutality of the colonists' enemy, England. In other paintings and drawings Vanderlyn depicts Indians as quaint curiosities, gentle spirits, or awestruck children of nature. Take, for example, his early landscape views of Niagara Falls (1801–1803) and, toward the end of his career, *The Landing of Columbus* (ca. 1840). In all these works, however, the Indian obviously conveys some political, racial, or ideological meaning.[14]

Before departing for Paris in 1796, Vanderlyn had been a devoted participant in a New York democratic workingman's club, the Tammany Society, which was named for the legendary Indian sachem Tammany, or Tamenund. Club members dressed themselves in Indian costume, concocted secret rites that emulated Indian traditions, called themselves by Indian names, and employed Indian phrases as code words—all as a means of setting themselves apart from the aristocratic, English pretensions of the Federalist clubs.[15] In 1773, rebellious colonists had symbolically dressed themselves as Indians when, in defiance of the Mother Country, they dumped British tea into Boston Harbor. Thus, by Vanderlyn's time it was common for political democrats to identify themselves—albeit superficially—with the American Indian. Like Vanderlyn, fellow democrat James Fenimore Cooper represented Indians as vicious and murderous thugs when plot or theme demanded. But he was also capable of depicting Indians in a favorable light; he concludes his *Last of the Mohicans* (1826) with the moving lament of Tamenund: "The pale-faces are masters of the earth, and the time of the red-man has not yet come again. My day has been too long. In the morning I saw [my people] happy and strong; and yet, before the night has come, have I lived to see the last warrior of the wise race of the Mohicans!"[16]

The legend of the Indian princess Pocahontas experienced a revival during the same period that Vanderlyn painted *Ariadne* and that the conventional symbol for America changed from an Indian princess to a classical Greek princess. Although this tale began circulating soon after Captain Smith's 1609 return to England, the incident did not take hold in popular imagination until John Davis wrote of it two centuries later. The current popularity of family melodrama was likely responsible in part for the revival, but the all-important question of American national origins and the moral justification of national expansion also played an important role. Philip Young observes:

> An informal survey of the children's sections of two small Midwestern libraries disclosed twenty-six different books on Pocahontas—and no wonder. Quite apart from the opportunity she presents to give children some notion of self-sacrifice, she is, in addition to all her other appeals, perfectly ideal propaganda for [the] state. . . . The story . . . informs us . . . that we are chosen, or preferred. Our own ways, race, religion, must be better—so much better that even an Indian, albeit an unusually fine one (witness her recognition of our superiority), perceived our rectitude.[17]

From the point of view of those who eventually obliterated the Powhatan Indians, Pocahontas possessed courage, insight, and virtue. By her very actions she acknowledged and legitimated the colonists' right to the American land. In the original Pocahontas play, *The Indian Princess: or La Belle Sauvage* of 1808, Pocahontas declaims to her husband, colonist John Rolfe:

> O! 'tis from thee that I have drawn my being:
> Thou'st ta'en me from the path of savage error,
> Blood-stain'd and rude, where rove my countrymen, And taught me heavenly truths, and fill'd my heart With sentiments sublime, and sweet, and social.[18]

Small wonder that Thomas Jefferson took keen notice of John Davis's melodramatic *First Settlers,* and allowed himself to be quoted on behalf of the second edition: "I have subscribed with much pleasure."[19] One of Jefferson's primary concerns during his administration was for the westward expansion of the country and with it an agrarian cultivation of the land thus acquired. This expansion had to occur at all costs, for in Jefferson's view a republic could only be great and its democracy true if the majority of citizens—that is, white males—were cultivators of the land, imbibing the wisdom and moral integrity that accrues from such honest labor.

Jefferson himself was well intentioned toward the Indian peoples, believing they would fare better as yeoman farmers than as nomadic hunters. According to one historian, the "self-esteem and confidence of the Revolutionary and early national generations made it difficult for them to believe that the Indians would not also see the desirability of an end to savagery and their acceptance of civilization."[20] Another historian, less generous toward the Jeffersonians, charges that to them the "Indian was the face of unreason. If he chose to remain an Indian, in the face of all paternalistic efforts to the contrary, then he confessed himself a madman or a fool who refused to enter the encompassing world of

reason and order. The red child then had to be expelled from the landscape of pastoral tranquillity—or buried under it."[21]

Of course the Jeffersonians did not always need to rely on peaceful indoctrination and military expulsion, for the whites ignored land treaties at this time and many Indians were tricked by false promises, often in the name of the American republic—the so-called "New Athens." They were intoxicated by whiskey, bought with trinkets, drawn away from their homes, cut off from their traditional lifelines, and left seduced and abandoned.

Perhaps in considering this unfortunate historical situation we can now understand what seemed paradoxical earlier: representations of Pocahontas began to proliferate in the American popular imagination exactly at the time that the nation's symbol of a nonspecific Indian princess was transferred to a classical Greek princess instead. During the Jefferson and Madison administrations the United States unofficially began war on all Indian nations that stood in the path of Manifest Destiny—a phrase not coined until later in the century, but a concept used almost from the century's start as a ready justification for geographic expansion. There was no longer any place in the national iconography for the Indian princess of the Revolutionary period, but there was a place, in folklore and melodrama, for one Indian princess who had shown the good sense to forsake her own civilization for that of the whites.

Still, if Princess Ariadne's melodramatic story is so similar in narrative to that of Princess Pocahontas, one wonders why Vanderlyn's painting was not more successful in capturing and maintaining public attention. Even though the generic Indian maiden was falling out of favor as an icon for America, why was the painting—which, after all, is not explicitly about Indians—unable to ride the tide of public interest in seduction melodramas? Despite favorable press reviews, praise from connoisseurs, and the curiosity of general

spectators (one contemporary source noted, "Eighty four Ladies went to day, which is a large number considering their strong objections to nakedness"). *Ariadne* failed to gain the critical or popular triumph for which Vanderlyn seems to have hoped when he transported the painting to America in 1815.[22] Otherwise, he might have been able to sell it for more than the six hundred dollars he received from Asher B. Durand.

The reasons are complicated and speculative at best as to why Vanderlyn's *Ariadne* never achieved the fame he desired for it. Its sensuality was shocking by contemporary American standards, and Vanderlyn's palette and style were too troublingly French and thus reminiscent of Jacobin radicalism and Napoleonic imperialism. Moreover, the family melodrama inherent in the myth on which the painting is based is not actively dramatized in the picture, which is compositionally static and, to those not familiar with classical mythology, nonanecdotal. Finally, if any of *Ariadne*'s white American viewers consciously, or even unconsciously, detected in it an allusion to their collective despoilment of the American Indian, they most likely would have found this discomforting or distasteful, further preventing a positive response. While the early-nineteenth-century narrative of the Pocahontas myth (and its contemporaneous variant, the story of Sacajawea, handmaiden to the Lewis and Clark Expedition) focuses on the glorious, self-sacrificing rescue rather than on the abandonment that followed, the Ariadne myth as Vanderlyn depicts it emphasizes churlish betrayal instead of noble self-sacrifice.

In 1820 Vanderlyn's friend Washington Irving lamented the fate of the American Indian:

They will vanish like a vapor from the face of the earth: their very history will be lost in forgetfulness. . . . Or if, perchance, some dubious memorial of them should survive, it may be in the romantic dreams of the poet [or painter], to people in imagination his glades and groves, like the fauns and satyrs and sylvan deities of antiquity. But should he venture upon the dark story of their wrongs and wretchedness; should he tell how they were invaded, corrupted, despoiled, driven from their native abodes and the sepulchers of their fathers . . . posterity will either turn with horror and incredulity from the tale, or blush with indignation at the inhumanity of their forefathers.[23]

Perhaps it was not only future generations that would turn away from painful reminders of the white people's despoilment of the Indians, but also the generation responsible. William Tudor, editor of the *North-American Review*, took an appalled glance at his Indian contemporaries:

The degenerate, miserable remains of the Indian nations, which have dwindled into insignificance and lingered among us, as the tide of civilization has flowed, mere floating deformities on its surface, poor, squalid and enervated with intoxicating liquors, should no more be taken for the representatives of their ancestors, who first met the Europeans on the edge of their boundless forests, severe and untamed as the regions they tenanted, than the Greek slaves, who now tremble at the frown of a petty Turkish tyrant, can be considered the likeness of their immortal progenitors.[24]

How pitiful, Tudor implies, that the tide of white civilization has caused the degeneration of noble savages—but all the same it is better to think of these sorry people as they once supposedly were, rather than as they have sadly become. In the words of a recent historian of the period, "eighteenth-century views of the Indian were fairly dichotomized between the Rousseauists, with their ideal of a natural morality in the innocence of the Forest, and those in the opposing camp, who suggested that life among the natives led to degeneracy."[25] Early nineteenth-century public figures such as *Review* editor Tudor seem to have deftly avoided this philosophic dichotomy by positing good Indians in the prewhite past but bad ones in the present.

Ariadne, with her "noble visage" and classical Greek allusions, harks back to a vanished golden age of good Indians that white America had wrongfully or rightfully superseded, depending on one's point of view. Yet at the same time, with her brazen, sensual nakedness and her unalert captivity in sleep, she might also be a reminder of the bad Indians of the present, who were stereotyped as overly sensual, immodest, and indolent.[26] In either case, the story—and with it the visual image—of a princess deceived, corrupted, and betrayed simply does not make good national mythology, the purpose of which is to instruct, inspire, and elicit public pride. This may be one of the reasons why the painting, despite its salient narrative and iconographic similarities to popular plays, fiction, and visual images that alluded explicitly to the American Indian, was so soon relegated to the margins of American art history. It was abandoned by a historiography that, with nationalistic purposes of its own, was not likely to care for the sad tale of racial betrayal and woe that *Ariadne,* when viewed in the context of such bedeviling social matters, calls to mind.

While we cannot prove that Vanderlyn's *Ariadne* allegorizes the despoilment of the innocent native American by the devious white man from across the sea, a link between the painting and a society implicated in that despoilment seems clear. And although Vanderlyn's intentions are unknown, as is the early-nineteenth-century viewers' reception of the work, we are able to situate the painting within the powerfully determining context of nationalism and westward expansion, Indian wars, collective white guilt and apologetics, disdain for the Indians of the present, nostalgia for their now-extinct ancestors, and an active, often profitable Indian industry— whether in academic painting, popular iconography, romantic fiction, sensationalist biography, or stage melodrama.

Placed within its historical context of national expansion and Indian crisis, Vanderlyn's *Ariadne* no longer seems so puzzlingly nonpolitical compared to *Marius* and *Jane McCrea.* Here too the painter was giving pictorial form to a myth of timely import. Unfortunately for Vanderlyn, however, this latter myth of seduction and abandonment was not one a white American audience would have appreciated, for in this particular melodrama their role was that of betrayer rather than betrayed.

NOTES

Revised by the author from *Smithsonian Studies in American Art* (Spring 1989). Reprinted by permission of the author and the National Museum of Art.

My thanks to the Stanford Humanities Center, where I wrote much of this essay, and to the American Council of Learned Societies for additional support.

1. Samuel Y. Edgerton, Jr., "The Murder of Jane McCrea: The Tragedy of an American *'Tableau d'Histoire,'" Art Bulletin* 47 (December 1965): 481–89; and Kathleen H. Pritchard, "John Vanderlyn and the Massacre of Jane McCrea," *Art Quarterly* 12 (1949): 361–66. Written at the close of the eighteenth century, *The Columbiad* was not actually published until 1807.

2. Kenneth C. Lindsay, *The Works of John Vanderlyn: From Tammany to the Capitol* (Binghamton, N.Y.: University Art Gallery, 1970), pp. 71–73, sees *Marius* as Vanderlyn's tribute to his close friend and former patron, Aaron Burr, who had recently suffered a series of notorious political reversals. This interpretation, of course, does not eliminate a Napoleonic interpretation so much as run parallel to it.

3. William Townsend Oedel, "John Vanderlyn: French Neoclassicism and the Search for an American Art" (Ph.D. diss., University of Delaware, Newark, 1981), pp. 13, 396.

4. John Durand, *The Life and Times of A. B. Durand* (New York: Charles Scribner's Sons, 1894), pp. 76–77.

5. Georg Benda's *Ariadne auf Naxos* was originally performed in Gotha, Germany, in 1774. Jean-Jacques Rousseau coined the term *mélo-drame* in 1766 to describe his own musical drama, *Pygmalion,* but it appears not to have been used again until Benda's *Ariadne* arrived in Paris. See Frank Rahill, *The World of Melodrama* (University Park, Pa.: Pennsylvania State University Press, 1967), pp. 121–22.

6. See Peter Brooks, *The Melodramatic Imagination: Balzac, Henry James, Melodrama, and the Mode of Excess* (New Haven: Yale University Press, 1976); also, Thomas Elsaesser, "Tales of Sound and Fury: Observations on the Family Melodrama," *Monogram* 4 (1972), pp. 2–15. This article is reprinted in Bill Nichols, ed., *Movies and Methods,* vol. 2 (Berkeley and Los Angeles: University of California Press, 1985), pp. 166–89. Also, Anita Brookner, *Greuze* (London: Phaidon, 1966); and Anna Clark, "The Politics of Seduction in English Popular Culture, 1748–1848," in *The Progress of Romance: The Politics of Popular Fiction,* ed. Jean Radford (London: Routledge & Kegan Paul, 1986), pp. 46–70.

7. Leslie A. Fiedler, *Love and Death in the American Novel* (1960; rev., New York: Stein and Day, 1966) provides a compelling account of melodramatic eighteenth-century literature along these lines. See also Terry Eagleton, *The Rape of Clarissa: Writing, Sexuality, and Class Struggle in Samuel Richardson* (Minneapolis: University of Minnesota Press, 1982), and Jay Fliegelman, *Patriarchs and Prodigals: The American Revolution against Patriarchal Authority 1750–1800* (Cambridge: Cambridge University Press, 1982). Fliegelman, analyzing the immense popularity of *Clarissa* in the American colonies, writes: "The archetypal story of a young woman's tortured escape from parental tyranny and the designs of an evil seducer offers more than a conveniently invoked literary parallel to America's flight from its parental tyrant, England. . . . In this regard, the novel is the quintessential presentation of the inner drama that would inform the rhetoric and ideology of the American revolution against patriarchal authority" (p. 83).

8. Philip Young, "The Mother of Us All: Pocahontas Reconsidered," *Kenyon Review* 24 (Summer 1962): 391–415. See also Rayna Green, "The Pocahontas Perplex: The Image of Indian Women in American Culture," *Massachusetts Review* 16 (Autumn 1975): 698–714.

9. Young, "The Mother of Us All," p. 409.

10. John Davis, *The First Settlers of Virginia, An Historical Novel* (New York: Riley and Co., 1806), p. 39.

11. William Tudor, "An Address Delivered to the Phi Beta Kappa Society, at Their Anniversary Meeting at Cambridge," *North-American Review* 2 (1815): 19.

12. E. McClung Fleming, "The American Image as Indian Princess, 1765–1783," *Winterthur Portfolio* 2 (1965): 65–81; and "From Indian Princess to Greek Goddess: The American Image, 1783–1815," *Winterthur Portfolio* 3 (1967): 37–66.

13. Fleming, "The American Image as Indian Princess," p. 73.

14. On Vanderlyn and his relatively frequent depiction of Indians, see Lindsay, *The Works of John Vanderlyn,* pp. 74, 142. Provocative material on the relationship between official Indian policies and official American art of the period, such as that originally planned for the United States Capitol, is detailed in Vivien Green Fryd, "Sculpture as History: Themes of Liberty, Unity and Manifest Destiny in American Sculpture, 1825–1865" (Ph.D. diss., University of Wisconsin, Madison, 1984). Part of this essay appears as "Two Sculptures for the Capitol: Horatio Greenough's *Rescue* and Luigi Persico's *Discovery of America,*" *American Art Journal* 19 (Spring 1987): 17–39. Essential contributions to any discussion concerning the conscious and unconscious attitudes of white Americans toward native Americans before, during, and after *Ariadne* are Roy Harvey Pearce, *The Savages of America: A Study of the Indian and the Idea of Civilization* (1953; rev. Baltimore: Johns Hopkins University Press, 1965); and two books by Richard Slotkin, *Regeneration Through Violence: The Mythology of the American Frontier, 1600–1860* (Middletown, Conn.: Wesleyan University Press, 1973) and *The Fatal Environment: The Myth of the Frontier in the Age of Industrialization, 1800–1890* (New York: Atheneum, 1985).

15. Gustavus Myers, *History of Tammany Hall* (New York: Dover Publications, 1971), pp. 4–6.

16. James Fenimore Cooper, *The Last of the Mohicans* (New York: Penguin Books, 1986), p. 350.

17. Young, "The Mother of Us All," p. 412.

18. James Nelson Barker, *The Indian Princess or La Belle Sauvage: An Operatic Melo-Drame in Three Acts* (1808; reprint, New York: Da Capo Press, 1972), p. 52.

19. Davis, *The First Settlers of Virginia*, p. vii.

20. Bernard W. Sheehan, *Seeds of Extinction: Jeffersonian Philanthropy and the American Indian* (Williamsburg, Va.: Institute of Early American History and Culture and Chapel Hill, N.C., University of North Carolina Press, 1973), p. 5.

21. Richard Drinnon, *Facing West: The Metaphysics of Indian-Hating and Empire-Building* (Minneapolis: University of Minnesota Press, 1980), p. 102.

22. L. Banney to John Vanderlyn, 25 February 1820, Henry Darrow Collection, Senate House Museum, Kingston, New York; this letter is quoted in Oedel, "John Vanderlyn," p. 408, no. 135. For further information on Vanderlyn see Louise Hunt Averill, "John Vanderlyn, American Painter" (Ph.D. diss., Yale University, New Haven, 1949); Wayne Craven, "The Grand Manner in Early Nineteenth-Century American Painting: Borrowings from Antiquity, the Renaissance, and the Baroque," *American Art Journal* 11 (April 1979): 4–43; Kenneth C. Lindsay, "John Vanderlyn in Retrospect," *American Art Journal* 7 (November 1975): 79–90; Lillian B. Miller, "John Vanderlyn and the Business of Art," *New York History* 32 (January 1951): 33–44; and Salvatore Mondello, "John Vanderlyn," *New-York Historical Society Quarterly* 52 (April 1968): 161–83.

23. Washington Irving, "Traits of Indian Character," in *The Sketch Book* (New York: New American Library, 1981), p. 282. The novelist and reformer Catharine Maria Sedgwick did indeed venture to tell how the Indians, in Irving's words, "were invaded, corrupted, despoiled, [and] driven from their native abodes," but contrary to what Irving might have predicted, her 1827 book, *Hope Leslie*, was a best-seller. Sedgwick's Pequod heroine, Magawisca, literally gives her right arm to save the life of a young white captive whom she loves, but the resulting deformity of the maiden—and, symbolically, of her people—is minimized in the text, with the noble self-sacrifice emphasized instead. Later in the story Magawisca is betrayed by other whites but not abandoned by the young man she had rescued; ultimately he saves her life, and although he marries someone of his own race, the book concludes with all lingering racial guilts happily erased. Mary Kelley, ed., *Hope Leslie; or, Early Times in Massachusetts* (New Brunswick, N.J.: Rutgers University Press, 1987).

24. Tudor, "An Address," p. 19.

25. Sydney J. Krause, in Charles Brockden Brown, *Edgar Huntly, or Memoirs of a Sleep-Walker*, ed. Sydney J. Krause and S. W. Reid (Kent, Ohio: Kent State University Press, 1984), p. xlix.

26. See John D'Emilio and Estelle B. Freedman, *Intimate Matters: A History of Sexuality in America* (New York: Harper & Row, 1988), pp. 6–9, 107–8. See also Michael Paul Rogin, *Fathers and Children: Andrew Jackson and the Subjugation of the American Indian* (New York: Alfred A. Knopf, 1975), pp. 5–13.

4

Thomas Cole and Jacksonian America

The Course of Empire *as Political Allegory*

Angela Miller

[Andrew Jackson] found a confederacy—he left an empire.[1]

In her discussion of this well-known allegorical series by Thomas Cole, Angela Miller challenges the notion that American landscape painting in the nineteenth century functioned as a transparent (and therefore neutral) symbol of national identity. Based on evidence in the artist's diaries and letters, Miller characterizes Cole as an anti-democratic conservative with strongly held political convictions that are manifest in his paintings. The Course of Empire *is thus understood in terms of the shifting political and social realities of the Jacksonian era, and Cole's personal anxiety about the consequences of America's transformation from an idealistic republic to an empire posing as a populist democracy.*

Exemplifying the interdisciplinary focus of recent scholarship on American art, Miller draws on a myriad of sources, from political cartoons to literature, in her reconstruction of the unstable cultural moment that this series embodies. When analyzed in light of the artist's perception of contemporary political events, The Course of Empire *emerges as a timely parable foretelling the dangers of reckless expansionism and the triumph in America of raw ambition and crude materialism, all of which Cole and his like-minded peers associated with the presidency of Andrew Jackson.*

Thomas Cole (1801–48) is best known for his role in placing the landscape genre in America on a secure artistic and intellectual foundation. Associating the beginnings of landscape art with the concurrent appearance of popular democracy, scholars have generally assumed that Cole shared the cultural and nationalistic premises of the native landscape school that developed under this influence. Other inaccurate assessments have followed, in particular the belief that Cole's political sympathies were democratic.[2] To take this for granted, however, is to overlook not only the anti-Jacksonian sentiment that Cole occasionally vented in his journals and letters, but also the veiled political and topical content of his well-known cycle, *The Course of Empire*. This neglect of the political content of Cole's art is part of a broader tendency to approach American landscape art as a genre lacking social or political content, as a transparent reflection of nature's central role in national culture.[3] The reappraisal of such assumptions begins with Cole, whose ideological challenge to the next generation of painters was made in the language

of landscape. This challenge will be considered briefly in my conclusion.

Cole was a profoundly conservative man whose social attitudes and loyalties suggest that he found more to admire in the hierarchical society of the 18th Century than in the more fluid democratic culture of the 19th Century. His family background was modest; he spent the first seventeen years of his life in England, in the industrialized county of Lancashire, the son of a woolens manufacturer who moved his family to America in 1817 in response to an economic recession. Raised in a Northern English tradition of dissenting Protestantism, Cole remained uneasy with the self-willed, utilitarian culture of 19th-Century American enterprise. Yet a measure of his dissatisfaction issued from his own frustrations as an artist attempting "a higher branch of art" than private patronage in America was willing or able to underwrite. Cole's spiritual withdrawal in the 1840s was accompanied by appeals to the ministry of art, as well as to other forms of culturally mediated experience. His longing for communal tradition and for institutional stability culminated in his embrace of the Episcopal Church in 1842.

At no point in his career were Cole's feelings about the direction of American society, many of which he confided only to his diary, brought more directly to bear on his art than in the conception and realization of his *Course of Empire,* Cole's ambitious serial allegory of national fortunes. Our understanding of the five-part narrative cycle stands to profit from an inquiry into its origins both in the partisan politics of the 1830s, and in the social and political realignments that accompanied the rise to power of the Democratic party. Although Cole veiled his message to contemporaries in the language of classical landscape and the antique, his choice of imagery finds parallels in the anti-Jacksonian rhetoric of the 1830s. His parable also comments ironically upon the imperial imagery that was frequently employed to celebrate the na-

tion's self-appointed historical mission and dramatic growth.

In 1829, soon after Andrew Jackson was elected to his first term as president, Cole departed for Europe. While his earliest full formulation of the "Course of Empire" theme dated from 1828 to 1829, the idea matured during Cole's three-year stay abroad. In 1833 Cole received the commission to paint *The Course of Empire* from new York merchant Luman Reed, enabling him to realize his ambitious conception.[4] During Cole's absence from the United States, the country had undergone substantial changes that subsequently found their way into his series. The period during which Cole completed *The Course of Empire* left its trace on Cole's cyclical vision of history; the impact of Jackson's second term on Cole was to transform a generalized Romantic *topos* of earthly mutability into a political and national allegory with a pointed import for his own time.

Cole consistently renounced overt partisan involvement throughout this entire period. He viewed political partisanship and religious sectarianism themselves as symptoms of a larger problem. By the mid-1830s, Cole had become convinced that American society was the victim of its own self-serving pursuits. Loyalties to anything beyond the immediate interests of the individual (usually economic in nature) were drowned out by the tide of self-pursuit. When Cole did express political opinions, however, they were distinctly anti-Democratic and Whiggish.[5] He commented scathingly on Jacksonian political behavior; he supported the Whig candidate William Henry Harrison in the campaign of 1840, and mourned his death not long after becoming president.[6] Cole's conservative critique of American culture intensified during the latter part of his career, bearing out his opposition to Jacksonian democracy in the 1830s. He opposed the expansionist warmongering of the Democratic Polk administration in 1846, fleetingly revealing his sentiments regarding the Mexican-

American War in a letter to Robert Cooke dated July 19, 1846, which demonstrates that he shared the widespread Whig opposition to the war: "The Oregon question is indeed settled; but nobody knows what this *vile* Mexican War will bring about."[7]

For those who, like Cole were critical of "the Democracy," Jackson's reelection in 1832 confirmed the disturbing direction in which the nation was moving. Eastern Whigs predicted financial ruin; Jackson's policies and his "Bank War" threatened the country's economic base and, with it, America's social stability.[8] Kirk Boott, campaigning for the Whig candidate Henry Clay following Jackson's first term of office, warned of impending financial ruin, using imagery that uncannily anticipated the final canvas of *The Course of Empire*. Referring to the drastic constriction of the nation's financial growth that he felt Jackson's campaign against the national bank would cause, Boott wrote, "Elect General Jackson and the grass will grow in your streets, owls will build their nests in the mills, and foxes burrow in your highways."[9] The devastating panic and ensuing depression of 1837 seemed to verify these dire predictions. Even as *The Course of Empire* was being hung, the financial bubble of speculation was about to burst, destroying fortunes and causing widespread economic and social hardship.[10] In the eyes of Jackson's Whig foes, the nation was paying for the sin of entrusting its fortunes to an imperious autocrat disdainful of the Constitution. In 1836, the year when *The Course of Empire* was first exhibited, New York City appeared to these disgruntled observers to be besieged by unruly mobs, brought low by vulgar ostentation, and imperiled by a breakdown of civil order and civic spirit.[11] Their verbal portrayals of the metropolis often mimic the imagery in *Consummation,* the central canvas of Cole's series.

Philip Hone, former mayor of New York and politically active Whig merchant, left a detailed chronicle of public life in that city between 1828 and 1851 that reveals a great deal about the anti-Jacksonian response to social and political change. Hone's reaction to the rise of popular democracy in particular resembled Cole's. His association with the artist, however, was more than simply ideological; he purchased early landscapes by Cole and followed his subsequent career with interest. His response to the political situation of the 1830s furnishes parallels to Cole's more reticent views at a period when the Whig party in New York found itself an embattled minority. From Hone's bleak perspective in 1837, across eight years of disastrous Democratic rule, Jackson played the part of a Belshazzar in a quasi-Biblical drama of retribution. Following a rash of bank failures that accompanied the panic and depression of 1837, Hone predicted "ruin, revolution, perhaps civil war," and quoted a mercantile committee that accused Jackson's administration of producing "a wider desolation than the pestilence which depopulated our streets [in 1832], or the conflagration which laid them in ashes [in 1835]."[12]

Hone's conflation of natural disasters such as cholera epidemics and fires with social upheaval, financial panic, and urban disorder was a turn-of-mind produced by the social and economic instability of the 1830s. Cole, who shared this vision, interpreted the brash arrogance of the youthful empire and its blindness to the lessons of history as a disruption of the natural order itself; his vision took form as a histrionic and storm-tossed nightmare of imperial collapse. The use of natural metaphors to describe social upheaval has a longer history, however. Volcanoes and earthquakes frequently served as images of popular revolt, suggesting the depth of the anxiety provoked by the unsettling of the social order.[13] Such images also betrayed a conservative bias that drew an analogy between the social and the natural orders, each in its way organic and incontestable. Revolution signified a radical challenge to established social authority and "natural" hierarchies. Anxieties engendered

by a variety of social, economic, and political changes took shape in lurid imaginings of a nature in rebellion against itself. Daniel Webster, a most eloquent spokesman for this organic version of the political order, raised the specter of the French Revolution in reply to Senator Robert Hayne ("Second Speech on Foot's Resolution," January 26, 1830), with the image of "a new-opened volcano," whose "smoke and cinders" reached America, "though not the burning lava."

Whig visions of national declension on one level responded to the unsettling of traditional social authority and to the erosion of older restraints on political and economic behavior. Those who, conversely, embraced the extension of individual liberties and its political results, celebrated the Democratic triumph in New York, even as Whigs wrung their hands in despair over the realignment of social and political influence. Social conservatism such as Hone's, however, frequently went hand in hand with financial speculation and expansion. Jackson's bank war brought with it severe restrictions on credit that deeply affected the financial ventures of Whigs such as Hone. Ironically, the mercantile empire that Cole depicted in *Consummation* resembles in certain respects the Whig economic program and its cultural benefits—public wealth, cosmopolitan tastes, and a robust civic life. Cole was not opposed to commerce as such; the evidence suggests that he was prepared to embrace a limited form of commercial enterprise whose fruits would benefit the republic as a whole.[14] What made him uneasy was the erosion of moral, social, and institutional restraints upon rampant individualism and its economic effects. He would most likely have supported the Whig commitment to the regulated use of public wealth for internal improvements, the tariff, and other governmental measures to foster the health of commerce. With the Whigs he believed in a balanced economy of agrarian and commercial interests. His most pointed criticisms were directed not at the accumulation of public wealth but at the transgression of the ordained limits that nature imposed upon economic activities, at the behavior of the citizens of the empire, and at the relationship between the rulers and the ruled. His commentary on contemporary political behavior is most apparent in the pivotal canvas of *The Course of Empire, Consummation* [1].

The narrative center of the painting depicts an imperial procession of war captives and citizens of the empire, bearing aloft a reclining emperor as they make their way toward a festooned triumphal arch. This central image reflected the unsympathetic interpretation that Whigs placed on the political behavior of Jackson's supporters, evoking their perception of Jackson's political style and the uncritical support of his followers.[15] Cole's robed and crowned emperor embodies Whig visions of imperial leadership, a form of political behavior starkly contrasted to the republican model of government implied in the preceding canvas. The citizens of Cole's pastoral republic engage in a peaceful mix of agrarian, commercial, and industrial pursuits, as the presence of shipbuilding along with plowing and shepherding indicates. The succeeding canvas exposes what was from Cole's point of view a serious decline in the standard of public life; the citizens of the empire idolatrously worship the emperor they bear aloft rather than jealously guard the rights and responsibilities of citizenship. *Consummation* represents a characteristically 18th-Century vision of republican declension fueled by the accumulation of wealth and the loss of public virtue. Yet despite its older pedigree, Cole's republican vision of a bloated empire brought down by its own vainglory would have appeared familiar enough to Whig contemporaries. In the eyes of the political opposition to Jackson, his imperious and arbitrary style of leadership made him a modern-day Caesar, prepared to manipulate the citizens of the republic for his own corrupt and self-serving ends.[16] Fearful of the dangers of imperial author-

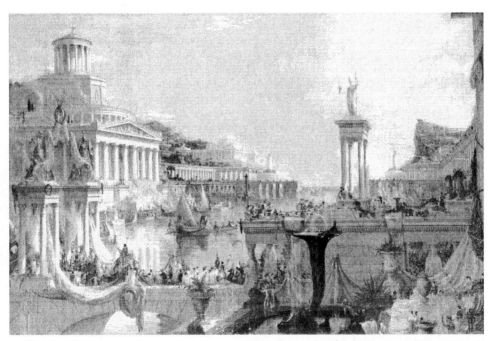

1. Thomas Cole, *The Course of Empire: Consummation;* collection of The New York Historical Society.

ity, Whigs claimed to be the moral guardians of America's republican legacy.[17]

To an American aristocracy familiar with classical analogies, Caesar was a figure who symbolized the greatest danger to the Roman republic. The frequent equation between Jackson and Caesar "accounted for the singular consternation which greeted his candidacy."[18] To many Whigs, Jackson threatened the delicate balance of republican consensus; like Caesar, he set the stage for the triumph of faction, the concentration of power, and the rise of the corrupt imperial state.

In the image of the emperor sustained by a submissive and stupefied populace, Cole was evoking a common perception of Andrew Jackson that found its way into contemporary political caricature.[19] Jackson was often paired with

Napoleon, a man whose personality and political style made him the very symbol of cold ambition and ruthless power. Admired and reviled, Napoleon's dual image mirrored Americans' own ambivalence about the pursuit of national ambition.[20] In a cartoon of 1836 done at the end of Jackson's second term of office, Jackson and his heir apparent, Martin Van Buren, are shown squaring off against the Whig candidate William Henry Harrison in a game of billiards symbolic of the presidential race. Harrison is positioned in front of a portrait of George Washington, with whose legacy he is associated, while Jackson stands in front of a portrait of the general and self-crowned French emperor. In the eyes of Jackson's opponents, at stake in Harrison's victory over the Jacksonian Democrats was republi-

canism itself. Jacksonians, however, also claimed a privileged association with the hallowed values of the Founders; Jackson himself answered his opponents in the language of Greek and Roman republicanism.[21]

Jackson's reputation of highhandedness, demagoguery, ruthless suppression of his enemies, and disregard for constitutional pieties also made him an easy target for political satire; he was widely censured for his abuse of executive authority. Many oppositional images of Jackson show him with imperial regalia—crowned, robed, and sceptered.[22] In a cartoon of 1833, *The Experiment in Full Operation* [2], Jackson, backed by Van Buren, is shown aboard a rat-infested ship of state, wearing a crown and carrying a whip as he commands a group of disgruntled tradesmen voicing the standard complaints about his administration and the devastating impact on commerce produced by his bank war. In the distance the "Constitution" is on fire. Here, as in other caricatures, the success of the republican experiment depends upon the health of the Constitution, and upon the encouragement of trade and commerce, both of which Jackson's opponents felt were languishing under his leadership.

A cartoon of 1833, *The Grand National Caravan Moving East,* employs processional imagery to depict Jackson seated on horseback with Van Buren behind, leading his political retinue during the election of 1832. Figures in the adoring crowd hold banners that carry references to "conquering heroes" and other ironic praise of Jackson as the "conqueror of hearts" and as "the man who has fill'd the measure of his countrys glory" (sic). In Jackson's train is a diabolically horned creature playing a fiddle, and a soldier in Napoleonic garb pulling a paddy wagon of captives bearing the banner "The Rights of Man," surmounted by a liberty cap. In the foreground a drunken man clutching a jug sprawls on the ground bellowing "Hail Columbia, happy land." Beneath the image is inscribed in biblical ca-

dences "There hath not been the like of them, neither shall there be any more after them, even to the years of many generations."[23]

Such processional imagery, as James Parton made clear in 1877, was inspired by pro-Jackson parades common in the weeks preceding the Presidential election: "Burlesque processions were also much in vogue in 1832. . . . To the oratory of Webster, Preston, Hoffman, and Everett, the Democracy replied by massive hickory poles, fifty feet long, drawn by eight, twelve or sixteen horses, and ridden by as many young Democrats as could get astride the emblematic log, waving flags and shouting 'Hurra for Jackson!' Live eagles were borne aloft on poles, banners were carried . . . and endless ranks of Democrats marched past, each wearing in his hat a sprig of the sacred tree."[24] Cole's imperial retinue in *Consummation* recalls such burlesque processions, in his eyes produced by a base demagoguery that blinded Jackson's followers to the loss of their own liberties.

In February 1836, only a few months before Cole's series opened, one of a series of "Hannington's Moving Dioramas," "The Triumph of America," appeared at the American Museum in New York. Featuring an obelisk commemorating American heroes of the War of 1812, a Temple of Peace, and a view of the Capitol building, the diorama displayed an allegorical figure of America "drawn in a splendid car, by four white horses, bearing the flag of the United States, followed by Victory, ready to crown her with laurels, proceeding . . . through a triumphal arch, with a numerous retinue." The diorama also included the figures of a young female "strewing the path with flowers," a mother with babe in arms kindling incense, and a third singing hymns. In America's train appeared "bands of Musicians, Victors, Prisoners of War, and numerous troops of cavalry and infantry . . . carrying trophies." The spectacle was presented "in the style . . . and costume of the ancient Romans" and accompanied by martial music.[25]

2. Thomas Cole, *The Experiment in Full Operation;* collection of the Library of Congress.

Such processional imagery was employed elsewhere to describe the nation's progress westward. In one instance, national expansion was compared to a "triumphal Roman chariot, bearing the eagle of the republic or the empire, victorious ever in its steady but bloodless advances."[26] Here, as in Hannington's diorama, the imperial analogy is employed with no apparent sense of historical caution or irony. Orestes Brownson, fully aware of the sinister implications of the imperial image, employed it in 1838 as a foil to his appeal to newly invigorated democratic values: "Free minds, free hearts, free souls are the materials, and the only materials, out of which free governments are constructed. And is he free in

mind, heart, soul, body, or limb, he who feels himself bound to the *triumphal car of the majority,* to be dragged whither its drivers please?"[27]

Hannington's diorama "The Triumph of America" embraced the imperial ideology contained in *Consummation,* with its subject peoples and its Roman trappings. Though apologists of American expansion were at pains to distinguish their nation's republican legacy from the aggressive imperial behavior of former empires, these distinctions were often overlooked by popular displays such as "The Triumph of America," which uncritically embraced the martial imagery of conquest and colonization that Cole also employed the same year in *Consummation* with far

different intent. Cole gauged well the manner in which popular audiences liked to imagine their nation's triumphant rise to national power, but he transformed this celebratory vision into a bad dream of America's imperial pretensions.

Cole clearly responded sympathetically to the oppositional imagery of Jackson as a ruthless tyrant. Believing in an 18th-Century politics of virtue, restraint, and deference, Cole abhorred Jackson's public style and the accompanying displays of popular emotion. In a journal entry of 1834, he wrote bitterly of partisan politics guided not by abstract values but by personal loyalties. Gathering mosses in the woods, his solitude was interrupted by "the shouts of a company of Jacksonmen who were rejoicing at the defeat of the Whigs of this country—." Were they celebrating, he asks rhetorically, "because of the triumph of good principles or the cause of virtue and morality? No! but because their party was victorious!"[28] The behavior of the citizens in *Consummation* recalls such popular demonstrations, which could easily devolve into the rule of the crowd, dubbed "Jackson law" by Philip Hone. For both Cole and Hone, such excesses reflected Jackson's own contempt for republican principles.[29] As Jackson left office in 1837 Hone accused him of governing the country with a rule "more absolute than that of any hereditary monarch of Europe." In embracing his leadership, Americans allowed Jackson to encroach on their hard-won rights, which "have sunk like water in the sands."[30] In the Whig interpretation of popular democracy to which both Hone and Cole subscribed, tyranny from above generated anarchy from below, which in turn reinforced tyrannical rule, a vicious cycle that undermined republican institutions. Hone drew the circular link between executive tyranny and the collapse of public virtue most pointedly in 1838 as he meditated upon Whig prospects in the coming years. Predicting civil war if the trend of popular behavior continued as it had, Hone wrote, "our republican institutions, theoretically so beautiful,

but relying unfortunately too much upon the virtue and intelligence of the people, will be broken into pieces, and a suffering and abused people will be compelled to submit to the degrading alternative of Jacobin misrule, or the tyranny of a Caesar, a Cromwell, or a Bonaparte."[31] Both forms of evil—executive tyranny and popular anarchy—were endemic to democracy. Republican government, poised upon a fragile equilibrium of competing interests, was susceptible to one extreme or the other. Like Hone, Cole interpreted the events of the 1830s as a devolution from a chaste republic to an unruly democracy vulnerable to corrupt leadership.

Whig concerns over executive tyranny were the latest expression of an older republican ideology rooted in the 18th Century. John Trumbull, self-styled patriarch of American painting and a Connecticut Federalist, summed up the fear that the older generation shared with their intellectual heirs, the Whigs, in words that anticipate anti-Jacksonian sentiment of the 1830s: "[A]fter having made use of Elections as long as they are consonant with the state of our Morals, we shall in the progress of our Existence pass thro' various stages of encreasing power to that last stage where all other Empires have sunk— where the governors are all and the governed nothing."[32]

For critics of Jacksonian democracy, the most immediate sign that the collective virtue so necessary to preserving republican institutions was under attack was the frequency of public disturbance. "Riot, disorder, and violence increase in our city," reported a morose Philip Hone in 1840, after twelve years of Democratic rule. His recollections reveal a dismal picture:

[1839] has been marked by individual and national distress in an unprecedented degree, the effect of improvidence and a want of sound moral and political principles on the part of the mass of the people, and bad government and a crushing down of everything good and great to subserve party objects on the part of the rulers.[33]

Hone looked back nostalgically to the disinterested leadership of the Revolutionary generation. July Fourth invariably inspired melancholy meditations in him.[34] Jackson proved to be a good subject for the Whig rhetoric of declension. Whig predictions for the future carried an uncompromising note of alarm. Such dire warnings often served a hortatory function in partisan polemics; for Cole they were quite genuine. Cole's anxious vision of contemporary America, moving forward oblivious of its own danger, resembled the prophetic structure of his series. *The Course of Empire* was his most concerted if disguised attack on attitudes that he condemned elsewhere as historically naive and shortsighted.

Cole confided his fears for the nation in a journal entry written a little more than a year before the imperial allegory that gave them programmatic expression opened in New York:

It appears to me that the moral principle of the nation is much lower than formerly—much less than vanity will allow—Americans are too fond of attributing the great prosperity of the country to their own good government instead of seeing the source of it in the unbounded resources and favorable political opportunities of the nation. It is with sorrow that I anticipated the downfall of pure republican government—its destruction will be a death blow to Freedom—for if the Free government of the U states cannot exist a century where shall we turn? The hope of the wise and the good will have perished—and scenes of tyranny and wrong, blood and oppression such as have been acted since the world was created—will be again performed as long as man exists—.[35]

Cole's critique of contemporary America in *The Course of Empire* embraced not only the transition from republic to democracy, but the attitudes and cultural behavior that this change engendered—in particular the crassly materialistic objectives fueling American expansion, and the utilitarian disregard for such Romantic pieties as the sanctity of nature. Even in the second canvas, *The Pastoral State,* the forces of development impelling the restless nation are evident in the violently spiked heartwood that projects from the tree trunk in the left foreground, a symbol of nature's brutal colonization.

Cole's aversion to popular democracy found reinforcement in his aristocratic sympathies, rooted in 18th-Century notions of deference and elite leadership, as well as in his personal identification with his wealthy and conservative patrons.[36] In a more immediate sense, however, the imagery of *The Course of Empire* was shaped by the changing political and social power structure of New York state in the 1830s. "It is curious," remarked Francis Hall many years earlier in the early 1800s, "to find a considerable remnant of feudalism in a young democracy of North America. This, however, is the case in the neighborhood of Albany. A Dutch gentleman, Mr. Van Renslaar [sic], still retains the title of Patroon. . . ."[37] The Dutch squirearchy observed by Hall was still in place in the 1830s. In the latter part of this decade, however, political power had begun to shift away from the landed aristocracy that had held it since the colonial period. Many of Cole's patrons—families such as the Van Rensellaers and the Stuyvesants—came from this landholding class most directly opposed to militant new democratic values.[38] Tied to this conservative society through patronage and friendship, Cole later experienced at one remove the unsettling impact of the anti-rent movement against the authority of the patroons, beginning in 1839.[39]

Cole's 1832 trip to Italy, however, had already predisposed him to view the Jacksonian redistribution of political and social authority in a particular manner. A journal passage that he penned following a May 1832 visit to the Roman Colosseum hints at the nature of the response to the turbulent democratic climate of the 1830s. The passage reveals that Cole had by then begun to think of popular energies such as those he depicted in *The Course of Empire* as the impetus for the historical cycles of empire.

"From the great multitude of wondrous things, I would select the Colosseum as the object that affected me the most." Cole responded imaginatively to the liminal quality of the Roman amphitheater, which looked "more like a work of nature than of man," its architectural lines obscured by "luxuriant herbage." He described the Colosseum in geological terms: "Crag rises over crag, green and breezy summits mount into the sky. . . . Let him ascend to its higher terraces, at that pensive time, and gaze down into the abyss, or hang his eye upon the ruinous ridge, where it gleams in the moon-rays, and charges boldly against the deep blue heaven. . . . Could man, indeed, have ministered either to its erection or its ruin?" Cole then compared the Colosseum to a "volcanic crater, whose fires, long extinguished, had left the ribbed and blasted rocks to the wildflower and the ivy." "In a sense," he mused, "the fancy is a truth: it was once the crater of human passions; there their terrible fires blazed forth with desolating power, and the thunder of the eruption shook the skies. But now all is desolation. In the morning the warbling of birds makes the quiet air melodious; in the hushed and holy twilight, the low chanting of monkish solemnities soothes the startled ear."[40] In a related image that demonstrates the resonance that volcanic imagery held for Americans observing the European revolutions of the next decade, Ephraim Peabody tellingly reanimated Cole's image of a defunct crater: "All may be smooth and fair on the surface, the sides of the mountain may be covered with verdure, the shepherd may keep his flocks, and the vineyards may put forth leaves, and the clusters may ripen in the sun, but the fires of a volcano are moving beneath the thin crust, and without warning, in a moment, they may burst through, and lay the labors of centuries in ruins."[41]

As the vestige of an extinct volcano, the crater was a natural ruin drained of all animating force. Like the Colosseum, the crater marked the site of once violent pressures. Bowl-shaped and surrounded by steep exterior walls, both the crater and the amphitheater were similar in form. Each carried on its scarred surface the inscriptions of its history—violent subterranean pressures on the one hand, and on the other, destructive human energies. A writer for the *Diadem* in 1846 echoed Cole's earlier image of the Colosseum, calling the ruin a "round, green crater of the burnt-out volcano which once swelled up at once nine thousand beasts, and which quenched itself with human blood."[42] Such passages fused the natural and the social into a single powerful image of violent forces and primitive instincts. Travelers to Rome greeted the Colosseum with a mixture of fascination and horror. Morally outraged by its history of institutionalized brutality, they were morbidly interested in the gruesome details of its past.[43] The Colosseum symbolized for 19th-Century tourists the popular corruptions of the imperial city and the destructive power of human passions unstructured by religion or patriotism. Confronted with the Colosseum, Longfellow asked rhetorically, "Where were the senators of Rome, her matrons, and her virgins? Where were the Christian martyrs . . . ? Where the barbarian gladiators . . . ? The awful silence answered, 'They are mine!'"[44] The Colosseum's present condition seemed a fitting conclusion to its role in history; its brutal entertainments, familiar to most visitors through Byron's well-known descriptions in *Childe Harold's Pilgrimage,* and in *Manfred,* ritualized the most sadistic and depraved aspects of crowds and exploited energies that, once released, were difficult to contain.[45]

The Colosseum's history of socially condoned savagery focused conservative American and European fears about the impact of uncontrolled demotic energies. American visitors to Rome were reminded of the unacknowledged pressures at work in their own society and of the revolutionary ferment in France, transformed from a liberal crusade to establish republican institutions into a dangerously unstable popular revolt.

American sympathies for European revolutionary movements generally extended only to the point where they remained safely in the control of liberal middle-class elements.[46] Men such as Hone and Cole drew little distinction between organized proletarian movements and mob violence. The latter was a threatening reality in antebellum America, from the Mummers' parades that frequently issued in action against unpopular members of the community, to the tarring and feathering of those beyond the reach of legal jurisdiction.[47]

The tendency to draw associations between the popular energies released by American democracy and similar forces fueling the social revolutions in Europe is evident in a passage in Nathaniel Parker Willis's *Rural Letters* which celebrated the productive channeling of plebeian energies into industrial activities such as lumbering. Having mentioned "the mobs of England, the revolutions of France, and the plots of Italy," Willis then muses that "there is, in every people under the sun, a *superflu* of spirits unconsumed by common occupation, which, if not turned adroitly or accidentally to some useful or harmless end, will expend its restless energy in trouble and mischief."[48]

Cole's empire falls prey to external foes. Yet the weakening of the internal fabric of society is well under way by the central canvas, setting the stage for the final *coup de grâce*. Internal dissolution and attack from without were two sides of the same coin and, in the 1830s, those most concerned about the stability of the republic feared the former far more than the latter.

Thirteen years after Cole penned his bleak forecast of social collapse (cited above), a famous contemporary of the artist delivered a similar national prognosis, predicting "revolution[s] and bloodshed." Looking backward over the last half-century James Fenimore Cooper saw "that a fearful progress has been made towards anarchy and its successor tyranny, in that period. Another such half century will, in my judgment, bring the whole country under the bayonet."[49] There is a certain irony in the fact that Cooper, still popularly conceived to be the prophet of frontier individualism, could have penned passages that to modern eyes sound like predictions of class warfare. Yet Cooper epitomized the troubled reaction that a transitional generation of Americans had to popular democracy and expansionist ideology. He articulated more explicitly than Cole did the social and political underpinnings of a shared cultural pessimism.[50]

Cooper was also one of the few observers who read *The Course of Empire* as an allegory of American society in the 1830s, for the topicality of the series was consistently overlooked by contemporary critics. While Cole reaped considerable financial and professional rewards from the series, he still found cause to lament to his patron Luman Reed that "[V]ery few will understand the scheme of [the paintings]—the philosophy that may be in them."[51] His assessment of the popular and critical misunderstanding of his series was largely accurate. Americans may have harbored private doubts about the rate of economic and geographical expansion, but with few exceptions they maintained a public belief in the nation's privileged exemption from the cycles of history that had characterized the great empires of the Old World. The nation's republican institutions and vast wilderness assured that expansion would strengthen rather than threaten the national experiment. Cole's contemporaries correctly read his series as a parable of corrupt empire but appear to have suppressed its implications for their own situation. One typical reviewer wrote of how "parents will bring their children here and explain to them the 'Course of Empire,' and tell them stories of other lands."[52]

Cooper's reaction to *The Course of Empire* was an exception to this general pattern of response. What he thought of the series when it first opened in 1836 is unrecorded. In 1849, however, Cooper was given an opportunity to comment on *The Course of Empire* following

Cole's sudden death in 1848. Answering a request from Cole's friend and biographer, Louis Noble, Cooper praised the cycle but belittled Cole's power as a social critic. "The criticism of this country is not of a very high order—and is apt to overlook the higher claim of either writer or artist else would this series have given Cole a niche, by himself in the temple of Fame." Cooper's meaning here remains puzzling; perhaps he regretted the absence of more explicit social content, or the overly programmatic character of Cole's narrative cycle.[53] Regardless of what Cooper intended, his comments to Noble assume, as few of his contemporaries did when the series first opened, that the subject of Cole's imperial allegory was indeed American itself.

Considered one of the nation's first native literary voices, Cooper angered American audiences, following his return from Europe in 1833, with a series of fictionalized portraits of American democratic vices. Following the publication of *Homeward Bound* and *Home as Found,* even Philip Hone accused him of being "an arrogant, acrimonious writer" full of "malicious spleen," hard words from one whose views frequently resembled Cooper's. Only a few years before his death in 1851, Cooper gave vent to his conviction that the social and cultural consensus so vital to national stability had come apart. His novel of 1847, *The Crater, or Vulcan's Peak,* is a parable of the republican cycle as he observed its progression in America during the middle decades of the century. It provides a revealing gloss on Cole's *Course of Empire,* with which it shares a common vision of a society in disorder.[54]

The protagonist of *The Crater* is a resourceful young mariner from Delaware who finds himself a Crusoe-like castaway on a remote volcanic archipelago. Through his enterprise and self-discipline, the islands are gradually domesticated, their barren wastes transformed into a pastoral paradise resembling America at the turn of the 19th Century. His solitary exile on the islands becomes a kind of test that will prepare him to lead the colony of settlers who follow in his wake. The society he creates is a blueprint for Cooper's model republic.

Cooper's pessimistic view of history becomes clear in the final chapters. The first omen that all is not well in Eden is the appearance of prosperity, accompanied by "luxurious idleness . . . [and] sensual indulgences," vainglory, pride, and physical expansion. The sudden declension of the colony from political and social unity to divisiveness is rapid and inexorable. In its transition to maturity, Cooper's island republic, like America, faces a multitude of threats, finding itself most endangered when it has conquered external obstacles—sterile agricultural conditions, hostile neighbors, and marauding pirates. Only then do the internal weaknesses of partisan dissension, sectarianism, and moral laxity begin to sap the native resourcefulness of the island colonists. Cooper's republican utopia is eventually engulfed in a minor apocalypse, the end to which his republican vision of history necessarily condemned it. The protagonist and his family are spared the tragedy to which their neighbors succumb, returning to find only a remnant of the island republic barely visible above the surface of the ocean. Recalling both Cole and Hone, Cooper expresses his understanding of social and political dynamics in terms of cataclysmic natural forces. The image of the crater connects the natural and the social; it is the visible emblem of subterranean forces that may become reactivated at any time.

Cooper shared with Cole a similar philosophy of history. Both employed the crater as a symbol of inert but potentially active social energies, and it is therefore fitting to find Cooper invoking *The Course of Empire* in the final lines of his novel. The still visible portion of Woolston's island crater resembles "that sublime rock, which is recognized as a part of the 'everlasting hills,' in Cole's series of noble landscapes . . . ever the same amid the changes of time, and civilization,

and decay, . . . naked, stormbeaten, and familiar to the eye, though surrounded no longer by the many delightful objects which had once been seen in its neighbourhood."[55]

Cooper's parable of a republican utopia gone sour betrays an extreme paranoia concerning America's future. Both Cole's and Cooper's imagery was permeated with the dread of a sudden and devastating popular eruption that would destroy the body politic. Writing toward the end of his life in an association clearly inspired by Cole's *Consummation*, Cooper remarked that "America, having passed between 1821 and 1849, was now entering the third stage of empire." The nation, he concluded, had no enemy to fear "but the one that resides within."[56]

Men such as Hone, Cole, and Cooper (though the latter in particular) were unprepared by background, philosophical disposition, and political beliefs to respond favorably to the volatile industrial democracy whose foundations were being laid in the 1840s.[57] The Whig rhetoric of social declension was directed at a vocal, newly empowered urban population better prepared to take advantage of altered economic conditions. To Cooper and Hone, these developments meant the end of a politics of consensus and deference, while, to Cole, they heralded a new utilitarian tide setting against the arts, as well as an economic order inimical to wilderness values. All three men held a vision of America's historical identity that appeared to be endangered by the new order. The greatest threat to America's existence was its own success.

Cole owned a copy of Gibbon's *Decline and Fall of the Roman Empire,* with its account of the internal corruption of Rome's civic institutions before its collapse. His study of history confirmed his forebodings of social declension. Popular democracy was destroying the influences that had so far kept the republic intact. "[T]he great strife political" prostrated "man's affections, sympathies, / Domestic joys and duties—makes the Guest / An Enemy and deadly

hate has placed / 'Twixt Brothers." The name of Liberty has been dishonored by "Shouts shrill, / Of selfishness . . . and lawless Will." Party spirit has usurped the "sacred throne" of Freedom, devalued by political demogogues and abused by a populace no longer restrained by moral, religious, and civic values.[58] In another untitled poem, Cole observed a similar pattern at work: "From avarice, prejudice . . . and pride . . . / [Come] all the hideous crew that stride / O'er Freedoms prostrate form and clamorous call / The sacred name—though guilty of her fall / And feed upon her triumph . . . And ask a nations plaudits for the deed." Here as in the preceding poem, appeals to freedom and liberty disguise new forms of tyranny.[59] Religious sectarianism represented for Cole yet another symptom of the erosion of virtue and piety. In turning to Episcopalianism in 1842, Cole chose the most ritualized and hierarchical of all American Protestant churches. His conversion represented a movement toward a more controlled and formal devotionalism, and a reaction against the proliferation of sects, each professing a particular social and religious panacea for the very problems that they themselves epitomized. Religion in America, he felt, had become as partisan as politics itself.

Perhaps the most graphic statement of Cole's disillusionment with American society and his sense of an impending national failure was an unpublished story dating from the early 1840s, "Verdura, or A Tale of after Time." His prophetic tale opens with a vision of America at the close of the 20th Century. Its population now numbers in the hundreds of millions, and its wilderness has given way to ploughed fields in a manner that ironically parallels Cole's programmatic landscape of 1836, *View from Mount Holyoke, Northampton, Massachusetts, after a Thunderstorm* ("The Oxbow of the Connecticut River") (Metropolitan Museum of Art). In fulfillment of the dream upon which so many of Cole's contemporaries had fixed their sights, the land "glittered with cities and capes and rivers [that] re-

flected uncounted buildings to the world. The strong desire of wise men of two centuries past was fulfilled and there was a great multitude spread over the land."

This opening prospect bears a deliberate and ironic resemblance to the national forecast conjured up by myriads of optimistic cultural spokesmen. Rather than celebrating America's triumph over the wilderness, however, Cole traces its disastrous consequences. In his late–20th-Century scenario, culture's conquest of nature issues in social anarchy and cataclysm:

> The Freedom of the individual Man—and the dignity of human nature favorite notions were now developed and exhibited themselves in vice profligacy irreligion and anarchy . . . the filmy threads of vanity and worldly prudence were broken and the *pride of man* with its haggard offspring Want like a tempest broke up the great deep bosom of society and there was no more calm; but a fearful heaving hither and thither of passions of men.[60]

The seeds of this appalling situation, present from the beginning, are only prevented from taking root by material circumstances:

> [A]s long as the lands were ample and large tracts unoccupied and every man has his . . . ground the States which once held the proud title of the 'United' bound in a loose band of interest and pride moved among nations as one nation—Though among them they jostled quarreled and blood had oft been let . . . love was not the chain that encircled them.

Only when the wilderness has been exhausted do intrinsic weaknesses become manifest, threatening the survival of history's newest republic. Human nature, and the historical laws that it generated, were everywhere the same; it was only a matter of time before the logic of these laws would catch up with, and triumph over, the exceptional conditions of American culture.

The apocalyptic note in Cole's writings and art gave way more and more, however, to religious resignation and nostalgia for a stable pastoral society mythically removed from the nation's present. Although Cole continued to denounce utilitarian greed, his next major serial composition, *The Voyage of Life,* heralded a more generalized expression of Romantic disillusionment. The series achieved for Cole an unprecedented popular audience through its circulation in reproductive prints. If, as one writer has argued, *The Voyage of Life* did contain a veiled commentary on the futility of America's youthful ambitions, this public or topical content was overshadowed by a universalized message of temporal loss and of the inevitable defeat of all ambitions rooted in the romance of the self.[61] In such narratives of moral and spiritual progress as *The Voyage of Life* and the uncompleted *Cross and the World,* religious faith assisted Cole in coping with his own deep disappointment while disguising its source in his personal ambitions as a painter; for one does not need to undervalue the depth and seriousness of Cole's critique of American culture to recognize that to some extent its origins lay in his feeling that America did not sufficiently appreciate and support its artistic visionaries. Cole's later series introjected the political and social content of *The Course of Empire,* transforming it into a private allegory of spiritual quest. His displacement of public content onto a moralizing narrative was a strategy employed repeatedly by American artists over the ensuing decades. This transformation of public into private, national into familial, and social into spiritual or moral prepared the way for the "Victorianization" of American art.

One significant exception to this general profile is a body of landscape art that extended—and transformed—Cole's legacy of large-scale, ambitious national allegory into terms suited to the midcentury. Eighteenth-Century cyclical models of history had largely lost currency for artists who matured in the next generation, re-

placed by the progressive versions of historical development that accompanied technological, scientific, and political developments in Europe and America throughout these decades.[62] For some of the major artists who followed in Cole's wake—Frederic Church, Asher B. Durand, and William Sonntag among them—Cole's prophetic voice, communicated in its least diluted form through *The Course of Empire,* furnished them early on with a critical example. A number of single and serial narrative paintings in the years following Cole's death effectively turned his pessimistic vision of history on its head.[63] Sonntag's *Progress of Civilization* (1847: unlocated), Church's *New England Scenery* (1851),

and Durand's *Progress, or The Advance of Civilization* (1853) neatly aligned the nation's grandest ambitions with the very structure of history itself as it unfolded upon the stage of New World nature. It was Cole's very authority as the father of a native landscape school that challenged the leading artists of the next generation to transform the bleak content of his ominous parable of empire and to reassert the persistence of nature's redemptive agency to the future of the republic. Such a transformation was necessary in order to sustain a belief in the providential—and republican—association between wilderness and national virtue that was the hallmark of Cole's art.

NOTES

Revised by the author from *Prospects.* Reprinted by permission of the author.

1. J. G. Baldwin, *Party Leaders: Sketches of Thomas Jefferson, Alexander Hamilton, Andrew Jackson, Henry Clay, John Randolph of Roanoke* (1855; rept. New York: D. Appleton and Co., 1861), p. 348.

2. An example is Helen Weinberg, "An American Grail: An Iconographic Study of Thomas Cole's 'Titan's Goblet,'" [*Prospects* 8: 261–280, (1983)], pp. 275 and 278, where Weinberg writes of Cole's "typically Jacksonian faith in American progress." With the exception of Alan Wallach, "Thomas Cole and the Aristocracy," *Arts Magazine* 56, no. 3 (November 1981): 94–106, most studies neglect Cole's involvement in the social, political, and historical context that pressed so hard upon him in the 1830s, and from which he increasingly withdrew in the 1840s. Matthew Baigell and Allen Kaufman, in "Thomas Cole's 'The Oxbow': A Critique of American Civilization," *Arts Magazine* 55, no. 5 (January 1981): 136–39, also touch upon Cole's anti-Jacksonian sentiments.

3. New studies more sensitive to this dimension of landscape include Roger Stein, *Susquehanna: Images of the Settled Landscape* (Binghamton, N.Y.: Roberson Center for the Arts and Sciences, 1981); and Franklin Kelly, *Frederic Edwin Church and the National Landscape* (Washington: Smithsonian Institu-

tion Press, 1988). This turning of the scholarly tide is already well under way in the field of British landscape studies. See John Barrell, *The Dark Side of the Landscape: The Rural Poor in English Landscape, 1730–1840* (Cambridge: Cambridge University Press, 1980); and David Solkin, *Richard Wilson: The Landscape of Reaction* (London: Tate Gallery, 1982); and Ann Bermingham, *Landscape and Ideology: The English Rustic Tradition, 1740–1860* (Berkeley: University of California Press, 1986).

4. On Reed, see Wayne Craven, "Luman Reed, Patron: His Collection and Gallery," *American Art Journal* 12, no. 2 (Spring 1980): 40–59.

5. On the distrust of the passions in Whig thought, see Daniel Walker Howe, *The Political Culture of the American Whigs* (Chicago: University of Chicago Press, 1979), ch. 3, esp. pp. 52–53.

6. Cole's comment on Harrison's death appears in a letter to William Adams, dated April 8, 1841, cited by Wallach, "Cole and the Aristocracy," p. 98.

7. Archives of American Art, Reel no. ALC1.

8. On Jackson's fiscal policies and the Whig response, see Howe, *The Political Culture of American Whigs,* p. 139.

9. Cited in Douglas Miller, *The Birth of Modern America, 1820–1850* (New York: Pegasus, 1970), p. 67.

10. On the Depression of 1837, see Samuel Rezneck, "The Social History of an American Depres-

sion, 1837–1843," *American Historical Review* 40, no. 4 (July 1935): 662–87; William Charvat, "American Romanticism and the Depression of 1837," *Science and Society* 2, no. 1 (Winter 1937): 67–82; *The Diary of Philip Hone, 1828–1851,* ed. Allan Nevins (New York: Dodd, Mead, 1936), entries for the years 1836 and 1837; Orestes Brownson, "Babylon Is Falling."

11. See Douglas Miller, *Jacksonian Aristocracy: Class and Democracy in New York, 1830–1860* (New York: Oxford University Press, 1967), pp. 78–79, 80.

12. *The Diary of Philip Hone,* May 8, 1837, pp. 255, 281.

13. Ronald Paulson, *Representations of Revolution, 1789–1820* (New Haven: Yale University Press, 1983), p. 75.

14. For further analysis of Cole's attitudes toward commerce, see Angela Miller, "'The Imperial Republic': Narratives of National Expansion in American Art, 1820 to 1860" (Ph.D. diss., Yale University, 1985), pp. 114–18.

15. Alan Wallach has previously noted the possible allusion to Jackson in the figure of the emperor in "Thomas Cole and the Aristocracy," p. 99.

16. See Edwin A. Miles, "The Whig Party and the Menace of Caesar," *Tennessee Historical Quarterly* 27, no. 4 (Winter 1968): 361–79.

17. See, for instance, Hone's *Diary,* December 7, 1838, p. 367; Daniel Walker Howe, *The Political Culture of American Whigs,* pp. 44, 79.

18. Arthur Schlesinger, Jr., *The Age of Jackson* (Boston: Little, Brown, 1945), p. 38.

19. For a survey of these images, see Frank Weitenkampf, *American Graphic Art* (New York: MacMillan, 1924), pp. 216–17; William Murrell, *A History of American Graphic Humor, 1747–1865* (New York: Whitney Museum of American Art, 1933), vol. 1, pp. 106–24 and passim; Stephen Hess and Milton Kaplan, *The Ungentlemanly Art: A History of American Political Cartoons* (New York: MacMillan, 1968), pp. 66–71; and Nancy R. Davison, "Andrew Jackson in Cartoon and Caricature," in *American Printmaking Before 1876; Fact, Fiction, and Fantasy* (Washington: Library of Congress, 1975), pp. 20–24.

20. See Perry Miller, *The Raven and the Whale: The War of Words and Wits in the Era of Poe and Melville* (New York: Harcourt, Brace, and World, 1956), p. 189.

21. See Miles, "The Whig Party and the Menace of Caesar," pp. 373–76.

22. See, for instance, *Born to Command: King Andrew the First,* which shows Jackson as an emperor holding a scroll inscribed "Veto" and standing upon the tattered remains of the Constitution and a coat of arms inscribed "Internal Improvements" (Kaplan and Hess, *The Ungentlemanly Art,* p. 68). The imperial image was transmitted to Van Buren as well, as in *Granny Harrison Delivering the Country of the Executive Federalist* (1840), showing Van Buren as a king being forcibly pulled from his throne by the next president. Reproduced in *The Image of America in Caricature and Cartoon* (Fort Worth: Amon Carter Museum of Western Art, 1975), p. 68.

23. This lithograph was the work of one "Hassan Straightshanks," and is listed as no. 115 in Murrell, *A History of American Graphic Humor,* p. 125.

24. Parton, *Caricature and Other Comic Arts,* as quoted in Murrell, *A History of American Graphic Humor,* p. 124.

25. *New-York Commercial Advertiser,* February 13, 1836, p. 3. I am indebted to Mariam Touba of the New-York Historical Society for tracing this reference.

26. "Progress of the Great West in Population, Agriculture, Arts and Commerce," *De Bow's Commercial Review of the South and West* 4, no. 1 (September 1847): 31.

27. "Democracy," in Alvan S. Ryan, ed., *The Brownson Reader* (New York: P. J. Kennedy, 1955), p. 39.

28. This reference appears in Cole's journal (Archives, Reel ALC3). The passage reappears in Noble/Vesell, *The Life and Works of Thomas Cole,* p. 140, with a typical omission: "[W]e heard the shouts of a company of men, rejoicing at the defeat of their political enemies."

29. Hone, *Diary,* August 11, 1835, p. 169. See also entry for May 20, 1834, p. 128.

30. Hone, *Diary,* May 4, 1837, p. 244.

31. *Diary,* December 7, 1838, p. 367. See also June, 1834, p. 131.

32. *Autobiography;* cited by Irma Jaffe, *John Trumbull: Patriot Artist of the American Revolution* (Boston: New York Graphic Society, 1975), p. 146.

33. *Diary,* p. 451; p. 450. See also December 2, 1839, p. 434, on the breakdown of civic order.

34. For one such meditation, see *Diary,* July 4, 1837, p. 267.

35. The entry is dated August 21, 1835. I am indebted to Kenneth J. LaBudde for his transcription of this passage from Cole's journals (personal correspondence). Cole's gloomy forebodings were shared by numerous foreign visitors. See George Pierson, *Tocqueville and Beaumont in America* (New York: Oxford University Press, 1938), pp. 775–76; Jane Louise Mesick, *The English Traveller in America, 1785–1835* (New York: Columbia University Press, 1922), p. 332; Captain Frederick Marryat, *Diary in America,* ed. Jules Zanger (1839; rept. Bloomington: Indiana University Press, 1960), pp. 43–44.

36. On this relationship, see Wallach, "Cole and the Aristocracy."

37. Francis Hall, *Travels in Canada, and the United States, in 1816 and 1817* (London: Longman, Hurst, Rees, Orme, and Brown, 1818), p. 35.

38. See Wallach, "Cole and the Aristocracy," for a discussion of the impact of such political changes on Cole and his New York patrons.

39. On the anti-rent movement, see Douglas Miller, *Jacksonian Aristocracy,* pp. 62–69; *History of the State of New York,* 10 vols., ed. Alexander C. Flick (New York State Historical Association, 1934), vol. 6, pp. 283–321; and Dixon Ryan Fox, *The Decline of Aristocracy in the Politics of New York, 1801–1840,* ed. Robert Rimini (1919; rept. New York: Harper Torchbooks, 1965), pp. 437–38.

40. Noble-Vesell, *The Life and Works of Thomas Cole,* pp. 115–16.

41. "A Sermon Delivered before the Boston Fraternity of Churches, April 2, 1846" (Boston, 1846), p. 7, quoted in Fred Somkin, *Unquiet Eagle: Memory and Desire in the Idea of American Freedom* (Ithaca: Cornell University Press, 1967), p. 39.

42. "The Coliseum," by T. C. Brooks, after Jean Paul Richter, *The Diadem* (Philadelphia, 1846), p. 91.

43. See, for instance, "Rome in Midsummer," in *Outre-Mer, Works of Henry Wadsworth Longfellow* (Boston: Houghton-Mifflin, 1886–91), vol. 7, pp. 251–54; James Fenimore Cooper, *Gleanings in Europe: Italy,* ed. Constance A. Denne (Albany: State University of New York Press, 1980), pp. 216–17; Bayard Taylor, "The Voices of Rome," in *Poetical Works of Bayard Taylor* (Boston: Houghton-Mifflin, 1883), p. 203; William Wetmore Story, *Roba di Roma* (London: Chapman and Hall, 1864), pp. 176–79; and Edgar Allan Poe, "The Coliseum," in *Complete Stories and Poems of Edgar Allan Poe* (Garden City, N.Y.: Doubleday, 1966), pp. 748–49. For pictorial equivalents, see John W. Coffey, *The Twilight of Arcadia: American Landscape Painters in Rome, 1830–1880* (Brunswick, Me.: Bowdoin College Museum of Art, 1987).

44. "Rome in Midsummer," p. 253.

45. Canto 4, stanzas 138–145 of *Childe Harold,* and Scene 4 from *Manfred,* in which Byron evokes the usual contrast between the past violence of the empire and the desolation of the present, are especially relevant. See also Paul Baker, *The Fortunate Pilgrims: Americans in Italy, 1800–1860* (Cambridge: Harvard University Press, 1964), p. 28; Alan Wallach, "Cole, Byron, and 'The Course of Empire'," *Art Bulletin* 50 (December 1968): 375–79. For a different analysis of the 19th-Century meanings of the Colosseum, see Lois Dinnerstein, "The Significance of the Colosseum in the First Century of American Art," *Arts Magazine* 58, no. 10 (June 1984): 116–20.

46. See John Higham, "From Boundlessness to Consolidation: The Transformation of American Culture, 1848–1860" (Ann Arbor: William L. Clements Library, 1969), pp. 16–17.

47. On Mummers' parades, see Susan Davis, "'Making Night Hideous': Christmas Revelry and Public Order in Nineteenth Century Philadelphia," *American Quarterly* 34, no. 2 (Summer 1982): 185–99. On the threat of mob violence, see "The Wants of the Age," *Godey's Lady's Book* 14 (April 1837): 164–65; and Michel Chevalier, *Society, Manners, and Politics in the United States,* ed. John William Ward (Ithaca: Cornell University Press, 1961), pp. 376–79, 391.

48. Nathaniel Parker Willis, *Rural Letters* (New York: Baker and Scribner, 1849), pp. 126–27. On the dangers of public insurrection, see "Thoughts on the Times," *The Knickerbocker* 9, no. 5 (May 1837): 488–93.

49. *Letters and Journals of James Fenimore Cooper,* 5 vols., ed. James Franklin Beard (Cambridge: Harvard University Press, 1960–64), vol. 5, p. 388.

50. On Cooper's vacillating political allegiances in the 1840s, see Schlesinger, *The Age of Jackson,* p. 379 and passim.

51. The letter, in the Archives of American Art, Reel ALC1, is dated March 6, 1836, and is partially quoted by Noble, *The Life and Works of Thomas Cole,* p. 160.

52. "Remarks," in the *Catalogue of the Exhibition of the New York Gallery of the Fine Arts,* p. 5 (Archives of American Art, Reel D6), frame 867.

53. Cooper's criticism may also reflect the general turn away from allegory that affected Cole's reputation beginning in the early 1850s.

54. On the affinities between Cole's and Cooper's vision of the American future, see Albert Gelpi, "White Light in the Wilderness," in *American Light: The Luminist Movement,* ed. John Wilmerding (Washington: National Gallery of Art, 1980), p. 295; Clive Bush, *The Dream of Reason* (New York: St. Martin's, 1978), pp. 332–33; and H. Daniel Peck, *A World by Itself: The Pastoral Moment in Cooper's Fiction* (New Haven: Yale University Press, 1977), pp. 155–59.

55. Cooper, *The Crater, or Vulcan's Peak,* ed. Thomas Philbrick (Cambridge: Harvard University Press, 1962), p. 456.

56. Cited by Perry Miller, "The Romantic Dilemma in American Nationalism and the Concept of Nature," in *Nature's Nation* (Cambridge: Harvard University Press, 1967), p. 205.

57. See Douglas Miller, *The Birth of Modern America;* Miller, *Jacksonian Aristocracy;* and Richard D. Brown, *Modernization: The Transformation of American Life, 1600–1865* (New York: Hill and Wang, 1976).

58. "Sonnet no. 45," in Marshall Tymn, *Thomas Cole's Poetry* (York, Penn.: Liberty Cap Press, 1972), p. 99.

59. Archives, Reel ALC3.

60. "Verdura, or A Tale of after Time." I am indebted to Kenneth LaBudde for his transcription of "Verdura."

61. Douglas Adams, in his essay "Environmental Concern and Ironic Views of American Expansionism Portrayed in Thomas Cole's Religious Paintings," in *Cry of the Environment: Rebuilding the Christian Creation Tradition,* ed. Philip N. Joranson and Ken Butigan (Santa Fe: Bear and Co., 1984), pp. 296–305, bases his evidence for Cole's ambivalence about expansion on *The Voyage of Life* as well as *The Course of Empire.*

62. See Rutherford E. Delmage, "The American Idea of Progress, 1750–1850," *Proceedings of the American Philosophical Society* 91, no. 4 (October 1947): 307–14; Robert Nisbet, *History of the Idea of Progress* (New York: Basic Books, 1980); and Arthur Ekirch, *The Idea of Progress in America, 1815–1860* (New York: Columbia University Press, 1944).

63. Kelly, *Frederic Church and the National Landscape,* examines how Cole's student Church transformed *The Pastoral State* and *Desolation* in his own landscape work during the 1850s. The subject of landscape allegories in the 1850s is examined further by Miller, "'The Imperial Republic'," pp. 192–264.

George Caleb Bingham's *The County Election*

Whig Tribute to the Will of the People

⬦

GAIL E. HUSCH

George Caleb Bingham's Election Series occupies a unique place in the history of American art due to its thematic focus on practical politics in a representative democracy. The artist's own passionate involvement with the frontier electoral process, including his personal experience as a candidate for office, has created an aura of authenticity around these paintings and invited speculation that Bingham's view of backwoods politics was based on a strong partisan bias. Consistent with recent scholarship on Bingham, Gail Husch emphasizes his Whig Party affiliation in her consideration of the Election Series; but she also challenges the consensus view that these works constitute a cynical critique of populist democracy by an orthodox Whig with elitist contempt for the common man.

Husch believes that the Election Series has been misread as an indictment of the American electorate by oversimplifying Whig ideology and misrepresenting the core of Bingham's own political convictions. She argues instead for an understanding of the series as an idealistic vision of national unity achievable through political compromise. Although she admits to Bingham's growing disillusionment with the electoral process and its capacity to resolve the problems created by westward expansion, Husch attributes Bingham's loss of faith in representative government to the growing corruption of self-serving politicians and their insistence on blind loyalty to partisan interests.

⬦

"Political excitement," lamented a female observer in 1848, is

> a pestilence which is forever racing through our land, seeking whom it may devour; destroying happy homes, turning aside our intellectual strength from the calm and healthy pursuits of literature or science, blinding consciences, embittering hearts, rasping the tempers of men, and blighting half the country with its feverish breath.[1]

This election fever must certainly have infected the Democratic voters whose raucous procession down the streets of New York was captured in a crude woodcut published on the second page of the *New York Morning Herald* on November 5, 1839. The print shows wild-eyed marchers advancing through a foreground littered with trampled bodies; in the far right of the scene a man vomits from excessive drink while behind him

and to the left another citizen punches his neighbor squarely on the chin. A print published in 1857 entitled "At the Polls" illustrates a similarly violent and chaotic scene, suggesting that public electoral behavior had not improved over the intervening years.[2]

In light of such depictions, however exaggerated, it is easy to see why political gatherings, with their ominous undercurrents of drunkenness and violence, did not become popular subjects for genteel oil paintings and prints in mid-nineteenth-century America. Torchlight parades, stump speeches, and public voting assemblies were rarely treated seriously by artists of this period and remained much more the province of caricaturists, even at a time when genre painting, with its emphasis on delineating national character, was in full bloom.

Those painters who did take up the subject of public electioneering generally chose to emphasize its boisterous spirit and did not, for the most part, depict sober citizens thoughtfully exercising their republican right of self-government.[3] Viewed in this context, George Caleb Bingham's Election Series stands out as this country's most seriously developed mid-nineteenth-century artistic treatment of the subject, and it has come to symbolize the rough and tumble energy of American politics before the Civil War.[4]

The County Election (of which there are two versions), *Stump Speaking,* and *The Verdict of the People* (also in two versions) are the major components of the Election Series, in terms of both size and complexity. They form a complete thematic overview of the public electioneering process, from the campaign, through the voting process, to the final outcome of the race.

The paintings of the Election Series have traditionally been viewed as essentially objective documents of Jacksonian innocence and optimism. Bingham's well-known political interests, however, have led recent historians of American art to study them for indications of the artist's own partisan biases. In 1970, Robert F. Westervelt presented a pioneering argument in which

he used the artist's Whig party affiliation to interpret the works—particularly *The County Election* of 1851–1852 [1][5]—as documents of social criticism, evidence of Bingham's negative attitude toward Jacksonian egalitarianism and the rule of the common man.[6]

Westervelt suggested that *The County Election* reflected Bingham's serious misgivings about the extension of suffrage in the United States to include propertyless or immigrant working-class voters. Basing much of his analysis on a traditional characterization of the Whig party and its programs as self-consciously elitist and aristocratic, Westervelt described the painting as a "Whig protest." The gathering of, to Westervelt's eye, disreputable voters in the painting was intended by the artist, he believed, to make a mockery of the words "The Will of the People the Supreme Law" printed on the blue banner leaning against a pillar of the courthouse.

A number of scholars have followed Westervelt's lead, most importantly Barbara Groseclose in an article of 1978 entitled "Painting, Politics and George Caleb Bingham."[7] Groseclose agreed with Westervelt's reading of *The County Election* and related Bingham's Election Series even more specifically to the general political climate of the time as well as to the artist's own political experiences. Groseclose reiterated this interpretation in a later article on politics and nineteenth-century American genre painting in which she wrote:

> [The] *County Election* may . . . be read as a mockery of Jacksonianism: the banner reading "The will of the people the supreme law" is an ironic commentary on the senseless drunk being dragged to the polls, the obsequious scouts pressing their attentions on naive farmers and the slumping figure of the battered partisan at the right.[8]

Similar negative readings have appeared in several recent publications and this undeniably compelling approach seems to have gained wide acceptance.[9]

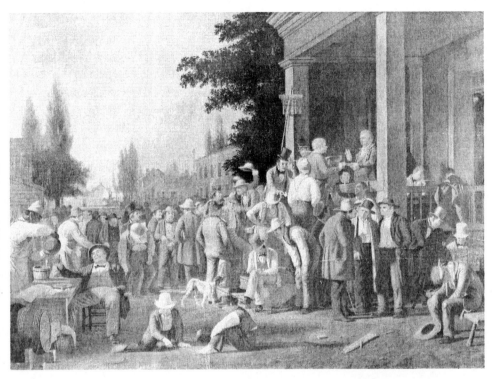

1. George Caleb Bingham, *The County Election,* 1851–1852; courtesy of the Saint Louis Art Museum.

Yet such an "anti–common man" analysis of *The County Election* does not do justice to Bingham's positive attitude toward populist government as revealed in his letters or to the stated ideals of the Whig party in which he so firmly believed and may, in fact, be a serious misrepresentation of them. Indeed, a look at the painting in light of contemporary Whig rhetoric points strongly to a conflicting interpretation. *The County Election* does seem, as Westervelt and Groseclose suggest, to reflect Bingham's specifically Whig beliefs and his reactions to contemporary political developments, but in a manner which affirms rather than denies the artist's essential faith in the American people.

The County Election was intended, I believe, as a primarily positive, even idealized (but by no means innocent), view of the American electoral process rather than as a mocking social comment, although some negative aspects of American politics in action are included in the scene. Using visual clues from the painting itself, contemporary reactions to it, the artist's letters and Whig writings, I hope to show that *The County Election* represents electoral activity as Bingham, a committed Whig, thought it should be, but not necessarily as it always was: the harmonious participation of all classes of society in the great experiment of self-government.

Bingham was a loyal Whig but his allegiance was not blind. He seems to have been an independent, almost naively idealistic thinker of moderate views who held to his beliefs even when they clashed with the party line. Bing-

ham's independence (as well as his exalted view of Whig integrity) is apparent in a letter written in 1841 to the artist's friend and political adviser James S. Rollins, a prominent Missouri Whig. Bingham wrote:

> ... [The] whigs are freemen, and not ... bound to model their thoughts to correspond with the wishes of a master. We differ, as men will ever differ who enjoy the consciousness of freedom, but are a unit in opposition to the men who would dare deprive us of the *right* to do so ...[10]

Whig propagandists often compared their party's tolerance of independent thinking to, as they saw it, Democratic party bondage. Historian Thomas Brown, for example, characterized the Whig party as a diverse assortment of citizens united, in part, against a Democratic

> centralized party apparatus that required the blind loyalty of its votaries ... While the Democrats asserted that party organization and discipline were necessary to concert opposition to subverters of the republic, the Whigs condemned party politics as itself a danger to government.[11]

But Bingham did more than mouth such typically Whig sentiments. In 1851, for example, he vehemently disagreed with a number of important Missouri Whigs who, for political ends, compromised their party's traditional position on slavery. Any interpretation of *The County Election* must give precedence to Bingham's own words and actions over political generalizations, and must examine the nature of Bingham's personally expressed attitude toward "the people"— that abstract mass of voters objectified in *The County Election*.

Bingham owned a small farm in Arrow Rock, in Missouri's Saline County—the heart of central Missouri's Democratic "Boonslick Country." Although not wealthy, the artist did associate with important social and political leaders of both parties as a fellow landowner, a politician,

and a portrait painter, and he certainly considered himself an educated member of society. Yet there is no evidence in Bingham's letters to Rollins or in his own political decisions that he held any fear of or contempt for the working classes or "the people," a contempt which has been construed by some modern scholars as a fundamental impulse behind *The County Election*.

In fact, Bingham's letters provide evidence that he respected the role of the American people in the government of their country. In 1841 Bingham was in Washington, D.C., painting portraits, shortly after the raucous presidential campaign of 1840 in which the Whig candidate William Henry Harrison trounced the Democratic incumbent Martin Van Buren. The artist wrote to Rollins:

> [T]he fact is I am no politician here, and ... the great question of the ability of the people to control their rulers is settled for the present. ... [U]nless another corrupt dynasty, like the one that has just been overthrown shall again arouse the whole people on behalf of a suffering Country, I shall be content to pursue the quiet tenor of a painters [*sic*] life ...[12]

Bingham twice invoked the name of "the people" in this passage, and he characterized Van Buren's late presidency as a corrupt, aristocratic dynasty, a popular device in Whig campaign rhetoric. Yet Bingham employed the reference in a private letter, not a public speech; he appears to have believed in the validity of such a characterization and to have been repelled by its implications. The artist was not out stumping for votes, but expressing to a close friend his faith in the ability of the American people to keep their elected officials in check.

It could be argued, however, that in 1841 Bingham was still a political innocent who had not yet run for elected office or personally experienced the uglier aspects of party politics, and that his faith was soon to be shaken. Indeed, the

artist's own political fortunes have been used by Westervelt and Groseclose as evidence to support a reading of *The County Election* as an embittered and cynical view of popular electoral politics.[13] Although Bingham's debut as a candidate *was* bitterly disappointing, the experience seems to have strengthened rather than shattered his confidence in the voting public. He first ran for a seat in the Missouri state legislature in 1846 and won by a slim majority. His opponent, a member of the Boonslick clique of Democratic merchants and landowners who controlled state politics, contested the election results and, with the help of a predominantly Democratic legislature, succeeded in usurping Bingham's seat.[14]

The artist was understandably indignant, but his ire was directed at unscrupulous politicians, not at the voters. He had, after all, won a popular majority, however small. In fact, Bingham suggested that he and his rival submit once more to, in Bingham's words, "the test of the ballot box, leaving to the people, according to the genuine republican method, to determine who shall be their representative."[15] In an address to the state legislature Bingham again emphasized the populist basis of his campaign as he perceived it and said:

> Against me was arrayed a large portion of the concentrated wealth of the country in which I reside. . . . The people rallied to my rescue, and notwithstanding the fearful odds against me I conquered in their strength and came off victorious.[16]

These words should not be dismissed as the exaggerations of a disappointed loser, for Bingham was just a small landowner and itinerant painter fighting an opponent who belonged to what some modern historians have called Missouri's aristocracy. According to Robert E. Shalhope, for example, these Boonslick Democrats had an "ingrained acceptance of political leadership by the social elite."[17]

In 1848, Bingham ran again for the same office and won; the artist must have been grateful

to the voters of his county for once again supporting him against the candidate of a powerful and wealthy political organization. In fact, while a member of the state legislature in 1849, he voted in favor of an amendment to Missouri's constitution which provided for the popular election of judges. Missouri had no property requirements for voters, thus Bingham helped to strengthen the franchise and the political voice of both the propertied and the propertyless classes.[18]

The respect for "the people" manifest in Bingham's words and actions suggests the artist really did believe, as the blue banner in *The County Election* claims, that the will of the people *was* the supreme law. And that Bingham considered *The County Election* an appropriate image for reproduction and public sale provides additional support for a positive interpretation of its message. The painting was not commissioned by a wealthy private patron; it was Bingham's personal visualization of a subject close to him yet planned with an eye to its popular appeal and consequent rewards of money and fame.[19]

The painting was grand enough in conception to be viewed as contemporary history painting. At least one viewer of the time wished that the figures were life-sized for, as he wrote, "the subject has the full dignity and interest requisite for a great historical painting."[20] Given the public nature of the painting and the artist's hopes for its success, it seems unlikely that he would have colored it with an elitist disdain for the working class, even if he had felt such a prejudice himself.

Bingham's populist sympathies did not make him a renegade Whig. As noted earlier, an antipopulist reading of *The County Election* is founded largely on the assumption that Whigs (Bingham included) were essentially conservative elistists and that Democrats were the progressive champions of the common man. But recent scholarly investigations into the realities of Jacksonian politics have found this dichotomy simplistic and inaccurate. It appears that the

leaders and constituents of both major parties were strikingly similar in their socioeconomic backgrounds, a generalization as true for Bingham's predominantly Democratic state of Missouri as for the rest of the country.[21] By 1839, about the time the artist first became active in political affairs, Missouri Whigs were emerging as, according to historian Perry McCandless, "representatives of a middle class, and not as a party of aristocratic capitalists to be contrasted with a Democratic party of small farmers and workers."[22] As we have seen, the real aristocrats of Bingham's home county were Democrats.

Not surprisingly, neither political party in any state wanted to be publicly stigmatized as the representative of the upper class: Whigs as well as Democrats claimed to be the people's true friend. A Whig propagandist writing in 1844, for instance, claimed that "the laboring and poorer classes have made an important discovery . . . [t]hat the Whig policy and Whig measures are best for them."[23] Whigs, in fact, thought that they were the genuine "democratic" party in America and would not grace their opponents with such a fine and hallowed name. Democrats were "Locofocos" to their Whig adversaries.[24]

This is not to imply that the two parties were indistinguishable in their ideals, aspirations, political strategies, or popular rhetoric. The Whig party, for instance, generally favored a strong federal government with the power to levy tariffs, subsidize internal improvements, and charter a national bank. Democrats, on the other hand, inclined toward a laissez-faire, free trade national policy: when governmental action was required they preferred to leave it to the states.[25]

These opposing attitudes toward the function of American government were matched by equally conflicting views of the structure of American society. As historian Daniel Walker Howe explained:

A recurring theme in Whig rhetoric was the organic unity of society. Whereas [Democrats] of-

ten spoke of the conflicting interests of . . . 'the house of have' and 'the house of want,' the Whigs were usually concerned with muting social conflict. The interdependence of different classes, geographical regions and interest groups within the nation was an article of Whig faith. Many Whig economic, political and cultural positions can be interpreted as efforts to create national unity and preserve a social harmony.[26]

Brown offered a similar assessment:

While the Democrats saw fundamental divisions in the polity, the Whigs saw underlying harmony. While the Democrats believed politics should be an instrument of the aggrieved against exploitation by special privileged interests, Whigs argued that it should help cement unity and consensus.[27]

A letter written to the American Art-Union by Bingham's Whig friend Rollins in January of 1852 suggests that such typically Whig ideals might, in fact, have found expression in Bingham's *The County Election*. Rollins hoped the Art-Union would purchase the painting and reproduce it for distribution among its members, and his letter adopted the lofty yet persuasive tone of a campaign speech:

[*The County Election*] is preeminently a *National* painting, for it presents just such a scene, as you would meet with on the Arrostock in Maine, or in the city of New York, or on the Rio Grande in Texas, on an election day. . . . As a mere work of art . . . it is superb. But this is not the point of view in which its excellence is to be regarded. The elective franchise is the very cornerstone, upon which rests our governmental superstructure and as illustrative of our fine institutions, the power and influence which the ballot exerts over our happiness as a people, the subject of this painting was happily chosen. . . . From its character and style of execution, it would arrest the attention of every class of our population . . . and such a picture *engraved* would be equally

[*sic*] sought after, to decorate the walls of a palace or those of a log cabin![28]

Rollins's emphasis on the national character of *The County Election,* and on the painting's appeal to all regions and all classes seems to reflect specifically Whig attitudes about the role of national government and the fabric of American society.

Bingham's own concern with this typically Whig ideal of national unity is expressed in a letter to John Sartain, the engraver responsible for reproducing *The County Election.* Bingham wrote to Sartain on October 4, 1852, voicing his concern over a small but telling detail of the composition:

> The title of the newspaper in the extreme right-hand corner of the picture, I wish you to change, so as to have in the print 'The National Intelligencer' [a Washington, D.C., publication] instead of 'Missouri Republican' [the state's leading Whig paper]. There will be nothing to mar the *general character* of the work, which I design to be as *national* as possible—applicable alike to every Section of the Union, and as illustrative of the manners of a free people and free institutions. As far as you have an opportunity of doing so, you will much favour me by inculcating this idea of Nationality in reference to the subject.[29]

Bingham, then, wanted *The County Election,* although set in a generically Western town, to express the national character of American democratic institutions. And an examination of the painting's figural types and compositional organization illustrates that, in its character and style of execution, *The County Election* may indeed depict a typically Whig vision of national unity, of social harmony, of diverse classes and interest groups joined in common purpose.

Although the painting was well received by the majority of its contemporary audience, a good deal of modern anti-populist interpretation

has been supported by reading the painting's cast of characters in a negative light. Patricia Hills, for example, described the scene as "a social comment replete with drunkards and bums."[30] Yet, in 1853, a Kentucky newspaper reporter, instead of focusing on the painting's few unwholesome characters, noted

> those groups of sturdy old farmers who have come to town with a sense of their responsibility as citizens . . . how serious and honest and sensible they look, as they gravely discuss the affairs of the country and the questions of the day![31]

Perhaps the men in *The County Election* were not intended by Bingham nor perceived by his contemporaries to be as crude, ignorant, and generally unpleasant as modern eyes might perceive them. There is no doubt, however, that these figures did serve their mid-nineteenth-century audience as readily recognizable and often humorous types; many commentators took evident delight in listing and describing the characters and their roles in this election tableau.[32]

The cast of *The County Election* does indeed run the gamut of social types; every stratum of male society seems to be represented, from top-hatted gentlemen and shirtsleeved laborers to voteless children and black men. With few exceptions, Bingham's figures are essentially respectable in their dress and demeanor, and they interact over class lines. A well-dressed gentleman, for example, holds the aforementioned newspaper, a similarly clothed figure by his side, while a roughly clad rustic, dressed in brown with his back to the viewer, completes the tightly composed group.

The artist appears to have deliberately broadened the scope of his assorted but well-behaved voters to include not just a range of social classes, but of special interest groups as well. The red-haired man in the bright red shirt who stands at the top of the courthouse steps—the only man in the painting who actually votes—was identified by at least one contemporary ob-

server as an Irishman, and his stereotypical pug nose and carrot hair support this identification.[33] The Irish, often the target of nativist prejudice and caricature, as a painting dated *c.* 1850 illustrates, were a sizable group of voters in Missouri as elsewhere at the time. Their votes were vigorously courted by both major parties, although usually won by the Democrats.

Articles in the *Missouri Republican* provide evidence of heated battles for Irish votes in several Missouri elections in the late 1840s and early 1850s. A tribute to loyal Irish Whigs printed in that newspaper on April 4, 1849, for example, illustrates the kind of rhetoric employed to flatter such voters and keep them within the Whig fold:

> [The voting] was done boldly, manfully and in defiance of the efforts of political demagogues to drive [the Irish] from the independent exercise of their right to choose who should rule over them. No sneers, no jibes, nor violent denunciations, could deter them from doing their duty . . . and we honor them for their independence.

Bingham's Irishman holds the place of honor in *The County Election* and, although roughly dressed, is treated with a dignity obviously lacking in his wildly gesticulating countryman. He holds his hat respectfully in his hand and seems to be taking the exercise of his vote seriously, as a good American should. This figure appears to reflect an attitude toward immigrants analogous to what Brown has described as the "traditional position of most Whigs, that the immigrant could be assimilated into American society through education and moral suasion."[34]

A few steps to the Irishman's left an ancient citizen with a white beard, identified in a preliminary drawing as the archetypal Revolutionary War veteran "Old '76," totters down the stairs, apparently having just cast his vote. "Old '76," was a stock character of the time (see, for instance, Richard Caton Woodville's *Old '76 and Young '48,* 1849) and either party would have

been happy to claim the loyalty of such a rare, respected, and patriotic citizen. Thus, the newly assimilated immigrant and the relic of the American War of Independence both appear on Bingham's varied roster of voters, next to the sturdy farmers and educated gentlemen, all of whom allow their neighbors to vote in peace, with no evidence of "sneers, jibes, or violent denunciations."[35]

There does seem to be a telling exception to Bingham's inclusiveness, however. The artist apparently chose not to mingle his well-known riverboatmen or fur trappers (at least none in distinctive costume) with his more settled and respectable townsmen.[36] Evidently such transients were not particularly welcome at the polls, and their presence on election days was often noted with displeasure. The *St. Louis Tri-Weekly Union,* for example, commented on November 7, 1848, that "an unusual number of river-men voted at [the poll in the third ward]—many of whom, to say the least, had a doubtful right to vote in Missouri . . ." In the days before strict voter registration, illegitimate votes were used to pack the polls, a serious problem of which Bingham was well aware.[37] Had he wished to make a pointed comment about corrupt and unregulated voting activity, the artist could have included some easily identifiable boatmen among the ranks of small town citizens.

Still, a cider barrel located in the lower left of the painting and the hearty drinker by its side do remind the viewer of the less than ideal aspects of American electoral behavior. Alcohol played a major role in election day activities in Missouri as elsewhere in the country at the time and, of course, for a long time thereafter; kegs of whiskey were provided by Missouri politicians to intensify partisan spirit.[38] An election scene claiming to take place in a frontier town (or, for that matter, anywhere in the United States in 1851) without some reference to drink would have been entirely unrealistic. The degree of association between exercising the right to vote

and getting drunk while doing so is graphically illustrated by the fact that in March of 1851 the city of St. Louis felt compelled to amend its charter to rule that "no election shall be held in a grog-shop, or any other place where intoxicating liquors are vended."[39]

Yet the majority of men in Bingham's painting are much more intent on and excited by political discussion and the voting process (which takes place in front of a courthouse, not in a bar or grog-shop) than they are on drinking. Whigs were, on the whole, much more involved with temperance reform at the time than were Democrats; it seems that Bingham himself did not drink.[40] Edward Pessen reports that "the Whig voters were apt to be relatively disinterested in liquor," and he asks "could this explain the heavier emphasis by Democratic campaigners on the free dispensation of large quantities of the stuff?"[41] For even if it is a Whig cider barrel which provides refreshment at the scene, the salient point is that very few of Bingham's voters pay any attention to it. It is, of course, impossible to determine the partisan sympathies of Bingham's characters, but perhaps they suggested to the artist a temperance more generally associated with Whigs than Democrats.

Only three figures in the entire composition can be associated unequivocally with drunkenness: the portly man on the far left; the man in the left middleground passed out in the arms of a campaign worker; and the bandaged figure slumped on the bench on the far right. This trio serves, in effect, as a subtle temperance warning, a warning which obviously transcends class lines. The man so heartily imbibing on the left is, after all, comfortably well dressed and well fed. His rosy-cheeked joviality and expansive gesture contrast markedly with the abject desolation of the bowed figure on the right who recuperates from what must have been an alcohol-fueled fight. Bingham does not seem to point a finger at an ill-mannered and drunken lower-class rabble, but rather appears to suggest that over-indulgence, whatever a man's social station, impairs his judgment as a citizen (witness the totally insensate figure in the middle) and may lead to such complete degradation as characterized by the man on the right.[42]

Election violence, as personified by this battered citizen, seems, like drunkenness, to have been openly acknowledged by the artist as an election day reality but not exploited or emphasized for satirical or harshly critical effect. Pessen notes that in mid-nineteenth-century America "members of opposing political parties . . . attacked one another brutally on election days, both in the city and countryside."[43] The constant threat of election-related violence in Bingham's immediate time and place is suggested by a newspaper account of an incident which occurred at a political rally in central Missouri in 1849. A citizen, accused of brandishing a six-barreled pistol, denied "that he carried any such naughty weapon . . . He had, it is true, a single-barreled pistol, designed to be used against any person who might attack *him*."[44] This is not to imply that violent behavior inevitably broke out at every polling place, or that it would have been impossible for Bingham to witness a peaceful election day. What is clear, however, is that he could have presented, had he so chosen, a much more disorderly and no less realistic view of Missouri elections than the overwhelmingly peaceful one depicted in the painting.

The County Election's two flanking foreground characters of drinker and fighter serve as thematic pendants, isolated from, yet enclosing, the central multi-figured composition and linked as well to the equally uninvolved but more innocent pair of boys playing in the foreground. They symbolically suggest the comedy and tragedy inherent in political battles, reminding the viewer of the often discordant reality of election activity, just as the faintly realized background figures offer a subtle note of unsuppressed excitement. Yet between these two figures and the background crowd, men congregate in a care-

fully balanced and composed world of sincere but restrained political discussion.

This classically ordered central group, aptly described by Maurice Bloch as a "chain of communication,"[45] forms the thematic as well as visual core of the painting. A Philadelphia critic, writing in 1854, observed that

> the chief group occupies nearly the center of the picture, and imparting the title to the work contains the major interest and action, while other subordinate assemblages contributing to the life and character, glide naturally into the ruling current of thought and purpose.[46]

Any break in this "ruling current of thought and purpose" is caused not by the voters but by unscrupulous politicians. A campaign worker on the courthouse steps tips his black top hat ingratiatingly, endeavoring to influence the vote of a rustic citizen who, significantly, makes no move to take the proffered ticket from the politician's hand. Another of the party faithful, also in a black stovepipe, struggles to drag a drunkard to the polls, a man who, without this questionable aid, would probably have had sense enough to sleep off his intoxication under a tree.[47]

Bingham had no patience for political hacks, self-serving men motivated solely by greed for power. In November of 1853 he wrote to Rollins:

> [I]t will be a glorious time for the country when the present day party organizations shall be broken up entirely. We need not expect until then to have a revival of the good old times, when honesty and capacity, rather than party servility, will be the qualifications for office.[48]

Once again, Bingham's words describe what can be identified as a basic Whig tenet. As Brown observed,

> [T]o the Whigs, the worst features of Jacksonian party politics were personified in the figure of the politician . . . pliant, manipulative and devious, he had no concern for the public good . . .

> [H]e was willing to do or advocate anything . . . if it promoted the welfare of the party.[49]

The orator in *Stump Speaking* of 1853–1854, described by the artist as a man "grown gray in the pursuit of office and the service of party," is another example of this breed of politician.[50] The fiery nature of the stump speaker's rhetoric and the corresponding wildness in his eyes is even more apparent in the preliminary drawing than in the painting. The toadying politicos in *The County Election* coupled with this ruthless demagogue present a less than flattering picture of the American politician. Such politicians— rather than any motley assortment of voters— must have represented to Bingham the truly contemptible aspect of American politics.

In fact, just before he began work on the first version of *The County Election,* Bingham was profoundly disturbed by political maneuvering on the part of some Whig leaders in Missouri. In Bingham's mind these men compromised Whig principles on the issue of slavery in order to hurt their long-time Democratic rival Senator Thomas Hart Benton and advance their own political careers.[51]

Bingham wrote to Rollins in November of 1851, while still at work on *The County Election,* of his hopes for the redemption and future unity of the Whig party. Redemption was possible only if, Bingham said, "the great mass of Whigs throughout the state will fearlessly express their views . . . and faithfully stand up to them."[52] Here again, the artist voiced his belief that the majority of voters would make the morally correct decision and set their errant leaders straight.

But the problems facing Bingham and his party at the time were far more serious than those caused by local political quarrels. Disputes over slavery grew increasingly divisive in the late 1840s and by the time Bingham painted *The County Election*—a scene, perhaps, of idealized cooperation—not only the Whigs but also the

nation itself were showing signs of disintegration. In 1849 the Missouri legislature passed the inflammatory Jackson Resolutions, which denied the federal government power to interfere with the establishment of slavery in the territories. In 1850 Bingham, as a member of the state legislature, called for their repeal and proposed instead the so-called Bingham Resolutions, a compromise which gave the federal government the authority to rule on slavery in the territories while recommending that it not do so.[53]

Such a conciliatory but fundamentally unrealistic suggestion implies that Bingham felt an overwhelming need to find and maintain national equilibrium at a time of dangerous imbalance, a desire for compromise completely in keeping with orthodox Whig concerns. As Brown wrote: "Many Whigs tried to respond to the territorial question in a manner consistent with the party's ideal of consensus."[54] Perhaps Bingham's *The County Election* served as a visual expression of this desire, an artistic counterpart to his compromise resolution.

Groseclose was the first to suggest that the contemporary political situation in Missouri affected Bingham enough to find expression in the painting. "Viewed in the light of its local political perspective," she wrote, "the undertones of ridicule in *The County Election* become more comprehensible."[55] I would argue, however, that the painting's undertones are not of ridicule but of praise. The artist, at work on *The County Election* at a time of crisis for himself and his party, may have seen the painting, at least on a private level, as the visual embodiment of his political hopes: Whig voters of all classes withstanding the wiles of self-serving politicians of either party and voting as true Whigs should, upholding the Whig ideal of peaceful compromise.

The County Election appears to be an earlier and less explicit example of the kind of personal commentary evident in Bingham's *The Verdict of the People,* 1854–1855, the final painting in the Election Series. Groseclose has convincingly ar-

gued that *The Verdict of the People,* begun in April, 1854, and completed in the late spring of 1855, sounds a somewhat veiled plea for "freedom for Kansas" at a time when the controversy over slavery ignited the violent border wars between Kansas, Nebraska, and Missouri.[56]

The Verdict of the People takes on a certain poignancy when viewed in light of the volatile spirit of the times, for Bingham was well aware of the gravity of recent events. He wrote to Rollins in late May of 1854, when the controversial Kansas-Nebraska Act—an inexorable step on the road to civil war—was passed after five months of debate: "The deed is done, and a storm is now brewing . . . which will sweep onward with a fury, which no human force can withstand."[57]

The painting, however, is an optimistic vision of almost universal celebration, produced at a time when the artist was anything but sanguine about the future of his country. Both *The Verdict of the People* and *The County Election,* when seen in relation to Bingham's dissatisfaction with current political events, can be viewed on the most profound level as utopian dreams rather than contemporary realities.

An awareness of Bingham's desire for national stability, of his hope for the renewed strength and moral courage of his party, and of his tenacious belief in the power of the people to direct their leaders, all in the face of growing disillusionment and doubt, enriches *The County Election* (like the later *The Verdict of the People*) with a quixotic sense of mission, a touch of melancholy courage not readily apparent on its exuberant face. But, as the artist would have undoubtedly asserted, the painting was above all a national statement and, as such, its public message is, I believe, overwhelmingly positive and encouraging.

The County Election was conceived and executed by a man who was, at the time, as much a Whig as he was an artist; some of the former must have guided the latter. Indeed, a Whig

newspaper editorial published in 1843 can serve as an uncannily evocative description and summary, not only of the character and demeanor of the vast majority of citizens in *The County Election,* but also of the painting's carefully orchestrated figural composition. The editorial also parallels Bingham's own feelings about unscrupulous politicians, and about the ability of the people to withstand their wiles:

[R]eckless partisans . . . are ever ready to arouse the feelings and prejudices of one class of the community against another, although all intelligent men know that the protection and prosperity of each particular class is necessary for the advancement of the whole and to the preservation of a sound and healthy action of government. Calmness and moderation in thought and action are indispensable to a well-regulated society. However each particular interest may differ, a general harmony, in all the component parts, is requisite to complete the order of the whole.[58]

Bingham's own commitment to what Brown has termed "the core values of Whiggery: moderation, self-restraint, rational persuasion, and a positive passion for the common good"[59] is echoed in the figures and forms of *The County Election.* The work is a vision of harmony conceived by an ardently involved citizen at a time when his country's social fabric was fraying badly. The painting, it would seem, presents an idealized Whig affirmation of egalitarianism rather than a protest against it and is a tribute to, rather than a mockery of, the participation of the American people in their government.

NOTES

Revised by the author from the *American Art Journal,* vol. 19, no. 4. Reprinted by permission of the author.

1. L. Maria Child, "Home and Politics," *The Union Magazine,* vol. III (July, 1848), p. 66.
2. The print was published in *Harper's Weekly,* November 7, 1857, p. 712.
3. For a discussion of genre paintings with political themes, many dealing with elections, see Barbara S. Groseclose, "Politics and American genre painting of the nineteenth century," *The Magazine Antiques,* vol. CXX (November, 1981), pp. 1210–17.
4. A recently published textbook of American history, for instance, called the paintings in Bingham's Election Series "perhaps the best artistic representations of Jacksonian politics in action." Robert A. Divine, *et al., America Past and Present, Volume I: to 1877* (Glenview, Illinois, and London, 1984), between pp. 288–89.

The paintings executed by Bingham which deal with electoral politics (excluding political banners) are: *The Stump Orator,* 1847 (present whereabouts unknown); *Country Politician,* 1849, Fine Arts Museums of San Francisco; *The County Election* (version one), 1851–1852, Saint Louis Art Museum, St. Louis, Missouri; *The County Election* (version two), 1852, Boatmen's National Bank of St. Louis, St. Louis, Missouri; *Canvassing for a Vote* or *Candidate Electioneering,* 1851–1852, Nelson-Atkins Museum of Art, Kansas City, Missouri; *Stump Speaking* or *The County Canvass,* 1853–1854, Boatmen's National Bank of St. Louis, St. Louis, Missouri; *The Verdict of the People* (version one) or *Announcement of the Result of the Election,* 1854–1855, Boatmen's National Bank of St. Louis, St. Louis, Missouri; *The Verdict of the People* (version two), after 1855, R. W. Norton Art Gallery, Shreveport, Louisiana.

The most important and thorough discussions of Bingham's life and art are: E. Maurice Bloch, *George Caleb Bingham: The Evolution of an Artist* (Berkeley and Los Angeles, 1967); Bloch, *The Paintings of George Caleb Bingham: A Catalogue Raisonné* (Columbia, Missouri, 1986); and James F. McDermott, *George Caleb Bingham: River Portraitist* (Norman, Oklahoma, 1959).

5. Bingham produced two versions of *The County Election*, probably, as Bloch suggests, because he needed a replica of the work to take with him on his travels through Missouri and neighboring states in search of subscribers for an engraving after the painting. The first version was painted between August, 1851, and February, 1852; the second between mid-August and October of 1852. The painting reproduced in Figure 1 is accepted as the second version, and is the composition which corresponds with the engraving executed by John Sartain of Philadelphia from August, 1852, until 1854. It is also the version which accompanied Bingham on his travels and which he sold in Kentucky in 1853. I am basing the present study of *The County Election* on the second version of the painting because it was Bingham's final and more considered presentation of the subject, the one publicly known through exhibitions and the engraving, and the work on which most contemporary reviewers and commentators based their discussions.

6. Bingham was a member of the Whig party and in 1848 was elected to the Missouri state legislature where he served one term. He was also a delegate to several Whig national conventions, and acted as State Treasurer of Missouri from 1862 until 1865. For a discussion of the artist's political activities, see Keith L. Bryant, "George Caleb Bingham, The Artist as Whig Politician," *Missouri Historical Review*, vol. LIX (July, 1965), pp. 448–63.

The traditional view of the series was summed up in a recent survey of American art, in which Milton W. Brown characterized the paintings as "an expression of [the artist's] faith in the democratic process at its grass roots. He avoided any serious consideration of issues and, instead, recorded with good-humored raillery the human aspect of the political process." Milton W. Brown, *et al., American Art* (New York, 1979), p. 224.

The documentary nature of the series has been emphasized by both John Demos, "George Caleb Bingham: The Artist as Social Historian," *American Quarterly*, vol. XVII (Summer, 1965), pp. 218–28; and George Ehrlich, "George Caleb Bingham as ethnographer: a variant view of his genre works," *American Studies*, vol. XIX (Fall, 1978), pp. 41–55.

Robert F. Westervelt dealt primarily with *The County Election* (also the focus of the present discussion) in his article, "The Whig Painter of Missouri," *American Art Journal*, vol. II (Spring, 1970), pp. 46–53.

7. Barbara S. Groseclose, "Painting, Politics and George Caleb Bingham," *American Art Journal*, vol. X (November, 1978), pp. 5–19.

8. Groseclose, "Politics and American genre painting of the nineteenth century," p. 1212.

9. Patricia Hills, for instance, supported Westervelt's reading in her study of American genre painting, *The Painter's America: Rural and Urban Life, 1810–1910* (New York and Washington, D.C., 1974). Edward J. Nygren, in a catalogue entry for John Sartain's engraving of *The County Election* which appeared in the exhibition catalogue entitled *Of Time and Place: American Figurative Art from the Corcoran Gallery*, also found Westervelt's argument "convincing" (Washington, D.C., 1981). William H. Truettner described *The County Election* as an "election scene that mocks the democratic process" in his article "The Art of History: American Exploration and Discovery Scenes, 1840–1860," *American Art Journal*, vol. XIV (Winter, 1982), p. 19. And the authors of *America Past and Present*, the textbook cited earlier, stated that "Bingham was a conservative Whig bent on satirizing the excesses of democratic politics" (Divine, *et al.,* between pp. 288–89).

10. Bingham to Rollins, February 21, 1841. "The Letters of George Caleb Bingham to Major James S. Rollins," *Missouri Historical Review*, vol. XXXII (October, 1937), p. 11. The letters which Bingham wrote to Rollins are in the collection of the State Historical Society of Missouri, Columbia. They were edited by Rollins's son C. B. Rollins, and those from 1837 to 1861 were published in the *Missouri Historical Review*, vol. XXXII (October, 1937), pp. 3–34; January, 1938, pp. 164–202; April, 1938, pp. 340–77; and July, 1938, pp. 484–522. References to these published letters will hereafter be cited as "Letters," *Missouri Historical Review*, vol. XXXII.

11. Thomas Brown. *Politics and Statesmanship: Essays on the American Whig Party* (New York, 1985), pp. 215–16. I will address Bingham's personal

attitude toward politicians at a later point in this article.

12. Bingham to Rollins, February 21, 1841, "Letters," *Missouri Historical Review,* vol. XXXII (October, 1937), pp. 11–12. Also in this letter, Bingham described newly elected President Harrison as "the president of the people" in a context which leaves no doubt as to the positive connotations of the title.

13. Westervelt, p. 48. Groseclose, "Painting, Politics and George Caleb Bingham," p. 5.

14. For a detailed discussion of Bingham's candidacy, see McDermott, p. 63, and Bryant, pp. 454–55.

15. *Columbia, Missouri Statesman,* October 2, 1846. Quoted in McDermott, p. 63.

16. Bingham addressed the Missouri House of Representatives on December 17, 1846; his speech was reported in the *Missouri Statesman.* Quoted in Bryant, p. 454.

17. Robert E. Shalhope, "Eugene Genovese, the Missouri Elite and Civil War Historiography," *Bulletin, Missouri Historical Society,* vol. XXVI (July, 1970), p. 278.

18. For Bingham's voting record, see Bryant, p. 456. For Missouri voting requirements and a description of the practice of *viva voce* voting (voting by voice in public, depicted in *The County Election*), see Frances Lea McCurdy, *Stump, Bar and Pulpit: Speechmaking on the Missouri Frontier* (Columbia, Missouri, 1969), pp. 73, 77, 93. Bingham's support of the popular election of judges seems to contradict Hills's suggestion (based on Westervelt's interpretation) that "the emphasis on unattractive types [in *The County Election*] may be a subtle indictment of the new laws which extended the franchise to the propertyless classes." Hills, p. 53.

19. *The County Election, Canvassing for a Vote, Stump Speaking,* and *The Verdict of the People* were all produced as prints: *The County Election* as an engraving by John Sartain in 1852–1854; *Canvassing for a Vote* as a lithograph by Claude Régnier in 1853; *Stump Speaking* as an engraving by Louis Adolphe Goutier, published in 1856; and *The Verdict of the People* as a lithograph (of which only two proofs are known to exist) by a German printer in 1858. See Bloch, *Catalogue Raisonné.*

20. *Louisville, Kentucky Daily Courier,* May 18, 1853. Quoted in McDermott, p. 99.

21. For a comparison of the economic and social organization of the two parties, see Edward Pessen, *Jacksonian America: Society, Personality and Politics* (Homewood, Illinois, 1978), especially chapter 11, "Who Were the Democrats? Who Were the Whigs? The Major Party Differences Evaluated," pp. 233–60.

22. Perry McCandless, *A History of Missouri: Volume II, 1820 to 1860* (Columbia, Missouri, 1972), p. 125.

23. Calvin Colton, *Democracy.* Number VI of the "Junius" Tracts (New York, 1844). Published in Daniel Walker Howe, ed., *The American Whigs, An Anthology* (New York, 1973), p. 101. Colton was a leading Whig propagandist and theoretician.

24. "Locofoco" was the name initially given to a radical northeastern urban faction of the Democrats. Bingham, in his letters to Rollins, consistently referred to the opposition party by such epithets as "unscrupulous" and "illegitimate" Locofocos. See, for instance, Bingham to Rollins, February 21, 1841, and November 2, 1846. In fact, Bingham called himself a "true democrat" humorously but not sarcastically in another letter to Rollins, dated December 12, 1853 ("Letters," *Missouri Historical Review,* vol. XXXII [January, 1936], p. 170).

25. See Howe, pp. 3–4.

26. *Ibid.* p. 106.

27. Brown, p. 216.

28. Rollins to Andrew Warner, January 11, 1852. Quoted in Bloch, *Evolution of an Artist,* pp. 144–45. The Art-Union declined to purchase and reproduce the painting, citing as an obstacle the amount of time and money it would have taken to engrave such a complex composition. Bloch, p. 140.

29. Bingham to Sartain, October 4, 1852. Published in George R. Brooks, "George Caleb Bingham and 'The County Election'," *Bulletin, Missouri Historical Society,* vol. XXI (October, 1964), p. 39.

30. Hills, p. 53.

31. *Louisville, Kentucky Daily Times,* April 6, 1853. Quoted in McDermott, p. 98. It must be acknowledged that at least one citizen of Louisville was displeased with the painting, condemning it as a defamation of one of America's most valuable institutions because of its "miserable loafers" and generally unrefined types. Letter signed "Common Weal," *Louisville, Kentucky Statesman,* May 24, 1853, quoted in McDermott, pp. 99–100. Westervelt used this letter to support his nega-

tive interpretation of *The County Election,* believing that most other contemporary viewers were blind to the subtlety of Bingham's irony (Westervelt, p. 46). I would suggest, instead, that "Common Weal's" critical reaction was due not to his unusually perceptive insight into the artist's "real" message, but more likely stemmed from that writer's own patrician bias. It is a little perverse to argue for a satirical reading of *The County Election* based on the evidence of one aberrant opinion, rather than to use the typically positive contemporary reactions as a guide.

32. See, for instance, a description which appeared in the *Columbia, Missouri Statesman* on October 31, 1851, quoted in Bloch, *Evolution of an Artist,* p. 144; another which was published in the *St. Louis Evening Intelligencer* in December, 1851, quoted in McDermott, p. 92; and one which appeared in the *Louisville Daily Times* on April 6, 1853, quoted in McDermott, pp. 97–98.

33. The figure is identified as Irish in an article published in the *Columbia, Missouri Statesman* on October 31, 1851. Quoted in McDermott, p. 91. Historian Dale T. Knobel described a "short, full figure" as characteristic of the popular idea of "Paddy" in America, and called "coarse, red hair . . . standard in the Irish stereotype. . . ." *Paddy and the Republic: Ethnicity and Nationality in Antebellum America* (Middletown, Connecticut, 1986), p. 123. Bingham's character clearly sports the red hair, short, full figure, and upturned nose of this Irish stereotype.

34. Brown, p. 221.

35. The relationship of the Irishman and "Old '76" suggests that Bingham recognized the rapid changes occurring in the character of American society due to recent immigration. "Old '76," perhaps symbolic of traditional Yankee America, is obviously on his last legs as he moves off the stage of national government, headed against the tide of a younger and more diverse America. Such a pictorial comment need not automatically be construed as negative; peaceful assimilation of immigrants was, as we have seen, a Whig goal.

36. None of the contemporary descriptions mentioned above or listed in note 31 identifies any of the figures as boatmen or trappers. Demos noted that Bingham rarely showed townsmen and boatmen mingling in his paintings, claiming that "it is impossible to identify any boatmen in Bingham's political paintings." Demos

saw this segregation as reflective of the actual separation of town and river cultures in Missouri at the time. (Demos, p. 224.) I suggest that it might be a more deliberate and meaningful segregation on the artist's part.

37. Bingham refers to this problem in a letter to Rollins dated November 2, 1846, "Letters," *Missouri Historical Review,* vol. XXXII (October, 1937), p. 16.

38. The vessel in the painting was identified by Bingham as a cider barrel in a letter to Rollins, December 12, 1852, "Letters," *Missouri Historical Review,* vol. XXXII (January, 1938), p. 171. The cider barrel was a well-known Whig party symbol, a legacy of the Log Cabin-Hard Cider campaign of 1840. See Groseclose, "Painting, Politics and George Caleb Bingham," p. 8. For a discussion of the distribution of alcohol on election days, see Pessen, *Jacksonian America,* p. 241; and Mark Edward Lender and James Kirby Martin, *Drinking in America: A History* (New York, 1982), pp. 54–56.

39. This amendment was reported in the *St. Louis, Missouri Republican,* April 1, 1851.

40. Bingham mentions his abstinence in a letter to Rollins. November 2, 1846, "Letters," *Missouri Historical Review,* vol. XXXII (October, 1937), pp. 14–15.

41. Pessen, *Jacksonian America,* p. 241.

42. This sequence follows the characteristic route of a man ruined by drink as described in the popular temperance warnings of the day. See, for example, the articles entitled "Steps to Ruin" published with illustrations by T. H. Matteson in *The Union Magazine* (Philadelphia), November, 1847.

43. Pessen, *Jacksonian America,* p. 12. See also McCurdy, p. 241. For graphic illustrations of such behavior, see both figures 2 and 3.

44. *St. Louis, Missouri Republican,* November 2, 1849.

45. Bloch, *Evolution of an Artist,* p. 151.

46. *Philadelphia Register,* September 7, 1854. Quoted in Bloch, *Evolution of an Artist,* p. 147. The inherently restrained and well-ordered nature of *The County Election* is underscored when the painting is compared to one of its visual sources. Bloch notes (p. 148) that "the political subject would have inevitably drawn [Bingham] to the series of election subjects by William Hogarth—in this case to an engraving in reverse of 'Canvassing for Votes,' from which Bingham apparently took over the stagelike architectural back-

ground, to say nothing of such motifs as the refreshment-stand in the left foreground, the seated drinker, and the group of three figures at center (at right in *The County Election*)." Although Bingham is certainly indebted to Hogarth (among other sources) for individual motifs, his view of electoral behavior is less jaundiced and pointedly satirical.

47. These men were identified as campaign workers in, for example, *Columbia, Missouri Statesman,* October 31, 1851, quoted in McDermott, p. 91; and the *Lousiville, Kentucky Daily Times,* April 6, 1853, quoted in McDermott, p. 98.

48. Bingham to Rollins, November 23, 1853, "Letters," *Missouri Historical Review,* vol. XXXII (January, 1938), p. 169.

49. Brown, p. 8.

50. Bingham to Rollins, December 12, 1853, "Letters," *Missouri Historical Review,* vol. XXXII (January, 1938), p. 170.

51. See Groseclose, "Painting, Politics and George Caleb Bingham," pp. 7–8, for a complete discussion of this situation.

52. Bingham to Rollins, November 24, 1851, "Letters," *Missouri Historical Review,* vol. XXXII (October, 1937), p. 23.

53. Groseclose, "Painting, Politics and George Caleb Bingham," p. 7.

54. Brown, p. 220. Eighteen fifty was a year of compromise for the nation as a whole. The Whig senator Henry Clay, for instance, presented eight resolutions to the Senate which he felt contained a comprehensive solution to the territorial problems facing the Union. The Compromise of 1850, based on Whig ideals of consensus, was passed, after many adjustments, but was so evasive that it did little to assuage the country's difficulties. See Brown, pp. 149–53.

55. Groseclose, p. 8.

56. *Ibid.,* pp. 13–14.

57. Bingham to Rollins, May 29, 1854, "Letters," *Missouri Historical Review,* vol. XXXII (January, 1938), p. 185.

58. *Jackson, Mississippi Southron,* April 26, 1843. Quoted in Brown, p. 216.

59. Brown, p. 10.

6

Two Sculptures for the Capitol

Horatio Greenough's Rescue *and*
Luigi Persico's Discovery of America

VIVIEN GREEN FRYD

The consequence of belief in America's "manifest destiny" to expand the nation westward—spreading democracy, Christianity, and civilization across the continent—has become a major theme of revisionist histories of the nineteenth century. In her study of the production and reception of two statues designed to ornament the nation's capitol, Vivien Fryd examines the use of public sculpture as a vehicle to convey, and to justify, official government policies that sanctioned the seizure of Western lands and the containment of the Native American population.

Focusing on themes that captivated the American imagination, such as the "discovery" of the New World and the subsequent conflict between "civilization" and "savagery," Fryd explains this pairing of an enlightened Columbus with a heroic American pioneer as a powerful endorsement of expansionist ideology. Through the posture of the American Indians within these sculptural groupings, which employ an unmistakable rhetoric of domination and triumph, awestruck reverence for Columbus is contrasted with savage brutality brought under control as a righteous settler defends his family and, by extension, the legitimacy of his predecessors' claims.

Horatio Greenough's *Rescue* [1] and Luigi Persico's *Discovery of America* [2], once promi-nently situated on the main staircase of the United States Capitol, created controversy even in their own day. Both the *Discovery* and the *Rescue* were intimately tied up with the ideas of America as a nation and its attitudes toward the Indian, and were the objects of considerable thought and debate in the press. By the twentieth century, the criticism had become intense. As early as 1939 a joint resolution submitted to, but not passed by, the House recommended that the *Rescue* be "ground into dust, and scattered to the four winds, that no more remembrance may be perpetuated of our barbaric past, and that it may not be a constant reminder to our American In-dian citizens. . . ."[1] Two years later, the House considered a joint resolution that suggested, "the group [the *Rescue*] now disgracing the entrance to the Capitol . . ." be replaced with "a statue of one of the great Indian leaders famous in Ameri-can history. . . ."[2] In 1952, the California Indian Rights Association objected to the racist imagery of both the *Discovery* and the *Rescue*.[3] Addi-tional correspondence from this and other Indian groups to various Congressmen and to the archi-tect of the Capitol demanded the removal of these two works.[4] In 1958, the federal govern-ment removed the sculptural decoration from the

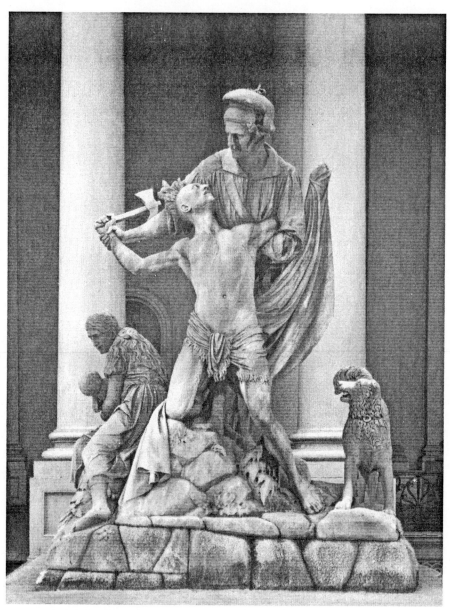

1. Horatio Greenough, *Rescue,* 1836–1853; courtesy of the Architect of the Capitol.

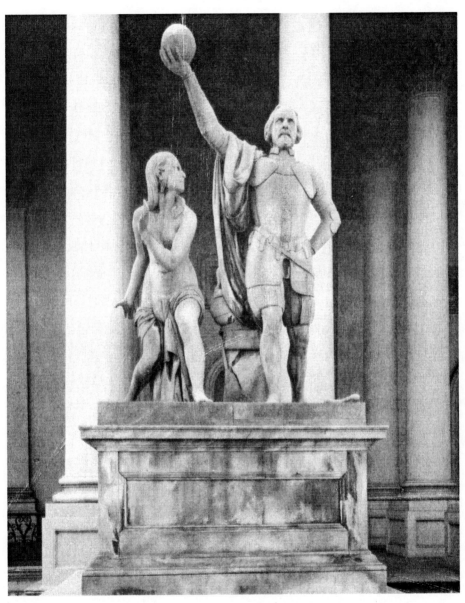

2. Luigi Persico, *Discovery of America*, 1836–1844; courtesy of the Architect of the Capitol.

east facade of the United States Capitol in preparation for the building's extension. Nearly all the works were replaced by duplicates, thereby preserving the originals from further deterioration, but Persico's *Discovery of America* and Greenough's *Rescue* were never reinstalled on the left and right sides of the main staircase. One letter of protest, published in the October, 1959, issue of *Harper's* magazine, included a cartoon of an Indian who proudly struts away from two piles of stone identified by markers as "The Discovery" and "The Rescue".[5] Holding a hammer over his shoulder and a sign inscribed "The End," this Indian, characterized as such by a feathered headdress, has destroyed the two objectionable statues. Ironically, in 1976 a crane accidentally dropped Greenough's *Rescue* while moving the statue to a new storage area; the work now exists in fragments in a Smithsonian storage facility in Maryland. Consequently, as the 1939 House resolution had first suggested, and as the *Harper's* cartoon had predicted, the *Rescue* was nearly "ground into dust," Persico's *Discovery of America* is also in poor condition and in storage beside the *Rescue.*

In the nineteenth century, however, the statues embodied attitudes shared by most white Americans toward the Indians. More specifically, the *Discovery of America* reflects the United States' fascination with earlier explorations which paralleled recent westward expansion. The *Rescue,* on the other hand, relates to an established thematic tradition of captivity in American art and literature. By relating the *Rescue* to this captivity genre, it will be demonstrated that Greenough reversed the standard image, and that the inversion of the captivity convention assumes an official appropriateness which seems to have condoned the acquisition of western lands and the federal government's policy toward Indians.

Proposals for sculptural decoration of the left and right sides of the Capitol's main staircase first arose on April 28, 1836, when James Buchanan. Democratic Senator from Pennsylvania and later fifteenth President of the United States, recommended that Congress order from Luigi Persico two groups for the eastern entrance.[6] Luigi Persico (1791–1860), a native of Naples who emigrated to America in 1818, moved to Washington, D.C., in 1825 where he established himself as a sculptor. Persico already had completed three monuments for the United States Capitol's east facade: the *Genius of America* (1825–1828) located in the central pediment of the building, and two single figures, *War* and *Peace* (1829–1835), placed within the niches that flank the central doorway. In anticipation of another federal commission, the Italian sculptor had exhibited a model of the *Discovery* for Congressional inspection; it is this design which prompted Buchanan's recommendation.

Buchanan's proposal stimulated lively debate on the propriety of supporting foreign artists; William C. Preston and John C. Calhoun (both South Carolinians who had actively supported Hiram Powers during his brief residence in the capital city) objected to Congressional support of foreign artists, advocating instead that Americans receive federal patronage. Preston recommended Horatio Greenough (1805–1852), "a man of unquestioned genius; one calculated to do honor to his country, and whom his country should delight to honor."[7] Already involved with his colossal portrait of George Washington ordered by Congress in 1832 for the Capitol Rotunda. Greenough seemed the appropriate sculptor for the second staircase group (opinions would change when Congress would actually see the completed portrait in 1841). After much debate, the Senate passed a resolution on May 17, 1836, authorizing the president to:

> consult and advise with such artists of skill and reputation as he may think necessary and proper, with a view of procuring two marble statues, or groups of statues, to be placed upon the pedestals upon each side of the steps which form the front entrance to the Capitol: . . .[8]

On April 3, 1837, President Martin Van Buren authorized Persico to execute his design for the left side of the staircase, stipulating that the statue follow the artist's model in representing the discovery of America by Christopher Columbus.[9] Following the advice of some Congressmen, the President then asked Horatio Greenough to execute the second group.

When Greenough and Persico learned that their respective groups would be companion pieces, the two artists met in Florence first in 1839 to discuss the dimensions for the base and the figures, and again in 1840 to purchase marble.[10] Although the *Discovery* was installed in 1844, Greenough did not complete his group until 1850.[11] Three years later, after the death of Greenough, Robert Mills, architect of public buildings in Washington, D.C., assembled the *Rescue* before the Capitol's east facade, but not without some controversy.

Persico's *Discovery of America* represents, in the words of Buchanan:

> the great discoverer when he first bounded with ecstacy upon the shore, all his toils past, presenting a hemisphere to the astonished world, with the name America inscribed upon it. Whilst he is thus standing upon the shore, a female savage, with awe and wonder depicted in her countenance, is gazing upon him.[12]

A solid and muscular Columbus steps forward with his right leg, holding the globe aloft in his right hand while his left arm is akimbo. Swung over his left shoulder is a swag of drapery, an incongruous ancient motif added to Columbus's fifteenth-century dress. Beside Columbus and to his right crouches a female Indian who steps forward while twisting to gaze in wonder at the discoverer. This figure is nude except for a cloth wrapped around her upper thighs and lower hips.

During the 1840s and 1850s—a period of great westward expansion—the subject of Columbus's discovery of the New World was popular in American literature and art. Washington Irving's *The Voyages of Christopher Columbus,* written between 1826 and 1827 and first published in 1828, initiated this historical theme and often provided the source and inspiration for such painted and sculpted images as John Vanderlyn's *Landing of Columbus* (1837-47), Emanuel Leutze's *Columbus Before the Queen of Spain* (1857), and Randolph Rogers's Rotunda doors in the United States Capitol, which outline the events in the life of the discoverer.[13] The pervasiveness of this theme in the American consciousness is furthermore evident in an advertisement for tobacco of 1866 in which the composition resembles Persico's sculpture in that a kneeling Indian maiden greets Columbus.

The discovery of the New World, as the subject appeared in nineteenth-century American art, symbolized the nation's belief in the cyclical theory of world progress first formulated in eighteenth-century Europe.[14] According to this theory, civilization first emerged in the Orient where it declined and was superseded in the Occident. From Europe, civilization traveled to the New World, and spread from its eastern ports to the great plains over the mountains of the far west to the Pacific coast. There a passage opened to the Orient, bringing enlightenment back to its origins.

This overall view of world history served the American concept of manifest destiny formulated by the 1840s. At mid-century, American popular belief held that the nation enjoyed a divine right to disseminate democracy within its continental boundaries and even beyond, that it in fact had a preordained mission to carry civilization to unenlightened lands.[15] The concept of manifest destiny became the motivating explanation for America's westward expansion. For example, John L. O'Sullivan, editor of *The United States Magazine and Democratic Review* and originator of the term manifest destiny, argued in favor of Texas's annexation by explaining the nation should realize "our *manifest destiny* [italics

mine] to overspread the continent allotted by Providence...."[16]

As an official expression of expansionist ideology, the United States Congress rhetorically evoked manifest destiny to sanction war against Mexico in 1846 and to annex Texas in 1845, Oregon in 1846, and California in 1848. In 1846, Robert C. Winthrop, Representative of Massachusetts, was the first to utilize the term in Congress. Arguing in favor of Oregon's joint occupation, he maintained it was "the right of our manifest destiny to spread over this whole continent."[17]

During the debate on the Oregon issue, some Congressmen exploited Columbus's discovery of America as the prelude in a New World destiny to absorb lands and march westward, carrying the torch of civilization and completing the providential circle of progress from the west back to its origins, the east. For example, William Sawyer, a Democratic Representative from Ohio, defended Oregon's annexation:

> We have received it [title to the Oregon territory] from high Heaven—from destiny.... In the course of events, in the progress and consummation of this destiny, Christopher Columbus was sent across the ocean to examine this country.... By-and-by, our fathers followed and took possession; here they established the seat of empire; here they sowed the seeds of democracy.... Columbus ... [was] the agent Heaven employed to place us in possession.... This ... continent—was made and set apart for our especial benefit. We have a right to every inch of it....[18]

Whether Persico intended this broader cultural and historical ideology is unknown, even if Buchanan insisted the Italian was "devoted to the institutions of this country."[19] More significantly, some mid-century Americans interpreted the *Discovery of America* as a statement in support of America's western expansion. For example, *The United States Magazine and Democratic Review* published and commented on an analysis of Persico's statue found in the weekly journal, *The New World:*

> The artist has grouped the history of man.... the providential guidance which overruled his destiny.... and the beginning of an enterprise, whose results have changed the character and condition of the world.... In Columbus, there is an emotion which ... carries recollection along through the dark chambers of five centuries, placing us, as it were, face to face, with a common ancestor, distinguished beyond the men of his time, and foremost in the march of civilisation and Christianity. Even this generation ... has formed a fellowship with the man and his age; [urging] the American heart ... [to] expand in glowing homage to the discoverer of a Continent, designed as the experiment and perpetuation of free institutions.[20]

The anonymous *Democratic Review* writer added:

> Its main point is this—that Columbus is supposed to be looking towards Europe from the New World of which he has just consummated the discovery; and in that New World, from the Capitol of the great American Union, the spot which may be regarded as the most intense concentration, to a single point, of the whole idea of the destiny of the New Continent, both as to its own incalculable future and as to the reaction of its influence on the rest of the world.[21]

At least one Congressman used Persico's *Discovery* as proof of America's manifest destiny and mission in his argument for the acquisition of Texas in January of 1845. James E. Belser, a Democratic Representative from Alabama, stated:

> Since [the first navigators from the Old World discovered this continent] ... in the arrangements of Providence, Indian possession had gradually given way before the advances of civilization. And so it must ever be. Gentlemen might talk as they pleased about their devotion

to the thirteen original States—about prescribing limits to the American people. There were none—there could be none! They would go, and go, and still continue to go, until they reached the ultimate boundary which the God of nature had set to the progress of the human race. . . .

Let gentlemen look on those two figures which have so recently been erected on the eastern portico of this Capitol, and learn an instructive lesson. Gentlemen might laugh at the nudity of one of them; but the artist, when he made Columbus the superior of the Indian princess in every respect, knew what he was doing. And when he likewise placed the ball in his hand, he intended further to represent the power of civilization, and what were to be the effects of the discovery of that wonderful man. . . . Freedom's pure and heavenly light . . . would continue to burn, with increasing brightness, till it had illumined this entire continent. . . . It would go onward and onward; it would fill Oregon; it would fill Texas; it would pour like a cataract over the Rocky mountains, and, passing to the great lakes of the West, it would open the forests of that far distant wilderness to . . . the far shores of the Pacific.[22]

Congressman Belser's comments indicate the general belief that civilization's advance would inevitably result in Indian migration and ultimate extinction. He also stated, "We got their [Indian] possessions by the strong arm of power. We removed these tribes from their hunting-grounds, who did not cultivate the land, in order that we might accomplish the greatest amount of good to the human race."[23]

In this statement, Belser referred to the Indian Removal Act of 1830, which had forced the relocation of tribes from the eastern to the western side of the Mississippi River. Prior to this, the Trade and Intercourse Acts passed between 1790 and 1834 set aside and protected Indian lands in the east to prepare for the education, civilization, and assimilation of tribes into white society. However, the alliance between the various Indian tribes and the British during the War of 1812 con-

vinced many American officials that the two races could not peacefully co-exist. As a result, the Senate passed a bill during President Monroe's administration that called for the removal of Indians beyond the boundaries of the states. Although the President and the Senate supported the legislation, the House failed to pass the resolution. Because the next president, John Quincy Adams, opposed removal, Congress did not change Indian policy during his administration. However, President Andrew Jackson and his Secretary of War, Lewis Cass, strongly supported the concept of removal and encouraged Congress to pass such a bill. After much debate in both houses, on May 28, 1830, the President signed into law, "an act to provide for an exchange of lands with the Indians residing in any of the States or Territories, and for their removal West of the river Mississippi."[24] During the next fifteen years, tribes were relocated in the west along the 95th meridian which, by 1840, became the "permanent" Indian frontier.

Within this context, Persico's *Discovery of America* seems to condone the federal government's Indian removal policy in support of westward expansion. In this group, Persico dramatized the first meeting between the Indian and the white man, savagery and civilization, heathenism and Christianity, wilderness and cultivation. Columbus stands triumphantly over the Indian who cowers in awe and fear. This is not an illustration of possible assimilation, but the representation of domination: the Indian must yield to civilization.

Discovery's companion, *Rescue,* once located on the right side of the steps, reiterated civilization's triumph over the Indian in its westward march. If *Discovery* elucidated the first meeting between discoverer and Indian, *Rescue* epitomized the result of this contact in subsequent settlement of the land. *Rescue* was an eclectic group sculpture inspired by classical art. Specifically, the Indian's pose and tilted head loosely resembled the main figure in the *Laocoön* (Vati-

can Museums, 1st century B.C.), a work praised by such eighteenth-century antiquarians as Winckelmann and Lessing.[25] Both applauded the *Laocoön*'s expression of extreme suffering, delighting in the swelling and dilating nostrils, the pressed eyebrows, the sunken upper lip, and the sorrowful mouth. Greenough's Indian, however, did not display the same extreme emotion as the *Laocoön,* although he was surprised and awestruck by the pioneer's strength and restraining power. The native's body was also considerably less muscular than that of the *Laocoön.* Behind the warrior stood a seemingly enormous settler spectacularly costumed as the liberating conqueror who restrained the nearly naked Indian in order to protect his family, the wife and child to the left. Balancing this group on the right was a single dog who barked at this dramatic struggle.

Shortly after Robert Mills assembled the *Rescue* group, some individuals asserted that he had not re-created accurately Greenough's intended composition. For instance, speaking on behalf of the sculptor's family, Edward G. Loring objected:

> In Horatio Greenough's group of the Backwoodsman and Indian, the mother and child are placed on the wrong side, thus the artist's conception is prevented from expression. As he [Greenough] told the story—the mother and child were before the Indian and she in her maternal instinct was shielding her child from his grasp, to prevent which the husband seizes back arms of the Indian, and bears him down at the same time—so the group told its story of the peril of the American wilderness, the ferocity of our Indians, the superiority of the white-man, and why and how civilization crowded the Indian from his soil, with the episode of woman and infancy and the sentiments that belong to them.
>
> Now all this is perverted, the mother and child are removed from this peril, which is the *causa causans* of the action of the piece and she is looking unconcernedly away from it.[26]

Despite these doubts, Mills's organization remained unchanged and it is impossible to determine whether the arrangement is accurate. Nevertheless, the meaning Greenough wished to convey is clearly outlined in his letters and corresponds to the composition as conceived by Robert Mills. On July 1, 1837, Greenough had written Secretary of State John Forsyth to accept his second Congressional commission and to describe its subject matter:

> I know of no single fact in profane history that can balance the one so wisely chosen by Mr. Persico as the subject of his group. . . . I propose to make a group, which shall commemorate the dangers and difficulty of peopling our continent, and which shall also serve as a memorial of the Indian race, and an embodying of the Indian character: . . . a subject which . . . has not been exhausted by the gentlemen whose bas reliefs adorn the Rotunda [*Conflict of Daniel Boone and the Indians* and *Landing of the Pilgrims* by Antonio Causici, *William Penn's Treaty With the Indians* by Nicholas Gevelot, and *Preservation of Captain Smith by Pocahontas* by Antonio Capellano]. . . . It has been objected to me in one instance that it is not a distinct individual historical fact & it has been recommended to me to represent instead of it, Washington raising from the ground the figure of America. . . . If not an individual historical fact, it will embody a whole class of facts, and perpetuate the ideas and sentiments connected with them.[27]

Greenough later elaborated, ". . . I have endeavoured to convey the idea of the triumph of the whites over the savage tribes, at the same time that it illustrates the dangers of peopling the country."[28] *Rescue,* then, does not portray a specific historical event, but rather symbolizes the white man's pacification of the New World's native inhabitants, "a whole class of facts" based on a long series of events from the continent's discovery to its recent westward migration. As such, it is an appropriate companion to Persico's *Discovery.*

In its representation of Indian and white pioneer locked in conflict, the *Rescue* relates to an established thematic tradition of captivity that developed as the first narrative form in American literature.[29] The earliest captivity tales were personal accounts by Puritan settlers who detailed their sufferings at the hands of Indians and who presented their imprisonment and subsequent rescue as a metaphor for spiritual salvation. These seventeenth-century religious works, especially those of Mary Rowlandson, John Norton, and Peter Williamson, became especially popular literature in the nineteenth century and established a pattern for later authors.[30] However, by the end of the eighteenth century, captivity narratives became increasingly sensationalized, with the emphasis often shifting from religious conversion to exaggerated tales of Indian cruelty. These fictionalized texts, especially those about female captives, recast the seventeenth-century *Judea capta,* "the Old Testament image of Israel suffering in Babylonian captivity," into terms of the sentimental heroine lost in the wilderness.[31] By the nineteenth century, pulp thrillers dramatized Indian savagery, contrasting their wild nature to the white woman's Christian purity. James Fenimore Cooper, for example, composed *The Last of the Mohicans* in 1826 as two separate captivity narratives.[32] The first occurs within the outer limits of civilization under the protection of Hawkeye and ends with the safe arrival of Cora and Alice at Fort William Henry. The second takes place in the depths of the "howling wilderness"[33] where Cora is exposed to the imagined moral perils of defeminization, rape, and Indianization, dangers implicit in captivity and feared by whites.[34] Her death, dramatized by Thomas Cole in *Landscape Scene from 'The Last of the Mohicans'* (1827), resulted in Cora's complete Indianization, for her burial beside Uncas in a mound symbolized her union with this Indian and hence, with the Mohican tribe.

This literary convention established the precedent for the captivity images which first appeared as illustrations for narratives. Among the earliest is the frontispiece for *Affecting History of the Dreadful Distresses of Frederick Manheim's Family . . .* published in 1794.[35] In this "fictitious anti-Indian propaganda collection,"[36] the torture of two "helpless virgins"[37] is graphically, albeit crudely, represented. Such illustrations of white captivity are relatively rare in seventeenth- and eighteenth-century narratives, but by the nineteenth century, engravings frequently accompanied the text. The frontispiece for *Narrative of the Massacre, by the Savages, of the Wife and Children of Thomas Baldwin . . . ,* for example, demonstrates in continuous narration seven scenes from the Baldwin family's adventure, including (moving from right to left) "a Savage in the act of Tomahawking Mrs. B." (2), her youngest daughter's supplication while she pleads for her life (3), two Indians, one in the process of tomahawking, the other in scalping Baldwin's eldest son (4), and Baldwin caught after attempting to escape (5).[38] Another narrative, *Struggles of Capt. Thomas Keith in America . . .* published in 1806, situates the dramatic captivity scene in the wilderness.[39] Located in the center is Captain Keith who battles against two Indians in an attempt to preserve his life and that of his wife and child who are still seated in a canoe.

Like the book illustrations, the earliest painted captivity image—John Vanderlyn's *The Death of Jane McCrea* of 1804 [3]—also emphasizes the ignoble savage's cruelty.[40] Commissioned by Joel Barlow to provide engravings for his epic poem, *The Columbiad,* Vanderlyn gave visual form to the author's description of Jane McCrea's death which had occurred in the summer of 1777. As related by Barlow, two Indians, employed by British soldiers to escort McCrea through the wilderness to meet her fiancé in General Burgoyne's army, took the woman captive and then raised their axes in preparation for

3. John Vanderlyn, *The Death of Jane McCrea,* 1804; courtesy of Wadsworth Atheneum, Hartford.

her brutal murder. Following Barlow's poetic description, Vanderlyn depicts McCrea as she falls to her knees, pleading unsuccessfully for her release. Vanderlyn never completed the illustration for Barlow's poem, because he instead painted *The Death of Jane McCrea* for the Paris Salon of 1804. Nevertheless, Vanderlyn's conception became the basis for Robert Smirke's image that did accompany Barlow's 1807 published text.[41] Both Vanderlyn's painting and Smirke's engraving dramatize the Indians' brutality and domination over the helpless and terrified woman whose exposed breast implies sexual abuse and the violation of Christian purity. Throughout the nineteenth century, the theme of Jane McCrea's captivity and subsequent murder continued to be popular in illustrations and engravings, as evident in Nathaniel Currier's 1846 lithograph which follows the compositional formula created by John Vanderlyn and Robert Smirke. These two works even established the basis for an illustration in a captivity novel that does not detail the history of Jane McCrea's death, but instead relates the imprisonment of another white woman: *The True Narrative of the Five Years' Suffering & Perilous Adventures. By Miss Barber . . .* (1872).[42]

Both the illustrations for captivity narratives and John Vanderlyn's painting established a precedent for visual images of captivity that were produced in nineteenth-century America. For example, Erastus Dow Palmer's sculpture, *White Captive* of 1859 epitomizes the captive female's fear and her virginal purity. Carved in white marble, Palmer's single figure is bound by a cloth to a tree stump and helplessly exposed to Indian cruelty. In George Caleb Bingham's *Captured By the Indians,* the captivity theme is recast into a religious context, emphasizing the white captive's salvation from the wilderness. On the one hand, the sleeping Indians evoke the three soldiers who guard Christ's tomb in scenes of the Resurrection, such as

Piero della Francesca's fifteenth-century fresco, *Resurrection* (c. 1463). At the same time, the pyramidal grouping of the mother and her son, and the woman's red and blue garb, both allude to the Madonna and Child in such images as *Holy Family on the Steps* by Nicolas Poussin (1648).

Although the *Rescue* relates to this captivity tradition, the standard image as represented in Vanderlyn's *The Death of Jane McCrea,* Palmer's *White Captive,* and Bingham's *Captured By the Indians* was of the white woman held captive, the Indian threatening her Christian virtues before taking her life. In contrast, Greenough's group shows the Indian captured by the settler. This represents a subsequent development of events, but the fact that Greenough has changed a traditional image by replacing the captive woman by the captive Indian suggests a conscious alteration of a motif that had become standard in American art and literature. Clothed in a Renaissance-type flat hat and robe that resembles the clothing worn by Hans Holbein's humanists and officials of Henry VIII's court, Greenough's pioneer symbolizes enlightenment. Looking down at the Indian, the colossal white settler represents civilization as a Renaissance Man who tames the wilderness, protecting and preserving Christianity as represented by the frontier mother and child.

Although Greenough intended his pioneer to be generic, an unknown artist identified him as Daniel Boone in the print by H. Schile dated 1874 and entitled *Daniel Boone Protects His Family.* Now situated in the wilderness, Boone is referred to as the "Pioneer of the West" and associated with "Civilization" (see the inscriptions on the right beneath the picture). John Filson's popular biography of Boone, published in 1784 and reissued several times, first had transformed the historical figure into a paradigm of white settlement on the frontier. Nineteenth-century literature reinforced his heroic stature: for example,

Daniel Bryan's epic poem, *The Mountain Muse: Comprising the Adventures of Daniel Boone, and the Power of Virtuous and Refined Beauty* of 1813 and Timothy Flint's *Biographical Memoir of Daniel Boone* of 1833 both perpetuated the notion of Boone as the agent of civilization.[43] As well, mid-century paintings such as George Caleb Bingham's 1851–1852 *The Emigration of Daniel Boone* reinforced Daniel Boone's identification as the mythic hunter-adventurer who leads the Chosen People westward.

Besides establishing the legendary status of Boone, Filson's biography also reported the pioneer's two captivities by the Indians. In the nineteenth century, revisions of Boone's biography embellished the imprisonment of the settler and his daughters so that the episodes adhered to the literary formula. Two of these, *Heroic Women of the West,* published in 1854, and John Beauchamp Jones's *Wild Western Scenes: A Narrative of Adventures in the Western Wilderness,* published in 1849, included engravings that correspond to the traditional captivity genre in the representations of Boone's daughters, helpless against the brutality of the tomahawk-wielding Indians.[44] In addition, paintings such as Charles Wimar's *The Abduction of Daniel Boone's Daughter by the Indians* (1853), and engravings such as *Daniel Boone & His Friends rescuing his Daughter Jemina* adhered with slight deviations to the Boone narrative as it developed in the nineteenth century.[45]

In its representation of a colossal pioneer who assumes mythic associations, the *Rescue,* like Persico's *Discovery of America,* referred to recent westward migration and served a polemic function in supporting Congressional legislation for the acquisition of western lands. Greenough's *Rescue* further related to the government's official policy toward the Indians. As Senator John Elliott of Georgia (a member of the Committee on Indian Affairs) had argued in favor of Indian removal:

> The measures proposed in this bill . . . have for their object the preservation of the Indian tribes within the United States, and the improvement of their condition, as well as the advancement of the wealth and power of the Union. . . . So long as the Indian tribes within our settlements were strong enough to wage war upon the States, and to pursue their trade of blood with the tomahawk and scalping-knife, it was neither the policy nor the duty of the Federal Government to consult their comfort, or to devise means for their preservation. The contest, then, was for the existence of our infant settlements, and for the attainment of that power by which a civilized and Christian people might safely occupy this promised land of civil and religious liberty. It was, then, to be regarded as a struggle for supremacy between savages and civilized men, between infidels and Christians.[46]

Horatio Greenough's *Rescue* visualizes the words in the last sentence, for it indeed represents the struggle for supremacy between the white man and the Indian, graphically illustrating the triumph of civilization, culture, and Christianity over savagism, heathenism, and untamed wilderness.

The majority of nineteenth-century Americans believed that this struggle would eventually result in the demise of the Indian race. As Senator Elliott had continued in his argument on behalf of dispossession:

> . . . like a promontory of sand, exposed to the ceaseless encroachments of the ocean, they [the Indians] have been gradually wasting away before the current of the white population. . . . and unless speedily removed, by the provisions of this bill, beyond the influence of this cause, a remnant will not long be found to point you to the graves of their ancestors, or to relate the sad story of their misfortunes![47]

In the 1850s. *The Crayon* advocated documentation of the native races as appropriate subject matter in American art, stating:

It should be held in dutiful remembrance that he [the Indian] is fast passing away from the face of the earth. Soon the last red man will have faded forever from his native land and those who come after us will trust to our scanty records for their knowledge of his habits and appearance. . . .[48]

Ethnologists, journalists, and artists began to record "primitive" cultures on the wane. James Fenimore Cooper's best-selling Leatherstocking novels, the paintings of Indians by George Catlin, Alfred Jacob Miller, and Seth Eastman, and sculpture such as Thomas Crawford's *The Indian: Dying Chief Contemplating the Progress of Civilization* (1856) were created as documents of a doomed people.[49] Greenough's *Rescue* must also be considered as, in Greenough's own words, "a memorial of the Indian race" (quoted earlier), a record of a culture quickly vanishing from the American continent because of white settlement on the frontier.

That some mid-century Americans correctly understood the complexity of *Rescue*'s meaning is evident in the *Bulletin of the American Art-Union*'s 1851 review:

The thought embodied in the action of the group, and immediately communicated to every spectator is the natural and necessary superiority of the Anglo-Saxon to the Indian. It typifies the settlement of the American continent, and the respective destinies of the two races who here come into collision. You see the exposure and suffering of the female emigrant—the ferocious and destructive instinct of the savage, and his easy subjugation under the superior manhood of the new colonist.

. . . He [the pioneer] whose destiny is to convert forests into cities; who conquers only to liberate, enlighten and elevate; who presents himself alike at the defiles of lonely wildernesses and the gates of degraded nations as the representative and legate of laws, and policy and morals; he the type of your own glorious nation, stands before you. His countenance . . . [has]

nothing vindictive or resentful in it; the cloud of passion has passed from the surface of that mirror of high thoughts and heroic feelings, and the severity of its rebuking force is a shade saddened and softened by the melancholy thought of the necessary extinction of the poor savage, whose nature is irreconcilable with society.[50]

Not all responses were favorable, however. *The Cosmopolitan Art Journal* criticized:

Greenough's group . . . represents neither dog, American Indian, nor backwoodsman. The white man has a Greek face, and his conventional repose of feature amounts to entire contemplative abstraction and for absence of mind. His eyes look vacantly far away, and his face is unmoved, while he contends in no very deadly struggle for his own life . . . the Indian is . . . Roman. . . . The work is well intended, but common place, and quite lacks the vigor of true artistic conception and characterization.[51]

A decade before these remarks were published, the new territories in the Union and the discovery of gold in California contributed to renewed conflict between the settlers and the Indians because the government had moved the Indians directly in the corridor of renewed westward expansion along the Oregon Trail. To resolve the problem, in 1853 Congress implemented the reservation system as it exists today; tribes were once again removed and isolated from whites in the hope that they eventually could be educated and civilized in the white man's way of thinking.[52] Again, Persico's *Discovery of America* and Greenough's *Rescue* served to condone Congressional policy, for the statues demonstrated that after the initial meeting between Indian and the white man on the frontier, civilization would triumph over savagery, thereby ensuring the realization of American empire.

By the twentieth century, however, attitudes toward the Indians began to change. In particular, The Indian Reorganization Act of 1934 marked a

turning point in federal policy and attitudes. Besides the encouragement of tribal governments and cultures, the act rejected "the erroneous, yet tragic, assumption that the Indians were a dying race—to be liquidated." The document furthermore acknowledged, "We took away their best lands; broke treaties, promises; tossed them the most nearly worthless scraps of a continent that had once been wholly theirs."[53] Nearly twenty years later, in 1953, the government granted full citizenship to the Indians, and terminated federal supervision and control of tribal affairs.

Thus the demands for the *Discovery*'s and the *Rescue*'s removal, beginning in 1939 and continuing until 1958, coincided with these two hall-mark legislative acts of the twentieth century. Although no evidence suggests that people recognized the connections between the statues, nineteenth-century westward expansion, and the dispossession of Indians from their ancestral lands, nonetheless a number of twentieth-century Americans regarded the imagery as inappropriate to contemporary developments. Nevertheless, because the works are kept in storage, many Americans today are unaware of the historical significance and stereotypical imagery of the works. Despite the difficulty in acknowledging this aspect of our historical past, the *Discovery* and the *Rescue* remind us that "civilization" has "triumphed" at the expense of native Americans.

NOTES

Revised by the author from *The American Art Journal,* vol. 19, no. 2. Reprinted by permission of the author.

1. United States Congress, House, 76th Congress, 1st session, April 26, 1939, House Joint Resolution 276.

2. United States Congress, House, 77th Congress, 1st session, April 14, 1941, House Resolution 176, p. 2.

3. Leta Myers Smart, an Omaha Indian from Nebraska, to David Lynn, Architect of the Capitol, October 6, 1952, Art and Reference Files, Office of the Curator of the Architect of the Capitol.

4. Leta Myers Smart to David Lynn, November 1, 1953; petition drafted for the California Indian Day in Los Angeles (no date, Smart enclosed this in her November 1 letter); Smart to Lynn, December 19, 1953; Smart to J. George Stewart, Architect of the Capitol, January 24, 1955; Smart to William Langer, Senator from North Carolina, January 24, 1955; Smart to Senator Theodore Francis Green, Chairman of the Joint Committee on the Library, August 15, 1958; Smart to Stewart, November 5, 1958 (Office of the Curator of the Architect of the Capitol).

5. Leta Myers Smart, "The Last Rescue," *Harper's,* vol. 219, no. 1313 (October, 1959), p. 92.

6. United States Congress, Senate, 24th Congress, 1st session, *Register of Debates,* April 28, 1836, pp. 1314–1318, and 24th Congress, 1st session, *Congressional Globe,* pp. 406–407.

7. *Register of Debates,* April 28, 1836, p. 1314.

8. United States Congress, Senate, 24th Congress, 1st session, Senate Resolution 17, May 17, 1836, p. 1.

9. United States Congress, House, 24th Congress, 2nd session, House Resolution 933, February 14, 1837.

10. Luigi Persico to John Forsyth, December 14, 1838, and May 13 and 14, 1840, Office of the Curator of the Architect of the Capitol.

11. Greenough to Robert Balmanno, October 29, 1850, Nathalia Wright, ed., *Letters of Horatio Greenough; American Sculptor* (Madison, Wisconsin, 1972), p. 381.

12. *Congressional Globe,* April 28, 1836, p. 1316.

13. William H. Truettner, "The Art of History: American Exploration and Discovery Scenes, 1840–1860," *American Art Journal,* vol. XIV, no. 1 (Winter, 1982), pp. 4–31.

14. See Dawn Glanz, *How the West Was Drawn: American Art and the Settling of the Frontier* (Ann Arbor, Michigan, 1982), pp. 58–59; and Arthur A. Ekirch, Jr., *The Idea of Progress in America, 1815–1860* (New York, 1951; reprint ed., 1969).

15. Literature on manifest destiny and westward expansion is extensive. Most helpful are Albert Katz Weinberg, *Manifest Destiny: A Study of Nationalist Expansionism in American History* (Chicago, 1963); and Frederick Merk, *Manifest Destiny and Mission in American History* (New York, 1966). See also Henry

Nash Smith, *Virgin Land: The American West as Symbol and Myth* (Cambridge and London, 1950; reprint ed., 1970); and Richard Slotkin, *The Fatal Environment: The Myth of the Frontier in the Age of Industrialization 1800–1890* (New York, 1985).

On the Puritan origins and religious connotations of the belief in divine mission, see Perry Miller, *Errand Into The Wilderness* (Cambridge and London, 1956; reprint ed., 1976); and Ernest Lee Tuveson, *Redeemer Nation: The Idea of America's Millennial Role* (Chicago, 1968).

16. John L. O'Sullivan, "Annexation," *The United States Magazine and Democratic Review,* vol. XVII, no. 85 (July–August, 1845), p. 5. See also Julius W. Pratt, "The Origin of 'Manifest Destiny,'" *American Historical Review,* vol. XXXII, no. 4 (July, 1927), pp. 795–798; and "John L. O'Sullivan and Manifest Destiny," *New York History,* vol. XIV, no. 3 (July, 1933), pp. 213–234, for a discussion of O'Sullivan's importance in defining and proselytizing manifest destiny.

17. Pratt, "The Origin of 'Manifest Destiny,'" p. 795.

18. United States Congress, House, 29th Congress, 1st session, *Congressional Globe,* February 3, 1846, p. 227.

19. *Register of Debates,* April 28, 1836, p. 1316.

20. "Persico's Columbus," p. 5.

21. *Ibid.,* p. 6.

22. United States Congress, House, 28th Congress, 2nd session, *Congressional Globe,* January, 1845, appendix, p. 43.

23. *Ibid.*

24. Quoted in Brian W. Dippie, *The Vanishing American: White Attitudes and U.S. Indian Policy* (Middletown, Connecticut, 1982), p. 68. For information on the Indian removal policy, see Roy Harvey Pearce, *Savagism and Civilization: A Study of the Indian and the American Mind,* 2nd ed. (Baltimore, Maryland, and London, 1965); Francis Paul Prucha, "American Indian Policy in the 1840's," in *Frontier Challenge: Responses to the Trans-Mississippi West,* ed. John G. Clark (Lawrence, Kansas, 1971), pp. 81–110; Ronald N. Satz, *American Indian Policy in the Jacksonian Era* (Lincoln, Nebraska, 1975); and Richard Slotkin, *Regeneration Through Violence: The Mythology of the American Frontier 1600–1860* (Middletown, Connecticut, 1974).

25. Francis Haskell and Nicholas Penny, *Taste and the Antique: The Lure of Classical Sculpture 1500–1900* (New Haven, Connecticut, and London, 1981), discusses the history and popularity of *Laocoön* (pp. 243–247). See also Johann J. Winckelmann, *Writings on Art,* ed. David Irwin (London, 1972); and Gotthold E. Lessing, *Laocoön; an Essay on the Limits of Painting and Poetry,* trans. Edward A. McCormick (Indianapolis, Indiana, 1962) for examples of eighteenth-century antiquarians' effusive praise and interpretations of the Hellenistic statue.

26. Edward G. Loring to James Pearce, February, 1859, Montgomery Meigs Letterbook, Records of the Architect of the Capitol. Henry Greenough, Horatio's brother, tried to reconstruct his brother's plan in a letter to Edward Everett. He wrote, ". . . the spectator has a front view of the Indian and backwoodsman facing the center of the composition, and a front view of the mother and child which are on the left of the spectator, although on the right of the principle [*sic*] figures." (Henry Greenough to Edward Everett, September 1, 1853, copy in Office of the Curator of the Architect of the Capitol from Records of the National Archives, vol. 33, numbers 3233 to 3306, January 6, 1852–December 23, 1853)

27. Greenough to John Forsyth, July 1, 1837, *Letters,* p. 214.

28. Greenough to Forsyth, November 15, 1837, *Letters,* p. 221.

29. Numerous articles on the literary convention of the captivity theme exist: Philips D. Carleton, "The Indian Captivity," *American Literature,* vol. XV, no. 2 (May, 1943), pp. 169–180; and Roy Harvey Pearce, "The Significances of the Captivity Narrative," *American Literature,* vol. XIX, no. 1 (March, 1947), pp. 1–20, are the most helpful. Pauline Turner Strong in "Captive Images," *Natural History,* vol. 94, no. 12 (December, 1985), pp. 50–57, employs the *Rescue* and Vanderlyn's *The Death of Jane McCrea* as illustrations in an article about the captivity genre.

30. Mary Rowlandson, *A True History of the Captivity and Restoration of Mrs. Mary Rowlandson* (New England, 1682; reprint ed., New York and London, 1977); John Norton, *The Redeemed Captive* (Boston, 1748; reprint ed., New York and London, 1977); Peter Williamson, *Sufferings of Peter Williamson* (Stockbridge, 1796; reprint ed., New York and London, 1978). The Garland Library of Narratives of North American Indian Captivities reprints three hundred

and eleven narratives, beginning with Mary Rowland-son's 1682 account and ending with twentieth-century versions of the captivity tale.

31. Annette Kolodny, *The Land Before Her: Fantasy and Experience of the American Frontiers, 1630–1860* (Chapel Hill, North Carolina, and London, 1984), pp. 19 and 24.

32. David T. Haberly, "Women and Indians: *The Last of the Mohicans* and the Captivity Tradition," *American Quarterly,* vol. XXVII, no. 4 (Fall, 1976), pp. 431–433.

33. James Fenimore Cooper, *The Last of the Mohicans: A Narrative of 1757* (New York and Scarborough, Ontario, 1962), p. 216.

34. Haberly, p. 434.

35. Lutz, p. 303. The composition for the illustration derives from Theodor de Bry, plate XVII, published in 1590 after a watercolor by John White illustrated in Paul Hulton, *America 1585: The Complete Drawings of John White* (Chapel Hill, North Carolina, and London, 1984), plate 39. *Affecting History* was first published in 1793.

36. *The Indians and Their Captives,* ed. James Levernier and Hennig Cohen (Westport, Connecticut, and London, 1977), p. 70.

37. *Ibid.*

38. Thomas Baldwin, *Narrative of the Massacre, By the Savages, of the Wife and Children of Thomas Baldwin* . . . (New York, 1835; reprint ed., New York and London, 1977).

39. *Struggles of Capt. Thomas Keith in America* . . . (London, 1806; reprint ed., New York and London, 1977).

40. For Vanderlyn's literary and historical sources, as well as other representations of Jane McCrea's capture, see Samuel Y. Edgerton, Jr., "The Murder of Jane McCrea: The Tragedy of an American *Tableau d'Histoire,*" *The Art Bulletin,* vol. XLVII, no. 4 (December, 1965), pp. 481–492.

41. *Ibid.,* p. 486. Edgerton provides a stylistic comparison of these two images (pp. 486–487).

42. [Mary Barber,] *The True Narrative of the Five Years' Suffering & Perilous Adventures,* . . . (Philadelphia, 1872; reprint ed., New York and London, 1978), p. 65.

43. Numerous scholars have discussed Boone's nineteenth-century mythology. Most helpful are Kolodny, chapter 4; and Henry Nash Smith. Dawn

Glanz discusses Boone's imagery and iconography in the visual arts (see chapter 2).

44. John Frost, *Heroic Women of the West: Comprising Thrilling Examples of Courage, Fortitude, Devotedness, and Self-Sacrifice, Among the Pioneer Mothers of the Western Country* (Philadelphia, 1854; reprint ed., New York and London, 1976), p. 31; and John Beauchamp Jones, *Wild Western Scenes: A Narrative of Adventures in the Western Wilderness.* . . . (Philadelphia, 1849), p. 13.

45. Wimar painted two versions of *The Abduction of Daniel Boone's Daughter by the Indians.* Martha Levy Lutz discusses the evolution of these two works and their relation to the captivity genre in literature and in painting in "Charles Wimar's *The Abduction of Daniel Boone's Daughter by the Indians,* 1853 and 1855: Evolving Myths," *Prospects,* vol. 7 (1982), pp. 301–314.

46. United States Congress, Senate, 18th Congress, 2nd session, *Register of Debates,* February 22, 1825, p. 639.

47. *Ibid.,* p. 640.

48. "Indian in American Art," *The Crayon,* vol. III (January, 1856), p. 28.

49. *The Indian: Dying Chief Contemplating the Progress of Civilization* is a marble copy of a figure found in Crawford's Senate pedimental group on the United States Capitol's east facade entitled *Progress of Civilization* (1853–1863). The sculpture expands upon the meaning of the *Discovery* and the *Rescue* by carefully outlining the inevitable demise of the Indian race, and by showing the economic and commercial reasons for westward expansion and government policy toward Indian tribes. For further information on Crawford's pediment, see Vivien Green Fryd, *Art and Empire: The Politics of Ethnicity in the U.S. Capitol, 1815–1860* (New Haven: Yale University Press, 1992).

50. *Bulletin of the American Art-Union* (September, 1851), p. 97.

51. *The Cosmopolitan Art Journal,* vol. III (September, 1859), p. 135.

52. Robert A. Trannert, Jr., *Alternative to Extinction: Federal Indian Policy and the Beginnings of the Reservation System, 1846–51* (Philadelphia, 1975), pp. 178 and 185.

53. Wilcomb E. Washburn, ed., *The Indian and the White Man* (Garden City, New York, 1964), p. 393. See also Dippie, pp. 271–322.

7

American Folk Art

Questions and Quandaries

———

JOHN MICHAEL VLACH

As art historians become more self-conscious about methodological practice, the review essay emerges as an opportunity to examine the beliefs that guide the process of historical inquiry. In his review of a recently published book on American folk art, John Vlach argues that scholarship on American folk art has been plagued by a set of flawed definitions and questionable assumptions. A lingering preoccupation with the aesthetic appreciation of folk art, rather than attempts at critical investigation leading to genuine understanding of the objects and the cultures that produced them, has caused students of folk art to create more confusion than clarity.

Vlach identifies a set of polarities used both to characterize folk art and to establish its difference from so-called fine art. Because these definitions rest not on genuine insight into folk cultures and their artistic traditions but are rooted rather in somewhat arbitrary aesthetic judgments and romanticized notions of the folk artist's naïveté, they are at once patronizing and misleading. Vlach insists on the need to reconsider the vast array of objects currently occupying the category of folk art, and he calls for greater precision of definition and more rigorous investigation into the meaning and function of these objects for the cultures that produced them.

———

As the discipline of folklore emerges as an independent field of study, the need for critical reassessment of definitions and theoretical assumptions continually presents itself as a perplexing issue.[1] Humanistic impulses push scholars toward an honest and forthright enjoyment of the materials which they consider. Their personal encounters in fieldwork stimulate a Whitmanesque desire to celebrate new discoveries and to provide a loud and public voice for those many creators whose achievements are so interesting but as yet unacknowledged. Although such emotional involvement may seem not only inevitable but even appropriate, it cannot eliminate the scholar's need for intellectual rigor and precision. Students of folk culture should not be torn between advocacy and accuracy, but, in fact, they often are. This dilemma of heart and head has led to pronouncements which are vague at best and at worst confused. While this circumstance pertains in part to all genres of folk expression, it is clearly seen in the study of folk art, a subfield of the newly emergent area dubbed "material culture."

In the United States the subject of folk art has not been given sufficient academic attention

even though it has attracted numerous devotees and collectors. Fifty years after the first major recognition of the subject at the Newark Museum, the field still lacks a consensus definition, a workable set of evaluative criteria, and a tenable theoretical framework. These deficiencies are by no means the result of a lack of concern; the bibliography on folk art topics is embarrassingly large.[2] The quandary of folk art stems from a continued reliance on the enthusiastic slogans of the 1930s—a reliance on populist declarations rather than considered investigations. While the study of academic art in Western society or the art of so-called primitive peoples has progressed remarkably, considerations of folk art continue to be tied to a joyous manifesto of 1930s discovery. Throughout the 1970s writers continually cited the work of Holger Cahill and seemingly refused to consider the issue in terms of more contemporary studies.[3] The growth of productive ideas in this area has been therefore comparatively stunted.

A 1978 publication of the Cleveland Museum of Art written by Lynette I. Rhodes, entitled *American Folk Art: From the Traditional to the Naive*, provides a convenient opportunity to review and comment upon the current status of folk art study. The assessment that follows is not directed specifically at Rhodes's book but, rather, at the chain of antecedents of which it is but the most recent link. She, in uncritically summarizing the past writings on folk art, has upheld a pattern of insufficient scholarship. Working as she has under the auspices of one of America's foremost museums, she has given the stamp of approval to the problematic definitions and a weak set of assumptions found in the usual folk art books by repeating them once more. It is appropriate, then, to comment at length on *American Folk Art*, if only to remind those interested in the subject of the possibility of an alternative point of view.

A succinct review of past folk art scholarship has already been provided by art historian Kenneth Ames.[4] He ably dissects this huge body of literature to reveal at its core a set of "myths," a body of syrupy and nostalgic catch phrases that have taken the place of clearheaded thinking. It would seem, however, that the issues he raises can bear further consideration, if for no other reason than the fact that popular myths are difficult to debunk. Moreover, if we are ever to become wise about folk art, the specialized perspectives of related fields of study must be joined together. I wish, then, to make common cause with the thrust of Ames's remarks even if my interests and tactics as a folklorist are somewhat different from his.

The Question of Definition

In the first section of her catalogue, Rhodes attempts to say what folk art is and to identify some of its basic characteristics. The definitional issues upon which she touches can be summarized as a series of polarized relationships: communal versus individual, simple versus complex, instinct versus intention, and naiveté versus competence. There are other contrasting sets of terms which might also be considered, including perhaps the ultimate dichotomy of folk versus elite. That broad paradigm, however, involves questions too general to consider here.[5] Let it suffice that we acknowledge that artistic communication derives much sense and significance from its social context.

Communal Versus Individual

After reading a generous selection of often-quoted works on American folk art we might be moved to ask, "Whose art is it, anyway?" Rhodes answers that "folk art is an everyday art" and consequently exists primarily in the domestic arena, where it is appreciated by "ordinary" people as they satisfy their collective material

and spiritual needs (p. 9). This is an important point, because if an artwork did not function in this manner, if it were unacceptable, the work of art would not be the expression of a group (of a folk) but, rather, the product of a single individual. Folk artists, by definition, submit to or are at least very aware of the demands and needs of their audience. They use their artworks to participate in the life of a community; they bond themselves to neighbors and kin with carvings, quilts, pots, baskets, and the like. Should they deviate markedly from the usual criteria they run the risk of rejection, that is, a social death. This social coercion promotes not only conformity, but also the continuity of tradition and the stability of artistic performance. It is evident, then, that in the day-to-day interaction between folk artists and their audiences success is determined by a mutual reckoning of communal standards. Folk artists, to some degree, surrender their personal desires to social demand. We find, then, in their works the denial of self, or ego. We also see that they are compensated for their sacrifice by the esteem granted to them as bearers of a tradition. The loss of personal power is balanced by the advantages of a social role. The folk artist, in effect, "kills" himself into the established art forms, only to grow in glory and prestige by interweaving himself into the fabric of the entire community's history.[6] It would then follow that any definition of folk art must emphasize the communal element which serves as the paradigm for creative standards.

To consider the folk artist as an individual creator is to ignore the fundamental reality of societies in which tradition is still the basis for action. But this is precisely what Rhodes does when she points to individuality as an outstanding hallmark of American folk art and touts diversity as its result. The art which she refers to as communal becomes then extremely personal. This shifting of opinion reveals a sense of indecision and promotes a confusing rhetoric in which the artist is presented as talented in spite

of his context. Rhodes, like many commentators before her, puts on blinders that hinder recognition of the very nature of the human situation out of which folk art is produced.[7] If the works presented under the banner of folk art do indeed manifest diversity, perhaps this is because several distinct traditions rather than a single tradition are present. Or, as is often the case particularly with collections of so-called folk painting, the works are in fact the product of a single talented person free from the strictures of social expectation.[8] Such works might be assigned to stylistic or historical periods, granted a biographical and geographical origin, but may never properly be considered folk art.

The famous Watts Towers by Simon Rodia are usually labeled folk sculpture when in fact in the United States there is not another creation like them.[9] They certainly stand out as a singular achievement even in Los Angeles, a city well known for its fantasy environments. The Watts Towers are not folk art but, rather, an outstanding piece of twentieth-century sculpture. They speak not for Watts or Los Angeles but for Simon Rodia, for his vivid imagination, and for his will to leave behind a monument to his existence. If we apply the criterion of communal orientation to much of what has been labeled folk art, we will find that a large portion of that work must be shifted into the category of untutored modern art. Some might argue that Rodia gave his towers to his neighborhood and thus they qualify as a communal statement. What Rodia gave was *his* work, however, not a form already known in the community. Folk artists emphasize the expectations of their families, friends, and neighbors more than their own desires.

Simple Versus Complex

Folk art writers hold back from granting creators who lack formal academic training the status of artists, even while they recognize a similarity of

purpose and achievement in the work of a fine artist and that of a "naive" one.[10] Rhodes calls this similarity an "ambiguous relationship" (p. 31). It is ambiguous because common sense demands that the two areas of endeavor be unified, while a sense of propriety (which often turns out to be snobbery) requires that the two be kept separate. Rhodes claims that fine art has distinct evaluative criteria, and against this yardstick she finds folk art to be "usually anonymous, nonacademic, and antitraditional" (p. 31). Taking these last two claims first, it is easy to see the "black spot" of ethnocentrism.

Works of folk art obviously have a tradition. Artworks grounded in social demands and communal preservation do not materialize out of thin air but are patterned out of ideas and values passed on from generation to generation. Folk art is nothing if not traditional, although its tradition might not be an academic one.[11] The lineage might not run from classical to Gothic to Italianate to Queen Anne, but folk art has a lineage nonetheless. The quality of academicism in fine art rises from a particular type of training, but what is most important is that the training is careful and deliberate. Folk artists also receive training, and, while it may be in some instances rather random and catch-as-catch-can, it still provides a set of standards for the deliberate production and evaluation of artworks. The fact that a folk artist's training may be informal does not necessarily condemn his effort to inferiority. We should recognize that folk artists and fine artists approach a similar goal by alternative means. The efficiency of the means is open to debate; the similarity of intention is not.

As for the assumed anonymity of folk art, this quality is more of an index of the writer's lack of information than a feature of traditional artworks. We often do not know who made a piece of art because the documentation is insufficient. But just because we in the twentieth century are still in the dark does not mean that a nineteenth-century community did not know its woodworkers, potters, and embroiderers. It is also misleading to assume that a group of similar objects—say four-gallon butter churns—which look alike to us are without individual personality indicative of authorship. Lanier Meaders, a folk potter from north Georgia, can identify the churns of his father and those of several uncles on the basis of rim shape. To an outsider they are virtually identical, without distinction, just crockery.[12] But the more we are able to look at them through informed eyes, the better we are prepared to discover the careers of different potters with slightly varying approaches to the same type of artifact. Assuming anonymity in folk art causes it to appear as just a simple statement when, in fact, it may demonstrate the complexities of personal experimentation within the boundaries of tradition.

The rigid separation of folk art from fine art presumes a value judgment which distinguishes the simple from the complex. Works of fine art are considered complex because they can be credited to known creators who have had their aesthetic sensitivities refined by formal training and because these works are said to advance the cause of "civilization." Yet can we not also say that folk art is created by specific persons who received a particular training and, moreover, that folk art advances and reaffirms the values of the little community in which it was created? In either case art has a complex role to play. It would then seem that the simple versus complex dialectic is mislabeled, since the differences confronted here are a matter of degree, not kind. A contrast of restricted versus elaborate might be more appropriate. All the art that we know is human art and therefore manifests a complexity of intelligence and feeling. To stratify art by celebrating one portion as complex is to poison perception with politics. Since all art is obviously not identical, we must have means to evaluate those differences. That differentiation should,

however, stem from a recognition of modes and processes in art, not from the artificial imposition of a dubious value system.

The key flaw in the ascription of a hierarchy of value is seen in Rhodes's illustration of two statues of the Marquis de Lafayette (pp. 28–29). The first is by Horatio Greenough, the well-known European-trained American sculptor of the early nineteenth century. His bust of Lafayette conforms to the trendy fashion of the day. The French general is rendered in the manner of a Roman senator, with close-cropped curls, patrician visage, and toga draped over one shoulder. The second figure is by painter David Gilmour Blythe who, as a young man, carved architectural ornaments. His Lafayette is an 8-foot-tall standing portrait of a man dressed in the garb of a gentleman on tour in America circa 1825. Size and attention to the details of finery combined to create an image of greatness. Blythe's work, however, is called "unsophisticated" and said to have a "lack of finesse." While the two works are clearly different, Greenough's statue is not better just because of its finesse, its sophistication, its pretension to aristocracy, or its complexity. Blythe was working in an alternative metaphor that had its own standards of worth. As a carver of architectural ornament he understood the power of dimension and monumentality. He carried this understanding into the making of his statue, which was to be placed at the top of a courthouse far from viewers. Moreover, the choice of nineteenth-century costume instead of a Roman toga does not, as Rhodes suggests, simply present the man as he was but, rather, recreates an image of wealth, rank, prestige, and accomplishment coequal with the meaning of a toga. Blythe should not be put down to put Greenough up. What is called a simplified style is, in fact, not simple at all.[13]

This truth is recognized again and again in works of folk art. The power of expression derived from an economy of means and materials is particularly striking today, as Rhodes observes: "Much of the aesthetic appeal of folk art lies in a strength of design integrated with idea" (p. 33). Yet many critics of folk art, while they are strong advocates for the excellence of the work, will withhold full recognition of the ability and, more particularly, the intentions of folk artists. Statements such as this one by Rhodes are commonplace in folk art commentaries: "Yet the fact remains that, unlike modern artists, folk artists were probably not interested in the intrinsic meaning of form and color. They were merely concerned with objective meanings and with trying to adapt their techniques to those concerns" (p. 31). The underlying assumption unvoiced here is that the simplicity of folk culture prevents those artisans from appreciating completely the fullness of their achievement, that their naiveté results in a performance into which the trained sophisticated critic may inject a more complete meaning. This attitude was once held for the arts of Africa and Oceania, but now it is understood that a lack of sophistication on the part of Western scholars blinded them to the rich aesthetic life of the "savage." It is sad that credit for artistic wholeness will be granted to peoples far away but denied to creators in our own backyards. It is almost as if someone must be held down to uphold the elevated position of folk art critics. As a result, folk art is more often patronized than understood.

Instinct Versus Intention

Because folk art scholarship trades most heavily in extensive aestheticizing, that is, in praise of artistic qualities, works of folk art are considered primarily as formal expressions from which significant messages must be extracted.[14] Consider the following statement by Rhodes: "American folk art is a succession of individual works loosely linked by the artists' instinctive eye and

their preference for images from their environment. The medium, technique, and style are more often determined by the materials at hand and a natural ability than by aesthetic considerations" (p. 14). While she quickly qualifies this remark by adding that community viewpoint and individual imagination are crucial determining factors, she concludes by describing folk art as "sincere" and "extemporaneous."

There is an implicit assumption in Rhodes's formulation which if pushed to its logical conclusion presents folk art in a very mistaken manner. The main drift of much folk art rhetoric leads one toward an emotional appraisal of artistic creation. Not knowing exactly what an artist had in mind, folk art commentators guess at what seems most plausible to them. They speculate on the set of environmental circumstances that might stimulate the imagination and prod an artist into action. Although chains of inference need to be forged when the required data are not available, presumptions on the nature of artistic motives seem to forgo any attempt at inference and instead find refuge in the unfortunate stereotype of the rustic naive.[15] These imagined artists, often conceived of as likable, happy souls, size up their materials and their tasks not from any basic fund of intelligence but from "instinct." (Note that the instinct manifested by fine artists is often called "knowledge" or "creativity.") What then results from folk artists' application of effort are enjoyable products that appear "naturally," indeed almost effortlessly, because thought is not required to create this art. The final product is defined as "good" because the rustic native artist is perceived as "sincere" and therefore as a good person. Pushing this stereotype further, critics presume that folk artists do the best they can within their limited potential (often thought to be confined by the simplicity of their experience). The net result of all these suppositions is that folk art becomes an automatic art, an art form that rolls endlessly from the hands of its makers and over which they have little control or responsibility.[16]

Were folk art writers to examine the ultimate implications of their assumptions, they might be less cavalier with their value judgments. Obviously art is not automatic, and folk artists are not Midas-like creators whose very touch transforms wood into whirligigs. But if we substitute guesswork for serious study we will continue to foist such preposterous images onto folk art. Given the complexity of communal situations, we quickly realize that individuals do not immediately understand the full range of social demands to which they are expected to conform. They have to be educated first. The artist, like any other member of a community, must learn about local standards, as well as acceptable modes of creative expression.[17] This acquisition of understanding is not instantaneous but gradual, it is not automatic but deliberate, it is not instinctual but intentional, it is not natural but rational. Folk artists undergo apprenticeship—sometimes in the workshop at the side of a master craftsman, sometimes in the home under the supervision of a close relative. It is often informal training, but it is training nonetheless. To slight this process is to patronize that which is different from our own twentieth-century experience once again. Were we sophisticated enough to understand the workings of traditional societies we would never accept such weak propositions as the "instinctive artist."

For many years the commentary on Afro-American music was weighed down by joyous exaltation of the supposed natural songwriting abilities of rural bluesmen. The image of the instinctive artist blinded critics to the fact that these performers spent years learning to play their guitars, playing in bands behind already mature talents, learning standard tunes, and experimenting with personal variations.[18] In short, the critics eliminated the history of the development of the individual within his community.

The challenge of history may be difficult, requiring the painstaking search for innumerable details, but unless that challenge is accepted we will find insight replaced by shallow speculation and false, often degrading, stereotypes. Folk art scholars would do well to take heed of the developments in folk music criticism. There is no need to continue to fall into the same intellectual trap.

Naiveté Versus Competence

If folk art is characterized as simple and instinctive, it is no surprise that it is also considered "naive." This is a term that Rhodes uses not only in her title but liberally throughout her text. It is a loaded word and thus a problem for analytical purposes. Other adjectives that often swirl about folk artworks are "quaint," "innocent," and "charming." These are the positive faces of naiveté which commentators usually promote as they describe a work of folk art. The term is also associated with things that are childlike, foolish, artless, or even crude. Given the wide ambivalence of the term, it is difficult to know if a critic means to praise folk art or condemn it. We may assume that a writer's apparent devotion to the subject signals some level of commitment or identification with folk art, but it must be asked whether the apologetic tone inherent in the term "naive" is an appropriate way to support folk art.

It seems that when folk artists are compared with fine artists (given the hierarchical value predisposition of that exercise), the folk artists come off as second rate. It is alleged that they do not have the same level of ability, say, for rendering the human figure. Their images appear distorted either by oversimplification or exaggeration of features of anatomy. Following the evaluative criteria of the mainstream art in the nineteenth century, which demanded faithful resemblance to the original subject—that a horse look like a real horse and so forth—folk art in that period would be seen as incompetent. However, what would be said of those works if we knew that their makers actually intended them to look that way? What if there was a specific aesthetic strategy in operation? Would we still feel that the works were incompetent? I suspect that information on the ideational background of folk art would cause it to rise in esteem.[19] The presence of mental concepts suggests the possibility of control and therefore meaning even if the work seems somehow aberrant. We look today at one of Jackson Pollock's splatter paintings and still give him credit for a high level of creativity because we know that he had something in mind. Carvers of gravestones in New England, to cite a group of folk artists sometimes considered simplistic, also had something in mind (usually the condition of the client's soul), which motivated them to render portraits of the deceased in a very distinctive manner.[20] Some of their portraits were minimal renderings, round-headed, eyes-nose-mouth affairs. Rhodes describes one example as "free from an evident concern for visual reality" (p. 18). Other carvers made images which have more details, more suggestion of personality, more aspects of control over reality. Indeed, some stones bear the finest likenesses of the day. Yet the minimal portraits were not naive and the detailed ones, by comparison, competent. An inspection of the minimal renderings reveals deft control over tools and medium. The carved lines are crisp and precise, the design is decisive and well executed. They are not the works of children, even though some would term them "childlike." Studies of the three centuries of gravestone carving in New England reveal three distinct modes of sanctioned imagery, each one successively blending slowly into the other. Winged skulls appeared first, followed by cherubs and portraits and, later, by impersonal urns and willows. The gradual transition from grinning skulls to fleshy faces corresponded to the growing pop-

ularity of a humane theology that replaced the harsher teachings of Puritanism. Because the change was not instantaneous, the first winged faces retain the minimal lines of a skull, and, progressively, the human faces, be they representations of an angel or portraits of the deceased, became more lifelike, more realistic. This transformation occurs over the period of ten years in some communities and over sixty years in others. It is clear that carvers could have attempted a realistic portrait at any time if there were reason to do so. Close analysis of their works and social contexts reveals that they matched their carvings to prevailing social philosophy. Aware of the attitudes regarding death in their communities, they performed according to these communal demands, ever conscious of what was appropriate. Hence the same carver might render figures that were iconic or minimal for one client and realistic for the next. The choice of format depended on one's perception of and participation in the religious reformation of the era. The carvers thus did not change from naive artists to competent ones simply by accepting certain "sophisticated" commissions; they were competent all along. The social standards, however, were changing, and so were the standards by which competence was judged.

Four centuries later, folk art critics look back and see the early carvings as simple—and indeed in formal terms they are—but the ideas upon which those minimal figures were based were far from simple. The fact of social complexity contributes intellectual complexity to a society's artworks. An imposition of inappropriate criteria on folk artists necessarily makes their work seem inadequate or naive. Removing folk art from its nurturing context and demanding that it be judged by the standard of verisimilitude, a criterion of questionable significance, deprives many artisans of a just evaluation. Ironically, it is often the critics who are naive about folk art.

The four sets of oppositions discussed here cover general issues in folk art study. These issues all grow out of the unresolved matter of definition. Scholars seem to know what fine art is, although it is often described circularly as what fine artists do, that is to say, as the works produced by known masters of pedigreed genres of expression. While it is recognized that folk art has many of the same qualities as fine art, there is an insistence that it is still outside the boundaries of art.[21] A presumed linear evolutionary model of art history locates folk art early in America's development and suggests that over time folk artists improve enough to become fine artists (p. 18). Such an approach would have folk art and the folk who produce it be simple, instinctive, and naive. I think that the case has already been made that these three qualities have been falsely connected with folk art. Furthermore, the notion that folk art is archaic is effectively challenged by the continued practice of traditional art forms. Folk art paradoxically is as contemporary as it is old fashioned. Rhodes writes that "folk art and academic art cannot be judged by the same standards since they have differing aims, differing audiences, and they were created by different types of artists" (p. 32). I would agree completely, but in recognizing that folk art has aims, audiences, and creators just as fine art does, there should be no need for the imposition of a priori assumptions on the method of study.

Whether critics study fine art or folk art they should be open minded and thorough. A holistically framed study of folk art would necessarily suggest that some folk artists perform poorly, others somewhat better, and a few excellently. If nothing else, this insight should reveal the disservice done to scholarship by stereotypical thinking. The reality of any community is that it is not an undifferentiated mass but an aggregation of personalities that demonstrate a rich human variety and versatility.[22] For the art scholar

the study of fine art and folk art are both potential subjects of inquiry. Were one to engage in an unbiased consideration of these diverse spheres of human achievement, accurate qualitative differences would emerge which could provide dependable bases for a definition of folk art.

The Forms of Folk Art

The larger portion of Rhodes's book is a sampler of the most common subject matters in American folk art collections. Divided into three sections—the utilitarian, the visionary, and twentieth-century folk art—the standard examples are reviewed. Prominently featured are works from New England, the Pennsylvania Germans, and the Spanish-American Southwest. These three act as points of triangulation between which American folk art can supposedly be located. Collectors of the 1920s and 1930s were taken with artworks from these regions, and the literature on folk art has since then been committed to the same bias. There is no question but that each of these locales or ethnic centers is distinctive and possesses folk art. However, the use of these same examples again and again (all the coffee-table books use this triad as a source of illustrations) indicates a need for reassessment of the field rather than another lineup of the old clichés. Rhodes does present some rarely seen examples of religiously inspired art, but the rest has been seen before. No historical examples of southern folk art either by whites or blacks, except for one duck decoy from Louisiana, are presented, and the Northwest and intermountain West are omitted altogether. The major problem in this section of the book is the criteria for the selection of objects. Rhodes wants to show diversity (and she does), but, in so doing, she includes much that is questionable as folk art. Judging from the footnotes, if a particular genre was called folk art somewhere before, it has

been included here. The major criticism should thus fall on the "folk art establishment," not on Rhodes.

Utilitarian Art

Under utilitarian art Rhodes includes production items such as stoneware crockery and the wooden boxes of the Shakers. While it is true that the items illustrated are embellished with decoration or, if undecorated, possess attractive forms, it is unclear that such works were made as art. Granted that aesthetics and pragmatics are often mutually present in traditional objects, we would do well to remember that they do not always exert equal influence. Some attention to the nature of pottery manufacture, including as it does the repetitive throwing of redundant standardized vessel shapes, would correct some of the lyricism with which folk ceramics is described.[23] Open crocks are primarily craftworks which may or may not have decorated surfaces. The fundamental craft object does not change when painted with a cobalt blue flower; it is still the same crock. It would seem that it is the potter's expertise in design painting that contributes the artistic element, a skill quite separable from ceramics.

The whole strategy of labeling decorated items "art" and plain items "craft" is rather shaky. Consider the matter of painted furniture. A Shaker chest of drawers with painted woodgraining is called "art," while the same dresser painted a stolid green goes to auction as "country furniture." Such splitting of hairs generates false distinctions. Why, for example, should carved woodenware when undecorated be called "treen," but when produced with painted floral motifs in Joseph Lehn's shop be called "art" (pp. 52–53)? Imposition of this category lifts these works out of their meaningful context. If we were to imagine a craft-art scale, Lehn ware would certainly

be closer to the art end but still could not be completely separated from plain treen ware. Rigid typologies hinder the perception of complex interrelationships and thus should be avoided.

Rhodes presents several Pennsylvania cookie molds as folk sculpture (p. 51). Indeed, for the mold maker they could have been his finest, most imaginative, and creative work—in short, his art. But before we celebrate the excellence of his talent, we should consider the life of this mold in a kitchen where it was impressed upon batches of dough to form repeated series of fancy cookies. Perhaps these edible sculptures were made for a holiday or festival occasion. The art of the mold is then not confined solely to one wooden object but extends into diverse social areas. The significance and importance of the image incised upon the mold rises and falls with the level of energy in the social network. It will have one meaning for the carver, another for the cook, and yet another for the guest at a feast. If the original meaning of folk art is important, we will only discover it when we accept the responsibility for all of its complexity.

The notion that utilitarian artworks derive form and content solely from their function may blind the observer to accurate recognition of principles tied to aesthetic rather than pragmatic concerns. Rhodes claims that the function of duck decoys, for example, leads to standardization and conformity. The decoys must closely resemble ducks, ducks have many general features in common, hence the formation of a distinct genre of folk sculpture—or so the logic would have it. By extension, the more a model looks like the real thing, the better it will work, hence the better it is as artwork. An important fact not mentioned is that ducks will approach unpainted chunks of wood or Styrofoam that are floating in the water. Thus, for some hunters the least ducklike object imaginable is perceived as a good decoy. Given the fact that it is not appearances that deceive the ducks, we soon recognize that the decoy makers' attempts at reproducing wild

game colors, markings, and anatomy is done more for their sense of control over media than to lure waterfowl.[24] The decoy artist does more than imitate nature; he dominates nature by stylizing birds as he feels they should look. He imagines that a wild goose will see the world as he does and so models an appropriate substitute that any self-respecting goose would accept as a friend or mate. The oversized frame decoys that Rhodes illustrates clearly reveal this human self-superiority (p. 41). These particular hunting tools are intended to make a faraway object look closer and thus interesting. A flock flying a quarter of a mile away, in theory, should be attracted by a goose decoy standing more than a yard tall. Other decoys of descending scale are then used in a series that presumably will draw the flock still closer once it has passed the first attraction. Unconsidered is the possibility that the flock of geese would see the first decoy as an impossibly oversized critter or just another one of those human things that litter their flyway. If the geese happen to land, it is the cunning deception of the hunter that is credited not the imprinted instinct of the waterfowl. The use of decoys gives man the feeling that he has the upper hand when, in fact, the hunter is decoyed more than the duck. The focus on utilitarian principles in the study of folk art can disguise the vital human aspects of an artwork. Decoys reveal a great deal about man's desire for order in his environment in his terms. This is an issue which impinges significantly on aesthetic performance. The major question to pursue is not how an object is used but, rather, how it bears meaning.

Visionary Art

Works that grow out of spiritual inspiration, either secular or sacred, can only be properly labeled folk art if the vision is a collective one. The vision must be the same for many even if it seizes artists one at a time. By this standard the

santos figures of New Mexico and the commonplace images of American eagles and Uncle Sam are expressions of folk culture. *Santos* figures demonstrate in physical form communal participation in a localized version of Roman Catholic liturgy and a belief in the accompanying Christian theology. Patriotic images reveal a political allegiance to, and identification with, the general principles of American citizenship. The religious figures belong to a regional group, the patriotic images are associated more generally with the nation, although specific neighborhoods may pride themselves on the use of a standard Uncle Sam mailbox statue or a particular bald eagle with wings outspread over their front doors.

The carvings of Edgar Tolson cannot, however, be accepted as folk sculpture even though they are sometimes religious (for example, scenes from Scripture) or patriotic (for example, Uncle Sam). Tolson is well known to folk art collectors, and his pieces have been exhibited in several major American museums as examples of folk art.[25] But as Rhodes indicates, his work is "unprecedented" (p. 89). They thus have no connection with a traditional source. His carvings begin and end with him. No one is known to have carved like him before, and no one else carves like him now. (He may be imitated in the future if the market for folk art remains active.) Since he has no local antecedents for his works and is not united to fellow artists by shared imagery, we can only call Tolson a gifted, talented individual. While he has no formal art training, that is not enough to call his work "folk." Since his discovery, he has become a successful contemporary artist following his private vision while earning the respect and admiration of a large national audience. Tolson's art has some of the same characteristics of *santos*—stiff pose, frontal presentation, distortion of anatomy—but since there is no historical connection between the carvings of Kentucky and of New Mexico, nothing can be substantiated by such a comparison. The *santero*'s vision is communal. Tolson's is private. These are distinct

social circumstances which, in like manner, mark the two sets of artwork as distinct.

Rhodes includes the several versions of *The Peaceable Kingdom* by Edward Hicks as visionary works because of their religious theme. In these paintings Hicks joined a scene from Scripture copied from a painting by Richard Westall with elements of local Pennsylvania landscape and history. The combination is considered emblematic of Quakerism, and Hicks was a Quaker minister. While these paintings undoubtedly connect with his religious convictions, it is significant that Hicks himself considered painting "'one of those trifling, insignificant arts which has never been of substantial advantage to mankind" (p. 84). His canvases were by his own admission unwitting artworks. Having painted decorative elements on coach doors before he was allowed to enter the ministry, he dabbled at painting once he became a man of God. He perceived these paintings as an unfortunate attachment to worldly pleasures, in short, as a curse. The art created from this anguish should not be taken as typical of the community, or as traditional. The circumstances of its creation were Hicks's and his alone. *The Peaceable Kingdom*, like Tolson's work, was a personal statement, although many others could understand it.

An attempt is made to justify Hicks's painting as folk on the basis of his personal history. A connection is suggested between his sign and furniture painting days and his canvases. But by his direct copying from Westall, he broke with the decorative tradition and jumped over to images from the English Royal Academy of Arts. The central image in *The Peaceable Kingdom* is derived from fine art. In some versions Westall's figures are closely imitated. Furthermore, the background to many versions is derived from Benjamin West's painting of William Penn treating with the Delaware Indians. Thus, to insist on folk roots is to turn a blind eye to the evidence. Why then are Hicks's paintings considered folk art? The reason is that he "naively" approximated

the forms of his original fine art models. The distance between Hicks's art and fine art is then perceived as great enough to have his works be part of a different mode than that from which they originated. Rather than being seen as imperfect but still attractive copies, they are called excellent folk art. Definitional gamesmanship strikes again!

Twentieth-Century Folk Art

The last set of examples which Rhodes presents constitute a hodgepodge of unconnected sculpture and painting by six contemporary artists. Since she states quite clearly that none of them can be "considered truly traditional folk artists" (p. 95), one wonders why it is necessary to include them at all. The footnotes again provide the answer; these creators and many others like them are the mainstay of current folk art collecting. The standards of this collecting are never clearly articulated. These works look like art but are not made by people who are professional artists; therefore, these pieces must be folk art. This if-you-don't-know-what-else-to-call-it-try-folk-art approach is light on evaluative criteria and heavy on emotional reaction, and prone to lead only to further confusion. But when a distinguished folklorist like Louis C. Jones writes, "I am more concerned with whether or not an object is art than I am with whether or not it is folk,"[26] it appears that value judgments based on subjective reactions will dominate folk art commentary for some time to come. Never is it suggested that excellent amateur artists just might be some of the best modern artists of the day; that would stun the elite art circles.[27] Instead, the term "folk art" (because the word "folk" remains generally ambiguous) becomes the dumping ground for all the newly discovered talents who are found in every context imaginable. This body of work should not be allowed to become folk art by default.

It should be recognized that folk art is a very distinctive form of human expression in which aspects of social philosophy dominate personal desires, in which tradition is preserved and perpetuated. Folk art is not made by just anyone with talent—although talent and skill are certainly necessary. Connection and commitment are also required; connection to one's community and commitment to its values. Folk art is an expression of involvement, of sharing. It is not a private project like Fred Alten's menagerie, or Edward Kay's satirical totem poles, or Felipe Archuleta's one-of-a-kind animals. These artists, sometimes termed the "naives," deserve attention, but not as something which they are not.[28]

The suggestion made by Rhodes that the study of contemporary naives will tell us something about developing folk art is spurious. To learn about folk art one had better study folk artists. Folk artists are not the people who, as Rhodes suggests, "work from a personal simplistic concept of art that is rooted in a single-minded vision that does not project beyond their immediate environment and personal concerns" (p. 95). This description applies to the objects collected in place of folk art.[29] Contrary to general opinion, there still are craftsmen and artists who continue to create traditional forms long known in their families and communities. Moreover, folk art is not always rare and precious, although it is valuable. Think of the numerous jack-o'-lanterns made every Halloween, the trees trimmed each Christmas, the quilts pieced for every wedding and every new baby, the flowers planted at the side of the front walk. These are a few of the frequently encountered expressions; other forms like ceramic sculpture or Fraktur may be atypical and archaic. Nevertheless, it is important to study genuine traditions in place of ersatz ones.

Conclusion

In her concluding "Perspective," Rhodes actually proposes a defensible definition of folk art, noting that it is "derived from the life, concerns,

and aspirations of ordinary people and as such, reflects the underlying life patterns of the culture as a whole" (p. 108). This is an amazing statement, following, as it does, many examples lacking any fundamental communal input. Rhodes quickly adds that a folk art tradition of this kind exists in a country like Japan but not the United States because American culture is too heterogeneous, too large, too chaotic to have a clearly identifiable "life pattern." While American culture is complex, it is not a melting pot in which all the elements in the cultural life of the nation are eventually stirred into an undifferentiable, seething, bubbling mass. American culture is rather more like a salad, with many ingredients joined together but each one still distinct. To pursue folk culture, one needs to look not at the whole bowl but to search for those portions of the mix which are folk or those spices that are folk in origin and give flavor to the nonfolk elements. American folk culture does not exist at the national level but at the regional, local, neighborhood, and family levels. There is not one folk culture but several. American folk art is not singular but plural like its people. To speak, then, of a national folk aesthetic is a serious error, if there is such a thing, it exists chiefly in the minds of some commentators rather than as a force within any community. The term "American," it turns out, is as ambiguous as the term "folk"; it too needs definition if it is to be used productively as a descriptive word.

Rhodes worries that some "untainted" folk art which has up to now been spared the contamination of modern values will fall prey to exploitation if exposed to scholarship. First, the notion of pure folk culture is an ideal construct never found in reality; while a community may be small, isolated, and stable, the materials and ideas that it possesses often have traveled great distances. Southern folk pottery, for example, is distinguished by the use of alkaline glazes which have oriental origins. The visit of an outsider can do little harm to traditions that have weathered centuries of changing conditions. Second, the primary fear should not be that folk art will be modified by contact (it is always changing slightly due to shifts in artists' desires and audiences' expectations) but, rather, that the faddish celebration of amateur art will deny folk art the attention that it deserves. If knowledge of a tradition creates a demand for its products, then the tradition might just be preserved. While it is not the business of scholarship to promote art sales, it is appropriate that scholars provide the interested public with the information needed to make intelligent decisions. Greater cultural awareness and sensitivity are required if folk art is to be appreciated for the right reasons. Should this goal be attained, both folk artists and folk art audiences will benefit.

NOTES

From *Winterthur Portfolio* (1980). © by the Henry Francis du Pont Winterthur Museum. Reprinted by permission of the author and the University of Chicago Press.

The author would like to thank Debora G. Kodish and Patricia A. Jasper for their comments on an earlier draft of this article.

1. The development of folklore studies is charted in several books edited by Richard M. Dorson: *Folklore and Folklife: An Introduction* (Chicago: University of Chicago Press, 1972); *Folklore: Selected Essays* (Bloomington: Indiana University Press, 1972); and *Folklore and Fakelore: Essays towards a Discipline of Folk Studies* (Cambridge, Mass.: Harvard University Press, 1976). For a critical assessment of the relationship of folklore and American culture, see Roger D. Abrahams and Richard Bauman with Susan Kalcik, "American Folklore and American Studies," *American Quarterly* 28, no. 3 (1976): 360–77.

2. More than 700 books and articles are cited in Simon J. Bronner, *A Critical Bibliography of American Folk Art*, Folklore Publications Group Monograph Se-

ries, vol. 3 (Bloomington, Ind.: Folklore Publications Group, 1978).

3. The source providing the dogmatic definition is Holger Cahill's *American Folk Art: The Art of the Common Man in America, 1750–1900* (New York: Museum of Modern Art and W. W. Norton, 1932). Never are works from the large anthropological literature cited, such as the essays in Charlotte Otten, ed., *Anthropology and Art: Readings in Cross-cultural Aesthetics* (Garden City, N.Y.: American Museum of Natural History, 1971); Carol Jopling, ed., *Art and Aesthetics in Primitive Societies* (New York: E. P. Dutton, 1971); or Anthony Forge, ed., *Primitive Art and Society* (London: Oxford University Press, 1973). These works and others have many insights about concept, method, and interpretation to offer folk art scholars.

4. Kenneth L. Ames, *Beyond Necessity: Art in the Folk Tradition* (Winterthur, Del.: Henry Francis du Pont Winterthur Museum, 1977).

5. For a more general discussion of this matter, see Robert Redfield, *Peasant Society and Culture* (Chicago: University of Chicago Press, 1956).

6. The image of the artist's death in performance comes from a lecture by Henry Glassie at the University of Maryland, February 1976.

7. See "What Is American Folk Art? A Symposium," *Antiques* 57, no. 5 (May 1950): 355–62.

8. More than 150 examples of pictures, most of which are free from any attachment to folk culture, are presented in Jean Lipman and Alice Winchester, *The Flowering of American Folk Art, 1776–1876* (New York: Viking Press and Whitney Museum of American Art, 1974), pp. 15–117.

9. Calvin Trillin, "Simon Rodia: Watts Towers," in *Naives and Visionaries,* ed. Martin Friedman (Minneapolis: Walker Art Center, 1974), pp. 21–31.

10. Tom Armstrong, "The Innocent Eye: American Folk Sculpture," in *Two Hundred Years of American Sculpture* (New York: David R. Godine and the Whitney Museum of American Art, 1976), p. 75.

11. Henry Glassie, "Folk Art," in Dorson, *Folklore and Folklife,* p. 258.

12. John A. Burrison, *The Meaders Family of Mossy Creek: Eighty Years of North Georgia Folk Pottery* (Atlanta: Georgia State University Art Gallery, 1976), p. 32.

13. Daniel J. Crowley, "Aesthetic Judgment and Cultural Relativism," *Journal of Aesthetics and Art Criticism* 17, no. 2 (December 1958): 187–93.

14. Johannes Fabian and Ilona Szombati-Fabian, "Folk Art from an Anthropological Perspective," in *Perspectives on American Folk Art,* ed. Ian M. G. Quimby and Scott T. Swank (New York: W. W. Norton, 1980), pp. 247–92.

15. Ames, *Beyond Necessity,* pp. 27–31.

16. For examples of this kind of thinking, see Elinor Lander Horowitz, *Contemporary American Folk Artists* (New York: J. B. Lippincott Co., 1975), p. 23; and Frederick S. Weiser, "Pennsylvania German Folk Art," in *How to Know American Folk Art,* ed. Ruth Andrews (New York: E. P. Dutton, 1977), p. 148.

17. A detailed portrait of how a chairmaker first acquires the standards of his community and then develops his own personalized viewpoint which is still tied to notions of tradition is provided in Michael Owen Jones, *The Handmade Object and Its Maker* (Berkeley: University of California Press, 1975), chap. 4.

18. The blues at work in culture is shown in Albert Murray, *The Omni-Americans: New Perspectives on Black Experience and American Culture* (New York: Outerbridge & Dienstfrey, 1970), pp. 54–66.

19. For a description of the hidden intention of a set of plain, ordinary houses which shows that they embody some of the key conflicts in Western civilization, see Henry Glassie, *Folk Housing in Middle Virginia: A Structural Analysis of Historic Artifacts* (Knoxville: University of Tennessee Press, 1975), chap. 7.

20. The recent interest in New England gravestones has in part developed because of the insightful studies of Allen I. Ludwig, Peter Benes, Dickran and Ann Tashjian, and others. James Deetz has written several articles that unite the formal study of mortuary art with social history; his important discoveries are summarized in his book, *In Small Things Forgotten: The Archaeology of Early American Life* (Garden City, N.Y.: Doubleday, Anchor Books, 1977), pp. 64–90.

21. Amy Goldin, "Problems in Folk Art," *Artforum* 14, no. 10 (June 1976): 48–52.

22. For an example of the variations even in a single family, see Oscar Lewis, *The Children of Sanchez* (New York: Random House, 1961).

23. Robert Bishop, *American Folk Sculpture* (New York: E. P. Dutton, 1974), p. 215.

24. Adele Earnest confirms that painting decoys was not necessary ("The Wildfowl Decoy," in Andrews, *How to Know American Folk Art,* p. 37).

25. For an extensive statement from collector Michael Hall on values he finds in Tolson's carvings, see Herbert W. Hemphill, Jr., *Folk Sculpture U.S.A.* (New York: Brooklyn Museum, 1976), pp. 39–44.

26. Louis C. Jones, "Introduction," in Andrews, *How to Know American Folk Art,* p. 13.

27. A recent exhibit of Afro-American quilts staged by Maude Wahlman and John Scully at the Yale University Art Gallery was judged by the painting faculty as the "first interesting show in a long time" (Maude Wahlman to John Michael Vlach, July 1979).

28. Herbert W. Hemphill, Jr., and Julia Weissman indiscriminately assign the label "folk artist" to all the creators in their compendium, *Twentieth-Century American Folk Art and Artists* (New York: E. P. Dutton, 1974).

29. For further discussion on the misuse of the term "folk art," see Simon J. Bronner, "Recent Folk Art Publications: A Review Essay," *Mid-South Folklore* 6, no. 1 (Spring 1978): 28.

8

New Mexican Santos and the Preservation of Religious Traditions

WILLIAM WROTH

John Michael Vlach identifies the santos figures of Hispanic New Mexico as examples of genuine folk art, representing a collective spiritual vision and communal participation in a specific religious tradition. William Wroth examines the role played by these holy figures in the transmission and preservation of core religious values within a unified indigenous culture under increased pressure from the forces of modernization and Americanization. He explains the resistance of Hispanic Catholics in New Mexico to the values imposed upon them first by the Mexican Republic and then by the occupying Anglo-Americans as a concerted effort to prevent the desacralization of their culture.

Many of these modern ideals were in direct conflict with the traditional way of life structured around communal landholding and common religious beliefs. Under constant pressure to adapt to the material and political realities of liberal capitalism, Hispanic New Mexicans sought to preserve the primacy of the Spanish Catholic spiritual values that were at the center of their social and cultural institutions. Finally, Wroth joins Vlach in his concern with the distortion and misunderstanding brought about by recent interest in the unique aesthetic qualities of these objects without attendant understanding of their pivotal role in the traditional culture for which they were made.

To what extent were Hispanic New Mexican cultural institutions influenced and shaped in the 1700s and 1800s by outside factors such as other cultures and the environment? To what extent did New Mexicans in those days adapt their institutions and values to the new circumstances they faced on the rough northern frontier? In the often disputed question of adaptability of New Mexican cultural institutions, it is necessary to distinguish between the material and religious realms. In material life the New Mexican settlers certainly were adaptable and innovative, often dealing creatively with severe conditions and scarce resources on the northern frontier.

In religious life, however, they were not innovative, but rather were preservers of ancient traditions having roots in medieval and Renaissance Spain. The first settlers brought Hispanic Catholicism to New Mexico in the late 1500s, and their descendants continued to practice it with little significant change for more than three hundred years. The main tenets of Catholicism as practiced in Spain and Mexico were well understood by Hispanic New Mexicans and were integrally woven into daily life continually finding expression in signal events such as birth, marriage, and death. They were incorporated into the annual calendar, with the communal celebration of Holy Week, Corpus Christi, Christmas, and the many saints' feast days. The orthodoxy of

Catholic practice was further reinforced by the Franciscan friars and secular priests in the territory, by the active participation of lay people in a variety of Catholic confraternities (*cofradías*), and even by civil law, which often specified requisite behavior in the religious realm.

Family life also served to maintain Catholic traditions. Just as language was naturally preserved and passed from generation to generation, so too were religious traditions in the many and varied forms in which they appeared in domestic life. Examples of this include the naming of children after saints and holy persons, the *compadrazgo* (godparent) tradition, the daily prayers and recitations of the rosary within the home, and the very forms of address among family members.

In these core cultural institutions there was no significant influence from the Pueblo Indians, nor did the isolation or harsh environment of New Mexico have a great impact. Indian influences for the most part were upon externals, such as material productions and the knowledge of medicinal plants.

The environment's effect was also on the externals: the churches were sparsely furnished and often poorly maintained.[1] It was not possible to re-create the full richness of Hispanic Catholic observance found further south, yet the essentials were determinedly maintained. The institutions of religion, community, family, and language constitute the identity of a people, and they are not easily or quickly affected by change in exterior circumstances.

After the American Occupation of 1846, the pressures upon traditional Hispanic cultural institutions greatly increased. New Mexicans responded by consciously seeking to protect their religion and way of life against the changes brought by American sovereignty. They did not welcome these changes—there were few conversions to Protestantism, and American ways were only gradually taken up, first by the urban merchant class rather than by the rural people.

Hispanic New Mexicans rejected American dynamism, not because they were passive or incapable of adopting it, as so many Anglo commentators of the day claimed, but because its extreme emphasis upon commerce and material gain was an inversion of normal priorities. The purpose of life was spiritual, not material reward. The Americans' insistence upon material gain at all cost was accompanied by the severe threat of desacralization of social and familial institutions. In rejecting Anglo dynamism, New Mexicans were consciously attempting to preserve the religious basis of their way of life. This protection of core religious values cannot be separated from political or cultural resistance to change, for New Mexican life, like that of most traditional cultures, was highly integrated. Its unity depended upon the primacy of religious values and the societal and familial institutions founded upon these values.

The desperate, often futile attempt in the late 1800s to preserve their land base was an integral part of Hispanic resistance to change. Without the land base, the community was gradually bled of its male members. The prevailing Anglo American cash economy drew them away to work as herders for large sheep-ranching concerns, or finally, to work for wages in the cities. Without a viable communal land base, Hispanics were soon forced into the cash economy of the Americans.[2]

It would be a mistake to see the Hispanic fight for preservation of land purely in material terms. The economic power which land represented was not an end in itself; rather, it was the means for community survival, for the preservation of a communal way of life based upon religious principles. Loss of land meant not merely economic suffering but more importantly, loss of community and the desacralization of a way of life in which the sense of the sacred had firmly dominated material concerns.

Hispanic New Mexicans were not alone at this time in resisting change brought from the out-

side. Rather, their situation reflected a world-wide pattern in the nineteenth century—the resistance of rural and native peoples everywhere to the modernizing and desacralizing effects of the industrial Western world.

To understand the pattern of resistance taken by New Mexicans, it is necessary to see that until 1846, in spite of isolation, the territory was an integral part of the larger cultural and political entity of Mexico, first under colonial rule and then, after 1821, under republican rule. With the advent of republican rule, Mexican rural people in many areas, both mestizos and Indians, were soon faced with direct encroachment upon their cultural and territorial integrity. After 1821, a series of republican governments made conscious efforts to break up the traditional communal landholdings of the rural people. At the same time, the anti-clericalism of these governments was expressed in laws seeking to de-emphasize the place of religion in community life.

The prevailing philosophy of classical liberalism adopted by the national leaders placed the individual at the center of the stage. In the liberal view, each individual had economic and social rights that could not be abrogated or impeded by institutions such as the Church or the State. In post-colonial Mexico, these newly advanced rights of the individual were pitted against those of the traditional community. According to the liberals, communal landholding prevented the individual from owning and developing land as he saw fit.

In addition, both communal landholding and communal religious expressions and beliefs were contrary to the efficient creation and employment of capital. Traditional land usage operated outside the realm of capitalism because its major purpose was sustenance and protection of the community rather than profit-making. Communal religious expressions were a constant interruption to the efficient production of capital, and traditional religious beliefs were antithetical to the very premises of liberal capitalism. Both

communal landholding and religious practices were seen as major obstacles to the development of a modern nation state.[3]

Each individual, in classical liberal thinking, had *de jure* equal rights and equal access to the material resources of the society, but *de facto* such equality was notoriously absent. In nineteenth-century Mexico, laws designed to break up lands of Indian and mestizo communities in practice had the effect of concentrating these lands in the hands of the liberal leaders and their supporters.[4] Often, the former community members became little more than serfs upon large haciendas assembled from the enforced distribution of their village lands. With the enactment of the laws of the Reform of 1857, which marked the triumph of liberalism in Mexico, the new leaders soon gained control of most of the best land in the country at the direct expense of local communities, reducing the rural population in many areas to a state of serfdom which continued until the 1910 Revolution.

The Reforma of 1857 also included a series of anti-religious laws aimed primarily at reducing the power of the Catholic Church. The "Leyes Lerdo" had been fashioned by the prominent anti-clerical statesman, Miguel Lerdo de Tejada. In 1873 his brother, President Sebastian Lerdo de Tejada, attempted to put these laws more fully into effect by raising them to constitutional status. Among other anti-clerical actions, he expelled the Jesuit order from Mexico and suppressed the Sisters of Charity, who were widely popular for their charitable works.[5] The Leyes Lerdo were intended to reduce the role of the Catholic religion in Mexican life, and this they accomplished through several means, the most prominent being the suppression of confraternities and the prohibition of public communal celebrations such as Holy Week and other important observances.[6]

Thus, the laws of the Reform had a twofold impact upon rural Mexicans; their land base was under pressure through enforced sale, and their

1. Juan Ramón Velasquez, *Crucifix;* courtesy of the School of American Research
Collections in the Museum of New Mexico, Museum of International Folk Art, Santa
Fe, N.Mex.

religious traditions were under attack. These two aspects particularly affected the Catholic lay confraternities in towns and villages, which not only were often the chief sponsors of public religious observances, but also were communal landholding organizations.

The products of cofradía lands were used not to enrich individuals, but rather to support religious activities; hence, in the eyes of the liberals, this use of land was unproductive—it did not engender capital. Yet the cofradías served an important role for rural people, for like the community itself, membership in a confraternity protected the individual from adverse actions of the state or powerful outsiders. The traditional corporate community was made up of a coherent grouping of smaller corporations; at one level was the confraternity and at another was the extended family, which also protected the individual.[7]

While under the sovereignty of republican Mexico (1821–1846), New Mexicans were not deeply affected by liberal legislation aimed at land and religion due primarily to their remoteness and to the severe internal problems faced by Mexico's central government. Under the new republican regime, however, some efforts were made in the 1820s to secularize New Mexico's missions and convert Pueblo Indian communal lands to individual ownership by Hispanic farmers. Secularization of the missions—their removal from Franciscan authority and conversion to secular parishes—was seen as a means of achieving "equality" for the Indians by abolishing their privileged status under Spanish law and thus abolishing their traditional communal landholdings. Conversion of Pueblo lands attempted under the new laws of the 1820s proved to be of limited success, thanks in part to the just decisions of the New Mexican general assembly (*diputación*).[8]

Secularization of the missions was also an attack upon religious traditions, for the Indians and Hispanic villagers had been under the spiritual administration of the Franciscan friars since the early colonial period. Efforts to remove the missions from Franciscan control reached a head in the mid-1820s when the ecclesiastical visitor Agustín Fernández de San Vicente came to New Mexico and recommended secularization of five important Franciscan missions. The lack of secular priests proved a practical obstacle to any immediate full-scale secularization, however. Fernández was the uncle of liberal President Guadalupe Victoria, who had authorized his appointment and given him orders to investigate the moral and political behavior of the Franciscan friars.[9] Fernández spent his time in New Mexico attacking the friars and trying to turn the people against them, but apparently with little immediate effect. In at least one community the residents petitioned, although without success, to keep their Franciscan friar as pastor, rejecting the newly appointed secular priest.[10]

In the 1830s and 1840s New Mexican religious traditions again came under attack, when Bishop José Antonio Laureano de Zubiría condemned the public observances of the penitential brotherhoods. His objections had little immediate effect in New Mexico, but it was the beginning of a long process of desacralization of New Mexican religious institutions, paralleling that which took place in Mexico. With the American Occupation of 1846 both the land base and the religion of Hispanic New Mexicans came under prolonged attack from the incoming Anglo Americans, whose world view was based in the same classical liberalism as that of the republicans in Mexico. New Mexicans fought a losing battle to preserve their communal land base and way of life against the influx of Americans; they also sought, somewhat more successfully, to protect the core values of their religion.

In the protection and preservation of religious values in New Mexico, the holy images known as *santos* played a significant part.[1] Images are material and visual expressions of religious val-

ues, and they are of particular importance in a rural society in which written documents have a small role. In New Mexico, the santos made in the 1700s and 1800s accurately reflect the orthodoxy of Catholic practice described earlier in this article.

It is often popularly thought that New Mexican santos made in this period are quite idiosyncratic, and that therefore New Mexican religious practices must have been full of local adaptations and particularistic forms. This notion most likely derives from the unusual style of New Mexican images, which is an extreme simplification of prevailing academic modes, constituting a reflowering of the spiritual imagery of medieval European Catholicism.

Yet, in spite of this unusual artistic style, the iconography of the images—that is, the choice of saint and the depiction of attributes—remains almost completely orthodox. New Mexicans developed neither a particularistic nor a syncretic form of Catholicism. Their faith was based directly upon that of Spain and Mexico, and their images reflect this faith. They depict in standard iconographical forms the holy personages and important saints of Spanish Catholicism, as well as those popular in Mexico, such as Our Lady of Guadalupe, Our Lady of San Juan de los Lagos, and the Holy Child of Atocha. Only in rare cases are there significant iconographic alterations in New Mexican depictions, and these appear to be the result of isolated misunderstandings rather than expressions of a pattern of local adaptation.

New Mexican santos not only accurately depicted the important personages of Hispanic Catholicism, but they also depicted a wide range of lesser known saints and complex symbolic or allegorical scenes, indicating a surprising richness in the religious life of this isolated territory. Both the accuracy and the range of this imagery suggest that Catholicism was well understood in New Mexico, in comparison, for instance, with the syncretic practices among some Hispanicized populations in Mexico and elsewhere in

Latin America. Such an understanding was possible because of the integral role that religion played in everyday life. Among all but the least Hispanicized portions of the population, there was an understanding of Catholic dogma, cosmology, and eschatology which played a determining role in the attitudes and behavior of the vast majority of community members and was the chief source of communal stability.

Religious images played an important part in the preservation of Catholic orthodoxy, for not only were the major holy personages depicted but also difficult concepts such as the Holy Trinity, the Immaculate Conception of Mary, Purgatory, and the Communion of Saints. Such concepts could best be understood with the aid of visual depictions, and some images even contained, in a concise symbolic form, the entire sacred cosmology and eschatology of Catholic teaching.

The primary value of images, however, was not in their didactic role but rather in their spiritual function as bridges between the individual and heaven. Images were visualizations and embodiments of the holy personages and saints; the faithful prayed before them to receive inspiration in the conduct of spiritual life and to receive divine mercies in this life and the next. Images thus were sacred objects, and miracles were often attributed to them. The image embodied and reflected the qualities of the holy prototype, but it was well understood that heaven, not the image, was the true source of the miracle or the mercy received by the petitioner.

It was this sacred quality of images which gave them their crucial role in the lives of the faithful. In New Mexico the santos were actively used in personal prayer and in public ceremonies and constituted an integral part of daily life. This is evident from the abundant folklore surrounding both images and the saints themselves, which was an important part of oral tradition.

With the coming of American sovereignty in 1846 and the full impact of nineteenth-century

liberalism, images assumed a most significant role in the preservation of core religious values. This may be seen, for instance, in the survival to the present day of the important Holy Week ceremonies for which locally made statues of Jesus and Mary are essential. Traditional religious values, however, were under a great deal of pressure from the incoming Americans of liberal Protestant faith, and the santos did not escape it. For the New Mexicans these images were sacred— the very word santo means "holy," "blessed," or "consecrated." For most of the Americans, however, the images were but "pieces of wood," and to worship before them was folly and ignorance. They denied both the sacred quality and the efficacy of images and derided the ceremonies in which the santos were used. Public expressions of piety, particularly penitential piety, were ridiculed; locally made images gradually fell out of use and were replaced by imported, commercially made statues and prints.

Thus there was a gradual process of desacralization of Hispanic communal institutions in New Mexico after 1846 which was very similar to the situation in Mexico in its causes and results; both the communal land base and the Hispanic Catholic faith were under severe pressures well into the twentieth century. It is certainly a testament to the fortitude of Hispanic New Mexicans that in spite of these pressures so much of their religion and culture have survived to the present day.

New Mexican santos made in the 1700s and 1800s are still revered in some homes and churches, but the majority of surviving images are now found in the hands of museums and art connoisseurs. Since the 1920s, the formerly denigrated santos have been avidly collected and esteemed by Anglo American patrons of the arts. This new attitude, on the one hand, is an admirable revaluation of the religious images and of the culture in which they were produced. On the other hand, the attitude has several potentially detrimental aspects, for the question of desacralization still exists in a new and more subtle form. New Mexican santos are often collected and displayed with little sensitivity to their cultural and religious significance. They are esteemed purely for aesthetic reasons, as their simplicity in execution is in keeping with contemporary aesthetic notions which place a high value upon directness, linearity, flatness of form, and lack of naturalism in both painting and sculpture.

In addition, the santos are valued for their quaintness and naivete, and the culture which produced them is frequently seen as equally quaint and naive.[11] They thus become vehicles of a subtly biased cultural stereotyping. What is often omitted from the appreciation of New Mexican santos is an understanding and respect for their religious meanings and uses within the culture. Hispanic Catholicism is often misunderstood or simply ignored by collectors of santos.[12] Thus the process of desacralization, begun in the mid-1800s, is completed when these images are stripped of their religious content and given a lesser significance by their new owners and interpreters.

The display of santos purely as isolated art objects not only desacralizes the images but is an unfortunate diminution of their significance for the person viewing them, for only the aesthetic and formal qualities are presented and the rich cultural context is ignored. Yet the aesthetic dimension meant little or nothing to those who created and used these objects. The sole purpose of santos was their religious content; their refreshing aesthetic qualities were a natural expression of this content and of an innate sense of form shared by virtually all traditional peoples.

Fortunately, some collectors and museums are sensitive to these issues, and they treat santos with the respect due to sacred objects. To those Hispanic Catholics who have misgivings about the display of santos in museums, we would respond that as long as the display is done in a respectful manner, conveying the religious signifi-

cance of the images, it is appropriate and even beneficial, for such a display helps to educate both Hispanics and non-Hispanics about the values and history of Hispanic culture, and it contributes to intercultural understanding and communication. In addition, the objects are often much safer in museums than they are in a village church which may not have the resources to protect and care for them.

Fortunately, the tradition of image veneration in Christianity has never stressed the uniqueness of any specific created image, for it is the holy prototype that is worshipped, not the material representation. A respectful and accurate copy of a holy image consequently conveys the same grace as the original. The recent flowering of traditionally conceived santos by Hispanic New Mexican carvers and painters provides an abundant source of images for churches and homes, and it testifies to the remarkable persistence of the image-making tradition through the last two hundred turbulent years, in which loss rather than survival of cultural values has been the dominant theme.

NOTES

From *El Palacio* (1988), vol. 94, no. 1. Reprinted by permission of the author.

1. It is often suggested that the poor condition of the churches as described by nineteenth-century commentators can be neatly equated with a lack of interest in religion on the part of Hispanic New Mexicans. Such a view overlooks the many other expressions of piety and fervor, such as the *santos* and all they imply as well as *promesas,* processions, and the penitential brotherhoods. It is more likely that the poor state of the churches was an expression of official neglect—improvements of conditions in New Mexico were not a priority—and also resulted from the extreme poverty of most rural New Mexicans in this period.

2. For a recent study of land loss and adoption of cash economy in northern New Mexico, see William deBuys, *Enchantment and Exploitation* (Albuquerque: University of New Mexico Press, 1985), especially pp. 163–213. See also Charles L. Briggs, "Remembering the Past: Chamisal and Peñasco in 1940," in William Wroth, ed., *Russell Lee's FSA Photographs of Chamisal and Peñasco, New Mexico* (Santa Fe: Ancient City Press for The Taylor Museum, 1985), pp. 5–15. On the historical basis of communal land holding in New Mexico, see John R. Van Ness, "Hispanic Village Organization in New Mexico: Corporate Community Structure in Historical and Comparative Perspective," in Paul Kutsche, ed., *The Survival of Spanish American Villages* (Colorado Springs: The Colorado College Studies, no. 15, 1975), pp. 21–44.

3. On nineteenth-century Mexican liberal thought, see Charles A. Hale, *Mexican Liberalism in the Age of Mora, 1821–1853* (New Haven: Yale University Press, 1968), and Wilfred H. Callcott, *Church and State in Mexico, 1822–1857* (Durham: Duke University Press, 1926). The idea that Catholic practices obstructed efficient economic activity was often expressed by nineteenth-century commentators. See, for instance, *Through the Land of the Aztecs . . . by a Gringo* (London: Sampson Low, Marston & Co., 1892), p. 119.

4. Richard N. Sinkin, *The Mexican Reform, 1855–1876* (Austin: The Institute of Latin American Studies, 1979), pp. 126–27, 170–72. See also Hale, *Mexican Liberalism,* pp. 220 ff., and Jean Meyer, *Problemas Campesinos y Revueltas Agrarias (1821–1910)* (Mexico: Sepsetentas, 1973). Prior to the establishment of republican rule in 1821, there were of course encroachments upon communal lands and large haciendas were established in many areas to the detriment of local communities. Such encroachments in the colonial period, however, occurred in defiance of Spanish law which sought to protect native land holdings, while after 1821, the republican governments actively supported the alienation of communal lands.

5. Luis Pérez Verdía, *Historia Particular del Estado de Jalisco* (Guadalajara, 1911), vol. 3, pp. 429–30.

6. The enactment of the Leyes Lerdo in 1873 resulted in the rebellion of the *religioneros* (1874–1876) throughout rural areas in much of central Mexico, a spontaneous uprising of rural people in defense of their religion. The

religioneros had neither articulate leaders nor the support of the conservative establishment. Conservative politicians used the rebellion to show the inadequacy of Lerdo's government, but they did not actively support it, and Catholic Church leaders publicly called for the end of rebellion and obedience to the government. Yet the religioneros were able to marshall more than 10,000 troops in the states of Michoacán, Jalisco, and Guanajuato, and smaller numbers in Querétaro, Hidalgo, Mexico, and Guerrero, and they dealt the federal troops several decisive defeats. In deposing the unpopular Sebastian Lerdo, Porfirio Diaz defused the rebellion and kept it defused during his long rule by not enforcing the anti-clerical laws and by maintaining a conciliatory stance towards the Church. On the religioneros, see Jean Meyer, *La Cristiada* (Mexico: Siglo Veintiuno Editores, 1973), vol. 2, pp. 31–42.

7. On liberal attitudes toward the confraternities, see Hale, *Mexican Liberalism*, pp. 228–30. On the role of *cofradías* in colonial Mexican Indian life (much of which also applies to mestizo communities), see Charles Gibson, *The Aztecs under Spanish Rule* (Stanford: Stanford University Press, 1964), pp. 127–35.

8. G. Emlen Hall and David J. Weber, "Mexican Liberals and the Pueblo Indians, 1821–1829," *New Mexico Historical Review* 59, no. 1, pp. 11–22.

9. On Fernández' *visita*, see Connie Cortazar, "The Santa Visita of Agustín Fernández de San Vicente to New Mexico, 1826," *New Mexico Historical Review* 59, no. 1, pp. 33–48.

10. David J. Weber, *The Mexican Frontier, 1821–1846* (Albuquerque: University of New Mexico Press, 1982), p. 59.

11. "If to be naive is to be direct and spontaneous, to know nothing of dissimulation and subterfuge . . . then unmodernized peoples certainly possess—or possessed—that kind of naivety; but if it is merely to be without intelligence or critical sense and to be open to all kinds of deception, then there is no reason to suppose that our contemporaries are any less naive than their forebears." Frithjof Schuon, *Light on the Ancient Worlds* (London: Perennial Books, 1965), p. 99.

12. Sharon Udall notes that painter Marsden Hartley was inspired by the aesthetic qualities of New Mexican santos but was uncomfortable with the religious values of Hispanic Catholicism. See her "Painted Litanies: Marsden Hartley and the Santos of New Mexico" in *El Palacio*, vol. 94, no. 1 (Summer/Fall 1988), pp. 47–53.

9

Albums of War

On Reading Civil War Photographs

ALAN TRACHTENBERG

Drawing on contemporary theories of representation and signification, Alan Trachtenberg considers the crucial role of photography in constructing historical narratives. Trachtenberg focuses on the Civil War as the first American crisis to fully avail itself of "historicism-by-photography," the creation of a palpable sense of reality in recollections of the past through photographic evidence. In particular, photographic albums that simulated historical archives, designed for the intimate conditions of home viewing, are examined for the extent to which they provide, through the judicious combination of image and text, a structured discourse about the events and meaning of the war.

Challenging the commonplace belief in the incontrovertible reality, and thus reliability, of the photograph, Trachtenberg argues that both the meaning and the documentary value of the photograph can be called into question. The Civil War photographic album emerges as a purposeful narrative construction of which the most compelling truth is affirmation of the camera's presence as a witness to the past and thus of its privileged status as authorized purveyor of historical knowledge.

The mere notation of photography, when we introduce it into our meditation on the genesis of historical knowledge and its true value, suggests this simple question: COULD SUCH AND SUCH A FACT, AS IT IS NARRATED, HAVE BEEN PHOTOGRAPHED?

—Paul Valéry

On August 17, 1861, not quite a month after the first serious blood-letting of the Civil War, at Bull Run, the *New York Times* reported that "Mr. Brady, the Photographer, has just returned from Washington with the magnificent series of views of scenes, groups, and incidents of the war which he has been making for the last two months": views, the report adds, that "will do more than the most elaborate descriptions to perpetuate the scenes of that brief campaign." Few signs of actual bloodshed show in the Bull Run series; on the whole Civil War photographs depict preparations and aftermaths rather than battle itself.[1] Nevertheless the point holds: the photographs perpetuate a collective image of the war as a sensible event, what it must have looked

like had we been there. As Paul Valéry implies in his "simple question," the idea of the camera has so implanted itself that our very imagination of the past takes the snapshot as its notion of adequacy, the equivalent of *having been there*. Photographs are the popular historicism of our era; they confer nothing less than reality itself.[2]

The first significant crisis in modern history to occur within the memorializing gaze of a camera,[3] the Civil War offers an occasion to examine this historicism-by-photography, this notion that historical knowledge declares its true value by its photographability. It does not exaggerate to say that, while historians may still debate causes and meanings,[4] the Civil War enjoys a physical presence, a palpable cultural reality, entirely the legacy of a handful of photographs. Indeed, proclaimed historian Francis Trevalyan Miller in the monumental *Photographic History of the Civil War* (1912), "these time-stained photographs" are the only unarguable facts to survive the war:

> We must all be of one and the same mind when we look upon the photographic evidence. It is in these photographs that all Americans can meet on the common ground of their beloved traditions. Here we are all united at the shrine where our fathers fought.[5]

By their apparent incontrovertibility the images possess a veritable sacral power; they define a "common ground," they delineate a symbolic "shrine," they provide us with "fathers." Thus the photograph not only historicizes, bringing "past history," as another writer put it, "into the present tense,"[6] but it discloses a hidden nerve within the event: the war as a unifying experience in our common "Anglo-Saxon" heritage: "No Grecian phalanx or Roman legion ever knew truer manhood than in those days on the American continent when Anglo-Saxon met Anglo-Saxon in the decision of a constitutional principle that beset their beloved nation."[7] With hardly a mention of slavery or of blacks, the *Photographic History* depicts a war that makes visible an overarching

trope: "the American War of the Roses." Thus the photograph seems to remove itself, and us, safely beyond controversy and threat.

The closer we look at the Civil War photographs, however, the more does their incontrovertibility come into question. They are, we learn, vulnerable to exactly the same obscurities of other forms of evidence. The simplest documentary questions of who did what, when, where, and why may be impossible to answer. And much more consequential matters of meaning and interpretation, of narrative and ideological tropes, of invisible presences and visible absences, have rarely even been asked. Much of the hard archival scholarship seems to have gone in pursuit of one particular red herring: the role of Mathew B. Brady, with whose name the entire Civil War project has long been unshakably identified. As everyone knew at the time, Brady was more an entrepreneur than a photographer, the proprietor of fashionable galleries in Washington and New York. It seemed to trouble no one that he was not himself the cameraman who made the pictures he signed "Brady." The first to organize a corps of photographers to cover the war at the front,[8] he also bought or otherwise appropriated all the war images that came within his reach to include within his several published series of stereographs, album cards, or large mounted prints. Recent scholarship has attempted to sort out just what role Brady performed during the war, what credit he deserves for the images he sold under his name.[9] This question of credit proves misleading, however, for it applies a category, of authorship, only marginally relevant to the commercial and discursive practices of photography at the time. To be sure, practices were in flux, and controversies over authorial credit as well as copyright came to a head at least once, in the quarrel between Brady and the manager of his Washington gallery, Alexander Gardner.[10]

More important than who made each image is how what was made came to be viewed as a

communication—how it came to have a meaning. It can be said that whoever may have authored Brady's images, "Brady" authorized them, gave them imprimatur. Indeed on occasion he placed—we might say inscribed—himself within the picture, clearly not as the photographer but the impresario or producer of the event itself. Most important, he placed the images in a distinct context, a structured discourse that has sealed them indelibly as "Civil War photographs." Although priority in this matter is minor, Brady does seem to have been the earliest to conceive of a form for the presentation of the pictures, a structure to contain and articulate them as a whole entity, a totality—and to enunciate them one by one as parts of that totality. "Among the sun-compellers," remarked the *New York Times* in November 1862 on the appearance of *Brady's Photographic Views of the War,* "Mr. Brady deserves honorable recognition as having been the first to make Photography the Clio of the war." While it is not astonishing that Brady should appear in the role,[11] it is striking that the muse of retrospection should be evoked about the picturing of an event still in progress. Brady's 1862 publication is the earliest effort to organize a rapidly accumulating mass of war and war-related images, to present, even as the war progressed and images piled up, the entire mass as a single whole, an emergent totality. We can gain some sense of the scope of the project, the range as well as the quantity of images, from Brady's account of the collection he offered for sale to Congress in 1869: "The pictures show the Battle-fields of the Rebellion, and its memorable localities and incidents: such as Military Camps, Fortifications, Bridges, Processions, Reviews, Siege Trains, Valleys, Rivers, Villages, Farm Houses, Plantations, and Famous Buildings of the South: together with Groups and Likenesses of the prominent actors, in the performance of duty; before and after the smoke of battle; around bivouac fires; in the trenches, and on the decks of iron-clads—the whole forming a complete Pictorial History of our great National Struggle."[12] The suggestion here of an inventory, of simple record keeping, implies a regularity among the images, a uniformity of value, each image serving equally well to delineate a detail within a total view. At the same time the list suggests something sweeping and epic, a motive as much rhetorical as inventorial, as much to tell as to show, to encompass a great struggle as if from the grand perspective of Providence.

The inventorial form was, of course, neither Brady's invention nor unique to his practice; it was simply the most obvious, even "natural" way to list such images. The very obviousness of the form is precisely what makes it at once so potent as a vehicle of cultural meaning and so hard for us to see. The archival form permitted the photographer-editor to hold together all the particulars of an emerging whole, to endow each image with what Foucault calls "enunciability."[13] As the maker and purveyor of galleries of images, Brady would have understood that without an encompassing structure, an archival totality, individual images remain empty signs, unable to communicate a determinate meaning. The archive empowers the image, but specifically by depriving it of its traditional powers as picture, as a unique formal event occurring within an enframed space. Taken as a discourse the archival mode of Brady's catalogs implies a much-diminished role for the individual image, no more than a single variable within a set of categorical regularities—e.g., "559. Killed at Battle of Antietam." The catalog empowers the image, then, not as a picture but as a datum, an item of sequential regularity.

In actual presentation the image underwent other transformations of status, none more crucial for the evolution of a popular culture in the decade of the war than that represented by the stereograph. Indeed so popular was this mode of dissemination that any discussion of the Civil War photographs and the problems of reading they pose must take the stereograph into account.[14]

The stereograph was an outgrowth of a major technological change in photographic reproduction. In the decade before the outbreak of war the wet-plate process had introduced two critical innovations. Reduction in exposure time (relative to the older daguerreotype process) made possible instantaneous or stop-action representations of motion; and as a negative-positive process the new development enabled the mechanical reproduction of unlimited editions of images from individual negatives. As developed by commercial photographers and manufacturers these innovations introduced a new popular imagery of everyday life: views of crowded city streets, of figures in motion caught in stride and, when photographed from above, in random patterns never before perceived. The stereoscope, meanwhile, introduced three-dimensionality as a new condition of viewing images, particularly images whose exactitude of representation made them seem virtual simulacra of the perceptible world. The importance of this small hand-held wooden device cannot be stressed enough; it not only made possible portable and private panoramas, but facilitated a decisive moment in the evolution of bourgeois domestic life: the transformation of the living room into a microcosmic world unto itself. Designed as a decorative item as well as an optical instrument, the stereoscope bespoke interiors and family hours; it bespoke new satisfactions of experiencing oneself as witness to the entire palpable world, a sedentary spectator of the outside now safely and sedately brought inside. Thus the stereoscope permitted not merely a discovery of what the quotidian consisted of—detail in such "frightful amount," wrote Oliver Wendell Holmes, that "the mind feels its way into the very depths of the picture"[15]—but a way of savoring that pleasurable fright from the safest of distances: that between one's eyes and a photograph. Seeming to chart new realms of visual (and vicarious) experience, the stereoscope made images appear as if boundless, unframed and unbordered, experienceable

as intimate personal events, as private spectacles. The design of the viewing device itself encouraged this privatization of spectatorship, the hooded eyepiece requiring total concentration upon the three-dimensional effect—a "half-magnetic" effect Holmes described as follows: "The shutting out of surrounding objects, and the concentration of the whole attention which is a consequence of this, produce a dream-like exaltation of the faculties, a kind of clairvoyance, in which we seem to leave the body behind us and sail away into one strange scene after another, like disembodied spirits."[16] The minuteness and clarity and magnification of photographic detail resulted, then, in an enjoyable estrangement from the familiar, the alien appearing safely and as if for one's own delectation, directly within the sphere of the familiar.

Issued in groups and series, stereographs often offered verbal information along with their visual data. In this capacity for a sequential viewing, stereographic series resembled another popular form, perhaps less pervasive as a mode for the distribution of Civil War images, but more accessible for analysis: the album. Like the stereograph the album had emerged only recently, as an adjunct to the extremely popular *cartes de visite,* small paper portraits mounted on cards.[17] Like the stereoscope the album belonged by design in a living or drawing room, a place of display and family viewing. In structure the earliest albums consisted of slotted pages permitting the insertion of cards within proscenium-like openings, a theatrical frame for the portrait. Presumably Brady adopted this mode as one of the formats for his views, a mode that would have encouraged the interchangeability of images. The viewer might arrange and rearrange the order of pictures according to whatever rules or purposes—to create, in effect, one's own sub-archive.

Strictly speaking the archive assembled by Brady recognized only spatial regularities and differences; temporality appeared only as a subcategory, not a major organizing principle. Non-

prescriptive (one can pick and choose and rearrange at will), the archive is non-narrative; it tells no stories. Nor, taken as a physical vehicle, does the album, which does, however, invite and facilitate a restructuring of the order of things and thus the making of countless personal sequences and stories. Mediating between the archive and innumerable unspecified cultural functions, the album (a kind of folk form of the age of mechanical reproduction) provides endless narrative-making possibilities. The form itself, by its very blankness (blankness being at the very root meaning of "album") prompts us to invert Valéry's innocent-seeming question, to ask whether it is possible to imagine photographs without narratives, without configurative structures to focus isolated images into a meaningful sequence or diegesis.

The albums of war we most wish to examine may well be lying forgotten in dark cellars or unused archives, the constructions of those many thousands who must have purchased *Brady's Album Gallery* and the blank book to go with it. Whatever albums Brady himself may have assembled and sold also seem lost or disassembled, and out of circulation.[18] Three remarkable and original works remain. Technically speaking, bound and including texts they are books or portfolios, but their mode of discourse, of presentation, is that of the album. Two have been reprinted and remain in circulation: Alexander Gardner's *Gardner's Photographic Sketchbook of the Civil War* (1866) and George P. Barnard's *Photographic Views of Sherman's Campaign* (1866).[19] The third is a little-known work by a well-known photographer: *Photographs Illustrative of Operations in Construction and Transportation* (1863), an instruction manual written by the military engineer Herman Haupt, illustrated with photographs made by A. J. Russell, and "sent to officers in command of Departments, Posts and Expeditions, with a view to increase the efficiency and economy of the Public Service."[20]

Differing as they do in uses, in their construction of narratives, in their relation to accompanying texts, each of these albums arises from or presupposes an archival base and thus represents a contradiction or discursive tension typical of this early moment in the emergence of photography as a medium of everyday (which is to say, historical) life. They share a dilemma that remains fundamental to the practice of a serious photography: how to make pictures in a medium incapable of suppressing its appetite for indiscriminate detail, a medium thought to be anti-pictorial in its disregard for hierarchies of representational value. How each of these albums of war confronts this intractable power to depict war as an event in everyday life, and by what ideological tropes they attempt to exploit or subdue those "obdurate realities" represented by the camera lens, are questions I want to ask of each album, questions, I want first to suggest, related to difficulties of perception arising from the war itself.

The domain of ideology coincides with the domain of signs. They equate with one another. Wherever a sign is present, ideology is present. Everything ideological possesses semiotic value.
—*V. N. Vološinov (M. M. Bakhtin)*

"Let him who wishes to know what war is," wrote Oliver Wendell Holmes in July 1863, "look at this series of illustrations."[21] The remark launches an extraordinary digression on images recently issued by Brady of the Antietam battlefield in what had otherwise been Holmes's charming and entertaining *Atlantic Monthly* essay.[22] Appropriately titled "The Doings of the Sunbeam," the essay had betrayed until then no particular sense that a war was then in progress, that casualties were grievous and mounting, that blood and dismemberment had become commonplace items of daily news. The elder Holmes had rushed to the site of the battle in search of his wounded son—a disheartening experience he

had recounted in an *Atlantic* essay a few months earlier;[23] the horror and revulsion now returned in a rush. "It was," he wrote, "so nearly like visiting the battle-field to look over these views, that all the emotions excited by the actual sight of the stained and sordid scene, strewed with rags and wrecks, came back to us, and we buried them in the recesses of our cabinet as we would have buried the mutilated remains of the dead they too vividly represented."

Only a paragraph buried in an otherwise cheerful essay, Holmes's account of his revulsion from the "terrible mementoes," his need to lock them safely away "in some secret drawer" conveniently at hand in his study, cannot help but draw attention to itself as an extraordinary eruption. It is a compelling moment of discomposure on the part of perhaps the most composed, the most properly buttoned and self-possessed of the Boston Brahmins (it was he who coined the phrase "the Brahmin caste of New England"), suggesting an overdetermined response, his language of repression seeming more appropriate to guilt than to disgust. Of course the horror may measure a father's conscience-stricken response to his son's hurt. Like others of his caste Holmes had welcomed the "war fever" for the very opportunity it would avail "our poor Brahmins" to test themselves and learn the virtues of heroism befitting aristocrats.[24] Whether or not the human wreckage he had just witnessed at Antietam chastened his fervor, the photographic remains of that sad event proved too much like tokens of the real thing to be endured. Shattering the security of that "dream-like exaltation" and disembodiment he had in an earlier essay described as comforting oneiric effects of the stereograph, these simulacra of dismembered bodies intruding upon his interior space somehow *re*embodied the viewer as one who "sickens at such sights." As if they were the "mutilated remains" themselves, the photographs must be stricken from sight.

But burial does not come easily. Undeniably, Holmes writes, the photographs represent actuality; better than the hand of a fallible human artist the "honest sunshine" provides at least "some conception of what a repulsive, brutal, sickening, hideous thing" war is. Still, such images compel us to face the following dilemma: "The end to be attained justifies the means, we are willing to believe; but the sight of these pictures is a commentary on civilization such as a savage might well triumph to show its [*sic*] missionaries." Is civilized savagery any less savage? The inescable clarity of the question suggests another motive for repression of the pictures, for now they appear not merely as tokens of a remembered horror, but also of an unendurable contradiction: a war fought for unequivocally admirable ends—with means such as those represented by "mutilated remains." The question wins no reply, only a counterassertion:

> Yet through such martyrdom must come our redemption. War is the surgery of crime. Bad as it is in itself, it always implies that something worse has gone before. Where is the American, worthy of his privileges, who does not now recognize the fact, if never until now, that the disease of our nation was organic, not functional, calling for the knife, and not for washes and anodynes?

The ploy here, of yoking together medical, religious, and legal allusions into a single metaphor, defines yet another role for the photographs. By linking war with surgery, the "crime" of rebellion (slavery being the lesser evil in Holmes's mind) with organic disease, and the knife with martyrdom and redemption—all in defense of putative privileges of a putative American, the metaphor not only authorizes Antietam, but also adds a sacred aura to the photographs. If what is "repulsive, brutal, sickening, hideous" is in fact the sign of surgical martyrdom, then are not the photographs—the only lasting vestige of actual

surgery, the remains of the remains—relics of a sort, emblems of that which we refuse to look at and yet cannot avoid seeing? What makes the pictures unseeable seems not the gruesome depictions themselves but what they portend: a potential fissure within Holmes's system of belief, the structure by which Northern intellectuals ranging from patricians to abolitionists explained to themselves the unexpected savagery and mass destruction of the war. The seeable represented the unspeakable: was Union worth the cost? Can the future rising from such unleashed violence be faced without a shudder? It is such vagrant and anarchic thoughts that must be buried, expunged from the experience of the pictures. To revise them as sacral emblems is to preserve at once the sight of them and one's peace of mind. Indeed peace of mind seems what Holmes's essay is chiefly about: a worldly-wise Brahmin's keeping (and displaying) his equanimity. While photography may be the overt theme, urbanity is the subliminal message, urbanity even in the face of the unseeable horrors of war. After recovering his poise Holmes proceeds upon the main business of the essay: to review the current state of photography, the "doings of the sunbeam." By watching him at work in the essay as a whole, we can better grasp the ideological underpinnings of his treatment of the war pictures.

The essay opens as a jaunty behind-the-scene tour of one of the "principal establishments in the country, that of Messrs. E. and H. T. Anthony, in Broadway, New York." Holmes wants here to establish "what a vast branch of commerce this business of sun-picturing" has become. What he finds is that behind closed doors the photography trade is an elaborate manufacturing enterprise complete with steam power, mass-production, and unskilled wage labor. Observing the making of such commodities as decorative portrait albums for the drawing room (and perhaps for the war views just then beginning to arrive upon the market), Holmes casts his eye upon the "operatives," many of them young women:

> A young person who mounts photographs on cards all day long confessed to having never, or almost never, seen a negative developed, though standing at the time within a few feet of the dark closet where the process was going on all day long. One forlorn individual will perhaps pass his days in the single work of cleaning the glass plates for negatives. Almost at his elbow is a toning bath, but he would think it a good joke, if you asked him whether a picture has lain long enough in the solution of gold or hyposulphite.

As an account of fragmented and alienated labor this could hardly be improved upon, particularly since Holmes then proceeds to describe in detail his own attempts at exactly those tasks of production that the assembly line keeps its operatives from learning—presumably even from wishing to learn—the preparation and exposure of the wet-plate negative, the development of the negative, and the making of the print. "Every stage of the process," he boasts, "from preparing a plate to mounting a finished sun-print, we have taught our hands to perform, and can therefore speak with a certain authority to those who wish to learn the way of working with the sunbeam." The "those" are not likely to include the operatives whose labor, not incidentally, supplies the material and the tools for the very simplification of the production of photographs that makes it possible for Holmes to remark "how little time is required for the acquisition of skill enough to make a passable negative and print a tolerable picture."

The second half of the article takes up particular genres of photographs, especially stereographs: landscapes, instantaneous city views, bird's-eye views of cities from balloons, microscopic and celestial photography, the fad of "spirit" photographs, the growing fashion of un-

acquainted correspondents exchanging pho-
tographs and developing a "photographic inti-
macy" as "a new form of friendship"—and war
views. It is in effect an archival survey of appli-
cations, all presupposing the processes described
in technical detail in the first section of the essay.
Yet in the second half Holmes somehow neglects
to recall what he disclosed in the first half—that
so far from being a pure reflex of nature, the free
"doings of the sunbeam," photography was a dis-
tinctly commercial enterprise undertaken under
distinct social relations, those of industrial capi-
talism—a mode of production and of social rela-
tions that in particular ways constrained and pre-
scribed the practice of both professionals and the
growing number of "amateur artists," including
those growing numbers of lonely persons who
found in photography some forlorn hope of alle-
viating isolation through exchange of images.
Moreover, after his discovery that behind the
doors marked No Admittance, at the very heart
of the "inner chamber," the "sanctuary of art,"
lies the worm of unskilled wage labor, unac-
countably Holmes begins to weave within his
descriptive language allusions to Acheron and
Styx and Hades, to speak of "mysterious forces"
and "that miracle" of photographic reproduction.
Like the images of Antietam, so the memory of
those forlorn operatives has been buried in some
secret drawer—all the more striking when we re-
call that the very Antietam stereographs whose
ostensibly unmediated actuality brought horror
to his soul were *produced* by the very E. and
H. T. Anthony Company where he observed a
"young person" mounting—blindly, as it were—
"photographs on cards all day long."

As in his compressed account of the burying
of the Antietam remains, so in the essay as a
whole Holmes virtually diagrams a process of
self-blinding, of seeing and forgetting, repress-
ing and displacing, that is a sign of ideology.
What difference that forlorn countenance might
have made to Holmes's experience of those pic-

tures, or ours, is not simple to say, but we can
say that to the extent that such social facts re-
main out of sight, invisible, irrecoverable, to that
extent photographs more easily seem unmedi-
ated, innocent representations—their seeming to
be without mediation being precisely the mes-
sage of an ideology: that they represent a pure
capture of nature by a marriage of science and
art. In the very act of seeming to make the world
visible the photograph as such vanished from
sight, the social labor it embodied banished from
thought. Thus the "mutilated remains" of the war
embraced hidden truths of the photographic pro-
cess itself.

*For every image of the past that is not recog-
nized by the present as one of its own concerns
threatens to disappear irretrievably.*
 —*Walter Benjamin*

"The real war will never get in the books." We
think of Whitman's words as a lament, a loss for
which, however, we can find consolation in pho-
tographs.[25] For are not the albums of war just that
real war gotten into a book, the war made visi-
ble, and in its visibility a *legible* event? Consider
the formal problems faced by Gardner and
Barnard: to provide an appropriate text for a
given image (Gardner) or an appropriate image
for a given text (Barnard). The apparent simplic-
ity deceives us, however, as it may well have de-
ceived the photographer-authors themselves, for
the passage from visibility to legibility proves a
more treacherous crossing than the figure of a
photographic historicism allows.

Although they adopt logistically different rela-
tions between image and text—Gardner places a
text opposite, along with a dated caption under
each of the one hundred prints that make up the
two volumes of *Gardner's Photographic Sketch-
book of the War* (1866); Barnard provides only a
number and identifying caption with each of the
sixty-one pictures in *Photographic Views of Sher-*

man's Campaign (1866) and adds a separate booklet with a narrative essay and maps—both assume a mutuality of picture and text in rendering a narrative: the story of a specific campaign in Barnard's case, of an entire war in Gardner's. In both the image is primary; Barnard would surely agree with Gardner that "verbal representations of such places, or scenes, may or may not have the merit of accuracy; but photographic presentments of them will be accepted by posterity with an undoubting faith." They share as well a physical or artifactual trait. They are both constructions in a mode without definite precedent: the book or portfolio of text and original photographs (*not* reproductions). Gold-toned albumen prints taken directly from the glass-plate negatives and mounted on heavy paper pages, the photographs are large and bold in size (roughly 8 × 10 inches in Gardner; close to 11 × 14 in Barnard), sensuous and vivacious in surface texture. They are decidedly not album cards or stereographs, nor popular photography. If any photographs at that time might lay a claim to fine art, it would be such prints. Indeed a review of Barnard's book in *Harper's Weekly,* remarking that "they are splendidly mounted and bound in a single volume in the most elegant style," recommended that "although, from its expense, the book cannot be popular, those who can afford to pay one hundred dollars for a work of fine art can not spend their money with more satisfactory results than would be realized in the possession of these views." Both books lay out of reach of a popular audience—for example, of former soldiers. Products of labor (printmaking; bookbinding) associated with fine art, they present themselves as artworks; not merely views but possessions. They soon became collector's items, redeeming their original commercial failure.[26]

Barnard's work seems the simpler; his text tells a continuous story with little direct mention of the pictures. Text and maps permit placement of each image within a narrative of events as well as within two distinct symbolic discourses: the spatiality of the map, the temporality of the text. No explicit evidence of narrative detail need be present in the actual images—indeed many of them are so bare of explicating detail that only the separate text makes sense of them as parts of a sequence. We can say that Barnard's text not only tells a story but *reads* the photographs, makes pictures of them even without direct allusion. Gardner does not aim at the same kind of continuity. He embraces the entire conflict; his pictures take their meaning not from their place within a specific unfolding event, but in relation to an immanent whole: the war. While Barnard's overt argument is simply to recount the events of a single campaign, Gardner's is to memorialize particular places, the site of events ranging from pitched battles to encampments to the fording of rivers, as "mementoes of the fearful struggle." While Gardner's sympathies are unmistakably with the Union, the struggle itself remains implied, not articulated either as a history of warfare or as a political event. Each of Gardner's texts addresses its specific image, often recounting brief narratives or random details incidental to the explicit subject of the photograph or to the large patterns of the war. Without accompanying maps, without any systematic effort to cover all major battles and campaigns, the *Sketchbook* assumes a unity given by the war itself, by the reader's presumed knowledge of the shape of events, the popular narrative that opens at Sumter and concludes at Appomattox. Thus Gardner feels free to open his book *in medias res* and to proceed excursively. His is a *tour* of the war, a series of sketches only casually connected by chronology.

So much seems obvious and unproblematic. Are these photographic constructions free, then, of the difficulties experienced by Holmes and apprehended by Whitman—difficulties arising from the antithetical character of the war itself, its fissure we can think of as sundering not only

hearthstones but also livid details of war from overarching ideologies, from containing narratives? It is in the relation between parts and whole, between the single image and the enclosing structure, where we might find signs of strain, of rupture of image and narrative, perception and ideology. Of course we might say that the need for a determinate structure, a specific unvarying sequence more rigorous than the interchangeability of the album, derives as much from the character of photographs as from any ideological crisis arising from the war: their intransigent ambiguity, for example, under all but the most controlled situations. But ambiguity appears typically in relation to some particular claim of certainty, some notion of distinctness; it appears as a resistance to specific pressures, as a local trope.

Take, for example, Plate 4 of Gardner's book, "Stone Church, Centreville, Va., March, 1862" [1]. It appears also as "Eve of the Conflict" in the essay on Bull Run in volume one of *The Photographic History of the Civil War* (1911), where it is described as a scene of troops en route to battle:

> Past this little stone church on the night of July 20, 1861, and long into the morning of the twenty-first marched lines of hurrying troops. Their uniforms were new, their muskets bright and polished, and though some faces were pale their spirits were elated, for after their short training they were going to take part, for the first time, in the great game of war.[27]

The text weaves the image into its own narrative of the eve of the first battle of the war, a moment of light-hearted innocence, the laughing young soldiers "hardly realizing in the contagion of their patriotic ardor the grim meaning of real war." But does close examination sustain this role the text imposes on the image? In fact we can hardly tell what the ten men visible in the image are doing there except looking at the camera, signifying their knowledge of and complicity in the making of a photograph from an elevated point above them. The blurred figure on the left tells us that the exposure was of long enough duration for his movement to be recorded, while the others are more successful in holding their poses, presumably as directed by the photographer. The country looks poor, the rutted road hardly inviting for the cart behind the line of soldiers. The expanse of bare and stony foreground heightens a sense of barrenness—strange for July. It is not a scene merely stumbled upon, but chosen by a photographer who wanted us to see something, though the 1911 text leaves us in the dark about what that might be.

The Gardner text is more helpful, though here too the explicit message remains invisible in the image, while the actual event recorded in the image—a group of soldiers in a particular landscape having their photograph taken—remains unacknowledged and unexplained. We learn that the stone church is the center of interest and that the image was made in March 1862, in the early spring almost a year after the Bull Run battle. Gardner's text evokes the natural cycle as the subtext of the picture itself. The prose begins by portraying the village as "perched upon the gentle slope" of a ridge, "looking across fertile fields," there always being "an odor of wild roses and honey-suckle about it, and a genial hospitality to welcome the stranger." But "war crushed it," and "scarcely a vestige of its former self remains." Now the land shows riflepits, redoubts, and graves; armies have passed through. "Guerillas have swarmed about it, cavalry have charged over its untilled fields, and demoralized divisions have bivouacked for roll-call behind its hills." What we see, then, is a trace of a history: the rutted road, the rocks lying about, a deserted town inhospitable to the soldier-strangers. Although the description is specific to this town, it seems an emblem of the war itself, a disruption

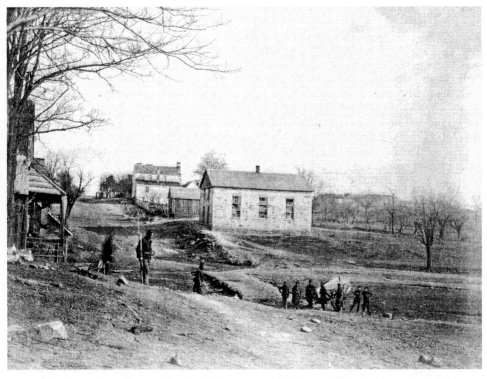

1. "Stone Church, Centreville, Va., March, 1862"; courtesy of the Library of Congress.

of the peaceful self-contained world that was the American countryside.

Gardner's text takes hold of the image, saturates it with a meaning, and allows the viewer to incorporate its details into a generalized narrative of the war as an unnatural event, a disruption of America's self-sufficient pastoral harmony. And indeed the image seems to answer to some of the interpretive demands placed upon it—the rutted road can be taken as a fortuitous sign of the very rift of the war slashing between past and present—but only as long as we repress a troublesome question: what does the only determinate act recorded in the image—the making of the photograph itself—have to do with Gardner's pastoral metaphor? The most immediate fact registered by the image is the presence of a camera at this particular scene.

Why is it there? Gardner's account says nothing about that presence and its implications for the character of this war and for the return of the pastoral harmony he envisions. Similar disjunctions between image and text can be found throughout the two volumes; indeed in almost all instances the picture can be turned against the text. Of course the very presence of a text

making metaphoric claims may itself bring forth ambiguity, a figure that may inhere in the relation of images and texts in the first place. But it is not the ambiguous relation we want to consider so much as the response to it: Gardner's effort to contain the image, to suffuse or saturate its quiddity with ideological import—which is to say, to distance the viewer from the specificity of the image, the opacity of its everyday detail.

The main effort occurs in the brief essays attached to each image, but it begins on the title page and is evident in the loosely diegetic sequence of the images. The essays interpose, as we have seen, not merely data—names, dates, events—to supplement the image and enhance its power as a moment in the large design that is the war, but also a certain tone and manner, a literariness, an air of self-conscious art. The title page inaugurates this major intonation of the book: both *Sketchbook* and the engraved vignettes appropriating to *Photographic* an association with drawing, the recording with pen or pencil of quick, incisive first-hand impressions directly from life. *Sketchbook* implies a certain latitude of structure, a casualness of pace, the detachment of an interested but unhurried observer, a posture at odds with that of a working wet-plate photographer in the field. The title page captures the reader/viewer in one of the familiar discourses of fine art, and further it specifies those discourses in two iconic ways: its panoramic vista proposing an aesthetic unity in what follows, a whole view to which the reader is invited as an eyewitness (as if, in the perspective of the title-page imagery, from a high elevation); its specific imagery preconceiving the subjects of the ensuing sketches to be the themes popular in actual newspaper and periodical sketches of the war—camp life to the right, battle to the left, draping flag framing the entire vista in the aura of a symbolic event, a suggestion continued by the setting sun in the deep

vista glimpsed at bottom center, signifying nature and its ongoing cycles as the stage for what follows. Moreover in the prominence of an officer on the right (gesturing as if presiding over the scene) and of a mounted officer on the left, as against the foot soldiers in battle and the diggers of trenches, the imagery projects not only a social hierarchy but a notion of representation that gives priority to officers and leaders, the mass of soldiers filling in the scene. In the two figures lounging in the foreground, however, we catch an echo of an American frontier vernacular: the campfire, the space in the wilderness, the relaxed posture of swapping tales, the long rifle at the ready. Representing continuity with an earlier way of life, and one that presumably persists even through the war, this trope of casual interchange between males at the threshold of the scene (and of the book) confirms the aura of *Sketchbook,* a motif repeated in the course of the book, as in Plate 50, "The Halt."

Gardner's discursive strategy of at once displacing attention from the figural surface of the print (its quotidian detail) and linking images into a large general narrative of the war[28] serves well the ideological principle he enunciates in the brief preface: the goal of preserving as "mementoes of the fearful struggle" images of "localities that would scarcely have been known, and probably never remembered" but that are now celebrated and "held sacred as memorable fields, where thousands of brave men yielded up their lives a willing sacrifice for the cause they had espoused." Like Holmes he proposes remembrance of sacrifice as a way of *re*membering the dismembered, reuniting the dead with the living. Gardner also takes the war as disease and speaks of victory as healing. As mementos the pictures are trophies of that therapeutic consummation: by memorializing, celebrating, remembering as sacred, the images participate in the process of making whole again, restoring American society to its familiar place in the bosom of nature. They

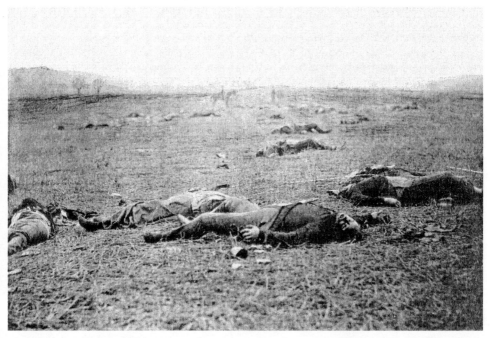

2. "A Harvest of Death, Gettysburg, July, 1863"; courtesy of the Library of Congress.

participate by proposing the visual terms on which victory and healing—the remembrance of sacrifice—might be conceived, proposing, that is, a way of *reading* traces of war on the landscape through the intermediary of the properly contextualized photographic sketch. Thus the book's most famous image, probably the most frequently reprinted of all Civil War photographs: Plate 36, "A Harvest of Death, Gettysburg, July, 1863" [2]. The title alone transposes the image from the realm of specificity to the realm of generality, of allegory and exhortation; indeed the title calls up associations by which we are led to read the figure of horse and rider dimly focused in the rear as the figure of the grim reaper, a symbolic presence materialized as if from the mist of battle. Without surprise we read, "Such a picture conveys a useful moral: It shows the blank horror and reality of war, in opposition to its pageantry. Here are the dreadful details! Let them aid in preventing such another calamity falling upon the nation." Thus the text reads the blankness, writes itself upon the scene. Frozen in their final agony, however, the corpses are self-memorializing prefigurations, not without reproach, of stone shafts and carvings that will shortly replace them as site markers of the horror of Gettysburg. Appropriately the book concludes not with an image of Appomattox, but of the "Dedication of Monument on Bull Run Battle-Field, June, 1865." The image shows not only the stone shaft in the rear, but the dedicatees monu-

mentalizing themselves by standing obediently for their picture.

The Barnard book also monumentalizes, though differently.[29] The subject of its memorializing logic is not the Union or even victory, but Sherman: the modern professional soldier represented in the text as a visionary who grasps totally the single-minded purpose of war—to win by destroying the enemy. Proceeding as if ineluctably from that vision in the opening studio portrait of "Sherman and His Generals" to the concluding image of devastation in "Ruins of the Railroad Depot, Charleston, South Carolina," the tightly structured march of images here generates the illusion of an unstoppable force thrusting itself through space, overturning everything in its path. It is not the force of righteousness or political rectitude, but merely military power: superior numbers, weaponry, and communications. None of Gardner's metaphorizing rhetoric is evident here. Yet the pictures employ a visual rhetoric that suggests a quite subtle relation between the arrangement of images and the ideological narrative (the celebration of Sherman and his methods). Two particular devices might be singled out, one formal and the other iconic: the consistent device of shifting the camera's perspective in contiguous images, a shot/reverse-shot procedure that first shows a position from one point of view, then takes up that position for yet another view; and iconically, the strategic deployment of the imagery of classical revival architecture. We can see both devices at work in Plates 2 and 3, of the capitol at Nashville, the Unionist staging ground for Sherman's movement into the Confederate South. The movement back and forth creates an illusion of spatiality and motion, an illusion that enforces the covert message of the images: the "city on the hill," as the text informs us, "the citadel of the fortifications about the city"—an image not only to be gazed upon but to look out from, and in surveying the world

from that eminence we are also, as we see, aiming guns upon it.

The opening chord resounds; classicism now represents political power backed by firepower. From this telling exchange of perspectives we proceed in Plate 4 across a trestle bridge hastily erected by the First Michigan Engineers and the Railroad Construction Corps on the ruins of a stone bridge destroyed by the enemy—a symbolically apt instance of Union skill in replacing an older masonry structure with a new industrial form—into the rugged and wild landscape of the following pictures, eventually to find ourselves among the ruins of Atlanta, Columbia—and Charleston, where it all began. The concluding two images disclose the destination to be not a simple physical site but a symbolic event foretold by the opening images of Sherman's commanding presence and the fortified, redoubtable, and triumphant neoclassicism of the Nashville capitol: the ruination of Southern classicism, echoing the devastation of the landscape that had been the chief trope in the disturbingly depopulated images at the heart of the book. The penultimate image, Plate 60, places two contemplative figures and a mirroring pond in the midst of ruins, reclaiming the scene for culture by aestheticizing it. The final image puts the seal on this ideological appropriation of the devastated South as *national* experience by making of the ruined railroad depot a Roman aqueduct in a desolate landscape, thus providing an aesthetically elevating ruin for the American landscape (the covert message being the real triumph over that classical portico by the trestle of industrialization).

It is striking how vacant, empty even of corpses, are Barnard's images, an emptiness perhaps in accord with the book's motive: the celebration of a military vision. It is, moreover, the vision of a *leader*. As does his text, Barnard's pictures efface the common soldier. The text opens with a Homeric (or Bancroftian) listing of

generals under Sherman. The text always identifies armies and smaller units by the name of their commanding officer—certainly not unusual, but a convention that underscores the importance of hierarchy, of subordination and obedience, one of the war's significant subliminal lessons.

This aspect of both Barnard's and Gardner's books—the distancing if not expunging of the *working* war—becomes especially notable in light of the most remarkable of the albums of war: Herman Haupt and A. J. Russell's *Photographs Illustrative of Operations in Construction and Transportation* (1863), an illustrated instruction manual including "experiments made to determine the most practical and expeditious modes to be resorted to in the construction, destruction and reconstruction of roads and bridges." Work is the entire theme here; the photographs themselves are working images representing particular tasks and tools. Each of Russell's photographs is keyed by number to Haupt's text, which in turn addresses the image entirely by its representation of an act or object associated with an act: "No. 1—Illustrates a mode of transportation which was adopted with great advantage on the Potomac in establishing a communication between Alexandria and Aquia Creek. It can be used to connect the various roads which have their termini on navigable rivers. . . ." And so on. Some of the images are closeups of tools or parts of rafts or bridges or torpedos for wrecking them. Most of them are scenes of labor, showing construction (or destruction) crews frozen in the performance of an act named and described in the text and made comprehensible as part of the larger picture of the construction and destruction of railroad systems. There is no diegesis, no telos, no memorial or monumentalization—only an archive of photographs illustrative of tasks and tools of labor. The text represents exactly the mentality of calculation and measurement that would turn immediately after the war to industrial produc-

tion, especially to the training of an industrial working class: "Forty men, working in pairs, with the material placed in front of them (see No. 70), put together twenty frames in sixteen minutes, and several of the pairs finished their frames in eight minutes. No. 71 represents the frame partly, and No. 72 entirely, finished. From five to eight minutes were consumed in tying on the blanket. From two to four minutes were required to untie and take off blankets. Five minutes were found sufficient to take frames apart and pile the sticks." Thus does time study appear in the belly of the war, the camera in attendance.

It is clear from the Haupt-Russell album how concretely the Civil War served as a proto-industrial experience.[30] Here there is no bother with an overtly ideological rhetoric, just as there is no display of that traditional flamboyance of the officer corps prominent in the other albums. Picture and text make instantly manifest the link between the war's regimentation and the industrialization that would so thoroughly transform the way of life of American society. The ideology of Russell's album lies in its transparency as a modernizing document, the clarity with which it concedes the role of its medium in representing the war's modernity—a modernity it shared, in fact, with the rest of the North's complex and, as it turned out, decisive communications infrastructure. Indeed photography proved a not inconsiderable element in the war's modernity, in what made that event such a profound watershed in the transformation of America into a modern nation-state and military-industrial power: the camera's endowment of *visibility,* in images virtually simultaneous with the event, sealing the final stamp of modernity on the war.

Taking them as evidence in the unambiguous sense of the word, moreover, we find that the Haupt-Russell pictures help establish one particular social fact: the use by the Union forces of free black labor. By their character as illustra-

tions the photographs show particularities as generalities, events and objects particularized—as only the camera was able to perform that representational act—for the sake of demonstrating a general point about construction and destruction. Particularities are not effaced by the text; they are simply not acknowledged; they are irrelevant distractions from the abstract issue at hand. The text rationalizes for the sake of efficient production; the pictures particularize for the sake of effective empirical and heuristic communication. The fact that *blacks* comprise a large portion of the labor force manifest in the images is strictly incidental to the purposes of the book; they appear as *labor,* freely and openly shown as such. As they are not in the other two albums, where their relative absence makes blacks most conspicuously present, an invisibility that argues that what the albums show is not so much the war as one ideological version of it.[31] The Russell pictures offer a perspective upon the other albums—not on their exclusion of blacks (or their confinement of them to marginal roles) but, using that as a major instance, on their containment of them within a finally restrictive and constricting ideology.

A genre scene in the *Sketchbook* shows a black youth standing next to a seated officer, poised as if to serve him a demijohn of whisky and a plate of food. As if oblivious to this scene are three other figures, also white officers, arranged in quasi-studio poses, their eyes sliding off at an angle oblique to the camera (the standing figure may be looking at the transaction between the black servant and his officer, though not necessarily). The picture declares a stilted staging of a scene, a theatricalization of an event—a typical exchange between master and servant, the text informs us: one asks, "What do I want, John Henry?" and the other, "that affectionate creature," replies with the demijohn of hard liquor, which is what "his untutored nature" always suggests. The rest of the sketch fills out

the portrait of "an unusual capacity for the care of boots and other attentions," a propensity for master's "spirits" and for "the other sex," and a distaste for "manual labor." The theatricality of the image itself discloses, albeit unconsciously, the theatricality of the scene: how racism represents itself in the staging of roles, roles self-proclaimed as artificial and theatrical and obviously accessible throughout the culture, North and South.

Another text, attached to Plate 94, "A Burial Party, Cold Harbor, Va., April, 1865" [3], offers the following:

> This sad scene represents the soldiers in the act of collecting the remains of their comrades, killed at the battles of Gaines' Mill and Cold Harbor. It speaks ill of the residents of that part of Virginia, that they allowed even the remains of those they considered enemies, to decay unnoticed where they fell. The soldiers, to whom commonly falls the task of burying the dead, may possibly have been called away before the task was completed. At such times the native dwellers of the neighborhood would usually come forward and provide sepulture for such as had been left uncovered.

At first we read that the scene "represents the soldiers," who then turn out to be missing; in their place, we learn next, are "native dwellers," though presumably *not* the ones alluded to as "residents of that part of Virginia" who allow the dead to remain unburied.

For whose benefit is this circumlocution? The resonance of the image continues beyond text and frame, its grim ironies and bizarre revelations suddenly flashing up before us, the very image of the remains Holmes and his culture wished to bury: the decomposing flesh and bleached bones of the dead attended by those very humans whose claim to full humanity represented an aim of the war already repressed during the war itself. In a gesture so simple that

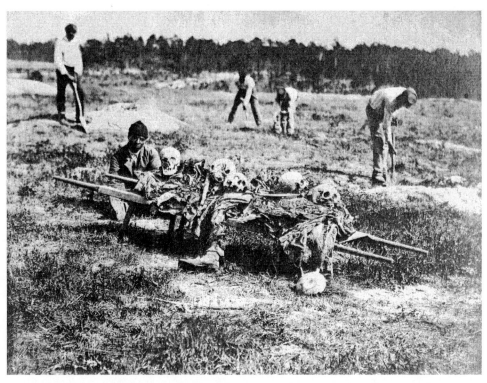

3. "A Burial Party, Cold Harbor, Va., April, 1865"; courtesy of the Library of Congress.

it eludes the author of the text, the two grand invisibilities of the war become palpable here: the dead in their state of utter decomposition and dissolution; blacks in the posture of field laborers whose performance of the task of sweeping the battlefield clean of its grim refuse prefigures a history we still inhabit. Shedding all conventional theatricality the image discloses a hidden logic: the visibility of the war has depended upon the invisibility of exactly the uncanny relation represented here.

How to recapture and recaption such images, to win them from authorized functions and meanings, away from practices that view them merely as "the past brought into the present tense"; how to save the image, in Benjamin's words, "from a conformism that is about to overpower it." The lesson of reading seems plain. If we assume a real war to which we might be present as surrogate spectators, we risk finding only the abstraction of disconnected moments. The real war lies in our own efforts to win images away from the clutch of historicizing ideologies, to recover a connected history by restoring those vanished mediators who might reconstitute the image as one of our own. The real war inhabits the albums of war only as we choose to wage it there.

NOTES

From *Representations* (Winter 1985). © The Regents of the University of California. Reprinted by permission of the author.

I wish to thank the Wilson Center and the Rockefeller Foundation for their generous support during the research for and the writing of this essay; Joe Thomas, chief of the Still Picture Branch of the National Archive, for his gracious sharing of information; and especially Jerald C. Maddox, Prints and Photographs Division, Library of Congress, for helpful advice and many acts of kindness.

1. This limitation seems the result of the cumbersome wet-plate process, which made photographing on the field awkward and dangerous. See Robert Taft, *Photography and the American Scene* (1938; reprint: New York, 1964), Reese Jenkins, *Image and Enterprise* (Baltimore, 1975), and Doug Munson, "The Practice of Wet-Plate Photography," in *The Documentary Photograph as a Work of Art* (Chicago, 1976), 33–38. For an argument that distant and high perspectives and lack of closeup views typical of the war photographs represent not technical limitations but a set of pictorial conventions, see Joel Snyder, "Photographers and Photographs of the Civil War," ibid., 17–22. But see "Photographs from the High Rockies," *Harper's New Monthly Magazine* (September 1869), 465: "The battle of Bull Run would have been photographed 'close-up' but for the fact that a shell from one of the rebel field-pieces took away the photographer's camera."

2. Of course cinema and video must also be included as photographic media. Even before D. W. Griffith's *The Birth of a Nation* (1915) the Civil War was one of the most popular themes of early cinema. See Jack Spears, *The Civil War on the Screen and Other Essays* (New York, 1977), and Paul G. Spehr, et al., *The Civil War in Motion Pictures* (Washington, D.C., 1961).

3. See Pat Hodgson, *Early War Photography* (Boston, 1974). Also, Helmut and Alison Gernsheim, *Roger Fenton: Photographer of the Crimean War* (London, 1954).

4. See Eric Foner, "The Causes of the American Civil War: Recent Interpretations and New Direc-

tions," in *Politics and Ideology in the Age of the Civil War* (New York, 1980), 15–33. For a brief incisive discussion of the war in a world context see David M. Potter, "The Civil War in the History of the Modern World: A Comparative View," in *The South and the Sectional Conflict* (Baton Rouge, 1968), 287–99.

5. Francis Trevalyan Miller, ed., *The Photographic History of the Civil War* (New York, 1912) 1: 16. The total number of photographs reproduced in these volumes is about 3,800. Ideological uses of Civil War photographs to propagate one or another version of the war, especially in the decades just after the introduction of half-tone reproduction in the 1880s, awaits serious study.

6. George Haven Putnam, "The Photographic Record as History," ibid., 60.

7. Ibid., 16.

8. The suggestion that photography might be of use to the War Department seems first to have been broached by the American Photographical Society, an amateur group, in 1861. The proposal seems to have floundered, and Brady then organized his own private venture. See William Welling, *Photography in America: The Formative Years, 1839–1900. A Documentary History* (New York, 1978), 150.

9. The entire photographic project related to the war remains to be sorted out. See Josephine Cobb, "Mathew B. Brady's Photographic Gallery in Washington," *The Columbia Historical Society Records* (1953–54), 28–69; "Alexander Gardner," *Image* 7 (1958), 124–36; "Photographers of the Civil War," *Military Affairs* 26 (Fall 1962), 127–35; Robert Taft, *Photography and the American Scene;* "M. B. Brady and the Daguerreotype Era," *American Photography* 29 (1935), 486–98, 548–60; Paul Vanderbilt, *Guide to the Special Collections of Prints & Photographs* (Washington, D.C., 1955), 18–25. The most ambitious effort so far to assign names, places, and dates to specific photographs can be found in the remarkably meticulous studies by William A. Frassanito: *Gettysburg: A Journey in Time* (New York, 1975), *Antietam: The Photographic Legacy of America's Bloodiest Day* (New York, 1978), *Grant and Lee: The Virginia Campaigns, 1864–1865* (New York, 1983).

10. Although the evidence is largely circumstantial, it seems that Gardner broke with Brady over the issue of credit. Gardner opened his own Washington gallery, fielded his own corps of cameramen, and always listed the maker of the negative (not always accurately) in his catalogs and publications. See Cobb, "Alexander Gardner." On the copyright situation at this time, see Welling, *Photography in America*.

11. On Brady as a popular historian during his career as a portrait photographer see Alan Trachtenberg, "Brady's Portraits," *Yale Review* 73 (Winter 1984), 230–53.

12. *Brady's National Historical Collection* (New York, 1869), 4. This document represents Brady's petition to Congress for sale of his collection. Cf. 3–4: "The Views were taken on the spot, during the progress of hostilities, by Mr. Brady and his assistants, and represent 'grim-visaged war' exactly as it appeared." For an account of Gardner's petition in the same year, see Cobb, "Alexander Gardner," 127: "That during that period he photographed all the important scenes and incidents which in the aggregate compose the only history of the Rebellion in that form and are known as *Gardner's Photographic Incidents and Memories of the War for the Union.*"

13. Michel Foucault, *The Archeology of Knowledge* (New York, 1976), 129. See also Rosalind Krauss, "Photography's Discursive Spaces: Landscape/View," *Art Journal* 42 (Winter 1982), 311–19.

14. Edward W. Earle, ed., *Points of View: The Stereograph in America. A Cultural History* (Rochester, N.Y., 1979).

15. "The Stereoscope and the Stereograph," *Atlantic Monthly* (June 1859), 744.

16. "Sun-Painting and Sun-Sculpture," *Atlantic Monthly* (July 1861), 14–15. For valuable commentary on parallels between Holmes's rhetoric and commodity production see Allan Sekula, "The Traffic in Photographs," *The Art Journal* 41, no. 1 (Spring 1981), 22–23.

17. Taft, *Photography and the American Scene*, 141–52.

18. Cobb refers to two Brady albums, *The Album Gallery* and *Incidents of the War*, in "Mathew B. Brady's Photographic Gallery in Washington," 53.

19. Both in Dover paperbacks: *Gardner's Photographic Sketchbook of the Civil War* (New York, 1959) and Barnard's *Photographic Views of Sherman's Campaign* (New York, 1977). A commercial photographer in Oswego, New York, before and after the war, Barnard worked at various times for Brady, Gardner, and the Union army as the official photographer of the Military Division of the Mississippi.

20. Herman Haupt, *Photographs Illustrative of Operations in Construction and Transportation, as Used to Facilitate the Movements of the Armies of the Rappahannock, of Virginia, and of the Potomac, including Experiments Made to Determine the Most Practical and Expeditious Modes to be Resorted to in the Construction, Destruction and Reconstruction of Roads and Bridges* (Boston, 1863). A commissioned Union officer assigned as photographer to Haupt's U.S. Military Railroad Construction Corps, Captain Andrew J. Russell also produced large-plate prints for the trade and assembled several presentation albums of great interest. See Joe Buberger and Matthew Isenberg, "Preface," in *Russell's Civil War Photographs* (New York, 1982), and William Gladstone, "Captain Andrew J. Russell: First Army Photographer," *Photographica* 10, no. 2 (February 1978), 7–9.

21. Oliver Wendell Holmes, "Doings of the Sunbeam," *Atlantic Monthly* (July 1863), 1–17. Subsequent references in text.

22. Frassanito attributes these images to Alexander Gardner. See *Antietam*, 14–18 and *passim* for his fascinating account. On October 20, 1862, the *New York Times* compared these pictures, displayed by Brady in his Broadway gallery, to "a few dripping bodies, fresh from the field, laid along the pavement." Such pictures "bring home to us the terrible reality and earnestness of war."

23. "My Hunt after 'The Captain,'" *Atlantic Monthly* (December 1862), 738–64.

24. See George M. Frederickson, *The Inner Civil War: Northern Intellectuals and the Crisis of the Union* (New York, 1965), 33–34 and *passim*.

25. See, for example, the sumptuously illustrated (133 photographs) edition of *Specimen Days* (Boston, 1971).

26. *Harper's Weekly*, December 8, 1866. For a bibliography of works on "photographically illustrated books," see Julia Van Haaften, "'Original Sun Pictures,'" *Bulletin of the New York Public Library* (Spring 1977), 355–61.

27. *Photographic History of the Civil War* 1: 149.

28. See, e.g., Plates 16 and 19 and their accompanying texts.

29. In what follows I am indebted to the excellent unpublished paper on Barnard's text by Danna Blesser.

30. See Foner, "Causes of the American Civil War." Also Richard D. Brown, *Modernization: The Transformation of American Life, 1600–1865* (New York, 1976), 159–86.

31. *The Photographic History of the Civil War,* vol. 9, presents the subject of "colored troops" under the heading of "The Lighter Side," 173–84. On blacks in Civil War photographs see William Gladstone, "The 29th Connecticut Colored Infantry," *Military Images* (May–June 1981), 16–27; Jackie C. Parker and William Gladstone, "James Monroe Trotter," *Negro History Bulletin* 45, no. 4 (December 1982), 95–96.

10

Trapper, Hunter, and Woodsman

Winslow Homer's Adirondack Figures

DAVID TATHAM

In his essay on Winslow Homer's Adirondack figures, David Tatham explores the manner by which the works of this celebrated "objective realist" consistently reveal both more and less than what the artist actually observed. Tatham's discussion is grounded in formal analysis of the paintings and careful consideration of available evidence regarding the artist's work habits, Adirondack topography, common hunting practices, and the actual identities of the woodsmen represented.

Rather than casting these men in their customary role as professional aides to vacationing sportsmen, Tatham argues that the guides, trappers, and hunters represented in Homer's Adirondack scenes are instead portrayed as rugged individualists for whom the wilderness is a natural habitat. This body of work is then linked to an evolving cultural climate shaped by late Victorian melancholy and the impact of diverse ideas, from Darwinism to aestheticism. Tatham characterizes Homer's vision of the Adirondacks as a powerful combination of accurate, gripping detail placed in the service of communicating larger truths about the meaning of the wilderness and the elemental forces of nature.

Winslow Homer (1836–1910) painted Adirondack subjects intermittently throughout four decades. His earliest painting of this northern wilderness dates from 1870, the year of his first visit to the region. His last is a watercolor of 1902, painted eight years before his final journey into the forest. No other place, not even Prout's Neck on the coast of Maine, held his attention for so many years. No other group of his paintings documents quite so well as those from the Adirondacks his ability to treat in an original way subjects that others seemed to have exhausted. And nowhere else in his work is it quite so clear how his thinking about the natural world and humanity's place in it moved from quiet optimism to something considerably graver.

One of his achievements in the Adirondacks was to revitalize an older American subject—the woodsman—and bring it from a status of peripheral interest in the world of art to center stage. He did this initially in 1870, in his very first Adirondack painting, *The Trapper, Adirondacks* [1].[1] *The Trapper*, in both its figure and its setting, broke a number of the conventions that had governed the work of most of Homer's predecessors in the region. It established him as an independent voice among both those who painted this northerly wilderness and those who portrayed the men who worked in it.

Part of his painting's originality could be found in its composition. Most earlier depictions

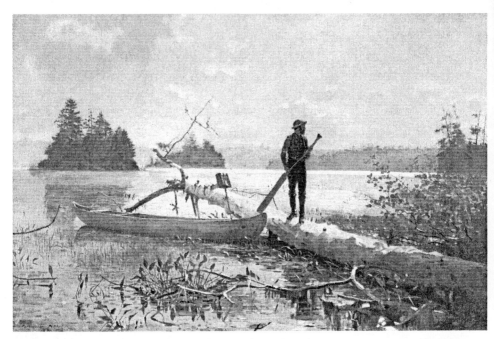

1. Winslow Homer, *The Trapper, Adirondacks,* 1870; courtesy of Colby College Art Museum. Gift of Mrs. Harold T. Pulsifer.

of the region's topography, beginning notably with Thomas Cole's *Schroon Mountain, Adirondacks* (1838), had accented the strongly felt verticals and ascending diagonals that typify mountain scenery, at least in the mind's eye. Homer suppressed these axes and built his design instead on horizontals. The vista he chose to paint (northeasterly across Mink Pond, several miles west of Minerva in Essex County), in fact, included the pyramidal form of Beaver Mountain, but he reduced the scale of the mountain and masked all but a small part of one lower flank with haze. He also made this bay of water seem more spacious than it actually is. Over the next thirty years Homer adjusted the size and shape of the mountain variously in more then two dozen Adirondack works, giving priority to design over topography. In the case of *The Trapper,* he al-

tered the scenery to make the solitary figure the composition's most vividly defined upright element, one that, despite its modest scale, rises strongly against the horizontal bands of water, land, and sky.[2] He further underscored the importance of the figure by depicting it in a turning movement. The stillness of the things around it—boat, log, water lilies, and water—makes the illusion of motion in the figure all the more graphic.[3]

The figure was not his only concern, however. What Homer chose to emphasize in his first report in paint on the natural world of the Adirondacks also set *The Trapper* apart from its predecessors. Earlier painters had nearly always given primacy to solid ground. Even when they had depicted boating scenes, their lakes and streams seemed secondary in significance to the sur-

rounding mountains, forest, clearings, shores, ledges, and campsites.[4] Homer reversed this ratio in *The Trapper,* painting more water than land. He extended the lake to the picture's edge, and by implication into the viewer's world. Not even Sanford Robinson Gifford, in the grand expanse of lake in his *A Twilight in the Adirondacks* of 1864, brought the viewer quite so close to water. Gifford's use of an elevated vantage point distances the spectator from it. By contrast, Homer places the viewer almost at eye level with the trapper; both stand virtually on the lake's surface.

By shifting the balance from land to water, Homer epitomized not only the level world of the lakeland trapper's continual rounds but also the common experience of visitors to the Adirondacks in his time. After arriving by train, most who ventured deeper into the region went by boat to lake or riverside hotels and campsites. There they found sport and recreation on and near water.[5] *The Trapper* affirmed what frequenters of the mountain playgrounds of the Northeast had come to understand: that the Adirondack region was unique in the eastern United States in its profusion of lakes among peaks. By comparison, the Berkshires, Catskills, and White Mountains were lakeless.[6]

While Homer's treatment of the landscape departed in these and other ways from the conventions of such earlier artists in the region as Gifford, William Trost Richards, Arthur Parton, Samuel Colman, James Hart, and John Lee Fitch, who by and large perpetuated the thought and manner of the Hudson River School, it was wholly consistent with his own work as painter since the Civil War.[7] Homer brought to the Adirondacks a highly individual style that had developed from two different sources. It was grounded first in his origins as a reporting artist for pictorial magazines such as *Harper's Weekly* in the late 1850s and early 1860s. His remarkable powers of observation and visual summation made him a journalist-illustrator of the first

rank, and he carried this talent intact into his work as a painter. But his style also reflected the impact of contemporary French painting.[8] This influence, which had been evident in his oils of the mid-1860s, before he visited France in 1866–1867, had not led him to imitate the style of any French master, or to any doctrinaire practice. Rather, he absorbed, probably at secondhand from American sources, the loosely knit body of developing ideas about subjects, light, and the uses of art that in France had fueled the great shift from Romanticism to Realism. *The Trapper*'s proto-Impressionist light, the naturalism of its figure, and the ordinariness of its subject are all in the spirit of the new French painting of the 1860s, without being directly derivative of it. Much of Homer's distinctive originality came from his synthesis of these aspects of style with his own reportorial instincts as a pictorial journalist.

What Homer reported in *The Trapper* distinguished him from earlier Adirondack painters of figures. The others had nearly always taken sportsmen—men from the cities—for their subjects.[9] His subject, however, was a trapper—a man of the woods—who happened also to be a guide. Guides sometimes appeared in multiple-figure works by other painters but they were given less attention than their employers, even though they were often the more intrinsically interesting of the two types. Some guides worked independently; more of them, including this trapper and most others that Homer painted, were affiliated with hotels and boardinghouses. They led sportsmen to fishing and hunting sites, carried boats, gear, and catch, made camp, cooked meals, rowed about lakes, recounted local lore, told tall tales, and were generally well paid for their efforts. By the 1880s, a small but growing number of sportswomen had joined their clientele. As a type, guides had been celebrated by Adirondack writers, but painters made little of them.[10] Not until Homer's *The Two Guides* of 1875 (Sterling and Francine Clark Art

Institute, Williamstown, Massachusetts) did an artist take them as the primary subject of a figure painting and invest them with some of the heightened individualism that the Adirondack writers described.[11]

The earlier practice of depicting guides appears in Arthur Fitzwilliam Tait's *Going Out: Deer Hunting in the Adirondacks* of 1862. In the foreground a sportsman calls out to others already underway while his guide readies their canoe for departure. The two foreground figures are differentiated not only by dress (one rough, the other refined) and activity (one works, the other waits for the work to be done), but also by the positioning of the guide lower than the sportsman in the composition. These amount to distinctions of social class, even though in this case, as in many, the sportsman had the highest respect for the guide. The sportsman is Tait in a recognizable self-portrait; the guide is the widely esteemed "Captain" Calvin Parker, who had served as a scout in the West and by 1862 was much in demand as a guide for his intimate knowledge of Adirondack terrain.[12] Yet, despite the overabundance of detail in this and other of Tait's depictions of guides, he says little about them in his paintings except to show certain of their tasks and their quasi-deferential manner toward "sports." He gives no hint that guiding was a seasonal activity and that nearly all guides held other vocations as farmers, loggers, trappers, innkeepers, artisans, or teamsters.

One of Homer's quiet innovations in *The Trapper* was to free the guide from the stereotypical image of servant to sportsmen that Tait and others had perpetuated (and that was an authentic part of every guide's experience) and present him instead as an independent man of the woods, interesting in his own right and subservient to no one. Guides appear in numerous other works by Homer over a period of nearly a third of a century, but never as a sportsman's aide. He sometimes depicted them in their other occupations, as trappers, hunters, loggers, and

boatmen. He also used them as models in compositions in which he modified certain realities of place or activity to achieve what he presumably believed to be a greater or purer essence of Adirondack experience. His journalist's eye saw good subjects capable of becoming better ones.

As a sport fisherman and outdoorsman, Homer undoubtedly admired the skills of the guides he knew. But he probably painted them as often as he did because they were available as models. Other persons at the only places in the Adirondacks where he is known to have stayed for any considerable duration could not properly have been called upon to pose, and Homer was a stickler for propriety.[13] The protocols of his time effectively prohibited his asking fellow hotel guests and club members to pose for payment, women especially, and there is no reason in any event to think that he found them particularly interesting as subjects. But guides, who were always paid to assist patrons, could honorably pose. Those associated with Homer apparently relished the opportunity to do so, not only for the extra money but also for the novelty of it. He probably paid them the standard guide wage, which in the mid-1890s was twenty-five cents an hour.[14]

The guide who posed for *The Trapper* was almost certainly Rufus Wallace. Homer had met him at the Baker farm, a rustic summer boardinghouse deep in forest nine miles west of the village of Minerva in Essex County. This clearing in the wilderness had become a favorite place of Fitch, Eliphalet Terry, and a few other artists who were also, like Homer, avid sport fishermen. Mink, Thumb, Split Rock, and the Beaver ponds all lay within two miles of the farmhouse and abounded with fish. The farm had been established in this unlikely location in the mid-1850s by the Reverend Thomas Baker, an active abolitionist. After his death in 1862, his widow, Eunice Harris Baker, and daughters Juliette and Jennie ran the farm with the aid of local men such as Wallace. Lumbering as well as trapping augmented the crops of the fields in this up-

land, far-from-ideal tract. These three women combined rusticity with cultural sophistication. They spent part of each winter with Harris relatives in New York City where they were entertained by their summer guests and saw the farm's artists' works in exhibitions. Their liberal, literary, and artistic sensibilities struck a chord with those of their summer clientele. When Homer joined the group in 1870, he found an informal, mutually supportive, cheerful, unpretentious band of like-minded people, proprietors and guests alike, and he continued his association with at least a few of them at this location for many years to come.[15]

Wallace and the other men who worked for the Bakers were an integral part of this society, even though they were by comparison less sophisticated in matters of urban culture. Their commanding knowledge of the ways of wilderness was admirable in itself and gave them a status that was, in its way, on a par with that of the artists. Both were masters of complex manual skills, dependent on visual acuity for success, and practiced in analyzing landscapes (for very different reasons). This contributed to the egalitarianism among guides, sportsmen, and hosts at the Baker farm that flavors the surviving correspondence relating to the place and flavors Homer's paintings as well.

Wallace owned a few acres in Minerva, trapped, and augmented his earnings further by working for the Bakers. This work included serving as a guide for the hostelry's guests. Homer depicted him a second time in 1870, in the wood engraving *Trapping in the Adirondacks,* published in the pictorial weekly magazine, *Every Saturday.* He paddles a canoe in which a fellow trapper and Baker farm guide, Charles Lancashire, holds up their catch. Both men were about forty, six years older than Homer.[16] He shows them on Mink Pond, the same body of water as in *The Trapper,* but here he allows the gently rising form of Beaver Mountain to be seen.

Because he meant it for a popular audience, the wood engraving is more anecdotal than the painting. The figures, much larger and closer to the picture plane, are the stuff of narrative illustration, though Homer had no prescribed text to follow. Wallace paddles stoutly; the pipe in his mouth is one of fine manufacture rather than rustic. Four years later Homer included Wallace (and his pipe) in the watercolor *Trappers Resting.* Lancashire raises the trap and its take—a mink from Mink Pond—as a trophy. The rifle lying across the canoe suggests activities other than trapping, as does the jack light in *The Trapper.* Each man of the woods was, virtually by definition, a hunter, trapper, logger, and guide as the season and circumstances warranted. Though Homer met these men in their role as sportsmen's guides, he chose to characterize them instead as exploiters of the bounty of this great northern wilderness.

The question arises whether Homer in these depictions of woodsmen recorded only what he found or to some degree staged his subjects. His works have often been felt to exemplify in all essentials the "cool observation of fact" of objective realism,[17] but a case can be made that some of them are also in part products of his powers of invention, powers expressed so subtly and within such a narrow range that they have long lain undervalued in assessments of his talents. The mix of the two approaches undoubtedly differs from work to work, and perhaps can never be definitively determined in any instance, but a group of subjects that Homer painted at the North Woods Club in 1891 and 1892 with guides as models offers clues suggesting that more than objective recording was involved in their creation.

In 1887, a private sporting organization, later named the North Woods Club, purchased the Baker tract.[18] Homer joined the club in 1888 and then returned to the old site in 1889, after a hiatus of fifteen years.[19] The nearly three dozen watercolors that he painted at the club that year

drew on all that he had learned in the medium earlier in the decade in England, at Prout's Neck, and in the Caribbean. He next visited in 1891 and 1892. In the first of these years he was in residence from June 9 through July 31, and again from October 1 to an undetermined date. The next year found him there from June 18 through July 28 and then from September 17 through October 10.[20] Fewer than ten watercolors came from the 1891 visit, but 1892 brought forth more than thirty.[21] Of the forty-odd sheets that survive from these two years, more than half include figures painted from guides.

At least three guides posed for these figures. The oldest of them, with a white beard and moustache, may well be Wallace who, by the time of these paintings, was in his early sixties. In the watercolor *After the Hunt* of 1892, he is the central figure in a complex composition. He grasps the neck of a dog at the corner of his boat while a younger figure, leaning on his elbows, looks around the older man at the partly submerged animal. The subject is the conclusion of a successful session of deer-hounding. A deer, driven into a lake and exhausted there by the boatmen and their dogs, who have kept it from shore, has been killed and pulled into the punt. The men will next transport it to a dock and roadway. Many people found this method of killing deer unsporting, and eventually it was banned, but guides found it to have a distinct advantage over still-hunting in the forest; it avoided the arduous carry over rough ground needed to get forest-shot deer to a camp or road. Deer-hounding was an old method. James Fenimore Cooper described it in *The Pioneers* in 1823.[22]

Deer-hounding is the subject of several of Homer's watercolors and one oil, all painted presumably from close observation, in the summers of 1889, 1891, and 1892. In one work, *Deer in the Adirondacks* (1889), he depicted a dog driving a deer into a pond. In others, he depicted the chase in water, and the dead deer, but never the

act of killing the animal. His juxtaposition of the quiet beauty of the place where the event occurred with the quieted aftermath of the recent violent act established a tension that adds to the painterly vitality of these works. It seems also to speak to the repressed propensity toward barbarism that makes civilized life both possible and fragile. At a different level, the deer-hounding paintings undoubtedly express Homer's admiration for the skills of the hunters in making a success of this multifaceted operation with its need to control the dogs, judge the deer's stamina, kill it, secure it, and deliver it. Because this has seemed to many to be a particularly cruel and unsporting way of hunting, the question has arisen whether Homer may have meant to protest it in certain of his paintings of the subject, but it is difficult to find any such critique in his work. The evidence of the watercolors is in a contrary direction.

Homer seems to have found the hunt exciting. Certainly it sustained his interest as an artist for a period of at least four years. He was, of course, a sportsman and no more squeamish about hunting than his fellow realist Thomas Eakins was about surgery. *After the Hunt* and his other hounding subjects are at one level prime examples of objective realism, even though Homer's dispassionate approach to his subject is confounded by the richness of his expression in rendering it. The opulence of his watercolor technique moves most viewers quickly enough beyond any prolonged consideration of the events. Those that he depicted were, in any case, the more benign of the sequence that constituted an episode of deer-hounding.

After the Hunt may strike the eye as a spontaneously executed record of a moment observed, but even granting Homer's remarkable visual memory, and his facility for capturing essentials in a quick sketch, this watercolor's design seems to have been as much a product of planning and consideration as it was of an inspired moment.

The balanced, interlocking forms of the men and the dog gathered at the corner of the punt are more likely to be an arranged pose than a chance occurrence, or, just as likely, a synthesis of separately observed details. Whatever the process of creation may have been, the final stages of work on this Adirondack subject took place at Prout's Neck. There Homer's finishing work, which was sometimes quite elaborate, occasionally required the restudying of figures. In these cases he is believed to have called upon certain of his neighbors, including John Gatchell, whose white beard made him a passable stand-in for the old guide.[23] Accordingly, the central figure in *After the Hunt* may be a composite of Wallace (if he was, in fact, the original model) and Gatchell, though the Adirondack model surely predominates.[24]

By comparison, Homer's watercolor *The End of the Hunt* seems less studied. It strikes the eye as an unaltered record of an observation. The boat's greater distance from the picture plane reinforces this sense of an unplanned, "snapshot" composition. The richness of the watercolor, however, dispels any thought that this is an "ordinary" composition even though its figures are perhaps less a product of creative construction than those in *After the Hunt.*

The older guide assumed here to be Wallace appears in more than a dozen other watercolors in these years. In *Burnt Mountain* of 1892, Homer painted him with a younger man, a woodsman and probably a guide at the North Woods Club, whose identity remains unknown. The diagonals in this work speak of mountain heights as much as the dominating horizontals in *The Trapper* tell of lakeland flatness. Homer's signature follows the slope of the ledge. The rifle, resting with its barrel on the ground and its stock in the air, echoes the ease of the figures and adds to the sense of well-being in the wilderness. Like its counterpart in the wood engraving, *Trapping in the Adirondacks,* it illustrates the woodsman's adage, "always keep your gun in

reach." Such details add a ring of authenticity to Homer's portrayal.

The title of this watercolor, as well as its composition and elevated view of distant water, implies that the figures have ascended some considerable height. They may well have, but it is quite possible that Homer, who tended not to carry his watercolor kit into the wilds, painted the scene not far from the clubhouse. He might have done so at Prospect Rock. This site, with its panoramic view to the south and west, was less than a quarter of a mile away by a graded trail. Another watercolor, *Bear Hunting, Prospect Rock* (1892), in which the bearded guide is again the central figure, celebrates this spot. The background topography does not correspond precisely to what is, in fact, seen from these ledges, but this is not a matter of great moment, since Homer often reshaped horizon lines and rearranged details of the landscape in his Adirondack works. Another height with grand views easily reachable from the clubhouse was Saint's Rest. In the case of *Burnt Mountain,* Homer may have ventured with two guides to some more distant, less visited ledges, cleared, as the title suggests, by recent fire, attracted perhaps by such picturesque relics as the serpentine crown of roots thrust against the sky by the blown-down tree.

A fair portion of his figural Adirondack works probably depict a scene that Homer had staged, posing his models rather than depending on a serendipitous discovery of them in a pictorially interesting arrangement. Such staging was the way most figure artists worked in Homer's day.

The youngest of the woodsmen Homer painted in these years, and who is the secondary figure in *After the Hunt* and *Prospect Rock,* is the only one about whom enough is known to allow a comparison between the historical person and the image Homer presented. He is Michael Francis Flynn (1871–1944) of Minerva, who began working at the North Woods Club at least as early as the summer of 1891, when he was nine-

teen.[25] He undoubtedly assisted older guides and did some guiding of his own. He may also have worked as a teamster, since he had remarkable skills with horses. The summer of 1892 may have been his last at the club, since in 1893, when recent lumbering in the region had intensified the threat of forest fires, he was appointed a state firewarden for Minerva.[26] He later worked in lumber camps, traveled to jobs in Vermont and elsewhere in New York, and then with his teams of horses helped to build the state road through the eastern margin of the mountains. In time he was appointed Commissioner of Roads for the Town of Minerva. In this post he not only widened the roads to allow two lanes of traffic but also introduced motorized, mechanical scraping to keep them passable year-round, thereby helping to bring this corner of the Adirondacks into the age of the automobile.[27] He was a rural person rather than a "man of the woods" and one who from at least as early as his years at the North Woods Club proved himself capable of carrying important responsibilities with distinction.

He was universally known as "Farmer" Flynn. This nickname had been given in jest following the failure of a youthful attempt to grow something.[28] It gained a new and more serious meaning in the years after Homer knew him, for while Flynn was never a professional farmer, he maintained large and productive gardens for his household and raised fodder for his horses. He was not, as some viewers have surmised from the evidence of Homer's paintings, laconic or silent.[29] He is remembered vividly as gregarious, big-hearted, witty, a singer of Irish and country songs, and a square dancer—very much a man of village life. His summer employment at the North Woods Club notwithstanding, he was not a professional guide, had little interest in fishing, did not hunt, and forbade firearms in his home.[30] Many years after the fact, he said in jest to one of his sons that as a youth he had been so handsome that "a famous artist" had painted him. In a more

serious vein, he recalled to his wife that sustaining the poses Homer specified was a challenging task—hard work—but one that he undertook not only for the wages but also out of respect for "Old Homer." The respect, universal at the North Woods Club, was for the person as well as for his skills as an artist.[31]

Flynn's actual appearance when he was young is known from two photographs. One, dating probably from the late 1880s, shows him with a younger brother. It documents (more clearly in the case of his brother than him) the Flynn practice of wearing hats with the crease in the crown running sideways rather than fore-and-aft. Homer seems to depict this idiosyncrasy in his *Prospect Rock*.[32] It can be seen as a light lateral cleft in *On the Trail*. The second photograph, dating probably from the mid-1890s, shows Flynn with a nattily dressed sportsman, on the grounds of a summer hotel in Minerva. The other men are Minerva locals. They hold the sportsman's string of fish. Flynn presumably was his boatman.[33]

The historical Flynn, whom we see in this photograph, stood well over six feet in height. Homer, who had always found idealization compatible with naturalism, tended to reconfigure him to a somewhat shorter stature when he painted him full-length. He is tallest in *The Woodcutter* (1891) and appears reasonably tall in the watercolor *Hunter in the Adirondacks* (1892), where the figure contributes strongly to the insistent verticality of the composition. Homer evokes here the segmented spaces and subdued light of forest interiors, but the prominence of the figure assures us that he had more than landscape in mind. This image of wilderness life, in which the hunter holds game in one hand and rests his foot on a second lifeless form, a fallen tree, echoes the ideas of primitivism that underlay so much of earlier American landscape painting and that persisted in Homer's realism.[34] It responds to that common, almost instinctive, impulse among city-dwellers to quit civilization and its complexities for a

restorative immersion in pure, wild nature of the kind that Homer portrays here.

Though Flynn may not have been a hunter, he was willing to pose with a rifle on his shoulder, and this suited Homer's aim of unifying a figure with its surroundings. Flynn's youthfulness helped, too, since he appears in a stand of mostly young trees; an ancient forest giant lies before him while another leans behind. Homer tended to use Flynn alone when youth was of significance to his subject, and Wallace alone when age mattered, as it does in the watercolor *Old Friends* (1894), with its kinship of old man and old tree. Age seems also to be an implicit aspect of the subject in such end-of-the-day scenes as *The Guide* (1889, Portland Museum of Art) and *Camp Fire, Adirondacks* (c. 1892, Art Institute of Chicago). In these cases the warm serenity of the late light and the colder array of downcast forms in the uprooted tree, each in its own way, speak of the end of things.

Age is of little consequence, however, when Flynn and the older guide appear together in *The Blue Boat* (1892). In this watercolor Homer made a rare return in his Adirondack work to the horizontal orientation of his *Trapper*. As in all of his pairings of Adirondack figures after *The Two Guides* of 1875, he gives no hint of active communication between them. The landscape, light, color, gliding boat, reflections in the still water, and Homer's technique carry the burden of interest, and carry it with exceptional grace.[35]

Flynn appears alone in the watercolor *Boy Fishing* (1892). His weight at one end of the boat lifts the other from the water. He turns his torso to his left, draws back his upper left arm, and twists his left wrist upward to move his fishing rod sharply to his right while he nets his catch. The kinetic precision of the figure comes from Homer's own experience as a fisherman as well as his observations of others, but it pertains only to a moment—a second or two before or after would find a different disposition of parts. In this regard, the subject is the antithesis of *The Blue Boat*, in which the figures might sustain their positions interminably. It seems likely that in *Boy Fishing* Homer had Flynn hold this pose for some time in order to capture its precise configuration. (Whether Flynn spent much, if any, time fishing at the North Woods Club, rather than posing as a fisherman, is an open question. Such fish as he may have caught would have gone to the club's ice lockers and then to the kitchen, since club rules prohibited the private consumption or sale of any fish from waters on its property.) But it seems clear that Homer felt it necessary to work from a model when he chose to include a well articulated figure as a major element of a watercolor in these years. When a figure is of less significance in a fishing subject, as in *Casting, A Rise* (1889) or a number of other Adirondack watercolors, it probably represents a fellow sportsman quickly sketched from a distance, perhaps unawares, and generalized beyond recognition.

A pair of works shed light on the ways in which Homer's conceptualization of a subject progressed. In the summer or early fall of 1891, Flynn posed for the watercolor *Guide Carrying a Deer* (1891). The setting is near the inlet of Mink pond; Beaver Mountain rises behind. Since the viewer is presumably not far from the water's edge, and no rifle is in sight, the subject can be taken as another treatment of deer-hounding (though why the deer would have been brought ashore at this point is unclear). Later in the year Homer painted the oil *Huntsman and Dogs* (1891), adapting the watercolor's composition and clarifying, among other things, the means of hunting. The guide of one title has become the huntsman of the other. A rifle appears; the carcass is reduced to skin and antlers. Two splendidly drawn hunting dogs leap in excitement, forming a dramatic and natural contrast to the still, unemotional hunter. The season has moved onward to late autumn, with a corresponding loss of foliage and light. The stumps in both versions reinforce the element of death in

the subject. As powerful forms they echo the brawny strength of the hunter.

This hunter is not a sportsman. A sportsman, at least at a private club, would be more finely dressed and would not himself have skinned a deer and set out to lug it away. Guides were paid to do that. Homer probably meant this figure to be read as a pot hunter, a local who hunted to survive—to "fill the pot"—and who had little regard for the decorum of sport hunting. This hunter bothers only with the deer's easily salable pelt and rack; he has discarded the venison. Homer coarsened and hardened the hunter's visage and this contributed to a contemporary critic's characterization of the figure as "low and brutal in the extreme."[36] But the changes may also have come from the use of a second model, perhaps John Gatchell's son Wiley at Prout's Neck where this oil was completed during the last months of 1891.[37]

Similar changes of visage distinguish the other instance in which Homer developed an oil from an Adirondack watercolor. His sketch for *Hound and Hunter,* dated 1892 though evidently all but finished in the summer of 1891, shows Flynn prone in a boat, about to fix a rope to the antlers of a just-killed buck.[38] A hound still excited by the chase swims toward the deer; the woodsman shouts to keep it from interfering with the task at hand. The oil version of this subject, *Hound and Hunter* [2], varies in many small details. The face is a recognizable likeness of Flynn, though Homer may have used a Prout's Neck model for what can be seen of the body. Whether Homer observed Flynn deer-hounding is an open question, but there can be little doubt that he posed him in a boat in water.

Many early viewers of this painting assumed wrongly that the deer was alive. Homer's response to this misapprehension, and to the painting's cool reception, exists in a letter to his patron, Thomas B. Clarke. It bristles with impatience and defensively elucidates a vital detail.

The critics may think that the deer is alive, but he is not—otherwise the boat and man would be knocked high and dry. I can shut the deer's eyes, and put pennies on them, if that will make it better understood. They will say that the head is the first to sink—that is so. This head has been underwater and from the tail first has been recovered in order to tie the head to the end of the boat.[39]

To the increasing number of younger artists who were caught up in the aestheticism of the 1890s, this insistence on objective documentation of details must have seemed beside the point. Indeed, to tastes formed by the aesthetic movement, *Hound and Hunter* must have been a distressing work of art, if not downright revolting. But Homer's thought, however inadequately he articulated it in words, was very much in step with other currents of thought in the 1890s, particularly those that had grown from Darwin's ideas concerning natural selection—the survival of the fittest in the struggle for existence.[40] Both *Hound and Hunter* and *Huntsman and Dogs,* Homer's last Adirondack oils, were wholly consistent with his steadily deepening preoccupation in these years with elemental struggles in nature. They are, among other things, a deep forest echo of the epic contest between sea and shore that he painted on the Maine coast in the very same years.

Whether Homer responded consciously or unconsciously to the intellectual currents of his times is difficult to say. The meager evidence of his thinking in relation to *Hound and Hunter* (beyond his insistence that the subject be accurately understood) is in the direction of craft in service to objective realism. Years after completing the painting, he said to Bryson Burroughs, artist and curator of paintings of the Metropolitan Museum of Art, who had praised the work,

I am glad that you like that picture; it's a good picture. Did you notice the boy's hands—all

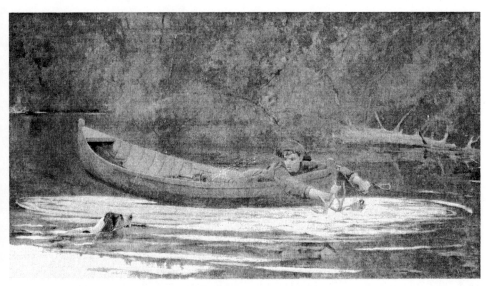

2. Winslow Homer, *Hound and Hunter,* 1892; courtesy of National Gallery of Art.

sunburnt—and the wrists somewhat sunburnt, but not as brown as the hands; and the bits of forearm where the sleeve is pulled back and not sunburnt at all. That was hard to paint. I spent more than a week painting those hands.[41]

The somber light of these last Adirondack oil paintings—the scudding, chillingly overcast sky of one and the dark, overgrown, cave-like space of the other—is a far cry from the translucent brightness of *The Trapper,* a painting full of all the promise that morning light brings. *The Trapper* speaks of beginnings, the others of ends. The jack light in the earlier work intimates that hunting will come with nightfall; the rifle and pelt in *Huntsman and Dogs* show that it is done. Despite their rusticity, *Hunter* and *Huntsman* seem touched by the mood of late Victorian melancholy that pervaded the arts in the 1890s in America as well as Europe. Neither the en-

ergy of Homer's subjects nor his execution of them quite masks an underlying feeling of disillusion, loss, and finality. He expressed the feeling more tacitly in a few watercolors of older guides, such as *Old Friends* and *The Pioneer* (1900), but the use of the youthful Flynn in these two somber oils of life ended gives them an ironic sharpness.

Twenty-one years separate the optimism of *The Trapper* from the graver tone of the later paintings. An equivalent change could be found in Homer himself and also, if one looked for it, in American society at large. But a constant that at a different level transcends and unifies these moods, and that was at play in all of Homer's Adirondack works, early and late, was the high value placed by cultivated Americans of his era on association with picturesque wilderness. The mountain forests, rivers, and lakes of the Adirondacks, largely untouched by civilization (except

for lodges, lean-tos, docks, boats, and other amenities for visitors), constituted a kind of paradise on earth. The stereotypical resident of this paradise—the Adam in this Empire State Eden— was the trapper-hunter-woodsman who guided his charges (if they were lucky) to a cleansed spirit and something akin to an atavistic return to the conditions of the American pioneer. Guides were the envy of those who were wearied by the daily round of modern life.

While Homer surely comprehended this role of the guide as arbiter between the life of the woods and the life of urban culture, he did not paint it. He chose instead to portray the woodsman in his putative natural setting, uncorrupted by the commerce of serving sportsmen. This was something of an invention, of course, since except for occasional fellow sportsmen, all the male figures Homer painted in the Adirondacks were guides in the employ of hotels or his club. But this was also pictorial journalism of the highest kind. It invested an already stereotypical person with a greater strength of character and poetic feeling than had any of the Adirondack writers.

The guide Homer conceptualized in paint would not often have been found in the field. The men of the woods Homer knew and who posed for him were as varied a lot as the men of the cities who hired them. Consider Michael Flynn. He has been known to the world for a century through Homer's powerful images of him as a hunter, fisherman, and boatman, but he was rarely any of these things in the course of his life, and then only incidentally so. A different story is told by a later image of him, a photograph taken in 1943 at North Creek, a few miles from Minerva. Dressed in the same fashion as city men— he might be taken for a museum director—he holds a grandson in his arms against a background of white pines and fields, with mountains rising in the distance. The roadway running close behind this road builder speaks of the new ease of access to the great Adirondack wilderness and of the steady encroachment upon it of the ways of urban life. An age had opened when men and women would travel to the Adirondacks on their own, and guide themselves to its wonders, in many cases seeking to see, and finding, what Homer had shown them. But what Homer had shown was both more and less than what he had seen. He not only selected his subjects, but he also developed them into something beyond a record of a moment's vision. He sought a greater, more universal and abiding truth about the Adirondacks and Adirondack people and his success in attaining this has for more than a century been one of the glories of American art.

NOTES

From *The American Art Journal*, vol. 22, no. 4. Reprinted by permission of the author.

I thank Mary Flynn Jenkins, Elizabeth Flynn Filkins, Rose Flynn Brown, and Patrick Flynn, all children of Michael Flynn, for their generous assistance in the preparation of this article.

1. Homer painted this subject twice, but it is unclear which is the original and which is the near-replica. The other version, *Adirondack Lake* (Henry Art Gallery, University of Washington, Seattle) is larger, 24 × 38". Both are dated 1870 on the canvas by Homer. Other than size, the sole significant difference is in the positioning of the jack light in the boat. In the Colby version it is upright; in the Henry version it lies in the boat. An oil lamp with a metal reflector, the jack light was positioned high on the bow of a boat and used at night to hunt deer. It illuminated and mesmerized animals who came to the water's edge but left the boatman and hunter in darkness. It is some measure of Homer's regard for his *Trapper* that he chose to exhibit one of the versions at the Century Association in New York in April, 1871, where it was described, undoubtedly by someone other than the artist, in the Century

list of exhibited works as "River Scene, Man on a De-cayed trunk, Guiding Boat" (City University of New York/Goodrich/Whitney Museum Record of the Works of Winslow Homer). The "river" is, in fact, Mink Pond.

2. In its vertical rise through horizontal bands, its turning motion, and diagonal implement, the figure is a variant of the larger one in his *The Veteran in a New Field* of 1865 (The Metropolitan Museum of Art, New York), though the differences outweigh the similari-ties. If the branch in the shape of a tilted cross rising against the sky from the end of the log once carried any special meaning, it now seems lost.

3. It is fair to assume that the figure turns his atten-tion to something seen or heard, or to someplace of in-terest, but Homer probably specified this pose in part to demonstrate his prowess as a figure painter. The figure turns, holds his paddle at the angle needed to control the boat, balances himself on the log's rounded surface, and directs his attention elsewhere. Homer rendered the kinetics of the moment impres-sively. The task of posing for this figure would have been challenging. Homer undoubtedly sketched it in the Adirondacks but transferred it to canvas and devel-oped it in his New York studio, perhaps using a second model.

4. For a representative sampling, see Patricia C. F. Mandel, *Fair Wilderness: American Paintings in the Collection of the Adirondack Museum* (Blue Mountain Lake, N.Y., 1990).

5. A good introduction to the omnipresence of wa-ter in the lives of visitors to the Adirondacks by a con-temporary of Homer, with an illuminating introduc-tion by a present-day historian of Adirondack culture, is William H. H. Murray, *Adventures in the Wilderness* (Boston, 1869); new ed., ed. William Verner (Syra-cuse, N.Y., 1970).

6. Lake Winnipesaukee, which lies within sight of the southernmost range of the White Mountains, has always been considered a separate domain. Even without Lake George, which in the minds of some has its own distinct regional identity, the Adirondacks would still easily be the most lake-filled of these mountainous areas. The others have gotten by with a sprinkling of ponds.

7. The first painter of significance to make the Adirondacks a speciality was Arthur Fitzwilliam Tait (1819–1905). Homer probably had firsthand reports

of the Adirondacks as early as the mid-1850s from two fellow graphic artists in Boston, Frederic Rondel (1826–1892), who also gave him some preliminary in-struction in painting, and Roswell Shurtleff (1838–1915). Some of his closest associates in the New York community of artists had painted in the Adirondacks in the 1850s and 1860s, including Homer Dodge Martin, John Lee Fitch, and Eliphalet Terry. Compared to them, Homer was a late arrival.

8. Henry Adams, "Winslow Homer's 'Impression-ism' and Its Relation to His Trip to France," in Nicolai Cikovsky, ed., *Winslow Homer: A Symposium* (Wash-ington, D.C., 1990), pp. 61–89.

9. Tait was the prototypical artist in this regard. See Warder Cadbury and Henry F. Marsh, *Arthur Fitzwilliam Tait* (Newark, Del., 1986).

10. Murray, *Adventures;* and Richard Roth, "The Adirondack Guide in History, Literature, and Art," Ph.D. dissertation, Syracuse University, 1990.

11. David Tatham, "The Two Guides: Winslow Homer at Keene Valley, Adirondacks," *The American Art Journal,* vol. 20, no. 2 (1988), pp. 20–34.

12. Cadbury and Marsh, *Tait,* pp. 63, 165.

13. In Keene Valley, Homer stayed at the Widow Beede's Cottage, a small summer hotel, in 1874, and perhaps also four years earlier; Tatham, "Two Guides," pp. 26–30. In Minerva he stayed at the Baker farm, a small boardinghouse, in 1870 and 1874, and at the same location on his many visits between 1889 and 1910, during which period it was the property of the sporting organization that in 1895 named itself the North Woods Club. Tatham, "Winslow Homer at the North Woods Club," in Cikovsky, *Homer,* pp. 115–130. If Homer visited any other place in the Adirondacks, no evidence of it has yet come to light.

14. *Minerva: A History of a Town in Essex County, N.Y.* (Minerva, 1967), p. 126. Homer's mid-Victorian middle-class rectitude in the matter of models can be inferred from what little is known of his practice. In New York he used professional models; the profes-sion was one of uncertain respectability. Outside New York, where professional models were not avail-able, he sometimes used friends. In Belmont, Mas-sachusetts, and at Houghton Farm in Mountainville, New York, he occasionally dressed boys as girls to avoid imputations of impropriety, since posing for pay was for middle-class girls and women a morally questionable act. By definition, a lady did not work

for money. Portraits were a different matter, since the sitter paid the artist (though Homer's few portraits were of friends and family and some were probably gifts to their subjects). In later life at Cullercoats in England and at Prout's Neck, where he was part of small, closely-knit communities of local workers, he paid his friends and neighbors to pose. In these things his views and practices seem to have been little different from those of other American artists of his generation, though from the vantage point of the late twentieth century, these attitudes toward models seem prudish and the practices bizarre. Not all the figures in Homer's work were rendered from models, but the major, thoroughly studied ones almost always were.

15. Leila Fosburgh Wilson, *The North Woods Club, 1886–1986* (n. p., 1986), pp. 8–9.

16. For biographical data on Wallace and Lancashire, I thank Noelle Donahue of the Minerva Historical Society, Olmstedville, New York. Lancashire's father spelled the family name Lankenshire. Wallace is believed to have died around the turn of the century.

17. The quoted phrase is from E. P. Richardson, *Painting in America* (New York, 1956), p. 313.

18. Wilson, *North Woods Club,* p. 7.

19. North Woods Club Minute Book, vol. 1. North Woods Club Register, The Adirondack Museum, Blue Mountain Lake, New York. See also Tatham, "North Woods Club," p. 118.

20. North Woods Club Register, The Adirondack Museum.

21. Lloyd Goodrich and Edith Havens Goodrich, "Adirondack Works by Winslow Homer," in *Winslow Homer in the Adirondacks,* catalogue for an exhibition at the Adirondack Museum (Blue Mountain Lake, 1959), pp. 25–26. The catalogue includes a useful note, "Some of Homer's Adirondack Models," by John R. Curry, and an essay, valuable for its insights, by James W. Fosburgh.

22. The description is in chapters 26 and 27. In a later edition of the novel published by Appleton & Co. (New York, 1874), pp. 129–131, this passage is illustrated by F. O. C. Darley. Natty Bumppo dispatches the exhausted deer by cutting its throat.

23. Philip C. Beam, *Winslow Homer at Prout's Neck* (Boston, 1966), pp. 102–104.

24. Since Homer meant to depict types and not to portray specific individuals, the use of more than one model for a figure presented no special problem. His earlier oil, *The Two Guides* (1875), differed in being a double portrait of two well-known persons.

25. He may have begun earlier, if the Flynn-like figure in the watercolor *An October Day* (Sterling and Francine Clark Art Institute, Williamstown, Massachusetts), dated 1889, is, in fact, Flynn.

26. *Minerva,* p. 64.

27. *Ibid.,* p. 20.

28. I am grateful to his son Patrick for this explanation of the origins of the nickname.

29. See, for example, Jean Gould, *Winslow Homer* (New York, 1962), pp. 238–239.

30. I am grateful to his daughter, Mary Flynn Jenkins, for much biographical information, including recollections of him as a dancer, storyteller, horseman, and teamster on road building projects as well as his dislike of guns. Flynn was descended from early Irish settlers on the New York–Canadian border. The Town of Minerva's first Irish families arrived in the mid-1830s.

31. Recalled by Patrick Flynn in conversation with the author.

32. Most often, Homer omitted a crease of any kind and used the crown as a round form.

33. A long-standing tradition in the Adirondacks holds that the sportsman is Homer, but there are reasons to question this identification. Homer's large moustache was dark into old age; the sportsman's much smaller moustache is light. The physique and facial features do not correspond to those in the several photographs of Homer taken in the 1880s and 1890s. On the weight of the visual evidence, this sportsman seems not to be Homer.

34. Underlying these ideas was the assumption that a better human condition once existed, that it had been in steady or cyclical decline for a long while (since the Fall of Man in one view), but that the decline had been less severe in some places than others, and least of all in those places where humankind lived closest to pure wilderness and in a nurturing relationship to it.

35. For a useful discussion of this work, see Helen Cooper, *Winslow Homer Watercolors* (New Haven, Conn., 1986), pp. 179–180.

36. Alfred Trumble, review in *The Collector,* January 1, 1892.

37. Beam, *Homer,* p. 107, identifies the young man in Homer's *Hound and Hunter* (see Fig. 2), who has the

same face as the figure in *Huntsman and Dogs*, as John Gatchell's son Wiley, but the resemblance to Flynn is unmistakable. When Homer adapted these images to the oil medium he may have used Wiley Gatchell for further work on the figures, but he preserved the essential characteristics of Flynn's face in both cases.

38. On October 15, 1891, Homer wrote to his brother Charles from the North Woods Club that he had commenced two oil paintings on October 2. These were *Huntsman and Dogs* and *Hound and Hunter.* Lloyd Goodrich, *Winslow Homer* (New York, 1944), p. 122. If this is to be taken literally, then Homer would have brought oils and canvas to the club with him when he arrived on October 1. He may, however, have meant that he had commenced work on the watercolor studies that he intended from the outset to develop into oils. The latter seems more plausible.

39. Quoted in Gordon Hendricks, *The Life and Work of Winslow Homer* (New York, 1979), pp. 210–211.

40. For a brief discussion of Homer and Darwinism, see Nicolai Cikovsky, *Winslow Homer* (New York, 1990), pp. 101–116.

41. Goodrich, *Homer,* p. 123.

11

Thomas Eakins and "Pure Art" Education

ELIZABETH JOHNS

*Among the many controversial aspects of Thomas
Eakins's career, none is more romanticized than his
legendary status as the uncompromising art teacher at
the Pennsylvania Academy who lost his job because he
refused to modify his instructional practices. As noted
Eakins scholar Elizabeth Johns explains, the common
presumption—that a series of discrete and identifiable
incidents involving the use of nude models in the
classroom led to his dismissal—is an oversimplifica-
tion of a complex situation. Drawing on Eakins's cor-
respondence and on the archival records of the
Academy, Johns locates the substance of the artist's
disputes with the Academy administration in a matrix
of pedagogical and curricular views emergent from
Eakins's own experience as an art student.*

*Eakins designed a rigorous curriculum in which
students could still have maximum autonomy to de-
velop on their own. His advocacy of "pure art educa-
tion," including instruction from the nude figure for all
art students, regardless of their personal interests, was
deemed impractical in a school that sought to accom-
modate a diverse population with varying professional
aspirations. In addition, his manifest reluctance to en-
gage in direct instruction was understood not as re-
spect for student autonomy (a condition he valued
highly in his own education) but rather as indifference
and neglect.*

What is best known about Thomas Eakins as a
teacher of artists is that he was fired. That was a
stunning conclusion to his career at the Pennsyl-

vania Academy of the Fine Arts. Although sev-
eral historians have enumerated in detail
Eakins's procedures and problems during his
years as a teacher at the Academy,[1] I will take a
more general and interpretive point of view in
this essay, assessing Eakins's teaching by dis-
cussing three questions: What aspects of it upset
the Academy authorities so drastically that they
fired him? On what examples did Eakins model
his teaching? And in what intellectual context
might we best understand Eakins's convictions
about teaching—and about learning?

Eakins (1844–1916) was on the faculty of the
Academy in Philadelphia for ten years: from
1876 to 1879, when he taught as an assistant;
from 1879 to 1882 when he taught as Professor
of Drawing and Painting; and from 1882 to
1886, when he was Director of the Schools.

When the Board of Trustees demanded
Eakins's resignation only four years into his
tenure as director, explanations for the rupture
focused on his use of the nude model: some said
that he was fired because he insisted on using
male and female models together, others that he
used students as nude models for the life class of
the opposite sex, still others that he lifted a loin
cloth from a male model in a female life class.
Although subsequent historians have endorsed
these explanations, a look at the larger picture in-
dicates that no such isolated actions by Eakins

led to his dismissal. Instead, two general areas of disagreement caused the clash.

First, Eakins had imposed a single instructional program on the Academy curriculum, and the board disagreed strongly with its narrowness. As Eakins made clear in a statement in 1882, he believed that the Academy's curriculum should train students exclusively in "pure art education." Acknowledging to the board that the Academy had three categories of students, Eakins set forth the philosophy that he insisted should undergird all Academy training: "To furnish facilities and instruction of the highest order to those intending to make painting or sculpture their profession. Secondarily, to extend as far as practicable the same benefits as a foundation for those pursuing . . . industrial art. Such persons are engravers, die-sinkers, illustrators, decorators, wood carvers, stone cutters, lithographers, photographers, etc., and have always been largely represented in the school. No other benefits whatever but those of pure art education are extended to them, they learning outside [the Academy] the mechanical parts of their art or trade. Lastly, to let amateurs profit by the same facilities . . . The course of study [for all three groups] is purely classical. . . . Its basis is the nude human figure."[2]

Disagreeing with Eakins's narrowly focused program, the board wanted to offer courses that would appeal to the practical needs of the Academy's diverse group of students—a group that included lithographers and decorators who wanted to improve their drawing skills, photographers who needed work on their compositional skills, and young women who wanted to learn watercolor technique. Although the board needed a broad tuition base so that the Academy could be self-sustaining, what had considerably more weight in their breach with Eakins was their belief that training in art should cater to students' immediate needs and wants. This was a position with which Eakins had no sympathy.

The second general difficulty that Eakins experienced with the Academy administration lay in his role as a teacher. When the board officially organized the Academy instruction in 1868 (after years of informal arrangements), they expected that the instructor would preside over the courses and the serious aspects of "art" in a conspicuous manner. But in Eakins's fulfillment of the role, he refused to give his students advice in such aesthetic matters as pictorial composition and the principles of beauty, and except for scheduled visits to the classrooms once or twice a week, he left his students alone. While such relative student autonomy was by no means unique to Philadelphia, it was certainly not consistent with the board's expectations. One of Eakins's students proudly reported later that his procedures "made [them] very self-reliant."[3] The Board considered such methods evidence of arrogance and disinterest, but Eakins did not conceive of teaching in any other way and was astonished by their interpretation.

In what preconceptions did Eakins's curriculum and teaching procedures originate?

Let us examine his own experience as an art student. It began in Philadelphia, actually in his high school drawing classes where he learned all types of drawing, including the copying of machines and of academic casts, under the principle that to draw correctly was to see and think correctly.[4] How closely his teacher guided his work is not possible to determine, but Eakins's drawing of a lathe done for one of his assignments reveals that he was an astonishingly capable draftsman. In 1862, after he had graduated from high school, he enrolled in the Pennsylvania Academy of the Fine Arts where he drew from casts, attended anatomy lectures, and eventually was admitted to the life class. Supervision by a teacher at the Academy was at a minimum; in fact, during these years before the board organized a curriculum, help was usually limited to occasional comments by older students. In 1866

Eakins went to Paris to begin his four years of study under Jean Léon Gérôme at the École des Beaux-Arts, his last experience as a student. We have reports of this training because he wrote letters home about it.

Several things about Eakins's studentship in Paris are distinctive. First, although the École's curriculum called for drawing from casts one or more days per week, Eakins skipped those days because he felt drawing from the antique hampered him as a painter. Second, he began painting from the model within a few months after his arrival in Gérôme's studio and relished it so much that he was seldom to draw again. The third distinctive aspect of Eakins's study in Paris was that he had a very difficult time learning to paint. His letters home are full of what he called "downheartedness" at his tendency to muddle colors, at his slowness; he reported that even his dreams were haunted by unruly colors night after night.[5] Then toward the end of his third year he began to write with a sense of triumph that because of his persistence he was finally overcoming his clumsiness. The fourth aspect of Eakins's study in Paris, closely related to this third, was that his teachers did not guide him closely, and Eakins considered the independence this gave him essential to his progress. Gérôme apparently looked frequently at his students' work, either making comments or keeping quiet to encourage the students simply by his endorsement. He actually took brush in hand to correct Eakins's work on only a few occasions, to which Eakins had varying reactions. Early on Eakins took the corrections in stride, reporting to his father that he was grateful for the help. But as Eakins developed his own working method, and watched the students around him developing theirs, he did not want correcting. Once when Gérôme repainted a head he had underway, Eakins was furious and wrote home that he would have learned more from "slathering around"[6] (by which he meant working and re-

working on his own even when the results were a mess). In fact, "slathering around" on his own had been and became even more firmly the central motif in Eakins's own development. For example, after he had been in Gérôme's studio about a year and was not making the kind of progress Gérôme and he both thought he should have been making, he rented his own studio to practice away from the class on techniques he needed to develop. As he had in Philadelphia, he went to nearby hospitals for further practice in dissection, deepening his understanding of human anatomy.

Thus as far as Eakins was concerned, his teachers' strength lay in their demand that their students depend on nothing but their own hard work and developing sensibility. Gérôme had been an excellent teacher, Eakins wrote his father as he drew close to the end of his studies. "Gérôme is too great to impose much. . . . aside [from] his overthrowing completely the ideas I had got before at home, & then telling me one or two little things in drawing, he has never been able to assist me much & oftener bothered me by mistaking my troubles."[7] Eakins had a similar assessment of the portraitist Léon Bonnat, with whom he studied for a month during his last year in Paris. Only a few years older than Eakins, Bonnat was particularly good as a teacher, Eakins wrote, because he remembered his own recent difficulties with tyrannical teachers. "Bonnat is now a big man. I am very glad to have gone to Bonnat & to have had his criticism. He says do it just as you like. He will never impose any way of working on his boys. . . . He never finds fault with any thing but the result."[8] And although Eakins did not study with Thomas Couture, he idolized him as a painter and wrote his father that Couture, too, had suffered under dictatorial teachers. "Couture came near giving up painting on account of his masters & his conclusion is the best thing a master can do is to let his pupils alone."[9]

The foundation of Eakins's trust in his teachers was that he extravagantly admired them as painters. He wrote home with long analyses of the paintings, the character, the fine looks of his teachers Gérôme and Bonnat and of Couture. He reported in detail the historical and psychological character he found in their work, and he emulated the self-discipline with which he believed they had developed their authority.

Six years after he returned from Paris, Eakins took up the role of teacher at the Pennsylvania Academy and modeled his procedures and expectations on what had been so important to him in Paris. In teaching methods, he criticized his students' work once or twice a week, by schedule, and the rest of the time pursued his own work. In commenting on student work, he was often direct, more often quiet, and only occasionally did he correct a study. He expected his students to work as hard as he had; because painting had not come easily to him, he did not look compassionately on students who would not persist. Just as in his own student years he had responded to the criticisms of Gérôme and Bonnat on the basis of their authority as painters, he expected his students to respond to his criticisms in the same way. It was an appropriate expectation; when Eakins began teaching in 1876, he had already painted the *Gross Clinic.*

In considering Eakins's curriculum, it is important to note that a few aspects of it were not of his making. Students at the Academy had been studying from the nude model before he began teaching, and they had been encouraged to paint rather than draw in the life class early in their studies. They had also been attending anatomy lectures, but irregularly.

Eakins made the following changes: using his own experience as a guide, he deemphasized drawing from the antique and indeed drawing of any kind; he turned the modeling class from a preparation for a career in sculpture to a study class for painters; and he instituted dissection for all advanced students (about one-fourth of the student body). He insisted that all students attend lectures on anatomy twice a week. He lectured on perspective, began classes in portraiture for the study of the human face, and proposed classes in still-life painting for the development of skills in color and tone. He introduced photography as a study of the human body in motion. Eakins was proud that in the context of other academies, the course was rigorous, and he boasted to the Committee on Instruction that it was "more thorough than in any other existing school." Not even at the École des Beaux-Arts was dissection so important (although students could take advantage of dissection facilities in the school if they wanted to); at no other academy was modeling from life required; at no other academies was drawing from the antique so discouraged.

What intellectual convictions guided Eakins's insistence on this rigorous curriculum for such a varied body of students, the majority of whom had industrial and amateur rather than professional goals?

The explanation lies, I think, in the world view in which Eakins was trained even before he studied as a painter. This was the Enlightenment conviction that empirical knowledge served as an ordering principle, derived as it was from careful observation and reflection, and furthermore, that a certain core of knowledge was a necessary basis for activity in any sphere whatsoever. This conviction dominated Eakins's education at Central High School, his father's career as a writer and teacher of script, and his own study as a developing artist. The Central High School curriculum, established in the early 1840s, called for the study of the natural sciences, of history, of foreign languages, of mathematics, and of writing and drawing; annually the School Board reaffirmed its conviction that all citizens in a democracy needed such training whether they later became physicians or stone masons, lawyers or bakers, artists or geologists. The High School even endorsed the teaching of anatomy and the

attendance of students at dissections so that they would see first hand the order of the physical universe and the correlation between what is seen and what is unseen. In Benjamin Eakins's capacity as a writer and teacher of script (a profession in which Thomas joined him during his first few years after high school), he himself subscribed to the faith in the ordering function of knowledge gained through experience. Writers of script saw their vocation as built on intellectual clarity: one could not draw or write correctly unless one first observed carefully and then ordered those observations. And finally, Eakins was guided by these convictions in his direction of his own study to be a portrait painter, a goal he declared quite early during his study in Paris. He assigned to himself the mastery of anatomy, of dissection, of sculpture as a study for painting, of perspective, of still life, all in addition to earnest investigation of a wide range of painting techniques. Knowledge was to be the foundation for painting even the simplest bust portrait.

Eakins's commitment to knowledge rings again and again in the memories of his students.

A contemporary wrote of the Academy under his direction that its objective was to impart knowledge, not inspiration.[10] "Strain your brain more than your eye," Eakins was reported to have urged his students;[11] and he commented on his own painting that it had not become good until he finally knew enough to paint from memory rather than observation.

Thus Eakins's insistence at the Academy on a pure art education, one that taught the students to look carefully at the real world, to know thoroughly what they saw, and to order it appropriately, grew from his education as a general citizen, from the ideals of his father's profession (for a while his own), and from his own extraordinarily disciplined study of art.

Although to his directors at the Academy Eakins's ideals were impractical, inefficient, and even threatening in their severity (an assessment most of us wrestle with in our own careers as educators), Eakins had no doubts. That an artist should receive a "pure" art education as a foundation for whatever he might do later with brush or pencil was to him a simple given.

NOTES

From *Archives of American Art*, vol. 23, no. 3 (1983). Reprinted by permission of the author.

This essay is adapted from a talk at the "Symposium on the Education of Artists in the United States" held at Mount Holyoke College, April 9, 1983. As the following footnotes indicate, material in the Archives of American Art assists the study of many dimensions of Eakins's career, including his teaching.

1. The most recent published secondary source for information on Eakins's years as a teacher is Lloyd Goodrich, *Thomas Eakins*, 2 vols. (Cambridge: Harvard University Press for the National Gallery of Art, 1982). Especially pertinent are vol. I, pp. 167–189 and 279–309, and accompanying notes. Two articles written during Eakins's lifetime are William C. Brownell, "The Art Schools of Philadelphia," *Scribner's Monthly Illustrated Magazine* 18 (September 1879): 737–750; and Fairman Rogers, "The Art Schools of Philadelphia," *The Penn Monthly* 12 (June 1881): 453–462. Reminiscences of an Eakins student are recorded by Charles Bregler, in "Thomas Eakins as a Teacher," *The Arts* 17 (March 1931): 378–386; and "Thomas Eakins as a Teacher: Second Article," *The Arts* 18 (October 1931): 18–42. Recent interpretive essays include Louise Lippincott, "Thomas Eakins and the Academy," *In This Academy: The Pennsylvania Academy of the Fine Arts, 1805–1976* (Philadelphia: Pennsylvania Academy of the Fine Arts, 1976); and Ronald J. Onorato, "Photography and Teaching: Eakins at the Academy," *American Art Review* 3 (July–August 1976): 127–140, and "The Context of

the Pennsylvania Academy: Thomas Eakins' Assistantship to Christian Schuessele," *Arts Magazine* 53, no. 9 (May 1979): 121–129.

2. Archives of the Pennsylvania Academy of the Fine Arts, Archives of American Art, microfilm roll P67, frame 1165.

3. Goodrich, I: 184.

4. I discuss Eakins's high school curriculum and its implications more fully in "Drawing Instruction at Central High School and Its Impact on Thomas Eakins," *Winterthur Portfolio* 15 (Summer 1980): 139–149.

5. Many of Eakins's letters from Paris to his family are owned by the Archives of American Art (microfilm roll 640, frames 1432–1565). Among these he dis-

cusses his general convictions about painting (especially that of his teachers) in letters to his sister Frances of November 13, 1867 (frames 1463–1465) and to his mother and sister of April 1, 1869 (frames 1480–1492). About his own progress in painting he usually wrote directly to his father, Benjamin Eakins; the most revealing of these letters, now lost but copied in 1930 by Lloyd Goodrich, are published in Goodrich, *Thomas Eakins* 1: 23–27, and 50–57.

6. Goodrich, I: 27.

7. Goodrich, I: 53.

8. Goodrich, I: 51.

9. Goodrich, I: 51–52.

10. Brownell, 746.

11. Bregler, "Thomas Eakins as a Teacher," p. 383.

12

The "Earnest, Untiring Worker" and the Magician of the Brush

Gender Politics in the Criticism of Cecilia Beaux and John Singer Sargent

SARAH BURNS

Cecilia Beaux and John Singer Sargent both enjoyed distinguished careers as portraitists to the social and intellectual élite of the Gilded Age. Their pronounced similarity of subjects, technical execution, and aesthetic values prompted critics to compare them—a practice that frequently resulted in an estimation of Sargent as the superior artist. But as Sarah Burns explains, the critical discourse that fashioned this hierarchy favoring Sargent was dependent upon the language of gender difference. Drawing on popular fiction as well as art criticism, Burns examines prevailing gender ideology at the turn of the century as it was brought to bear on conceptions of artistic creativity and the analysis of portraiture.

The contrast between Sargent and Beaux was stated in terms of a "natural" distinction between the artistic temperaments of an objective, analytical male and an emotionally sensitive female. Similarly, their respective portraits were admired for the degree to which they manifest penetrating insight into (Sargent), or sympathetic understanding of (Beaux), the sitter's character. Burns connects this impulse toward critical evaluation structured in gendered terms to broader cultural patterns, including growing anxiety about the feminization of American culture and the collapse of gender difference forecast by modern feminism. Finally, she identifies a parallel situation in the medical profession, wherein hierarchical distinctions between dynamic male scientist/doctors and self-effacing female caretaker/nurses were preserved through linguistic construction as well as institutional practice.

When Cecilia Beaux exhibited *Sita and Sarita* (1893) in the 1895 Society of American Artists show in New York, one reviewer wrote that despite the risk of seeming 'over-enthusiastic' should one claim that Beaux painted as well as John Singer Sargent, nonetheless, 'I am going to say that I don't see how even Mr Sargent could paint a portrait with more distinction than that of the woman with a black cat by Miss Beaux in the present exhibition.'[1] For a critic to establish virtual parity between Beaux and Sargent was uncommon, though visual evidence might prompt us to inquire why. Exact contemporaries, Beaux (1855–1942) and Sargent (1856–1925) were both French-trained cosmopolitans. Both were

acknowledged and celebrated as leading portrait painters, exhibiting in major American and European shows and, by 1895, both were approaching the heights of their careers. More often than not, their portraits appear strikingly similar in scale, tone, and liveliness of execution; each wielded a broad and dashing brush to produce bold, animated, commanding images of the social and intellectual élite. Critics before and after the turn of the century, however, almost invariably contrasted the two painters' works as expressions of an essentially feminine versus an essentially masculine nature and, with almost no exceptions, declared Sargent the superior. While Sargent's superstardom went unchallenged, Beaux was accorded the status of worthy contender, albeit 'the greatest living woman painter' and recipient of numerous awards and honours.[2]

In this essay, I examine the corpus of Beaux-Sargent criticism in order to expose the workings of language in manufacturing gender difference and hierarchy, and to explore the ways in which this language, which imposed gendered readings on paintings closely comparable in subject and style, played a powerful role in support of a specific agenda. By creating, accentuating, and encoding difference, this art-critical language proved instrumental in maintaining male domination of painting practices and public art culture at a time—around the turn of the twentieth century—when women were moving into the art professions in growing numbers. Finally, by looking at the discourse of gender and professionalism in medicine, I suggest that the language of Beaux-Sargent criticism models in miniature the configuration of gender conflict and contest in the wider socio-cultural arena.[3]

The bulk of the criticism investigated here dates from the mid-1890s to about 1910, the period showing the highest incidence of Beaux-Sargent comparisons. Prior to the early 1890s, Beaux, born in Philadelphia, had established a strong reputation as a highly promising portrait painter in a solid, sombre, naturalistic style rem-iniscent of native son Thomas Eakins's works.[4] In the early 1890s, however, a more brilliant and painterly manner emerged after a stay of nineteen months in Europe, many of them in Paris, where Beaux had studied in various academic ateliers. After her return to the United States, she settled in New York city and continued to build her reputation by exhibiting and winning prizes in shows sponsored by the most prestigious art institutions of the time: the National Academy of Design, the Pennsylvania Academy of the Fine Arts, the Society of American Artists, as well as, in Paris, the Champs de Mars exhibition in 1896 and the Exposition Universelle of 1900.[5] Despite the probability that her new style represented an eclectic, individualistic fusion of ideas—*Sita and Sarita,* for instance, evokes Edouard Manet in certain passages—critics tended from the start to assume that Sargent was her inspiration. 'It looks as if he had had a pupil who had learned her master's art', observed one on viewing Beaux's work at the National Academy of Design in 1892.[6] At the same time, Sargent's reputation was on the rise in America, with critical 'Sargentolatry' beginning in the mid-1890s, as Gary Reynolds has noted. Frequently exhibited in New York, Boston, and other eastern cities during an era when cosmopolitan portraiture was at its popular and critical height, by the turn of the century Sargent's works occupied the very pinnacles of fame and, in the critics' eyes, served accordingly as benchmarks for Beaux.[7] After about 1910, however, the incidence of Beaux-Sargent comparisons dropped off. Beaux's fame had achieved its own pinnacle by then (she was safely enshrined as an Old Mistress); Sargent was no longer an active producer of portraits, and virility had reasserted itself in the art capitals of America.

Before turning to the Beaux-Sargent criticism, a few more preliminary observations are in order. First, it is important to note that comparisons of Cecilia Beaux and John Singer Sargent did not always or even often occupy the fore-

ground of critical attention. Most articles featuring Sargent never mentioned her, except perhaps as one of a train of followers. Nor did writers on Beaux necessarily leap to the question of how she measured up to her expatriate countryman; admirers could and did devote many paragraphs and pages to sheer praise of her skill, taste, and genius. Typically, a reviewer might state that Beaux was an artist of power, distinction, originality, and abundant vitality; another might assert that Beaux was 'among artists, regardless of sex [. . .] of the first rank.'[8] The more gender-biased rankings of Beaux and Sargent occupied the crevices of the discourse; an aside here; a paragraph there. It is only when one surveys a long string of reviews and essays that a pattern becomes clear; what is relatively insignificant as a sentence or two in one piece becomes more important as part of a whole.

Second, the pattern I trace here may seem schematic, too neat in its insistent binary oppositions of maleness and femaleness. This binarism is, however, a straightforward reproduction of the language employed a century ago with the precise (if unstated) goal of maintaining 'natural' gender distinctions. While it might be a worthwhile further project to create alternative positions from which to describe and experience the works of these two painters, the agenda here is primarily to analyze the language that helped shape the way their works were seen and understood at a specific historical juncture, and to discover how certain signs of maleness and femaleness were read into their works by turn-of-the-century critics.

Last, a word about the latter. With the rise of the mass newspaper and periodical presses in the late nineteenth century came the establishment of increasingly professional and informed art criticism. Major magazines and newspapers carried regular features about contemporary art trends and exhibitions, and through these publications, certain critics achieved considerable visibility and power. In this article, I tend to cite two in particular: Royal Cortissoz, critic on the

New York Tribune and contributor to various élite magazines such as *The Century,* and Charles Caffin, critic on the *New York Post* and other papers and journals, and prolific author of books on art for the layman. While Cortissoz was decidedly more committed to the high cultural tradition of the Renaissance than the pluralist Caffin, both shared the view that art should unify, elevate and ennoble contemporary society, and they dedicated themselves to the mission of educating the public to know and appreciate the approved forms of artistic production. Therefore, what they and other critics of the time had to say about Cecilia Beaux and John Singer Sargent represents the voice of authority, working to mould opinion along very specific lines.[9]

In order to discover the arbitrariness of language, which does so much to organize our understanding of meaning, including that of gender, we need only consider representative portraits by Beaux and Sargent with reference to lists of keywords and phrases culled from contemporary commentary. The Beaux painting depicts *Bertha Vaughan* [1]; Sargent's portrays *Catherine Vlasto* [2]. *Bertha Vaughan* is executed *con brio,* with the dazzling white and shimmering pale green of the woman's evening costume set off by bands of blue-black trim. Dangling a gold monocle on a chain, Bertha Vaughan looks directly out, her features, it would seem, rendered in a blunt, unglamorized manner. *Catherine Vlasto* is a study in muted tones, shadowy browns and greys setting off the crisp white of the sitter's dress; her face is shadowed; she looks away. The following cluster of descriptive phrases would most likely attach itself to one of these portraits: it is a work showing little evidence of sympathy or kindliness; a work altogether brilliant, vigorous, incisive, penetrating, and aggressive, with colour sharp and vibrating, rather than deep or tender. The other would more likely be described as the work of a quiet, unassuming sensibility; sensitive, abounding in sympathy, full of feeling, and exhibiting a

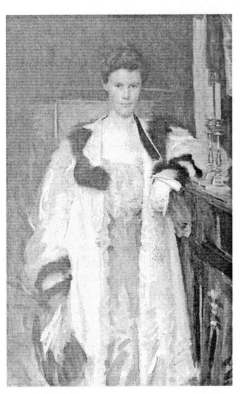

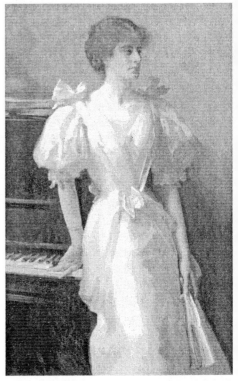

1. Cecilia Beaux, *Portrait of Bertha Vaughan,*
1901; courtesy of Radcliffe College.

2. John Singer Sargent, *Catherine Vlasto,* 1897;
courtesy of Hirshhorn Museum and Sculpture Garden,
Smithsonian Institution. Gift of Joseph H. Hirshhorn,
1972.

poetic grasp of character. Which one of these
paintings matches which cluster of attributes?
Which one is brilliant and which sympathetic? If
we scrutinize individual passages of brushwork,
which marks display aggression and which ones
display sensitivity? Surely, the first cluster which
represents typical terms of approbation for Sar-
gent's work—terms then explicitly identified
with masculinity—might gravitate quite readily
to *Bertha Vaughan,* while the other, inscribed
with signs of femininity, might seem more com-
patible with *Catherine Vlasto;* or, indeed, one

could argue that both clusters interpose distort-
ing screens of language, between subject and ob-
ject, however they might be applied.

Does Sargent's portrait signal some essence of
maleness that distinguishes it absolutely from
Beaux's, or is it rather that the language used to
describe the two has constructed an arbitrary
system of differences, of relative values, in
which the nominally feminine style is squeezed
into a mould of charm and sensitivity to sustain
and reinforce distance from the masculine? Oc-
casionally, it is true, critics did use terms such as

'penetrating' and even 'virile' of Beaux's canvases. Even then, however, they tended to modify them with some complementary feminine quality, as did Charles Caffin: 'She has the masculine breadth of technique, allied to a point of view exclusively feminine; so feminine, indeed, that the traits which she represents, while they come to us from a man like Sargent, for example, with all the piquancy of a discovery, have in her representation an obviousness which is apt to be a little dry and prosaic.'[10] Significantly, too, even when commentators failed to make references to Sargent, they saw Beaux's portraits in femininized terms, emphasizing their charm, tenderness, and emotionalism.

Consider another nearly contemporary pair: Beaux's *Mrs Larz Anderson* (1900) and Sargent's *Mrs George Swinton* (1897). These two share a closer resemblance than the Vaughan and Vlasto portraits, being life-size, full-length images of white-gowned society hostesses in luxurious interiors. Sargent's painting vividly demonstrates his bravura stroke, while Beaux's work, though broadly rendered, exhibits a relative composure. They are similar, yet distinguishable as the works of different individuals. To determine which one is the superior piece of painting might rest on rather arbitrarily chosen criteria. Yet to one reviewer of Beaux's 1903 solo show at the Durand Ruel Gallery in New York, her works held together only when they shunned a potentially fatal proximity with Sargent's. This writer began by stating enthusiastically that 'Miss Beaux's work challenges comparison with the best of its kind', and that her paintings exhibited a 'rare degree of accomplishment', but went on to say:

These portraits would command attention beside almost any of their kind, except a Sargent. Next a Sargent, the best of them would doubtless suffer; we should miss the perfect grasp of things, the infallible logic that makes a good portrait by Mr Sargent so indisputable whether you want to like it or not. We should then begin to find lapses in Miss Beaux's work where everything hung together with absolute precision in her rival's; passages almost but not quite true to the intention; approximate values almost but not quite realized; forms almost, but not quite clearly compassed.[11]

Listen, too, to painter Samuel Isham in 1905:

Miss Beaux's handling is broad and strong, the color flowing free and pure from the brush with many of those felicities that seem most accidental when they are the highest art; but neither in her work nor in that of any other artist is there the amazing jugglery of Sargent, which has something aggressive in its force and sureness, nor has she his impersonal, vivid insight into character. She is in sympathy with her sitters, and they are likeable and charming and enlist the affections of the spectator as those of Sargent rarely do after they get beyond the age of eight or ten.[12]

In the first instance, the difference between the two was asserted simply as a self-evident fact, without recourse to elaboration on the marks of femininity in Beaux's work. In the second, however, the two were differentiated according to supposedly gender-based traits, and this was a key manoeuvre in negotiating the Beaux's slightly yet firmly subordinate status.

The best illustration of this manoeuvre is Charles Caffin's assessment of Beaux. Unlike nearly every other reviewer, Caffin criticized Beaux for a perceived lack of sympathy with her subjects, finding in some works, indeed, so complete an absence of intimacy that the effect was 'positively callous'. Beaux's portrait of *Mrs Theodore Roosevelt and Her Daughter Ethel* (1901–1902) earned Caffin's approval, though, because the characterization of the head was 'more sympathetic' than usual; in fact, the image of Mrs Roosevelt proved superior to many of Beaux's portrayals precisely because of the sympathy with the subject displayed here. In Caffin's judgement, Beaux's work often lacked this qual-

ity and seemed mainly to be an exhibition 'only of exceedingly brilliant craftsmanship'.[13] It is illuminating to turn directly from this to Caffin's appraisal of Sargent two years later in an article entitled 'The Greatest Contemporary Portrait Painter'. The components of this greatness, according to Caffin, consisted in a manner 'seldom sympathetic and often callously indifferent'. Sargent's attitude toward his sitters was one of 'unconcealed superiority' and aloofness which was also 'entirely professional', because free of sympathy and cynicism alike. Sargent's *Mrs Carl Meyer and Her Children* (1896) exemplified the cool, factual, dissecting vision that distinguished Sargent from his contemporaries. At first glance, said Caffin, this portrait appeared ravishingly dainty, sweetness itself. But Mrs Meyer's maternal gesture, the elegant, calculated gesture of a fashionable woman toward the two children 'to whom she is almost entirely a stranger' revealed the exquisite blossom's fatal flaw.[14]

Many another piece of commentary extolled or deplored Sargent's bluntness: he was 'horribly literal, appallingly uncomplimentary'; his art was 'extremely uncompromising', refusing to make the slightest concessions to points of view other than his own; his portraits were wanting in intimate sympathy, and calmly intellectual, with little sentiment. Yet these qualities were intrinsic to his maleness. When Royal Cortissoz reviewed *The Work of John S. Sargent, R.A.* (New York, 1903) he attacked Mrs Alice Meynell's introductory essay for its 'delicate affectations [. . .] totally inappropriate to the occasion. Mr Sargent's work is too masculine, too brilliant, to be made the subject of pretty vaporings.'[15] All this was in decided contrast to assessments of Beaux's faculties. Caffin excepted, most critics perceived her work to be infused with intimate, sympathetic feeling. William Walton, who contributed a long appreciation of Beaux to *Scribner's Magazine*, finished his essay with a homily on the importance of spiritualizing the real:

The detective work of the true realist is only extremely good photography. But when the right way of knowing things takes the place of the narrow way of knowing them, when the artist's light for his camera renderings is that beautiful one we call spiritual, then is his work glorified. That to a woman's hand should be given this power to portray sympathetically the souls of her neighbors, their strength, their intelligence, their charm, is most fit and admirable, and fortunate are the bystanders who see it done.[16]

Homer St-Gaudens (in a short article illustrated by a reproduction of *Mrs Larz Anderson*) commented on Beaux's 'capacity for strength without that brutality so common to women in search of masculine qualities', and praised her 'dignified and assured method', in which 'intimate conceptions' abounded in 'sympathy for more than externals'.[17] In the contemporary construction of femininity, sympathy was a 'natural' outgrowth of womanliness. If Beaux manifested sympathy in abundance, she was fully and appropriately a womanly artist; if she evinced too little, as Caffin maintained, she was a callous technician, and never quite Sargent's equal in either instance.

In all the criticism I have cited, the issue of masculine artistic superiority was somehow at stake, but the linguistic construction of Beaux as Sargent's ever-so-slightly inferior counterpart suggests that the contest was rigged from the start and the outcome predictable. Why it was necessary for the game to be fixed pertains to the key circumstances of gender conflict and social transformations of the late nineteenth century. Complex and often intertwining social changes, encompassing reactions against, and accommodations to, modernization characterized the decades spanning the turn of the twentieth century in America. Incorporation and the rapid development of industrial capitalism eroded the sense (at least among the middle classes) of individual autonomy; simultaneously, certain critics feared that American culture and society were

becoming overcivilized, effeminate, sapped of vitality and will.[18] At the same time, middle-class 'new women', rejecting domesticity, entered higher education and public life—including the artistic professions—in escalating numbers, challenging bourgeois masculine authority and control of knowledge. The emergent culture of feminism in turn provoked response in the form of various movements toward masculinization, which included the gradual appropriation of aesthetic culture, nominally at least a feminized realm in the nineteenth century, to masculine spheres of interest.[19]

Speaking as editors, critics, and other symbols of authority, men (and in certain cases, women) contemplated, warned against, and resisted the threat of shifting gender power relations. Charles Dudley Warner, editor of the august *Harper's Monthly Magazine,* feared that men were in danger of losing cultural control as the 'new social order' (the day of the 'Subjection of Man') asserted itself. 'The impartial observer', he wrote, 'is likely to be confused, if he is not swept away by the rising tide of femininity in modern life.' While men were busy making money and reading little else but newspapers, innumerable women's clubs were pursuing 'literature, art, languages, botany, history, geography, geology, mythology'. Never before had there been 'so many women who are superior musicians [. . .] who can draw well [. . .] who are successful in literature, who write stories, translate, compile.' 'Man is a noble creation', said Warner, 'and he has fine and sturdy qualities which command the admiration of the other sex; but how will it be when that sex, by reason of superior acquirements is able to look down on him intellectually?' Warner's light tone throughout failed to disguise an underlying note of anxiety.[20] However much culture might serve as an instrument of female progress—and perhaps precisely for that reason—it was also perceived as marginal and potentially devitalizing. One editor argued that only moral fibre, not civilization, manufac-

ture, or education could save a nation: 'Music, the drama, the arts of beauty, the sports and games, have their place, but it is a secondary one, and wo [sic] to the land that puts them first.'[21] Some, including Theodore Roosevelt and his many disciples, put their faith in physical fibre and advanced the cult of action and ardent athleticism as the means to restore virility in a nation made soft by the effects of excessive, prolonged peace and prosperity, which (hypothetically) promoted effeminate tendencies in young men. One Roosevelt enthusiast, taking note of the 'multitudinous appliances invented for softening, polishing, and refining away the grosser features of masculinity, the training of the schools, of the social circles, of the home, of the church', was much heartened by the recent 'great wave of interest in manly physical exercises and training', and by the recent United States' triumph in the 'short and glorious' Spanish-American War. Other manoeuvres supplemented physical culture. Feminist Ida Husted Harper deplored them in an article dedicated to the enumeration of such tactics, including a 1903 episode at the University of Chicago, when the University's president, disturbed that women students had won more than their share of honours, decreed that they should be in separate classes to prevent their competing with men.[22]

The same discourses pervaded the art world. Even the preponderance of women as the subject of art worried Charles Caffin, who advanced the somewhat ludicrous theory that the decline of the English School in the late eighteenth century:

was due in a large measure to the excessive popularity of women of fashion [. . .] and equally in modern America the same cause is at work, retarding the lustier growth of our painting. For throughout our art from the high-priced easel portrait to the illustrations in the humblest magazines, our artists are encouraged by that strongest of inducements, a fatter pocketbook, to exploit continually the eternal female [. . .] until a considerable portion of our art is obsessed

with femininity and many a young artist [. . .] is seduced from such virility, as he may have had, into a lady-like condition of mind, young ladyish at that.

While it might appear that Sargent himself would fit neatly into this category, as the painter *sine qua non* of modern élite womanhood, he stood exempt. 'No painter of the present day can better render the elegance of fashionable femininity', wrote Caffin, 'but while he revels in the opportunity of luxurious display, he is never carried away by it. It interests him as a problem for his brush.'[23] The marginality of the over-refined artist was suggested by stories and novels like Frank Norris's *The Pit: A Story of Chicago,* in which the artist Sheldon Corthell serves as foil to daring, aggressive stock speculator Curtis Jadwin, who wages daily the 'Battle of the Street'. Corthell, by contrast, 'kept himself far from the fighting, his hands unstained, his feet unsullied. He passed his life gently, in the calm, still atmosphere of art, in the cult of the beautiful, unperturbed, tranquil; painting, reading, or, piece by piece, developing his beautiful stained glass. Him women could know, with him they could sympathise. And he could enter fully into their lives and help and stimulate them.' One reviewer of the novel scornfully dismissed Corthell as a 'meretricious aesthete', while admiring Jadwin, bold and commanding for all his vulgarity.[24] The threat, ultimately, was double-edged: on one hand, it seemed that women—as artists, writers, musicians, amateur enthusiasts, or even as subjects of art—had enervated culture in the course of appropriating it. On the other, by being an artist, the male took the risk of becoming both feminized and marginalized.

As in the case of society broadly conceived, implicitly or explicitly stated in the rhetoric surrounding art was the prescription for reinvigorating (and reappropriating) culture with infusions of pure, powerful manliness. This course was recommended by sculptor and critic William Ordway Partridge in an impassioned plea for 'manhood in art'. Like the soft young men deplored by advocates of the strenuous life, the artist needed to toughen himself, to shut out 'many alluring pleasures'. 'The moment an artist gives himself over to the benumbing pleasure of sense, that moment he ceases to be a great artist, because he ceases to govern himself.' Like other contemporaries concerned about the erosion of native physical and moral fibre, Partridge displaced the feminine onto a demonized image of France, which was 'falling into decadence because her virility is cankered at the heart' through abandonment to the senses. Though thus far preserved from such a decadence, America was not immune; one had only to observe warning signs in the world of art, where painters had become specialists in trivia of the most egregious sort. 'Our artists are not big enough *men;* first man then artist. Fame is won for painting fabrics and making dots of color like the actual stuff . . . The artist today is too much the slave of his palette and the latest sensation of the Paris school.' True manhood in art—discipline, bigness, purity, sanity, nobility—would in turn produce a 'manly tone in society', which to Partridge meant the same thing as social and cultural health.[25]

Movements toward the remasculinization of art and culture were complemented by manoeuvres to control and limit femininity to 'traditional' domestic and subordinate roles. The same decade that saw the materialization of the Women's Building at the 1893 World's Columbian Exposition in Chicago also witnessed an outpouring of cultural criticism, prose, and pictures that mapped out a scientifically legitimated discourse of woman's 'natural' inferiority and difference in the field of art as in every other area, from public, professional life to the fundamental workings of biology. One facet of this discursive formation maintained that genius, or even the higher forms of creativity, were exclusively male properties. This argument was

hardly a new one; Christine Battersby has traced it from classical Greece through Romanticism and Modernism. Its essence was that 'women had procreative and domestic duties that would take all their (limited) energy . . . Romanticism turned the artist into a demi-god: the genius. Women, by contrast, became simply "Other". The occasional female creator could be countenanced; but being a creator and a truly feminine female were deemed to be in conflict.'[26] Such was precisely the substance of scores of articles appearing in American journals during the turn-of-the-century era, when, in the context of feminism and socio-cultural transformations, the subject assumed particular urgency. One overheated opinion piece declared outright that 'the power to create is entirely lacking in women'. Had it not been for men, women would have remained 'in utter barbarism . . . They could supply the civilization of the emotions, but men had to supply material civilization; and a law as inexorable as the law of gravity shuts women out from the highest form of intellectual life.' This writer and others granted women a faculty for decorative, 'minor' arts associated with domestic life, such as china painting or the manufacture of silk hangings, but 'women have lacked the masculine emotions necessary for the production of great paintings'. Virtually the only exception to this rule was Rosa Bonheur, the French painter of heroic animal subjects, who approached the masculine in both dress and behaviour.[27] Rooted in their emotions and instincts, incapable of ascending to the realms of abstraction, women found their appropriate level in domestic life; anything other was against nature and indeed would diminish and impoverish society. Along those lines, E. A. Randall, another anxious anti-feminist, morosely forecast a sterile, utilitarian future, a 'hard, gray world [. . .] out of which all the grace and softness would be gone; a world of self-supporting old maids and business men', should 'anti-feminine' women succeed in dissolving the sex distinctions that had evolved

'naturally' in the civilizing process. Whereas the 'high masculine qualities' consisted of knowledge and application, those intrinsic to femininity were responsiveness and sympathy. Following Herbert Spencer's model of specialization through evolution toward high civilization, Randall declared that 'civilized man' had specialized himself on logical intelligence and practical handicraft, civilized woman on emotions and intuitions, home and family. Because of her natural limitations, no woman could be a genius. Yet the genius possessed something akin to feminine intuition, which, when coupled with his own 'natural' male knowledge and logic, produced 'the masterpieces of the world's progress'.[28] In the male, female qualities contributed to genius; in the female, the same qualities barred her from it. This strategy of appropriation at one and the same time nullified women's contributions to culture and legitimated its masculinization. Precisely because she was a creature of sympathy and feeling, woman was the inferior artist. English essayist A. C. Benson, widely read in the United States, asserted that the successful artistic temperament combined a superficial layer of 'glittering emotion' with a bedrock of intellect. Lacking this fundamental attribute, women, 'with all their power of swift impressions, of subtle intuition', had 'seldom achieved the highest stations in art.' Male artists were single-minded, driven, and egotistical, but women's artistic gifts were ever subordinated to deeper purposes: 'the desire of giving and serving'. The best art, wrote Benson, in semantically loaded terms, had a 'hard, vigorous, hammered quality', generated by a masculine temperament grounded upon a 'hard, intellectual force' and guided by a spirit 'cold and critical'.[29]

The work of proclaiming the truth and naturalness of woman's artistic triviality was also to be found in popular fiction and satire. Occasional cartoons exhibited women artists as vacillating dilettantes and incompetents. In 'Apropos [sic] of the Painting', for example, a critic sits in a studio

scrutinizing work displayed on an easel. As he 'quizzes' the painting through his lorgnette, the young woman artist queries, 'Well, what do you think?' and receives this response: 'H'm! Did you ever try *writing* for a living?'[30] Commentary and tales in the popular press rehearsed an almost unvarying litany of feminine artistic fakery and failure. The very term 'artistic' as a modifier for any sort of female took on a pejorative cast. Lampooning the ideals and preoccupations of the Aesthetic Movement, one poem entitled 'My Artistic Wife' belittled female art production as a silly fad that distracted woman from her domestic duties, plunging her into a frenzy of carving, modelling, and painting: 'With her chisel, and her mallet, and her brushes, and her palette,/ And her canvas, and her plaster, and her clay;/ Small wonder I'm complaining, for my love she is disdaining,/ And she snubs me, and she dubs me "in the way".' Not only is she wasting time and neglecting her husband, but she is also putting her mental health at risk: 'And so great is her delusion that I'm forced to the conclusion / That she's crazy and fanatical and daft.' Far more pernicious than a mere hobby, woman's involvement in the arts could be a sign of psychic abnormality. In some stories, woman pursued art in default of marriage and on achieving the state of wifehood gladly abandoned their creative efforts. The young women in Clara Green's short story 'The Emancipation of Theodorus' is representative of many a female artist in popular fiction. Endowed with a modicum of talent and intelligence, she fills in the time between girlhood and marriage with shallow ventures into the arts, seeking to find the most congenial medium of expression. 'People called her talented, and spoke of her as one from whom something uncommon might be expected. She herself shared this expectation . . . Just how, she was not quite certain, though it had been manifest in various ways. For a time it took the form of art, and the walls of her home were made glad and, perhaps, a little glaring, with waving cornfields, cabbage-heads, hollyhocks,

and windmills described on wood, matting, silk, velvet, and every conceivable material.' Having exhausted the charms of art, she soon moves on to other pastimes. In the illustration accompanying this text, the attractive hobbyist executes a plein air painting; she sports the crisp smock and decorative sun hat of the well-dressed lady artist; a completely equipped painting kit stands next to her. The hand holding the brush, however, seems to signal the frivolity of her commitment: in its exaggerated daintiness of gesture, it is the hand of a dabbler.[31]

Other stories stressed the likelihood that catastrophic failure awaited many a woman who would undertake the study of art. Although fictional, these tales implicitly accept certain public stereotypes of the woman art student. Discussing the relative artistic success of men and women, a writer for the *Philadelphia Times* predicted that the proportion of high achievement among the 'girl graduates' would be less than among young men, 'even without regard to any differences in the artistic capacity of the two sexes'. The explanation was, simply, that when young men decided to become artists, they actually had some sort of talent or vocation, whereas in young women, 'some little dilletante [sic] taste' could easily be mistaken for genuine talent, with the result that 'in every city there are many times more women trying to paint than ever will become artists.' While women students were granted access to art education—by the last third of the century the Pennsylvania Academy, the National Academy of Design, the Art Students League and others all admitted them—there were other institutional barriers in their way. As Michele Bogart has shown, for example, there was a concerted attempt to establish the new and burgeoning field of illustration as a manly profession. Howard Pyle, one of the most famous illustrators of the day, discouraged women from enrolling in his schools, and the Society of Illustrators (formed in 1901) limited its female membership to a very small, token component.[32]

The failure scenario, with appropriate embellishments, played itself out in fiction. In one story, Cora Price of Lynxville, Massachusetts, wins a prize for two years' study in Paris, where she hopes to learn to paint heads 'well enough to teach, not well enough to sell'. On seeing her work, the august master of the atelier judges it remarkably bad, the production of a woman hopelessly untalented. Eventually, the prize fund committee cuts off her support, and her fledging career collapses. Her teacher is pleased: 'One female art student the less [. . .] Cora had ceased to interest him as an individual, and he considered her only as one of an obnoxious class.' Near-Gothic horror attended a purportedly factual account of failure in the Midwest. A girl of eighteen from an 'ugly little town in Iowa' is obsessed with the ambition to become an artist; she refuses a marriage offer from a wealthy farmer and runs away to Chicago to enrol in the school of the Art Institute. She suffers extreme hardship, working as a chambermaid, shivering through the winter in summer clothes so that she can buy more paint, to little avail because 'all her work was wretched'. As she toils on, 'slowly her personality changed. She looked prematurely old and weazened; her gentle rounded face grew sallow and harsh; her eyes grew bright, absorbed, and fiercely jealous—as all around her she saw other girls who worked no harder and whose work improved.' Finally, she topples into demented despair:

> As she worked, almost hopeless now, her passion for beauty gave place to an all-absorbing passion of jealousy, and this slowly centered on one girl student who had twice taken honors. At last, just before a big competition, late one night, when the students had gone, she stole this girl's drawing, took it to her hotel bedroom, sat up all night staring at it, and finally tore it to shreds. And then she disappeared.

Male artists, of course, were hardly exempt from failure. But in fiction at least they were somewhat more likely to be failed geniuses, rather than unsuccessful, talentless nonentities.[33]

Cecilia Beaux was obviously neither dilettante nor failure; she painted with 'masculine' breadth (albeit with 'feminine' sympathies) and renounced marriage and family in the interests of her career. Yet the issues discussed above bear on the subject of her status in the art world. The language of difference that constructed a hierarchy of value ordering the comparison of Beaux's and Sargent's paintings grew directly out of the contemporary language whose project was to maintain masculine-determined social order in a world where emergent feminism threatened established gender boundaries. While Beaux was indisputably a successful artist, she was in a sense allowed to be the exception that proved the rule: others might fail ignominiously, or vanish into married life, but Beaux had made her mark. Accorded the status of greatest woman painter, she functioned to affirm the possibility of feminine achievement in a world otherwise structured to discourage it, and to demonstrate that female success need not be grossly incompatible with socially constructed and approved modes of feminine behaviour. Sculptor and critic Lorado Taft's 1899 article on Beaux makes it unmistakably clear that she did perform such a symbolic role. Taft wrote of the difficulty of teaching young women and being asked to predict their chances in the professional arena: 'When you assure a pupil that there is no reason why a woman should not achieve the highest success in the walks of art, it is depressing to be obliged to add "But she never has".' Until today, indeed, the world had never seen a truly great woman painter, but now, through her superb accomplishment, Beaux, 'as admirable technically as any of the cleverest of our men', had emancipated her sex. Having asserted Beaux's greatness in the strongest terms, however, Taft then coupled her name with that of black artist Henry Ossawa Tanner, confirming the marginality of both: 'She has not only made a record, but like Mr Tanner,

the colored painter, has shown the potentialities of her kind.' In his day, Tanner functioned as the token great black American painter, despite the fact that he lived as an expatriate in Paris, the social and racial climate of the United States having proven unfriendly to his ambitions. Beaux's role was similar: both remained privileged Others, painting to considerable acclaim in styles defined and validated by the white, male mainstream.

Having asserted Beaux's greatness and otherness almost simultaneously, Taft took up the question of femininity. It was unfortunate, he noted, that women who had won some distinction in art were often 'the most manlike in characteristics', as was notably the case with Rosa Bonheur or the tomboyish American sculptor Harriet Hosmer, seen here in abbreviated, unladylike skirts, working on her colossal statue of Senator Thomas Hart Benton. On visiting Beaux's studio, however, Taft was '*relieved* to find that the gifted artist was in no sense mannish; on the contrary, she gives the impression of a most womanly woman', with her air of dignity, grace, and cultivation (italics added). The fact that Taft ingenuously expressed his relief on meeting the womanly Beaux provides a useful index to the degree of the male artist's anxiety over the prospect of confronting a strong, successful female. Unlike the stereotyped, 'masculine' new woman, castigated in contemporary medical discourse as an unnatural monster of degeneracy, Beaux in her womanliness—despite the fact that she remained single and therefore potentially undomesticated—posed no danger to masculine hegemony. As a womanly woman, she still inhabited an unthreatening sphere. Her status as a great woman artist, therefore, was relatively unproblematic, or at least its problematic nature was contained in this way.[34]

Before concluding, I would like to turn briefly to the late nineteenth-century medical world, where symbolic language reinforcing gender difference was voiced by speakers attempting to

control access to medical professions and knowledge at a time when increasing numbers of women were aggressively in pursuit of these goals, and when medicine itself had but recently undergone reform and upgrading through rationalization and advances in clinical science.[35] It is illuminating to glance at the discourses surrounding the medical profession, because they confirm that the linguistic construction of gender difference and hierarchy circulated pervasively throughout all fields of public life in which women sought professional credentials and status, and that this language represented an attempt to impose or restore order in a new world of fluid and disturbing social movement. By looking at the characteristics deemed natural and appropriate in medical men and women, I want to suggest that Sargent's authority as the world's greatest portrait painter derived in part from his possession of certain skills and a particular kind of vision not unlike those attributed to (male) physicians, and to suggest further that medical women, particularly nurses, were rendered subordinate by the same 'feminine' traits—sympathy, emotions over reason—that many critics attributed to Beaux.

Women who wished to become physicians in nineteenth-century America faced formidable opposition from the male establishment, represented, for example, by the American Medical Association, which had through concerted action done its best to discredit and disempower lay healers, midwives, and alternative, 'irregular' health care practitioners, such as homeopaths. Women entering the medical profession had to confront the hostility of males who feared the threat of competition in a field already overcrowded. The rhetoric designed to help bar women from professional medical practice emphasized their unfitness, decreed not simply by men, but by nature. Concerning women in medicine, AMA president Dr Alfred Stille had the harshest words in 1871: 'Certain women seek to rival men in manly sports [. . .] and the

strong-minded ape them in all things, even in dress. In doing so, they command a sort of admiration such as all monstrous productions inspire, especially when they tend toward a higher type than their own.' Apprehensive that the entry of women into the profession would feminize it and thereby threaten its hard-won status, doctors, as Mary Roth Walsh has noted, liked to describe their work in highly masculine terms. One Boston doctor, belittling female physicians, said: 'If they cannot stride a mustang or mend bullet holes, so much the better for an enterprising and skillful practitioner of the sterner sex.' The eminent Dr D. Hayes Agnew, who once refused reelection to his post as surgeon to the Pennsylvania Hospital when women were officially admitted to clinical lectures there, strongly disapproved of medical education for women. Reflecting the prevalent view that medicine would defeminize women, Agnew declared that a woman needed only to be taught 'housekeeping, hygiene, and *belles lettres*', but 'after that, the more she knew, the worse off she was.' On the other hand, however, he considered nursing uniquely suited and natural to women.[36]

In the late nineteenth century nursing, formerly associated with working-class women and quasi-domestic service, was in the process of attempting to claim higher, fully professional status through the establishment of schools, the enforcement of rigorous educational standards, licensing, and the formation of official nursing organizations. Despite that, nursing remained a field separate from, and always subordinate to, that of physicians and surgeons. Florence Nightingale herself, who played a major role in modernizing nursing, believed that it involved a separate body of knowledge from that of medicine, being primarily responsible for the comfort and welfare of patients. 'A nurse is not a medical man', she wrote, 'nor is she a "medical woman".'[37] Just as women, in contemporary scientific discourse, were ranked as biologically inferior to men, so too was the nurse the deferen-

tial handmaid of medicine at a time when, thanks to the recently forged alliance between medicine and science, the doctor's professional prestige, authority, and mystique were on the rise. As the Johns Hopkins Nurses' Code of Ethics stated, a nurse's first duty was to carry out the physician's instructions, never to criticize him, and to accord respect for the higher professional position.[38] To women fell the more domestic and social aspects of health care, as illustrated by this admiring description of a young trained nurse: 'Her skillful hand prepared the food, her watchful eye anticipated every want. She was calm, patient, and sympathizing [. . .] eager to please and cheer.' The nurse's role in this discourse was identical to the one assigned to middle-class wives: to sympathize, to serve, to nurture, to comfort—not to make a diagnosis and prescribe a course of treatment. Only in her 'natural' nurturing capacity did nurse outrank doctor. One medical writer stated: 'In many cases [. . .] the labor of the nurse is undoubtedly more important than that of the physician. For the reduction of medicine from a science to an art good nursing is absolutely indispensable.'[39] Discipline and good character, along with proper education, were mandated for the new, modern nurse, and womanliness headed the list of desired virtues: 'the true trained nurse [is a] womanly woman who [. . .] inspires hope and confidence in all around her', as one nursing leader put it. Other virtues commonly listed figured the nurse as 'kind, gentle, quiet, conscientious, tactful, and dignified.'[40]

The parallels with the Beaux-Sargent situation are suggestive. She too, in Lorado Taft's words, was a 'most womanly woman', full of grace and dignity. Her deportment and life style were the very opposite of flamboyant. One admirer summed her up as 'an earnest and untiring worker and of very quiet unassuming character'. Another noted that Beaux had inspired great respect in the art world, her place being as firmly established as Sargent's, 'but she lives and works

calmly and quietly, without fireworks or eccentricity of any kind.' Certainly, Beaux would match the nurse and her role—unassuming, quiet, hardworking—rather than that of the woman doctor, threatening male authority and hegemony.[41]

The language of gender hierarchy attributed to Sargent the possession of a masculine grasp on knowledge and physical truth, underscored by a scientific attitude toward his material. In this he matched the new image of the physician, or, more generally, the scientist, during a time when science, specialization, and expertise were on the ascent as superior modes of knowledge, organization, and reform. Many identified American progress itself with scientific advance: 'America has become a nation of science. There is no industry [. . .] that is not shaped by research and its results; there is not one of our fifteen millions of families that does not enjoy the benefits of scientific advancement; there is [. . .] no motive in our conduct, that has not been made juster by the straightforward and unselfish habit of thought fostered by scientific methods.' As Barbara Ehrenreich and Deirdre English have written, the prestige of science around the turn of the century amounted to a secularized religion, with the scientist as its prophet: 'It was tough yet transcendent—hardheaded and masculine.' In particular, the new experimental biology aggressively and dispassionately pursued nature, entrapped it in the laboratory, and relentlessly probed it until some essential truth lay exposed. Dr Oliver Wendell Holmes's crude metaphor vividly evokes this scientific stance *vis-à-vis* nature: 'I liked [. . .] to see a relentless observer get hold of Nature and squeeze her until the sweat broke out all over her and Sphincters loosened.' Also telling are the words of Johns Hopkins' Dr William Osler, probably one of the most distinguished and influential physicians of the time, whose lectures made it plain that science was strictly a masculine preserve. The study of biology, he said, 'trains the mind in accurate methods of observation and cor-

rect methods of reasoning, and gives to a man a clearer point of view.' This was of special importance to the physician, for whom scientific discipline would give exactness to habits of thought and temper the mind with 'that judicious faculty of distrust'. The pursuit of science, moreover, was to the highest degree rational: 'With reason science never parts company, but with feeling, emotion, passion, what has she to do? They are not of her; they owe her no allegiance. She may study, analyze and define, she can never control them, and by no possibility can their ways be justified to her.' The gender bias in Osler's speech jumps into high relief if we consult his remarks delivered to student nurses at Johns Hopkins in 1897. Where he urged medical men to embrace scientific knowledge as their creed, Osler urged nurses just as strongly to have nothing to do with it: it was not their territory. At most, a nurse might acquire a veneer of pseudo-science, 'that most fatal and common of mental states. In your daily work you involuntarily catch the accents and learn the language of science, often without a clear conception of its meaning.' They would be happier and better, he advised, if they knew nothing at all: 'It must be very difficult to resist the fascination of a desire to know more, much more, of the deeper depths of the things you see and hear, and often this ignorance must be very tantalizing, but it is more wholesome than an assurance which rests on a thin veneer of knowledge.'[42]

Much of the language employed to describe the highly analytical quality of Sargent's vision matched the language celebrating the analytical, critical spirit of masculine science. With a scientific eye, wrote Cortissoz, Sargent violated the 'secret recesses of human vanity', bringing 'hidden traits to life'. Many a piece of criticism celebrated his 'diagnostic' gaze. One critic, commenting that Sargent was an 'acute, though not always kindly, analyst of character', even accused him of 'painting with a scalpel'. Charles Caffin noted that Sargent's attitude toward his sitters was 'entirely professional', for the most

part without sympathy, equally free from cynicism. In its 'peculiar intimacy', this attitude corresponded to the relations between physician and patient, or lawyer and client, except that those were privileged, whereas 'Sargent's diagnosis and his analysis of his client's strong and weak points are published to the world'. In an even more pointed metaphor, Royal Cortissoz commended Sargent's 'deadly surgeon-like precision and success' in his single-minded concentration on 'the identity of the portrait'.[43]

The surgeon metaphor is of particular interest because surgery itself was perhaps the most stubbornly masculinized area of medical practice: as one doctor proclaimed: 'The primary requisite of a good surgeon is to *be a man*—a man of courage.' Thomas Eakins too saw surgery as a 'natural' male province, writing that: 'I do not believe that great painting or sculpture or surgery will ever be done by women', though he conceded that 'good enough work is continually done by them' to be worth while. Sargent's 'surgeon-like precision', then, connoted his distinctively masculine competence. Indeed, his often noted technical prowess and dexterity matched those skills possessed by Dr Agnew, reported to be sure, calm, rapid, and extremely dextrous in performing surgical operations. The information conveyed in portraits by Sargent covered precisely the same range recommended by Agnew in his treatise on surgery: in order to deal successfully with disease, said Agnew, the doctor must have 'knowledge of the Age, Sex, Occupation, Habits, Mental and Moral States, Personal History and Temperament, Social Condition, Residence, and Knowledge of the Patient by Others.'[44] Like Agnew's ideal surgeon, Sargent too, probed both the material and moral circumstances of his sitters:

He is incurious as to whether his sitters have souls [. . .] but as to this present commonplace world of business and pleasure he is full of the most minute and valuable information. He tells

whether they are pompous or cordial or shy, if they have or have not a sense of humor, whether they are nervous or stolid, sensible or eccentric, kindly or malicious. He diagnoses their health, shows their degree of education, displays the style of their establishment, and suggests approximately their annual rate of expenditure.[45]

Even Sargent's portraits of children, such as *Helen Sears* (1895) bore the signs of the diagnostic gaze. In these works, wrote Harrison Morris, Sargent, looking for reality, not sentiment, and always in pursuit of the facts, 'discards as beyond his province those tender influences that may seem to hinder manly analysis [. . .] He deals by choice with the portrait as a solvent of character and enjoys the biologic practice of revealing the secrets of life with a brush.' By contrast, Beaux's images of childhood, such as the much-admired and perennially popular *Ernesta with Nurse* (1894), were, as Cortissoz effusively declared, full of naturalness and charm, 'the most artless, flowerlike interpretations of life'. *Ernesta* was 'enchantment itself, and from the artist's sympathy there had passed into the workmanship 'a wave of that atmosphere which minimizes the material elements of a material side of art'.[46] Certainly, there is some difference here: in painting *Helen Sears,* Sargent seems not to have pursued opportunities to accentuate, through pose and expression, the appeal of little girlhood, whereas Beaux's toddler, looking out at the viewer with her big, dark eyes, is surely meant to charm. Whether the difference arises from the painters' respective genders is another question. At least it can be noted here that what Morris claimed for Sargent could just as easily pertain, for example, to Mary Cassatt's images of small children, inspected by the painter's probing and dispassionate eye. At the turn of the century, however, such a question would not have been raised. Possessor of knowledge, master of analysis, Sargent was ultimately the superior artist and the absolute professional by virtue of gender-

specific attributes, within the frame of dominant discourses. Possessor of emotion, mistress of sympathy, as the 'world's greatest woman artist' Beaux ranked second best, her linguistically and socially constructed qualities of womanly softness ultimately no match for Sargent's manly firmness of intellect.

How ironic yet inevitable, then, that Sargent should receive the prestigious commission to paint the famous 'big four'—the prestigious medical innovators Drs Welch, Kelly, Osler, and Halsted—for Johns Hopkins Medical School, on the occasion of Osler's resignation to accept a chair at Oxford University.[47] Shortly thereafter, the Johns Hopkins nurses' alumni association, conscious of the significance of the doctors' grand portrait, commissioned Beaux to paint Mary Adelaide Nutting, the influential nursing reformer and educator who was leaving to join the faculty at Columbia Teachers' College in New York. Before the Nutting portrait was presented to the Johns Hopkins trustees, it appeared in an exhibition at the Corcoran Gallery, where Sargent's *Four Doctors* (1906) also hung. Praising Sargent, Royal Cortissoz said that the *Four Doctors* epitomized the characteristic note of the artist's style: 'a splendid mastery of his instruments, a strong masculine way of recording a truthful impression, the way of a man brimming over with the nervous force of our modern life [. . .] and so skillful that before one of his portraits you feel yourself in the presence of a kind of effortless technical perfection [. . .] through the magic of Sargent's brush, future generations will look at the doctors in this painting, and greet them with sympathy.' Observing the Nutting portrait, *The Boston Transcript*'s critic noted: 'No one stands up beside Sargent in the display, for he is in a class by himself. But Miss Beaux crowds him a little all the same.' Her portrait of Nutting, said the reviewer, was 'quite the best performance we have on record for her. Its simplicity, directness, and feminine charm are not to be mistaken, while technically it leaves nothing

to be desired.'[48] In this pair of portraits, the gulf between doctor and nurse is literally measurable. The *Four Doctors* inhabit a grand, shadowy space, with accoutrements of culture—weighty tomes, an antique Venetian globe—and black academic gowns, validating, as Patricia Hills has pointed out, the doctors' seriousness and intellectual powers.[49] Mary Adelaide Nutting, on the other hand, wears her contemporary uniform—at once a sign of the nurse's new professionalism and of her difference from doctors—and stands for herself, unsupported by symbols of high culture or intellectual substance. Sargent's somewhat overblown portrait embodies the loftiness of the doctors' status and aspirations; Beaux's is unpretentious, down-to-earth. Sargent was a figurative doctor painting doctors, Beaux a figurative nurse, painting another, with all the hierarchical difference that these acts implied.

The question remains, finally, whether reviewers were responding to anything *in* the paintings themselves, connotative of masculinity or femininity, or whether they were reading gender *into* the works. Certainly, as I mentioned at the outset, there are distinct differences between Beaux and Sargent, for all the manifest similarities. The *Four Doctors* and the *Mary Adelaide Nutting* (c. 1907) portraits, indeed, show the two painters for once at the extremes of contrast. It is equally difficult to imagine Beaux as the author of the lofty doctors, as to envision Sargent painting the businesslike Nutting. Although the two artists are very closely comparable if we consider facture by itself, their compositional modes are sometimes distinct. Sargent's *Mrs Carl Meyer and Her Children,* with its high vantage point, clashing curved and zig-zag lines, occult balance, and unexpected poses—the mother's arm straining backward, the children peering over the sofa back—exemplifies Sargent's manner of incorporating tensions into his designs (though he was equally capable of composing harmoniously), while Beaux's *Mrs Theodore Roosevelt and Her Daughter Ethel* demonstrates her ten-

dency toward equilibrium: this work is vigorously painted, but centred, without any vertiginous angles, the two figures together creating a strong, simple mass, expressing greater composure than animation. In other cases the differences are in the details. The almost awkward contortion and strain of *Catherine Vlasto*'s hand on the keyboard behind her, for instance, evokes what Albert Boime has characterized as the Aesthetic Movement's love of the exaggerated posture and transformation of the body into a decorative object, whereas the hands of Beaux's *Bertha Vaughan* display an easy grace, a poise without stress.[50] Certain differences, then, are clear—sometimes marked, sometimes subtle. But are they gendered? I would suggest that the critics appropriated certain features of each painter's style—Beaux's relative calm, Sargent's relative agitation—and proceeded to construe them as unequivocal signs of gender. In this process, existing distinctions of manner were inscribed with the markers of sex distinction, and critics brought their assumptions and preconceptions to the works, imposing upon them what they expected or wanted to see there, their expectations in turn being determined or influenced to some degree by volatile contemporary issues centring on contested gender roles.[51]

The contemporary context of gender conflict and anxiety about changing social roles not only illuminates the agenda (hidden or not) of critics who stressed Beaux's fundamental femininity, for all the 'virility' of her technique, but also allows us to see the insistence on Sargent's masculinity in a different light. In an era when firm social definitions and constructions of gender seemed in danger of slipping their moorings to travel who knew where, defenders of masculine cultural hegemony had a stake in appropriating Sargent's broad, vigorous style in support of their interests. For all his cosmopolitanism, Sargent, superstar of the nineties, had to be claimed for America and for the male gender, had to be celebrated as the supreme masculine practitioner of the art of portrait painting. Speaking abstractly, there was no solid phenomenological absolute on which to base the association of breadth with masculinity. Breadth, with its connotations of flowing paint, liquidity, and emotional colourism as opposed to 'intellectual' classical linearity, could with equal plausibility be assigned to the feminine, but the socio-cultural circumstances of the period forestalled any consideration of such an option. Sargent was stereotyped as an aesthetic he-man just as surely as Beaux was conscripted to serve as his thoroughly womanly complement, and the language that translated their paintings into words contributed to the reification of those stereotypes.[52]

Contemporary discourses on sexuality and power encoded gender difference and hierarchy into the works of Cecilia Beaux and John Singer Sargent, precisely at a time when male cultural élites, resisting women's challenges to the balance of power, sought to maintain social and cultural order. When in the early twentieth century the swashbuckling urban realists, led by self-styled 'revolutionary' Robert Henri, launched their campaign against what they condemned as pallid, effeminate, academic taste, they received hearty approbation for revitalizing the American art scene with large doses of much-needed virility.[53] What this seemingly abrupt shift masks is the fact that far from being a break, Henri's acts represented in fact an ultimate masculine victory in a contested discourse on power and knowledge in the realm of public art culture. The 'triumph' of a fresh new virility in American culture had already been negotiated and secured in the ranks of those very academic painters Henri and his followers had resolved to supercede. And as long as language engendered criticism and manufactured difference, the situation was not likely to change in more than superficial ways.[54]

This article is a revised and expanded version of a paper given in the section on the gender politics of American art and culture at the College Art Association Annual Meeting in 1991.

NOTES

From *The Oxford Art Journal* (1992). Reprinted by permission of the author.

1. 'The Lounger', *The Critic,* vol. 26, 1895, March 30, p. 247.
2. The bibliography on Cecilia Beaux is not large. Useful works include: Cecilia Beaux's autobiography, *Background with Figures* (Houghton Mifflin, Boston, 1930); *Cecilia Beaux: Portrait of an Artist* (Pennsylvania Academy of the Fine Arts, Philadelphia, 1974); Judith E. Stein, 'Profile of Cecilia Beaux', *Feminist Art Journal,* vol. 4, Winter, 1975–6, pp. 25–33, and Tara L. Tappert, 'Choices, the Life and Career of Cecilia Beaux: A Professional Biography', Ph.D., George Washington University, 1990. On Sargent, see Richard Ormond, *John Singer Sargent: Paintings, Drawings, Watercolours* (Phaidon, London, 1970); *John Singer Sargent and the Edwardian Age* (Leeds Art Gallery; National Portrait Gallery, London; Detroit Institute of Arts, April, 1979–December, 1979); *John Singer Sargent* (Whitney Museum of American Art, New York; The Art Institute of Chicago, October, 1986–April, 1987), with excellent essays by Patricia Hills, Albert Boime, Gary A. Reynolds, and others; and Trevor J. Fairbrother, *John Singer Sargent and America* (Garland Publishing, New York, 1986). Prominent painter William Merritt Chase made the statement about Beaux's greatness, in an 1899 speech on Founders' Day at the Carnegie Institute, Pittsburgh; Beaux's portrait *Mother and Daughter* (Pennsylvania Academy of the Fine Arts) had just been awarded first prize at the Carnegie Galleries exhibition.
3. The idea of language as an instrument for the production and maintenance of 'reality' is a component in the theoretical edifice proposed by Peter Berger and Thomas Luckmann. *The Social Construction of Reality: A Treatise in the Sociology of Knowledge* (1966; rpt. Penguin Books, New York, 1984), which provides conceptual support for my arguments here. Roszika Parker and Griselda Pollock have touched on the issue of male domination of artistic practice in *Old Mistresses: Women, Art, and Ideology* (Pantheon Books, New York, 1981), noting (p. 44) that in the late nineteenth century, 'art by women was subsumed into bourgeois notions of femininity and furthermore, art historically, relegated to a special cate-

gory which was presented as distinct from mainstream cultural activity and public professionalism—the preserve of masculinity. Thus at the very moment of a numerical increase in the numbers of women artists working professionally, women artists were represented as different, distinct, and separate on account of their sex alone.' Tappert, 'Choices, the Life and Career of Cecilia Beaux', pp. 413–35, discusses Beaux's status along lines similar to those mapped out by Parker and Pollock; she also surveys the critical review of Beaux but does not pursue its implications as I do here.
4. As a young art student, Beaux received private instruction from New York–based William Sartain, a friend and erstwhile travelling companion of Eakins. Although she denied having any association with the Pennsylvania Academy of the Fine Arts, where Eakins himself taught, her name did appear twice in the registry of students, 1877–9; see Franklin H. Goodyear, 'Introduction', *Cecilia Beaux: Portrait of an Artist,* p. 21.
5. Among other honours, Beaux was awarded the Dodge Prize by the National Academy of Design, 1893; the Gold Medal of Honour by the Pennsylvania Academy, 1898, and a Gold Medal at the Pan-American Exposition, Buffalo, New York, 1900.
6. Untitled clipping, 1892, Cecilia Beaux Papers. Microfilm roll no. 428, Archives of American Art, Smithsonian Institution, Washington, D.C. Hereafter referred to as Beaux papers.
7. Gary A. Reynolds, 'Sargent's Late Portraits', *John Singer Sargent,* p. 162; Fairbrother, *John Singer Sargent and America,* is indispensable for any study dealing with this aspect of the artist's career; 'Sargentolatry' was coined by the English painter, Walter Sickert.
8. Clippings, 'The Fine Arts', Dec. 1, 1897, and Pauline King, 'Cecilia Beaux', from *Harper's Bazaar,* 1899; Beaux Papers, Roll 429.
9. See H. Wayne Morgan, *Keepers of Culture: The Art-Thought of Kenyon Cox, Royal Cortissoz, and Frank Jewell Mather, Jr.* (Kent State University Press, Kent, Ohio, 1989); and Sandra Lee Underwood, 'Charles H. Caffin: A Voice for Modernism 1897–1918', Ph.D., Indiana University, 1981.
10. Charles Caffin, 'Some American Portrait Painters', *The Critic,* vol. 44, 1904, January, pp. 43–4.

11. Clipping, 'Miss Cecilia Beaux and Mr. W. M. Chase', *New York Evening Sun*, March 6, 1903, Beaux Papers, Roll 429.

12. Samuel Isham, *The History of American Painting* (1905; rev. ed. Macmillan, New York, 1936), p. 530. In the early twentieth century, this book was one of the authoritative treatments of the subject; its author was a well-respected artist who belonged to prestigious clubs, exhibited widely, and served on numerous art show juries.

13. Charles Caffin, 'The Picture Exhibition at the Pan-American Exposition', *International Studio*, vol. 14, 1901, Spring, p. xxviii; Caffin, 'Exhibition of the Pennsylvania Academy', *International Studio*, vol. 19, 1903, March, p. cxvi.

14. Caffin, 'John Singer Sargent, the Greatest Contemporary Portrait Painter', *World's Work*, vol. 7, 1903, November, pp. 4100, 4116.

15. A. L. Baldry, 'The Art of J. S. Sargent, R. A.', Part I, *International Studio*, vol. 10, 1900, p. 9; George W. Smalley, 'American Artists Abroad', *Munsey's Magazine*, vol. 27, 1902, April, p. 47; John C. Van Dyke, 'Sargent the Portrait Painter', *The Outlook*, vol. 74, 1903, May 2, p. 32; Royall Cortissoz, 'Books New and Old', *Atlantic Monthly*, vol. 93, 1904, March, p. 413.

16. William Walton, 'Cecilia Beaux', *Scribner's Magazine*, vol. 22, 1897, October, p. 485.

17. Homer St-Gaudens, 'Cecilia Beaux', *The Critic*, vol. 47, 1905, July, p. 39.

18. One of the best studies of these changes is Jackson Lears, *No Place of Grace: Antimodernism and the Transformation of American Culture, 1880–1920* (Pantheon, New York, 1981); see especially pp. 3–58; equally excellent, but based on a different model, is Alan Trachtenberg, *The Incorporation of America: Culture and Society in the Gilded Age* (Hill and Wang, New York, 1982); see pp. 140–7 for a discussion of the feminization of culture.

19. See Carroll Smith-Rosenberg, *Disorderly Conduct: Visions of Gender in Victorian America* (Knopf, New York, 1985), pp. 167–81 for a lucid discussion of the social factors surrounding the emergence of the 'New Woman'. On masculinizing movements, see Michael S. Kimmel, 'Men's Responses to Feminism at the Turn of the Century', *Gender & Society*, vol. I, 1987, September, pp. 261–83, and Clyde Griffen, 'Reconstructing Masculinity from the Evangelical Revival to the Waning of Progressivism: A Speculative Synthesis', in Mark C. Carnes and Clyde Griffen, eds., *Meanings for Manhood: Constructions of Masculinity in Victorian America* (University of Chicago Press, Chicago, 1990) pp. 183–204.

20. Charles Dudley Warner, 'Editor's Drawer', *Harper's Monthly Magazine*, vol. 80, 1890, May, pp. 972–3.

21. 'The Decay of Nations', *The Independent*, vol. 64, 1908, February 20, pp. 430–1.

22. Maurice Thompson, 'Vigorous Men, a Vigorous Nation', *The Independent*, vol. 50, 1898, September 1, pp. 609–11; Ida Husted Harper, 'Men vs. Women: An Indictment', *The Independent*, vol. 64, 1908, April 2, p. 741. Ida Harper's version of the University of Chicago story was probably somewhat skewed to give women a heroic edge; according to Marion Talbot, who served as Dean of Women at the University of Chicago during that time, President Harper and others were concerned over the increasing enrolment of women students, and the threat this might pose to the character of masculine life on campus; see Talbot's *More Than Lore: Reminiscences* (University of Chicago Press, Chicago, 1936). On masculinity, see Joe L. Dubbert, *A Man's Place: Masculinity in Transition* (Prentice-Hall, Englewood Cliffs, New Jersey, 1979); E. Anthony Rotundo. 'Body and Soul: Changing Ideals of American Middle-Class Manhood, 1770–1920', *Journal of Social History*, vol. 16, 1983, Summer, pp. 23–38; Peter Gabriel Filene, *Him/Her/Self: Sex Roles in Modern America* (Harcourt, Brace, Jovanovich, New York, 1974).

23. Charles Caffin, 'The Story of American Painting', *American Illustrated Magazine*, vol. 61, 1906, March, p. 597; Caffin, *The Story of American Painting* (Frederick A. Stokes, Co., New York, 1907), pp. 246–9.

24. Frank Norris, *The Pit: A Story of Chicago* (1903; rpt. Grove Press, New York, n.d.), pp. 64–5; 'The Last Work of Frank Norris', *Harper's Weekly Magazine*, vol. 47, 1903, March 4, p. 433.

25. William Ordway Partridge, 'Manhood in Art', *New England Magazine*, n.s. vol. 9, 1893, November, pp. 281–8.

26. Christine Battersby, *Gender and Genius: Toward a Feminist Aesthetics* (Indiana University Press, Bloomington, 1990), p. 6.

27. Molly Elliott Seawell, 'On the Absence of the Creative Faculty in Women', *The Critic*, vol. 19, 1891, November 29, pp. 292–4; E. A. Randall, 'The Artistic Impulse in Man and Woman', *The Arena*, vol. 24, 1990, October, p. 420.

28. Grant Allen, 'Woman's Intuition', *Forum*, vol. 9, 1890, May, pp. 334–7.

29. A. C. Benson, 'From a College Window', *Living Age*, vol. 247, 1905, December 16, p. 652.

30. It should be noted that there seem to be relatively few cartoons about women artists; most of the cartoons in the 1890s featured male artists, and a few of these poke fun at artists and critics. The very dearth of cartoons on the subject of women artists, though, might be taken as a sign of their marginal status in the art world of the period.

31. 'My Artistic Wife', *Munsey's Magazine*, vol. 15, 1896, September, p. 758; Clara Bellinger Green, 'The Emancipation of Theodorus', *Scribner's Magazine*, vol. 31, 1902, March, p. 369.

32. Clipping, 'The Fine Arts', *Philadelphia Times*, March 20, 1887, Beaux Papers, roll 428; Michele Bogart, 'Artistic Ideals and Commercial Practices: The Problem of Status for American Illustrators', *Prospects*, vol. 15, 1990, pp. 232–7.

33. E. A. Alexander, 'The Prize-Fund Beneficiary', *Harper's Monthly Magazine*, vol. 94, 1897, January, pp. 253–62; Ernest Poole, 'Art and Democracy, First Paper: How the Chicago Art Institute Reaches the People', *The Outlook*, vol. 85, 1907, March, pp. 671–3.

34. Clipping, Lorado Taft, 'The Work of Cecilia Beaux', *Record* [Chicago], Dec. 21, 1899, Beaux Papers, roll 429. On the 'new woman' and degeneracy see Smith-Rosenberg, *Disorderly Conduct*, pp. 245–96, which documents and analyzes the scientific/medical campaign to abnormalize the independent, feminist career woman. Regarding women painters at the turn of the century, I have found no conclusive evidence supporting the existence of an institutionalized critical category of 'feminine art' such as that explored by Tamar Garb, '"L'Art Féminin": The Formation of a Critical Category in Late Nineteenth-Century France', *Art History*, vol. 12, 1989, March, pp. 39–65.

35. There are numerous useful studies of these changes in American medicine. See especially Paul Starr, 'The Consolidation of Professional Authority 1850–1930', Ch. 3, *The Social Transformation of American Medicine* (Basic Books, New York, 1982); also William G. Rothstein, *American Physicians of the Nineteenth Century: From Sects to Science* (Johns Hopkins University Press, Baltimore, 1972); Joseph Kett, *The Formation of the American Medical Profession: The Role of Institutions, 1780–1860* (Greenwood Press, Westport, Connecticut, 1980).

36. Alfred Stille, quoted in Richard Harrison Shryock, *Medicine in America: Historical Essays* (The Johns Hopkins University Press, Baltimore, 1966), p. 185. On p. 187 Shryock cites an article in the *Boston Medical Journal* expressing concern over competition by women doctors, who were already taking a cut of the profits in obstetrics cases. Boston doctor: Chadwick Scrapbook, Courtway Library, Boston, quoted in Mary Roth Walsh, *'Doctors Wanted': No Women Need Apply: Sexual Barriers in the Medical Profession, 1835–1975* (Yale University Press, New Haven, 1977), p. 139; J. Howe Adams, *History of the Life of D. Hayes Agnew, M.D., Ll.D* (F. A. Davis, Philadelphia, 1892), p. 148. On women in medicine, see Roth, *'Doctors Wanted'*; Regina Markell Morantz-Sanchez, *Sympathy and Science: Women Physicians in American Medicine* (Oxford University Press. New York, 1985); Shryock, *Medicine in America*, pp. 177–99; Penina Migdal Glazer, *Unequal Colleagues: The Entrance of Women into the Professions 1890–1940* (Rutgers University Press, New Brunswick, New Jersey, 1987).

37. Josephine A. Dolan, M. Louis Fitzpatrick and Eleanor Krohn Hermann, *Nursing in Society: A Historical Perspective* (1916; 15th ed. W. B. Saunders, Philadelphia, 1983), pp. 165, 196.

38. Quoted in Helen E. Marshall, *Mary Adelaide Nutting: Pioneer of Modern Nursing* (Johns Hopkins University Press, Baltimore, 1972), p. 81.

39. Franklin H. North, 'A New Profession for Women', *Century Magazine*, vol. 25, 1882, November, p. 38; Charles Francis Withington, *The Relation of Hospitals to Medical Education* [Boston, 1886], quoted in Dolan et al., *Nursing in Society*, p. 249.

40. Alma Revelle O'Keefe, president of the Kansas State Nurses' Association, quoted in Susan M. Reverby, *Ordered to Care: The Dilemma of American Nursing, 1850–1945* (Cambridge University Press, New York, 1987), p. 49; the list of other virtues is in *idem.*, p. 227, note 40. I am indebted to Reverdy's ex-

cellent study for my discussion of nursing. Also useful are Christopher Maggs, ed., *Nursing History: The State of the Art* (Croom Helm, London, 1987), Ellen Condliffe Lagemann, ed., *Nursing in History: New Perspectives, New Possibilities* (Teachers College Press, New York, 1983), and Barbara Melosh, *'The Physician's Hand': Work, Culture, and Conflict in American Nursing* (Temple University Press, Philadelphia, 1982).

41. Taft: see *supra*, note 34; Mrs Arthur Bell, 'The Work of Cecilia Beaux', *The Studio*, vol. 17, 1899, September, p. 216; clipping, Pauline King, 'Cecilia Beaux', *Harper's Bazaar*, 1899, Beaux Papers, roll 429.

42. W. J. McGee, 'Fifty Years of American Science', *Atlantic Monthly*, vol. 82, 1898, p. 320; Barbara Ehrenreich and Deirdre English, *For Her Own Good: 150 Years of the Experts' Advice to Women* (1978; rpt. Anchor Books, New York, 1989), pp. 69–78; Oliver Wendell Holmes, letter to S. Weir Mitchell, May 8, 1862, Anna Robeson Burr, *Weir Mitchell: His Life and Letters* (Duffield and Co., New York, 1929), pp. 82–3, quoted in Ehrenrich and English, *For Her Own Good*, p. 76; William Osler, 'The Leaven of Science' and 'Nurse and Patient', *Aequanimitas; with Other Addresses to Medical Students, Nurses, and Practitioners of Medicine*, 2nd ed. (P. Blackiston's Son & Co., Philadelphia, 1910), pp. 97–9, 161. Charles Rosenberg, *No Other Gods: On Science and American Social Thought* (Johns Hopkins University Press, Baltimore, 1976), extensively discusses the growth of scientific prestige and influence in the late nineteenth century, and its social implications and consequences.

43. Royal Cortissoz, 'John Singer Sargent', *Scribner's Magazine*, vol. 34, 1903, November, p. 524; Christian Brinton, 'Sargent and His Art', *Munsey's Magazine*, vol. 36, 1906, December, p. 283: Sargent is 'shrewdly diagnostic' in his readings of character; 'Portraits of Women', *The Critic*, vol. 25, 1894, November 10, p. 317; Caffin, 'John Singer Sargent, the Greatest Contemporary Portrait Painter', p. 4116; Cortissoz, 'Sargent, the Painter of Modern Tenseness', *Scribner's Magazine*, vol. 75, 1924, March, p. 348.

44. Edward Andrews, 'The Surgeon', Chicago Medical Examiner, vol. 2, 1861, quoted in Morantz-Sanchez, *Sympathy and Science*, p. 53; letter, Thomas Eakins to Edward Horner Coates, September 11, 1886, Kathleen A. Foster and Cheryl Leibold, *Writing about Eakins: The Manuscripts in Charles Bregler's Thomas Eakins Collection* (University of Pennsylvania Press, Philadelphia, 1990), p. 236; Margaret Supplee Smith, 'The Agnew Clinic: "Not Cheerful for Ladies to Look At"', *Prospects*, vol. 11, 1987, pp. 168–9; D. Hayes Agnew, *The Principles and Practice of Surgery* (Lippincott, Philadelphia, 1878), vol. I, chapter 1, quoted in Diana Long, 'The Medical World of *The Agnew Clinic*: A World We have Lost?', *Prospects*, vol. 11, 1987, p. 188. I thank Kathleen Foster for bringing the Eakins letter to my attention.

45. Isham, *History of American Painting*, p. 434.

46. Harrison S. Morris, 'American Portraiture of Children', *Scribner's Magazine*, vol. 30, 1901, December, p. 651; Clipping, Royal Cortissoz, 'Cecilia Beaux. Her Portraits of Children and Women', *New York Daily Tribune*, June 16, 1895, Beaux Papers, roll 429.

47. On this portrait see Patricia Hills, 'Thomas Eakins's *Agnew Clinic* and John S. Sargent's *Four Doctors*: Sublimity, Decorum, and Professionalism', *Prospects*, vol. 11, 1987, pp. 217–30.

48. Royal Cortissoz, address given at the unveiling of *Four Doctors*, January 19, 1907, *Johns Hopkins University Circular*, February, 1907, pp. 26–7; *Boston Transcript*, quoted in Marshall, *Nutting*, p. 145.

49. Hills, 'Eakins's *Agnew Clinic* and Sargent's *Four Doctors*', p. 223.

50. Albert Boime discusses the theme of the aestheticized body in his essay 'Sargent in Paris and London: A Portrait of the Artist as Dorian Gray', in *John Singer Sargent*, pp. 75–109.

51. Here I do not consider the issue, as formulated by Griselda Pollock, of painting practice in itself as a site for the inscription of sexual difference, determined by social positionality in terms of both class and gender. See 'Modernity and the Spaces of Femininity', *Vision and Difference: Femininity, Feminism, and the Histories of Art* (Routledge, New York, 1988), pp. 81–2. To consider this fully would demand a separate article. I would like to note, though, that certain factors in the consideration of Beaux and Sargent would indicate some adjustment to Pollock's model. The question of masculine (public) and feminine (private) spaces is central to Pollock's discussion of Mary Cassatt and Berthe Morisot. Portrait painting of the type considered here, however, is very much a public practice, making public subjects even out of private individuals.

The question, then, would be: to what degree might the conventions and public function of portraiture tend to mask or neutralize the inscription of sexual difference in a portrait painted by Cecilia Beaux?
52. This is all the more ironic, since the nature of Sargent's sexuality is something of a puzzle. Recent scholarship has pointed to the likelihood of strong if suppressed homosexual inclinations in Sargent, something that would hardly commend him to the aesthetic strenuous lifers, given that the turn of the century period saw the first strong stirrings of homophobia in America. See Trevor Fairbrother, 'Sargent's Genre Paintings and the Issues of Suppression and Privacy', in Doreen Bolger and Nicolai Cikovsky Jr., eds., *American Art around 1900: Lectures in Memory of Daniel Fraad, Studies in the History of Art*, vol. 37 (National Gallery of Art, Washington, D.C., 1990), pp. 29–49. Fairbrother argues (p. 42) that: 'The sensuality of so much of [Sargent's] work has been ignored, in

part because it would mar celebrations of him as a recorder and defender of upper-class privilege, but also because some of its flavor is unmistakeably erotic', notably his studies of sprawling, nude young men.
53. See, for example, Samuel Swift, 'Revolutionary Figures in American Art', *Harper's Weekly Magazine*, vol. 51, 1907, April 13, pp. 534–6: commenting that turn-of-the-century painting was virtually devitalized, Swift praised the 'school of Robert Henri': 'There is a virility in what they have done, but virility without loss of tenderness; a manly strength that worships beauty, an art that is conceivably a true echo of the significant American life around them.'
54. Anna Chave has addressed the issue of gender-biased criticism in the career and work of Georgia O'Keeffe in the 1920s and later: 'O'Keefe and the Masculine Gaze', *Art in America*, vol. 78, 1990, January, pp. 115–24, 177–9.

13

Lifting the "Veil"

Henry O. Tanner's The Banjo Lesson *and* The Thankful Poor

~~~~~~~

## JUDITH WILSON

*In her discussion of two domestic genre scenes by Henry Ossawa Tanner, Judith Wilson argues that although the technical sophistication of these works testifies to Tanner's artistic maturation and his allegiance to European aesthetic ideals, his strategic choice of subjects—black musical and religious practice—also enabled him to subtly undermine two very specific stereotypes of African Americans. Contrary to the widespread popular belief in innate black musicality and the superstitious emotionalism of black religion, Tanner crafts an image of African Americans in these paintings that personifies instead the values of education and dignified self-restraint fostered by the African Methodist Episcopal Church and black intellectuals such as W.E.B. Du Bois.*

*As an educated black man who embodied the ideological tension of the so-called talented tenth, Tanner sought to convey a conception of African-American life and behavior more consistent with his own experience. Wilson further establishes that the radical challenge to prevailing representational conventions raised by these paintings has been overlooked in the face of an emergent black cultural nationalism that eschews earlier strategies of accommodation embraced by Tanner and his peers at the turn of the nineteenth century.*

~~~

Henry O. Tanner's 1893 painting, *The Banjo Lesson,* marks a turning point in African-American art history. It was Tanner's first masterpiece, the first work in which he demonstrated his control of a range of technical skills unmatched by any previous black artist. For with Tanner we have the first Afro-American suited for greatness in the visual arts not only by talent and by temperament but also by training. Indeed his study with the eminent American realist Thomas Eakins at the period's leading art school, the Pennsylvania Academy of Fine Arts, provided him with the most advanced art education then available in the United States.[1] And subsequently, when a nine-year struggle to survive as an artist in his native land[2] was ended by a generous pair of patrons who enabled him to go abroad, Tanner gained access to Europe's cultural resources—an experience then considered indispensable, the final step in an American artist's training.[3] Thus, Tanner probably was the first U.S. black fully equipped to succeed as a painter.[4]

But *The Banjo Lesson* was not only a crowning symbol of the century-old Afro-American quest to obtain the skills, the sophistication, and

the financial support needed to attain real mastery as a fine artist. This canvas was also the site of a profound psychic break or break-through—a declaration of African-American self-esteem that anticipated the twin emphases on racial pride and vernacular culture that would come to characterize the work of numbers of black artists only in the 20th century, beginning with the so-called Harlem Renaissance. Until recently, however, only a handful of authors have shown any recognition of this painting's epochal significance.[5] How could the ideological import of a canonical work of Afro-American art be underrated or overlooked for so long? A glance at the initial reception of a pair of key works of mid-19th-century French art—paintings generically related to Tanner's masterpiece—is instructive.[6]

When Jean François Millet's *The Sower* and Gustave Courbet's *The Burial at Ornans* appeared in the 1850–51 Paris Salon, the latter provoked a furor among contemporary critics, while their response to the former was relatively mild. Both canvases displayed the harsh realities of French provincial life with unprecedented candor. But as Marxist art historian T. J. Clark has noted, where Courbet's audience was jarred as much by the innovative style of his image as by its subversive content, a veneer of pastoral convention led most viewers to overlook the radical implications of Millet's art.[7] "[W]here the tradition survived, the critics saw the tradition more easily than its transformation," Clark concluded.

A similar veil of tradition has concealed the unorthodox nature of Henry O. Tanner's late 19th-century image of Afro-Americans. As we shall see though, Tanner's allegiance to accepted pictorial codes—to an anecdotal mode that could be traced to seventeenth-century Dutch genre painting[8] and to a scientifically precise but lyrically inflected realism—is neither the sole nor the most significant factor that has obscured his art's subversive import.

Four years after Henry O. Tanner painted *The Banjo Lesson*, W.E.B. Du Bois outlined a cultural agenda that would provide the chief interpretative frame for Afro-American art through much of our own century.[9] In order to assume their proper role on the world-historical stage, Du Bois declared, U.S. blacks must assert themselves culturally, demonstrating "not a servile imitation of Anglo-Saxon culture, but a stalwart originality which shall unswervingly follow Negro ideals."[10]

To this day, many commentators on the work of African-American artists remain tangled in the inherent contradictions of this nationalist-oriented program, struggling to separate some fixed set of "Negro ideals" from an "Anglo-Saxon culture" they have conceptualized in equally ahistoric, essentialist terms and expecting "a stalwart originality" to result from pursuit of such Sisyphusian efforts. All too often, obsession with an elusive black cultural autonomy obscures the degree to which African-American artists have registered specific responses to their historical experiences as Americans of African descent. It is my contention that this failure to recognize the shifting nature of black socio-cultural priorities—and, thus, to adequately contextualize black cultural products—has encouraged persistent misreadings of Henry O. Tanner's art depicting black subjects.[11]

Aspects of the Artist's Early Life and Ideological Formation

Born on the eve of the Civil War, in 1859 in Pittsburgh, Henry O. Tanner was the eldest of seven children of Benjamin Tucker Tanner, a free-born "Pittsburger of three generations,"[12] and Sarah Elizabeth Miller. The granddaughter of a Virginia planter and a black woman who presumably was his slave, the artist's mother had been born in bondage but was emancipated a year later, along with the rest of her family.[13] The

Millers subsequently headed North, settling in Pittsburgh in 1846.[14]

At a time when perhaps as few as half of the one-tenth of black Americans who were free managed to attain literacy,[15] Benjamin Tanner and his bride possessed an unusual amount of formal education, which they endeavored to share with less fortunate members of their race. Having attended Pennsylvania's Avery College, Sarah Miller Tanner conducted a private school in her home.[16] Her husband, an Avery College graduate, converted to Christianity in 1856 and joined the African Methodist Episcopal Church. He subsequently trained for the ministry at Western Theological Seminary and was ordained the year after his son Henry's birth.[17]

Thus, the future painter belonged to a small but crucially placed segment of mid-19th-century African America. Northern-born and personally a stranger to the "peculiar institution," he is nonetheless apt to have felt strong ties to the Southern, ex-slave majority of his race, thanks to his mother's family history. At the same time, a paternal legacy of longstanding freedom may have contributed an unusual degree of self-confidence and racial pride. And as the scion of educated parents, he was automatically a member of the African-American elite, a group that—especially after Emancipation—must have felt tremendous pressure to fill various psychic and social leadership roles.

While it is likely that Henry O. Tanner's convictions stemmed from more than one source, there can be no doubt that his father provided an intimate model of ideological commitment. The intensity of the senior Tanner's feelings about racial injustice can be gauged by the fact that he gave his first-born the middle name "Ossawa." By awarding his son this unusual name, he apparently sought to register—in a discreetly oblique fashion—his approval of the controversial 1856 incident near Osawatomie, Kansas, in which the militant white abolitionist John Brown allegedly killed five pro-slavery men.[18]

In his own contributions to his people's struggles—both before and after Emancipation—Benjamin Tanner seems to have focused on the intellectual and spiritual arenas, however. In 1861, he founded a school for newly emancipated blacks in Washington, D.C. Five years later, he headed another freedmen's school, this time in Maryland. Meanwhile, having served as pastor to various congregations in the District of Columbia and Maryland during 1859 to 1866, Tanner established his reputation as "a brilliant ecclesiastical scholar" with the publication of his first book, *An Apology for African Methodism,* in 1867. This, in turn, would lead to his election to the post of editor of the A.M.E. Church's Philadelphia-based organ, *The Christian Recorder,* the following year.[19]

Dubbed "the greatest social institution of American Negroes" by W.E.B. Du Bois,[20] the A.M.E. Church had stood for black pride, self-help, and self-determination since its inception. Launched in 1794 with the dedication of Bethel African Methodist Episcopal Church, the seeds of the denomination had been planted in Philadelphia in 1787 when a group of free blacks refused to accede to white demands that they occupy a separate section of a local church. During the nineteenth century, the A.M.E. Church would play a central role in combatting segregation, promoting black education, and developing international ties between people of African descent.[21]

From the start, the church had put a premium on education, founding its first school in 1798 and taking control of what would become the nation's oldest black college, Wilberforce University, in 1863. By the turn of the century, the denomination could boast "a college in every Southern state."[22] In its stress on education, though, the church tended to promote European-derived cultural values, thus revealing an apparent contradiction. For its rhetoric of black self-esteem was accompanied by revulsion for certain traditional African practices.[23] Above all,

church leaders were generally inclined to frown upon what they held to be the emotional abandon associated with African-derived styles of worship.

The autobiography of Bishop Daniel Payne, the leading figure in A.M.E. affairs throughout most of the second half of the 19th century and the man who directed much of Benjamin Tanner's pastoral career, contains an especially striking example of this aversion to traditional black religious practices. Payne's description of the performance of a ring shout by participants in an 1878 "'bush meeting'" is unabashedly scornful: "After the sermon they formed a ring, and with coats off sung, clapped their hands and stamped their feet in a most ridiculous and heathenish way." Subsequently, he informed the group's leader that this mode of worship was "disgraceful to themselves, the race, and the Christian name."[24]

Payne's words echo an earlier incident in which members of the A.M.E. Church parent organization, the Philadelphia-based Free African Society, had condemned the revelry of their Boston counterparts as "'a shameful practice . . . that enables our enemies to declare that we are not fit for freedom'." Apparently, Bishop Payne shared what historian Allen B. Ballard calls the Free African Society's "deep-seated antipathy . . . toward dance and song."[25]

Benjamin Tucker Tanner had received his first pastoral assignment from Bishop Payne, who became a family friend and one of his artist son's first patrons.[26] Both Payne's views on black worship (which Benjamin Tanner is apt to have shared) and the A.M.E. emphasis on education bear directly on the two examples of Henry O. Tanner's art that are the focus of this study. But while his father's church regarded certain Africanisms with a jaundiced eye, Henry O. Tanner is likely to have imbibed a counter-dose of pride in his African heritage from sources both at school and at home.

The Robert Vaux School, from which he graduated, was Philadelphia's "first black public school [staffed] with black teachers." Its founder, Jacob White, Jr., had trained at the city's Institute for Colored Youth, the nation's first black high school. Along with a rigorous program of classics, mathematics and science, the ICY offered an education informed by the presence in antebellum Philadelphia of three groups of highly politicized African Americans—veterans of the Haitian Revolution, the Underground Railroad, and the abolition movement. White and other ICY graduates are said to have routinely informed their pupils about such facets of black history as "the greatness of Africa and the revolutionary heroism of Toussaint L'Ouverture."[27]

In addition to the influence of his teachers at the Vaux School, young Tanner had the example of his father's work as an educator of freedmen and a religious leader whose church had a long tradition of social activism.[28] After serving as editor of *The Christian Recorder* for sixteen years, Benjamin Tucker Tanner launched *The A.M.E. Church Review*, which he edited until his election to the bishopric in 1888. These national organs were key to the far-reaching influence of the A.M.E. Church: *The Recorder*, founded in 1847 as *The Christian Herald* was one of the few black newspapers to span the antebellum through post-Reconstruction eras; *The Review*, a quarterly journal, when it began in 1884 "was apparently the only national magazine published by blacks."[29]

Benjamin Tanner's stress on black solidarity and economic self-reliance has led August Meier to count him among A.M.E. Church leaders with "proclivities toward radicalism."[30] In a study of the church's social orientation during the late nineteenth and early twentieth centuries, however, David Wood Wills faults Meier for oversimplifying Tanner's position.[31] Wills sees Tanner as one of the church's "theological conservatives," deeply opposed to any theory or program involving "what seemed to him infidelity to Biblical truth"—such as evolutionism.[32]

Yet he also lists Tanner as one of the three leaders of the denomination he considers "most forceful and imaginative" in linking "theological reflection and social criticism."[33]

At first glance, Benjamin Tanner's thinking seems rife with contradictions: Although an opponent of post-bellum African emigration schemes, Tanner favored limited colonization in order to accelerate the continent's conversion to Christianity.[34] And while he advocated eventual elimination of the ethnic prefix from the A.M.E. Church name, he was quick to deplore white scholars' use of Biblical terminology that obscured the African identity of certain ancient civilizations.[35]

In matters of political economy too, Benjamin Tanner's views initially appear inconsistent. Disdainful of T. Thomas Fortune's socio-economic radicalism in the latter's 1884 *Black and White: Land, Labor and Politics in the South,* two years later Tanner himself would pen an editorial entitled "Capital and Labor" in which he lamented capitalist greed and spoke favorably of workers' strikes. By 1887, the unions' practice of racial exclusion and what he viewed as their "excessive" demands had soured him on the labor movement.[36]

Viewed in the context of A.M.E. history, however, this black ideologue and theologian's apparently conflicting stances gain coherence. Originally spawned by Philadelphia's Free African Society, from the start the church was committed to a program of racial uplift via industry, thrift, and economic cooperation combined with moral and intellectual self-improvement.[37] Yet, faced with the racism of their white Methodist brethren, the church's founders chose to create a separate denomination, instead of rejecting Christianity altogether—a choice that suggests the degree to which these blacks were committed to assimilation at the same time they proudly labeled themselves and their organizations "African" and opted for institutional autonomy. In other words, theirs was a strategic separatism—a dignified and communally productive self-segregation in response to the threatened imposition of a demeaning and inequitable color bar. They did not embrace separatism as a social ideal, however. Indeed, their foremost 19th-century leader, Daniel Payne, is said to have "removed a minister at Mother Bethel Church who refused to permit a white woman to join the congregation."[38]

Benjamin Tanner's views on racial matters, then, exhibit a blend of assimilationist idealism and black nationalist pragmatism that was prevalent in his denomination from its beginnings through the second half of the 19th century. Indeed, one could argue that this oxymoronic stance was typical of late 19th-century black ideology in general—or at least of the thinking of the educated few whose views have mainly been recorded. It is not surprising, therefore, to find Bishop Tanner privately and publicly associated with both Booker T. Washington *and* W.E.B. Du Bois during this period.[39]

He was, for example, one of a dozen or so black educators, intellectuals, and political strategists, including Washington and Du Bois, who in 1897 founded the American Negro Academy—an organization that aimed to "promote publication of scholarly works," "encourage 'youths of genius,'" "establish an archive,'" "aid in 'the vindication of the Negro race,'" and "publish an annual 'designed to raise the standard of intellectual endeavor among American Negroes.'"[40] In its stress on nurturing black talent and vindicating the race, as well as its emphasis upon intellectual achievement, the Academy's goals seem congruent with the ideals of the A.M.E. Church. And Benjamin Tanner's involvement in an institution with such goals again suggests his son Henry was raised in a milieu in which education and social service were presumed to go hand-in-hand.

It is my contention that it was precisely this ideological climate that conditioned the younger Tanner to perform an unprecedented act of black

cultural self-assertion in the creation of his two most famous canvases, *The Banjo Lesson* and *The Thankful Poor.* But within a few years of their execution, these paintings' ideological significance would be obscured by a new train of thought set in motion by W.E.B. Du Bois. In "The Conservation of Races," a paper he delivered to the American Negro Academy in 1897, Du Bois began to articulate a conscious form of African-American nationalism that differed markedly from earlier, largely expedient brands of black separatism.

"The Conservation of Races" initiates Du Bois' prolonged grappling with the problem of African-American cultural identity[41]—a project that would lead him to formulate the concept of "double-consciousness" in an essay from the same year, a revised version of which became the first chapter of his 1903 masterpiece *The Souls of Black Folk.*[42]

Du Boisian Double-Consciousness and the Art of Henry O. Tanner

. . . if in America it is to be proven . . . that not only are Negroes capable of evolving individual men like Toussaint the Saviour, but are a nation stored with wonderful possibilities of culture, then their destiny is not a servile imitation of Anglo-Saxon culture, but a stalwart originality which shall unswervingly follow Negro ideals.
—*W.E.B. Du Bois, "The Conservation of Races" (1897)*[43]

When W.E.B. Du Bois proclaimed the African-American creative mission was "not a servile imitation of Anglo-Saxon culture, but a stalwart originality which shall unswervingly follow Negro ideals," his words were conditioned by his own immersion in the very culture he urged fellow members of the American Negro Academy to eschew. Indeed, this call for independence from U.S. majority culture unwittingly echoed

sentiments that were widespread among 19th-century European and Euro-American artists.[44] The impulse, on one hand, to create a uniquely "American" art and, on the other, celebrate "the common man" created a social agenda for 19th-century Euro-American art, the basic assumptions of which Du Bois shared. This is not to say, of course, that white Americans who concentrated on local genre, like William Sidney Mount or George Caleb Bingham, were concerned with promoting *Afro*-American cultural autonomy. Nor that white Americans like William Morris Hunt, who returned from Europe with peasants on their minds, necessarily saw blacks as the salt of the American soil.

Du Bois's fusion of cultural nationalist sentiments with a nostalgic populist essentialism becomes clearer when we turn from his remarks in "The Conservation of Races" to their amplification in the revised 1897 essay that constitutes the first chapter of *The Souls of Black Folk*, "Of Our Spiritual Strivings." The essay opens with the author's well-known discussion of "double consciousness," a discussion Du Bois concludes by describing the alleged effects of this psychic split on the African-American artist:

> The innate love of harmony and beauty that set the ruder souls of his people a-dancing and a-singing raised but confusion and doubt in the soul of the black artist; for the beauty revealed to him was the soul-beauty of a race which his larger audience despised, and he could not articulate the message of another people.[45]

This hypothetical account of late 19th-century African-American artists' attitudes toward black subject matter contrasts markedly with the words of Henry O. Tanner, one of the few late 19th-century Afro-American painters to actually make such "ruder souls" his subjects.[46] In an undated letter, probably written around 1893, the artist, referring to himself in the third person, explained:

Since his return from Europe he has painted many Negro subjects; he feels drawn to such subjects on account of the newness of the field and because of a desire to represent the serious and pathetic side of life among them. . . . To his mind many of the artists who have represented Negro life have only seen the comic, the ludicrous side of it, and have lacked sympathy with and affection for the warm big heart that dwells within such a rough exterior.[47]

Judging by these remarks, Tanner seems not to have been afflicted with the cultural ambivalence posited by Du Bois. Rather than being daunted by white American disdain for Afro-American life, the artist appears to have embraced the challenge of counteracting white prejudices. The oppositional character of this self-appointed mission is the central point I want to make about *The Banjo Lesson* and *The Thankful Poor.* But it would be unwise to completely discount the possibility that double consciousness played a role in the painter's thinking, given his subsequent abandonment of black subject matter.[48] As we shall see, the tensions Du Bois described *are* embedded in Tanner's two masterpieces of black genre. But the degree of their presence suggests much less ambivalence than Du Bois attributed to African-American artists.

In "Of Our Spiritual Strivings" Du Bois not only diagnosed his race's spiritual malaise but also prescribed an antidote. Education—specifically the quest for literacy—he maintained, offered at least a partial solution to the problem of double consciousness. Describing the ex-slave's struggle to seize "the power of the cabalistic letters of the white man" as an arduous journey, he claimed its rigors "changed the child of Emancipation to the youth with dawning self-consciousness, self-realization, self-respect." Eventually, this phenomenological pilgrim: "saw himself,—darkly as through a veil; and . . . [h]e began to have a dim feeling that, to attain his place in the world, he must be himself, and not another."[49]

For Tanner, too, based on the evidence provided by *The Banjo Lesson* and *The Thankful Poor,* education played a central role in shaping black self-hood. Significantly though, the two men focused on different brands of education. Du Bois's model, with its emphasis on "'book-learning,'" is clearly that of a European-derived, institutionalized pedagogy. Tanner, however, illustrates training processes that are domestic, informal and, one guesses, more closely linked to intragroup—as opposed to externally imposed—traditions.[50]

The Banjo Lesson and *The Thankful Poor*

In summer 1893, Tanner returned to Philadelphia from France in order to renew his funds and complete his recovery from typhoid fever. *The Banjo Lesson* [1] probably was painted at that time. It was first exhibited at a Philadelphia gallery in October 1893.[51] Until recently, Tanner was thought to have based this composition on sketches he executed during an 1889 stay in North Carolina's Blue Ridge Mountains.[52] Such sketches have never materialized, but a photograph of his models—which may have been shot in North Carolina—has been found.[53]

The picture focuses upon two figures—a grey-haired man, who is seated, and a young boy, who stands between the older man's spread legs. The child plucks a banjo that looks nearly as tall as he is and seems to partially rest against the seated man's arm and leg. One of the child's legs is bent, as if he were either struggling to keep the instrument in place or perhaps patting a foot in time to the music he is attempting to make. He is assisted in his efforts by the adult, who fingers the banjo's uppermost strings with his left hand, while the child fingers a lower group of strings within his own reach. The child peers down at the instrument, his lips pursed and his brow

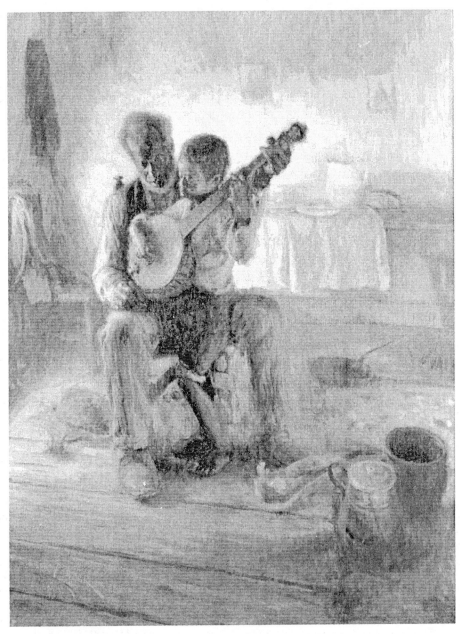

1. Henry Ossawa Tanner, *The Banjo Lesson*, 1893; courtesy of Hampton University Museum, Hampton, Va.

slightly furrowed in concentration, while the old man cocks his head a bit to the side and down, wearing a look of bemused attention.

It is a quietly affectionate scene, gently orchestrated by the play of shadows that centers on the dark-skinned pair and echoes—in a diagonal ascent—from the triangle of shadows surrounding a pair of vessels at the painting's lower right corner, to the dark cloth (or article of clothing) hanging on a wall at upper left. Both figures are in shirtsleeves. The boy's pants are rolled above his knees. Although the clothes of the figures look well-worn, the tatters and patches so often seen in either sentimental or derogatory, late 19th-century images of African Americans are conspicuously absent.

Similarly, their surroundings look humble but do not suggest the most abject forms of poverty: There is a wood plank floor, instead of mere dirt. Instead of unplaned, unpainted timber, the walls are whitewashed and plastered. There are even two small pictures of some kind, in frames against the rear wall. But the simplicity of this home is indicated by what appears to be a skillet resting on the floor, which, along with a pile of kindling and the vessels in the foreground, suggests the presence of an open hearth, probably the only cooking facility, nearby. The table setting in the background—with its rumpled cloth that does not entirely cover the tabletop, its bare white pitcher and a chunk of bread—adds to the impression of slender means.

The Thankful Poor was painted in 1894. The man and boy in the second painting resemble the pair in the first, although both are seen in profile. The table at which they are seated is covered by a white cloth like the one in *The Banjo Lesson*. The crockery placed on the table also resembles that in the earlier canvas. There are some differences, however. A latticed window with a white curtain covering its lower half can be seen behind the grey-haired man at left. His chair is unlike either of the two chairs in the other picture,[54] while the boy is seated on what looks like a small bench or crate, neither of which appears in the other image. And although the man's dress seems to coincide with that of the man in the first painting, the boy in this picture wears a vest, while the boy in the earlier canvas does not.

The second painting shows man and boy with heads bowed in prayer over a meager repast. The two face one another across a table covered by worn and rumpled linen. The man props his elbows on the table, clasps his hands together, and presses a thumb against his forehead. His features are lost in shadow, but the boy's can be seen clearly. The child's eyes are closed and he touches his forehead with the side of one closed hand, while he grasps the table edge with the other in a gesture that suggests his effort to emulate his elder's devotion is mixed with youthful eagerness to start the meal.

The table setting is quite sparse: a pitcher, two small vessels—one lidded and one with a utensil stuck inside—that probably contain cream and sugar, a platter bearing a small quantity of meat, two rounds of bread that rest directly on the tablecloth, two cups, two plates, and two spoons. Aside from the old man's spoke-backed chair and the child's bench-like seat, the curtained window is the only other visible feature of the room. Thus, the information is highly concentrated, permitting no distractions from the central image of youth and age, poverty and prayer.

The Banjo Lesson and *The Thankful Poor* illustrate an interlocking set of arguments. The former debunks a widespread myth of innate black musicality by showing the deliberate care with which a black elder *instructs* a black child in playing the banjo—the central instrument of minstrelsy, the chief cultural form with which blacks were identified and by which they were defined in the popular imagination in the post-Reconstruction era. The latter counters an equally prevalent contemporary perception of black religiosity as overwhelmingly emotional—and thus, presumably inferior to an allegedly more tranquil, stable and introspective white brand of piety.[55]

Both paintings address their themes on the level of private rather than public practice, presenting domestic scenes in which the protagonists appear to be family members—possibly grandfather and grandson. Thus, in both instances the focus appears to be on individuals linked by biology and by social intimacy, making them perfect symbols of the competing claims of heredity versus socialization as explanations of black cultural difference in late 19th-century America.

Henry O. Tanner's views on the subject are conveyed by a grammar of poses and gestures that the artist deploys subtly, yet persuasively. In both scenes, the protagonists' faces are turned down or away from the viewer; their eyes are averted. Man and boy concentrate on their respective activities. In *The Banjo Lesson,* we see the adult straining to hear and guide a child's efforts on the banjo, and the child struggling to master the stringed instrument. In *The Thankful Poor,* we see the child's imperfect emulation of his elder's complete absorption in prayer. Neither image presents anything like the unctious, approval-seeking, vacuous or irrepressibly sensual creatures of antebellum legend or postbellum propaganda.[56]

Both canvases invest their ordinary, underprivileged, black subjects with a degree of dignity and self-possession that seems extraordinary for the times in which they were painted. And perhaps most remarkable of all is the artist's emotional poise, his successful avoidance of melodrama, exoticism, cloying sentimentality, excessive moralizing, triteness. But to late 20th-century eyes—which a long line of genuinely demeaning myths and correspondingly demoralizing images[57] have conditioned to read "passivity," "impotence," and/or denial of cultural identity into almost any scene in which the activity of black males falls short of armed rebellion or suggests something less than complete rejection of Euro-American culture—the ideological significance of Tanner's eschewal of the psychic trappings of 19th-century anti-black stereotypes may not be readily apparent. Thus, we must turn to the work of Henry O. Tanner's predecessors in order to further contextualize his accomplishment.

The Black Image in 19th-Century American Painting Prior to *The Banjo Lesson* and *The Thankful Poor*

In the fine arts, 19th-century America produced not one, but two, painted records of its black population—that is to say, African Americans' vision of themselves and their compatriots' vision of them. Because these accounts differed markedly in quantity, character, and circumstances of production, they will be examined separately at first, then compared with one another, and finally with Tanner's late 19th-century revision.

Afro-American painting prior to Tanner is distinguished by three facts: (1) the free status of its antebellum-era creators, (2) an apparent dearth of black images,[58] and (3) a highly skewed representation of social class. These phenomena are not unrelated. Lacking the leisure, the educational background, as well as the frequent exposure to fine art that enabled European aristocrats to become art patrons and connoisseurs, young America's merchants, shippers, industrialists, and planters placed no high stakes on painting. Thus, a slave's ability to reproduce a likeness or sketch a scene would not have been valued, while the skills of slave potters, carpenters, and seamstresses were both cultivated and rewarded. Hence, we have some surviving examples of slave craft and decorative artwork, but extant works of fine art—especially painting[59]—by black bondsmen and bondswomen so far remain unknown.

To the extent that the new nation's thrifty and pragmatic citizens supported non-utilitarian painting at all, their overwhelming preference was for portraiture. Among blacks though, few of even those who were free could afford to

commission a likeness of themselves. Thus, portraits of prosperous whites constitute the bulk of 19th-century images painted by Afro-Americans. The extant oeuvre of the earliest black artist to whom a substantial body of work can be reliably attributed (Baltimore painter Joshua Johnson of the federal period) amply demonstrates this. Of the 80-odd surviving portraits by Johnson, only two depict blacks.[60]

The question of class orientation in 19th-century art by African Americans is more complicated. During the second quarter of the 19th century, the American public's almost exclusive focus on portraiture began yielding to a growing interest in landscape and genre. By mid-century, Ohio artist Robert S. Duncanson, son of a free black or mulatto woman and a Canadian man of Scottish descent, was painting wilderness scenes in the Hudson River School mode, along with portraits of various white abolitionist patrons. Only two Duncanson paintings that are known at present include black subjects—his *c.* 1851 *View of Cincinnati, Ohio, from Covington, Kentucky* and his 1853 *Uncle Tom and Little Eva*, the latter a commissioned work based on Harriet Beecher Stowe's controversial anti-slavery novel.[61]

Between Johnson, working in the century's first decades, and Duncanson's activity at mid-century, there is a scattering of portraits of blacks by such figures as the New Orleans *homme de couleur* Jules Lion, Boston artist William Simpson, and Philadelphia's A. B. Wilson. Together with the aforementioned canvases by Johnson and Duncanson, such works compose a sparse roster of black faces painted by African Americans prior to the Civil War.

Given the slave status of the African-American majority and the marginal economic condition of most antebellum-era free blacks, it is striking, to say the least, that the fictional houseslave in Duncanson's *Uncle Tom and Little Eva* and the black couple in his *View of Cincinnati, Ohio, from Covington, Kentucky* are the only figures found among these paintings who appear to

be chattel.[62] Slavery and economic oppression were subjects a 19th-century African-American artist could hardly approach with equanimity and ones few whites cared to see depicted unromantically. Here, the dearth of images belonging to certain categories probably indicates intensity of feeling, rather than indifference.

In contrast to Duncanson's Uncle Tom or his Covington couple, Joshua Johnson's federal-era portraits include one that has been tentatively identified as Daniel Coker, a founder of what would become Baltimore's first A.M.E. church, and a second, unknown, but equally distinguished-looking figure.[63] Similarly, the black subjects depicted by Hudson, Lion, Simpson, and Wilson are decidedly atypical figures—a member of New Orleans' mulatto elite, for example, or church leaders like Jermain Loguen, an upstate New York A.M.E. bishop who had been a fugitive slave and became an important abolitionist orator.[64] In keeping with these individuals' "exceptional" character, their poses, dress, and surroundings (when indicated) convey extreme dignity and suggest some degree of social elevation. Thus, works like Johnson's 1805–1810 *Daniel Coker,* Wilson's 1848 *Bishop Daniel Payne and Family,* and Simpson's 1864 *Bishop Jermain Wesley Loguen* employ various signals of bourgeois respectability—elegant but austere clothing, solemn expressions, and static poses—to pay homage to black moral and political authority figures.[65]

In celebrating African-American achievement or advertising African-American pride, none of the 19th-century black creators of these images questioned European-derived cultural norms or submitted African-derived alternatives, however. It is not simply that these artists painted in the prevailing Western styles of their day—an inevitability, given the absence of both an African heritage of portable, illusionistic painting and an African-American economic infrastructure capable of supporting an autonomous painting tradition. Rather, one is struck by *the absence of any*

representation of cultural difference. It is as if, prior to Emancipation, black artists dared not plead their people's cause in terms that were anything but flattering to whites.

The three-decade gap between slavery's end and the appearance of the next set of Afro-American images by Afro-American painters—such works as Henry O. Tanner's *The Banjo Lesson* (1893) and *The Thankful Poor* (1894), and Edward Mitchell Bannister's *The Hay Gatherers* (1893)[66]—suggests a weighty coil of psychic and ideological shackles remained in place long after the last slave got word of freedom. Even as the turn of the century approached and Tanner managed to depict African Americans in ways that announced a radical break with the past, Bannister, an almost equally skilled painter, was unable to bring forth a comparably "emancipated" vision.

A New England–based painter, Bannister, like Duncanson before him, is best known for his landscapes. *The Hay Gatherers* resembles Duncanson's *View of Cincinnati . . .* in that both works subordinate their human subjects to the surrounding landscape. For Duncanson, *View of Cincinnati . . .*, painted around the same time as his masterly *Blue Hole, Flood Waters, Little Miami River* (1851), apparently was a transitional piece—an awkward blend of the Claudian theatricality he would deploy much more effectively after an 1853 trip to Europe and a topographical objectivity drawn from his experience as a daguerreotypist and diorama painter. Here, unlike the less experimental, but more successful *Blue Hole . . .*, the artist's figures are unsatisfactorily integrated with their setting—a failure that probably contributes to the painting's thematic obscurity.

Bannister, in contrast, so successfully melds his laborers into his moodily atmospheric, American Barbizon–style landscape that they are virtually indistinguishable from it. Despite the physical beauty of the resulting canvas and its evidence of Bannister's technical prowess, the view of black America communicated by *The Hay Gatherers* seems romantic at best. Represented as essentially elements of nature, Bannister's black laborers can be seen as either emblems of pastoral nostalgia and longing for a cosmic unity ostensibly lost to modern, urban, industrialized humanity or as signs of class or racial predisposition to humble, non-cerebral, "traditional" ways of life, in which "tradition" is presumed to be a fixed entity, miraculously immune to the dynamics of history.

It is precisely this latter, quite pernicious association of African Americans with "nature"— and, by extension, with innate tendencies and an inexorable fate—as opposed to "culture" (that is to say, with a socially constructed and, therefore, constantly shifting, changing, and to some degree change-*able* web of conditions and consciousness) that Henry O. Tanner undermines in his African-American genre paintings. And in contrast to the majority of his predecessors, Tanner debunks black stereotypes without confining himself to images of a minuscule black elite.[67] But to see why a gifted young African-American painter, armed with an acute sense of cultural mission and a relatively advanced ideological formation, would attack the particular set of myths he did at this time, we must now turn to 19th-century white American images of blacks.

Where black painters tended to make black subjects the focus of portraits of specific individuals, whites were far more apt to depict blacks as either anonymous figures in group scenes—for example, the waiters in Henry Sargent's *The Dinner Party* (*c.* 1820–30), William Sidney Mount's *California News* (1850), and George Caleb Bingham's *The County Election (I)* (1851–2)—or as generic types—for example, Mount's *Banjo Player* (1856), the contented slaves of Eastman Johnson's *Negro Life at the South* (a.k.a. *Old Kentucky Home*) (1859), and Winslow Homer's *Cotton Pickers* (1876). Blacks most often produced images of Afro-American achievement, showing the race's religious and

social leaders or members of their families and investing them with the prevailing signs of dignity and prosperity, whereas when white artists described black Americans, their economic and social status precipitously declined. With few exceptions (e.g., Thomas Sully's 1864 portrait of Liberian president Daniel Dashiel Warner or the startlingly prosperous-looking Philadelphia family in Thomas Hovenden's 1888 *Their Pride*), when seen through white eyes, black America—free or enslaved—became a nation of servants, musicians, and rural laborers.

Many of these images do not seem intentionally unflattering. Homer invested the pair of young women in his *Cotton Pickers*, for example, with remarkable charm in one case (the left figure), and a positively subversive air of sullen dignity in the other (the right figure). Clearly impoverished, these black females nonetheless resist the easy imaginative access implied by such controlling or dismissive labels as "quaint," "pathetic," or "picturesque." Similarly, Mount's *Banjo Player*, far from conforming to the emasculating myths of minstrelsy, is the epitome of "gleaming youth," male vigor, and effervescent charm. Spectacularly handsome and somewhat flamboyantly dressed, by 19th-century, middle-class white standards, he nonetheless looks neither pompous nor servile nor mindlessly sensual. Indeed, the improbable grimace of "darkie" caricatures is replaced by a brilliantly self-confident smile and humorous sidelong glance brimming with lively intelligence.

There *were* paintings by 19th-century whites, however, that depicted blacks with evident disdain as charlatans, cowards, and buffoons— works like John Quidor's 1832 *The Money Diggers*, based on Washington Irving's *Tales of a Traveller*, or Charles Deas' 1836 and Tompkins H. Matteson's 1857 *The Turkey Shoots*, both interpretations of a scene from James Fenimore Cooper's novel *The Pioneers* (and, as such, reminders that racist stereotypes were widespread not only in visual art and on the minstrel stage

but in 19th-century American literature as well). Above all though, whether they meant well or ill, white artists generally pictured blacks patronizingly—as perpetually good-humored, peripheral, or generalized figures, whose painted activities seldom threatened racist beliefs in the innate inferiority of people of African descent. Such portrayals tended to deny blacks intellectual or emotional complexity, stripping them of family ties, group loyalties, and traditions. At the same time, these images generally negated black psychic or social autonomy, denying the very possibility of an African-American consciousness centered upon itself.[68]

For Tanner then, white American art offered no mirrors of his own experience—no images that took into account or accounted for the pragmatic separatism espoused by his father and other A.M.E. Church leaders, none that reflected both the pride in African heritage he had learned at the Robert Vaux School and the fluency in Western culture of someone raised in a household headed by a college-educated minister who composed poems with lengthy titles in Latin.[69] Nor did white images of the economically deprived black masses ring true to the young Philadelphia artist who would observe that "many of the artists who have represented Negro life have only seen the . . . ludicrous side of it" and declare his own "desire to represent the serious, and pathetic side" instead.

Conclusion

With *The Banjo Lesson* and *The Thankful Poor*, Henry O. Tanner lifted what Du Bois would call "the Veil of Race"[70] to give art audiences an unprecedented "inside look" at Afro-American culture. We have seen that, in focusing upon ordinary, impoverished blacks, these two paintings significantly depart from most previous images by African-American artists. And we have seen that by according his subjects a dignity usually

reserved for affluent whites and "exceptional" people of color[71] Tanner countered the patronizing or derogatory tendencies of most 19th-century white American portrayals of blacks.

Despite this marked break with convention, the polemical character of *The Banjo Lesson* and *The Thankful Poor* has been obscured by a profound shift in Afro-American ideology, of which Du Bois's turn-of-the-century writing was both an early symptom and a catalyst. It is a shift that corresponds to the replacement of the pragmatic nationalism of a Benjamin Tucker Tanner with the programmatic nationalism of Du Bois in his "Conservation of Races."

While the latter would subsequently claim "double consciousness" made black artists reluctant to celebrate black vernacular culture,[72] Bishop Tanner's eldest son had, in a circa 1893 letter, indicated an eagerness to paint images that contested prevailing anti-black stereotypes. By making black music and black worship his subjects, Henry O. Tanner took aim at two of the period's most widespread and pernicious assumptions about African Americans: (1) that their obvious musical gifts were innate and, therefore, involuntary and incommensurate with the white cultural achievements; (2) that their evident piety, instead of indicating moral elevation signified the opposite condition, being a mere outgrowth of an allegedly "superstitious" African past and a persistent inclination toward emotional excess.

The former subject placed Tanner in direct competition with figures like William Sidney Mount, George Caleb Bingham, and Eastman Johnson—the leading white American genre painters of the century—each of whom had linked blacks to music in ways that now seem idealized and romantic. The latter pitted Tanner's image of a pair of impoverished black males against images of African-American religious leaders—Joshua Johnson's 1805–10 portrait of Daniel Coker, Baltimore Methodist minister and future founder of that city's first black Methodist church;[73] A. B. Wilson's 1840 portrait of Philadelphia's Bethel A.M.E. pastor John Cornish[74] and his 1848 *Bishop Daniel Payne and Family,* and William Simpson's 1864 portrait of Syracuse A.M.E. bishop Jermain Loguen—images that inscribed black dignity and pride in codes of an overwhelmingly bourgeois and Eurocentric character.

In both instances, Tanner revealed a preoccupation with informal, domestic modes of education—what we might more accurately call "enculturation"—that, at first glance, betrays little of the cultural ambivalence Du Bois labels "double consciousness." Yet we may detect a symptom of such identity conflict in Tanner's avoidance of precisely the more energetic, African-derived style of worship that Daniel Payne and other figures in the A.M.E. Church viewed with alarm.

Nonetheless, the magnitude of Tanner's break with the past is made clear by comparison of *The Banjo Lesson* and *The Thankful Poor* with the testimony of a young man destined to succeed Booker T. Washington as president of Tuskegee Institute. In 1885, Robert Russa Moton left behind a childhood of "rural poverty" and entered Hampton Normal and Agricultural Institute, where he is said to have

> spent his first Sunday night . . . listening to the white chaplain deliver an inspiring prayer which was followed by the singing of spirituals. . . . He was . . . deeply disappointed to hear plantation songs sung by educated people in an educational institution: "I had come to school to learn to do things differently. . . . I objected to exhibiting the religious and emotional side of our people to white folks; for I supposed the latter listened to these songs simply for entertainment and perhaps amusement." Moton was to spend three years at Hampton before he was willing to sing Negro songs in the presence of whites.[75]

In contrast, although Henry O. Tanner was unwilling to "shout," to show his people engaged in

such quintessentially African practices—and unable to see that capturing their spirit (as opposed to their likeness) might require something other than existing European-derived stylistic means[76]—he nevertheless made an unprecedented attempt to "sing Negro songs," to celebrate Afro-American culture at a time and in a nation that did not make it easy for him to do so.

NOTES

Revised by the author from *Contributions in Black Studies* 9/10 (1990–1992). Reprinted by permission of the author.

I am extremely grateful to Robert L. Herbert, whose fall 1981 graduate seminar at Yale on Jean François Millet and Gustave Courbet's treatment of peasant subject matter inspired the initial version of this essay, and to Ernest Allen, Jr., editor of the journal *Contributions in Black Studies,* in which this essay originally appeared.

1. Louise Lippincott, "Thomas Eakins and the Academy," *In This Academy: The Pennsylvania Academy of Fine Arts, 1805–1976* (Philadelphia: Pennsylvania Academy of Fine Arts, 1976), p. 182.

2. Marcia M. Mathews, *Henry Ossawa Tanner, 1859–1937* (Chicago: University of Chicago Press, 1969), pp. 15–16, 31–32; Lynda Roscoe Hartigan, *Sharing Traditions: Five Black Artists in Nineteenth-Century America* (exhibition catalog), Washington, DC: National Museum of American Art, January 15–April 7, 1985, pp. 102–103.

3. Mathews, p. 41.

4. Tanner was not the first African-American artist to travel to Europe. But painters like Robert S. Duncanson and Robert Douglass, Jr., who preceded him there, followed the earlier practice of "studying" by copying Old Master works at major museums, rather than taking classes in which one not only absorbed the lessons of the master/instructor but also interacted with a peer group. Hartigan, pp. 58–60; James A. Porter, *Modern Negro Art* (New York: Arno Press, 1969), p. 34.

5. That the situation has now changed was powerfully signalled by a 1993 article in which Albert Boime independently arrived at a view of the painting much like that of the present essay, which originally had been published in 1992. Boime, "Henry Ossawa Tanner's Subversion of Genre," *The Art Bulletin,* Vol. 75, no. 3 (September 1993): 415–442. Judith Wilson, "Lifting 'The Veil': Henry O. Tanner's *The Banjo Lesson* and *The Thankful Poor,*" *Contributions in Black Studies,* nos. 9/10 (1990–1992): 31–54.

With a few notable exceptions, general blindness to *The Banjo Lesson*'s pivotal status prevailed as late as 1991, when the Philadelphia Museum of Art published the catalog for its monumental Tanner exhibition co-curated by Dewey Mosby and Darrel Sewell. Recognizing Tanner's "departure from conventional treatments" of black subject matter, Sewell hailed him as "the first African-American artist to produce black genre works" and shed unprecedented light on the formal achievement of *The Banjo Lesson* by observing that, while "[s]omething of the same seriousness and intense observation can be found in Thomas Eakins's watercolor *Negro Boy Dancing,* . . . the rich color keyed to the values of the subjects' skin is unique to Tanner."

Sewell failed to appreciate the ideological significance of the artist's innovations, however, claiming that "[i]n choosing the theme of *The Banjo Lesson* Tanner did not break new ground." Sewell, *Henry Ossawa Tanner* (exhibition catalog), Philadelphia: Philadelphia Museum of Art, January 20–April 14, 1991; pp. 119–120.

In contrast, in publications released around the same time, Naurice Frank Woods, Guy G. McElroy, and Albert Boime each noted and attributed varying degrees of significance to the contrast between "stereotyped images of the 'banjo-plucking darkey'" (Woods) and Tanner's careful differentiation of "[musical] education" from "entertainment" (McElroy). Woods, "Lending Color to Canvas: Henry O. Tanner's African-American Themes," *American Visions,* Vol. 6, no. 1 (February 1991): 14, 17. McElroy, *Facing History: The Black Image in American Art 1710–1940* (exhibition catalog), Washington, DC: The Corcoran Gallery of Art, January 13–March 25, 1990; p. 102. Boime, *The Art of Exclusion: Representing Blacks in*

the Nineteenth Century (Washington, DC: Smithsonian Institution Press, 1990), p. 101.

Previously, first Marcia Mathews, then co-authors Romare Bearden and Harry Henderson, followed by Ellwood Parry and Lynda Roscoe Hartigan had touched on *The Banjo Lesson*'s importance without fully measuring it. Mathews, in her 1969 Tanner biography, ascribed a "dignity and pathos . . . that has none of the banality of ordinary genre" to the painting, observing that it "elevates the poor Negro to a higher role than that of the simpleminded darky." Bearden and Henderson wrote the painting "refuted the caricatures of black people in wide circulation at that time," adding in a caption that it "portrays the transmission of black America's musical heritage from one generation to another with dignity." Parry described the canvas tersely as "a sobering antidote to sixty years of minstrel shows in America." In a brief, two-paragraph discussion of Tanner's black genre paintings, Hartigan provided the first published assessment of *The Banjo Lesson* that both mentioned its dual themes of "family ties" and "heritage transmitted from generation to generation" and broadly contextualized it within the history of American art by referencing previous treatments of similar subjects by both black and white artists. Mathews, pp. 37–38. Romare Bearden and Harry Henderson, *Six Black Masters of American Art* (Garden City, NY: Zenith Books, 1972), p. 49 and after p. 56. Ellwood Parry, *The Image of the Indian and the Black Man in American Art, 1590–1900* (New York: George Braziller, 1974), p. 167. Lynda Roscoe Hartigan, *Sharing Traditions: Five Black Artists in Nineteenth-Century America* (exhibition catalog), Washington, DC: National Museum of American Art, January 15–April 7, 1985; p. 104.

6. Tanner painted several Breton peasant scenes after his arrival in France in 1891. Because they depict African Americans, his two most famous paintings—*The Banjo Lesson* (1893) and *The Thankful Poor* (1894)—usually have been placed in a separate category, "black genre," which obscures historical and stylistic links between this expatriot's images of French rural workers and his representations of their African-American counterparts. For recent attempts to connect Tanner's French peasant and black genre works, see Sewell, p. 120; Woods, pp. 16–17; Boime (1993), pp. 422–426, and Dewey F. Mosby, *Across*

Continents and Cultures: The Art and Life of Henry Ossawa Tanner (exhibition catalog) Kansas City, MO: The Nelson-Atkins Museum of Art, June 25–August 20, 1995; pp. 30–32, 36–37.

7. T. J. Clark, *The Absolute Bourgeois: Artists and Politics in France, 1848–1851* (Greenwich, CT: New York Graphic Society Ltd., 1973), pp. 95–96.

8. Both seventeenth-century Dutch genre painting and eighteenth-century British work indebted to Dutch models enjoyed great popularity in nineteenth-century America, influencing the emergence of an indigenous school of genre that, like its European antecedents, served up slices of ordinary people's daily lives, frequently portraying representative 'types.' John Wilmerding, *American Art* (New York: Penguin, 1976), p. 114.

But, as Frances K. Pohl has pointed out, Tanner's approach to black genre differs from the "comic" images of many of his white predecessors in its "solemnity." Pohl attributes this difference to the fact that "Tanner looked to another seventeenth-century Dutch" source "for inspiration," drawing our attention to his use of "Rembrandt's looser brushwork" and spare, uncluttered design, as well as the great Dutch master's "golden light entering from the side." Pohl, "Black and White in America," in *Nineteenth Century Art: A Critical History,* by Stephen F. Eisenman, et al. (New York: Thames and Hudson, 1994), pp. 186–187.

9. Philip S. Foner (ed.), *W.E.B. Du Bois Speaks: Speeches and Addresses, 1890–1919* (New York: Pathfinder Press, 1970), p. 73.

10. W.E.B. Du Bois, "The Conservation of Races," in *ibid.,* p. 79.

11. While the views I am putting forward here are frequently denounced by people of color as stemming from a European intellectual elite, I am struck by the tendency in the U.S. of both friends and foes of "new theory" to ignore the role of Frantz Fanon in laying much of the groundwork for current critiques of cultural essentialism. In this regard, see the final chapter of his *Black Skin White Masks* (New York: Grove Press, 1967), pp. 223–232.

12. Tanner, "The Story of an Artist's Life," *The World's Work,* vol. 18 (June 1909), p. 11662.

13. Unsigned, "The Tanner Family," *The Negro History Bulletin,* vol. 10 (April 1947), p. 148.

14. Mathews, p. 6.

15. E. Franklin Frazier, cited in *ibid.,* p. 38.

16. Rae Alexander-Minter, "The Tanner Family: A Grandniece's Chronicle," in Mathews, *Henry Ossawa Tanner,* p. 23. Unsigned, "The Tanner Family," p. 148.

17. *Ibid.,* p. 147. Alexander-Minter, p. 24.

18. Walter Augustus Simon, "Henry O. Tanner—Study of the Development of an American Negro Artist: 1859–1937" (unpublished Ph.D. dissertation, New York University, 1961), p. 50.

19. Alexander-Minter, pp. 25–26.

20. W.E.B. Du Bois, *The Autobiography of W.E.B. Du Bois* (New York: International Publishers, 1968), p. 187.

21. Richard R. Wright, *Bishops of the A.M.E. Church* (Nashville: A.M.E. Sunday School Union, 1963), p. 23; John Hope Franklin, *From Slavery to Freedom: A History of Negro Americans,* 3rd edition (New York: Vintage, 1969), pp. 162–163; Allen B. Ballard, *One More Day's Journey: The Story of a Family and a People* (New York: McGraw-Hill, 1984), pp. 39–40, 44, 46–47.

22. Wright, pp. 13–19.

23. Ballard, p. 45.

24. Daniel Alexander Payne, *Recollections of Seventy Years* [orig. 1886] cited in Albert J. Raboteau, *Slave Religion: The "Invisible Institution" in the Antebellum South* (New York: Oxford University Press, 1980), p. 68.

25. Ballard, p. 42.

26. Mathews, pp. 4, 32.

27. Ballard, pp. 55–58.

28. *Ibid.,* p. 47.

29. David Wood Wills, "Aspects of Social Thought in the African Methodist Episcopal Church 1884–1910" (unpublished Ph.D. thesis, Harvard University, Department of Religion, February 1975), p. 66.

30. August Meier, *Negro Thought in America, 1880–1915* (Ann Arbor: University of Michigan Press, 1969), p. 218.

31. Wills, p. 51.

32. *Ibid.,* pp. 125, 94.

33. *Ibid.,* pp. 125, 123.

34. *Ibid.,* p. 196, n.5.

35. *Ibid.,* pp. 196, n.4; 131.

36. *Ibid.,* pp. 206–207, 214–215.

37. Ballard, pp. 39–40.

38. *Ibid.,* pp. 45–46. Ballard also notes Payne's disapproval of the political nationalism of Martin Delany.

39. Unlike Meier who attributed "proclivities toward radicalism" to Bishop Tanner, Rae Alexander-Minter was impressed by the bishop's political savvy and noted that the Tanner and Booker T. Washington families maintained close ties for a number of years. Meier, p. 218. Dr. Alexander-Minter, personal communication, March 21, 1988.

Boime objects to my claim that the bishop associated with both Washington and Du Bois, citing a lack of evidence that either the senior Tanner or his son "had any sympathy for the Niagara Movement led by Du Bois, which was launched in 1905 . . . to protest Washington's policies." But it is precisely my point that in the late 19th century, the opposing tendencies of figures like Washington and Du Bois were not yet seen as completely irreconcilable. Boime (1993), p. 429, n.49.

40. The organization lasted until 1924. Herbert Aptheker (ed.), *The Correspondence of W.E.B. Du Bois,* Vol. II (Amherst: University of Massachusetts Press, 1976), p. 281, n.1.

41. Anthony Appiah has traced Du Bois' concern with cultural identity under the guise of racial difference from his 1897 "Conservation of Races" through his 1940 autobiography *Dusk of Dawn.* Appiah, "The Uncompleted Argument: Du Bois and the Illusion of Race," *"Race," Writing, and Difference,* ed. by Henry Louis Gates, Jr. (Chicago: University of Chicago Press, 1986), pp. 23–35.

42. "Of Our Spiritual Strivings," the famous first chapter of *The Souls of Black Folk,* was based on an essay entitled "Strivings of the Negro People" that appeared in *Atlantic Monthly* in 1897. Robert B. Stepto, *From Behind the Veil* (Urbana: University of Illinois, 1979), pp. 53–54, 196.

43. Du Bois in Foner, p. 79.

44. Matthew Baigell, *A Concise History of American Painting and Sculpture* (New York: Harper & Row, 1984), pp. 126–138.

45. W. E. Burghardt Du Bois, *The Souls of Black Folk* (Greenwich, CT: Fawcett Publications, 1961), p. 18.

46. Of the 19th-century African-American artists for whom a substantial amount of work can be discussed at present, however, Duncanson, who shows a

rustic black couple in his *View of Cincinnati* and paints the slave Tom in his 1853 *Uncle Tom and Little Eva,* Tanner and Edward M. Bannister, who depicted New England black laborers in his 1893 *The Hay Gatherers* and whose 1869 *Newspaper Boy* may represent an African-American youth, are the only painters known to this author who produced images of non-elite blacks during the second half of the century. Thus, it seems likely that Tanner was almost alone, among African-American artists, in his pursuit of such subject matter at the time. See above, pp. 26–28.

47. Parry, pp. 165, 167, 177, notes 27, 28.

48. In his 1995 essay, Dewey Mosby lucidly summarizes the documentary evidence for Tanner's views on racial identity, much of which was detailed in Boime's 1993 article. In addition though, Boime also provided crucial contextual frame for these views that had been neglected by other authors—i.e., Tanner's position as a member of a distinct color-based caste within African America. Mosby (1995), pp. 7–9, 30–33. Boime (1993), pp. 415–422.

Using different polemical strategies, Jennifer Harper, Mosby, and Boime have each countered prior readings of Tanner's turn to religious subjects as a form of denial of racial identity. Harper, "The Early Religious Paintings of Henry Ossawa Tanner: A Study of the Influence of Church, Family, and Era," *American Art,* Vol. 6, no. 4 (Fall 1992): 69–85. Mosby (1995), pp. 34–41, 44–48. Boime (1993), pp. 433–441.

49. Du Bois, *Souls,* pp. 19, 20.

50. Guy McElroy's observation that "[i]mages of men teaching were not at all common in the American genre tradition" underscores the particularity of Tanner's approach. McElroy, p. 102.

Albert Boime has significantly enlarged the historical framework in which this strategic maneuver must be seen. In a chapter devoted to the subject, Boime shows that the question of black mental and moral competency, a central theme of nineteenth-century debates concerning slavery and integration, is a leitmotif of the era's popular and high art representations of African Americans. Boime (1990), pp. 79–124.

Naurice Frank Woods provides a tantalizing glimpse of another important and previously neglected source of inspiration for the appearance of education as a theme in Tanner's art, noting that by spending his summers "living and working among the French peasants," Tanner was "following a tradition

established . . . by Jean-François Millet," whose "sensitive studies of the simple everyday lives of the Barbizon peasants included several teaching themes, notably *The Knitting Lesson,* circa 1854, *The Reading Lesson,* circa 1860, and *The Sewing Lesson,* 1874." Woods, p. 16.

Frances Pohl writes that "[Thomas] Eakins' *Negro Boy Dancing* may well have inspired Tanner's own tribute to the transmission of knowledge from one generation to the next, *The Banjo Lesson.*" But comparison of the two works elides the insidiousness of Eakins' juxtaposition of an image of white 'book-learning'—the small portrait on the wall "of Lincoln and his son 'Tad' examining a book together"—and a scene of black transgenerational musicality—the trio of African-American males engaged in "passing on . . . knowledge" in the form of "dancing and playing the banjo." As a result, Pohl overlooks the *critical* relationship of Tanner's composition to that of his own former teacher.

However, she adds an extremely rich, new level of possible meaning to the theme of instruction in Tanner by reading the boy in *The Banjo Lesson*'s plucking style "as a reaffirmation . . . of the banjo as a distinctly African and African American instrument and of the ability of African Americans . . . to master new techniques and acquire new knowledge." Pohl, pp. 185–187.

In his 1993 article, Boime argues persuasively against my use of Du Bois' educational views in this context, observing that "Tanner's emphasis on the transmission of [manual] skills in the 1890s probably places him closer to the philosophy of Washington than to that of Du Bois." Boime (1993), p. 429, n.49.

51. Sewell, pp. 116, 118.

52. Mathews, p. 37.

53. Sewell, p. 119. In 1981, I surmised that *The Banjo Lesson* was based on a photographic source, because of the painting's unusual perspective—i.e., its steeply raked floor and simultaneous high-angled view of the sitters, the tabletop, etc., a contradictory blend of viewing angles that is characteristic of images produced by old-fashioned view cameras—and a compositional style reminiscent of photographic cropping. I am grateful to Kim Sichel, whose work on the French photographer Atget made me aware of the peculiar perspectival effect of view camera photography. In 1988, Alvia Wardlaw informed me that Rae

Alexander-Minter had discovered a photograph of Tanner's sitters for *The Banjo Lesson,* which Dr. Alexander-Minter subsequently was kind enough to show me. Sichel, seminar report, Yale University, fall 1981. Wardlaw, personal communication, Houston, TX, February 12, 1988. Author's meeting with Dr. Alexander-Minter, New York, March 24, 1988.

Mathews mentions Tanner's photographic activity in North Carolina, citing the artist's own account of photographing local scenery. Woods cites a lost work, which an 1890 newspaper reports as depicting "'an old colored man taking his little cotton to market on a rattletrap ox-cart.'" Sewell sees this missing canvas as evidence that Tanner's interest in black genre dated from his Atlanta period—which includes his summer's stay in North Carolina. Mathews, p. 37. Woods, cited in Sewell.

If it *was* his stay in the rural South that inspired Tanner's black genre paintings, then this creative shift parallels Du Bois's re-orientation in *Souls.* As Robert Stepto has pointed out, *Souls* is unique among African-American narratives of its time in describing a journey—not north "to freedom"—but south, to the cradle of Afro-U.S. cultural experience and the land on which the majority of blacks still labored in the early 20th century. Stepto, p. 67.

54. A close squint at the legs of all three chairs indicates this.

55. A mid-century white churchman's comments are typical of accounts written throughout the 19th century. "Considering the mere excitement manifested in these disorderly ways, I could but ask: What religion is there in this? . . . Some allowance, of course must be made for the *excitability* of the Negro temperament" (italics in text). In 1894, Richard Rudolph Michaux reported that, after touring the South, "[a] prominent Methodist" minister concluded, "'[T]he negro has taken to religion as a matter of amusement, in place of his former employment of banjo playing, singing and dancing.'" Both prelates witnessed, but failed to recognize, products of a cultural heritage in which modes of worship largely foreign to mainstream middle-class Protestantism were not only permitted, but privileged, and in which the boundaries between "sacred and secular" were virtually nonexistent. As Dena Epstein observes, the African-American religious practices—"general participation in the singing (and dancing), wide dependence on short mu-

sical units and on antiphonal techniques, . . . improvisation, clapping, and bodily movement"—that frequently "horrified genteel Protestants in the United States, were characteristic of African cultures." Letter from Rev. R. Q. Mallard to Mrs. Mary S. Mallard, Chattanooga, May 18 [1859], quoted in Dena J. Epstein, *Sinful Tunes and Spirituals: Black Folk Music to the Civil War* (Urbana: University of Illinois Press, 1977), p. 205; Michaux, *Sketches of Life in North Carolina . . .* in Epstein, p. 218; Epstein, pp. 206, 219.

That 19th-century black Christians could be as unenlightened in this regard as their white counterparts is demonstrated by an incident cited by Ballard in which members of Philadelphia's Free African Society condemned a Boston chapter's dancing and singing, pronouncing it "'a shameful practice that we, as a people, are particularly guilty of.'" Later, the Philadelphia black Episcopalian priest William Douglass exhibited a corresponding bias in claiming his own denomination was unsuitable for the African-American masses, because they needed a religion that "appealed 'chiefly to the feelings and affectations . . . which are always strongest among undisciplined minds.'" Ballard, pp. 42, 44.

Given this widespread myopia about the significance of black religious departures from Euro-American norms, it seems likely that Henry O. Tanner shared his contemporaries' inability to appreciate the cultural authenticity of ecstatic black worship practices.

56. Caroline L. Mastin expands this list of stereotypes in her catalog for an exhibition of 19th-century graphic representations (cartoons, handbills, broadsides and sheet music covers) of blacks. Mastin, "The Negro-Victim of Stereotype and Prejudice," *"Am I Not a Man and a Brother?": American Nineteenth Century Prints: A Media of Prejudice* (Wellesley, MA: Wellesley College Museum, May 2–June 14, 1970), p. 14.

57. While anti-black stereotypes were prevalent in 19th-century literature, music, and theater, as well as in the visual arts, it seems likely that the volume of oppressive *images* increased during the 20th century, thanks to the development and proliferation of various mass media, marketing and production techniques that were nonexistent or embryonic previously.

58. The 1988 "discovery" of Edmonia Lewis' long-lost monumental sculpture *Death of Cleopatra* (c. 1872–76) and the 1987 exhibition of 68 canvases by a previously unknown, 19th-century, Connecticut-based still life painter, Charles Ethan Porter, suggest the necessarily provisional status of current statements about 19th-century African-American art.

59. Given the inutility of fine art and the absence of an African tradition of portable, illusionistic painting, the lack of slave-made works on canvas is not surprising. What is startling though and underlines the degree to which African creativity was thwarted by North American bondage is the fact that we have only one surviving piece of slave *sculpture*—a medium at which many Africans had excelled in their homelands. John Michael Vlach, *The Afro-American Tradition in the Decorative Arts* (exhibition catalog), Cleveland, Cleveland Museum of Art, February 1–April 2, 1978, pp. 108–110.

60. Carolyn J. Weekley, *et al., Joshua Johnson: Freeman and Early American Portrait Painter* (Colonial Williamsburg, VA and Baltimore: Abby Aldrich Rockefeller Folk Art Center and Maryland Historical Society, 1987), cat. nos. 39 and 40, illustrated on pp. 133–134.

61. Hartigan, p. 54, illus.; p. 56, fig. 12; p. 57, fig. 13.

62. In reading Duncanson's *View of Cincinnati . . .* (1851) as "an image of cultural separatism" in which the "rural simplicity" of the Kentucky black farm family is juxtaposed with "the distant city, symbol of American progress," Hartigan seems to have overlooked some key historical facts. Kentucky was a slave state; Ohio, a free state, was a frequent and well-known destination of runaway slaves, and the Covington area was a convenient site for escape because of its proximity to Ohio. Hartigan, p. 54. John W. Blassingame (ed.), *Slave Testimony: Two Centuries of Letters, Speeches, Interviews, and Autobiographies* (Baton Rouge: Louisiana State University Press, 1977), pp. 518–519, 525–527.

As Joseph Ketner observes, Albert Boime's uncertainty about whether Duncanson intended the black figures in *View of Cincinnati . . .* to be seen as slaves or free blacks seems similarly misguided, given the artist's associations with abolitionism and the regional politics invoked by the depicted locale. Joseph D. Ketner, *The Emergence of the African-American Artist:*

Robert S. Duncanson, 1821–1872 (Columbia: University of Missouri Press, 1993), pp. 41 and 211, n.16. Boime, *The Magisterial Gaze: Manifest Destiny and American Landscape Paintings, c. 1830–1865* (Washington, DC: Smithsonian Institution Press, 1991), pp. 121–123.

In light of the preceding literature, it seems especially odd that David Lubin includes *View of Cincinnati . . .* in his discussion of Duncanson's use of riverine motifs as evidence of the artist's wish to escape the prison of race, yet labels the black figures in this painting an "industrious black farmer" and "the farmer's wife" instead of a pair of slaves. Lubin, "Reconstructing Duncanson," *Picturing a Nation: Art and Social Change in Nineteenth-Century America* (New Haven: Yale University Press, 1994), p. 141.

63. The subject of the latter portrait was previously identified as "a cleric" on the basis of his shirt's neckband, but we now know this style of neckwear was not confined to religious figures. Weekley, *et al.,* pp. 133, 140.

64. Jules Lion's *Ashur Moses Nathan and Son* (c. 1845) is reproduced in Regenia A. Perry, *Selections of Nineteenth-Century Afro-American Art* (exhibition catalog), New York, The Metropolitan Museum of Art, June 19–August 1, 1976, fig. 6, unpag. and cover. William Simpson's *Jermain Loguen* (1864) appears in Fine misdated to 1835, at which time the artist would have been only sixteen or seventeen years old, according to Lynn Moody Igoe. Elsa Honig Fine, *The Afro-American Artist: A Search for Identity* (New York: Holt, Rinehart & Winston, 1973), p. 35. Igoe, *250 Years of Afro-American Art: An Annotated Bibliography* (New York: R. R. Bowker Co., 1981), p. 1102. A. B. Wilson's *Bishop Daniel Payne and Family* (1848) and M. A. Traubel's lithograph of Wilson's *John Cornish* (1840) are both illustrated in Fine, pp. 36–37.

The 1992 version of this essay omitted the so-called *Self-Portrait* (1839) by Julien Hudson, because of a 1991 article in which Patricia Brady reported "there is . . . no documentation or logical argument that indicates . . . this is a self-portrait" or that Hudson was of African descent. More recently, however, Brady has unearthed evidence of Hudson's biracial ancestry, but the identity of the subject in the 1839 portrait remains unknown. Perry, fig. 7, unpag. Fine, p. 30. Brady, "Black Artists in Antebellum New Or-

leans," *Louisiana History,* Vol. 32, no. 1 (Winter 1991): 5–28. Brady, "A Mixed Palette: Free Artists of Color of Antebellum New Orleans," *International Review of African American Art,* Vol. 12, no. 3 (1995): 6–8, 56, notes 4 and 10.

65. I have omitted Wilson's portrait of *John Cornish* because the actual canvas is no longer extant.

66. I have excluded Bannister's undated portrait of his part-black, part-Narragansett Indian wife, Christiana Carteaux, from this list of postbellum works, because of the possibility that it does not post-date the Civil War. Regardless of its date, the Carteaux portrait can be placed in the ranks of "achievement images"— i.e., images of African Americans who attained an exceptional degree of social status and self-determination, and frequently devoted themselves to some form of public service to less fortunate members of the race.

I have also omitted Bannister's *Newspaper Boy* (1869) and his *People Near Boat* (1893) because I do not share Juanita Marie Holland's certainty that they depict light-skinned African Americans. Holland, "Reaching Through the Veil: African-American Artist Edward Mitchell Bannister," *Edward Mitchell Bannister, 1828–1901* (exhibition catalog), New York: Kenkeleba House/Harry N. Abrams, November 19, 1992–January 27, 1993; pp. 16, 27, 50, 53, 55. *Newspaper Boy* is illustrated in Hartigan, p. 30, plate vi.

67. Indeed, the only Tanner canvases I would place in the ranks of the dominant 19th-century, Afro-American mode—bourgeois portraiture or "achievement images"—are his 1897 portraits of his father and mother and his 1917 posthumous portrait of Booker T. Washington. For illustrations of his *Bishop Benjamin*

Tucker Tanner and *The Artist's Mother,* see Fine, pp. 68, 67. For his portrait of Washington, see Sewell, cat. no. 86, p. 257.

68. It is striking that, for example, even in Eastman Johnson's *Negro Life at the South,* a white intruder— the young mistress in her elaborate gown making a cautious entrance through a rude portal—has been inserted as if to reassure white audiences of their ubiquity.

69. See, for example, Benjamin Tucker Tanner's "Non Enim Possumus Aliquid Adversus Veritatem" in the April 1885 *A.M.E. Church Review,* Vol. I, p. 367.

70. Du Bois, *Souls,* p. 67.

71. Such dignified white images of "exceptional" people of color include Nathaniel Jocelyn's *Cinque* and Charles Bird King's portraits of Native American leaders.

72. Du Bois, *Souls,* p. 18.

73. Historian Leroy Graham describes Coker's activities and Carolyn Weekley discusses the evidence that Coker is the sitter in Weekley, *et al.,* pp. 41, 42, 133, 136.

74. Cornish was the pastor of Philadelphia's Bethel A.M.E. Church. Fine, p. 37.

75. Lawrence W. Levine, *Black Culture and Black Consciousness: Afro-American Folk Thought from Slavery to Freedom* (Oxford: Oxford University Press, 1977), p. 162.

76. Only in the 20th century, with the example of European modernism's appropriation of formal characteristics derived from African sculpture, on one hand, and the influence of jazz as a successful model of African-American aesthetic "creolization," on the other, would Afro-American artists begin to depart from traditional Western stylistic models.

14

Columbus and Columbia

Man of Genius Meets Generic Woman, Chicago, 1893

JUDY SUND

The World's Columbian Exposition, held in Chicago in 1893, exploited the 400th anniversary of Columbus's voyage as an opportunity to celebrate the accomplishments and aspirations of American civilization. Although the focus of the Exposition was on America's technological modernity, Judy Sund argues that the event was also a landmark in the history of American women. For diverse women's groups, from suffragettes to prominent socialites, the Columbian Exposition became an occasion to raise consciousness about the role of women in American culture. But, as Sund explains, a marked inconsistency emerged between the verbal and visual rhetoric centering on women at the fair.

Close scrutiny of the Exposition's visual environment, in particular the Court of Honor and the Women's Pavilion, reveals the manner in which progressive oratory on women's issues was undermined by works of art that served to reinforce conventional notions of generic womanhood. From the allegorical sculpture to the exotic images of foreigners on the Midway, women were represented as idealized abstractions of feminine virtue and sexuality and as such stood in sharp contrast to the heroic presence of historical male figures such as Columbus, whose spirit the Fair commemorated. Sund attributes this failure to realize a compelling, dynamic vision of modern female identity, which also characterized the murals executed for the Women's Pavilion by Mary Cassatt, to ideological disagreements between the various groups who competed for the right to represent women's interests at the Exposition.

The World's Columbian Exposition, which opened to the public in May 1893 and ran through October of that year, was an aggrandizing national fête designed to outdo the international expositions that had preceded it while commemorating the 400th anniversary of Christopher Columbus's North American landfall.[1] Thanks to relentless mythologizing in both literature and art, the most momentous events of Columbus's life—his audience with the junta at Salamanca, his sojourn at La Rábida, his landing on San Salvador, his alternately triumphal and humiliating returns to Spain—were etched into the public consciousness,[2] and his would-be countenance[3] was a powerful signifier of visionary spirit and reasoned risk-taking. In Europe, a movement to secure Columbus's canonization was underway;[4] in the United States, the Italian-born and Spanish-funded admiral was widely hailed as yet another father to the country, and

his willful determination to traverse the Atlantic linked to the strapping republic's own westward-ho agenda. The anniversary of his first voyage provided a compelling excuse to grand-stand, and the bold pursuit of new horizons that his image evoked struck the right chords in a country that prided itself on expansionism, and in a newly-built city of notable modernity.[5]

In the course of its materialization, however, the Columbian Exposition also emerged in the minds of many as something its first proponents did not foresee: a watershed event for U.S. women. Building upon efforts to make their cause conspicuous at the Centennial Exposition held in Philadelphia in 1876, suffragists were determined to claim a more central position for women at the 1893 Fair. While the Columbian Exposition was still in its embryonic stages, Susan B. Anthony petitioned Congress to guarantee places for women on its national organizing committee, and in the summer of 1889—even as varied U.S. municipalities continued to wrangle for the honor of hosting the World's Columbian Exposition—a group of Chicago women founded the Isabella Association, an alliance of suffragists (many of them career women) who hoped to make their organization a mouthpiece for U.S. women at the projected fair. Taking their name from the Spanish monarch who legendarily bankrolled Columbus's voyage with her jewels, the Isabella Association sought from the start to establish a powerful female image for and presence at the celebration planned to mark the events of 1492.[6] Among other goals, the group was determined to make its namesake queen visible at any Columbus-driven celebration, though championing a long-dead Spanish monarch who was a woman and a Catholic as well as an initiator of the Inquisition was no easy task in the nineteenth-century United States.[7] One of the Isabella Association's first acts was to commission Harriet Hosmer, a prominent American sculptor resident in Rome, to design a statue of the queen for the upcoming exhibition; they envisioned a

large-scale bronze for prominent display on the fairgrounds, and Hosmer, with that understanding, began work on a modello in 1890.

Through the efforts of dozens of concerned women—socialites as well as suffragists—feminine accomplishments and aspirations were ultimately highlighted at the Columbian Exposition in a women's pavilion designed by a female architect[8] and at the International Women's Congress convened on the fairgrounds from May 15–22 under the auspices of what was known by then as the Department of Women's Progress. The progressive oratory and agendas articulated there were countered and undercut, however, by the conservative visual imagery that dominated the Fair; despite the high hopes of the Isabellas, the Expo's official arts program reified the conservative visions of generic womanhood that feminists combatted, and at the same time overlooked both individual women who had contributed to the country's past and the legion of so-called "New Women" who fought to shape its future.[9]

In April 1890, a Fair Bill designating Chicago the site of the upcoming World's Columbian Exposition was signed into law by President Benjamin Harrison. Though a provision to provide funding for a monument to Queen Isabella was excised from the signed bill, the document did contain a backhanded concession to the Isabella Association and their ilk: an amendment that established a "Board of Lady Managers" to promote women's interests at the Fair. Attempts to define those interests, however, soon provoked in-fighting among its members and hard feelings within its constituency, and the Board became a nemesis to many of those it was created to appease. An ideological tug-of-war between the socialites who dominated the Board and the suffragists (many of them Isabellas) who disparaged them marred the process of establishing a strong female presence at the Fair, as did the Lady Managers' tepid and ineffectual response to African-American women who sought

representation on the all-white board. The 117 Lady Managers were middle- and upper-class women (many related to prominent men) recruited from the United States and its territories by the all-male National Committee; proposals to add a woman of color to their ranks provoked much uneasiness and some outrage, and in the end the interests of black women were left in the hands of a white Lady Manager from Kentucky.[10]

When the Board of Lady Managers met for the first time, in November 1890, they elected Bertha Honoré Palmer (1849–1918), a Kentucky-born Chicagoan with excellent social credentials,[11] their president. Palmer, by all accounts a consummate diplomat, tactfully steered a moderate course on women's issues during her tenure. Though ill-disposed toward the Isabella Association, which she considered divisive and overly strident,[12] she—like many female speakers at the Fair and Congress—invoked Queen Isabella's support of Columbus's enterprise as an example of feminine capacity and nurturance and man's longtime reliance upon them.[13] At the Fair's Opening Day ceremonies Palmer pointedly reminded the 150,000-member audience that "Columbus . . . inspired though his visions may have been, yet required the aid of an Isabella to transform them into realities."[14] She did not, however, go so far as those female polemicists who sought to inspire their gender toward self-determined action—as opposed to the helpmeet role into which history cast Isabella, and society cast women in general—by allying their own quest for equality to Columbus's brave conquest of new horizons. The spirit of daring advance which Columbus's name evoked was co-opted for feminist discourse by speakers who recalled Frances E. Willard's famous pronouncement that "the greatest discovery of the nineteenth century is the discovery of woman by herself,"[15] but rather than embracing Willard's celebration of nineteenth-century woman's self-discovery, Palmer—in a twist on Willard's maxim—instead suggested woman's validation

by patriarchal approbation when she declared: "Even more important than the discovery of Columbus, which we are gathered together to celebrate, is the fact that the General Government has just discovered woman."[16]

As Palmer was surely aware, one of the main things the "General Government" had discovered about women was how persistent and inconvenient they could be, and in retrospect it seems that the men of the National Committee dealt with that realization in a cynical way. Rather than granting women a central role in organizing the Fair as a whole, the Committee—while giving the impression of accommodation—effectively isolated them by creating the Board of Lady Managers and larding that organization with reliably mainstream women like Palmer—many of whom, though committed to general social reform and to the practical matters of securing better pay and working conditions for female breadwinners—were adamantly uninterested in (to quote Palmer herself) "politics, suffrage, or other irrelevant issues."[17] Leading feminists had, from the start, opposed a separate female governing body, as well as the ghettoization of women and their concerns that a separate women's pavilion would allow; they instead demanded female representation on the National Committee itself[18] and the inclusion of women's production in the general exhibition spaces at the heart of the Fair.[19] Nonetheless, the Board of Lady Managers soon sanctioned—even called for—the construction of a Woman's Building, which eventually was built on the periphery of the exposition's ceremonial space. The siting of the Woman's Building, as well as its diminutive scale,[20] evidenced the marginal and unimposing place women's issues actually were allotted at the Columbian Exposition, as well as in the nation the Fair was meant to represent in idealized microcosm. Moreover, the displays housed by the Woman's Building—with their emphases on housework, cookery, child care and nursing—ratified rather than revised standard notions of

women's potential to contribute to society, even as growing ranks of well-educated, affluent "New Women" rejected conventional roles and, according to Carroll Smith-Rosenberg, "asserting their right to a career, a public voice, to visible power, laid claim to the rights and privileges customarily accorded bourgeois men."[21]

Historians of the Columbian Exposition already have noted the mixed messages the Fair sent to women. Reid Badger, for instance, writes of the "inherent confusion" of images that "was present not only in the speeches but throughout the exhibits and activities of the Women's Department."[22] Alan Trachtenberg, while acknowledging that "champions of women's political rights and radical reform," including Susan B. Anthony and Elizabeth Cady Stanton, were given the opportunity to address the Women's Congress, reminds readers that these same women "did not appear among the more socially proper figures of the Lady managers, nor did militant notes ring prominently in the exhibitions. Instead, the prevailing note was domesticity ... woman as mothers, homemakers, teachers, and cooks."[23]

Less discussed but equally telling is the visual imagery produced for the Columbian Exposition[24]—from monumental sculptures to middlebrow illustrations and souvenirs—much of which countermanded the feminist polemic issuing from its rostra by prominently perpetuating another of woman's traditional roles: that of the empedestalled personification of abstract ideas.[25] Though Hosmer's plaster modello of Isabella was installed on the fairgrounds (the Isabella Association ultimately failed to raise adequate funding for the bronze), it was by no means showcased. Instead, it stood outside the California pavilion, at some distance from the Exposition's ceremonial center.[26] Much more visible to the Fair's audience than this (albeit fanciful) portrait of a once-living woman were the outsized, idealized, and much-photographed feminine personifications of the Republic and Columbia which dominated the Court of Honor.

A complex of Italianate buildings set along a vast basin and punctuated by monumental statuary, the Court of Honor [1] was the formal centerpiece of the Columbian Exposition, rigorously planned and lavishly executed despite the ultimately ephemeral nature of its monuments.[27] After dark, still-novel electric illumination animated and colored its façades and statuary. The Court's visual highlights were the grandiose representations of allegorical women that faced each other across the Great Basin: the gilded giantess called the *Republic* and the multifigure *Columbia Fountain*. These were by all accounts "the most conspicuous works of sculpture at the exposition and certainly the dominant attractions within the Great Basin itself,"[28] thus the most freighted with significance, for as Maurice Agulhon writes, monumental sculpture is "the most public and therefore the most naturally political of the plastic arts."[29] The sculptural program of the Court was the brainchild of preeminent American sculptor Augustus Saint-Gaudens (1848–1907), a Paris-trained promoter of the Beaux-Arts style who had been asked by the Exposition's Grounds and Buildings Committee to be the official advisor on sculptural decoration; as such, he devised the placement and general outlines of monuments for the Court of Honor and employed promising colleagues to bring his conceptions into being. Early in the planning process, Saint-Gaudens designated the eastern end of the Court its focal point, and decided it would be marked by a commanding single-figure representation of the Republic. He made a rough sketch of the proposed monument and presented it to Daniel Chester French (1850–1931), the contemporary whom he charged with executing the statue.[30]

Though loosely resembling Frédéric-August Bartholdi's recently dedicated (1886) Statue of Liberty—another feminine colossus perched above water—French's *Republic* was not only smaller[31] but more stiffly posed, lacking the sort of Beaux-Arts fluidity Saint-Gaudens favored and doubtless hoped for. Whereas *Liberty*'s con-

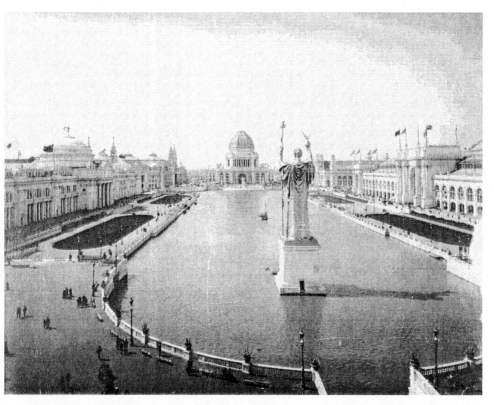

1. C. D. Arnold, "Court of Honor Looking West, View of the Great Basin from the Peristyle," World's Columbian Exposition, Chicago, 1893; courtesy of Chicago Historical Society.

trapposto throws her weight to her left side as she hoists a torch with her right, French's *Republic* was solidly planted on both feet, each arm raised high. One hand held a globe surmounted by an American eagle, the other a pike topped by a liberty cap. Henry Van Brunt, a member of the Fair's team of architects, observed at the time that French's statue was "treated somewhat in the Greek archaic manner, with a strong accentuation of vertical lines, but with a simplicity and breadth which give to the figure an aspect of majesty and power."[32] Connotations of "majesty

and power" surely were enhanced by the fact that the statue, modelled in staff on an iron framework, was clad and coiffed in gold leaf, and crowned by a ring of lights. As the sculptor's daughter later recalled, "Lo! an American goddess stood forth, with golden hair, clothed in shimmering draperies, and by night a halo of stars around her head."[33] Moreover, though diminutive compared to Bartholdi's *Liberty,* French's *Republic*—at that time the largest statue ever made in the United States[34]—towered above its immediate surroundings. The sixty-

five-foot figure stood on a pedestal set into the Basin, and their combined height of about one hundred feet created an effect of gigantism in the Court of Honor, where the buildings all held to a sixty-foot cornice line.

The *Republic* was a highly visible and readily legible emblem of state: immense, unbending, secular, wealthy (by virtue of its gold sheen), imperialistic (the eagle-topped globe) and dedicated to liberty (the pike and cap). The bilateral symmetry of the body and the head's impassive features suggested an unyielding nature; the figure's few curves were overwhelmed by a preponderance of straight lines, the personification more stern than graceful. The sculptor's wife liked to think that the *Republic*'s face was modelled on her own,[35] but one is hard-pressed to find the mark of an actual, living woman in that impeccably classical countenance. Badger convincingly characterizes the *Republic* as a "chaste" rendering of "idealized" American womanhood, at odds with both quotidian reality and feminist visions,[36] and indeed, even the moderate Mrs. Palmer could be heard to decry the sort of feminine image to which French's traditionalist statue conformed. In her Opening Day address, for instance, Palmer proclaimed, "After centuries of careful pruning into conventional shapes, to meet the requirements of an artificial standard, the shears and props have been thrown away. We shall learn by watching the beauty and vigor of natural growth . . . how artificial and false was the ideal [of womanhood] we had previously cherished."[37] Also notable in the context of the Court's golden eminence are remarks Palmer made at the dedication of the Woman's Building in May 1893: "The sentimentalist . . . exclaims: 'Would you have woman step down from her pedestal in order to enter practical life?' Yes! A thousand times, yes . . . I am not a believer in the pedestal theory."[38] Ironically, these objections to the aggrandizement of an artificial feminine ideal were raised almost literally in the shadow of French's oversized embodiment of just such a nemesis.

Countering the austerity and verticality of the *Republic* was the Great Basin's western focal point, the *Columbia Fountain* by Frederick Macmonnies, a Beaux-Arts extravaganza featuring twenty-eight figures—none less than twelve feet high—striking lively postures on and around an ornate caravel. Macmonnies (1863–1937), an erstwhile student of Saint-Gaudens who had gone to Paris to study in 1884 and continued to live there, undertook the execution of the fountain on the condition that Saint-Gaudens give him creative control,[39] though the *Columbia Fountain*, like the *Republic*, was conceived by the older sculptor. Saint-Gaudens sent a sketch of the fountain he envisioned for the fairgrounds (it included a barque with a winged figure at its prow) and urged Macmonnies to draw inspiration from a fountain designed by Jules Coutan for the Parisian Exposition Universelle of 1889.[40]

Macmonnies's finished work (which also was known as *The Triumph of Columbia* and *The Barge of State*) was a water-borne victory pageant honoring the feminine personification of the United States, "goddess of the Fair."[41] As Henry Van Brunt wrote at the time, Macmonnies showed Columbia "high aloft on a throne, supported by cherubs . . . a fair, youthful figure, eager and alert, not reposing upon the past, but poised in high expectation."[42] As saucy as the *Republic* was staid, this goddess perched at the edge of her antique armchair as if ready to rise. Her so-called "barge of state"—its forward motion suggested by blowing drapes and repeated diagonal lines—was steered by Time (in the form of a vigorous, scantily clad old man), oared by eight lithe female forms representing the Arts (starboard) and Sciences and Industries (port side), and accompanied by young men on seahorses, who symbolized Modern Commerce. A winged personification of Victory at the ship's stern heralded Columbia's ascendancy, while jet-spewed water and a school of carved dolphins further animated the scene. About forty feet tall at its apex, Macmonnies's fountain spread out

laterally by way of subsidiary figures that ranged over a circular base 150 feet in diameter; verticality was thus balanced by horizontal expansion, and cohesion within complexity achieved by the uniform whiteness of the plaster figures.

The implied eastward progress of Columbia's retinue channeled attention toward the stationary *Republic* at the other end of the pool; the orientation of the Great Basin's two sculptural monuments surely was intended to suggest the reciprocal relation of the concepts they personified. Columbia and the Republic might be seen as two aspects of a feminized United States: the one emblematic of its physicality (the land, the continent, Columbia), the other of its ideals and/or institutions (i.e., the Republic). In this sense, the two might be seen as sisters, or as two sides of the same feminized coin. It is also possible, however, to interpret the two personas as generationally differentiated, the Republic being a more evolved outgrowth of the "virgin" America Columbus encountered in 1492[43]—thus, Columbia/North America as the nurturing mother of the Republic/United States. The latter interpretation perhaps sheds light on the fact that, as Van Brunt observed at the time, Macmonnies's representation of Columbia differed from many nineteenth-century renderings that presented her as Columbus ostensibly met her: "reposing upon the past" as well as on uncultivated resources.[44] Macmonnies's was a decidedly modern vision of an evolving allegorical persona; his depiction suggested temporal progression as Columbia/North America was pushed ahead by Time, and energized by acquired culture (the Arts and Sciences) and economic development (Industry and Commerce). Youthful, but no longer the passive maiden, this Columbia seemed to command her own ship, and that ship was on course toward the Republic. Hence, one might reasonably read French's *Republic* as the embodiment of this Columbia's destination, and—by extension—an indication of what the continent had become, and/or of the product Columbia spawned.

Columbus, of course, was credited with initiating Columbia's transformation, and nowhere was his Svengali-like role so spotlighted as at the Columbian Exposition. On the Court of Honor, the admiral's orchestrating presence behind the "barge of state" was made materially manifest by Saint-Gaudens's sculptural program, for directly behind the *Columbia Fountain*—on the pavement separating the Basin from the Administration Building (itself emblazoned with the admiral's deeds[45])—stood a statue depicting Columbus on San Salvador. Execution of this three-times-life-size portrait sculpture was initially entrusted to Saint-Gaudens's brother Louis, but when he was unable to finish it, the commission passed to his student Mary Lawrence. She depicted the admiral with a raised sword in one hand and a cross-topped flagstaff in the other, planting the Spanish flag on North American soil—that is, taking physical and figurative possession of North America/Columbia, and vigorously defending his right to do so. Metaphorically speaking, Columbus by this act fathered the Republic; J.G. Blaine alluded to a popular fantasy of mythic genesis when he called Columbus "the man who planted with his flagstaff the seeds of the greatest republic this planet has yet known."[46]

Moreover, even as the historical Columbus stood stalwartly behind Columbia's triumphal procession—her metamorphosis ultimately traceable to his decisively planted "flagstaff"—an apotheosized Columbus looked down upon the gleaming personification of his and Columbia's putative offspring, the Republic, at the Basin's eastern end. The Court of Honor's eastern boundary was marked by a monumental peristyle standing 150 feet high and crowned by a sculptural group depicting a Columbus riding in a quadriga accompanied by women in classical garb. This ensemble—sometimes called *The Triumph of Columbus*—was made by the *Republic*'s sculptor, Daniel Chester French, in collaboration with Edward C. Potter (who specialized in

animal pieces and sculpted the horses). The admiral's symbolic ascendancy was here established by the sculpture's physical elevation to one of the Court's highest points—so high, in fact, that the piece was the least visible of the area's four major sculptures.

Though somewhat upstaged by the physical scale and lavishness of the Court's allegorical megawomen, Columbus (in imaginative reconstruction) played a key conceptual role in that exalted venue. His presence was instrumental to the activation of narrative within a realm otherwise dominated by spectacle, and by means of two separate sculptures on the Court, he was seen both making history and transcending it. The dual images of this man of genius effectively bracketed the basin where the Republic and Columbia held forth, and while those feminine personifications ruled the water, Columbus appropriately laid claim to the land. The four monuments were set along an axis that ran from the peristyle to the Administration Building, bisecting the Great Basin lengthwise. Chronologically they read from west to east, as components of a myth that both began and ended with the Fair's namesake. The hero was seen to set the ball of history in motion and, in the process of possessing Columbia and engendering the Republic, to transform himself from mere mortal to demigod.[47]

The Court of Honor served as the Columbian Exposition's composed public face, and as such suggested the mind that surmounted the matter of its unruly and anticlassical underbelly, the Midway Plaisance, an arena of popular amusement and the preferred destination of thrill- and pleasure-seekers. A conglomeration of rides, oddities, peep shows and entertainment from which future midways took their name, it featured the first Ferris Wheel and a panorama of often debased otherness: "exotic" dancers,[48] international concessions, and evocations of faraway places. Ostensibly pedagogic in aim (it fell under the purview of the Exposition's Department of Ethnology), the Midway was a decidedly commercial arena that capitalized upon a carnivalesque construction of difference as spectacle—what one visitor described as "a legalized harlequinade of other people's habits."[49] Trachtenberg argues that "the carnival atmosphere of the Midway Plaisance confirmed by contrast the dignity of the center [i.e., the Court of Honor]. And, of course," he elaborates, "the center represented America through its exhibitions, the outlying Midway stood for the rest of the world in subordinate relation."[50] All along the Midway—"that mile-long babel where you've been elbowed and cheated"[51]—nonwhite foreigners engagingly scandalized[52] gape-jawed and mostly Caucasian masses and reinforced prevailing stereotypes of non-Europeans as overbearing hucksters,[53] rude primitives, objectified curiosities, and perennial underlings.[54] African-Americans who had vainly fought an unstated but effective color barrier in the Expo's planning phase[55] were angered by the Midway's display of sub-Saharan "savages,"[56] and fairgoing "ladies" and impressionable young men were warned away from the dances and songs performed there by North African women who enacted risqué caricatures of feminine allure that—as one guidebook held—"will deprive you of a peaceful night's rest for months to come."[57] Chicago theater critic Amy Leslie described one such entertainment:

> A writhing Scheherezade in two shades of pink floated about the miniature stage by a series of muscular dislocations most alarming to a citizen of less sinuous education. I never beheld quite such an exhibition and I beheld this particular one for about two minutes. I have been working my eyes slowly back to original orbits ever since.[58]

As modern scholars of the Fair have suggested, the bawdy performances at the Fair's outer edge conjured up a sort of womanliness that stood in dichotomous relation to the static

and decorous feminine embodiments at the center.[59] The chaste *Republic* in particular can be seen to have played virgin to the Midway's "whores," the sanctity of that golden icon enhanced by opposition to the fleshly temptresses outside the spaces of "Honor." Their polarity staged a traditionalist dialectic of the feminine that remained intact despite the more temperate images of womanhood promulgated by the Fair's female organizers and participants. The average female fairgoer—neither secular saint nor exotic seductress—arguably lived at complete remove from the clichéd spectacle of bifurcated womanliness she witnessed in the Fair's neatly divided public realm. Yet the grounds' designers may be seen to have positioned her on the cusp of those clichés, for as Trachtenberg notes, the space officially accorded modern woman at the Fair, the Woman's Building, occupied the "exact junction between the Court of Honor and the Midway Plaisance, just at the point of transition from the official view of reality to the world of exotic amusement, of pleasure."[60] The symbolic potential of this siting apparently was not lost on actual fairgoers, though one female character in C.L. Burnham's Fair-based dime novel, *Sweet Clover,* offered a slightly different interpretation: "When you're feeling bewildered with the smells and sounds and sights [of the Midway], changin' like one o' these kaleidoscopes . . . you pass under a bridge and all of a sudden you are in a great beautiful silence. The angels of the Woman's Building smile down and bless you, and you know . . . you've passed out o' darkness into light."[61] To her mind, then, the Woman's Building stood apart from the ignominy of unbridled otherness, as the portal—and last outpost—of rectitude.

Given its conceptual origins and the processes that brought it into being,[62] the Woman's Building was the one Fair venue where actual women, rather than embodiments or enactments of fantasy, might be expected to dominate—despite the sculpted "angels" ranged along its roofline[63]

or the allegorical image of a feminized Republic painted in the rotunda.[64] In fact, that pavilion did feature extensive displays of women's production, from traditional handicrafts like lace and needlework to a 7,000-volume collection of books by female authors and a wide range of women's paintings, drawings, prints and sculptures, to a room of inventions by women.[65] Moreover, its exhibits included a series of 150 portraits of famous women.[66] The Woman's Building also was home to the Woman's Congress, and for several days in May its walls resounded with feminine—and feminist—rhetoric.

The most discussed products and images of women in the Woman's Building, however, were a set of murals in the main hall portraying "primitive" and "modern" woman. They were made by two American artists resident in Paris, Mary Fairchild Macmonnies (1858–1946) and Mary Cassatt (1844–1926). In Paris in the spring of 1892, both artists met with Bertha Honoré Palmer (who was guided by Sara Hallowell, a longtime art consultant to both private collectors and museums who had been made secretary to the Expo's Director of Fine Arts), and Macmonnies (whose husband was at work on his Columbia Fountain) agreed to paint primitive woman, while Cassatt consented to make the corresponding image of modern woman. Palmer herself apparently devised the subject of the murals,[67] but unlike Saint-Gaudens, she did not provide sketches of the images she proposed. She did, however, comment on the works' progress in correspondence with the two artists. The finished murals (now lost) were mounted in tympana at opposite ends of the main hall. Each showed several figures, mainly female, in a landscape. Both compositions were divided into three parts—Macmonnies's subtly so (its sectors delimited by prominent trees) Cassatt's by means of elaborate painted frames—but each was unified by a continuous horizon line. These large-scale murals (about sixty feet long, and twelve to fourteen

feet high at the tallest point of their curved upper edges) were very much written about at the time of the Columbian Exposition and continue to be the most discussed artifacts of the Fair even to-day.[68]

As works by women for women, the paintings—especially Cassatt's—have been linked by some modern scholars to the feminist causes promoted there. Such interpretations seem to derive in part from biographical data, for the outlines of Macmonnies's and Cassatt's lives can be loosely aligned to the profile of the "New Woman"[69]: well-educated, independent-minded, pursuing careers outside the home, and—in Cassatt's case—unfettered by marriage.[70] Moreover, the prominence of the Woman's Building murals and the circumstances of their commission undoubtedly advanced notions of women's proficiency as artists and patrons. But if their makers' life-styles and the murals' very existence bespoke nineteenth-century women's progress, the paintings' iconography did not; instead, the messages they sent about woman's historical status, contemporary position and goals for the future can be seen to have undermined the sorts of progressive agendas that fostered their creation, and conformed to traditionalist notions of womanhood ubiquitous at the Fair.[71]

Macmonnies's mural—like many Fair speakers' tributes to Queen Isabella—generally reaffirmed women's historical indispensability as support staff: by showing women hauling water, caring for children and tending to a man returned from the hunt, it suggested that even in prehistoric times women, by attending to gender-defined domestic duties, had enabled men to be productive in the world beyond the home. The leftmost image of Macmonnies's painting, a group of women sowing, was the most potentially provocative. Women were more traditionally recipients than casters of seed, and this depiction of feminine engagement in a generative action might be seen to challenge notions of women as mere vessels—and possibly to reflect

Macmonnies's own productive practice. Ever since Christ in a Parable cast himself in the role of a sower, that act had the metaphoric potential to connote the dispersal of new ideas by powerful forces of change,[72] and by that token Macmonnies's female sowers could have been interpreted as heralds of the future in a still-"primitive" world.[73] No evidence exists, however, to indicate that any contemporary viewer read them as such, and it is clear that the artist herself intended her figures to suggest the opposite: woman's longtime satisfaction with the status quo. In an interview Macmonnies asserted, "These women indicate with the completest possible simplicity the bearer of burdens, the tillers of the earth, the servants of man, and more than this, being without ambition, contented with her lot."[74]

Taking up Palmer's suggestion that her assigned tableau be "a classic one in the manner of [Pierre] Puvis [de Chavannes],"[75] Macmonnies—a great admirer of that renowned French muralist[76]—devised a planar composition comprising large, simplified forms, grayed hues, and Puvis-like generalities of type and costume to "express an abstract and universal idea"[77] in what she called "an entirely allegorical-symbolical representation."[78] Puvis's purposely anti-illusionistic tendencies were widely regarded as well-suited to evocations of the distant past, and in emulating his style Macmonnies tapped an established language of archaism that served her project well. Moreover, Puvis through his work had asserted the viability of vagueness. His paintings rarely were allegorical in the traditional sense; only occasionally did he use figures or props as metaphoric equivalents of discrete concepts. Indeed, as John La Farge wrote of Puvis in 1900, "His allegories . . . resist the wish of the critic to bring them to a definite limitation, in the same way that all general ideas have resisted the attempts at classifying them . . ."[79] Following Puvis's lead, Macmonnies avoided specifics in pursuit of the "universal."[80]

Cassatt did much the same thing within the context of a more problematic assignment: to portray the very audience for which her mural was intended—and in an era in which conventional female behaviors and roles were being alternately challenged and affirmed. Potential viewers of the Woman's Building murals were arguably more invested in a rendering of Modern Woman than of her ancient forebear, and many would expect to see themselves and/or their lives somehow mirrored there. Further, Cassatt had been asked to render her vision of "modernity" in a monumental mural—a format that on the one hand harked back to the past and (because of its scale) seemed conducive to public statement, but on the other hand was, in the 1890s, being rethought and revitalized by the Parisian avant-garde as an arena of nonanecdotal decoration.[81] Cassatt had never before attempted a monumental work; as Nancy Mowll Mathews remarks, "As a genre painter, then an Impressionist, then a specialist in the mother and child theme, [Cassatt] had been concerned with intimate subject matter and the depiction of private moments," and most recently had focused on a suite of Japanese-influenced color prints (shown in 1891), "the ultimate in nonpublic art in that they were designed as a portfolio and were not necessarily intended to hang on a wall."[82] Finally, Cassatt—a longtime expatriate—was commissioned to design her mural for a U.S. audience that had never embraced her art as warmly as she had wished[83] and whose desires and expectations she could only vaguely discern from her communications with Mrs. Palmer. Though her work before 1892 shows Cassatt to be a figure painter devoted to female subjects and an Impressionist committed to the portrayal of contemporary life and thus well-prepared to depict Modern Woman,[84] many aspects of the project demanded that she negotiate uneven and unfamiliar terrain.

Cassatt's mural was meant to counter Macmonnies's,[85] and formally their opposition was clear. Cassatt's mural [2] was animated by un-modulated prismatic colors and lively pattern plays, and marked by stylizations and flattenings of form that probably owed as much to Japanese prints as to Puvis's simplifications. Puvis's work surely provided a general model for both Woman's Building murals, but whereas Macmonnies's classicizing panel was unified by a Puvis-like palette of close-keyed colors (one writer called them "light and silvery"[86]) and rhythmic, fluid lines, the more disjunctive quality of Cassatt's colors and contours was assertively—some felt stridently[87]—modernist. Critics who lamented the two murals' lack of stylistic continuity[88] failed to see that the artists' disparate means were suited, intentionally or not,[89] to the contrariness of their assigned subjects, and helped to underscore the ostensible distance between Modern Woman and her "primitive" sister.

The two murals differed iconographically as well, though perhaps not so profoundly and/or in quite the manner that feminists might have hoped—or cognoscenti of Cassatt's easel paintings might expect. Though Cassatt's gender and class had consistently prevented her from painting outside the restricted arena in which elite women were allowed to operate,[90] the artist had nonetheless established herself by 1892 as a painter of empowered peers: oft-cited examples of such women in her work include the female spectator of *At the Opera,* 1879, who exercises the traditionally male prerogative of the appraising gaze,[91] and the commanding figure who literally takes the reins (and consigns a male groom to the back seat) in *Woman and Child Driving,* 1881.[92] In marked contrast to these assertive and thoroughly modern urbanites, the women of Cassatt's Fair mural pursued age-old activities in generic landscapes—far removed, it would seem, from contemporary concerns like suffrage, social reform, or adequate pay for women's work outside the home. The only distinctly "modern" thing about them was their dress, which looked to be high-fashion Parisian; Cas-

2. Mary Cassatt, "Modern Woman," World's Columbian Exposition, Chicago, 1893; courtesy of Chicago Historical Society.

satt herself acknowledged, "I have tried to express modern woman in the fashion of our day and have tried to represent those fashions as accurately and in as much detail as possible."[93] Ironically, however, the sort of clothing she so faithfully reproduced as a signifier of contemporaneity came under attack at the Fair, as feminists championed less restrictive garb and the "Rational Dress Movement" promoted shorter, looser dresses as examples of practical daywear.[94]

Apart from issues of attire, the most striking difference between the women in Cassatt's mural and their counterparts in Macmonnies's was that the "primitives" labored while their latter-day sisters enjoyed genteel leisure. The right panel of Cassatt's work, for instance, showed the making and enjoyment of art (one woman played a stringed instrument, one watched a third dance), and though the central scene showed women at an agrarian task—harvesting fruit—their elegant costume and careful toilettes established them as urban elites enjoying an arcadian interlude rather than wage workers toiling to make a living. Cassatt meant to endow each panel with broader significance. The right panel emblematized women's contributions to the arts as both producers and consumers. The larger, central one, according to Cassatt, was meant to suggest "young women plucking the fruits of Knowledge and Science,"[95] and some contemporary scholars see it as a possibly feminist revision of Eve in the Garden.[96] Whatever her intent, however, the artist left the door to double entendre ajar when she chose this well-established metaphor of wrongheaded feminine adventurousness in a supposed tribute to modern woman's erudition, and surely some nineteenth-century viewers found a less than encouraging message for striving contemporary women imbedded in its familiar imagery.

Those who sensed negativism in the image of female fruit pickers probably were not dissuaded from that impression by the leftmost panel of Cassatt's ensemble, a scene that was similarly allusive, and likewise ambiguous. An allegory of ambition, it showed young girls breaking away from the "contentment with their lot" that Macmonnies aimed to depict in her mural. The girls Cassatt presented were seen in hot pursuit of a small winged nude representing Fame, an elusive quarry that flew beyond their grasp. In describing her subject, the artist declared, "This seems to me very modern and besides will give me an opportunity for some figures in clinging draperies."[97] Though late twentieth-century viewers might like to interpret Cassatt's image as an empathic portrayal of modern woman's struggles toward recognition—rooted, perhaps, in the artist's own experiences—that decoding is impeded by the fact that those who gave chase in her mural were not mature women, but barefoot girls: not only childish, but ill-equipped for their quest. Their energetic exuberance could be written off to youthful naiveté and their chances of success seemed slight. The inconclusiveness of the depicted action allowed this scene to be understood as a bitter and/or deprecating comment on the futility—even silliness—of feminine ambition,[98] and it was likely such a reading that led one nineteenth-century woman to label Cassatt's mural "cynical."[99]

As Cassatt worked to imbue her Fair mural with both the timeless universality many deemed appropriate to monumental public art and the modernism her commission demanded, she surely looked to the work of Puvis, who was not only the era's undisputed master of muralism, but an artist heralded as an exemplar of both classicism and modernism. Her decision to make a modern-dress pastoral of her mural probably was specifically influenced by Puvis's *Inter Artes et Naturam,* a sketch for which had been exhibited at the Salon du Champ-de-Mars in 1890.[100] An innovative coupling of timeless

custom and contemporary dress, Puvis's picture was described by Vincent van Gogh as "a strange and happy meeting of very distant antiquities and crude modernity,"[101] and Richard J. Wattenmaker claims it "was immediately seized upon" in Paris "as confirmation that Puvis de Chavannes could utilize figures in contemporary rather than classical dress, something which they had to overlook in their admiration for the purely pictorial qualities of his earlier work."[102] Similar in content to Cassatt's mural, *Inter Artes et Naturam* shows art-making and refined socializing in a garden setting, as if to suggest the acquisition of culture against a backdrop of nature. It seems likely that Puvis's precedent more generally influenced Cassatt to avoid specifics in her monumental work (as Macmonnies claimed to do in hers) and—in the interests of universality and decorativeness—to rely instead upon understated allusion. But while Puvis's stratagem of equivocation played well among avant-garde Parisians enamored of Symbolist suggestion, the figurative language of Cassatt's mural perplexed many visitors to the Woman's Building. *Modern Woman* apparently was hamstrung by its illegibility, and consequently judged unsatisfactory by the audience for whom it was made. In language as amorphous as Cassatt's own, one Fair publication noted that "some of the Western 'Lady Managers' thought this conception of 'Modern Woman'—her theme—somewhat inaccurate,"[103] and in the *Art Amateur* a more forthright, if anonymous, critic called the two end panels of "this erratic production by a woman of unquestionable talent" "more or less ridiculous."[104]

While interpretations of the painting's (intentionally evasive?) metaphoric language remain contestable, an indisputable fact of its iconography is that Cassatt, by depicting modern woman in symbolic terms, neglected real women and their actual achievements. Rather than singling out notable individuals, or even distinctive

types—for instance, the sorts of scientists, educators, homemakers and suffragists who attended the Women's Congress[105]—in representative domains, Cassatt presented the viewer with clusters of young, resemblant women, homogenous in class and race.[106] Neither a presumed goal of universality nor the conventions of allegory can truly account for the dearth of diversity in this sisterhood—especially in light of what Carroll Smith-Rosenberg calls "the New Women's sense of solidarity across class boundaries, which they took with them into the settlement-house and social justice movements."[107] Moreover, despite indisputable reference to acquired culture in the mural's right panel, the figures of Cassatt's monumental pastoral seemed more closely allied to the realm of nature[108]— "modern" women paradoxically untouched by industrialization, urbanization, or masculine presence.

Cassatt consciously excluded male figures from her mural,[109] in opposition, Susan Fillin-Yeh suggests, to "the tradition which defines women only in their relation to men."[110] In both *At the Opera* and *Woman and Child Driving,* however, Cassatt had managed to present commanding women in male company, their power underscored rather than diminished by the presence of men. The artist herself held that men were amply represented at the Chicago Fair and needed no further representation in the Woman's Building: "Men," she wrote, ". . . are painted in all their vigor on the walls of other buildings; to us the sweetness of childhood, the charm of womanhood; if I have not conveyed some sense of that charm . . . if I have not been absolutely feminine, then I have failed."[111] Her position was not without merit, but her reasoning was not apparent to Woman's Building visitors, and Cassatt's depiction there of a women-only world engendered puzzlement and disapproval.[112] While it may be argued that those who railed against Cassatt's man-free vision

were themselves in the thrall of traditionalist thinking, it is also clear that the artist, in her stated desire to be "absolutely feminine," shied away from hard realities and hardwon victories in favor of "charm" and "clinging draperies"— and effectively shortchanged those reform-oriented contemporary women who confronted patriarchy head-on. As Nancy Hale writes, "The murals did indeed depict woman apart from her relation with man, and as such, apart from conflict"; Hale characterizes that aspect of the mural as "a step backward" from Cassatt's recent work.[113] Advancement of women's issues and causes had not been and would not be effected in the idyllic isolation to which Cassatt consigned Modern Woman; instead, as one Woman's Congress speaker, lawyer Charlotte C. Holt, pointed out, that woman "has been to school in the great world and is part of it. Not from choice, nor from the realization of broader opportunities for women, but through stern and bitter necessity."[114]

Fairgoing New Women like Holt—who adamantly asserted that modern woman "is not drawn from imagination, she is a living, breathing reality . . . intensely human . . . with all the desires and limitations, all the faults and aspirations, with all the virtues and failures that are common to the human family" and asked, "May we not know women in the concrete, that unit from whom we may gather our personal inspiration?"[115]—found few reflections of themselves or contemporaries they admired in the resplendent visual imagery that surrounded them in Chicago. Saint-Gaudens's sculptural program presented women of stylized features and idealized form as receptacles and vehicles for abstract notions; the exotic others of the Midway fed fantasies of reckless eroticism; and in the most prominent paintings at the Woman's Building feminine individuality—of both aspect and activity—was overruled by subservience to the traditional and symbolic.

Whereas Columbus, the prominent male protagonist of the Fair, was a particularized historical personage, known by specific acts and lionized by the prevalent Euro-American cult of individual (male) genius, his most visible female counterpart there was no Isabella—a specific and fallible human being to whom both actual and mythic power attached—but instead that malleable feminine shell, the generic woman. Neither ruler nor homemaker, suffragist, doctor or factory worker, this "universal," hence depersonalized, female mannequin had no profession, no accomplishments, no personhood; her ever-flexible identity resided in her signifying—if shopworn—accessories. At the 1893 Fair, she was most often seen in the guise of Columbia, though her inherently generic nature meant that minimal changes in packaging/labeling transformed her into the Republic. She might just as easily have metamorphosed into Liberty, Justice, Truth, or any other member of the vast sorority of personified ideals, and—with the right clothes—might even be passed off as a representative "Modern Woman."

Despite growing suspicions about the allegorical uses to which female bodies were put,[116] art commissioned by women from women, with the female Fair audience in mind, failed to provide a trenchant alternative to the prepossessing man-devised, woman-based confections in the Great Basin. When man met woman in the Fair's visual artifacts hero met goddess. He was an entity of known accomplishments, she more often than not was one of a succession of feminized emblems: "womanly" by virtue of costume and physique (and pliancy?), but humanoid rather than human. The image of that much-lauded nineteenth-century voyager, the self-discovered woman—who rivaled Columbus in feminist rhetoric that challenged the reign of generic goddesses—rose vividly in the mind's eye, but much less so in the material culture spawned by the national birthday party she attended to such fanfare.

NOTES

Revised by the author from *Art Bulletin* 75, no. 3 (September 1993). Reprinted by permission of the author and the College Art Association, Inc.

1. As Wim de Wit notes, the Exposition Universelle held in Paris in 1889 set the standard against which organizers of the Chicago Fair measured their success, and "the World's Columbian Exposition did, in fact, far surpass its Parisian precedent in the dimensions of the site and the size of the buildings" ("Building an Illusion," in N. Harris *et al., Grand Illusions: Chicago's World's Fair of 1893*, Chicago, 1993, 43–98, 49). Opening Day ceremonies were held on the still-unfinished grounds in October 1892, the Fair did not open to the public until the following May.

2. Joel Barlow's epic *Columbiad* (1807) mythologized Columbus without dwelling upon the particulars of his biography, but the admiral's life story was recounted in painstaking detail by Washington Irving in his multivolume study, *The Life and Voyages of Christopher Columbus* (1828), which highlights a series of oft-recounted incidents, several of which had been and would be taken up by printmakers, painters and sculptors in Europe and America. Eugène Delacroix, for instance, made pictures of *Columbus at La Rábida* (1838) and *Columbus's Return to Spain* (1839), and Emmanuel Leutze painted at least six scenes from the admiral's life, including *Columbus in Chains* (1842) and *Columbus Before Isabella* (1843). John Vanderlyn completed his mural of *The Landing of Columbus* at the U.S. Capitol in 1842, and in the 1850s Randolph Rogers presented Columbus's life as an episodic narrative in a pair of multipaneled bronze doors for the same building.

3. According to Hugh Honour, none of the known portraits of Columbus was made in his lifetime; all are instead posthumous reconstructions, and many fail to reflect verbal descriptions recorded by the admiral's contemporaries. A committee convened at the Chicago Fair considered and rejected seventy-one versions of Columbus's visage in its ill-fated search for a "true" likeness ("L'Image de Christophe Colomb," *Revue du Louvre*, XXVI, 1976, 255–67, 255).

4. See L'Abbé Casablanca, *Glorification religieuse de Christophe Colomb*, Paris, 1892.

5. About 2,000 acres of central Chicago were destroyed by the Great Fire of October 1871, but the city made a remarkable physical and economic recovery in the two decades that followed. Louis Sullivan arrived in the city in 1873 and was one of several architects who participated in the city's rebuilding; the verticality of Chicago's skyscraper-studded horizon gave the city a distinctly modern profile by the 1890s.

6. For a history of the Isabella Association, see M. Weimann, *The Fair Women*, Chicago, 1981.

7. *Ibid.*, 39.

8. An architectural competition for the design of the Woman's Building was won by Sophia Hayden of Boston, a twenty-five-year-old graduate of MIT. Weimann (pp. 144–156, 174–180) relates the fate of that design (which was modified by male planners and builders) and of Hayden's displeasure with the finished product (she reportedly suffered a nervous breakdown in 1892, and did not design any other buildings, though she lived until 1953). See also J. Paine, "Sophia Hayden and the Woman's Building," *Helicon Nine*, I, Fall/Winter 1979, 29–37.

9. For thorough discussion of the New Woman—who became a well-known type in U.S. society in the 1880s—see C. Smith-Rosenberg, *Disorderly Conduct: Visions of Gender in Victorian America*, New York, 1985.

10. See A. Massa, "Black Women in the White City," *Journal of American Studies*, VIII, Dec. 1974, 319–337.

11. Bertha Palmer was the wife of Potter Palmer, a highly successful retailer and real estate developer; they were among Chicago's leading art patrons. Potter Palmer was himself involved in planning the World's Columbian Exposition—as second vice president of the city's own Fair board, known as the Chicago Fair Corporation. He served on two of its subcommittees: Fine Arts and Grounds and Buildings.

12. See Weimann, chapter IV.

13. For the dedication of the Woman's Building, Flora Wilkinson composed an ode that urged listeners to "join to man's glory the woman's" by remembering Isabella's "heed to a stranger's appeal," and concluded, "Here, gravely let us be grateful/as heirs of a generous past/For the pleasures and powers and duties/fallen to women at last" (see Maj. B.C. Truman, ed., *History of the World's Fair, Being a Complete De-*

scription of the World's Columbian Exposition from Its Inception, Chicago, 1893, 175).

14. Palmer's Opening Day address is transcribed in its entirety in Truman, 111–114; for her remarks on Isabella, see p. 111.

15. See, for instance, L.D.F. Gordon, "Women's Sphere from a Woman's Standpoint," and H.L. Bullock, "Power and Purposes of Women," in M.K.O. Eagle, ed., *The Congress of Women,* New York, 1893, 76, 143.

16. Palmer, Opening Day address, as recorded in Truman, 114.

17. Truman, 112.

18. At the outset of Fair planning, Susan B. Anthony petitioned legislators to appoint female members to the main organizational committee; she never suggested that women be shunted onto a board of their own (see R. Badger, *The Great American Fair: The World's Columbian Exposition & American Culture,* Chicago, 1979, 79). Once the Board of Lady Managers was established, Frances E. Willard criticized the concept even as she acknowledged the opportunity it presented (see Weimann, 36).

19. Truman, for instance, describes a "strong sentiment" "against taking the exhibits of women from the general buildings and placing them apart in a 'Woman's Department'" (pp. 163–4), and Badger (p. 79) points out that at an organizational meeting held in November 1890 the Board of Lady Managers "agreed that women's exhibits should not be segregated from the main displays at the fair (as they had been at the centennial)."

20. At 200 × 400 feet (i.e., about 1.8 acres) the Woman's Building was the smallest of the Fair's exhibition halls; of the Fair's pavilions, only the Administration Building (at about 1.3 acres) was smaller. See D.R. Jamieson, "Women's Rights at the World's Fair, 1893," *Illinois Quarterly,* XXXVII, Dec. 1974, 5–20, 7; and Weimann, 152.

21. Smith-Rosenberg, 176.

22. Badger, 121; for elaboration, see his chapter XVI, "A Confusion of Symbols."

23. A. Trachtenberg, *The Incorporation of America: Culture and Society in the Gilded Age,* New York, 1982, 221.

24. Badger (p. 122) touches upon the problematics of visual images produced for the Fair when he notes that "taken as a whole . . . the World's Columbian Ex-

position offered a conflicting picture of American women, in its symbolic artifacts, exhibits, and in its notably representative women."

25. See M. Warner, *Monuments and Maidens: The Allegory of the Female Form,* London, 1985.

26. Hosmer opposed her statue's display in the gender-isolating environment of the Woman's Building; see D. Sherwood, *Harriet Hosmer, American Sculptor,* Columbia, Mo., 1991, 325; and A.M. Kimball and W. Wellner, "Fair Ways to Freedom," *The Independent Woman,* XVII, Nov. 1938, 343, 360–2. The plaster *modello* is now lost, but Hosmer did cast a bronze which she sold to the Pope.

27. The Fair's pavilions and statuary—never intended to endure—were constructed of staff, a mixture of plaster, cement and straw. The fairgrounds were abandoned after the Exposition's official closure on Oct. 30, 1893, but by the winter of 1893–4 the deserted exhibition halls were used by vagrants and Chicago's homeless. In the months after the Expo closed, several small fires damaged the staff structures, and in July 1894 a more sweeping blaze destroyed much of what stood—spurring a decision to demolish almost everything that remained. The Arts Palace was preserved, and in a refurbished state now houses Chicago's Museum of Science and Industry.

28. D.F. Burg, *Chicago's White City of 1893,* Lexington, Ky., 1976, 122; see also J. Connor and J. Rosenkrantz, *Rediscoveries in American Sculpture,* Austin, Tx., 1989, 7.

29. M. Agulhon, *Marianne into Battle: Republican Imagery and Symbolism in France, 1789–1880,* trans. J. Lloyd, Paris, 1979, 4.

30. Saint-Gaudens's sketch for the *Republic* (made in 1891) is now in the Burnham Library of Architecture at the Art Institute of Chicago; French noted on its verso that it indicated Saint-Gaudens's "idea of what should be the central statue of the Court of Honor." See J.L. Riedy, *Chicago Sculpture,* Urbana, Ill., 1981, 28, n. 12.

31. *Liberty* is about 150 feet high; French's *Republic*—an ephemeral work in an enclosed setting—measured sixty-five feet high.

32. H. Van Brunt, "Architecture at the World's Fair, Pt. I," *The Century Magazine,* May 1892, 81–99; 94.

33. M.F. Cresson, *Journey into Fame,* Cambridge, Mass., 1946, 171. As described by F.H. Burnett in *Two Little Pilgrims' Progress: A Story of the City*

Beautiful (Chicago, 1895), the *Republic* was "a great statue of gold tower[ing] noble and marvelous, with uplifted arms holding high the emblems of its spirit and power" (138); in *The Adventures of Uncle Jeremiah and Family at the Great Fair* (Chicago, 1893), C.M. Stevens (writing as Quondam) describes the same monument by night and spotlighted, "resplendent as though carved from a block of flame" (p. 71).

34. Cresson (as in n. 33).

35. Mrs. D.C. French, *Memories of a Sculptor's Wife*, Boston, 1928, 167–168.

36. Badger, 121.

37. Palmer, Opening Day address, as recorded in Truman, 114.

38. Palmer, "Address Delivered on the Occasion of the Opening of the Woman's Building," in Eagle, 25–9; 27.

39. E.A. Gordon, *Frederick Macmonnies, Mary Fairchild Macmonnies: Deux Artistes Américains à Giverny,* Vernon, France, 1988, 41.

40. *Ibid.*

41. Connor and Rosenkrantz, 127. Other images of the triumphant Columbia dotted the fairgrounds, and Columbia enthroned appeared in two other prominent spots on the Court of Honor: at the center of the pediment of Machinery Hall (the Fair's largest structure) and in the dome of the Administration Building (Burg, 126, 156).

42. Van Brunt, p. 94.

43. As then–Secretary of State James G. Blaine remarked, "America was kept intact and virgin from shore to shore, tenanted by no man and no race that left an institution to hamper the future" ("Progress and Development of the Western World," in Blaine *et al., Columbus and Columbia: A Pictorial History of the Man and the Nation,* Springfield, Ohio, 1892).

44. See E.M. Fleming, "From Indian Princess to Greek Goddess: The American Image, 1783–1815," *Winterthur Portfolio,* III, 1967, 37–66.

45. The Administration Building bore carved inscriptions over each of its four entrances referring to Columbus's life and accomplishments.

46. Blaine *et al.,* 43.

47. My interpretation of Saint-Gaudens's sculptural program is informed by Laura Mulvey's "Visual Pleasure and Narrative Cinema" (*Screen,* XVI, Autumn 1975, 6–18).

48. The "danse du ventre" was performed in four theaters on the Midway by women clad in "gauze silk through which the warm flesh tints are distinctly visible" (see "Danse De [sic] Ventre on the Plaisance," *Chicago Mail,* June 3, 1893; cited by R. Rydell, "A Cultural Frankenstein?" in Harris *et al.,* 143–170, 164).

49. A. Leslie [pseud. for L. Buck], *Amy Leslie at the Fair,* Chicago, 1893, 99.

50. Trachtenberg, 213. R.W. Rydell makes a similar assessment, writing: "On the Midway at the World's Columbian Exposition, evolution, ethnology, and popular amusements interlocked as active agents and bulwarks of hegemonic assertion of ruling-class authority" (*All the World's a Fair: Visions of Empire at American International Expositions, 1876–1916,* Chicago, 1984, 41).

51. C.L. Burnham, *Sweet Clover: A Romance of the White City,* Boston, 1894, 201.

52. Midway regular Amy Leslie observes, for instance, that on the Plaisance "there is an unspoken notion that exquisitely wicked things are uncloaked under the arc lights of the Turkish theater and that Dahomey teems with savage awfulness quite too utterly shocking . . ." (p. 99).

53. Leslie (p. 70) writes that the North African merchants on the Midway "will nag the life out of a Christian."

54. The pages of C.L. Burnham's Fair novel, *Sweet Clover,* are rife with expressions of such attitudes. A fictional visitor to the Dahomey Village, for instance, reflects that "some of those savages were unpleasantly personal" (p. 238), and the author sighs at the unorthodox sales tactics of Midway concessioners (pp. 274–275). The eponymous Clover, having witnessed a performance at the Chinese Theater, declares, "I want one of those brown girls to take home as bricabrac . . . Aren't they the roundest, prettiest little creatures?" (p. 305), and a young man observing an African on the Midway who appears to him "like a splendid bronze," remarks to his companion, "If that woman had been brought up in a different environment she would have been superb. Fancy having her well-trained for a servant?" (p. 272). The plainspoken housekeeper who is presented as the novel's voice of reason denounces the area's habitués *en masse* (p. 201): "To listen to 'em yell and see 'em dance is a mighty queer thing for Christians to seek as entertainment, it seems to *me.* If

I could go into that Plaisance with plenty o' hot water and Castile soap, and some sensible clothes, and could help those poor critters to a more godly way o' livin' that would be a different thing; but when I want a good time I ain't goin' to try to get it bein' trod on by camels and yelled at by Turks, all the time smellin' smells I don't know the name of and would be afraid to, no sir."

55. Despite petitions to him and to Congress, President Harrison, according to Badger (p. 105), "refused to appoint blacks to the 208-member National Committee." Moreover, Badger writes, African-Americans were "quietly denied positions in the construction, administration, or even operation of the fair, except as menials."

56. Frederick Douglass doubtless spoke for many when he declared, "As if to shame the Negro, the Dahomians are . . . here to exhibit the Negro as a repulsive savage" (Douglass, "Introduction," in F. Douglass and I. Wells, *The Reason Why the Colored American Is Not in the World's Columbian Exposition,* Chicago, n.d., 9).

57. Anon., *The Vanishing City: A Photographic Encyclopedia of the World's Columbian Exposition,* Chicago, 1893; cited by J. Doenecke, "Myths, Machines and Markets: The Columbian Exposition of 1893," *Journal of Popular Culture,* Winter 1972, 535–549, 537. The temptations of the Midway are much alluded to in dime novels of the era; a young man in *The Adventures of Uncle Jeremiah* is counseled (p. 111): "Beware of that Midway. It'll do no good for young men at all, at all. You'd lose your head . . . ," and in *Sweet Clover* (p. 239) an older woman jokingly tells a young wife, "Your husband has been to the Midway . . . Don't be surprised at anything he may say or do."

58. Leslie, 39.

59. See Badger, 121; and Trachtenberg, 222.

60. Trachtenberg, 221–22.

61. Burnham, 201.

62. As one guidebook hyperbolically declared of the Woman's Building, "No masculine hand has interfered; no idea or suggestion has emanated from the masculine mind" (cited by Doenecke, 542).

63. The winged figures atop the Woman's Building were made by Alice Rideout, a 19-year-old Californian. They were in fact feminine personifications of Innocence and Enlightenment, garbed in long, loose gowns. Each formed the 12-foot-high centerpiece of a three-figure group, and each group was repeated four times along the building's roofline. Innocence was flanked by smaller, seated women representing Charity (a matron nursing two orphans) and Sacrifice (a nun placing jewelry on an altar). Enlightenment was accompanied by a student (in cap and gown) and a dejected homemaker (wearing an apron); the homemaker was interpreted by one viewer as suggestive of "a forlorn hope for the advancement of women . . . [to] intellectual achievement" (cited by Weimann, 263). Maud Howe Elliott thought Rideout's sculptural groups stood in "delightful contrast to the familiar and hackneyed types that serve to represent Virtue, Sacrifice, Charity and the other qualities which sculptors have personified, time out of mind, by large, heavy, dull-looking stone women" (cited by Weimann, 173). The winged figures, "impossible . . . to see clearly from the ground" (Weimann, 263), often are described as angels in popular accounts of the time.

64. Burg, 166.

65. See E.M. Henrotin, "An Outsider's View of the Woman's Exhibit," *The Cosmopolitan,* XV, Sept. 1893, 560–566; and M.H. Elliott, ed., *Art and Handicraft in the Woman's Building of the World's Columbian Exposition,* Chicago, 1895. F.K. Pohl points out that this array "represented not the achievements of all women, but only those who conformed to the Board's well-defined aesthetic, intellectual, and moral standards," and notes that items on display were presented "in isolation from the fields, sweatshops, and mills in which they were produced" ("Historical Reality or Utopian Ideal? The Women's Building at the World's Columbian Exposition, Chicago, 1893," *International Journal of Women's Studies,* V, Sept./Oct. 1982, 289–311, 297–299).

66. Burg, p. 166. The Great Hall of the Woman's Building also honored notable individuals; its walls were adorned with the "golden names of women who in past and present centuries have done honor to the human race" (see Weimann, 227–228). Those so honored included women from Joan of Arc to Lady Godiva.

67. In a letter to Hallowell dated Feb. 24, 1892, Palmer wrote: "My idea was that perhaps we might show woman in her primitive condition as a bearer of burdens and doing drudgery, either in an Indian scene or a classic one in the manner of Puvis, and as a con-

trast, woman in the position she occupies today" (cited by Weimann, 191). Palmer's idea was a feminized variant upon a popular conceit pitting modern man against his primitive forebear; a fairly contemporaneous example is provided by Albert Besnard's paired murals of *Primitive Man* and *Modern Man*, made in the early 1880s for the Ecole de Pharmacie in Paris.

68. For modern scholarship on the Macmonnies and Cassatt murals, see Gordon, p. 23; Pohl; Weimann, chapter IX; M. Smart, "Sunshine and Shade: Mary Fairchild Macmonnies Low," *Woman's Art Journal,* IV, Fall/Winter 1983–84, 20–25; J.D. Kysela, "Mary Cassatt's Mystery Mural and the World's Fair of 1893," *The Art Quarterly,* XXIX, 1966, 128–145; S. Webster, "Mary Cassatt's Allegory of Modern Woman," *Helicon Nine,* I, Fall/Winter 1979, 38–47. This project is also discussed in N. Hale, *Mary Cassatt,* New York, 1975; G. Pollock, *Mary Cassatt,* London, 1980; and N.M. Mathews, *Mary Cassatt,* New York, 1987.

69. If Smith-Rosenberg's criteria of New Womanhood are strictly applied, Cassatt (b. 1844) was actually too old to be so labeled, since the New Woman was "born between the late 1850s and 1900" (p. 176). Apropos both Cassatt and Macmonnies, it is pertinent to note Smith-Rosenberg's contention that the New Woman was "quintessentially American" (p. 245); the term "New Woman" was popularized by Henry James, who used it to refer to the affluent and autonomous U.S. women who people his novels—and whom he usually placed in European settings (p. 176).

70. One contemporary commentator characterized Macmonnies as "a charming symbol of the 'Coming Woman'" (E.E. Greatorex, "Mary Fairchild Macmonnies," *Godey's Ladies Magazine,* CXXVI, 1893, 624–632; cited in S. Waller, ed., *Women Artists in the Modern Era: A Documentary History,* London, 1991, 253). Modern writers on Cassatt have noted her engagement with feminist causes; Mathews (p. 84) writes that she "subscribed to feminist tenets," and Pollock (p. 6) notes that Cassatt "became more and more involved in radical politics in her lifetime, [and] was a staunch supporter of women's rights . . ."

71. Both Badger (p. 121) and Trachtenberg (p. 221) remark on the clichés perpetuated by the Woman's Building murals, where—in Badger's words—"one stereotype was juxtaposed against another."

72. The sower was a popular emblem of revolution in nineteenth-century Europe; some commentators saw J.-F. Millet's famous *Sower* of 1850–51 in that light.

73. A Psalms-inspired female sower did in fact become an omnipresent emblem for the woman's suffrage movement in England just a few years after Macmonnies completed *Primitive Woman;* Sylvia Pankhurst included a 13-foot-high female sower in her wall decorations for the Woman's Social and Political Union exhibition held in 1909, and variations upon it soon "appeared everywhere in the militant movement," according to Lisa Tickner (*The Spectacle of Women: Imagery of the Suffrage Campaign, 1907–14,* Chicago, 1988, 32).

74. Macmonnies as quoted by Greatorex; see Waller, 252–253.

75. Palmer to Hallowell, Feb. 24, 1892 (cited by Weimann, 191). Palmer and her husband owned the reduced version of Puvis's *Sacred Grove* (R.J. Wattenmaker, *Puvis de Chavannes and the Modern Tradition,* Toronto, 1975, 186).

76. See Gordon, 23; Smart, 25.

77. Macmonnies as quoted by Greatorex; see Waller, 252.

78. Macmonnies to Palmer, Jan. 23, 1893 (cited by Weimann, 210).

79. La Farge as quoted by Wattenmaker, 6.

80. Macmonnies later told an interviewer that in planning her mural she "reject[ed] in turn the idea of the savage, the pre-historic, the slave, the oriental woman, or any that would require precision as to detail of costume, race or environment as being unfit to express an abstract and universal idea"; see Waller, 252.

81. See N. Troy, *Modernism and the Decorative Arts in France: Art Nouveau to Le Corbusier,* New Haven, 1991, 2.

82. Mathews, 84.

83. See, for instance, N.M. Mathews, ed., *Cassatt and her Circle: Selected Letters,* New York, 1984, 210.

84. Matthews, 84.

85. Palmer to Hallowell, Feb. 24, 1892 (cited by Weimann, 191 [see n. 67]).

86. H.B. Fuller, review in the *Chicago Record* (cited by Weimann, 316).

87. K.D. McCarthy reports, for instance, that "some of the Lady Managers privately condemned Cassatt's painting as 'uncouth'" (McCarthy, *Women's Culture: American Philanthropy and Art, 1830–1930,* Chicago, 1991, 103), and H.B. Fuller remarked that Cassatt's

"impudent greens and brutal blues" were indicative of "an aggressive personality with which compromise and cooperation would be impossible. Indeed, Miss Cassatt has a reputation for being strong and daring; she works with the men in Paris on their own ground" (cited by Pohl, 305).

88. Fuller suggested that Macmonnies and Cassatt must have decided to "ignore or even repulse" one another's work for the Fair (cited by Weimann, 316).

89. Cassatt and Macmonnies apparently did not see each other's work in progress, but are known to have corresponded about the murals. Cassatt (in a note written in summer 1892) assured her colleague that—in light of how high and how far from one another the paintings were to hang—there was "no necessity for unity" (cited by F.A. Sweet, *Miss Mary Cassatt, Impressionist from Pennsylvania*, Norman, Okla., 1966, 126).

90. K. Adler and T. Garb, *Berthe Morisot*, Oxford, 1987; see also G. Pollock, "Modernity and the Spaces of Femininity," in *idem., Vision & Difference*, London, 1988, 50–90.

91. See Pollock (as in note 90), 75–6.

92. The driver is Cassatt's sister, Lydia. Norma Broude remarks that her assertive role and posture "carry . . . a veiled challenge to the normal social order of things" (*Impressionism: A Feminist Reading*, New York, 1991, 156).

93. Cassatt to Palmer in a letter of Oct. 11, 1892 (cited by Sweet, 130).

94. See Jamieson, 13–14; and Anon., "Dress Reform at the Fair," *Review of Reviews*, VII, Apr. 1893, 313–335.

95. Cassatt to Palmer, Oct. 11, 1892 (cited by Sweet, 130–131).

96. Pollock, for instance, is struck by the way Cassatt's oeuvre "questioned, transformed and subverted the traditional images of Woman, Madonna, Venus, Vanity and Eve," but observes that the fact that Cassatt did not move Modern Woman out of the Garden is "surprising because the metaphor of the Garden of Eden had been used consistently in the nineteenth century to confine women" (p. 27). Webster (p. 46) asserts that "Cassatt departs . . . from tradition for there is no evil serpent, no Adam, and Eve is not guilty of original sin. Instead, women are shown as actually passing the fruits of knowledge from one generation to the next." In a similar vein, Mathews (pp. 86–89) describes *Modern Woman* as "a modern statement about independent

women taking upon themselves the pursuit of knowledge and its dissemination."

97. Cassatt to Palmer, Oct. 11, 1892 (cited by Sweet, 131).

98. Florence F. Miller remarked that these "three hideous girls" suggested "'Modern Woman' in the useless pursuit of fame" ("Art in the Women's Section of the Chicago Exhibition," *Art Journal* [London], LV, 1893; cited by Pohl, 304).

99. Henrotin, 561. Henrotin was partial to Macmonnies's mural, which she found "reverent in tone and dignified in treatment."

100. The large, finished version of *Inter Artes et Naturam* was destined for the Musée des Beaux-Arts, Rouen. Wattenmaker (p. 186) suggests that Cassatt saw Puvis's exhibited sketch, and discusses the impact of *Inter Artes et Naturam* on *Modern Woman.*

101. *The Complete Letters of Vincent van Gogh*, New York, 1978, III, 471.

102. Wattenmaker, 79.

103. Cited by Sweet, 133.

104. Cited by Hale, 164.

105. The sculptor Alice Rideout presented women from varied walks of life in the bas relief pediment that surmounted the main entrance to the Woman's Building; they included a female painter, poet, musician, philanthropist, worker, teacher and housekeeper, and Mary Newbury Adams called Rideout's conception "the poetic key to the building and its use" (cited by Weimann, 263).

106. Cassatt's assemblage may be seen, in the women's sameness, to parallel the Board of Lady Managers, an organization Pohl describes as "permeated" by racism and classism (p. 290).

107. Smith-Rosenberg, 264.

108. Sherry B. Ortner observes that women's "pan-cultural second-class status could be accounted for, quite simply, by postulating that women are being identified or symbolically associated with nature, as opposed to men, who are identified with culture." While culture "recognizes that women are active participants in its special processes," she writes, it "at the same time sees them as being more rooted in or having more direct affinity with nature" ("Is Female to Male as Nature Is to Culture?" in: M.Z. Rosaldo and L. Lamphere, eds., *Woman, Culture, and Society*, Palo Alto, Calif., 1974, 67–87, 73).

109. As she worked on the picture, Cassatt told Palmer, "An American friend asked me in a rather

huffy tone the other day, 'Then this is woman apart from her relations to man?' I told him it was." Cassatt to Palmer, Oct. 11, 1892 (cited by Sweet, 131).

110. S. Fillin-Yeh, "Mary Cassatt's Images of Women," *Art Journal*, XXXV, Summer 1976, 359–63; 361. Fillin-Yeh's remark is directed toward Cassatt's oeuvre as a whole.

111. Cassatt to Palmer, Oct. 11, 1892 (cited by Sweet, 131). Her linkage of womanhood with childhood restates a commonplace of patriarchal thought. Moreover, as Ortner observes, "Mothers and their children, according to cultural reasoning, belong together," and "the sheer fact of constant association with children" bonds women to the realm of nature in a nature/culture dialectic (p. 77).

112. Frances E. Willard was among those who voiced disapproval of Cassatt's omission of male figures; see Weimann, 314.

113. Hale, 164.

114. The text of Holt's address is transcribed in Eagle, 190–193; see 191. Holt also advocated enlightened collaboration between the genders in U.S. society; she closed her speech before the Women's Congress with the assertion that modern woman "believes in man and woman. She also believes in that land, on the hills of which walk brave women and brave men hand in hand" (p. 193).

115. Holt in Eagle, 191–192, 190.

116. Minnie D. Louis, in her speech to the Fair's Congress of Women, observed, for instance, that even "the veriest misogynist pictures his ideal of purity in female form"; see "Woman, the Inciter to Reform," in Eagle, 539–43, 542.

FREQUENTLY CITED SOURCES

R. Badger, *The Great American Fair: The World's Columbian Exposition & American Culture,* Chicago, 1979.

J.G. Blaine et al., *Columbus and Columbia: A Pictorial History of the Man and the Nation,* Springfield, Ohio, 1892.

D.F. Burg, *Chicago's White City of 1893,* Lexington, Kentucky, 1976.

C.L. Burnham, *Sweet Clover: A Romance of the White City,* Boston, 1894.

J. Connor and J. Rosenkrantz, *Rediscoveries in American Sculpture,* Austin, Texas, 1989.

J. Doenecke, "Myths, Machines and Markets: The Columbian Exposition of 1893," *Journal of Popular Culture,* winter 1972, pp. 535–49.

M.K.O. Eagle (ed.), *The Congress of Women,* New York, 1893.

Mrs. D.C. French, *Memories of a Sculptor's Wife,* Boston, 1928.

E.A. Gordon, *Frederick Macmonnies, Mary Fairchild Macmonnies: Deux artistes américains à Giverny,* Vernon, France, 1988.

N. Hale, *Mary Cassatt,* New York, 1975.

A. Leslie (pseud. for L. Buck), *Amy Leslie at the Fair,* Chicago, 1893.

N.M. Mathews, *Mary Cassatt,* New York, 1987.

G. Pollock, *Mary Cassatt,* London, 1980.

Quondam (C.M. Stevens), *The Adventures of Uncle Jeremiah and Family at the Great Fair: Their Observations and Triumphs,* Chicago, 1893.

C. Smith-Rosenberg, *Disorderly Conduct: Visions of Gender in Victorian America,* New York, 1985.

F.A. Sweet, *Miss Mary Cassatt, Impressionist from Pennsylvania,* Norman, Oklahoma, 1966.

A. Trachtenberg, *The Incorporation of America: Culture and Society in the Gilded Age,* New York, 1982.

Maj. B.C. Truman (ed.), *History of the World's Fair, being a Complete Description of the World's Columbian Exposition from its Inception,* Chicago, 1893.

S. Waller (ed.), *Women Artists in the Modern Era: A Documentary History,* London, 1991.

M. Weimann, *The Fair Women,* Chicago, 1981.

15

George Bellows's *Stag at Sharkey's*

Boxing, Violence, and Male Identity

Robert E. Haywood

In this provocative essay, Robert Haywood considers the boxing paintings of George Bellows in the context of American attitudes toward sports and masculinity in the early twentieth century. As a young artist in New York, Bellows resided first at the YMCA and later in close proximity to Sharkey's Athletic Club, institutions that provided vastly different experiences of male athletic activity. Based on Bellows's own experience and popular beliefs of the time, Haywood draws an important distinction between the illegal prizefight represented in this painting and pugilism as a legitimate sport practiced within the respectable environment of the YMCA, where participation in sports was thought to build character and strengthen the body.

Stag at Sharkey's *captures the illicit excitement of the prizefight from the standpoint of the spectator-voyeur who enters this decadent world in search of danger and excitement. Haywood understands boxing as a complex enactment of power and aggression, where the male body becomes a site encoded with signs of not only physical strength but also sexual potency. The evident fascination with the spectacle of violence captured by Bellows is connected both to conflicted notions of masculine identity at the turn of the century and to the homoerotic implications of boxing itself as a ritual of desire coupled with physical brutality.*

When George Bellows left Columbus, Ohio, in 1904 and began his education at the New York School of Art, he chose the Young Men's Christian Association on Broadway and West Fifty-Seventh as his new home. The twenty-two-year-old had pursued both arts and athletics in his hometown, and at the YMCA he could participate in sports during his free time. Bellows's parents approved of this housing—the YMCA was known for its clean and wholesome environment; it was an institution that linked exercise to morality and manliness.

During this era, one YMCA official posited that the correct use of sports could play a large role in a boy's character development. If young men were properly supervised, he believed, they would avoid frequenting gambling halls and pool rooms, and they would be less inclined toward using profanity and drinking alcohol.[1] The YMCA stressed that a healthy body housed a healthy mind, that a well-developed physique was evidence of alertness and strength.

For those desiring a firmer form, the YMCA offered facilities and instruction in physical improvement. Bellows satirized this physical fitness concern among white-collar men in a 1916

lithograph entitled *Business-Men's Class, YMCA,* which the artist described as "Brain workers taking their exercise".[2] *Shower Bath,* produced a year later, depicts nude men—some scrawny, the remainder corpulent—heartily pampering their bodies after a workout at the YMCA. These underdeveloped, effeminate men and their sagging, gluttonous counterparts are the soft types that even President Theodore Roosevelt disdained. Roosevelt was fully behind the YMCA's effort to shape up America, declaring that he did not like "to see young Christians with shoulders that slope like a champagne bottle."[3]

In 1906 Bellows moved from the YMCA into his first studio. Later he wrote about the location: "Before I married and became semi-respectable, I lived on Broadway opposite The Sharkey Athletic Club where it was possible under the law to become a 'member' and see the fights for a price."[4] Bellows painted *Stag at Sharkey's* in 1909 from the memory of a bout there.

At the packed, smoky club in the painting, some of the men around the jury-rigged ring move forward with excitement, others duck away, and more distant faces blur into the darkness. Wrapped around the ring's corner pole are two shouting men who, enthralled by the match, emerge out of the background toward the spotlighted ring as if to propel the fighters. The two fighters swell above the boxing ring and crush into each other with excruciating force. The strength of the boxers locking head to head is so insistent that the hefty referee's efforts to break their clinch seems futile.

Turning away from the fight and making eye contact with the viewer is a man gesturing toward the ring with a wave, directing us to the drama inside the ropes. Directly below the apex formed by the boxers, and pushed close to the ring by the crowd of men behind, a young boy peers up at the grueling fight. In contrast to the wild enthusiasm of the man who invites us in and some of the spectators, the boy, with half his face blocked by the ring, looks worried, reluctant, and innocent amid this ritual of manhood.

Manhattan venues such as the Sharkey Athletic Club provided a forum for boxing and its style of male camaraderie. The state strove to prevent matches at which admission was charged (page 587 of the 1900 edition of *Laws of the State of New York* records that prizefighting was illegal), but the law proved an insufficient obstruction for the fans and promoters.[5]

At Sharkey's, Bellows witnessed an institution entirely different from that of the YMCA. Comparing the Sharkey Athletic Club and the Young Men's Christian Association illustrates the conflicting attitudes toward sports and sports institutions prevalent in the early part of this century, attitudes that Bellows advances and satirizes in his work. The YMCA was upheld by middle-class society as moral, sanitary, and in harmony with social and individual improvement. Participating in the YMCA's sports program provided an active route for integration into respectable society, which valued a healthy and vital body. Viewed by these mainstream moralists, clubs like Sharkey's were often condemned as sordid spaces, where lowly men, many of whom were immigrants, engaged in dangerous, animal-like combat. Participating by attending a fight at Sharkey's offered the thrill of illicitness and revolt against authority and mainstream society. The YMCA was founded partly to teach young men how to be law-abiding citizens, while Sharkey's flourished helping prizefighting fans circumvent the law.

Stag at Sharkey's and Bellows's other major boxing painting of this period, *Both Members of This Club,* forcefully capture the tawdry underworld flavor that was associated with the "prizefighting clubs." In 1909 the state exerted control through raids and arrests, attempting to prevent a fight altogether. Soon prizefighting was not only legal again, it was also watched by a regulatory agency, the New York Boxing Commission. It was highly fashionable to attend the extrava-

gantly publicized Dempsey and Firpo match of 1924, while the fights staged just fifteen years earlier at Sharkey's lured unfashionable men into its dark, illicit space. Bellows's effectiveness in rendering this world is emphasized when we contrast *Stag at Sharkey's* with his 1924 painting, *Dempsey and Firpo,* commissioned for the *New York Evening Journal.*[6]

Unlike *Dempsey and Firpo,* with its controlled lines, solid forms, and slick surface—an inoffensive illustration suitable for a mass audience—*Stag at Sharkey's* has an energetic, variegated surface that reeks with public and private conflict. *Stag at Sharkey's,* therefore, is distinguished not only as a masterpiece of passion and anxiety, but also as one that reverberates with the public contentions about boxing prevalent during Bellows's lifetime.

Boxing has been controversial in America since it was first transplanted from England, sometime in the eighteenth century.[7] At the turn of the twentieth century, there was an unsuccessful attempt to clearly differentiate between boxing as a "pure" and gentlemanly sport and prizefighting, which was viewed as combat between corrupted, money-hungry barbarians. Theodore Roosevelt attempted to distinguish boxing as a healthy and manly sport while condemning prizefighting as "simply brutal and degrading" and debased by gamblers.[8] Roosevelt boxed for sport while at Harvard College, and he continued the practice in the White House until he suffered a serious blow to his left eye. While the president publicly criticized prizefighting, he evidently found the same male-to-male combat attractive and exciting when under the name of boxing.

From the gentlemanly point of view, boxing possessed dignity for the fighter and fans. In Thomas Eakins's 1898 painting *Salutat,* the fighter, Billy Smith, and the spectators are identifiable men.[9] The anonymous fighters and spectators packed around the ring in *Stag at Sharkey's* are not as tidy or noble; they are of an inferior order.

Bellows said in 1910 that "I am not interested in the morality of prize fighting. But let me say that the atmosphere around the fighters is a lot more immoral than the fighters themselves."[10] Bellows accents the illicit aura surrounding the fight. Behind and below the breathtaking physical strength of the fighters, whose bodies are illuminated by a bright light, is a murky, forbidding environment. Within the tightly packed room, the blood red burning on the fighters' faces is smeared onto some of the spectators.

Bellows's verbal critique of the ring's atmosphere suggests an artist on the outside looking into the drama of a fight. The artist, like the spectator, is a voyeur, utterly enthralled by the drama of a fight and the surrounding atmosphere, however demonic it may be. The action we witness in *Stag at Sharkey's* was illegal, which only adds to its attraction as highly charged entertainment, irrepressibly captivating. For Bellows, to paint *Stag at Sharkey's* was to engage in the thrill of the fight.

A 1909 essay entitled "In Defense of Pugilism," published in the popular monthly *American Magazine,* addressed boxing's unrestrainable appeal. The author observed that while laws and fashions may put boxing down, it continually reappears.[11] He then offered a challenge: "I would defy a Christian Science reader to see such a contest as I was privileged to see the other night and not feel a thrill in his heart." The author called pugilism "the manly art" and suggested that boxing was outside the realm of rationality. Boxing provided a release for natural primal desires, as well as lively evening entertainment after a prosaic day. Therefore, while boxing was perhaps deplorable, it was insuppressible. While a Christian may dutifully abide by certain restrictions, the author concludes that the thrill of a boxing match would force one to surrender all civilized restraint. Without sermonizing, Bellows is able to capture this dichotomy in *Stag at Sharkey's* and *Both Members of This Club.*

The boxer's power over his own body and his attempt to exert power over another body were seen in the early 1900s as natural masculine preoccupations. Because masculinity was so closely connected to physical form, there was great anxiety centered on and around the male body. Insufficient attention to bodily development was viewed as a symbol of weakness. Sports not only provided a remedy for weakness, but also required work and action, thus giving the well-developed body a function. The deep concern for male potency, and the perception of sports as a generator of virility and endurance, helped to reinforce and expand interest in boxing, whether at Sharkey's or the White House. Good fighters were glorified because they had to have courage and extraordinary stamina. They also served as models of the active and rugged male.

Boxing rings, such as the one in the Sharkey Athletic Club, were stages on which male bodies were displayed as objects for admiration. Bellows once wrote: "A fight, particularly under the night light, is of all sports the most classically picturesque. It is the only instance in everyday life where the nude figure is displayed."[12] The agile bodies on stage were admired for their muscular symmetry, order, tautness, and classical vigor.

When idealized by turn-of-the-century eyes, a boxer was a paradigm of well-developed form. Thomas Eakins, whom Bellows admired, found boxers excellent models for the study of anatomy and musculature. Unlike Bellows, Eakins did not paint fighters in action. Instead, as in *Salutat*, he shows a boxer after a fight, poised, celebrated, and ennobled. In *Taking the Count* of 1898 [1], one boxer with a well-defined anatomy is standing, while the other boxer is kneeling; neither is bitterly bruised or exhausted.

Eakins's interest in the body positions of boxers is explored in a series of photographs that he or one of his assistants made around 1883.[13] Several of these posed photographs show naked young men lounging in the grass while enjoying the informal play of two other men boxing. While the photographs were intended as experiments and studies in anatomy and motion, they are also studies in youthful homoeroticism (in this case staged), witnessed and documented by the photographer.

Boxing also provided Eadweard Muybridge with a ready activity for the "scientific" study of speed and motion.[14] In the late nineteenth century Muybridge conducted photographic investigations of motion at the University of Pennsylvania. Of the numerous plates in his *Animal Locomotion* series of 1887, several are dissections of boxing movements. But like Eakins's photographs, Muybridge's studies display a coy eroticism. Two near-naked men posture and punch, frame after frame after frame.

When considering Eakins's and Muybridge's scientific but gentle studies of boxers in motion and the dignity of the fighter in Eakins's *Salutat, Stag at Sharkey's* [2] by contrast is all the more striking in its portrayal of raw power. Bellows had studied ancient art, and the front fighter in *Stag at Sharkey's*, whose back swells in a dramatic curve, recalls the Graeco-Roman marble *The Belvedere Torso*. The fighter has the liveliness, massive strength, and mysterious anonymity of the torso. But unlike the sensual vigor of the marble's smooth surface, Bellows's slashing brushstrokes themselves are a violent act, magnifying boxing's anxiety and vehemence toward the perfected body. The brutal brushstrokes, combined with the fighters' extended limbs, exaggerate boxing as a muscular primal performance. The legs, ribs, backs, and arms of Bellows's fighters are stressed and stretched beyond the most violent moments of a boxing match. Their indistinct faces are a mass of flesh and blood. Bellows once said: "I am just painting two men trying to kill each other."[15] With *Stag at Sharkey's* he fulfilled his intent.

For the artist, as for the spectator, a boxing match was a theatrical performance of passion and horror. Boxers in action provided a grand

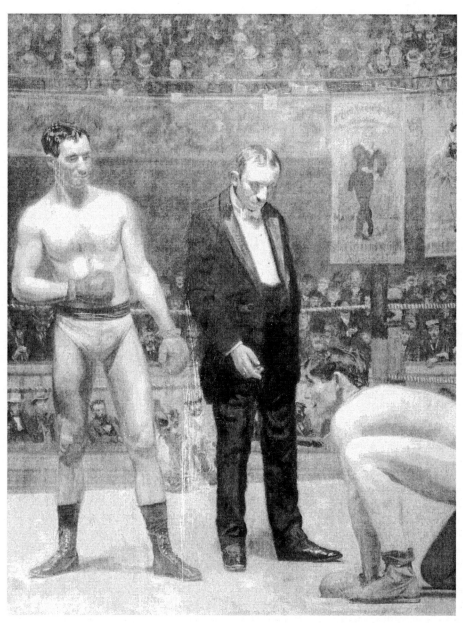

1. Thomas Eakins, *Taking the Count,* 1898; courtesy of Yale University Art Museum.

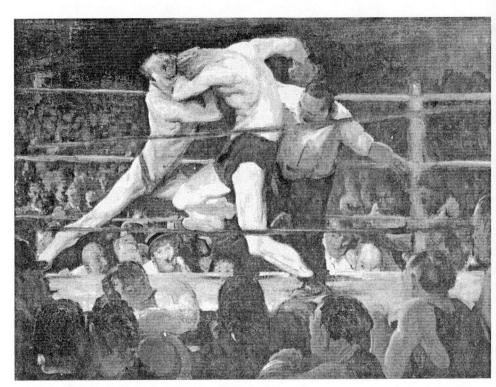

2. George Bellows, *Stag at Sharkey's,* 1909; courtesy of the Cleveland Museum of Art, Hinman B. Hurlbut Collection, 1133.1922.

drama, a work of art filled with pomp and ceremony, kinetic forms and colors, and emotional extravagance. Moreover, a boxing match was an event of extreme contrasts: brutality and spirituality, quiet control and riotous expression, heart-throbbing climax and cathartic release. Ramon Casas, a Spanish artist who visited the United States in 1909, was rhapsodic over boxing's aesthetic element: "Did you ever see anything more wonderful than the struggle of the two men, seen through the haze of gray smoke.... Then the fallen champion—the dying gladiator of the moment—a mass of crumpled muscles and limp

flesh which a moment before was vital with life at its utmost throb.... Oh, it was great dramatic, artistic magnifique!"[16]

If a fight was a work of art, it was one that required an engaged and active audience to make the performance a public drama. As seen in *Stag at Sharkey's,* the spectators seek fulfillment of the same desires being enacted in the ring. The elevated ring on which fighters perform raises them to a position of power that the spectators envy from below. But the spectators themselves are vicarious participants in the fight, encouraging a favored fighter and reacting to and with the

punches until the bout's end. Therefore, boxing, as a demonstration of male strength, belongs to the spectators as much as the fighters, who are their actors.

The struggle of two men encaged and on display magnified the tensions and private desires between men. Boxing functioned in a concrete way as an agent for maintaining and reinforcing an ideology of the dominant, virile male. The power issues at stake were self-generating (overpowering the opponent is the understood goal) and self-reinforcing (strength is rewarded, weakness punished). Within the boxing ring, general rules were outlined and the sentiments involved, although unarticulated, were predetermined. The possible outcomes were calculated and limited—a winner, a loser, a survivor, a death, a renewal of power, or a redefinition of it.

In order to succeed in the boxing system, a fighter had to have knowledge of the body's areas of strength and vulnerability. Certain areas of the body were marked as spots for abuse, while others were off-limits.[17] The marking off and focus on the body—the assignment or restriction of zones for touch and for legal punches—assume overtones of sexuality, particularly sadomasochism. In boxing, pleasure and power are derived from pain, from resistance to pain, or from stamina, which is often the ability to endure pain. For the spectator the boxing match is an acting out, a sadomasochistic fantasy made real. Not only, then, is the body subjected to the enactment and determination of power, but signs of desire and sexual fear are also coded on the boxer's body.

In *Stag at Sharkey's* the boxers' flesh is exposed, except for the barely dressed groin. In boxing, the groin is sacred. The boxing shorts serve as markers that highlight an area of both anxiety and pleasure. In Bellows's painting, the libidinal powers propelling the boxers are emphasized by the accent on this region. One boxer's knee points at his opponent's groin, which is marked by scanty green briefs. This fo-

cus recapitulates the issue at stake: the one who is defeated becomes the castrated male. He is passive and powerless. The loser is symbolically emasculated—the winner pulverizes his head, there is a public declaration of loss, and he is pronounced the defeated.

The implications of the defeat are depicted in Bellows's lithographs *A Knock Out* and *Counted Out*. In each, the prizefighter, overpowered by his opponent, collapses in defeat after giving it his all; his face is covered in shame and pain. In *A Knock Out* the victor is standing with his face exposed as he looks down on the battered man.

Not all of boxing is forceful or violent. There are moments of pause and rest when two boxers, exhausted or seeking protection, lean on and embrace each other in support.[18] In boxing, these moments of touch and intimacy are countered by regained energy and more powerful blows.

For the boxer and the boxing fan, the obsession with violence and with the success of violent acts engages the symbol of the supreme, potent male. But boxing represents a commingling of desires, a deliberate confusion of brutality and sexuality in which the former hides the latter. The paradox of boxing is that while the whole environment centers around anxiety of masculine adequacy and demonstration of male potency, the homoeroticism that boxing attempts to escape is inescapably built into the action. Men are in combat *and* contact. Men also pose, posture, and punch for the pleasure and thrill of other men. However, in boxing, as *Stag at Sharkey's* poignantly insists, admiration and affection never stand alone.

Boxing is a ritual act whose ultimate purpose is the display of desire and then desire's destruction. From this perspective, boxing is homoerotic desire displaced, enacted, and re-repressed.[19] Moments of intimacy between men are obstructed and destroyed by the relentless drive to "punish" and damage the body. Two well-developed men

alternate courting and whipping each other. Boxing, as exposed and powerfully accentuated as it is in *Stag at Sharkey's*, is male to male masochistic foreplay, craved and detested, on public display.

The force of *Stag at Sharkey's* lies not only in the artist's rigorous and remarkable manipulation of paint and his magnification of boxing's eroticism and brutality, but also in Bellows's treatment of an athletic event that struggled to maintain itself despite its illegal status. The de-

sire for fighting events, which served a ritual function, was greater than the strength of the law. In the early part of the twentieth century, boxing provided many men with a forum for understanding and reinforcing a conception of masculinity that was constructed out of conflicting methods and desires: individual authority and control were gained by resisting public authority, sensuality and intimacy were intertwined with violence, and physical perfection and admiration were countered by destruction.

NOTES

Revised by the author from *Smithsonian Studies in American Art* (Spring 1988). Reprinted by permission of the author and the National Museum of American Art.

A version of this essay was first presented at the Tenth Annual Whitney Symposium on American Art in April 1987. For their comments on the original essay, I wish to thank Diane Kirkpatrick, Janice Simon, Richard Rand, and Thomas Crow. The essay is reprinted here with only slight modification.

For background information on George Bellows, see: Charles H. Morgan, *George Bellows: Painter of America* (New York: Reynal & Co., 1965); Donald Braider, *George Bellows and the Ashcan School of Painting* (New York: Doubleday & Co., 1971); E. A. Carmean, John Wilmerding, Linda Ayers, and Deborah Chotner, *Bellows: The Boxing Pictures* (Washington, D.C.: National Gallery of Art, 1982); and Lauris Mason, *The Lithographs of George Bellows* (New York: KTO Press, 1977).

Since the publication of this essay on masculinity and boxing at the turn of the century, numerous studies on the topic have appeared; particularly relevant books include: Gail Bederman, *Manliness and Civilization: A Cultural History of Gender and Race in the United States, 1880–1917* (Chicago: University of Chicago Press, 1995) and Michael Kimmel, *Manhood in America: A Cultural History* (New York: The Free Press, 1996). For the most recent book on George Bellows's art see Marianne Doezema, *George Bellows and Urban America* (New Haven: Yale University Press, 1992). Of the numerous studies on Thomas

Eakins, a notable essay related to my analysis of Eakins's photographs is by Whitney Davis, "Erotic Revision in Thomas Eakins's Narratives of Male Nudity," *Art History*, vol. 17, September 1994, pp. 301–41.

1. See Donald J. Mrozek, *Sport and American Mentality: 1880–1910* (Knoxville: University of Tennessee Press, 1983), p. 207.

2. Quoted in Mason, *Lithographs*, p. 61.

3. Theodore Roosevelt, *Theodore Roosevelt—An Autobiography* (New York: Macmillan Co., 1913), p. 49.

4. Letter from Bellows dated 10 June 1922 to William Milliken, then director of the Cleveland Museum of Art. Now in the archives of the Cleveland Museum of Art.

5. See "Boxing Flourishing Here," *New York Times*, 16 November 1905, p. 12.

6. For an account of the Dempsey and Firpo fight, see Jack Dempsey, *Dempsey* (New York: Harper & Row, 1977).

7. For an excellent study of boxing in America in the late eighteenth and nineteenth century, see Elliot J. Gorn, *The Manly Art: Bare-Knuckle Prize Fighting in America* (Ithaca: Cornell University Press, 1986).

8. The positive nature of boxing, as distinguished from prizefighting, and the paradox of such a distinction, was stated in a *New York Times* editorial of 7 April 1909 entitled "Prizefighting Not Easy to Suppress." On this day, prizefighting was called "unquestionably a great evil"—the evil element being money.

Roosevelt said in 1890 that "The prize fighters [are] . . . the very worst foes with whom the cause of general athletic development has to contend." Quoted in Gorn, *Manly Art,* p. 196. As president, however, Roosevelt invited former champion John L. Sullivan, one of the rowdiest of fighters, to the White House. See Roy R. Dibble, *John L. Sullivan* (Boston: Little, Brown & Co., 1925), pp. 176–79.

9. See Gordon Hendricks, *The Life and Work of Thomas Eakins* (New York: Grossman Publishers, 1974), p. 236).

10. Quoted in Carmean et al., *Boxing Pictures,* p. 51.

11. "In Defense of Pugilism," *American Magazine,* August 1909, pp. 414–16.

12. Letter dated 10 June 1922 in the archives of the Cleveland Museum of Art.

13. Ellen Handy pointed out to me that photograph, often attributed to Eakins directly, is actually a "copy of a copy of the original print" by Eakins or one of his assistants.

14. See Eadweard Muybridge, *Animal Locomotion* (New York: Dover Publications, 1979).

15. Quoted in Carmean et al., *Boxing Pictures,* p. 30.

16. "As a Spanish Artist Sees Us: Ramon Casas Is Impressed by the Prizefight," *Sun* (New York), 11 April 1909. I am grateful to Carmen Lord for sharing this article with me.

17. Michel Foucault's writings have informed my discussion of the body as a subject of power. See Michel Foucault, "The Subject and Power," *Art After Modernism: Rethinking Representation,* ed. Brian Wallis (New York: New Museum of Contemporary Art, 1984), p. 417. See especially Michel Foucault, *Discipline and Punish: The Birth of the Prison* (New York: Vintage Books, 1979).

18. For observations on boxing's mix of affection and violence in recent times, see Joyce Carol Oates, "Kid Dynamite," *Life* (March 1987): 66.

19. In raising the issue of boxing and the homoerotic, beyond any reference to a specific biography, my aim is to show how boxing complicates and temporarily undermines any stable heterosexist structure of an encounter between men. Yet, in the end, boxing only reinforces and deepens the dominant model of masculinity.

For various views of boxing that are, at least in part, in opposition to my own, see the following (note that these writings are mostly about professional boxing): Arthur Krystal, "Ifs, Ands, Butts: The Literary Sensibility at Ringside," *Harper's* (June 1987): 63–67; Joyce Carol Oates, *On Boxing* (New York: Dolphin/Doubleday, 1987); Ronald Levao, "Reading the Fights: Making Sense of Professional Boxing," *Raritan* (Spring 1986): 59–76.

For Arthur Krystal "a fight is a fight," not "an aesthetic enactment, erotic dance, savage ceremony, or chess match." Ronald Levao concludes that boxing is most truly "highly skilled and highly dangerous, a keenly focused public exhibition of human will and intelligence translated into articulate energy." Like a number of other scholars, I am reading this "articulate energy" as partly erotic in nature. For example, see Gorn, *Manly Art,* p. 142. For essays on sexuality, gender, and sports, see Ross Runfola and Donald F. Sabo, Jr., eds., *Jock: Sports and Male Identity* (Englewood Cliffs, N.J.: Prentice-Hall, 1980).

16

Who Will Paint New York?

The World's New Art Center and the
New York Paintings of Georgia O'Keeffe

ANNA C. CHAVE

To Europeans visiting America in the early decades of the twentieth century, New York was the undisputed center of modernity and the skyscraper its most telling emblem. Although these architectural wonders formed the very core of the city's identity, they were regarded as elusive candidates for artistic representation, especially in the medium of painting. American artists who relied on the conventions of European modernism to capture the spirit and energy of the city had not done it justice as a physical presence and national icon. As Anna Chave points out, the task fell to Georgia O'Keeffe, an artist prized for her independence from these foreign influences, to capture the overwhelming power and visual splendor of the city's architecture.

According to Chave, O'Keeffe's attainment also derived from her personal circumstances, as she was the first artist to actually reside in a skyscraper and thus experience with regularity the unique aspects of life atop an urban mountain. Her views of buildings such as the Shelton Hotel, with uncomplicated silhouettes that accentuate their sturdy form and imposing height, possess a clarity and directness that underscored the city's iconic status. Long before abstract expressionism was hailed as the quintessential expression of modern urban angst, and therefore credited with reorienting the sphere of cultural influence from Paris to New York, Georgia O'Keeffe's paintings of New York skyscrapers *fashioned a compelling image of the American city thought to embody the very essence of urban modernity.*

Standard histories of modern art tell how New York became the world's new art center after World War II through the ascendance of the New York School spearheaded by Jackson Pollock. Where United States artists had historically journeyed to Europe for cultural nourishment and to associate or train with renowned artists, Pollock declined to make the trip. It followed not merely from that, but from the startling way he made paintings, that Pollock's art lent itself as a fulcrum for the shift of the world's modern art center from Paris to New York City. And, though he produced his famed, poured paintings not in the metropolis itself but in a distant Long Island barn, Pollock's art would still be called "an attempt to cope with urban life; [for] it dwells entirely in the lonely jungle of immediate sensations, impulses and notions."[1]

Pollock was not the first U.S. artist to refuse on principle a European sojourn: Georgia O'Keeffe

preceded him. What kept her contented painting in her native land were above all the enthralling landscapes of the Southwest; but in the 1920s she had been entranced also by New York. She believed that her images of the city included "probably my best paintings," and had even dared to hope that they would "turn the world over."[2] That ambition notwithstanding, O'Keeffe's art has generally been diminished, if not disqualified altogether from inclusion in the customary, Eurocentric narratives of modern art. In the present essay, my aim is to argue for the unmatched effectiveness of O'Keeffe's paintings of New York City in light of the immense importance attached to the task of painting the city in her day, and, more importantly, to challenge the received view that the city she rendered was a backwater. As I will demonstrate, by many established measures, New York was already the world's new art center at the time O'Keeffe pictured it.

European artists began turning the tide of travel, from the "Old World" to the New, not after World War II, but during World War I. "For the First Time Europe Seeks Inspiration at Our Shores in the Persons of a Group of Modernist French Artists, Who Find Europe Impossible Because of Its War-Drenched Atmosphere—Macmonnies Predicts that the Effect of this Migration will be Far-Reaching on Art of America and the Older Continent" read a prolix headline in the *New York Tribune* in October 1915. The French artists in question concurred that New York was "destined to become the artistic centre of the world," and not only because of the war. Albert Gleizes averred that New York's skyscrapers were "works of art . . . which equal the most admired old world creations," and that "The genius who built the Brooklyn Bridge is to be classed alongside the genius who built Notre Dame de Paris." Francis Picabia argued that, "Since machinery is the soul of the modern world, and since the genius of machinery attains its highest expression in America, why is it not reasonable

to believe that in America the art of the future will flower most brilliantly?" Independently, Marcel Duchamp complained: "If only America would realize that the art of Europe is finished—dead—and that America is the country of the art of the future, instead of trying to base everything she does on European traditions! And yet in spite of it, try as she will, she gets beyond these traditions even in dimension alone," he continued, alluding to the city's great skyscrapers.[3]

Though these Parisian avant-gardists had sought New York out as a remote haven during wartime, they found that they had landed not at the peripheries of modern culture, as they anticipated, but at something like its very hub. "The Great War . . . hastened what prophets regarded as inevitable," Frederick James Gregg announced in *Vanity Fair* in January of 1915; "New York is now, for the time being at least, the art capital of the world." This momentous declaration—that New York had become "The World's New Art Centre"—was hardly to be the last of its kind: Henry McBride made the same claim in the late 1920s; Clement Greenberg in 1948. Yet only Greenberg's declaration, that "the main premises of Western art have at last migrated to the United States, along with the center of gravity of industrial production and political power," would lodge in the standard narratives of modern art. The pivotal shifts in power to which Greenberg referred occurred not after the second World War, however, but following World War I when New York replaced London as the financial capital of the world, while the United States as a whole became the leading economic power in the world.[4]

The United States' newfound affluence was manifest most visibly in a construction boom, with extensive building being necessary to accommodate the flow of people from rural areas to the city. In the 1920s the population of urban America grew by 27 percent as the nation became for the first time predominantly urban. New York "got a brand new skyline" in this pe-

riod with the area around Grand Central Station, in particular, almost totally transformed by the tall buildings that increasingly were greeted as the avatar of a new era. The U.S. architectural theorist Claude Bragdon observed in 1925:

> Eminent European critics, visiting these shores, are in the habit of declaring that the American Spirit expresses itself most eloquently in jazz music and in the skyscraper. . . . Not only is the skyscraper a symbol of the American Spirit—restless, centrifugal, perilously poised—but it is the only truly original development in the field of architecture to which we can lay unchallenged claim.[5]

Bragdon made these observations in an essay on the newly completed Shelton Hotel, then the most celebrated feature of that new skyline near Grand Central. As it happened, he lived in an apartment in the Shelton close to that of O'Keeffe and her husband, Alfred Stieglitz. And it was precisely this manifestation of the "American Spirit"—the Shelton Hotel [1] and other new skyscrapers from the same burgeoning Manhattan neighborhood—that O'Keeffe would capture in an extraordinary series of urban landscapes realized between 1925 and 1930. Evincing a forthright pragmatism unashamedly overtaken by a visionary romanticism, O'Keeffe's skyscraper paintings glorified that astonishing phenomenon that—as the first artifact of U.S. culture to attract sustained international attention—had unexpectedly succeeded in conferring on New York City a unique, global profile.

"Paris is no longer the capital of Cosmopolis . . . New York . . . has become the battleground of modern civilization," declared McBride in 1929; and U.S. artists who persisted in going abroad to work were "jeopardizing their careers for the dubious consommations [sic] of the Cafe de la Rotunde."[6] McBride's counsel was wasted on O'Keeffe, who spurned the European capitals until her old age. But others balked at such advice even when it hailed from Paris itself. In a letter from Paris in 1921, a puzzled Charles Demuth noted the French avant-garde's inexplicable interest in events in New York City: "Sometimes it seems impossible to come back,—we are so out of it," he lamented. "Then one sees Marcel [Duchamp] or Gleizes and they will say,—'Oh! Paris. New York is the place,—there are the modern ideas,—Europe is finished." For Demuth and other U.S. artists, however, the daunting problem was that "Our art is, as yet, outside of our art world," as Robert J. Coady put it in 1917, citing the skyscraper, the steam shovel, and Charlie Chaplin, among other examples. In Duchamp's view, this was no obstacle: "New York itself is a work of art, a complete work of art," he proclaimed in 1915; and he blithely proposed to designate Cass Gilbert's Woolworth tower, the architectural sensation of the day, as one of his "ready-mades." Duchamp saw no reason to use an antiquated medium such as painting to represent New York; but photography was another matter: "I would like to see it make people despise painting until something else will make photography unbearable," he confided to Stieglitz in 1922. For that matter, New York proved from the outset a less tractable subject for painters (not to mention sculptors) than for photographers such as Stieglitz or Berenice Abbott.[7] But since painting was historically the authoritative medium, Coady assumed that an authoritative image of New York would have to be a painted image.

"Who will paint New York? Who?" Coady beseeched in the first issue of *Soil* magazine, published in 1916. His cry was echoed by others. Exclaimed Henry Tyrrell in the *New York World* in 1923:

> New York, grandiose and glittering—the modern Wonder City of dynamic pulses, wireless, magnetism, electricity and tempered steel, of piled-up architecture like magic pinnacles of Alpine ice . . . and far underneath the throbbing arteries of subway and tunnel—New York, epitome of the living world, civilization's latest child, the

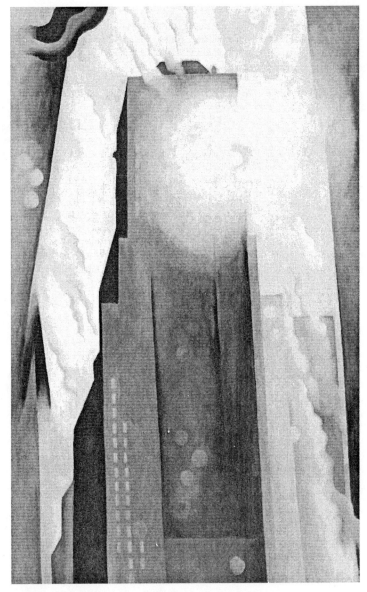

1. Georgia O'Keeffe, *The Shelton with Sunspots,* 1926; courtesy of The Art
Institute of Chicago, Gift of Leigh B. Block, 1985.206. Photograph © 1997, The
Art Institute of Chicago. All rights reserved.

heir of all the ages, in the foremost rank of time
. . . There she stands, matchless and overwhelm-
ing. Who shall paint her portrait? This to modern
art is the flaming cynosure, this to modern artists
the task that beckons with the fatalistic fascina-
tion of the unattainable.[8]

Attempts at painting the city made by artists like
Abraham Walkowitz and Joseph Stella did not
solve the problem, as Coady and Tyrrell saw it,
for these artists pictured New York not as dis-
tinct, but more or less as Fernand Léger and
Robert Delaunay had pictured Paris: in the im-
ported vernacular of Cubism.

That New York was intrinsically "the Cubist
city" had been decreed by Picabia upon his ar-
rival there. Fresh from Paris, he claimed that he
saw "much, much more" in New York "than you
who are used to see[ing] it" and that he could
show U.S. artists how to portray New York ef-
fectively, namely with an idiom then current in
Paris. By its fractured, mosaicized aspect, Cub-
ism stressed the disjunctiveness of lives lived at
quickening tempos in Europe's ever more
crowded capitals, where artifacts of new regimes
surfaced abruptly amid the pervasive artifacts of
a pretechnological order. But to paint New York,
where the new was fairly continuous with the old
(which was not so old in any case) and where the
new looked newer than anywhere else, posed a
different problem. To solve this problem seemed
to spell a solution to the greatest of all problems
for U.S. artists, moreover: that of devising an in-
digenous mode of expression, a new art for the
New World.[9]

Cubism undertook "the task of [the] revalua-
tion of old values in Art and . . . perform[ed] it
with violence," Naum Gabo once remarked. Cub-
ist paintings are "like a heap of shards from a
vessel exploded from within." The Futurists
seized on Cubism's violence from the first,
stressing that artists had to destroy the preexist-
ing visual order to recover space for their own vi-
sions. Making room for new structures by demol-

ishing old ones was a radical proposition to the
Italians and the French, but it was a routine prac-
tise in a U.S. city such as New York. While Euro-
pean artists had liberating dreams of a tabula
rasa, the specter of a cultural void was a terrify-
ing because all too real prospect to their U.S.
counterparts: what history they had was second-
hand—rootless, eclectic, and reimagined—and
that was the kind of history they often endeav-
ored not to eradicate, but to recuperate and inte-
grate into their work. In scavenging remnants of
European culture, Americans acted to piece to-
gether their own self-image as former colonials.
The skyscraper Duchamp proposed to designate a
ready-made, for example—the Woolworth build-
ing—is an ornate, ersatz, Neo-Gothic cathedral
commissioned by a dimestore magnate.[10]

"Look at the sky-scrapers!" Duchamp ex-
horted. "Has Europe anything to show more
beautiful than these?" However Europeanized
the Woolworth building was—and Duchamp re-
gretted that aspect of its architecture—no one
could imagine such an illimitable structure in
Europe. Both because and in spite of its histori-
cal veneer, then, the skyscraper appeared at once
distinctly American and modern—a persuasive
answer to that pressing question: "What will the
building of the twentieth century look like?" The
U.S. critic Charles Downing Lay observed in
1923, "Like all great art [New York's architec-
ture] has grown from the conditions of our life
. . . as an expression of our composite genius,"
while singling out the Shelton Hotel for his
praise. But those huge, ornamented, masonry
structures, such as the Woolworth building and
the Shelton, which were seen as exemplary by
critics in their day, were later generally down-
played by historians in favor of those (less repre-
sentative) buildings that can be seen as forecast-
ing the sleek, modernist vision of the
International Style. By the early 1920s, Euro-
pean architects such as Ludwig Mies van der
Rohe were applying Bauhaus principles to
skyscraper design, picturing an ideal tower—a

geometric volume, cleansed of ornament and historical referents—made possible by new building technologies. There was no call in Europe for such structures, however, so these architects looked hopefully instead to the U.S. for opportunities to realize their visions, perceiving it as a country that had "escaped Europe and its history willfully, in order to create a new universe and to initiate a new time," as Thomas van Leeuwen expresses it: "America was free, it was unlimited in space, it abounded in natural resources and in money. It knew no tradition, it had no history."[11]

From this perspective, the fact that U.S. architects and artists persisted in following the precepts of tradition was baffling and even unforgivable; and many Europeans became convinced that they had a clearer vision of the new art and architecture that belonged in the New World than those who lived there. "The American character contains the elements of an extraordinary art," because American life is "abstract," "scientific" and "cold" like the twentieth century itself, Duchamp reasoned in 1915; but "the traditions weigh too heavily upon you, turn you into a sort of religious fanatics [sic] as little yourselves as possible." For Duchamp as for Mies, the advent of the skyscraper signalled "the call of utility."[12] Americans, however, saw their "cathedrals of commerce" not only as models of efficiency but also as magic mountains of steel and stone, signifying at once their material and their spiritual ambitions. While some of Mies' pristine towers were eventually built in the United States, they would never capture the public imagination as did those towers that evoked great historical and natural monuments; instead, they would inspire antipathy.

"The major formal and theoretical changes in skyscraper design began in the early 1920s with the work of Ferriss, Goodhue, Hood, and others," Carol Willis has argued. "The characteristics of this new aesthetic were an emphasis on formal values of mass and silhouette with a sub-

ordination of ornament."[13] The identifiable buildings painted by O'Keeffe all dated from this period and were all located in the city's second great outcropping of skyscrapers. Ignoring the areas of New York rendered by artists before her—the tall buildings packed along the narrow lanes of the Wall Street area, which Joseph Pennell had etched, and the low-rise, bohemian district of Greenwich Village depicted by John Sloan, for instance—O'Keeffe made her own the stately skyscrapers rising along the broad avenues of her midtown neighborhood. This area boasted fashionable shops, galleries, offices (including the celebrated Radiator Building, designed by Raymond Hood) and, her preferred subject, upscale residential hotels—the Shelton, the Berkley, and the Ritz Tower. With these buildings as her subjects, O'Keeffe contrived her own, ravishing vision of New York as a city awash in sunlight, moonglow, or the dazzling aura of an artificial firmament.

It is difficult now, except in O'Keeffe's pictures of it, to see the appeal of the Shelton Hotel—her favorite architectural motif—which exemplifies a vital turning point in skyscraper design. But to critics of the day this mammoth, austere structure was a revelation; it was "not a tower on a building, but it is itself a tower and . . . a really thrilling example of vertical movement in composition . . . No one, I believe, can look on the Shelton from near or far without some lifting of the spirit."[14] The hotel O'Keeffe chose to live in was the center of interest in architectural circles for technical reasons as well. As one of the first major buildings to make effective use of the setback mode necessitated by a 1916 zoning law (enacted to ensure that tall buildings not prevent sunlight from reaching the streets), the Shelton proved highly influential. Hugh Ferriss had executed a series of studies of architectural solutions to the law's stipulations, and, in designing the Shelton, Arthur Loomis Harmon followed his basic dictum that the setbacks be boldly articulated in architectural form,

not camouflaged by ornamentation. Ferriss' own renderings of the Shelton shared with O'Keeffe's an emphasis on its stepped, massive, zigguratlike silhouette. Historically, the ziggurat was a "cosmic mountain," a symbolic image of the cosmos, and both artists rendered the atmosphere enveloping the building in dramatic ways, suggesting cosmic overtones.

To Ferriss, there was in the Shelton "something reminiscent of the mountain. Many people choose it as a residence, or frequent its upper terraces, because . . . it evokes that undefinable sense of satisfaction which man ever finds on the slope of the pyramid or the mountainside." O'Keeffe and Stieglitz regarded their lofty quarters as just such a refuge. Stieglitz wrote to his friend Sherwood Anderson:

> New York is madder than ever . . . But Georgia and I somehow don't seem to be of New York—nor of anywhere. We live high up in the Shelton Hotel . . . We feel as if we were out at mid-ocean—All is so quiet except the wind—& the trembling shaking hulk of steel in which we live—It's a wonderful place.[15]

O'Keeffe's vision of the Shelton stressed its natural aspect, making of it an architectural mountain faced by a sheer cliff. To her, the experience of the skyscraper was one of sublimity, and by omitting human figures within her images, she helped adduce an unmediated access to that experience, picturing a New York viewed from too elevated a position or with the head tilted too far back to admit the presence of others.

When asked about his interest in the vaunted architectural traditions of the Ecole des Beaux-Arts, Ferriss replied that he preferred "to seek the masses of the Grand Canyon and the peaks and spaces of southern California for inspiration rather than the past of Europe" because, "they are more truly American." The perceived Americanness and naturalness of O'Keeffe's vision was likewise a factor in the reception of her work. "O'Keeffe is America's. Its own exclusive product," Frances O'Brien boasted in the *Nation* in 1927. "It is refreshing to realize that she has never been to Europe. More refreshing still that she has no ambition to go there . . . In her painting as in herself is the scattered soul of America come into kingdom." What was so American about O'Keeffe's art was not only that she painted, and painted in, a skyscraper, but also that she painted with clarity and directness. Appreciative critics saw her as refusing the abstruse and dissembling ways of the continent for a mode of visualisation founded squarely on perception and resemblance. In 1927 McBride praised one of her aerial views of New York as "a sufficiently literal rendering of one of the most amazing scenes on earth . . . The mere facts are overpowering without any mysticism."[16]

McBride also perceptively praised O'Keeffe for painting the skyscrapers "as though their largeness was their main attraction—as it probably is." Forgoing the splintering effects of Cubism, O'Keeffe pictured the midtown towers as virtually whole, sometimes isolated icons of modernity, perceived from the unobstructed viewpoints the New York of her day more often afforded. Constructing her portraits of skyscrapers with a few bold, vertical shapes (sometimes punctuated by rows of minuscule windows), arranged on narrow, vertical canvases, O'Keeffe formulated a vision of the tall building complementing the architects' own. Louis Sullivan identified "the dominant characteristic of the tall office building" as "its tallness: the force of altitude must be in it. Let it be therefore 'a proud and soaring thing, without a dissenting line from bottom to top.'" O'Keeffe's acute sense of the skyscraper's height was undoubtedly enhanced by her living and working in one, as she was the first artist—and among the first people ever—to reside in a skyscraper. She was able to find an apartment atop a tall building in 1925, whereas Duchamp had failed in his efforts to do so a decade earlier, because the building codes had changed in the interim, allowing not only office

buildings but also residential hotels (though not, as yet, apartment houses) to take the form of towers.[17]

For O'Keeffe, the prospect of living in a skyscraper prompted the idea of painting New York:

> when I was looking for a place to live, I decided to try the Shelton. I was shown two rooms on the 30th floor. I had never lived up so high before and was so excited that I began talking about trying to paint New York. Of course, I was told that it was an impossible idea—even the men hadn't done too well with it.

New York was regarded as a man's subject, no doubt, because of the skyscrapers' priapic form, because rendering the city meant taking the kind of commanding perspective that men alone were ordinarily socialized to assume, and because men controlled the civic space.[18] O'Keeffe knew well, for that matter, that New York was Stieglitz's milieu more than her own. (In her picture of the Radiator Building she whimsically inscribed "AL-FRED STIEGLITZ" in a big, illuminated, red sign atop an adjacent building.) But moving to the Shelton eased that feeling for a time, as she became attuned to the city's poetry and discovered ways of visualizing it. Numerous of her New York pictures offer relatively intimate or circumscribed views, calling attention to the spaces between and around at most a few buildings, stressing the distinctive urban canyons or voids as much as the towers' solid forms. "I saw a sky shape near the Chatham Hotel where buildings were going up," O'Keeffe recalled. "It was the buildings that made this fine shape, so I sketched it and then painted it. This was in the early twenties and was my first New York painting."[19]

To work and live atop a skyscraper was to realize a peculiarly modern and American vision of success and emancipation—one not commonly identified with professional women; but once she started realizing some income from her art, O'Keeffe's ideal urban home became a corner suite (without a kitchen) on an upper floor of a stylish residential hotel initially designed for bachelors. "Miss O'Keeffe lives there [at the Shelton]—by choice," McBride assured his readers in 1928. "It has long lines, long surfaces—it has everything. At night it looks as though it reached to the stars, and the searchlights that cut across the sky back of it do appear to carry messages to other worlds."[20]

"I realize it's unusual for an artist to work way up near the roof of a big hotel in the heart of the roaring city," O'Keeffe admitted in 1928, "but I think that's just what the artist of today needs for stimulus. He has to have a place where he can behold the city as a unit before his eyes." Gazing East from the Shelton in the late mornings or through the late afternoon haze, O'Keeffe could render one of those spectacular, urban vistas—over the river and the industrial districts of Queens—which constitute a uniquely modern vantage. Looking North from her corner aerie in the evening, she could capture the whimsical pagoda-roofed tower of the nearby Beckley Hotel and the bright stream of headlights coursing down Lexington Avenue into the red, stoplight and neon-lit well at the base of her building. More impressive still were her awesome views of the towers seen from street level, especially the Shelton illuminated by the sun and the moon; the black and silvery Radiator Building lit up like a colossal Christmas tree; as well as some anonymous structures. In a subtly abstracted way, O'Keeffe limned the flat, continuous shapes the tall buildings carved into the sky. In her nocturnal views of the Radiator Building [2] and the Beckley Hotel, she captured the fantastic ornamentation of the buildings' crowns and the complex patterns created by the extravagant displays of artificial light from within and without, thus evoking New York's spellbinding theatre both in its epic and in its vaudevillian aspects. "Her summation of Manhattan, unequalled in painting, has the rude thrust as well as the delicacy and glitter

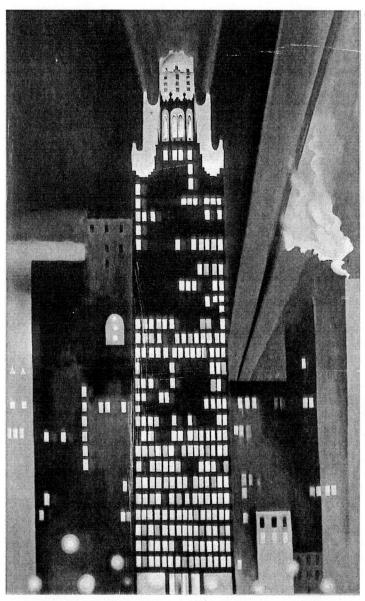

2. Georgia O'Keeffe, *Radiator Building, Night, New York,* 1927; courtesy of
Fisk University, Van Vechten Art Gallery, Nashville, Tenn.

that distinguishes the city of America," judged Herbert Seligmann.[21]

O'Keeffe produced more than twenty New York scenes between 1925 and 1930, and while her own recollections do not comprise a seamless account of the course of events, she evidently painted her first city picture—*New York at Night with Moon*—early in 1925, when she lived in an apartment at 35 East 58th Street. Probably in March of 1925 (not the fall as she recalled), she urged Stieglitz to exhibit the picture in a group show he was organizing at the Anderson Galleries, but, anxious about premiering her outsized flower paintings at the same show, he refused. Her city paintings had their debut instead in her solo show in February and March 1926. *New York at Night with Moon* was the first painting to sell, by her account, on the day the show opened. "No one ever objected to my painting New York after that," she wryly recalled.[22] Nine New York paintings would lead off the list for O'Keeffe's 1926 exhibition, which the *New Yorker* hailed as a "marvelous show of a genius which it would be foolish to miss." Six New York pictures topped the list of works at her annual show in 1927, and three city paintings headed the list the following year.[23]

O'Keeffe's New York paintings drew some special mention in the press. But a number of her regular supporters—Paul Rosenfeld, Waldo Frank, Paul Strand, and Lewis Mumford, who had been attracted by the organic quality of her art—disapproved of the skyscraper, complaining of its dehumanizing effects. What influenced O'Keeffe to quit painting New York around 1930, however, was probably less the disinterest of those critics in her city pictures than the fact that the newfound spirit of U.S. cultural pride that so permeated her urban vision collapsed in October 1929 with the stock market crash. (It was perhaps a factor too that Stieglitz resumed photographing the city at this time, capturing the view west and north from the Shelton of the construction of Rockefeller Center, since O'Keeffe disliked sharing subjects with him.)

What may be O'Keeffe's last painting of New York, executed in the 1940s, was a rather dry and rigid image of the Brooklyn Bridge. Another late painting of the city was a failed but telling experiment: a triptych showing a panorama of Manhattan rendered in a Cubist syntax and dotted with her trademark flowers.[24] O'Keeffe contrived this awkward work for an invitational exhibition of mural proposals by U.S. artists. Organized by the Museum of Modern Art in 1932, the show was meant to convince the designers of Radio City Music Hall that they should not look exclusively abroad for talent to decorate the building. The show's premise and the Eurocentric bias of the Museum of Modern Art must have influenced O'Keeffe in an exceptional (or unique?) attempt to demonstrate her command of the dominant modernist language. Her shrewd entry to the exhibition brought the desired outcome, a chance to decorate the women's powder room at Radio City, but Stieglitz interfered, and O'Keeffe withdrew from the project.[25]

Stieglitz was ambivalent about publicizing O'Keeffe's work within the United States, and he declined to promote her art abroad: "I have been asked to let this work go to Europe," he remarked of the show in which the city paintings premiered. "But they do not take the Woolworth Tower to Europe. And this work here is as American as the Woolworth Tower." European vanguardists might not have recognized in O'Keeffe's pictures their image of the New World's new art or architecture, in any case, for they generally perceived as truly modern only that art which conformed to their own visions of the new visual order. They widely intimated that Americans did not yet know themselves—at least not as well as the Europeans knew them. "When the Americans have traveled sufficiently across the old world to perceive their own richness, they will be able to see their own country

for what it is," said a paternalistic Henri Matisse in 1930. While Matisse regarded Americans as cultural "primitives," no paintings come as close as O'Keeffe's *Radiator Building, City Night* or *Shelton with Sunspots* to capturing the exhilarating effect of the skyscraper city as he himself described it (while comparing New York favorably both to Paris and to the Swiss Alps): "The first time that I saw America, I mean New York, at seven o'clock in the evening, this gold and black block in the night, reflected in the water, I was in complete ecstasy . . . New York seemed to me like a gold nugget." Strolling down the "grand avenues" of the midtown area that O'Keeffe had painted, Matisse was "truly electrified" to discover that the skyscrapers created "a feeling of lightness . . . [and] of liberty through the possession of a larger space."[26]

The same New York that inspired both O'Keeffe and Matisse equally inspired the leading sculptor of the Paris avant-garde. An awed Constantin Brancusi discovered in New York in 1926 "a great new poetry seeking its peculiar expression. In architecture you have found it already in the great skyscrapers. We in Europe are far behind you in this field." Faced with O'Keeffe's paintings of the city on a visit to Stieglitz's gallery, Brancusi exulted, "There is no imitation of Europe here . . . It is a force, a liberating free force." A sense of liberation was what the sculptor sought in his own work also, and he reveled in the relation of his soaring *Bird in Space* series (1923–1940) to the "wonderful, inspiring flight heavenward" of the city's skyscrapers. Piet Mondrian, arriving in New York in 1940, likewise perceived a profound affinity between his art and the architecture of the city, particularly as it was laid out on the clear grid of streets in the midtown area. In New York, Mondrian painted the most ambitious pictures of his career—*Broadway Boogie-Woogie* (1942–43, Museum of Modern Art) and the unfinished *Victory Boogie-Woogie* (1943–44)—and he found a circle of devotees, as well as entrees to the market and the public. In fact, the first and only solo

show Mondrian had in his lifetime was held in New York (as no dealer had offered to represent him during the more than twenty years he lived in Paris).[27]

To a steady stream of major, European avantgarde artists who traveled to New York between the first and fifth decades of the twentieth century, then, the city's great skyscrapers were more than architectural marvels: they were the beacons of and for the new art. New York's "skyscrapers . . . say that the country understands art," decreed Brancusi, who had reason to deem Americans "best qualified to speak authoritatively of modern art." All of his major patrons were American, and all of his solo exhibitions until the year before he died occurred in the United States, beginning with a show at Stieglitz's "291" gallery in 1914. (O'Keeffe's first solo show took place at the same gallery in 1917.) Matisse also knew that a greater public for modern art existed in the United States than among the French, as his most devoted patrons were nearly all American. Matisse had the first showing of his sculpture at "291" in 1912. He conjectured that "Americans are interested in modern painting because of its immediate translation of feeling . . . It is more in rapport with the activity of their spirit." As for Duchamp, who would eventually make a home in New York and become a U.S. citizen, it was in the United States and not in France that he was treated, from the time of the Armory Show, as a celebrity and an authority: he had both his first solo show and his first major retrospective in the U.S.[28]

In sum, many of those pivotal figures who are ordinarily credited with making Paris the world's art center saw New York in that role instead well before the end of the second World War. After World War I, New York generally provided artists with better opportunities for showing and selling modern art, and zealous art patrons worked to make modern art publicly accessible in New York in a way it was not in Paris. Stieglitz's subsidized "291" gallery was the pre-

lude to Katherine Dreier's non-profit Societe Anonyme gallery, which opened in a New York brownstone in 1920, and to A. E. Gallatin's Gallery of Living Art, which opened at New York University in 1927. Two years later the Museum of Modern Art, the brainstorm of a cartel of society women, opened to the public. The Whitney Museum of American Art began operations in 1931, financed by the wealthy sculptor, Gertrude Vanderbilt Whitney, and Solomon R. Guggenheim made his collection public in the Museum of Non-Objective Art in 1939.

The sense that Paris had become an "onlooker" to events in New York dawned on different observers at different moments. In a 1931 essay on the "most beautiful spectacle in the world," Fernand Léger exclaimed how Manhattan, that "daring vertical new continent," prefigured a whole new egalitarian world marked by a "new reli-

gion" consecrated to business and technology. "New York and the telephone came into the world on the same day, on the same boat, to conquer the world. Mechanical life is at its apogee here." Picturing the mechanical was Léger's forte, but he could not believe that any artist would ever successfully describe New York: "It is madness to think of employing such a subject artistically. One admires it humbly, and that's all."[29]

So who would dare to paint New York? Léger and Matisse would not even try it, and Mondrian's vision of the city, however compelling, was largely continuous with his vision of Paris and London. It was Georgia O'Keeffe who would paint New York, depicting its towering buildings in a legible, lyrical way that reciprocated the democratized aspect of the city while evincing the limitless aspirations embodied in its newfound imago: the skyscraper.

NOTES

This is a revised version of an essay published in *Smithsonian Studies in American Art* (Winter/Spring 1991). I wish again to acknowledge Carol Willis' help with that article. Reprinted with permission by Anna C. Chave.

1. *Clement Greenberg: The Collected Essays and Criticism,* ed. John O'Brian (Chicago: University of Chicago Press, 1986), vol. 2, *Arrogant Purpose, 1945–1949,* p. 166. It bears adding that it took a protracted campaign by U.S. critics to persuade Europeans of the legitimacy of Pollock's vision. The Musée National d'Art Moderne, for example, would not acquire its first Pollock until 1972.

2. Jack Cowart, Juan Hamilton with Sarah Greenough, *Georgia O'Keeffe: Art and Letters* (Washington, D.C.: National Gallery of Art, 1987), pp. 183, 179. Her estimation of her city pictures and her sense that they had been unjustly treated emerged when, as an old woman, she troubled to show an interviewer an almost fifty-year old reference in a review by McBride to "one of the best skyscraper pictures that I have seen anywhere. It combines fact and fancy admirably." She

remarked pointedly, "I'd be pleased to have that said in your article"; quoted in Mary Lynn Kotz, "Georgia O'Keeffe at Ninety," *Art News* 76 (December 1977): 45.

3. *New York Tribune,* quoted in *New York Dada,* ed. Rudolf E. Kuenzli (New York: Willis Locker and Owens, 1986), pp. 130, 132; Marcel Duchamp, quoted in "The Iconoclastic Opinions of M. Marcel Duchamps [sic] Concerning Art and America," *Current Opinion* 59 (November 1915): 346.

4. F.J.G. [Frederick James Gregg], "The World's New Art Centre," *Vanity Fair* 5 (January 1915): 31; Greenberg, quoted in O'Brian, ed., p. 215.

According to William E. Leuchtenberg, "In 1914 the United States was a debtor nation; American citizens owed foreign investors three billion dollars. By the end of 1919 the United States was a creditor nation, with foreigners owing American investors nearly three billion dollars. In addition the United States had loaned over ten billion dollars to foreign countries, mostly to carry on the war, in part for postwar reconstruction. These figures represent one of those great

shifts of power that occurs but rarely in the history of nations"; Leuchtenberg, *The Perils of Prosperity: 1914–1932* (Chicago: University of Chicago Press, 1958), pp. 108, 225–26.

5. Leuchtenberg, pp. 227, 182; Claude Bragdon, "The Shelton Hotel, New York," *The Architectural Record* 58 (July 1925): 1.

6. Henry McBride, quoted in *The Flow of Art: Essays and Criticisms of Henry McBride*, ed. Daniel Cotton Rich (New York: Atheneum, 1975), p. 256.

7. Charles Demuth, quoted in Joshua C. Taylor, *America as Art* (New York: Harper and Row, 1976), p. 190; R. J. Coady, "American Art," *Soil* 2 (January 1917): 55, and 1 (December 1916): 3; "A Complete Reversal of Art Opinions By Marcel Duchamp, Iconoclast," *Arts and Decoration* 5 (September 1915): 428; "Can A Photograph Have the Significance of Art?" *Manuscripts* 4 (December 1922): 2. On the Woolworth tower as a "ready-made," see Merrill Schleier, *The Skyscraper in American Art, 1890–1931* (Ann Arbor, Mich.: U.M.I. Research Press, 1986), p. 55. Abbott conceived the idea of compiling an intensive photographic record of New York (such as Eugène Atget had done of Paris) in 1929, and she left Paris for Manhattan that year, before the October crash, to begin her first major photographic project, *Changing New York*.

8. Coady, *Soil* 1 (December 1916): 3; Henry Tyrrell, *New York World*, 21 January 1923.

9. Francis Picabia, quoted in Jean-Luc Daval, *Avant-Garde Art, 1914–1939* (New York: Rizzoli, 1980), p. 17, in Schleier, p. 65, and in "Picabia, Art Rebel, Here to Teach a New Movement, *New York Times*, 16 February 1913, p. 9. After years of exhibiting European modernists, by the 1920s, Stieglitz was showing only American artists and stressing to them the importance of developing a native vision. But O'Keeffe observed of the Stieglitz circle: "I knew that at that time almost any one of those great minds would have been living in Europe if it had been possible for them. They didn't even want to live in New York—how was the Great American Thing going to happen?"; O'Keeffe, *Georgia O'Keeffe* (New York: Viking, 1976), n.p.

10. Naum Gabo, "The Constructive Idea in Art," in *Circle: International Survey of Constructive Art*, ed. J. L. Martin, Ben Nicholson, Gabo (1937; reprint,

New York: Praeger, 1971), pp. 4, 3. Said Duchamp: "I believe that your idea of demolishing old buildings, old souvenirs, is fine. It is in line with that so much misunderstood manifesto issued by the Italian Futurists . . . The dead should not be permitted to be so much stronger than the living. We must learn to forget the past, to live our own lives in our own time"; "A Complete Reversal," p. 428.

11. Duchamp, quoted in "Iconoclastic Opinions," p. 346; Charles Downing Lay, "New Architecture in New York," *The Arts* 4 (August 1923): 67; Thomas A. P. van Leeuwen, *The Skyward Trend of Thought: The Metaphysics of the American Skyscraper* (Cambridge, Mass.: M.I.T. Press, 1988), pp. 22–25. According to van Leeuwen, as the skyscraper's story is usually told, Louis Sullivan emerges as its father, Chicago as its birthplace; but the Sullivan given that role is a man most unlike himself, one who spurned ornament and placed function above all else.

12. Duchamp, quoted in "A Complete Reversal," p. 428.

13. Carol Willis, "Drawing Towards Metropolis," in Hugh Ferris, *Metropolis of Tomorrow* (1929; reprint, Princeton, N.J.: Princeton Architectural Press, 1986), p. 166. The way the story is usually told, the turning point in skyscraper design occurred in 1925, when the U.S. looked to Paris—to the Exposition of Decorative and Industrial Arts—to formulate an Art Deco style. By Willis' account, however, the Art Deco aesthetic "was hardly more than a decorative applique."

14. Lay, p. 68. The Shelton (now the Halloran House) Hotel is on the East side of Lexington Avenue between 48th and 49th Streets.

15. Ferriss, p. 30; Alfred Stieglitz, quoted in Sarah Greenough and Juan Hamilton, *Alfred Stieglitz: Photographs and Writings* (Washington D.C.: National Gallery of Art, n.d.), p. 214.

16. Ferriss, quoted in Willis, p. 167; Frances O'Brien, "Americans We Like: Georgia O'Keeffe," *Nation* 12 (October 1927): 361–62; Henry McBride, quoted in Barbara Buhler Lynes, *O'Keeffe, Stieglitz and the Critics, 1916–1929* (Ann Arbor, Mich.: U.M.I. Research Press, 1989), p. 296.

17. Henry McBride, "O'Keeffe at the Museum," *New York Sun*, 18 May 1946; Sullivan, paraphrased and quoted by Claude Bragdon, *The Secret Spring: An Autobiography* (London: Andrew Dakers, 1938), p.

147. On Duchamp's apartment search, see "Iconoclastic Opinions," p. 346. In 1930 the pioneering photojournalist, Margaret Bourke-White made her studio and wanted (but was not permitted) to make her home high up in the newly completed Chrysler Building, one of her favorite photographic subjects. See Vicki Goldberg, *Margaret Bourke-White: A Biography* (New York: Harper and Row, 1986), p. 115. Making their offices on the top floors of skyscrapers, preferably of their own design, was also the practice of numerous architects in this period.

18. O'Keeffe, n.p. Inevitably, some critics have intimated that O'Keeffe's gender precluded her picturing the city effectively. Of her city pictures, which are mostly painted in neutral tones and black, Milton W. Brown wrote that "her prettiness of color is an intrusion, her lack of strength obvious. Such paintings as *The Shelton . . .* and *The American Radiator Building . . .* in which she introduced irrelevant embellishments, are decorative designs no more substantial than flower petals"; Brown, *American Painting: From the Armory Show to the Depression* (Princeton, N.J.: Princeton University Press, 1955), pp. 127–28.

19. O'Keeffe, quoted in Katharine Kuh, *The Artist's Voice: Talks with Seventeen Artists* (New York: Harper and Row, 1960), p. 191.

20. Henry McBride, quoted in Rich, ed., p. 236.

21. O'Keeffe, quoted in Lynes, p. 287; Herbert J. Seligmann, quoted in James Moore, "So Clear Where the Sun Will Come . . . : Georgia O'Keeffe's *Gray Cross with Blue*," *Artspace* (Summer 1986): 35.

22. Regarding O'Keeffe's first city picture, see O'Keeffe, n.p. As O'Keeffe told it, the huge buildings springing up all over the city were what impelled her to enlarge her flowers in the first place; see Kuh, p. 191. As *New York at Night with Moon* is not listed by that title in the brochure of the 1926 show, she may have exhibited it under another title.

23. "Goings On About Town," *New Yorker* 2 (13 March 1926): 5. The show was so popular that its run was extended. The 1926 show included *The Shelton— New York* (I–IV), *Street, New York* (I–II), and *East River from the Shelton* (I–III). The 1927 show included *New York Night, A Building New York—Night, The Shelton at Night,* and *East River* (I–III). In 1928, O'Keeffe showed *East River from the Shelton* (VI–VII) and *Ritz Tower, Night.* For mentions in the press, see Murdock Pemberton, "The Art Galleries: The Great Wall of Manhattan, or New York for Live New Yorkers," *New Yorker* 2 (13 March 1926): 36–37, and "The Art Galleries," *New Yorker* 3 (21 January 1928): 44.

24. O'Keeffe's painting has not been reproduced since it was first shown, and she is said to have destroyed at least part of it. Each of the triptych's panels was 48 × 21 inches, with the center panel done in a second, full-scale version, 7 × 4 feet (the dimensions were set by the museum). See *Murals by American Painters and Photographers* (New York: Museum of Modern Art, 1932), n.p.

25. Stieglitz objected to the Radio City commission because he did not believe in the "democratization" of art and because of the low fee. He told the head of design for the Music Hall, Donald Deskey, that O'Keeffe was a child and not responsible for her actions in signing the contract. Deskey and O'Keeffe were undaunted by Stieglitz's protests until O'Keeffe discovered that the walls she was to paint had been improperly prepared and that there was insufficient time for her to complete the murals. She then withdrew from the project and suffered a breakdown, which left her virtually unable to work for over a year. See Laurie Lisle, *Portrait of an Artist: A Biography of Georgia O'Keeffe* (New York: Washington Square Press, 1980), pp. 258–61. It seems she never painted New York's buildings again and started to spend more time in New Mexico, where Stieglitz would not go. O'Keeffe's ambition to work on a large scale—even to design an entire house—dated to 1926, when she first exhibited her New York paintings. See Herbert J. Seligmann, *Alfred Stieglitz Talking: Notes on Some of his Conversations, 1925–1931* (New Haven: Yale University Library, 1966), p. 60.

26. Stieglitz, quoted in Seligmann, pp. 27–28; Matisse, quoted in *Matisse on Art,* ed. Jack D. Flam (New York: E.P. Dutton, 1978), pp. 63, 62. Matisse, passing through New York while en route to Tahiti, wrote to his wife, "what I find here is really and truly a new world: it's great and majestic like the sea—and on top of that one senses the human effort behind it . . . On my way to see idle primitives, I've started out seeing active primitives,—two extremes. Where do we fit in? That's the question!" quoted in Pierre Schneider, *Matisse* (New York: Rizzoli, 1984), pp. 606–7.

27. Constantin Brancusi, quoted in "Brancusi Returns Here for Display," *New York World,* 30 Septem-

ber 1926, in Seligmann, p. 69, and in "America Holds Future of Art, Brancusi Says," *Evening Union* (Springfield, Mass.), 20 December 1927. Mondrian's commercial show was at the Valentine Dudensing gallery in 1942; the Museum of Modern Art honored him with a memorial retrospective in 1944. The same museum had acquired the first of its major collection of Mondrian paintings in 1937, whereas the Musée National d'Art Moderne in Paris did not acquire a painting by the artist until 1975.

28. Brancusi, quoted in "America Holds"; Matisse, quoted in Flam, ed., p. 63. On Duchamp, see Moira Roth, "Marcel Duchamp in America: A Self Ready-Made," *Arts* 51 (May 1977): 92. (Henri Rousseau's first public solo show, a commemorative exhibition in 1910, also occurred in the United States, at Stieglitz's "291" gallery.)

29. Fernand Léger, *Functions of Painting*, trans. Alexandra Anderson, ed. Edward F. Fry (New York: Viking, 1973), pp. 90, 84–86.

17

American Art and National Identity

The 1920s

MATTHEW BAIGELL

In this essay on cultural nationalism in the 1920s, Matthew Baigell demonstrates that the quest for national identity in American art, which defined the spirit of the interwar decades, was to be drastically altered by the nativist propaganda of the 1930s. Responding to what was perceived as a crisis in the nation's cultural identity, American art and literature of the 1920s was more focused on self-discovery than self-definition. Notions of national expression were expansive and flexible, rooted in complex understandings of American character and experience, rather than narrowly conceived nativism.

But with the onslaught of the Depression and the ascendence of the so-called American Scene Movement—the name given to the preference among American artists for subjects drawn from American life—many critics became increasingly chauvinistic and intolerant in their demands for cultural nationalism. Baigell describes the process whereby an ambivalent search for national identity characteristic of the 1920s was transformed in the 1930s into the hardening of a particular kind of identity, one far less open to the diversity of American heritage and experience.

Beginning in 1916 and continuing for the next five or six years, a major s hift occurred in American art comparable to the change that took place in the mid-1940s with the emergence of Abstract Expressionism. At that earlier time artists grew increasingly aware of themselves as American artists and wanted to reveal in their art an American presence. For the next twenty odd years the exploration and revelation of their American qualities served as a major animating force, culminating in the American Scene Movement of the 1930s. But the American Scene Movement as interpreted through the voices of chauvinistic critics, such as Thomas Craven and through the various governmental art projects, betrayed the original intentions of those searching for a national identity in American art. For the search that had once seemed free and open in the early twenties became institutionalized, the search for recognition and definition of the American self had turned nativist, toward a particular kind of American self. The several American selves that began to be revealed by artists (such as Stuart Davis, Charles Burchfield, Charles Sheeler, Charles Demuth, Edward Hopper and the early Thomas Hart Benton) were closeted. Description replaced examination. Programmatic notions of American art replaced what just a few years before had seemed to be a sense of free inquiry and personal exploration.

In the first decade of the century, critics encouraged American artists to shake loose from the European influences that were academic, Barbizon or Impressionist. In doing so, artists would learn to express themselves and, by extension, would reflect American values and characteristics. As Giles Edgerton (Mary Fanton Roberts) said, an artist "*must* paint best what he feels and knows and understands best" in order to express himself.[1] It is this attitude, that national identity went hand in hand with self-expression, that was lost in the 1930s.

Robert Henri, the leader of the Ash-Can School, was quite articulate in this matter. Seeking both the release of and the expression of the American spirit in art, he wrote in 1910:

As I see it, there is only one reason for the development of art in America, and that is that the people of America learn the means of expressing themselves in their own time and in their own land. In this country we have no need for art as a culture; no need of art as a refined and elegant performance; no need of art for poetry's sake, or any of these things for their own sake. What we do need is art that expresses the *spirit* of the people today. It is necessary for the people of this country . . . to understand that [art] is the expression of the temperament of our people . . .[2]

In effect, Henri was reminding Americans of their European dependency, that art did not belong in a hothouse and that art should be a vehicle for national self-discovery. He did not try to define the American spirit or say where it came from because I do not think it really mattered to him. He seemed much less a nationalist than a person who believed that self-expression was primary and that it would reveal larger national patterns because of the interaction between the artist and his environment. He was less influenced by nativist feelings than by the thoughts of figures such as Ralph Waldo Emerson, Hippolyte Taine and Leo Tolstoy which provided him with a conceptual framework and a language with which to articulate his thoughts. Emerson and Tolstoy both wanted artists to respond to and to reflect the societies in which they lived. Taine sought explanation for art in these responses and reflections. When Henri wrote that an American art required "a real understanding of the fundamental conditions personal to a country and then the relation of the individual to these conditions," he clearly reflected Taine's dictum that to understand the mind of the artist, his taste, choice of style, character and sentiments, then "we must seek for them in the social and intellectual conditions of the community in the midst of which he lived.[3]

Others, in the period before World War I, also wanted an American spirit and character to emerge in art, but left less to chance than Henri. They had a better idea of the qualities American art should reveal, but these, in truth, had little relation to reality. Instead, both an ideal and an idyllic vision were offered, made up of good intentions, self-delusions, and a profound misreading of this or any other country. The range of vision reached from the gentle to the genteel. One observer found a lyric quality to be important. "The more national quality, especially in painting and preeminently in the works of our landscape men, is the lyric note." The landscapists, more than any others, knew "the birthplace of so much of our poetry and of our strength, of the humor and of the kindly tendency of our nation."[4] Others found the dominating qualities in American art that revealed American ideals to be "simplicity in subject and treatment . . . , honesty of presentation, sincerity of execution," and a "light, spontaneous charm . . . , a refined vigor."[5] These same observers were as much pro-American as they were anti-European in their encouragement of American artists to find their own and their American voices. Patriotism coalesced with competition in their desire to see the emergence of a free and independent American art.

Not surprisingly, the Armory Show of 1913 forced American artists and critics to focus on

the question of national identity in art and how it might be found. Randolph Bourne, one of the ablest cultural critics of the period, felt profoundly humiliated by the exhibition and suggested that it was held "with the frankly avowed purpose of showing American artists how bad they were in comparison with the modern French." The exhibition represented to him "an appalling degradation of attitude which would be quite impossible in any other country. Such groveling humility, he continued, "can only have the effect of making us feeble imitators." Believing that "our cultural humility before the civilizations of Europe ... is the chief obstacle which prevents us from producing any true indigenous culture of our own," he felt that "the only remedy for this deplorable condition is the cultivation of a new American nationalism."[6]

Where would the source of that nationalism lie? European artists who visited the United States in 1913 for the Armory Show and in 1915 because of the outbreak of war in Europe offered one answer—the present. Instead of agonizing over the health of or the release of the American spirit or assuming that American art should evolve from the nation's real or imagined heritage, they realized that it should spring from the immediate moment. American artists should seize the present to which one only need be alive to respond. Their iconoclasm was frightening, surely, and the inference that American artists could be American if they thought *modern* rather than *American* must have been eye-popping.

In 1913, Francis Picabia, visiting the country for the Armory Show, said in an interview, "France is almost outplayed. It is in America that I believe that the theories of The New Art will hold most tenaciously."[7] Heady stuff, but the arrival of Picabia, Marcel Duchamp, Albert Gleizes and others in 1915 must really have provoked artists and critics to question inherited and outmoded traditions. Picabia, particularly, indicated that American art needed no past. In the famous interviews given by the Europeans in the

New York Tribune in 1915, Picabia said, "since machinery is the soul of the modern world, and since the genius of machinery attains its highest expression in America, why is it not reasonable to believe that in America the art of the future will flower most brilliantly?"[8]

Picabia and the others must have assumed that the American spirit to be revealed by American artists would be one of daring, chance-taking and a disdain for the past. The Europeans must also have assumed that the art of the future would be abstract and therefore universal, and would rise above local and national concerns. Some American artists, such as Man Ray and Morton Livingstone Schamberg responded accordingly, but most could not leave America behind. For artists such as Charles Sheeler and Charles Demuth the future had to grow from the past and the past would have to be embedded in the future in complex ways. For figures such as Charles Burchfield and Edward Hopper the past was essentially an urban one only a generation or two in age. In the 1920s, Benton responded to both past and present; Stuart Davis to the present alone.

By 1916 the terms of the quest for an American art had changed. The vague search for the American spirit and an American identity in art, as well as the genial encouragement of artists to find these, were transformed in two paradoxical ways. On the one hand the nation as a whole— its materialism, its past, its heritage, its prospects—was savaged for not allowing an American art to emerge. On the other, an almost mystical belief gained strength that reflected a longing for a vital self-sustaining and independent American culture. Or, to say it differently, before a new American culture could emerge, the old one had to be identified and destroyed. Things had become quite serious.

The attacks were vicious. Briefly, the American character was considered frayed, fragmented, and buried beneath generations of psychological and sexual repression. People lacked

a sense of organic culture and also lived in profound isolation from each other. A few examples will suffice. Van Wyck Brooks, a devout critic of American culture at the time, noted in 1917 "if we are dreaming of a 'national culture' today it is because our inherited culture has so utterly failed to meet the exigencies of our life, to seize and fertilize its roots."[9] Where Brooks found spiritual values drowning in a sea of material ones, Harold Stearns found Americans unable even to face the truths of their existence. He believed that American writers and artists "have not yet learned how to get below the surface of things. Nor will they until our optimistic compulsion has been destroyed, until in the world of the spirit of the mind we find that there is one moral obligation and only one: to tell the truth as we honestly see and feel it."[10] This observation was only slightly less devastating than his depressing, more general assessment of the times. "Great art is the expression of an age, and that age must itself be great. Ours is not, it has nothing to express."[11] Even within the circle of modernists around Alfred Stieglitz, critiques of American culture were evident. Marius de Zayas, for example, found "the real American life . . . still unexpressed . . . , America remains to be discovered."[12] Still others found that the diverse heritage of Americans and their willingness to maintain Euro-American cultures prevented the emergence of a deeply rooted national culture.[13] The yearning for such a culture was so strong that artists were accused of not being strong enough to break through "the crust of mere appearance . . . , to face this America in which [they] live . . ." As a result, "American painting in the sense of a deep national expression . . . has not been born yet."[14]

The effects of World War I also added a measure of urgency to the quest for a national culture. The diversity of national feelings about the war indicated that assimilation was not as successful as had been assumed. People had not melted enough in the melting pot.[15] In addition, the effects of the war so challenged well-received ideals, beliefs, and illusions that the confusions thus engendered in the American psyche strongly suggested that "the most important task [confronting] patriotic Americans is that of assisting in the recovery of a common and confident national consciousness."[16]

But even before America's entry into the war, a concerted effort had begun to reinvigorate the American spirit. In journals such as *The Dial, The New Republic,* and, most of all, *The Seven Arts,* one can follow both the devastating critiques of and the encouraging cheers for American culture. Under the criticisms there lay a peculiar kind of hope that from honest soul-searching, a genuine American culture might emerge, a unitary culture derived from the American plurality, self-aware, tough-minded, yet based on spiritual rather than material values. James Oppenheim, Editor of *The Seven Arts,* nursed the hope of a renascent period in American arts, of "the coming of that national self-consciousness which is the beginning of greatness . . . ," of "an expression of our American arts which shall be fundamentally an expression of our American life." Without a "tradition to continue" and "no school of style to build up," artists were free to explore and to find as they might. Oppenheim, taking an extreme position, found no traditions, no symbols, nor even a sense of destiny in American culture. Yet he held that "it is in nationality today that the race finds that larger self to which the individual may give all and become human and high."[17] Like Nietzsche, who believed that art marked the apex of a civilization, Oppenheim wanted "to incarnate our longings and our aspirations in works that shall reveal us to ourselves. A nation finds itself when it creates a great book, a great architecture, a great music."[18]

Responding to similar motivations and promptings in American society as a whole as well as within the narrower confines of the art world, artists began to look at the American

scene, increasingly aware of themselves as American artists and as artists in America. Artists whose styles had been formed before the late teens—Impressionists such as Childe Hassam, realists such as George Luks—were congratulated on their American qualities, which might range from a spiritual connection to Walt Whitman to an appreciation for a particular landscape.[19] For example, Paul Strand, the photographer, especially liked John Marin's watercolors of Maine. "His [Marin's] work attests frankly to a conscious recognition on his part that he is rooted in this American continent," Strand said. "This is Maine and nowhere else. It is America and nowhere else. We are made to experience something which is our own, as nothing which has grown in Europe can be our own. We are taken up bodily . . . and are shoved into the core of our own world—made to look at it."[20] Strand seems to be asserting that through examining the particular environment, one could find America—through evoking the local, the national. For Strand, Marin's landscapes were successful in their lack of generalization and he was pleased to note that they could not be mistaken for Californian, let alone European, scenes. No doubt, Strand was reacting to the steady stream of articles asserting that the works of American Impressionists, such as Childe Hassam, Willard Metcalf, and Edward Redfield, were thoroughly American despite their obvious French derivation.[21] Marin himself was aware of what he was doing. In a letter to Stieglitz written from Maine in 1919, he indicated that he did not care to paint with memories of older styles in mind. Instead, he wanted his work to be "seething with the whole atmosphere of Maine."[22]

Other younger artists, borne along by the desire to find a sense of national identity in their art, began to look at the American environment. Perhaps, like James Oppenheim and similarly-minded critics, they sought an all-encompassing national spirit, but more likely—and more realistically—their own perceptions, guided by personal and local concerns, filtered out such grandiose visions. None, except Thomas Hart Benton, really thought of defining his work in terms of a national expression.

At least two artists reacted along lines suggested by Francis Picabia—to an America liberated from its past. Joseph Stella, like the poet Hart Crane, turned to the Brooklyn Bridge as a symbol of modern America, seeing it as "the shrine containing all the efforts of the new civilization of AMERICA".[23] It is worthwhile noting here that Stella used the word "America," not the phrase "the modern age" in identifying the new civilization. And Louis Lozowick, who toured the country in 1919, completed a series of paintings by the middle 1920s that evoked the modern metropolis. Believing that "the dominant trend in America today, beneath all the apparent chaos and confusion, is towards order and organization which find their outward sign and symbol in the rigid geometry of the American city," Lozowick caught the rhythm of modern America through angular forms and sweeping arcs.[24] He painted an urban America, a historyless America, cut off from its past. Because his work was perhaps too impersonal and modernist, he did not become a central figure like Charles Sheeler in the 1920s. (It is also true that Lozowick was abroad for several years during the decade.)

Sheeler, like Burchfield, Demuth, Davis, Hopper and Benton, turned a more probing eye upon the country just before and after 1920. Sheeler reexamining the premises of his art in 1916–17, altered his style and thematic concerns, but unlike Lozowick he combined an interest in the forms of modern America with those of the past. Until 1915 Sheeler produced works such as *House and Trees* that were generically Cubist, innocent of specific national or local references. By 1917, however, his studies of barns in Bucks County, Pennsylvania, referred to barns in that area and in no other area. Although abstracted into flattened planes, they are described with great accuracy, their parts clearly seen and easily

identified. It is as if he already understood the in-
tentions of his future friend, William Carlos
Williams, who would write in the introduction to
his *In the American Grain* in 1925, "I have
sought to rename the things seen, now lost in
chaos of borrowed titles, many of them inappro-
priate, under which the true character lies hid."[25]

During the 1920s critics were especially
pleased to recognize the Americanness of his
works, one of them stating that "no artist has
done more for the neglected native scene, the
very spirit of early America, than has Charles
Sheeler."[26] But it was more than just a matter of
recall and antiquarianism. Another critic, setting
off Sheeler from French artists who "paint by
theory" and muddle "their paint with philoso-
phy," said that he became most American when
he expressed "in terms of extremely simplified
realism the permanent and essential character of
the natural object."[27] Sheeler's disdain for
nonessentials was also considered very Ameri-
can. That is, he could get right down to funda-
mentals.

Sheeler was certainly aware of the American
qualities critics found in his work. He also real-
ized in the 1930s his need to remain physically
in the American environment in order to absorb
and to respond to its visual forms and cultural
configurations. As he recounted in his autobio-
graphical statement written in the mid 1930s:

> I have found that quite unconsciously the things
> which have to do with indigenous social necessi-
> ties have for the most part claimed my inter-
> est. . . . For this reason, and despite the enjoy-
> ment of European visits, a prolonged residence
> abroad has never seemed desirable. It remains a
> persistent necessity that I should feel a sense of
> derivation from the country in which I live and
> work.[28]

But I think it was more than just the forms of
American buildings or furniture invoked in his
work or a presumed American sense of paring
things to their essential components that
prompted observers to comment on his Ameri-

can qualities. I think it existed in his rational or-
ganization of things.[29] This can be seen best in
his Ford Motor Car Company paintings of about
1930. These works reveal him as the true artist of
corporate capitalism. In these works he painted
the system of a success. Everything is properly
groomed and in its place. Managerial efficiency
dominates both the composition of the paintings
and in the ways the buildings are portrayed. In a
tradition that includes Edward Bellamy's *Look-
ing Backward* (1888) and the time and motion
studies of Frederick Taylor (*The Principles of
Scientific Management,* 1911), Sheeler records
the organization of modern life into carefully ar-
ranged, articulated, and idealized units. No effort
or motion is wasted. The experts have tamed the
anarchy of industrial capitalism.

In comparison, Thomas Doughty in his
Gilpin's Mill on the Brandywine (1826), to para-
phrase Leo Marx's image of the machine in the
garden, shows an idyllic nineteenth-century vi-
sion of the machine domesticated in the garden.[30]
Two boys swim at the waterhole now shared by
a mill, suggesting that rustic and industrial can
easily thrive on the same turf. Sheeler, in a twen-
tieth-century version, shows the garden, now re-
duced to a small pond with its rowboat, ab-
sorbed, dominated and surrounded by the clean,
well-ordered and superbly functioning American
machine. Man's order has replaced God's. Per-
haps Sheeler caught in his Ford Company paint-
ings the rational capabilities of the American
mind, the true expression of the American spirit
and national character. I do not know if this re-
flects the hoped for liberation of the American
spirit or the nailing of it to the wall, but there is
certainly an American element in these works.

Surprisingly, Thomas Hart Benton did try to
nail capitalism to the wall in the 1920s, and
even the 1930s. Like Sheeler, he too changed
styles and thematic concerns around 1920. At
least until he served in the navy during World
War I, he had been a modernist.[31] Soon after, he
turned to American themes, and in a series of
mural studies, the Historical American Epic, on

1. Thomas Hart Benton, *The Path Finder,* 1926; courtesy of the Nelson-Atkins Museum of Art, Kansas City, Mo. (Bequest of the Artist). © T. H. Benton and R. P. Benton Testamentary Trusts/Licensed by VAGA, New York, N.Y.

which he worked until 1927, he tried to develop a uniquely American style [1]. Much later, in 1951 Benton admitted that his original purpose had been "to present a people's history" in order "to show that the people's behaviors, their action on the opening land, was the primary reality of American life." He also wanted to show that "as civilization and technology advanced," the people "became increasingly separated from the benefits" of their labors.[32] In effect he had painted a Marxist history in murals. As he recollected, he:

could then see no conflict between American democratic ideals and the ideals of Soviet Russia. My readings in American history were convincing me that the people of America, the simple hardworking, hard fighting people who had . . . built up the country were, more often than not, deprived of the fruits of their labors by combinations of politicians and big businessmen. I was convinced that the American dream had been continually discounted by capitalist organizations which had grown beyond the people's control. All of this kept me in substantial agreement with those Marxist historians and political

theorists who were describing America in Marxist terms.[33]

Benton's ties to the left were in fact quite strong during the early 1920s. He had even conspired with Robert Minor, a cartoonist and party functionary, "to provide secret meeting places for the persecuted members of the communist party, one of which included my own apartment in New York."[34] Benton broke with Marxism in the late 1920s but remained critical of modern American capitalism, ultimately retreating into a pre-industrial nativism.

In the early 1920s, Stuart Davis was also caught up in defining himself and his art in an American context. His *Autumn Landscape* of 1919 does not describe a particular American place or state of mind, but his Tobacco pictures of 1921, *Lucky Strike, Sweet Caporal* and *Bull Durham* are of especial interest because, although their European connections are obvious, their American associations have not been fully explored. Davis wrote in his journal in May 1921, "I feel that my Tobacco pictures are an original note without parallel so far as I can see." Now able to create, as he said "really original American work," he attacked the Cubists as "metaphysicians," the Dadaists as "European jugglers with whom we have been acquainted in vaudeville for some years. In America are only imitators of these." He felt that copying Cézanne, Matisse, and Picasso caused Americans to ignore their own abilities "by our foolish worship of the foreign God."[35] Later, in March, 1922, he wrote about another unidentified group of works, "starting now I will begin a series of paintings that shall be rigorously, logically American, not French. America has had her scientists, her inventors, now she will have her artists."[36]

Davis wanted to paint "direct simple pictures of classic beauty—expressing the immediate life of the day. . . . Pictures of this kind should be self-supporting. They have nothing in common with the trade in art galleries. They should be sold [in reproduction] in stores like newspapers and magazines."[37] He even identified himself with objects like newspapers which existed in multiples rather than as unique objects, adding "I do not belong to the human race but am a product made by the American Can Company and the New York *Evening Journal*."[38]

By identifying himself and his art so radically with nonartistic sources and products, he allied himself with figures such as Robert Coady, Editor of *Soil,* a magazine published in 1916 and 1917, and Matthew Josephson, Editor of *Broom,* published in the early 1920s. Coady, seeking an American art based on objects found in the environment, found aesthetic values in industrial objects such as cranes, piers, drills, motors, and grain elevators:

> Our art is, as yet, outside of our art world. It is in the spirit of the Panama Canal . . . , the skyscraper, the bridges and docks . . . , Walt Whitman . . . , electric signs, the factories and mills—this is American art. It is not an illustration to a theory, it is an expression of life—a complex life—American life.[39]

Matthew Josephson wanted home products examined—billboards, movies, newspapers, skyscrapers, jazz and, perhaps, cigarette wrappings, as well. Self-conscious, like Davis, in calling for the creation of an American heritage, he wanted writers and artists to "react to purely American panorama. . . ."[40] He felt, and Davis would have agreed, that "America will never enjoy an indigenous art, if, led by its intellectuals, it adopts approved European methods of painting and writing."[41]

In the early twenties then, Davis responded to Picabia's interest in the present, or something similar to it, as well as to the radical ideas of Coady and Josephson for finding forms and subjects in nonartistic materials. Years later, in the 1940s, Davis reemphasized these aspects of his work when he wrote that artists who have flown, traveled by train and car, and used the telegraph, telephone, and radio feel differently about time

and space than those who have not. And, he added a few years later, he had "enjoyed the dynamic American scene . . . and all my pictures are referential to it. They all have their originating impulse in the impact of the contemporary American environment."[42] This included gas stations, chair store fronts, taxicabs, electric signs, movies and, once again, presumably cigarette wrappings. Davis clearly tapped into that aspect of the American character that responded affirmatively to change, to challenge, to the frontier, and insisted on doing so in contemporary terms. He rejected the paraphernalia of the past and maintained a sense of high adventure.

Davis, like Coady and almost everybody else at the time, invoked Walt Whitman's name in print as well as conversation and acknowledged him to be the hero of their generation. "I, too," Davis said, "feel the thing Walt Whitman felt— and I too will express it in pictures of America—the wonderful place we live in."[43] Malcolm Cowley, barely exaggerating commonly held opinion, held that "before Walt Whitman America hardly existed."[44] How Davis and others must have thrilled to Whitman's call in *Democratic Vistas* for a poet to project "what is universal, native, common to all, inland and seaboard, northern and southern," and to create a "programme of culture . . . with an eye to practical life, west, the workingman, the facts of farms and jackplanes and engineers."[45] One senses that at the time Davis did indeed want to create Whitman-like images that were modern, common, and American. But editorials and articles in magazines including *The Arts, The Seven Arts* and *The Dial* lamented the fact that an artist had yet to appear who was Whitman's equal.[46] I suspect that Benton might have seen himself as such an artist. Certainly of all the significant figures of the interwar years, he, more than any other, sought an imagery that would, as he later said, have meaning for as many Americans as possible.[47]

Charles Demuth's America was much more anemic than Davis's or Benton's and his celebration of it much more ambivalent. After adopting a Cubist style in 1916–17, he turned to recognizable American subject matter by 1919. Attracted and repulsed at the same time by America, he expressed his confusions about the country in letters to Alfred Stieglitz in 1921. While abroad that year, he admitted that "I feel 'in' America even though its insides are empty. Maybe I can help fill them."[48] After he returned home, and although deploring the lack of support for art, he wrote to Stieglitz, "What work I do will be done here; terrible as it is to work in this 'our land of the free'. . . . Together we will add to the American Scene. . . ."[49] Demuth's love-hate relationship, although hidden under sophisticated irony, did not fool anybody. One critic found his "souvenirs of Sir Christopher Wren [drawn] with an intensity that suggests inward rage."[50] Another found his watercolors "were not American in the sense that Lincoln and Whitman were American," because "beautiful as they were, they were distinctly morbid."[51]

Charles Burchfield's middle-period paintings, those done between 1918 and 1943, are morose rather than morbid. Before 1918 he painted lovely landscapes based on childhood memories and raptures. By 1919 he began to feel, as he reported, the great epic of Midwestern American life and his own being in connection to it.[52] He had read Sherwood Anderson's *Winesburg, Ohio*, almost as soon as it was published in 1919, which helped him turn his eyes outward toward his native landscape. But to what effect? One critic wrote in 1920 that "Mr. Burchfield had the great good fortune to pass his young life . . . in the loathsome town of Salem, Ohio, and his pictures grew out of his detestation of this place. . . . There is almost nothing in his work but this hatred."[53]

Edward Hopper observed, similarly, that Burchfield had captured "all the sweltering tawdry life of the American small town," but also noted without commenting upon his love-hate relationship, similar to that of John Steinbeck and other Midwestern writers, that "his is an art

rooted in our land."[54] This bleak vision was then central to Burchfield's view of America. One wonders that had he ever painted, as he had intended, the equivalent of *Finlandia* by the Finnish composer Sibelius for America would he have painted the equivalent of a tone poem or a series of dirges? Burchfield's townscapes recall Van Wyck Brooks's observation that ancestral bonds are really not to be found in America. "Old American things," Brooks wrote in 1916, "are old without majesty, old without mellowness, old without pathos, just shabby and bloodless and worn out."[55]

Hopper's works from the 1920s are not really so dissimilar. His thematic and stylistic interests crystallized in the early part of the decade, a few years later than the other figures, after he completed a set of about twenty etchings. These interests were to last until his death, indicating that he, unlike the others, was to remain a painter of the 1920s throughout the rest of his life. Hopper was very aware of the American element in his work. In 1927 he praised members of the Ash-Can School for not trading their American birthright for a European one. He responded especially to their reaction to the American land and to their "simple visual honesty and intensely emotional vision."[56] But what was Hopper's own vision? Like Burchfield's, it appears to have been a passive one. The neighborhood is changing, getting more rundown. But there is nothing to be done about it. There seems to be no way to work with these changes, but to survive in some marginal way. The buildings, the streets, the people offer no resistance to the modern industrial age passing them by. These are not mean streets, but dead streets, lacking heroism, strength or even dignity. Social cohesion has given way to fragmentation. Hopper and Burchfield painted the vanquished and, more important, the loss of community in the modern age. They reveal that the people and their spirit were emotionally stillborn. They painted a distraught community. Taking a hard inward look at the American charac-

ter, they found confusion and despair in the face of modern times [2].

They also painted a problematic American condition. For as Alexis de Tocqueville noticed in the 1830s, American capitalism can create conditions of isolation and separation, since competitive economic individualism insures that some will win, others will lose, and that sympathy is in very short supply.[57] Loss of community is built into the American way, as it were. Yet by 1927 Hopper was considered the most successful interpreter of the American scene in that, "He succeeds in getting the essence of his subject."[58] Lloyd Goodrich, then a young critic, found it "Hard to think of another painter today who is getting more of the quality of America in his canvases than Edward Hopper."[59] That quality seems to be exactly what the literary and cultural critics condemned in America. Burchfield's and Hopper's work seems the exact opposite of Sheeler's.

Other artists such as George Ault through his use of urban and rural themes and even dealers such as Stephen Bourgeois contributed to the rising interest in an American artistic identity.[60] As one scans the paintings and the writings of the time, one senses an openness to different points of view and a quality of adventure and discovery. Exploration of the self coincided with exploration of the national self. The search for a national identity or for the American spirit did not reveal among the painters a single point of view or lead to a single set of themes, but rather to a remarkable multiplicity of concerns and responses that made the decade of the 1920s one of the richest in all of American art. One might argue that the development of the American Scene movement in the 1930s and the support given through the various government art programs capped this development. But I would argue the reverse, that American Scene painting and the government art programs led to a narrower artistic focus, a constriction of the American spirit as understood around 1920 and the

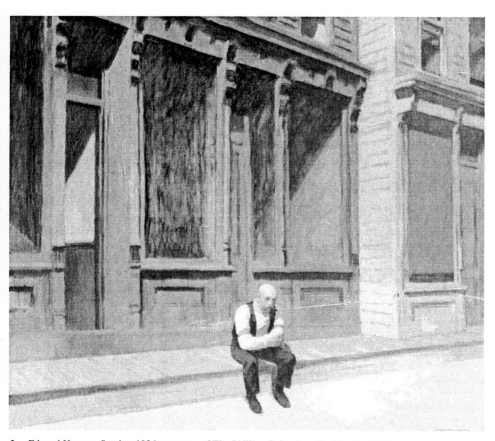

2. Edward Hopper, *Sunday*, 1926; courtesy of The Phillips Collection, Washington, D.C.

cloaking of the art world under a blanket of nativism.

The nativist bias contained three interrelated aspects—the desire to exclude from consideration those lacking a proper American heritage, an emphasis on rural subject matter and, especially in the government mural projects, the avoidance of the kind of disagreeable subjects a Hopper or a Burchfield might want to introduce. In any event, the sense of free and generous exploration suggested by figures such as Robert Henri or *The Seven Arts* group was lost.

Even as early as 1920, an article published in *The Nation* was symptomatic of the nativist response. Mary Austin, its author and a critic of some stature at the time, chided certain New York critics for confusing New York City with America, naming Waldo Frank and Louis Untermeyer, but not James Oppenheim and Paul Rosenfeld who wrote for journals such as *The Seven Arts* and *The Dial*. She said that these critics, whom she described as being Jewish, could not really be interpreters of America, could not hope to develop an American consciousness in

the arts from New York and did not understand underlying forces in American life. "Decentralization," she said, was "the only way to accomplish the release of the American genius."[61] Austin was really offering a double argument. First, in the conflicting tensions between national unity and local tradition, between nation and region, an American art would grow only from the region and from past experiences at the local level. Second, recent immigrants, or the children of recent immigrants, who congregated in large cities had little or nothing to say in these matters. In effect, national identity had no place in the immigrant's dream of America, the displaced person's dream of finding community in a new and strange land in which becoming American was itself part of the dream. Ironically, figures like Oppenheim, Frank, and Rosenfeld did not cast themselves as outsiders who pointed to the problems of American society as, say, Kafka did in central European society. They wanted to become part of American society, to be absorbed by it, but were reminded instead of their status as outsiders.

Through the middle years of the decade the attack against recent immigrants was channeled primarily at modernist painters, but the implications were clear. Only those who possessed a certain kind of American heritage were considered American. Royal Cortissoz, the conservative critic, in observing the contemporary art scene, noted:

> There is something in this art situation analogous to what has been so long going on in our racial melting pot. The United States is invaded by aliens, thousands of whom constitute so many acute perils to the health of the body politic. Modernism is precisely of the same heterogeneous alien origin and is imperiling the republic of art in the same way . . . These movements have been promoted by types not yet fitted for their first papers in aesthetic naturalization—the makers of true Ellis Island art.[62]

In 1925, Thomas Craven, the xenophobe and anti-Semite, in discussing the famous Forum Exhibition of modern American art which took place in 1916, indicated clearly that he did not care for artists such as Oscar Bluemner, Ben Benn, Andrew Dasburg, Abraham Walkowitz, George Of and William Zorach posing as Americans. He added to this list Max Weber, Joseph Stella, Jules Pascin, Walt Kuhn, Maurice Stern and Louis Bouche.[63] And Forbes Watson, in 1930, in discussing a list of artists informally elected in an all-American popularity poll, questioned whether Japanese-born Yasuo Kuniyoshi, Jules Pascin, a Jew from Bulgaria, Lyonel Feininger, essentially a German, among others, were really Americans.[64]

The bias against foreigners taking part in forming an American art was perhaps best expressed by Benton in the early 1930s when in an article about the Ozark Mountains he wrote "The future is and must continue to be heavily conditioned by the past and in this land, yet flavored by the pioneer spirit, the nature of our fundamental American psychology can best be understood."[65] So pervasive was this attitude that even a poet as sophisticated as William Carlos Williams in his own search for an American heritage could still believe that "the mountain woman lives untouched by modern life. In two centuries mountain people have changed so little that they are in many ways the typical Americans."[66] This point of view was clearly exclusionary of all ethnic and religious groups which did not share a pioneer or rural heritage. By this reasoning recent immigrant groups and urban dwellers would never understand America, or lay any claim to understanding it and its heritage. Regrettably, this attitude is still very much present in American political life. As reported in the *New York Daily News* for August 24, 1986, presidential aspirant and television preacher Pat Robertson attacked Norman Lear, a Jew and a founder of the liberal group People for the American Way, in the following way:

I have a fairly good idea of what the American way is because it was my ancestors who helped make this country. Regretfully, Norman Lear does not have the same sense of history that somebody of my heritage has.[67]

The American character and spirit represented by Benton's and Williams's opinions were ungenerous, narrow, and nativist. One wonders therefore, if some of the great praise heaped on Hopper and Burchfield in the late 1920s was based on the fact that however broken down it was, they painted the old American home. What all of this suggests, and it is only symptomatic of one point of view in the 1920s, is that the buoyant release of the American spirit could not really take place because those who thought they possessed it would not share it with anybody else. They were more concerned with hoarding it than with nourishing it, and with insisting that it be conditioned by the past known only to them. The search for a usable past in this context became a burden. Or, as Van Wyck Brooks, already attacking this position as early as 1917, noted "I think we are driven to the conclusion that our life is, on all levels, in a state of arrested development, that it has lost, if indeed it ever possessed, the principle of growth."[68]

To grow and to flourish like Davis, Sheeler, Hopper, Burchfield, and Demuth meant focusing on the evolving present rather than feeling beholden to a past that might no longer be relevant. It is of more than passing interest to note that these artists, despite their obvious concern for American subject matter, dissociated themselves from the American Scene movement and perhaps even thought it was a betrayal of their original intentions. Edward Hopper, late in his life, said:

The thing that makes me so mad is the American Scene business, I never tried to do that American Scene as Benton and Curry and the Midwestern painters did. I think the American Scene painters caricatured America. I always wanted to do myself . . . The American quality is in a painter—he doesn't have to strive for it.[69]

Burchfield also distanced himself from the more obvious implication of American Scene painting. He once wrote to his dealer, Frank Rehn that Regionalism made him sick.[70] Burchfield did not mind if an artist lived in and worked for "one locality, but still [reached] out to the art, past and present, of the whole world for inspiration and background."[71] Sheeler's reactions were more elliptical. "My paintings," he said, "have nothing to do with history or the record—it's purely my response to intrinsic realities of forms and environment . . ." and again, "I am interested in intrinsic qualities in art not related to transitory things. I could never indulge in social comment . . . I think of art as being fundamentally on a different plane."[72] Stuart Davis, among the most politically militant artists during the 1930s, believed that "regional jingoism and racial chauvinism will not have a place in great art of the future."[73] It would seem that they considered American Scene painting to be fundamentally different from their art and intentions.

The various government projects during the 1930s, however helpful and sustaining they were, need also to be considered in this light since in the mural programs especially, generally acceptable ranges of subject matter were imposed on artists and a bureaucratic layer of administrators grew up between artists and their subject matter.[74] The growth of the American spirit in art became equated with a national inventory of historical events and of topographical features rather than inciting observation, let alone personal soul-searching. Artists of the left, associated with Social Realism, kept alive the kinds of critical readings one finds in Hopper and Burchfield, but they did not search for national identity in their art as much as national commentary and criticism. Like Benton in the

1930s, they brought to their American subject matter an agenda that dictated the kinds of scenes they chose to paint. The free and open interaction with American culture, which characterized art around 1920—however difficult and implausible that might have been—was smothered by programmatic and restrictive ways of thinking. Artists found what they were searching for rather than finding liberation in a break with the past or with outmoded art styles. The quest for national identity in art became institutionalized rather than inciting, conscious rather than intuitive, and thus became something other than the quest that had begun earlier in the century.

NOTES

From *Arts Magazine* (February 1987). Reprinted by permission of the author.

1. Giles Edgerton (Mary Fanton Roberts), "The Younger American Painters," *The Craftsman*, 13 (February, 1908), 521.

2. Robert Henri, "The New York Independent Artists," *The Craftsman*, 18 (May, 1910), [6]. See also Gustave Stickley, "A Greater Sincerity Necessary for the True Development of American Art," *The Craftsman*, 16 (April, 1909), 55–59.

3. Hippolyte Taine, *Lectures on Art*, trans. by John Durand (New York: Henry Holt, 1883), p. 30. See also Leo Tolstoy, *What Is Art?*, trans. Charles Johnston (Philadelphia: Henry Altemus, 1898); John Albert Macy, "Tolstoi's Moral Theory of Art," *The Century*, 52 (June, 1901), 300; and Joseph Kwait, "Robert Henri and the Emerson-Whitman tradition," *PMLA*, 71 (September, 1956), 617–36.

4. Edgerton, "American Painters of Outdoors: Their Rank and Their Success," *The Craftsman*, 16 (June, 1909), 282.

5. "The National Note in Our Art: A Distinctive American Quality Dominant at the Pennsylvania Academy," *The Craftsman*, 9 (March, 1906), 753; "Irving R. Wiles: Distinctive American Portrait Painter," *The Craftsman*, 18 (June, 1910), 353. See also Bayard Boyeson, "The National Note in American Art," *Putnam's Monthly*, 4 (May, 1908). 133–35; and Kenyon Cox. "The American School of Painting," *Scribner's Magazine*, 50 (December, 1911), 765–68.

6. Randolph Bourne, "Our Cultural Humility," *The Atlantic Monthly*, 114 (October, 1914), 506.

7. "Picabia, Art Rebel, Here to Teach New Movement," *The New York Times*, February 16, 1913, sect. 5, p. 9.

8. "French Artists Spur on an American Art," *New York Tribune*, October 24, 1915, sect. 4, p. 2. See also "The European Art Invasion," *The Literary Digest*, 51 (November 1927, 1915), 1224; "The Iconoclastic Opinions of M. Marcel Duchamp Concerning Art and America," *Current Opinion*, 59 (November, 1915), 346, cited in Dickran Tashjian, *Skyscraper Primitives* (Middletown, Conn.: Wesleyan University Press, 1975), p. 50.

9. Van Wyck Brooks, "The Culture of Industrialism," *The Seven Arts*, 1 (April, 1917), 655.

10. Harold Stearns, *America and the Young Intellectual* (New York: Doran, 1918), pp. 80–81.

11. *Ibid.*, p. 22.

12. From *291*, 5–6 (July–August, 1915), reprinted in *Camera Work*, 48 (October, 1916), 69, cited in Tashjian, *op. cit.*, p. 41.

13. Bourne, "Trans-National America," *The Atlantic Monthly*, 118 (July, 1916), 88–91; and Maxwell Bodenheim, "American Art?", *The Dial*, 66 (May 31, 1919), 544.

14. Paul Strand, "American Water Colors at the Brooklyn Museum," *The Arts*, 2 (December, 1921), 149, 150.

15. Bourne, "Trans-National America," 86.

16. "America As the Promised Land," *The New Republic*, 32 (October 4, 1922), 135. See also Winifred Kirkland, "Americanization and Walt Whitman," *The Dial*, 66 (May 31, 1919), 537.

17. Editorials, *The Seven Arts*, 1 (November, 1916), 52, 53, and 1 (March, 1917), 505.

18. Ibid., 506.

19. On Hassam, see William Gerdts, *American Impressionism* (New York: Abbeville, 1984), p. 299. On Luks, see "Comment on the Arts, *The Arts*, 1 (February–March, 1921), 34.

20. Strand, "American Watercolors," 152.

21. See Gerdts, *op. cit.,* pp. 199, 299; and Thomas Folk, *Edward Redfield* (New Brunswick: Rutgers University Art Gallery, 1981), p. 3.

22. Dorothy Norman, ed., *The Selected Writings of John Marin* (New York: Pellegrini and Cudahy, 1949), p. 50.

23. *Transition,* 16–17 (June, 1929), n. p., in the Joseph Stella File, Whitney Museum of American Art.

24. Louis Lozowick, "The Americanization of Art," essay for The Machine Age Exposition, May, 1927, reprinted in Janet Flint, *The Prints of Louis Lozowick* (New York: Hudson Hills, 1982), pp. 18–19.

25. William Carlos Williams, *In the American Grain* (New York: New Directions), 1956, p. v, first published in 1925. This reference was kindly provided by Sarah Greenough, National Gallery of Art.

26. Robert Allerton Parker, "The Classical Vision of Charles Sheeler," *International Studio,* 84 (May, 1926), 71.

27. Forbes Watson, "Charles Sheeler," *The Arts,* 3 (May, 1923), 335, 341.

28. Archives of American Art, Charles Sheeler Papers, Microfilm Roll NSH 1, Frame 102.

29. This and the immediately following observations grew from conversations with Dr. Allen Kaufman, University of New Hampshire.

30. Leo Marx, *The Machine in the Garden: Technology and the Pastoral Ideal in America* (New York: Oxford University Press), 1964.

31. Thomas Hart Benton, *An Artist in America,* 4th rev. ed. (Columbia: University of Missouri Press, 1983), p. 44.

32. Benton, "American Regionalism: A Personal History," *An American in Art* (Lawrence: University Press of Kansas, 1969), p. 149, originally published in *University of Kansas City Review,* 18 (Autumn, 1951), 11–74.

33. Benton, *An American in Art,* p. 167.

34. Archives of American Art, Thomas Hart Benton Papers, Manuscript entitled "The 1930s," Microfilm Roll 2326, Frame 1478.

35. Stuart Davis, Journal 1920–1922. Collection of Wyatt H. Davis (microfilm copy courtesy of Robert Hunter), pp. 39–40. I want to thank Dr. John R. Lane, Museum of Art, Carnegie Institute, for information on the Journal.

36. Davis, Journal, p. 68.

37. *Ibid.,* pp. 39–40.

38. John R. Lane, *Stuart Davis: Art and Art Theory* (New York: The Brooklyn Museum, 1978), p. 94.

39. *Soil,* 1 (January, 1917), 55, cited in Barbara Zabel, "The Machine as Metaphor, Model, and Microcosm: Technology in American Art, 1915–1930," *Arts Magazine,* 57 (December, 1982), 103.

40. "Made in America," *Broom,* 2 (June, 1922), 270.

41. "The Great American Billposter," *Broom,* 3 (November, 1922), 305.

42. From Bulletin of *America's Town Meeting of the Air,* 5 (February, 1940), in Diane Kelder (ed.), *Stuart Davis* (New York: Praeger, 1971), p. 121; and Davis, "The Cube Root," *ARTnews* (February 1, 1943), in Kelder, *op. cit., 130.*

43. Davis, Journal, May, 1921, p. 39.

44. Malcolm Cowley, "Pascin's America," *Broom,* 4 (January, 1923), 136.

45. Walt Whitman, *Complete Poetry and Selected Prose,* ed. by James E. Miller, Jr. (Boston: Houghton, Mifflin, 1959), pp. 460, 479.

46. Editorial in *The Seven Arts,* 1 (April, 1917), 630; Editorial in *The Arts,* 2 (November, 1921), 65; Paul Rosenfeld, "American Painting," *The Dial,* 71 (December, 1921), 656; and Marsden Hartley, "America as Landscape," *El Palacio* (December, 1918), 340–41. The last reference was kindly provided by Elizabeth Broun, National Museum of American Art.

47. Statement by Benton in John I.H. Baur, ed., *New Art in America* (Greenwich, Conn.: New York Graphic Society, 1951), p. 131.

48. Letter to Alfred Stieglitz, October 10, 1921, cited in Tashjian, *William Carlos Williams and the American Scene, 1920–1940* (New York: Whitney Museum of American Art, 1978), p. 77.

49. Letter to Stieglitz, November 28, 1921, cited in Emily Farnham, *Charles Demuth: Behind a Laughing Mask* (Norman: University of Oklahoma Press, 1971), 136, 137.

50. Henry McBride, "Modern Art," *The Dial,* 70 (February, 1921), 235.

51. "Comment on the Arts," *The Arts,* 1 (January, 1921), 31.

52. Charles Burchfield, "On the Middle Border," *Creative Arts,* 3 (September, 1928), xxv–xxxi.

53. [Henry McBride?], "The Winter of Our Discontent," *The Dial,* 69 (August, 1920), 159.

54. Edward Hopper, "Charles Burchfield: American," *The Arts,* 14 (July, 1928), 6, 10.

55. Brooks, "Enterprise," *The Seven Arts,* 1 (November, 1916), 60.

56. Hopper, "John Sloan and the Philadelphians," *The Arts,* 11 (April, 1927), 170.

57. Alexis de Tocqueville, *Democracy in America,* ed. by J.P. Mayer and Max Lerner, trans. by George Lawrence (New York: Harper and Row, 1966), p. 477.

58. *The Art Digest,* 1 (March, 1927), 14.

59. Lloyd Goodrich, "The Paintings of Edward Hopper," *The Arts,* 11 (March, 1927), 136.

60. For Ault and Bourgeois, see Typescript of Questions and Answers for an Exhibition [1920s?], Archives of American Art, George Ault Papers, Microfilm Roll D247, Frames 14–15.

61. Mary Austin, "New York: Dictator of American Criticism," *The Nation,* 111 (July 31, 1920), 129–130.

62. Royal Cortissoz, *American Art* (New York: Charles Scribner's Sons, 1923), p. 18.

63. Thomas Craven, "Men of Art: American Style," *The American Mercury,* 6 (December, 1925), 426.

64. Forbes Watson, "The All American Nineteen," *The Arts,* 16 (January, 1930), 303.

65. Benton, "America's Yesterday," *Travel,* 63 (July, 1934), 9.

66. Williams, *The Great American Novel [1923],* in Webster Schott, ed., *Imaginations* (New York: New Directions, 1970), p. 220.

67. "Quarterly Press Clips," People for the American Way (July–September, 1986), p. 5.

68. Brooks, "Toward a National Culture," *The Seven Arts,* 1 (March, 1917), 538.

69. Brian O'Doherty, "Portrait: Edward Hopper," *Art in America,* 52 (December, 1964), 72.

70. Letter to Frank Rehn, October 11, 1938, Charles Burchfield File, Whitney Museum of American Art.

71. Henry G. Keller, "Charles Burchfield," *The American Magazine of Art,* 29 (September, 1936), 592. See also *Charles Burchfield* (New York: American Artists Group, 1945).

72. Frederick S. Wight, "Charles Sheeler," *Art in America,* 42 (October, 1954), 205; and Wight, *Charles Sheeler* (Los Angeles: Art Galleries of the University of California, 1954), p. 28.

73. Davis, "Rejoinder to [Thomas Hart] Benton," *The Art Digest,* 9 (April 1, 1935), 12.

74. See, for example, Richard D. McKinzie, *The New Deal for Artists* (Princeton: Princeton University Press, 1973, p. 110; and Marlene Park and Gerald E. Markowitz, *Democratic Vistas: Post Offices and Public Art in the New Deal* (Philadelphia: Temple University Press, 1984), pp. 178–81.

18

"In My Family of Primitiveness and Tradition"

William H. Johnson's Jesus and the Three Marys

RICHARD J. POWELL

As an American artist of mixed-race ancestry who matured in the climate of European modernism, painter William H. Johnson stands apart from the conventional primitivists of the early twentieth century. Johnson was part of a generation of visual artists captivated by tribal art, imitated and admired as the creation of exotic primitive peoples whose racial origins positioned them in a world of casual naturalism and mystical spirituality that had been lost to the industrialized West. But as Richard Powell argues, Johnson's connection to primitivism can be explained neither as a manifestation of racial essentialism nor in terms of the widespread modernist practice of stylistic appropriation from tribal art forms. Rather, it was a complex and deeply felt conviction based on his prolonged self-examination as a person of color who identified with traditional folk cultures and the experience of cultural difference.

Jesus and the Three Marys is understood here as a highly individual work of modern religious art whose formal qualities and emotional tenor are located in the uniqueness of African-American religious experience, specifically the expressive, physical mode of worship practiced by black fundamentalist Christians. Powell attributes to Johnson, as an artist whose works incorporate multiple stylistic and cultural sources, from European modernism to the Harlem Renaissance, an authentic "internalized primitivism" liberated from the degrading connotations with which the term has been encoded.

> It is not only what we inherit from our
> fathers and mothers that keeps on
> returning in us.
> —Henrik Ibsen, *Ghosts* (1881)

Jesus and the Three Marys, by the American artist William Henry Johnson (1901–1970), presents a provocative addendum to the current discussion on primitivism in modern art [1]. Unlike the level of involvement of many modern painters and sculptors usually identified as being artistically conscious of Africa, Oceania, and the aboriginal Americas, Johnson's commitment to primitivism was neither shallow nor temporary. His interest was a career-long pursuit, manifested at times in intellectual apprenticeships with traditional cultures and at other times in a bold painting style marked by intense colors and figural distortions. Moreover, in contrast to the identification of most artists who appropriated the forms and moods of non-Western artworks, Johnson's African-American background and his

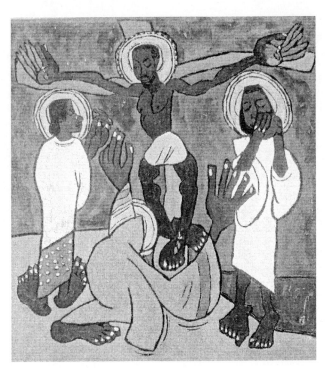

1. William Henry Johnson, *Jesus and the Three Marys,* ca.
1939–1940; courtesy of Howard University Gallery of Art, Washington,
D.C.

assertive self-identification with other peoples of color set his primitivism apart from the standard examples and raised it to another level of discourse—far beyond the categories discussed in either Robert Goldwater's classic *Primitivism in Modern Painting* or in the more recent study by William Rubin and Kirk Varnedoe, *"Primitivism" in Twentieth Century Art.*[1]

When he painted *Jesus and the Three Marys,* Johnson had just returned to the United States following twelve productive years in France, Denmark, and Norway. The works produced during this time—lively, expressive landscapes and searing, confrontational portraits—shared the chromatic brilliance and contorted forms of their French, German, and Scandinavian counterparts. Still, Johnson believed his work stood apart from the then-prevalent European preoccupation with "the primitive." "And even if I have studied for many years and all over the world," he observed in a 1932 interview for a Danish newspaper, "I have still been able to preserve the primitive in me. . . . My aim is to express in a natural way what I feel, what is in me, both rhythmically and spiritually, all that which in time has been saved up in my family of primitiveness and tradition, and which is now concentrated in me."[2]

Johnson's notion of an internalized primitivism was partially the product of what he often described in interviews as his "Negro-Indian" heritage. As the professed offspring of a black father and an Indian mother, Johnson frequently attributed his artistic talents to his background's racial and cultural blend. Apart from his assumption of biological determinism, the evidence suggests that, contrary to his claims, Johnson was probably the offspring of a white father and black mother.[3]

Nevertheless, the works Johnson produced during his European residency, rather than exemplifying anything innately African American or Native American, were conventional in subject matter, European in attitude, and thoroughly modernist in style. The series of watercolors he painted during a three-month sojourn in North Africa in 1932, for example, have more in common with the fluid, emotional works of the French and German Expressionist painters than with the flat, decorative sensibilities of the folk artisans of Africa and the Americas.

Still, one should not dismiss Johnson's primitivist pronouncements in Europe, as these ideas had more meaning for him intellectually than practically. In the context of 1930s Scandinavia, where folk and the so-called primitive arts enjoyed a wider appreciation than they did in other parts of Europe, Johnson's overtures to primitivism rang true.[4] For Johnson as well as other artists, the primitive impulse presented itself not only in works that resembled so-called tribal arts but in all works that took a life-and-death, heartfelt, and intuitive cue from their non-Western counterparts.[5]

Jesus and the Three Marys, painted circa 1939–40, shortly after Johnson arrived in the United States, carried his notion of primitivism into a new format. In a 1938 letter from Denmark, Johnson told his American agents that one phase of his artistic development was closing and another, anticipated on his return home, was soon to follow. "I am feeling," he wrote, "that I

would like my own homeland next, as I know of no better country to inspire me at this period of my artistic development."[6] No doubt Johnson realized he had changed during his years abroad. He began there as a disciple of his American teachers Charles Webster Hawthorne and George B. Luks and developed into an internationalist, carefully choosing, in the manner of the Scandinavian smorgasbord, a slice of Post-Impressionism, a generous serving of Expressionism, and a dash of the primitivist philosophy. This artistic course would culminate upon his return to America in an image like *Jesus and the Three Marys,* which proclaims its affinities with several artistic sources.

In Johnson's rendition of a classic Crucifixion scene with an unorthodox, African-American countenance, primitivism is given a more familial and empathetic treatment. Unlike the European moderns, whose principal encounters with "tribal" cultures took place in stilted colonial settings, in dusty ethnographic museums, or in private collections of foreign curiosities, Johnson, through *Jesus and the Three Marys,* discovered "the primitive"—the roots, sources, and essences of culture—*within.*

The components of *Jesus and the Three Marys,* though readily observable, are still worth mentioning. Jesus, the central figure, is shown hanging from a blue cross and flanked on either side by a Mary, and in the foreground is a third Mary. The three Marys are the women who stood at the foot of the cross while Jesus was crucified: Mary, the mother of Jesus; Mary, the wife of Cleophas; and Mary Magdalene.[7] Unlike the two flanking Marys, the Mary in the foreground, arms flung upward, is bowed over and partially concealed by an orange cloth set in free-form motion. All four figures are placed against a seminaturalistic landscape, with reddish-brown and dark blue earth below the horizon line and a muddy brown firmament above it. Golden halos encircle their heads, and their hands and feet are large. All the pictorial ele-

ments, figural and nonfigural, are outlined in black.

In contrast to the somber moods of most Crucifixion images, *Jesus and the Three Marys* shifts freely between melancholy and euphoria. The figures' wrenched and stigmatized hands and feet, for example, suggest a set of emotions that stands in sharp contrast to the mood conveyed by their facial expressions. Similarly, the dark, moody colors in the painting's background are offset by the lighter, vibrant colors that depict the figures. This dialectic is especially evident in the image of the crucified Christ, who appears serene on the blue cross in spite of the dunglike, muddy color that surrounds him.

Johnson's focus on this time-honored New Testament theme has obvious links to the Crucifixion imagery of the great Northern Renaissance artist Matthias Grünewald. But aside from the shared subject matter—and the fact that Johnson, like other Expressionists, saw protomodernist elements in Grünewald's paintings—the emotional and philosophical territories explored by the two artists testify to diverging points of view.[8]

Grünewald's emphasis on death, earthly suffering, and the exemplary nature of Jesus' ordeal is simply absent from Johnson's painting. Nowhere in *Jesus and the Three Marys* is there a sense of angst like that conveyed by Grünewald's *Crucifixion*. On the contrary, Johnson's painting presents a traditionally sorrowful subject in a highly animated and colorful manner. Though the bare feet and groping hands of Johnson's characters might imply humility and want, their larger-than-normal size and abstract conceptualization cancel out any single emotional interpretation.

The hands and feet of the figures in *Jesus and the Three Marys* are imploring, prayerful, exalted, and brutishly physical. One might use these same adjectives to describe the hands and feet of the figures in Grünewald's *Crucifixion,* but the incisive, mannered depiction of limbs in

the Northern Renaissance work reflects a decidedly Germanic sense of physical reality that was obviously not Johnson's intention. The pain and anguish that emanate from Grünewald's characters are present in Johnson's painting only as imposed by Western audiences culturally attuned to responding to Crucifixion scenes with sorrow. The crosscurrents of reserved supplication, rapture, and coarse physicality in *Jesus and the Three Marys* set Johnson's painting apart from the traditional religious context.

This highly individual version of a familiar biblical scene parallels similar revisions in modern religious art. Georges Rouault, among others, depicted people and events from the Bible in new, unconventional ways. Although the works are anchored in the Judeo-Christian tradition through their titles and subjects, the formal and symbolic dictates of modernism push them into contemporary settings in which the circumstances and dilemmas of modern life are aligned with biblical accounts of sacrifice, faith, and moral deliberation.

In *Ecce Homo* (1926), one of the best-known works by Johnson's fellow artist and brother-in-law, the German sculptor Christoph Voll, one also sees a thoroughly modern depiction of a standard religious icon. Like Johnson's central figure in *Jesus and the Three Marys,* Voll's Jesus exudes a twentieth-century expressivity and individuality. This sinewy, three-dimensional interpretation of the Latin allusion to a scorned and taunted Jesus—"Behold the Man"—bears the stamp of true Expressionism in its heightening of emotional potential through roughly textured surfaces and the exaggerated renderings of hands and feet. Like Johnson, Voll chose not to present Jesus as he is usually portrayed in Western art. Rather, Voll's Christ is an indigent beggar—naked, elderly, and agonizingly sensuous. The almost nightmarish figural distortions and wrenching emotions in *Ecce Homo* link Voll with his fellow German Expressionists and with such artistic ancestors as Grünewald.[9] Ironically,

Voll's own artistic "crucifixion" in 1937 during Munich's infamous "Degenerate Art" exhibition, as well as his premature death in 1939 following altercations with Third Reich officials over his expressionist stance in art, has an eerie, narrative parallel in Johnson's *Jesus and the Three Marys.*[10]

Yet, while *Jesus and the Three Marys* shares obvious thematic elements with *Ecce Homo* as well as a tendency toward anatomical exaggeration and artistic license, it avoids the emotional excesses that Voll and his artistic counterparts engaged in so freely. Johnson transformed his Crucifixion scene into a spirited yet dispassionate visual essay, and, in doing so, he set it apart from the majority of primitivist works of his day.

What distinguishes *Jesus and the Three Marys* may very well be the degree and the quality of its reliance on non-Western artistic traditions. Among German Expressionists like Emil Nolde, for example, the arts of Africa, Oceania, and Native America were often used as artistic ammunition against conservative aesthetics and what was then perceived as the emotionally repressive culture of the West.[11] In Johnson's case, however, the "primitive" is not so much a reaction against something as it is a testimony to humanity in its original and preindustrialized state.

As opposed to the "very superficial" and "complicated" societies of modern Europe and America, Johnson believed that the peoples of Africa, the aboriginal populations of the world, and even the "primitive" fishermen of Denmark all "have preserved the [essential] characteristics of their nature" and were collectively a people "in whom there is an element of tradition." Primitivism, as viewed by Johnson, had less to do with the artistic products of peoples of color than it did with the community values and folkways of all marginalized peoples. "Primitives," concluded Johnson, "can be found all over the world."[12]

Johnson's familiarity with African sculpture—through his early associations with the Parisian

art dealer Pierre Loeb and the Harlem Renaissance patriarch Alain Locke and, later, through visits to the Copenhagen apartment of the Danish collector and amateur ethnographer Carl Kjersmeier—differed fundamentally from his European counterparts in two important ways. First, these early encounters with African art seemed to be little more than passing; they rarely informed his European-based work.[13] Second, as a self-proclaimed "person of color" and heir to the Harlem Renaissance's emphasis on folk roots, derived in part from the writings of Friedrich Nietzsche, Johnson recognized the intrinsic value of African art and culture as a historical, cultural, and personal locator in a way that his fellow Europeans never could.[14] During his 1932 visit to Tunisia, for example, Johnson studied firsthand that culture's millennium-old pottery industry, took part in traditional religious ceremonies, and even dressed in the robes and turbans of the North Africans, all in the interest of making a direct, personal connection with Africa.

Johnson's later experimentation with African forms and images, though tinged with a wonderment and an objectification similar to the attitudes expressed by many European artists, was balanced by an understanding of African art's formal capacity to convey something about the life and spiritual dimensions of black people. In several studies of African sculpture executed by Johnson circa 1939, one perceives an intentional meshing of the wooden and inanimate with the corporeal and humanistic. By rounding off, or naturalizing, the sharp edges and angles on selected African figures and masks, Johnson infused these objects with a life of their own. When these sculptural studies are paired with the nude studies of the mostly African-American models Johnson was producing at the same time, the overall effect is one of art imitating life imitating art. Like the symbolic poses and gestures in *Jesus and the Three Marys,* Johnson's figural studies possess an inner vitality and power that,

unlike many African-derived figures in modern painting and sculpture, propel them into a specific, painted discourse on black style and bearing.

Johnson's identification with the so-called primitive is, therefore, derived from several sources: first, the standard Western European attraction to and appropriation of African art forms; second, the prevailing perception of African and other preindustrialized cultures as radical, liberating forces in the face of Western technological "decadence"; and third, the idea that so-called primitive peoples have a more harmonious relationship with nature and consequently a stronger spiritual foundation than their industrialized counterparts. Of course, it almost goes without saying that none of these notions of primitivism have anything *really* to do with the arts, religions, and beliefs of African, Oceanic, or Native-American peoples; rather, they are Western concepts imposed from the outside.

Johnson's primitivism, however, in addition to incorporating these Western notions, was predicated on a formal and philosophical examination of the African-American self. As opposed to a primitivism that looks exclusively to exotic wooden sculptures or faraway places for inspiration, Johnson's primitivism turned inward, focusing on a self defined by racial difference, cultural distinctiveness, a marginal status in society, and an identification with black, fundamentalist spirituality.

Jesus and the Three Marys, the first of many primitive paintings by Johnson, draws its peculiar strength and appeal from flesh-and-blood, church-going black folk in America, who express their religion in a physical, outward manner. The bowing and gesturing Mary in the painting's foreground surpasses all of the standard depictions of mourning and lamentation in Christian art and specifically recalls a real-life, African-American worshiper, caught up in an ecstatic, spirit-induced "holy dance." This image—derived from Johnson's South Carolina youth and witnessed on his

reentry into Harlem about 1939—carries in its undulating, elemental form the very notion of primitivism. But rather than a primitivism that connotes something foreign and uncultivated, the primitivism of *Jesus and the Three Marys* is familiar, stylized, and highly developed. Instead of the romantic and denigrating implications usually attached to the term, Johnson's primitivism, in the context of works like *Jesus and the Three Marys,* suggests being original, unadulterated, and primal—descriptions that also apply to the "sanctified" African-American worshipers Johnson evokes in these works.

In his quest for a painting style that would complement the spiritual yet forceful intentions of this post-1938 phase, Johnson modified his previous, more painterly technique by creating simpler, more lucid compositions. He rendered all his figural elements in black outlines and applied his oil paint onto the canvas or wooden panel with a heavy, impasto consistency. The final effect is not unlike that of the cartoons in the Sunday paper. Although Johnson had long abandoned his original goal of becoming a cartoonist, the genre's main components—narrative compositions constructed from colorful, interlocking shapes outlined in black—found a place in Johnson's post-1938 artistic phase.

Emily Genauer, the *New York World-Telegram* art critic, observed that Johnson's paintings were "almost like cartoons in their approach, but they're put together with an extremely original flair for design, with a pervading sense of movement and rhythm, and with a cadence which seems to suggest Negro spirituals somewhat."[15] In addition to his personal fascination with cartoons, Johnson probably realized that this popular art form was an ideal model for an egalitarian yet truly modern painting technique. In this respect, *Jesus and the Three Marys* can be compared to contemporaneous paintings by artists like Stuart Davis and John Graham, who, in their own ways, juggled modernist tenets and primitivist and popular sources with relative ease.

This balancing act between modernity and tradition was identified in a review of the "Exhibition of the Art of the American Negro" show, held in conjunction with the American Negro Exposition in Chicago from July to September 1940. Singling out Johnson's contributions to the exhibition, which included *Jesus and the Three Marys,* one reviewer noted:

> The heavy paint, the free drawing of the figures and the discarding of nonessentials might at first glance make us think he is a naive. But each color mass holds its own as a color and yet is related to every other mass, without getting lost or sweet. This proves that Johnson, as an artist with a mind and emotion, knows what the great modern masters have contributed to the clarification and progress of color.[16]

The broad appeal of the cartoons was certainly a factor in Johnson's overtures toward a chromatic, linear, and narrative painting technique. The cartoon's emphasis on caricature—its visual shorthand and exaggeration of reality—is also an element in his paintings from this period. Johnson had a knack for capturing the likenesses of people and the essential features of a landscape through minimal yet expressive brushwork. Evidence of his creative fusion of caricature and modern portraiture is a self-portrait painted toward the end of his two-year stay in Norway. Although *Self-Portrait with Pipe* (1935–1938) owes much of its formulation to such artistic role models as Edvard Munch and Emil Nolde, Johnson was, by the mid 1930s, already a master of expressive portraiture, improvisational painting, and visual synthesis in art.

In *Jesus and the Three Marys,* Johnson employed comparable techniques to suggest not only specific characterizations but also the emotional states and social conditions of his subjects. The large hands and feet on Jesus, the three Marys, and the other black figures can be interpreted as exaggerated visual indicators of a people of lowly status—a class of women and men whose lives are defined by manual labor and rough, calloused appendages. Old sayings and popular tunes from black America about overworked and distended limbs—like Thomas ("Fats") Waller's "Your Feets Too Big!"—become larger-than-life, though recognizable, tropes in paintings like *Jesus and the Three Marys.*

Johnson's religious works following *Jesus and the Three Marys* also show a debt to the visual shorthand and narrative power of cartoons. The monumental *I Baptize Thee* combines a colorful, planar approach with a theme that unabashedly revels in a primal religiosity. In both works reductive approaches to form and composition underscore Johnson's attempt to make his subjects elemental and accessible to all, while the anatomical distortions fuel a sense of religious ecstasy and transcendence.

The spirituality and drama in these paintings have a counterpart in another popular, African-American art form of the twentieth century: gospel music. This essentially post–Civil War variety of black religious music fuses slave-era spirituals and hymns with modern blues, jazz, and pop instrumentation. The original proponents of gospel music were, for the most part, black fundamentalists whose religious affiliations—the Holiness Church, the Church of God in Christ, and the Pentecostal Church—were outside the African-American Baptist mainstream.[17] The religious services and modes of worship among black fundamentalists are characterized by outwardly expressive, physical responses. Involuntary jerking and rhythmic body movements, syncopated singing and hand clapping, and, sometimes, falling into a trance as a result of spiritual possession are the most obvious features of church services that feature gospel music.[18]

A circa-1940 drawing by Johnson showing black worshipers surrounding an old upright piano, in what appears to be a converted, storefront church, illustrates his awareness of black

religious fundamentalism and the centrality of gospel music to modern black religious expression. When examined together, *Jesus and the Three Marys, I Baptize Thee,* and a host of later paintings and drawings on African-American religion constitute a body of work that unequivocally celebrates black spirituality from both a liturgical and a sociological point of view. What is perhaps all the more amazing about these works is that they avoid the intellectual trap of a professed objectivity as well as the methodological pitfall of viewing black religion from an essentially European cultural standard. As expressed in these and other paintings, Johnson's 1932 pronouncement crediting his innate "family of primitiveness and tradition" as the guiding forces in his work finally takes a concrete form.

The rediscovery of William H. Johnson as an accomplished artist in Europe and the United States in the 1930s and 1940s and the reassessment of his contributions to art during those watershed years open up yet another tract on modern art and the concept of primitivism. As *Jesus and the Three Marys* demonstrates, the concept achieves a new viability when examined in light of an artist whose notions of "primitiveness and tradition" are undergirded by his social and aesthetic identification with "the folk." Johnson's quest for an authentic, inner primitivism took him beyond Paris (and his initial affinity for the Impressionist style), through the south of France, Scandinavia, Germany, Tunisia, and back to a previously untapped American source—a journey that demonstrates that the so-called Western world, too, has its share of "tribal" impulses. By articulating his primitivism primarily through his own African-American and Judeo-Christian background, Johnson compels serious reconsideration of a concept that is sometimes dismissed as a superficial attraction for "the other." When, as in Johnson's case, the artist is a self-conscious, willful, culturally grounded "primitive," one discovers in primitivism a profound and fascinating search—not just for a radical new image but for the very root itself.

NOTES

From *American Art* (Fall 1991). Reprinted by permission of the author and the National Museum of American Art.

1. Robert Goldwater, *Primitivism in Modern Painting* (New York: Harper, 1938); William Rubin and Kirk Varnedoe, eds., *"Primitivism" in Twentieth Century Art: Affinity of the Tribal and Modern,* 2 vols. (New York: Museum of Modern Art, 1984). Although published more than fifty years ago, Goldwater's pioneering study is still considered the definitive book on the subject. Rubin and Varnedoe's study continues Goldwater's investigations, tracing the concept of primitivism across national and stylistic boundaries and up to the 1980s. Unfortunately, neither work discusses artists like William H. Johnson, Frida Kahlo, and others who have actual as well as professed links with so-called primitive cultures. A serious study of

these Third World (i.e., traditional) modernists promises an invigorating exploration of twentieth-century art movements and the cyclical pull in modern art toward traditional and primitive archetypes.

2. William H. Johnson, quoted in Thomasius, "Dagens Interview: Med Indianer-og Negerblod i Aarene. Chinos-Maleren William H. Johnson fortæller lidt om sin Afrikarejse, primitiv Kunst, m.m.," *Fyns Stiftidende* (Odense, Denmark), 27 November 1932, p. 3.

3. "My father was black and my mother is Indian," Johnson was fond of telling reporters, "and both of these people have in them an artistic tendency which clearly has culminated in me." Johnson, quoted in Thomasius, p. 3. See also Dr. Rank, "Kunstnerisk Krydsning Kulmineret i København . . . ," *Ekstrabladet* (Copenhagen, Denmark), 18 April 1933, p. 6. For biographical information about Johnson, see Richard J. Powell, *Homecoming: The Art and Life of*

William H. Johnson (New York: Rizzoli International Publications for the National Museum of American Art, 1991).

4. In response to the Museum of Modern Art's 1984 exhibition *"Primitivism" in Twentieth Century Art* and Rubin and Varnedoe's accompanying catalogue, the Louisiana Museum in Denmark organized an exhibition and produced a publication in 1986 that examined primitivism as an aesthetic issue among modern and contemporary Danish artists and intellectuals. For one of the most informative essays accompanying the Danish exhibition, see Mette Nørredam, "Primitivisme i dansk kunst," *Louisiana Revy* 26 (May 1986): 16–26. For a provocative study of the evolving attitudes of Germans concerning blacks and their culture, see Jost Hermand, "Artificial Atavism: German Expressionism and Blacks," in *Blacks and German Culture,* ed. Reinhold Grimm and Jost Hermand (Madison: University of Wisconsin Press, 1986), pp. 65–86.

5. Primitivism as an active component of modern intellectual discourse in the West is thoroughly examined in Marianna Torgovnick, *Gone Primitive: Savage Intellects, Modern Lives* (Chicago: University of Chicago Press, 1990).

6. William H. Johnson to Mary Beattie Brady, 22 August 1938, Harmon Foundation Papers, Manuscript Division, Library of Congress, Washington, D.C.

7. John 19:25.

8. Several postcard details of Grünewald's Crucifixion panel in the *Isenheim Altarpiece* (ca. 1513–15, Unterlinden Museum, Colmar, France) are pasted in Johnson's personal scrapbook; William H. Johnson Papers, Archives of American Art, Smithsonian Institution, Washington, D.C. Twentieth-century writings that discuss the importance of Grünewald's work for modernists include J. K. Huysman, *Trois Primitifs: Les Grünewald du Musée de Colmar, le maitre de Flémalle et la Florentine du Musée de Francfort-sur-le-Mein* (Paris: Librarie Léon Vanier, 1905); Hans Bodensieck, "Matthias Grünewald und der Expressionismus," *Christliches Kunstblatt* 61 (1919): 154–59; and Christian Zervos, *Matthias Grünewald: Le Retable d'Isenheim* (Paris: Cahiers d'art, 1936).

9. For biographical information on Christoph Voll, see Roberto Tassi and Emilio Bertonati, *Christoph Voll: Skulptren, Aquarelle, Zeichnungen* (Munich:

Galleria del Levante, 1981); Stephanie Barron, *German Expressionist Sculpture* (Los Angeles: Los Angeles County Museum of Art, 1983); and Stephanie Barron, ed., *German Expressionism, 1915–1925: The Second Generation* (Munich: Prestel, 1988). I am also indebted to Christoph Voll's granddaughter, Johanna Voll, for sharing family anecdotes with me during visits to her home in Skodsborg, Denmark, between September 1984 and June 1985.

10. Johanna Voll, interview with author, Skodsborg, Denmark, 5 October 1984. See also Stephanie Barron, ed., *"Degenerate Art": The Fate of the Avant-Garde in Nazi Germany* (New York: Harry N. Abrams for the Los Angeles County Museum of Art, 1991).

11. See Jost Hermand, pp. 65–86, and Stephen Eric Bronner, "Emil Nolde and the Politics of Rage," in *Passion and Rebellion: The Expressionist Heritage,* ed. Stephen Eric Bonner and Douglas Kellner (New York: Universe Books, 1983), pp. 293–311.

12. Johnson, quoted in Bodil Bech, "En 'Indian-Negro' Maler i Kerteminde," *Tidens Kvinder* 9 (10 November 1931): 10, and Rank, p. 6.

13. As evidenced in several letters from his scrapbook, Johnson met the famous art dealer Pierre Loeb during his initial stay in Paris (ca. 1926–27). Johnson had made Alain Locke's acquaintance in New York City (ca. 1929–30) on the occasion of being awarded the 1929 Harmon Foundation gold medal for distinguished achievements among Negroes in the fine arts. Although it is not known when Johnson first met the Danish collector and amateur ethnographer Carl Kjersmeier, personal reminiscences mention a visit (accompanied by the singer and actor Paul Robeson) to Kjersmeier's Copenhagen apartment in January 1935 to view his superb collection of African art. Scrapbook and biographical sketch of Holcha Krake Johnson, n.d. (ca. 1946), Johnson Papers.

14. For a comparison of the two philosophical spheres that Johnson periodically explored in the context of his evolving primitivism, see Edmund Barry Gaither, "Heritage Reclaimed: An Historical Perspective and Chronology," in *Black Art—Ancestral Legacy: The African Impulse in African-American Art,* ed. Alvia Wardlaw (Dallas: Dallas Museum of Art, 1989), pp. 17–34, and Donald Gordon, "German Expressionism," in Rubin and Varnedoe, eds., pp. 369–403.

15. Emily Genauer, "Latest Johnson Work Placed on Exhibition," *New York World-Telegram,* 1 May 1943, p. 9.

16. Fritzi Weisenborn, "Pier Exhibition Poses Some Questions," *Chicago Sunday Times,* 21 July 1940, p. M13.

17. For a brief history of these black religious organizations, see C. Eric Lincoln and Lawrence H. Mamiya, "The Black Pentecostals: The Spiritual Legacy with a Black Beginning," in *The Black Church in the African American Experience,* ed. C. Eric Lincoln and Lawrence H. Mamiya (Durham, N.C.: Duke University Press, 1990), pp. 76–91.

18. For a discussion of the origins of gospel music, see Paul Oliver, "Gospel Music," in *The New Grove Gospel, Blues and Jazz,* ed. Paul Oliver (New York: W. W. Norton, 1986), pp. 189–99.

19

Images of American Women in the 1930s

Reginald Marsh and Paramount Picture

ERIKA L. DOSS

In Reginald Marsh's Paramount Picture, *the larger-than-life-size poster image of* Cleopatra *serves as the backdrop for a rather ordinary, somewhat world-weary female who stands outside the theater. Such representations of the cinema provide a glimpse of the manner in which popular entertainment contributed to the formation, and transmission, of American social attitudes. Erika Doss examines this phenomenon as it is brought to bear on the construction of female identity during the Depression. Weaving together film history, employment statistics, and attitudes toward women in the workplace, Doss exposes the destructive influence of the many complex messages sent to women who frequented the movies.*

The historical figure of Cleopatra epitomizes a stock character of this so-called golden age of the American cinema: the attractive, scheming seductress whose abuse of power resulted in her tragic downfall. At a time when competition for employment was fierce, the growing visibility of women in the workplace was cause for concern. Unlike the fantasy world of film heroines, however, ordinary working women did not lead glamorous lives that ended in blissful romantic unions, so long as their ambition was held in check. As Doss concludes, women audiences found little evidence of the reality of their own lives in these films, which served rather as cautionary tales for the enlightenment of ambitious women.

The subject matter of popular entertainment—bowling alleys and burlesque, movie theaters and radio shows, amusement parks and nightclubs—has long been a topic to which American artists have turned. From George Caleb Bingham's 19th-century *Raftsmen Playing Cards* to George Bellows's 1924 paean to boxing, *Dempsey and Firpo,* American painting is noteworthy for its delineation of the pleasurable pastimes and pursuits of Americans at play. Perhaps no American artist during the 20th century was more preoccupied with what Americans did with their leisure time than Reginald Marsh (1898–1954), who sketched and painted the social activities of his New York neighbors throughout his career. Spying on the urban populace with binoculars from the ninth floor of his 14th Street studio, or wandering around the Bowery, Coney Island, or Broadway, Marsh watched how people shopped, flirted, waited in line, or amused themselves in a variety of pas-

times. Although well known for his burlesque paintings (one, *Strip Tease in New Jersey,* 1945, shows his friends and patrons Senator William Benton and *Life* publisher Henry Luce captivated by a robust Gypsy Rose Lee–like figure), Marsh's movie paintings and his sketches of moviegoers and movie theaters record the effect of movie culture on American life in the early decades of the 20th century. Especially during the 1930s, the golden age of the movies when hundreds of films were released annually and millions watched them in theaters across the country. Marsh made movie culture—moviemaking, moviegoing, moviewatching, the movies themselves—a major theme in many of his significant paintings. From *Twenty Cent Movie* (1936) to *Death of Dillinger* (1939) and *One Hour of News* (1940), Marsh described the facades of movie palaces and the wide-ranging audiences who frequented them. In *Paramount Picture* (1934), a portrait of the Times Square movie house, the Paramount Theatre, Marsh focused on the ironic contrast between the content of Hollywood films and the reality of American life during the Depression.

At the painting's left, a dark-clad young woman poses in front of a huge movie poster advertising Claudette Colbert and Henry Wilcoxon in the Cecil B. DeMille epic, *Cleopatra* (1934). At the far right a well-dressed middle-aged couple, he in a fashionable fedora, she swathed in furs, waits outside the theater entrance, and deep inside the doorway can be seen a woman purchasing a ticket. Specific details in the painting point to Marsh's fascination with the topical: the signs "CLAUD," and "A Paramount Picture"; the distinctive architectural features of the gaudy rococo theater; the clothing of the seemingly-affluent movie patrons on the far right. But Marsh's formal concentration on the *Cleopatra* poster and the woman standing beneath it suggest the iconographic priorities in *Paramount Picture:* the contrasting images of women in the 1930s.

Claudette Colbert's seductive milky figure looms large over the waiting woman, who is nestled between the movie star's bosom and bejeweled arms. Dark complected and dressed in a purplish rayon outfit typical of the 1930s working girl, she clutches a handbag crammed with papers and glares out from under her tilted cloche with a piercing look. Unsmiling and weary, she is separated from the alluring Colbert by her rigid stance and somber clothing. By playing on the diversity of these two women, the one a movie culture concoction of sultry femininity, the other a fatigued shop girl or stenographer (or, more likely, unemployed), Marsh details the contradictions inherent between the coy goddess Hollywood considered the ultimate in womanhood and the bleak reality of the working girl. By placing the weary female squarely in movie queen Colbert's clutches, Marsh posits, perhaps, that Hollywood movies are guilty of spawning the sort of personal unrest and unhappiness evidenced in the ordinary women of the period. He may also be suggesting to his viewers that movies like *Cleopatra*—lavish, fantastic spectacles chronicling the escapades of an unrestrained queen—were leading factors in contributing to the confusion women felt about their image and status in America.

Marsh's artistic training combined academic and commercial pursuits, both of which prepared him for a career devoted to the exploration of the sociocultural phenomena recognized in *Paramount Picture.* Born at the turn of the century in a Parisian apartment above the Café du Dôme (later a haunt of the Montmartre Cubists), Marsh was the son of two artists. His father was one of the earliest American painters to depict modern industry and his mother was a miniaturist.[1] Lloyd Goodrich, a friend of the artist since their boyhood together in Nutley, New Jersey, revealed that Marsh "began to draw before he was three, and for the rest of his life he drew constantly, unceasingly."[2] Marsh's ability to draw made him the star illustrator of *The Yale Record* and gave

the magazine an edge over its collegiate competitors. *Record* editor William Benton (future Senator and publisher of the *Encyclopedia Britannica*) paid Marsh an unprecedented $50 a month for his popular illustrations.[3]

Following graduation, Marsh joined the staff of the New York *Daily News,* where from 1922–25 his assignments ranged from theater reviews to court trials. Benton recalled this period in Marsh's life:

> Vaudeville was in its Orpheum heyday. Reg drew sketches of six or seven of the acts on the program vertically, one under the other, in a full column, and then he'd give to each act a rating, 50 percent—10 percent—95 percent. One day he would cover the Palace; the next day the Keith Orpheum up on Columbus Circle; the following day the big vaudeville house in Brooklyn. He was New York's first and only daily pictorial theatrical critic.[4]

Also during the 1920s Marsh designed the sets and curtains for John Murray Anderson's production of *The Greenwich Village Follies* and collaborated with Robert Edmond Jones and Cleon Throckmorton in the theater designs for the Provincetown Playhouse.[5] During the 1923–24 season he designed a drop curtain for the Broadway production of Melchior Lengyel's *Sancho Panza* (in which Otis Skinner played the title role of Don Quixote's squire).[6] Marsh's commercial work—the vaudeville reviews for the *Daily News,* his theater set designs, cartoons for *Vanity Fair,* and movie reviews for the *New Yorker*—was marked by an intentional cultural empiricism which effectively captured the spirit of the decade. His work in oil, which he started seriously in 1923 after sporadic study at the Art Students League under the tutelage of John Sloan and Kenneth Hayes Miller, was also colored by this attention to popular cultural events.

Besides Marsh, other American artists, many of whom studied and taught at the Art Students League, worked within the same popular culture framework, and, in probing the fads and novelties of urban life, turned their attention to the movies. As early as 1907, John Sloan painted a pioneer depiction of "going to the movies" in his *5¢ Movie;* 30 years later, at the very height of movieland's cultural impact, Thomas Hart Benton painted the dynamic montage mural *Hollywood.* Edward Hopper, indebted to movie culture not only for the topical subject matter it provided but also for its formal qualities, mirrored the sensibility of *film noir* in paintings such as *Office at Night* (1940) and *Nighthawks* (1942).[7] In paintings from the riotous *Twenty Cent Movie* (1936) to *Box Office Line, with Barbara Stanwyck* (1946), Marsh analyzed the participatory aspects of movie culture, interpreting the "social" nature of going to the movies. In these pictures women dressed for the occasion, chatting and primping, are seen within the portals of typical Depression-era movie palaces. Marsh portrays them standing beneath huge posters of Hollywood screen goddesses—the sumptuous blonde Anna Sten in *Twenty Cent Movie* and an amorous, negligee-costumed Barbara Stanwyck in *Box Office Line*—and further delineates contrasting female images. In these movie paintings, and especially in *Paramount Picture,* Marsh examines both the act of movie going and the meaning of movies in American life.

The story of Caesar, Antony, and Cleopatra has been filmed at least ten times, and until the 1963 version (with Elizabeth Taylor), Paramount Pictures' 1934 *Cleopatra* was considered the definitive and most dazzling tribute to the mysterious Queen of Egypt.[8] During the teens and 1920s, Cecil B. DeMille made several "bedroom and bathroom" movies in which female stars were viewed relaxing in spacious marble and chrome bathrooms (Gloria Swanson in *Male and Female,* 1919), or disrobing in luxurious, stylish bedrooms (Lillian Rich in *The Golden Bed,* 1925). With *The Ten Commandments* (1923), *The King of Kings* (1927), and *The Sign of the*

Cross (1932), DeMille embarked on a series of historical movie epics spiced with sex and spectacle from which he rarely deviated. *Cleopatra* is typical; there is a show of skin "in which De-Mille reveled at his erotic best."[9] Colbert first seduces Caesar (tempting the haughty emperor by whispering: "It's strange to see you working. I've always pictured you either fighting . . . or loving."), and then debauches with Antony. Advertised as "a love affair that shook the world, set in a spectacle of thrilling magnificence," some ads also subtitled the film, *The Siren of the Nile*.[10] The film is replete with scantily clad slave girls performing exotic dances. A garlanded ox is caressed by seminaked girls; girls dressed only in seaweed sprawl on the decks of boats; and in the bedroom of her swan-necked barge the gauze-clad Cleopatra plots, seduces, and dies. As DeMille described Colbert's performance: "In all her scenes she was perfect. She was the imperious Queen. She was the vivacious, alluring woman. She was Egypt."[11]

DeMille's account of Colbert's screen presence recalls the basic image attractive, successful women communicated in Hollywood films of the 1930s: essentially they were "celluloid aphrodisiacs," dressed in tight fitting gowns with plunging necklines, and very often their feminine strengths were equated with evil.[12] Even though Colbert was not a "blonde bombshell" (she is a brunette), in *Cleopatra* she looked and acted very much like those blonde Hollywood sex goddesses—Jean Harlow, Mae West, Joan Blondell, Constance Bennett—who tempted men with their beauty and sexuality. Dressed in silks and satins, moving gracefully but provocatively, whispering or chattering in low-keyed, coy dialogue, these women were objectified as soft, smooth, statuesque sex objects. And especially after the Hays Office Production Code went into full effect (between 1933 and 1934), women's sexuality was generally presented as both cunning and destructive—hence DeMille's direction of the beauteous Cleopatra

as a plotting, all-devouring, and eventually ruinous schemer. Obviously, he was acting in accordance with the demands of the story, but earlier and subsequent versions of the Cleopatra saga (Theda Bara in 1917 and Taylor in 1963) show a less venomous, more subtle approach to the queen's sexuality, schemes, and demise. What happened to Cleopatra in the 1934 film is essentially what happened to most strongwilled and successful women in 1930s films: their strength is dismissed as something "bad," and because of their strength they are classified as the Evil Woman, the prototypical Hollywood Bitch. Bette Davis personified this "type" in such films as *Of Human Bondage* (1934, in which she destroys medical student Leslie Howard), *Jezebel* (1938, where a former beau is slain in a duel born of her plotting), and *The Little Foxes* (1941, where she withholds heart medicine from her husband and watches him die); in each instance she either repents or is punished. Other women acting in roles which demanded that they be strong and successful were treated similarly—Barbara Stanwyck in *Baby Face* (1932) and Katharine Hepburn in *Christopher Strong* (1933) are but two examples. In all likelihood, accomplished, powerful women were treated this way in Depression films because in real life their existence was regarded as both a slap in the face and a threat: movie studio heads presumed that unemployed American men would not appreciate viewing successful women, on screen or off.

Although some feminist ground had been gained in 1920s films like *A Woman's Woman* (1922) and *His Secretary* (1926), which realistically projected socially mobile American women in the urban work market, few movies during the Depression delineated the dismal status of the unemployed.[13] Again, Hollywood decision makers presumed, probably correctly, that unemployed Americans did not want to see movies about themselves at the breadlines and unemployment offices. Robert and Helen Lynd, in

their second study of Muncie, Indiana, claimed *Les Miserables* was a flop because:

> Audiences, according to the exhibitors, have been definitely wanting more pictures "on the happy side" in the depression. They have wanted the movies more than ever to supply the lacks in their existence. The "fairyland" type of picture has been more popular than ever—the type of picture that lifts people into a happy world of gaiety and evening clothes.[14]

That is not to say that Hollywood strayed from the working girl picture developed in the 1920s. They continued to be made, but the truth about the deplorable conditions for working women was distorted deliberately in cheery movies like *The Gilded Lily* (1935), *Traveling Saleslady* (1935), and *Gold Diggers of 1937*. As film historian Marjorie Rosen observes, "Depression movies portrayed women working by their wits. . . . In the name of escapism, films were guilty of extravagant misrepresentations, exuding a sense of well-being to the nation in general and women in particular."[15] Hollywood's working women were dressed and housed elegantly. As girl reporters, detectives, secretaries and fashion illustrators, movie career women had glamorous, exciting jobs and were surrounded constantly by the attractive men to whom they catered and, more often than not, married. But these sagas of the successful working girl were, according to Rosen, fantastically packaged lies which insulated females "from the facts of their social and economic undermining."[16]

Despite the apparent "flood tide" of female employment that swept the country during the 1920s (the number of professional women increased by 460,000 and business women by over 100,000), working women in the 1930s were indeed "undermined" by the Depression.[17] At the start of 1930, ten million women were employed in America; however, by the end of the year more than two million had lost their jobs. Reports from the National Industrial Conference Board and the American Federation of Labor in 1936 showed that women formed almost 60% of the total unemployed. Since in one out of six urban families women were the sole wage earners, and 10% of all unemployed women were heads of families, even the exigencies of the Depression do not seem to justify this economic discrimination.[18] Though women worked at lower wages than men in the same jobs, government and labor organizations and mass audience women's magazines like *McCall's* and the *Ladies Home Journal* suggested that women should be self-sacrificing and give up their places in the job market in order for men to find employment. Women were urged to "volunteer" their labor; the fact that many women had to work was generally ignored. Even the first female Secretary of Labor, Francis Perkins, denounced the "pin-money" female worker, calling her a "menace to society, a selfish short-sighted creature who ought to be ashamed of herself."[19]

In Marsh's 1934 painting *Paramount Picture,* the Hollywood image of woman towers above, and even embraces the typical urban working woman beneath it. Indeed, standing in front of this emblem of screen femininity, Marsh's tired New York working woman is affronted by a complex series of ironic and contradictory messages generated in Hollywood by movieland culture brokers. First, blatant propaganda like the poster for *Cleopatra* suggests that women can be towering, successful figures; but if she watches the movie, she learns that accomplished women are punished for their strength. (Claudette Colbert as Cleopatra dies clutching an asp to her bosom.) Second, such a woman learns, if not through this Paramount picture, through many others, that working women in America have glamorous jobs, are well paid, and are happy. Perhaps Marsh's working woman looks so weary because, making less than $25.00 a week, she knows this movie myth has no bearing on her own life. Third, the woman Marsh portrays is nettled by the insistent

Hollywood image that women are meant to be like Claudette Colbert, sexy and alluring; and that if they are attractive to men they quickly will be married. But statistics show that during the 1930s women were not marrying: "the marriage rate per thousand population fell from 10.14 in 1929 to 7.87 in 1932"; the birthrate fell also.[20] Despite the movieland suggestion that women can have everything, the facts of the Depression indicated otherwise. The average woman during the 1930s was assaulted by contradictory messages from all sides: on the one hand she was told not to work, but on the other hand she was less likely to assume the role of housewife and mother. And those women who did work were often insulted and called menaces to society.

Even more disconcerting than these incongruities is the fact that movies were made with women moviegoers in mind. As the Lynds discovered in the 1930s, "Middletown is probably representative of other localities in the fact that adult females predominate heavily in the audience" and, as one producer remarked, "set the type of picture that will 'go'."[21] As early as the teens it was the American woman who told the movie studios what type of movie would make a profit. During the 1920s she went to the movies to see her newly liberated working-girl self on the screen. Habits formed, American women, like the women in Reginald Marsh's *Paramount Picture,* went to the movies in the 1930s with the same vicarious idealism in mind, but then they were greeted by Hollywood falsehoods which contradicted their rather dismal status in American society. Only in the soap-opera "woman's film" genre, which started in the 1930s, and in which ordinary, middle-class women were depicted as victims, did the Hollywood film begin to approach the real experience of women in American society.[22]

NOTES

From *The Woman's Art Journal.* Reprinted by permission of the author.

1. Lloyd Goodrich, "Introduction," in Norman Sasowky, *The Prints of Reginald Marsh* (New York: Clarkson N. Potter, 1976), 8.

2. Lloyd Goodrich, "Reginald Marsh," *Selections from the Felicia Meyer Marsh Bequest* (New York: Whitney Museum, 1979).

3. Lloyd Goodrich, *Reginald Marsh* (New York: Whitney Museum, 1955), 3.

4. William Benton, "Artist and Artisan of the Theatre," *Theatre Arts* (April 1956), 68.

5. Lloyd Goodrich, *Reginald Marsh* (New York: Abrams, 1972), 27.

6. Benton, "Artist and Artisan of the Theatre," 67.

7. On Hopper's movie paintings, see Erika L. Doss, "Edward Hopper, *Nighthawks,* and *Film Noir,*" *Post Script: Essays in Film and the Humanities* (Winter 1983). A version of "*Paramount Picture*" appeared in *American Studies Exchange* (Fall 1982).

8. Jon Solomon, *The Ancient World in the Cinema* (New York: Barnes, 1978), 41–2.

9. Gabe Essoe and Raymond Lee, *DeMille: The Man and His Pictures* (New York: Barnes, 1970), 112.

10. Leslie Halliwell, *Mountain of Dreams, The Golden Years of Paramount Pictures* (New York: Stonehill, 1976), 28.

11. Cecil B. DeMille, *The Autobiography of Cecil B. DeMille,* Donald Hayne, ed. (Englewood Cliffs, N.J.: Prentice-Hall, 1959), 338.

12. The term "celluloid aphrodisiac" is taken from Marjorie Rosen, *Popcorn Venus: Women, Movies, and the American Dream* (New York: Avon, 1972), 154.

13. For the image of women in 1920s films see Mary P. Ryan, "The Projection of a New Womanhood, The Movie Moderns in the 1920s," in Jean E. Friedman and William G. Shade, eds., *Our American Sisters: Women in American Life and Thought* (Boston: Allyn and Bacon, 1973), 366–84.

14. Robert and Helen Lynd, *Middletown in Transition: A Study in Cultural Conflicts* (New York: Harcourt Brace, 1937), 261.

15. Rosen, *Popcorn Venus,* 140.

16. *Ibid.,* 154.

17. For information on women's employment in the 1920s, see William Chafe, *The American Woman, Her Changing Social, Economic, and Political Roles, 1920–1970* (New York: Oxford University, 1972), 89.

18. For facts concerning the unemployment of women in the 1930s, see Mary Elizabeth Pidgeon, "Women in the Economy of the United States of America—A Summary Report," *U.S. Women's Bureau Bulletin,* No. 155, U.S. Department of Labor, 1937, 35–7.

19. Quoted in Chafe, *The American Women,* 107. In fact, the numbers of women in prestigious career areas (law, medicine, business) declined during the 1930s, as William Chafe documents in "The Paradox of Progress," in *Our American Sisters,* 386. Most females who could find jobs worked as typists or office clerks. As the U.S. Department of Labor summarized in 1937: "Next to domestic and personal service, clerical occupations employ more women than any other general type of work." (See Pidgeon, "Women in the Economy of the United States," 37, 49, 71.) With rare exceptions, men were paid considerably more than women for similar clerical positions. The average monthly salary for a male Chicago clerical worker in 1931–32 was $135.00; the average female earned only $99.00. (By contrast, Claudette Colbert was in 1938 America's highest paid screen star, commanding $426,944 in a single year, as Leo C. Rosten notes in

Hollywood, The Movie Colony, The Movie Makers (New York: Harcourt Brace, 1941, 342). Even more interesting, in 1930 women filled almost 50% of all clerical positions; by 1936, 46.9% of women seeking work were formerly clerical workers. Despite Hollywood's claims to the contrary, the number of women working as reporters, detectives, and fashion illustrators was negligible in the 1930s.

20. Frederick Lewis Allen, *Since Yesterday, The 1930s in America* (New York: Harper & Row, 1939), 107.

21. Lynd, *Middletown in Transition,* 261. For other figures relating to the influence of the American female at the box office see Margaret Farrand Thorp, *America at the Movies* (New Haven, Conn.: Yale University, 1939), 5–8.

22. "Women's films," which ranged in the 1930s from the soapy melodrama *I Married A Doctor* (1936) to the mother-love picture *Stella Dallas* (1937) and the unctuous *Daughters Courageous* (1939) were, at the lowest soap-opera level, "soft-core emotional porn for the frustrated housewife." On the other hand, "That there should be a need and an audience for such an opiate suggests an unholy amount of real misery." For an analysis of women's films see Molly Haskell, *From Reverence to Rape, The Treatment of Women in the Movies* (New York: Penguin, 1974), 153–88.

20

Florine Stettheimer

Rococo Subversive

LINDA NOCHLIN

The eccentric and ultra-feminine Florine Stettheimer seems an unlikely candidate for inclusion in the lexicon of socially minded artists in America. As Linda Nochlin explains, it is customary to regard the camp sensibility that so defines Stettheimer's lifestyle and art as irreconcilable with a social intent. Social art is explicit and public; an art of exaggerated artifice and wit is aesthetic and private. However, when Stettheimer's work is reconsidered in light of contemporary understandings of political relevance, shaped in part by constituencies for which camp and affectation can often be understood as agents of subversion, Nochlin suggests it is possible to regard her self-referential vision and love of artifice as compatible with shrewd social insight.

Nochlin examines Stettheimer's paintings and her poetry for evidence of this reconciliation of the personal and political, of camp stylization and social awareness, understanding it as yet another paradox in the life of this singular American painter. She identifies various themes in Stettheimer's paintings, such as patriotism and black culture, which underscore the artist's engagement with political and social realities. Finally, through detailed analysis of the artist's celebrated Cathedrals *series, in which Stettheimer pays homage to her beloved cosmopolitan universe, Nochlin demonstrates that these imaginative paeans to the city of New York enact a skillful merging of the artist's critical instincts and personal sense of history with a richly detailed tableau of her private, privileged world.*

It is admittedly difficult to reconcile the style and subject matter of Florine Stettheimer with conventional notions of a socially conscious art.[1] The Stettheimer style is gossamer light, highly artificed and complex; the iconography, refined, recondite, and personal in its references. In one of her best known works, *Family Portrait No. 2* [1] of 1933, we see the artist in her preferred setting: New York, West Side, feminine, floral, familial. The family group includes her sister Ettie, whom she had portrayed in an equally memorable individual portrait ten years earlier, sitting to the artist's right. Ettie was a philosopher who had earned a doctorate in Germany with a thesis on William James, but later turned to fiction. She wrote two highly wrought novels, *Philosophy* and *Love Days*, publishing under the pseudonym "Henrie Waste,"[2] novels which would certainly by today's standards be considered feminist in their insistence that woman's self-realization is incompatible with romantic love, and, in the case

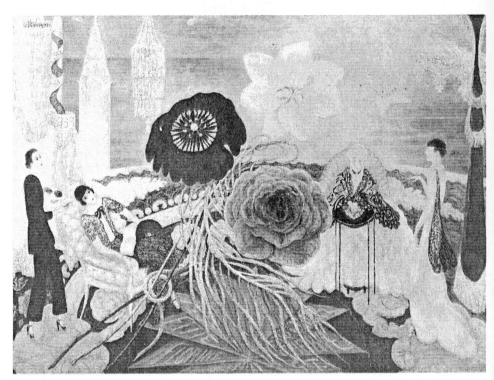

1. Florine Stettheimer, *Family Portrait No. 2*, 1933; courtesy of The Museum of Modern Art. Gift of Miss Ettie Stettheimer. Photograph © 1997 by The Museum of Modern Art, New York.

of *Love Days,* in the demonstration of the devastating results of the wrong sort of amorous attachment.

To the far right is her sister, Carrie, also subject of an earlier individual portrait, hostess of the family parties and creator of the dollhouse now in the Museum of the City of New York. This last project was the work of a lifetime, complete with miniature reproductions of masterpieces by such artist-friends of the Stettheimers as Gaston Lachaise and William and Marguerite Zorach, as well as a thumbnail version by Marcel Duchamp of his *Nude Descending a Staircase.* Off center, hieratically enshrined in a shell-like golden mandorla, is the matriarch, Rosetta

Walter Stettheimer. She is here shawled in lace, Florine's favorite fabric, which Ettie and Carrie are wearing as well.[3] The artist herself, however, is clad in the dark painting suit that served as her work outfit, although this relatively sober turnout is here set off by sprightly red high-heeled sandals. The whole world of the Stettheimers, set aloft amid Manhattan's significant spires, with the blue waters surrounding the island visible below, is guarded by a stellar Statue of Liberty and domesticated by the exuberant baldachin of 182 West 58th Street (the Alwyn Court, their dwelling place). The scene is at once distanced and brought to the surface of the canvas by the resplendent three-part bouquet that dominates

the composition. Perhaps each flower is meant as a reference to a sister; perhaps the willow-like frond binding them all together is meant to refer to their mother.[4] In any case, the stylish floral life of the bouquet dwarfs and overpowers the human life in the painting. One may choose to see that bouquet, and indeed, the painting as a whole, as a kind of testimonial offered by the artist to her family, her city, and to the very world of vivid artifice she created with them. "My attitude is one of Love/is all adoration/for all the fringes/all the color/all tinsel creation," she wrote.[5]

Certainly the mature style of Florine Stettheimer is based on highly idiosyncratic responses to a wide variety of sources, ranging from the later effusions of Symbolism (including the American variety recently brought to focus by Charles Eldredge in an exhibition at the Grey Gallery) to the decorative style of Henri Matisse and the set designs of the Russian Ballet—projects by Bakst, Benois, and Goncharova—which the artist encountered in Paris before World War I. More specifically, she seems to have been influenced by her friend Adolfo Best-Maugard, the Mexican artist and theorist, who playfully juggles the seven basic forms of his esthetic system in his hand in Stettheimer's 1920 portrait of him. Best-Maugard's *A Method of Creative Design,* first published in 1926, systematizes various vanguard notions of the time into decorative, linear, at times quite witty configurations. His illustrations to the book—"Curtains," "Rosettes and Flowers," or "Modern Surroundings," for example—share many characteristics of Stettheimer's treatment of the same themes, yet can hardly be considered a unique source. On the contrary: Stettheimer had acquired a thorough knowledge of the European art tradition during her years on the Continent; as a student abroad, she had commented on artists, art work and collections at considerable length and often with great astuteness in the pages of her diary.[6] At the same time, she was well aware of the most advanced currents of the art of her own period, and was closely allied through friendship and mutual interest with the people who made it. The Stettheimers' circle of friends included Marcel Duchamp, whose portrait Florine painted in 1923, Elie Nadelman, Albert Gleizes, Gaston Lachaise, William and Marguerite Zorach, and many others. Primitive and folk art seem to have played a role in the formation of the artist's style as well—as did, perhaps, the elegant and incisive graphic stylishness of contemporary *Vanity Fair* cartoons. A comparison of Stettheimer's *Natatorium Undine* of 1927 and *Divers, Divers,* a cartoon of the same year by the witty and feminine Fish,[7] gives some indication of just how far-ranging Stettheimer's eye actually was.

Often, just when we think she is being her most naïvely "uninfluenced," Stettheimer is in fact translating some recherché source into her own idiom. Such is the case with the *Portrait of Myself* of 1923, which draws upon the eccentric and visionary art of William Blake, whose reversal of natural scale, and androgynous figure style, and intensified drawing seem to have stirred a responsive chord in Stettheimer's imagination. Blake's illustration for his *Song of Los,* with the figure reclining weightlessly on a flower, seems to have been the prototype for Stettheimer's memorable self-portrait, and indeed it had been published in Laurence Binyon's *Drawings and Engravings of William Blake* in 1922. Certainly, the artist was conversant with the literature of art: "I think she must have read everything concerning art published in English, French and German . . . ," wrote her sister Ettie in the introduction to Florine's posthumously published poems in 1949.[8]

But as much as Stettheimer's evolved style depends on resourceful borrowing and translation, even more does it depend, like all original styles, on a good deal of forceful rejection. In order to arrive at her own idiosyncratic language of form, she had to turn away not only from traditional formal values like those embodied in the aca-

demic nudes she painted around the turn of the century (while studying with Kenyon Cox at the Art Students' League), but also those of modernist abstraction. In any case, no matter what its derivations or its novelties, Stettheimer's style, at first glance, hardly seems an appropriate vehicle for the rhetoric of social message.

Nor do the subjects of many of the artist's more "documentary" works, like *Studio Party* of 1915 or *Sunday Afternoon in the Country* of 1917, seem to have that public character, that easy accessibility characteristic of a public art of social consciousness. The social character of these works is of a very private kind. The sitters are the privileged denizens of a most exclusive world, the world of the Stettheimers' entertainments, soirées and picnics. In *Studio Party,* along with Florine herself, that world is seen to include the Lachaises, Albert Gleizes, Avery Hopwood, and Leo Stein; in *Sunday Afternoon,* those enjoying themselves in the elaborately cultivated garden of André Brook, the Stettheimers' place in the country, are Marcel Duchamp, Edward Steichen, Adolph Bolm, the dancer, and Jo Davidson, the sculptor. And—an additional touch of esthetic distancing—Stettheimer herself seems to have seen these gatherings as justified by her transformation of them into works of art. In a poem of about 1917, recorded in her diary and later published in *Crystal Flowers,* she says: "Our Parties/Our Picnics/Our Banquets/Our Friends/ Have at last—a raison d'être/Seen in color and design/ It amuses me/ To recreate them/ To paint them."[9]

Indeed, far from looking like an art of social purpose, Stettheimer's paintings seem as though they might best be considered an expression of Camp sensibility at its highest—the figures weightless, sinuous and androgynous; the settings unswervingly theatrical; the inherent populism or even vulgarity of some subjects, like *Beauty Contest*[10] of 1924 or *Spring Sale at Bendel's* of 1922, mediated by a pictorial structure fantastically rococo, distanced by decorative reit-

eration. And Camp sensibility, defined by Susan Sontag in her seminal article of 1964 as "a certain mode of aestheticism," of seeing the world in terms of a degree of artifice, of stylization[11] (a definition which serves admirably to sum up Stettheimer's pictorial expression), is explicitly contrasted by Sontag with artistic attitudes of deep social concern and awareness. She sees Camp sensibility as opposing both the moralism of high culture and the tension between moral and esthetic passion which she finds characteristic of avant-garde art; it is, in her phrase, "wholly aesthetic."[12] "It goes without saying," she asserts, "that the Camp sensibility is disengaged, depoliticized—or at least apolitical."[13]

Yet in insisting on the explicitly *social* impulse behind Stettheimer's art while pointing out its overtly Camp qualities, I am not being merely paradoxical. Rather, it seems to me that events and shifts of ideological position in the more than fifteen years since "Notes on 'Camp'" appeared—above all, that striking redefinition of what is generally considered to be social and political in import rather than private or even esthetic, a change effected largely by public and militant activism of blacks, women, and gays (the very territory of Camp itself, from *Prancing Nigger* to the present)—have made us far more aware of an actively subversive component inherent to Camp sensibility itself. This subversiveness may be quite validly viewed as social or political commitment in its own right.

In 1980, there is justification for seeing Camp—in many ways a fiercer and more self-assured continuation of the half-petulant, half-parodic foot-stamping poses of fin-de-siècle Decadence—as a kind of permanent revolution of self-mocking sensibility against the strictures of a patriarchal tradition and the solemn, formalist teleology of vanguardism. This recent transformation of the ideological implications of Camp is itself a good reason for taking seriously a notion like that of the "social consciousness" of Stettheimer.

When we get down to looking at the artist and her work concretely and in detail, however, we might do better to view her reconciliation of social awareness and a highly wrought Camp vision of life as simply one of a number of paradoxes inherent to her nature and her situation. First of all, Stettheimer was both an insider and an outsider: comfortably wealthy, a giver of parties, a friend of many interesting and famous people, but Jewish (and, as the pages of her diary reveal, very aware of it) and, although an artist, a very private artist, known only to a rather special group of admirers, and a woman artist at that. Secondly, she was a determined feminist, yet equally determined to be feminine in the most conventional sense of the term: her bedroom was a dream-construction of lace and cellophane, her clothing and demeanor ladylike; yet at the same time, she was capable of voicing in her poetry a quite outspoken and prickly antagonism toward male domination. One such poem, published in the posthumous volume of her verse, *Crystal Flowers,* is an ironic musing on models: "Must one have models/ must one have models forever/ nude ones/ draped ones/ costumed ones/ 'The Blue Hat'/ 'The Yellow Shawl'/ 'The Patent Leather Slippers'/ Possibly men painters really/ need them—they created them."[14] Still another, titled "To a Gentleman Friend," begins, quite startlingly: "You fooled me you little floating worm . . .";[15] while another, more poignant and untitled, sums up bitterly the self-muting deception forced on women by the men who admire them: "Occasionally/ A human being/ Saw my light/ Rushed in/ Got singed/ Got scared/ Rushed out/ Called fire/ Or it happened/ That he tried/ To subdue it/ Or it happened/ He tried to extinguish it/ Never did a friend/ Enjoy it/ The way it was/ So I learned to/ Turn it low/ Turn it out/ When I meet a stranger—/ Out of courtesy/ I turn on a soft/ Pink light/ Which is found modest/ Even charming/ It is a protection/ Against wear/ And tears/ And when/ I am rid of/ The Always-to-be-Stranger/ I turn on my light/ And become myself."[16]

Self-contradictions abound in the Stettheimer personality and outlook. She was a snob but an ardent New Dealer, a fanatic party-giver who in her diary complained of a particularly spectacular party given in her honor that "it was enough to make a socialist of any human being with a mind." Some of these contradictory stances are admittedly trivial; others are less paradoxical than they seem. For a woman, for instance, the boundaries between subjective preoccupation and social awareness are by no means absolute; at times they effectively coincide. Then again, both the snob and the social activist share a highly developed sensitivity to the defining characteristics of class and milieu. And finally, and perhaps most important in separating apparent contradiction from the real variety, although Florine Stettheimer may have gloried in *artifice*—that is to say, the authentic and deliberate creation of fantasy through suitably recondite means—she absolutely loathed *phoniness,* that pretentious public display of false feeling she associated with the high culture establishment. Two of the most significant poems in *Crystal Flowers* make this distinction perfectly clear, and, at the same time, together, are a perfect paradigm of the loves and hates of Camp sensibility. On the one hand, "I hate Beethoven": "Oh horrors!/ I hate Beethoven/ And I was brought up/ To revere him/ Adore him/ Oh horrors/ I hate Beethoven// I am hearing the/ 5th Symphony/ Led by Stokowsky/ It's being done heroically/ Cheerfully pompous/ Insistently infallible/ It says assertively/ Ja-Ja-Ja-Ja// Jawohl—Jawohl/ Pflicht—!—Pflicht!/ Jawohl!!/ Herrliche!/ Pflicht!/ Deutsche Pflicht/ Ja-Ja-Ja-Ja/ And heads nod/ In the German way/ Devoutly—/affirmatively/ Oh—horrors."[17]

Pomposity, dutifulness, the heavy, automatic response to an implicitly patriarchal infallibility—such are the things which fill Florine Stettheimer with horror. What inspires her with delight is the very opposite of all that is heavy, dutiful, solemn, or imposed by authority; she ar-

ticulates her loves in a hymn to lightness, lace, feminine sensibility, and the goddess of it, her mother; a paean to the adored textures, sounds and objets d'art of childhood: "And Things I loved—/ Mother in a low-cut dress/ Her neck like alabaster/ A laced up bodice of Veronese green/ A skirt all puffs of deeper shades/ With flounces of point lace/ Shawls of Blonde and Chantilly/ Fichues of Honeton and Point d'Esprit/ A silk jewel box painted with morning glories/ Filled with ropes of Roman pearls/ . . . Embroidered dresses of white Marseilles/ Adored sash of pale watered silk/ Ribbons with gay Roman stripes/ A carpet strewn with flower bouquets/ Sèvres vases and gilt console tables/ Mother reading us fairy tales/ When sick in bed with childhood ills—/ All loved and unforgettable thrills."[18] Mother, lace, and fairy tales belong to the cherished world of dream-artifice; Beethoven, German solemnity, and hollow affirmation to that of dreary falsehood: nowhere is she more forthright about the distinction.

With that distinction in mind, one might well raise some questions about conventional notions of an art of social concern itself, especially as these have recently been articulated in our own country. Must a public art of this kind be solemn, pompous, and alienated? Or can it, on the contrary, be personal, witty, and satirical? Can one's friends and family be seen as participants in history, and, conversely, can the major figures of history be envisioned as intimates, as part of one's own experience? Is it possible for imagination and reality to converge in a lively, problematic image of contemporary society? Must history, in other words, be conceived of as something idealized, distant, and dead that happened to other people, or is it something that involves the self? And what, precisely, are the boundaries between the public and the private? Why has such a distinction been made in the creation of art? All these issues are raised, although hardly resolved, by the art of Florine Stettheimer.

On the simplest level of historical awareness and political conviction, there is Florine Stettheimer's lifelong admiration for America and Americanness: her own kind of patriotism. Both *West Point* of 1917, now at the U.S. Military Academy, and *New York* of 1918, in the collection of Virgil Thomson, offer examples of it, warmed by the glow of the expatriate recently reunited with her birthplace—the Stettheimer sisters and their mother had returned to New York from Europe at the outbreak of World War I. *West Point,* commemorating a visit of August 29, 1917, is a pictorial record—a topographically accurate continuous narrative—of the Stettheimers' trip to the Military Academy by Hudson Dayliner, by car, and on foot. The composition features the symbolic flag and eagle, and places George Washington—a lifelong idol of Florine's and perhaps, as father of her country, an apotheosis of the missing Stettheimer *père*—at the heart of the composition in the form of a bronze copy of the 1853 Union Square equestrian portrait by Henry Kirke Brown (which had recently been obtained by Clarence P. Towne and dedicated in 1915). In *New York,* Washington plays a relatively minor role as a tiny statue in front of the Subtreasury, at the end of a long vista, but the painting is really an homage to another symbol of American grandeur: the Statue of Liberty. The painting, inspired by Woodrow Wilson's visit to the Peace Conference of 1918, is minutely detailed, and the historic implications of the panorama are underscored by the palpability of the statue, built up in relief of putty impasto covered with gold leaf, so that, literally as well as figuratively, Liberty stands out.[19]

Although Stettheimer can hardly be counted among the ranks of notable activists in the cause of racial equality, it is nevertheless true that black people figured quite regularly in her work, from the time of *Jenny and Genevieve* of about 1915 to that of *Four Saints in Three Acts,* the Gertrude Stein–Virgil Thomson opera for which

she designed the sets and costumes in 1934. Her sympathy for black causes can, in addition, be inferred not merely from her work but from her close friendship with one of the staunchest supporters of black culture, the music critic, belle lettrist, and bon vivant, Carl Van Vechten. One of the most ambitious and complex of all Florine Stettheimer's social investigations of the twenties is devoted to a black environment, the segregated beach of *Asbury Park South,* now in the collection of Fisk University. The subject, which also inspired a poem,[20] may well have been suggested by Van Vechten, whose portrait she did in 1922, and who figures in the reviewing stand to the left in *Asbury Park South.*[21] An extraordinarily active promoter of black cultural interests, Van Vechten spent most of his free hours in Harlem literary salons and nightclubs during the twenties. He loved and publicized jazz, which, he maintained in his capacity as a music critic in 1924, was "the only music of value produced in America." The black writer James Weldon Johnson said in the early days of the Negro literary and artistic renaissance that Carl Van Vechten, by means of his personal efforts and his articles in journals, did more than anyone else in the country to forward it. Walter White, founder of the NAACP, was a close friend, as were literary figures like Langston Hughes, Countee Cullen and Zora Neale Hurston. In his later avatar as a photographer, Van Vechten created an extensive gallery of portraits of blacks prominent in the arts; he received an honorary doctorate in 1955 from Fisk University, to which he donated his collection of black musical literature and where he established the Florine Stettheimer Collection of Books on the Fine Arts.

The extent of Van Vechten's involvement with black culture was noted in the pages of *Vanity Fair* in the form of a caricature of the music critic in blackface by his friend Covarrubias, the Mexican draftsman, and a popular song of about 1924, "Go Harlem," advised its listeners to "go inspectin' like Van Vechten." Van Vechten's parties were famous for their heady mixture of black and white celebrities; Bessie Smith might be found rubbing shoulders with Helena Rubinstein. Florine noted in the pages of her diary meeting Paul Robeson and Somerset Maugham at one of Carl and Fania's parties.[22] In 1926, Van Vechten published *Nigger Heaven,* a brilliant, poignant, unstereotyped, and sexy novel about various social circles in Harlem, in which the author reveals the richness and authenticity of black culture and, at the same time, the tragedy that might ensue for the more educated members of Harlem society when they tried to enter the white world.[23] Van Vechten dedicated this work to the Stettheimer sisters, and Florine thanked him for her copy with a poem: "Darling Moses// Your Black Chillun/ Are floundering/ In the sea// Gentle Moses// The waves don't part/ To let us Travel free// Holy Moses// Lead us on/ To Happyland/ We'll follow/ Thee// Dear Carlo, this is to you in admiration of your courage. Florine, West End, August 1st, 1926."[24]

The impact of Van Vechten's passion for all aspects of black cultural expression was felt not only by Florine but also by his friend Covarrubias, whose impressions of nightlife in Harlem appeared in *Vanity Fair* in the twenties and were published as *Negro Drawings* in 1927. Certainly, these drawings offer stylistic parallels to the figure style of *Asbury Park South* in their sinuous compression and simplification of form, which Parker Tyler, in the case of Stettheimer's painting, has likened to paleolithic art or Rhodesian rock painting.[25] We may feel that works such as Covarrubias's or Stettheimer's are demeaning or caricatural, but at the time, they were viewed by both blacks and whites as homages to black elegance, grace, and energy.[26] Florine's vision of blacks—campy, satirical, and admiring at once, idiosyncratic, clearly a vision of high life and high times rather than of a worthy but unjustly treated proletariat—is very different from the blander ideal of the benign melting pot, which

informs the iconography of a work like Lucienne Bloch's mural *The Cycle of a Woman's Life,* completed for the New York Women's House of Detention in 1936 under the New Deal. In some ways, Florine Stettheimer's vision is closer to today's sensibility in the way it stresses racial uniqueness and self-identification rather than brotherhood at the expense of authentic ethnicity. But here again, the issue of public versus private expression comes into question: Stettheimer's work is intended for a relatively restricted and, of course, voluntary audience. It does not preach or offer solace. The other is meant for a public place—a prison at that—and is therefore fated to uplift and to promulgate a consoling mythology.

But perhaps the most consistent and ambitious expressions of Stettheimer's social consciousness are the four *Cathedrals,* a series that engaged her intermittently from approximately 1929 until her death in 1944. All of them are in the Metropolitan Museum; all are large-scale—about 60 by 50 inches—and packed with incident. In these, her masterpieces, she ingeniously and inextricably mingles the realms of reality and fantasy, observation and invention. The *Cathedrals* are grand, secular shrines dedicated to the celebration of American life, as exemplified in its most cosmopolitan, expansive, yet for Stettheimer, most intimately known city: New York. She subdivides this celebration of urban excitements into four major categories: the world of theater and film in the case of *Cathedrals of Broadway,* ca. 1929; the world of shops and high society in *Cathedrals of Fifth Avenue,* ca. 1931; the world of money and politics in *Cathedrals of Wall Street,* ca. 1939; and finally, the world of art—her own particular world within New York—in the unfinished *Cathedrals of Art.* The compositions are centralized and hieratic, as befits secular icons presided over by contemporary cult figures, yet this centralization is never ponderous or static, but, on the contrary, airy and mobile, energized by fluid, swirling

rhythms, animated by a weightless, breezy sort of dynamism. The iconography of the *Cathedrals* is both serious and lightheartedly outrageous, giving evidence of the artist's view that admiration and social criticism are far from mutually exclusive. The color is sparkling, the drawing soft and crackling at the same time. Each *Cathedral,* in addition to celebrating a permanent aspect of New York life, at the same time commemorates a particular event—in the case of *Cathedrals of Broadway,* for instance, the shift from silent films to talkies. In the center, golden Silence is roped off beneath a newsreel-gray image of Jimmy Walker opening the New York baseball season, while the blazing marquees of the Strand and the Roxy to left and right proclaim the advent of the talking film. *Cathedrals of Fifth Avenue,* besides celebrating a society wedding and the glories of Hudnut's, Tiffany's, B. Altman's, Maillard's, and Delmonico's, is also a commemoration of Lindbergh's flight—the hero can be seen parading in an open car in the background to the left. In all of the *Cathedrals,* Florine, her sisters, and her interesting friends figure prominently; they are part of New York's ongoing life, participants in historic occasions. In *Cathedrals of Fifth Avenue,* for instance, above the hood of the car decorated with a dollar sign on the right, appear the artist and her sisters; between the family group and the wedding party are Charles Demuth, with Mrs. Valentine Dudensing and her daughter in front of him and Muriel Draper leaning on Max Ewing to his left. Arnold Genthe is photographing the ceremony, and Mrs. Walter Rosen stands next to him in yellow.[27]

Florine's celebration of her city finds close parallels, once more, in her poetry. Not only do several poems explicitly deal with the varied joys of the city, but in one untitled work the very brand-name explicitness of that loving celebration is reiterated: "My attitude is one of Love/ is all adoration/ for all the fringes/ all the color/ all tinsel creation/ I like slippers gold/ I like oysters

cold/ and my garden of mixed flowers/ and the sky full of towers/ and traffic in the streets/ and Maillard's sweets/ and Bendel's clothes/ and Nat Lewis hose/ and Tappé's window arrays/ and crystal fixtures/ and my pictures/ and Walt Disney cartoons/ and colored balloons."[28]

Yet the *Cathedrals* depend upon more than mere affection and a sense of personal participation for their striking unity of feeling and design. Their complex yet highly readable structure may, indeed, strike a familiar chord. Despite basic differences of attitude, there is a strange and, as it were, distilled reminiscence of the murals of Diego Rivera in these works. A comparison with the revolutionary murals of the Mexican artist may seem farfetched or even perverse; nevertheless, the Ministry of Education frescoes in Mexico City were published in this country in 1929,[29] the year of the earliest of the *Cathedral* paintings, and certain common features may be observed to exist in Rivera's *The Billionaires* or his *Song of the Revolution* and Stettheimer's *Cathedrals of Broadway* or *Cathedrals of Wall Street*. It might also be kept in mind that both Stettheimer and Rivera had made extensive art tours of Europe and had returned to their native lands thoroughly familiar with both traditional European artistic culture and the new pictorial experiments of the avant-garde. Both were highly responsive to the popular culture and folk art of their own nations. Both regarded their native lands with critical and loving eyes, and both felt free, for the purposes of their message—and because both folk and vanguard art encouraged it—to incorporate verbal elements into the pictorial fabric of their works, a procedure which Stettheimer plays to the hilt in *Cathedrals of Fifth Avenue*, where "Tiffany's" is spelled out in jewels, "Altman's" in household furnishings and dry goods.

The third of the series, *Cathedrals of Wall Street*, signed and dated 1939 but probably finished after that date, is worth studying in considerable detail, partly because a good deal of mate-

rial relating to its genesis is available, partly because it unites in a single, scintillating image so many of Stettheimer's responses to the social issues of her time, as well as her political commitments—in her own terms, of course. In *Wall Street* Big Business confronts popular pageantry; the historic past confronts contemporary American life; her beloved New York shelters the major representatives of her equally beloved New Deal. The painting then is a satiric icon—almost Byzantine in its symmetry, frontality, and golden effulgence—but an icon up-to-date and jazzy in its staccato rhythms and concrete detail; presiding over this icon are the Father, Son, and Holy Ghost of a patriotic Trinity: Washington, Roosevelt, and the American Eagle.

Cathedrals of Wall Street is an homage to Mrs. Roosevelt, elegant in an Eleanor-blue gown in the center of the piece. She is escorted by Mayor La Guardia, and is about to be thrilled by "The Star-Spangled Banner" intoned by Grace Moore, who stands to the right center. Among the other identified figures are Michael Ericson in an American Legion uniform; Michael J. Sullivan, a Civil War veteran; Claget Wilson; and an Indian chief.[30] Yet perhaps primarily, *Cathedrals of Wall Street* is dedicated to the memory of George Washington; the artist herself is depicted offering his statue a bouquet inscribed "To George Washington from Florine St." at the far right. Stettheimer's affection for the father of her country was long-standing, going back at least as far as the outbreak of World War I. The sitting room in her Beaux-Arts apartment included a bust of Washington enshrined in a niche. The pages of her diary make reverent reference to painting the figure of Washington in *Cathedrals of Wall Street* on the anniversary of his birth. She notes: "Feb. 22. *Washington's Day* 1939—I put lots of gold on Washington"; on Feb. 22, 1940: "Washington's day—Painted all day—Washington in the painting."

As far as the Roosevelts were concerned, her affections, though of more recent vintage, were

not less fervent. Evidently, she wanted Van Vechten to introduce her to Mrs. Roosevelt because she so admired her, and of course, wished to put her into her painting, but Van Vechten evidently did not know the First Lady.[31] Florine was an ardent supporter of FDR. In her diary she notes: "Nov. Fifth 1940—Have just registered my vote for Roosevelt"; on the 6th: "I took off my tel. receiver at seven A.M.—'Roosevelt' said the voice instead of 'good morning'"; on Jan. 2, 1941: "Inauguration Day—Thank goodness it came off—heard oath and speech. . . ." On Oct. 24, 1940, she had noted with dismay: "McBride and Clagg [Claget Wilson] for Wilkie oh horrors! Showed them Cathedrals of Wall Street and Clagg in marine uniform in it."

The date inscribed on the painting suggests still further and even more concrete memorial connections. Nineteen-thirty-nine was the year dedicated to celebrating the 150th anniversary of George Washington's inauguration in New York. In *George Washington in New York,* a far less ambitious work which, done in the same year, may well be related to *Cathedrals of Wall Street,* Stettheimer makes her point by simply juxtaposing a bust of George with the New York skyline. The inauguration had taken place just where she set her Wall Street painting, on the steps of the old Subtreasury Building, then Federal Hall, at Wall and Nassau Streets, a site marked by John Quincy Adams Ward's 1883 bronze statue of Washington, so prominently featured in the painting. The major civic event of 1939, the New York World's Fair, like *Cathedrals of Wall Street,* was planned to commemorate this momentous occasion, and, like the painting, was intended as a tribute to the father of our country, as the cover of the special "World's Fair Supplement" to the *New York Times* magazine section clearly indicates.

The first diary notations about *Cathedrals of Wall Street* occur in 1938, when plans for various First Inaugural commemorations, and, of course, for the New York World's Fair, the

biggest celebration of Washington's inauguration of all, were well under way. On April 18 of that year, Florine makes reference to putting Grace Moore singing "The Star-Spangled Banner" into *Wall Street,* and to meeting the celebrated singer at Rose Laird's beauty salon. On April 19, she notes: "Started to stain the outlines of my new painting 'Cathedrals of Wall Street.'" She was evidently still working on it well into 1940, when, according to notations in her diary, she went to visit the Stock Exchange and had her friend, the lawyer Joseph Solomon, bring her ticker tape to copy. The date 1939 inscribed on the painting, then, refers to the event it commemorates rather than the year the painting was actually completed.

All during the period preceding the inauguration celebrations, sources of inspiration for the artist's project offered themselves in the press. For example, although it is not specifically related to the Washington festivities themselves, a major illustrated article by Elliot V. Bell titled "What is Wall Street?" which ran in the *New York Times* of Jan. 2, 1938, almost sounds like a description of the subject and setting of Stettheimer's painting. The writer discusses the new focus of attention which has shifted to Wall Street in order to counteract the business depression, and includes what might be considered a verbal equivalent of major features of the canvas: "The geographical center of the district lies at the intersection where Broad Street ends and Nassau Street begins. Here on one corner stands the Stock Exchange, on another J. P. Morgan's and on a third the outmoded temple of the old United States Subtreasury upon which the statue of George Washington stands with lifted hand to mark the site where the first President on April 30, 1789, took the oath of office. . . ."[32] On April 30, 1938, the *New York Times* ran an illustrated account of "A Patriotic Ceremony in Wall Street," subtitled "A view of the exercises in front of the Subtreasury Building yesterday commemorating the inauguration of George

Washington as the first President of the United States." The report went on to describe the representatives of many patriotic organizations, military and naval groups with their massed colors which had joined the previous day in commemorating the first inauguration, which had taken place 149 years ago; the accompanying photograph is remarkably similar to the right-hand portion of Stettheimer's painting.[33]

In April of the following year, 1939, the 150th anniversary of the occasion, an eight-day reenactment of Washington's celebrated trip from Mount Vernon to New York took place, with the participants decked out in eighteenth-century costume, traveling from Virginia to New York in a 160-year-old coach and crossing from New Jersey to Manhattan by barge. On April 30, Inauguration Day itself, there was a ceremony in front of Federal Hall during which wreaths like the ones in Stettheimer's painting were reverently laid at the feet of Washington's statue; all the patriotic societies paraded, and, according to the *New York Times* report, "the nearly empty financial district . . . echoed and reechoed the blaring music of military bands."[34] Denys Wortman, an artist and cartoonist who took the part of Washington, was received by Mayor La Guardia at City Hall.[35]

None of these celebrations could, however, match in elaborateness or scale the climactic event of the eight-day journey—the reenactment of the First Inaugural. The reconstructed ceremony took place beneath the colossal 68-foot-high statue of the Father of Our Country on Constitution Mall as part of the opening day festivities on April 30 of the New York World's Fair; Denys Wortman and his costumed entourage were whisked from Manhattan to Flushing Meadows by speedboat for the occasion.[36]

All these events must have struck an answering spark in the breast of someone who admired Washington as much as Florine Stettheimer did, and many of the reports and announcements of these happenings were illustrated with drawings

and photographs which may well have added fuel to the fire. One can imagine Stettheimer's enthusiasm for a commemoration which united her favorite historic personage with her favorite contemporary entertainment—George Washington with the World's Fair. And she adored the Fair, visited it almost daily during the spring and summer of 1939, and, according to her sister Ettie, hoped to be asked to commemorate it in her art, a hope which remained unfulfilled. *Cathedrals of Wall Street* must then serve by proxy as her pictorial tribute to the exuberance and optimism—alas, ill founded—with which the Fair approached the future.

At the same time, *Cathedrals of Wall Street* hardly seems to call down unmixed blessings on the present-day Republic. George Washington seems a bit startled by the presence of Bernard Baruch, John D. Rockefeller, and J. P. Morgan in the pediment of the Stock Exchange. The ubiquity of gold seems to have more than Byzantine implications; it impinges on the very rays of light infiltrating the floor of the Exchange. And the juxtaposition of Salvation Army and Stock Exchange offers a trenchant pictorial paraphrase of George Bernard Shaw's pointed question from the end of *Major Barbara:* "What price salvation?" Washington is both the guardian of and admittedly a bit peripheral to the modern world of drum majorettes and high finance.

Stettheimer's final work in the *Cathedrals* series celebrated that aspect of New York achievement with which she was most intimately connected: the world of art. *Cathedrals of Art* [2], dated 1942 but left unfinished at the time of her death in 1944, is her ultimate pictorial statement about the inextricable connection between public and private, between the friends she cherished and the works of art to which they dedicated their lives. The grand, three-part setting, dominated by the red-carpeted main staircase of the old Metropolitan Museum, clearly distinguishes art *in* America, the province of the Museum of Modern Art (to the left), from *American* art, the realm of

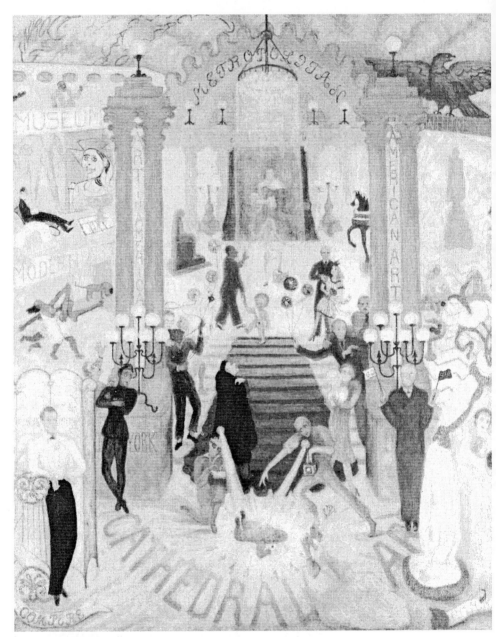

2. Florine Stettheimer, *Cathedrals of Art*, 1942; courtesy of The Metropolitan Museum of Art. Gift of Ettie Stettheimer, 1953 (53.24.1).

the Whitney Museum (to the right), with the Metropolitan Museum itself providing that overarching tradition which—spatially as well as chronologically—lies behind both. On the crossbar of the stretcher, in 1941, Florine identified the work as "Our Dawn of Art." And indeed, in the foreground, baby Art—based on a recently acquired statue of Eros, depicted here as born drawing—is being photographed by George Platt Lynes in a blaze of light, while being worshiped by a female art lover to his right.[37] Baby Art ascends the stairs, hand in hand with the Metropolitan's director, Francis Henry Taylor, to join curator of paintings Harry B. Wehle, standing at the top of the stairs with a young woman holding a clearly labeled "prize." The red-carpeted staircase is flanked by museum directors, critics, and art dealers; perhaps a certain reminiscence of Raphael's *School of Athens* gives added resonance to the composition. Among the art-world notables present are Alfred Stieglitz on the staircase to the left, grandly cloaked and turning his profile upward to follow youthful Art's progress; A. Everett (Chick) Austin, Jr., the enterprising director of the Wadsworth Atheneum, standing with folded arms at the base of the left-hand column inscribed "Art in America"; his counterpart at the base of the right-hand column, inscribed "American Art," is Stettheimer's friend and supporter, the critic Henry McBride, with "Stop" and "Go" signs in his hand.

In the center of the composition, Francis Henry Taylor leads the infant to the High Altar of the Cathedral of Art in the form of a portrait, perhaps reminiscent of Mrs. Stettheimer, by one of the artists whom Florine most admired, Frans Hals. This sedate and portly figure from the past is set in opposition to a sprightly and up-to-date young female figure, also directly on central axis, labeled "cocktail dress"—perhaps meant to represent the modern feminine ideal as opposed to the more traditional one.[38]

In the left-hand "panel" of what might well be considered a triptych, Art plays hopscotch on a Mondrian laid out at the feet of Alfred Barr, Jr., seated most appropriately in what looks like a Corbusier chair before two striking Picassos. Immediately beneath Barr, the two *Women on the Beach* break loose from their canvas in front of the Douanier Rousseau's lion. In the upper part of the right-hand "panel," dedicated to the Whitney Museum, stands Juliana Force in front of a sculptured figure by Gertrude Vanderbilt Whitney, guarded by an American eagle. To the lower right and lower left foreground, isolated by a screen and a white-and-gold lily-topped canopy respectively, stand Robert Locher (an old friend), and Stettheimer herself, as *compère* and *commère* of the spectacle—an idea, incidentally, that the artist probably derived from *Four Saints in Three Acts*. The two figure as patron saints or intercessors between the world of art and its audience. *Cathedrals of Art,* then, is not only a tribute to art but to New York's art institutions and to the people who run them. The only other painting about art that is as original in both its richness of allusion and its sense of intimate personal involvement is of course Courbet's *Painter's Studio*. Like Courbet's *Studio, Cathedrals of Art* is an *allégorie réelle*, an allegory that takes its terms from experienced reality, and as such, like Courbet's work, it emphasizes the role of friendship, of mutual support and of contemporary inventiveness in sustaining a living art.

In "Public Use of Art," an important article which appeared in *Art Front* in 1936, Meyer Schapiro inveighed against the public murals of the New Deal, seeing in "their seemingly neutral glorification of work, progress and national history the instruments of a class"—the dominating class of the nation. "The conceptions of such mural paintings," Schapiro maintained, "rooted in naïve, sentimental ideas of social reality, cannot help betray the utmost banality and poverty of invention."[39] While one may feel that Schapiro is too sweeping in his condemnation of the public art of his day, and that Stettheimer's playful

and in many ways arcane creations hardly offer a viable alternative to the mural programs sponsored under the New Deal, his criticism is nevertheless relevant to Stettheimer's art. Her ideas of social reality, if idiosyncratic, are neither naïve nor sentimental, her pictorial invention the opposite of "banal" or "poor." Nor is her vision, in *Cathedrals of Art,* totally affirmative.

Beneath the glowing admiration for American institutions and personae in this work, as in the other paintings of the *Cathedrals* series, exists a pointed and knowing critique of them as well. The *Cathedrals,* as I have indicated, are by no means pure affirmations of American, or even New York, values. The most effective revelations of social reality are not necessarily either intentional or from the left, as both Engels and Georg Lukács have reminded us. Balzac, upholder of monarchy, was in fact the most acute and critical analyst of the social reality of his time. Look again at *Wall Street;* or look again at *Cathedrals of Art,* with each little chieftain smugly ensconced in his or her domain, the dealers feverishly waving their artists' balloons or clutching their wares, the critic with his mechanical signals, the avid photographers—and the blinded, worshipful public.

Florine Stettheimer, the artist, existed in this world, it is true, but still somewhat apart from it—as her painting exists apart from the major currents of her time. She knew herself to be, as an artist, a peripheral if cherished figure, unappreciated and unbought by the broader public. She may indeed, in her discreet way, have felt rather bitter about this larger neglect. After a disastrous exhibition at Knoedler's in 1916, although she would often show a work or two at group shows at the Whitney, the Carnegie Institute, or the Society of Independent Artists, she never had a major retrospective until 1946, after her death.[40]

In a poem from *Crystal Flowers,* Stettheimer succinctly sums up the position of art in a capitalist society: "Art is spelled with a capital A/ And capital also backs it/ Ignorance also makes it sway/ The chief thing is to make it pay/ In a quite dizzy way/ Hurrah—Hurrah—."[41] Here, certainly, is social consciousness about art if ever there was.

NOTES

From *Women, Art, and Power and Other Essays* by Linda Nochlin. © 1988 by Linda Nochlin. Reprinted by permission of the author and HarperCollins Publishers.

1. The major sources of information about Florine Stettheimer are the exhibition catalogue *Florine Stettheimer,* New York, Museum of Modern Art, 1946, edited by Henry McBride; and Parker Tyler's *Florine Stettheimer: A Life in Art,* New York, 1963. In addition, the Florine Stettheimer archive in the Beinecke Rare Book and Manuscript Library of Yale University contains the manuscript (unfortunately mutilated by her sister Ettie's scissors) of Florine's diary, as well as typed and manuscript versions of her poetry. Recent publications include the exhibition catalogues *Florine Stettheimer: An Exhibition of Paintings, Watercolors, Drawings,* Low Memorial Library, Columbia University, 1973; *Florine Stettheimer: Still Lifes, Portraits and Pageants 1910 to 1942,* Institute of Contemporary Art, Boston, 1980; and an article by Barbara Zucker, "Autobiography of Visual Poems," *Art News,* Feb. 1977, pp. 68–73.

2. *Philosophy [An Autobiographical Fragment]* was originally published in 1917; *Love Days* in 1923. Both were republished along with a group of short stories and an English translation of her doctoral dissertation, written in 1907 for Freiburg University, on William James's *The Will to Believe* in *Memorial Volume of and by Ettie Stettheimer,* New York, 1951.

3. Stettheimer also painted an individual *Portrait of My Mother* (1925), her best work in the opinion of Henry McBride (Museum of Modern Art catalogue, 1946, p. 39).

4. For a somewhat different interpretation of the significance of the bouquet, see Tyler, p. 15.

5. Florine Stettheimer, *Crystal Flowers*, New York, 1949. This edition of Florine's verses was published after her death by her sister, Ettie, who also provided an introduction.

6. All references to the diary refer to the manuscript in the Beinecke Rare Book and Manuscript Library mentioned in n. 1 above. Her comments range from remarks on the Aegina Pediment in Munich; to her ideas and feelings about the old masters viewed on visits to Italian churches, museums, and palaces in 1906; to comments on a Rodin Exhibition in 1910 and on some Stücks seen at the Munich Secession. In 1912, she notes, on a trip to Madrid, that "the beauty of the Titian Venus and the Danae" is "intoxicatingly beautiful" and that *Las Meninas,* to her surprise, "had the quality of realism attributed to it by those who write about it." In Toledo, she admits that she doesn't think El Greco so marvelous. In Paris she exclaims: "I can't bear Carpeaux. His Hugolin [sic] is stupid . . ." and declares Regnault's *Salome,* now in the Metropolitan Museum, "an abomination." She admires Manet and declares Monet's "new Venice painting the most attractive things he has done so far." Her reaction to Gustave Moreau's work is measured. In 1913, she notes a very good loan show of van Gogh flowers.

7. Miss Fish was an extremely popular cartoonist for the cognoscenti who read *Vanity Fair.* A full-page advertisement for her *High Society: A Book of Satirical Drawings,* by Fish, which appeared in *Vanity Fair,* Nov. 1920, p. 24, claimed that "'High Society' is the smartest book of the season" and that ". . . the patterns of the flappers' frocks are like laces and hangings by Beardsley." There has been an exhibition of Miss Fish's work in New York recently, but I have been unable to locate a reference to it.

8. E. Stettheimer, *Crystal Flowers,* introduction, p. iii.

9. Manuscript version, Beinecke Library, dated about 1917.

10. For a fuller discussion of *Beauty Contest,* see the exhibition catalogue *Women Artists: 1550–1950,* by A. S. Harris and L. Nochlin, Los Angeles County Museum of Art, 1976, p. 267.

11. Susan Sontag, "Notes on 'Camp'" (1964), in *Against Interpretation and Other Essays,* New York, 1967, p. 277.

12. Sontag, p. 287.

13. Sontag, p. 277. For a more recent and equally provocative discussion of Camp and associated issues, see Brigid Brophy's *Prancing Novelist: A Defense of Fiction in the Form of a Critical Biography in Praise of Ronald Firbank,* New York, 1973, especially pp. 171–73; but also 406–7 for the social subversiveness of Wilde's and Firbank's fictions, their emancipation of women and proletarians; and pp. 551–59 for *Prancing Nigger.*

14. *Crystal Flowers,* p. 78. Florine did not intend her poems for publication. This assumption of privacy may have something to do with their remarkable frankness.

15. *Crystal Flowers,* p. 43.

16. *Crystal Flowers,* p. 42.

17. This version of the poem and its punctuation are taken from the manuscript in the Beinecke Library, IV–VI.

18. Manuscript, Beinecke Library, VII–IX.

19. For a poem related to this painting beginning: "Then back to New York . . . ," see *Crystal Flowers,* p. 79.

20. Manuscript, Beinecke, IV–VI. "Asbury Park" begins: "It swings/it rings/it's full of noisy things. . . ."

21. Other friends present are: Van Vechten's wife, the actress Fania Marinoff; Marcel Duchamp; Avery Hopwood; Paul Thenevaz.

22. Most of the information about Van Vechten is obtained from Bruce Kellner's excellent study, *Carl Van Vechten and the Irreverent Decades,* Norman, Oklahoma, 1968. For a different, far more critical view of Van Vechten's relationship to Harlem and black culture, see Nathan Irvin Higgins, *Harlem Renaissance,* Oxford and New York, 1971, pp. 93–118. Not surprisingly, Van Vechten was not only an aficionado of black culture, but also the major promoter of Ronald Firbank in this country (Higgins, p. 95). It was Van Vechten who convinced Firbank to change the title of his *Sorrow in Sunlight* to *Prancing Nigger* when it was published in this country (Higgins, p. 112).

23. See Kellner, p. 202.

24. Manuscript, Beinecke, VII–IX. Evidently Carl Van Vechten typed up copies of Florine's letters to

him—those about his books—and sent them, after Florine's death, to her sister Ettie.

25. Tyler, p. 131.

26. See, for instance, the introduction to Miguel Covarrubias, *Negro Drawings*, New York, 1927, by Frank Crowninshield, in which it is claimed that Covarrubias is "the first important artist in America . . . to bestow upon our Negro anything like the reverent attention . . . which Gauguin bestowed upon the natives of the South Seas" (np).

27. These identifications appear in the Stettheimer Archives in the Metropolitan Museum. They seem to follow those established by Henry McBride, Museum of Modern Art catalogue, 1946, table of contents.

28. *Crystal Flowers*, p. 23.

29. See *The Frescoes of Diego Rivera*, introduction by E. Evans, New York, 1929.

30. Identifications from McBride, Museum of Modern Art catalogue, 1946, p. 48, and Stettheimer Archives, Metropolitan Museum. I have been unable to discover any account, in either newspapers or biographies of the First Lady, of a visit by Mrs. Roosevelt to Wall Street at the time the painting was begun. Perhaps further investigation will reveal such a visitation; until then, one might best consider it an invention of Stettheimer's.

31. Tyler, p. 107.

32. *New York Times Magazine*, Jan. 2, 1938. The piece begins with a consideration of government credit expansion, "tried to the tune of $20,000,000,000." Could this figure be a clue to the meaning of the "19,000,000,000" inscribed to the left and to the right of Roosevelt's head in the painting? It is close, if not exact. The article continues with a description of the ". . . blackened spires of Trinity Church" as opposed to the "sun lit docks of the East River . . ." and refers to the ". . . itinerant preachers [who] often take their stand outside the Bankers' Trust

at the corner of Wall and Nassau Streets, exhorting the noon-time crowds of clerks and office boys to forsake Mammon and return to God . . ." in roughly the same spot that Stettheimer placed her Salvation Army "Glory Hole."

33. *New York Times*, April 30, 1938, p. 3.

34. *New York Times*, May 1, 1939, p. 8.

35. See such articles as "Reenactment . . . ," *New York Times*, Tues., April 25, 1939, p. 3, and "In Washington's Footsteps," by H. I. Broch, *New York Times Magazine*, Sun., April 30, 1939, p. 6, as well as accounts in *New York Times*, Mon., May 1, 1939, p. 8.

36. *New York Times*, May 1, 1939, p. 8, with photograph of ceremony.

37. Once more, the identifications are from McBride, Museum of Modern Art catalogue, 1946, p. 53, and the Metropolitan Museum Archives. For a lengthier discussion, see Tyler, pp. 74–78.

38. I have not been able to pin down any specific incident which may be said to have "inspired" *Cathedrals of Art*. There are, however, several possibilities which may have contributed to its genesis: for example, the recent appointment of Francis Henry Taylor as director on Jan. 8, 1940; the reinstallation of the paintings in almost all the galleries, a project nearing completion in Aug. 1941 (*Bulletin of the Metropolitan Museum*, Aug. 1941, pp. 163–165); or a contemporary costume show, held in the museum shortly before the artist began her painting, which featured a "cocktail dress" like the one that figures so prominently in her work (Tyler, p. 74).

39. Meyer Schapiro, "Public Use of Art," *Art Front*, Nov. 1936, p. 6. I am grateful to Dr. Greta Berman for calling this article to my attention.

40. A third exhibition, "The Flowers of Florine Stettheimer," organized by Kirk Askew Jr., was held at Durlacher Bros. in 1948.

41. *Crystal Flowers*, p. 26.

About the Editor
and Contributors

Mary Ann Calo is associate professor in the Department of Art and Art History at Colgate University. She is the author of *Bernard Berenson and the Twentieth Century* (1994).

Matthew Baigell, author of *A Concise History of American Painting and Sculpture* (1984, 1996) and the *Dictionary of American Art* (1979), holds the rank of Professor II in the Department of Art History at Rutgers University. He has published widely on various aspects of American art. His most recent books include *Soviet Dissidents Artists: Interviews After Perestroika* (1995) and *Jewish-American Artists and the Holocaust* (1997).

Sarah Burns, professor in the Hope School of Fine Arts at Indiana University, writes on nineteenth-century American art and culture. She is the author of *Pastoral Inventions: Rural Life in Nineteenth-Century American Art and Culture* (1989) and *Inventing the Modern Artist: Art and Culture in Gilded Age America* (1996).

Anna C. Chave is professor of the history of art at Queens College and The Graduate Center, C.U.N.Y. Among her numerous publications on twentieth-century art are *Constantin Brancusi: Shifting the Basis of Art* (1993) and *Mark Rothko: Subjects in Abstraction* (1989).

Wanda M. Corn, noted scholar of late nineteenth-and early twentieth-century American art, is professor of art history in the Art Department of Stanford University. Her study on American modernism during the interwar period will be published in 1998.

Erika L. Doss teaches art history at the University of Colorado, Boulder. She is the author of *Benton, Pol-*lock, and the Politics of Modernism: From Regionalism to Abstract Expressionism* (1991) and *Spirit Poles and Flying Pigs: Public Art and Cultural Democracy in American Communities* (1995).

Vivien Green Fryd is associate professor in the Department of Fine Arts at Vanderbilt University. She is the author of *Art and Empire: The Politics of Ethnicity in the United States Capitol, 1815–1860* (1992).

Robert E. Haywood is assistant professor of modern and contemporary European and American art at the University of Notre Dame. He has published on Claes Oldenburg is currently at work on a book about Happenings in the 1960s.

Gail E. Husch, associate professor of art history at Goucher College, writes on nineteenth-century American genre, religious and historical imagery.

Elizabeth Johns is Silfen Term Professor of American Art History at the University of Pennsylvania. She is author of *Thomas Eakins: The Heroism of Modern Life* (1983) and *American Genre Painting: The Politics of Everyday Life* (1991), as well as numerous articles and exhibition catalog essays on American art.

Margaretta M. Lovell is associate professor of the history of art and co-director of American studies at the University of California, Berkeley. She is the author of *A Visitable Past: Views of Venice by American Artists, 1860–1915* (1986) and other essays on eighteenth- and nineteenth-century American art and material culture.

David M. Lubin, author of *Picturing a Nation: Art and Social Change in Nineteenth-Century America*

(1994) and *The Act of Portrayal: Eakins, Sargent, James* (1985), is the Gillespie Professor of Art and American Studies at Colby College.

Angela Miller is associate professor of art history at Washington University. She is the author of *Empire of the Eye: Landscape Representation and American Cultural Politics, 1825–1875* (1993), which was awarded the John Hope Franklin Prize in American Studies.

Linda Nochlin is Lila Acheson Wallace Professor of Modern Art at the Institute of Fine Arts, New York University. She has published extensively on a wide range of issues within the history of modern art. A number of her essays have been collected in *Women, Art, and Power and Other Essays* (1980) and *The Politics of Vision: Essays on Nineteenth-Century Art and Society* (1989).

Richard J. Powell is associate professor and chair of the Department of Art and Art History at Duke University. He is the author of several books, exhibition catalogs, and articles on the arts of the African Diaspora, including *The Blues Aesthetic: Black Culture and Modernism* (1989), *Homecoming: The Art and Life of William H. Johnson* (1991), and *Black Art and Culture in the 20th Century* (1997).

Judy Sund, associate professor of art history at the City University of New York, teaches and writes about European and U.S. art of the eighteenth through the twentieth centuries. She is the author of *True to Temperament: Vincent van Gogh and French Naturalist Literature* (1992).

David Tatham, author of *Winslow Homer in the Adirondacks* (1996), is professor of fine arts at Syracuse University. He has published widely on Winslow Homer and is the author of numerous articles on nineteenth-century American art.

Alan Trachtenberg is Neil Grey, Jr. Professor of English and American Studies at Yale University. Among his many publications on American culture are *Brooklyn Bridge: Fact and Symbol* (1965) and *The Incorporation of America: Culture and Society in the Gilded Age* (1982). A number of his essays on photography have been collected in *Reading American Photographs: Images as History, Mathew Brady to Walker Evans* (1989).

John Michael Vlach is professor of American studies and anthropology at The George Washington University, where he also serves as director of the Folklife Program. Among his numerous publications in the areas of folklore, American material culture, and vernacular architecture are *Plain Painters: Making Sense of American Folk Art* (1988) and *Folk Art and Art Worlds* (1986, with Simon J. Bronner).

Judith Wilson is assistant professor in the Department of the History of Art and the African and African-American Studies Program at Yale University. She has just completed a study of the painter Bob Thompson (soon to be an exhibition at the Whitney Museum) and is the author of numerous articles, reviews, and catalog essays on African-American art of the nineteenth and twentieth centuries.

William Wroth is a specialist on Hispanic and Indian art and cultures of the Southwest and Mexico. An independent curator and writer, he is the author of *Christian Images in Hispanic New Mexico* (1982) and *Images of Penance, Images of Mercy: Southwestern Santos in the Late Nineteenth Century* (1991), among other works.

Index

Artist names are in boldface type.

Abbott, Berenice, 255
Abduction of Daniel Boone's Daughter by the Indians (Wimar painting), 104, 108(n45)
Abrams, Ann, 16
Abstract Expressionism, 4, 10, 269
Academic artists, 12
Adams, John, 42
Adamson, Jeremy, 16
Adirondacks, 157, 167(n6). *See also under* Homer, Winslow
Aesthetic Movement, 193
Africa, 289
African-American nationalism, 204, 212
African-American women, 200, 222–223
African figures and masks (Johnson sculptures), 289–290
African Methodist Episcopal (A.M.E.) Church, 201—202, 203, 209, 212
After the Hunt (Homer watercolor), 160–161
Agnew, D. Hayes, 189, 191
Agulhon, Maurice, 224
AHAA. *See* Association of the Historians of American Art
Allston, Washington, 9
Alten, Fred, 120
A.M.E. Church. *See* African Methodist Episcopal Church
"America as Art" exhibition (1946), 12
American art
 analysis, 10–23
 compared to European art, 3–4, 6, 13, 29(n18), 271, 276
 defined, 27(n1)
 diversity, 1, 9, 10. *See also* Revisionism
 eighteenth- and nineteenth-century surveys, 9, 10–11, 12
 historians, 1, 2, 3, 15–16, 19, 20—21, 25
 journals, 5, 7
 museum exhibitions, 1, 4, 9, 10, 11, 12, 13, 14, 16, 21–22, 23

 national perspective, 3, 5–6, 21, 82–83, 93, 269–273, 281–282
 private collections, 2, 9
 scholarship, 1–3, 5, 6–12, 15–16, 23–25
 and social and economic forces, 5–6, 110, 177–179, 270, 296. *See also* Cultural change; Family relationships changes; Feminism; Race
 traditions, 10, 11, 13
"American Art: 1750–1800" exhibition, 22
American artists abroad, 12, 13, 14–15, 35, 43, 229, 286
American Art Journal, 5, 24
American Art-Union, 82, 105
American character, 271–272
American Civilization programs, 5, 8
"American Colonial Portraits: 1700–1776" exhibition, 21
American Impressionism, 9, 273
Americanists, 5, 7, 14, 19, 23
"American Light: The Luminist Movement, 1850–1875" exhibition (1980), 11
American Magazine, 245
American Museum (N.Y.), 64
American Negro Academy, 203, 204
American Negro Exposition (1940), 291
American Quarterly, 5
American Renaissance, 13
"American Sampler, An: Folk Art from the Shelburne Museum" exhibition (1987), 23
American Scene Movement, 269, 278–280, 281
American Studies programs, 5, 16, 19–20
American Tradition in Painting (McCoubrey), 10
Ames, Kenneth L., 110
Anatomy, 174
Anderson, Sherwood, 277
Animal Locomotion photographic series (Mybridge), 246
Anthony, Susan B., 222, 224

Apollo Belvedere, 52
Architecture, 3, 224, 236(n8), 255, 257–258
Archives, 2, 5
Archives of American Art, 5
Ariadne, 50–51, 52
Ariadne Asleep on the Island of Naxos (Vanderlyn painting), 48(photo), 49, 50, 52, 55
 criticism, 47, 49, 54–55
 themes, 47–48, 49–52, 56
Armory Show (1913), 270–271
Art Bulletin, 23
Art education, 172–175
 and women, 186
Art Front (journal), 315
Arthur Middleton, His Wife, Mary (née Izard) and Their Son, Henry (West portrait), 41
Artist's Family, The (West portrait), 35–36, 37
Artist studies, 9–10, 13, 15, 16
Art patronage, 9, 15, 60, 164, 199
 federal, 13, 96, 97, 269, 278, 281. *See also* New Deal
Arts (journal), 277
Art Students League (N.Y.), 186, 297, 306
Asbury Park South (Stettheimer painting), 309
Ash-Can School, 270, 278
Asian American artists, 25, 280
Association of the Historians of American Art (AHAA), 2
Atlantic Monthly, 139, 140
At the Opera (Cassatt painting), 231, 234
"At the Polls" (woodcut), 78
Audubon, John, 8
Ault, George, 278
Austin, Mary, 279–280
Avant-garde painting, 13, 254, 263

Bacon, Peggy, 12
Badger, Reid, 224, 226
Baigell, Matthew, 9
Baillie Family (Gainsborough portrait), 41
Bakhtin, M. M., 139
Ballard, Allen B., 202